Vision & Accident

Presented

To the Kensington Museum

Which owes its existence

To the great & good Prince

by

His sorrowing Widow

Victoria R

June 22 1869

Vision & Accident

The Story of the
Victoria and Albert Museum

Anthony Burton

V&A Publications

This book is dedicated to the
memory of Shirley Bury
(who died on 25 March 1999)
and to John Physick.

First published by V&A Publications, 1999

V&A Publications
160 Brompton Road
London SW3 1HW

© The Board of Trustees of the Victoria and
Albert Museum 1999

Anthony Burton asserts his moral right to be
identified as the author of this book

Designed by James Shurmer

ISBN 185177 2928

A catalogue record for this book is available
from the British Library

Printed and bound in Great Britain
by Butler & Tanner Ltd, Frome

Frontispiece: Inscription by Queen Victoria,
from Charles Grey's *Early Years of the Prince
Consort*, 1868. V&A: NAL

CONTENTS

ACKNOWLEDGMENTS

Because I have worked at the V&A since February 1968, this history is bound to be in some respects an insider's view. But my career in the V&A has been sufficiently erratic to enable me to develop a 'semi-detached' attitude. I have been at the centre of things sometimes (taking the minutes at Advisory Council Meetings; responsible in earlier times for the training of junior staff; occupying a seat at the cabinet table, as a departmental head). But the departments in which I have chiefly worked – the National Art Library and the Bethnal Green Museum of Childhood – are somewhat out of the mainstream of the museum, and tend to inculcate slightly oppositional attitudes in their staff.

So my career path, together with personal obstreperousness (for which I probably owe some apology to my bosses in my early days, John Harthan and Ronald Lightbown, from whom I learned much, in spite of being restive), has, I hope, enabled me to take a fairly independent and unbiased view of the museum. I was appointed in Pope-Hennessy's time, but never knew him well. Roy Strong and Elizabeth Esteve-Coll were the Directors who shaped my working life, and I am grateful to them for opportunities and encouragement. Now, under Alan Borg, I am a sort of veteran in the chimney corner, but am heartened by his interest.

Among my mentors in the museum, I must put first the late Robert Kenedy, Assistant Keeper of the Library, a free-ranging intellectual who did not fit into the museum at all comfortably, and therefore constantly revealed its oddities and imperfections by the light of his own originality. Alongside him, I am indebted to Shirley Bury and John Physick, who, as historians of the museum, are the giants upon whose shoulders I sit. They inherited the role of historian from Charles Gibbs-Smith, whom I also knew when, after retirement, he settled in the Library as a super-numerary Assistant Keeper. He was an inexhaustibly eccentric but life-enhancing person. Our little apostolic succession of museum historians also includes Elizabeth Bonython (working on a biography of Henry Cole), who has provided constant stimulus and encouragement.

One is, perhaps, influenced most (though often indirectly) by one's own generational cohort, which in my case means (in alphabetical order) Charles Avery, Anne Hobbs, Simon Jervis, Susan Lambert, Santina Levey, John Murdoch. While at the Bethnal Green Museum of Childhood I had the good fortune to work with Jim Close (as boss) and Vera Kaden (as colleague), both of whom were beacons of sanity. Irene Whalley and Simon Tait were also staunch allies.

Others who have worked on the history of the museum, and to whom I am indebted, are Clive Wainwright and Ann Eatwell. In the National Art Library, contributions have been made by Chiara Barontini, Helen Pye-Smith and, above all, by Elizabeth James, who has not only published a bibliography of V&A publications, but also reshelved them all in order in a convenient place. Another fairly recent feature in the V&A, of immense value to the historian, is the V&A Archive at Blythe Road, where I have been helped by Serena Kelly, Christopher Marsden, Eva White and Maureen Mulvanny. For help from other institutions, thanks are due to Iain Young of the James McBey Art Reference Library, Aberdeen Art Gallery; Susan Bennett of the Royal Society of Arts; Mairead Dunlevy of the National Museum of Ireland; Cathy Ross of the Museum of London.

In obtaining the illustrations for this book, I am especially indebted to Lucy Dean of the National Art Library; and to Andrew Spira (Metalwork), Nick Umney and Sally Merriman (British Galleries) and Katie Christie (Major Projects). For photography, thanks to James Stevenson, Head of the V&A's Photo Studio and Picture Library, and to many of his staff, including Ken Jackson, Dominic Naish, Rachel Coates, Mike Larkin and Jo Wallace. For help in obtaining illustrations from outside the museum, I acknowledge the National Portrait Gallery; Jonathan Riddell at the London Transport Museum; Anne Hobbs; Hazel Nash; and Nicholas Bromley.

I am grateful to those who have read parts of the text (any remaining errors are, of course, my responsibility): David Anderson, Susanna Avery-Quash, Malcolm Baker, Nicholas and Helen Bromley, Susan Haskins, Monica Hastings and, especially, Elizabeth Bonython and John Physick. Carol Baker has given all the encouragement (ranging from consolation to admonition) which only a spouse can provide.

The time and space to write this book were provided by the Research Department, a relatively recent innovation at the V&A, the purpose of which is to ensure that the substantial knowledge garnered by curators is turned into a form that can be enjoyed by the world at large, in publications or exhibitions. Under the supervision of Paul Greenhalgh, Malcolm Baker has motivated me, and criticized and approved my efforts. My thanks also to Mary Butler and Miranda Harrison of V&A Publications, and to Mandy Greenfield, my editor.

Finally, I should say that this book is not the last word on the history of the V&A: there is plenty more work to be done.

PREFACE

As a genre, museum histories, as Alan Wallach has recently said, have tended to be 'pretty much a celebratory discourse'.[1] Only in recent years has a greater critical rigour entered into the writing of them. The V&A has never published a comprehensive view of its history. There has been an architectural history of its building,[2] and a brief history of its collections,[3] but nothing on the ethos and working of the institution itself. Few other museums, indeed, have written their own histories, perhaps because even a celebratory discourse involves a degree of self-reflexiveness that seems not to come easily to curators. By contrast, the National Trust, which is intrinsically a campaigning body, has published (or provoked) at least ten histories during its first century of existence.[4]

The author of this history has been employed at the V&A for many years. I joined in 1968, worked in various parts of the museum, and am still on the payroll as I write this. My account is, therefore, in a way 'official'. It does draw on a sense of piety, and of dutiful dependence. But I hope it is not a bland, complacent, celebratory account. Scandal and absurdity are reported here, not only because we need to give even a museum history market appeal (the economic imperative reaches everywhere nowadays), but because these are inescapable aspects of the story. If I have a critical position, it is, I hope, not based on any particular ideology, but on my personal notion of what museums should do to memorialize, re-invigorate and mould our common culture. I hope, too, that the recently accelerated work on the definition of professional museum skills and on the theoretical deconstruction of museum practice has informed what I have written.

So far as I can see, during its first hundred years the V&A formulated no coherent version of its own history. Policy statements were few and far between and, where history entered into them, it was generally angled to suit some particular contemporary circumstance. When a somewhat more shaped narrative begins to be communicated after the Second World War, I detect the hand of Charles Gibbs-Smith in it. He would have felt duty-bound to present the museum in a tidy and fairly imposing guise.

More recently, authors of short articles have begun to approach the V&A from diverse perspectives. I wrote a piece construing the V&A's history as a conflict between scholarship and administration.[5] Tim Barringer has looked at the V&A in the light of imperialism.[6] Rafael Denis has used the curious military ethos that suffused South Kensington as an explanatory metaphor,[7] and Louise Purbrick has taken the economic imperative as a theme.[8] Charlotte Benton has speculated on how the building shaped the attitudes of those within it.[9]

A corporate reassessment of the V&A's history has recently been conducted through the exhibition *A Grand Design: The Art of the Victoria and Albert Museum*, which travelled in North America in 1988–9, with a London showing in autumn 1999. The contributors to the catalogue of the exhibition, under Malcolm Baker's guiding hand, have – while writing specifically about the objects – contrived to make these throw light on the museum's practices and ideologies.

In a book-length study like this one, all these approaches – and more – must be apt from time to time, perhaps creating an indigestible mixture. I am conscious, though, that I have had two chief preoccupations. I have tried wherever possible to present the museum as its public saw it. This involves a lot of quotations, with a perhaps not-very-invisible author steering them. Whatever its faults, this method can be applied right through the story, up to the present, imparting at least apparent objectivity to the treatment of events in which I was personally involved. It seems to me that the attempt to see the museum as its audience saw it is appropriate at this juncture, since the main development in museum life in my time has undoubtedly been the rediscovery of the audience.

It has struck me too that, just as inside every fat man there is supposed to be a thin man struggling to get out, so within the pompous, remote and quarrelsome V&A there has always been a more humane and generous museum trying to emerge. This amiable, clubbable V&A is surely more to be encouraged than the aloof, exclusive V&A that has sometimes cold-shouldered the public.

For the creative impulse in humankind is no respecter of persons. The ability to make imaginative constructions, and to realize them in words, or in music, or in more concrete form as objects or pictures, is found in all sorts and conditions of people. The products of creativity, however, are not equally shared. To be sure, literature can be widely and cheaply distributed. But paintings, sculpture and things finely made for use in mankind's social, religious or domestic life have tended to remain the prerogatives of the rich and privileged.

Over the last two hundred years, with the spread of democratic politics, such cultural capital has to some extent been redistributed, transferred from the possession of the rich and the privileged to the ownership of the larger community. Museums have been the means by which this transfer of ownership has taken place. Museums, as the

new owners of cultural property, are surrogates for the person in the street. Some museums take to this more happily than others; it is all too easy for museums absent-mindedly to slip back into the roles of surrogates for the rich and privileged, even after these castes have been disempowered.

The V&A has, over the years, tended to station itself in that part of the museum world where prestige, power and privilege still retain a foothold. It is one of a select group of national museums in Britain, and one of the grandest museums in the world. Official accounts of its origin tend to suggest that such grandeur was there from the start, and often imply that there was a historical inevitability behind the museum's foundation. 'It had long been thought desirable ... to form a Museum of Manufactures ... illustrative of the history and progress of industrial art.'[10] 'The need for such a Museum had long been foreseen.'[11] But such views overestimate the purposiveness of the museum's development.

This book suggests that the V&A appeared on the scene almost by chance, and that, in its development, accident continued to modify vision and purpose. Because, however, the museum began with a powerful commitment to ideology, its vision and purpose were constantly and passionately proclaimed and debated. This sets it apart from most museums, which silently devote themselves (with passion, often, but an unavowed and even unconscious passion) to simple increase. The V&A certainly increased at a great rate, but all the while haranguing and grumbling, scheming and extemporizing – which makes a vivid story.

NOTES

1 Alan Wallach, *Exhibiting Contradictions: Essays on the Art Museum in the United States*, Amherst, Mass.: University of Massachusetts Press, 1998 p. 2

2 John Physick, *The Victoria and Albert Museum. The History of its Building*, London: Victoria and Albert Museum, 1982.

3 Anna Somers Cocks, *The Victoria and Albert Museum: The Making of the Collection*, Leicester: Windward, 1980.

4 For example, J. Lees-Milne (1945); C. Williams-Ellis (1945); R. Fedden (1968); G. Murphy (1987); J. Gaze (1988); J. Lees-Milne (1992); J. Jenkins and P. James (1994); M. Waterson (1994); P. Weidegger (1994); H. Newby (1995).

5 Anthony Burton, 'The Image of the Curator', *V&A Album 4*, 1985, pp. 372–87.

6 Tim Barringer, 'Re-presenting the Imperial Archive: South Kensington and its Museums', *Journal of Victorian Cultures*, vol. 3, no. 2, autumn 1998, pp. 357–73.

7 Rafael Cardoso Denis, 'The Brompton Barracks: War, Peace, and the Rise of Victorian Art and Design Education', *Journal of Design History*, vol. 8, 1995, pp. 11–25.

8 Louise Purbrick, 'South Kensington Museum: The Building of the House of Henry Cole', in Marcia Pointon (ed.), *Art Apart: Art Institutions and Ideology across England and North America*, Manchester: University Press, 1994, pp. 69–86.

9 Charlotte Benton, '"An insult to everything the Museum stands for" or "Ariadne's thread" to "Knowledge" and "Inspiration"? Daniel Libeskind's Extension for the V&A and its Context. Part II', *Journal of Design History*, vol. 10, 1997, pp. 309–28.

10 John C.L.Sparkes, *Schools of Art: Their Origin, History, Work, and Influence*, London: Clowes, 1884, p. 69

11 Royal Commission on National Museums & Galleries, *Interim Report dated 1st September, 1928*, London: H.M.S.O., 1928, p. 17

ABBREVIATIONS

When an abbreviated reference (e.g. a short title, or op. cit., indicating a work already quoted) is given in an endnote, full details of the work concerned will be found within the notes of the chapter to which the abbreviated reference applies. The following abbreviations, however, apply throughout.

Archive The archive of the V&A's own official papers, which may be consulted in the Reading Room of the NAL's Archive of Art and Design at Blythe House, Kensington.

Cole Diary Henry Cole's original diaries, together with a typed transcript by Elizabeth Bonython (from which my quotations are drawn), covering the years 1822–34, 1837–54, 1856–82, are in the NAL.

DNB *Dictionary of National Biography*.

Fifty Years Alan and Henrietta Cole (eds), *Fifty Years of Public Work of Sir Henry Cole, K.C.B. Accounted for in his Deeds, Speeches and Writings*, 2 vols, London: Bell, 1884.

First Report [for 1853], *Second Report* [for 1854], etc.
 The Department of Science and Art published an annual printed report ('blue book'), each volume being issued in the year following the year on which it reported. These volumes are referred to by the above formulae.

HMSO Her (His) Majesty's Stationery Office.

NAL The National Art Library in the V&A.

Physick John Physick, *The Victoria and Albert Museum. The History of its Building*, London: Victoria and Albert Museum, 1982.

Précis The papers of the Board of the Department of Science and Art are held in the Public Record Office. A printed *Précis of Board Minutes* was periodically produced, recording decisions taken, in summary form. Volumes in this series (available in the NAL) are referred to as *Précis*, followed by dates indicating a particular volume.

Survey of London...The Museums Area
 Survey of London...Volume XXXVIII. The Museums Area of South Kensington and Westminster, published for the Greater London Council, London: University of London, Athlone Press, 1975.

V&A Cuttings Book Press cuttings were kept by the museum in albums, arranged in various ways over the years. These may be consulted in the Archive of Art and Design, where a list is kept. References in the endnotes give dates and other formulae necessary to identify a particular volume.

Art and Industry in the 1830s and '40s

Many of the world's great public art museums and galleries originated in the private collections of royal or noble families, which were given to, or appropriated by, modern states. Dispensing with royalty and nobility in favour of republican or democratic forms of government, such states nonetheless accepted the aristocrats' art at the aristocrats' estimation. The new public museums continued to uphold a canon of High Art that had been established in western Europe in the Renaissance, and developed in later centuries. The odd thing about the Victoria and Albert Museum is that it did not belong to this tradition. It started from nothing in a School of Design, which the Government set up in 1836, as a result of a House of Commons Select Committee on Arts and Manufactures that sat in 1835–6. While this statement may well suggest that what took place was sagacious deliberation and resolute action by an enlightened state, reality, as we shall see, was more haphazard. At first the V&A directed itself towards the common populace and adopted an anti-Establishment stance. From there its journey was ever upward, as it found favour with the élite. In order to understand what the V&A was in its earliest days, we need to be aware of what it was not. It is appropriate, therefore, to look at the status and advancement of High Art in early nineteenth-century England.

High Art and public patronage

Debates on creative achievement or museum practice nowadays seem quite often and quite early to throw up the question: 'Yes, but is it Art?' This question takes for granted that 'Art' constitutes a distinct category of activity or production – self-defining, exclusive and unchallengeable. Most people, at any rate in the West, seem to have this assumption as part of their mind-set. Post-modern pluralism has done something to shake what might be called the absolutism of Art. But there is a lot at stake in terms of prestige and money, so the Art world still tends to project itself as an exclusive zone. One of its secret weapons is the accepted usage of the word Art: in the singular, with a capital letter (implied, if not always actual).

In the 1830s, Art-as-cultural-commodity (the pictures and objects) was accessible to far fewer people than it is today, but, paradoxically, the word art was much more freely available. For, as has often been pointed out, 'in England the use of "Art" implying "the Fine Arts" is a 19th-century usage'.[1] Before the change of use, art simply meant skill, and had done so for centuries, taking this sense from the Latin word *ars*, from which the English is derived. If we want to sample eighteenth-century usage, a conspicuous test-case might be the annual lectures that Sir Joshua Reynolds delivered to the students of the Royal Academy. These are usually known now as his *Discourses on Art*, but Reynolds hardly ever used the word art in a 'unitary' sense.[2] In discoursing on painting, he spoke often of 'the art' (meaning 'the Art which we profess'[3] at the Academy) and often of 'our art'. The inference may be drawn that there are many arts, pertaining to many kinds of people. This is implicit, too, in the gnomic sentence from the tenth Discourse, which is carved over the main entrance to the V&A: 'The excellence of every art must consist in the complete accomplishment of its purpose.' Whatever this means,[4] it implies that there are many arts, not one domain

Vignette: The final plate in William Dyce's *Drawing Book of the Government School of Design* (1842). Intended to guide the student from the simplest geometrical patterns onwards, the book was never completed and only a few parts were published. This illustration could represent the limited extent of instruction available at the School, but the course nonetheless inspired in students a 'fear of Dyce's Outlines, especially those at the end of the book', according to the architect William Burges (*Art Applied to Industry*, 1865, p.5).

of Art. For Reynolds, the world of arts ranged from 'the Polite Arts' or 'the arts of elegance', which were the natural concern of top people,[5] to 'the mechanick and ornamental arts'.[6] He always directed his students towards the best (the 'great style' that would embody 'ideal beauty' or 'the highest perfection') and certainly contributed to an élitist view of art. But he did not believe in art as 'a kind of *inspiration*, as a *gift* bestowed upon peculiar favourites at their birth',[7] a view that was to be asserted by Romantic critics.[8] For him there was a hierarchy of arts, with history painting at the top, but room for many other arts lower down.

The eighteenth-century use of 'arts' is preserved in the title of the Royal Society of Arts. When founded in 1754, this body took as its name 'The Society for the Encouragement of Arts, Manufactures and Commerce', for it was concerned with all kinds of human ingenuity – not excluding the pictorial arts, but not exalting them above industrial and agricultural pursuits. It is significant that this Society was the platform from which the principal shaper of the V&A, Henry Cole, launched his projects throughout his life. 'By means of the Society of Arts Mr Cole has ... been able to set the public in motion; by such means, also, what may be called his Department of the Government was brought into existence; and upon the same means he has always relied for public co-operation with his official projects when they required such help.'[9] Taking his stand, thus, on 'Arts' rather than 'Art', it is hardly surprising that Cole gave some thought to the changing meanings of the word. In his memoirs, for example, he asked himself 'at what period the use of the word "ART", to imply "Fine Art", first arose'. He could not answer this, but noted that 'the old encyclopaedias and dictionaries, before 1851, gave the usual explanation of "Art" as practice or doing'.[10] He quotes from an article in the *Encyclopaedia Britannica* (9th edition, 1875–89) by the critic and curator Sidney Colvin, who, accepting the traditional view that Art is the antithesis of Nature, defines art as skill or practical ability.

Colvin also defines art by setting it against science. This word, too, did not mean in the early nineteenth century quite what it means now, and it is worth noticing this because, for the first half-century of its existence, the V&A was part of a 'Department of Science and Art'. This Government department was created in March 1853, and it seems likely that Prince Albert had much to do with the appearance in the spotlight of 'Science', which seems to have taken many people by surprise. At the prorogation of Parliament in summer 1852, the Queen committed her Government 'to develop and encourage industry, art, and science' and it was said that 'this is the first time that the word *Science* has, in the hearing of Parliament, been pronounced from the throne of England'.[11] Although the Queen seems to have used the word in the sense of 'those

branches of study that relate to the phenomena of the material universe and their laws' (*New English Dictionary*), it could still be used as more or less synonymous with 'theory', as opposed to practice. As Colvin put it, 'Science consists in knowing, Art consists in doing.'

It followed that any art might have its own science (i.e. its theory), and, vice versa, that one might speak of the art (i.e. the practical aspects) of a scientific discipline. A writer discussing engineering training in 1838 could, therefore, deploy the terms thus [my italics]: 'Let [the student] follow out the general course of *science* until as he advances to its *practical applications* he fixes upon some particular mechanical or chemical *art*, towards which his peculiar talent ... directs him; let him then embrace that *art*, and follow out the *science* of it ...'[12] Later, in the 1850s, in the Prospectus of the Government School of Mines (the first Government body concerned with scientific education), a student could read that, while the School offered 'general instruction in Science', its basic purpose was to teach 'the *actual practice* of Mining, or of the *Arts* [my italics] which he may be called upon to conduct'. In the nineteenth century, 'pure' science tended to be called 'abstract science', while 'practical science' signified what came to be called 'technology'. (This word was recorded as newly in use – no one 'could pronounce it without palpable hesitation' – at a meeting in 1872, but did not come into common use until the twentieth century.)[13] When Science and Art were yoked together in the new Government department, it must to some extent have led to each defining itself (if only negatively) in terms of the other; perhaps the resulting opposition of ideas may have contributed to the estrangement between 'the two cultures', which was to lead to acrimonious controversy in England a century later.[14]

Aware, then, that in considering art and science in the nineteenth century we are moving on a semantic travellator, we can now return to consider the state of 'Art' in England in the 1830s. England was richly endowed with Art-as-cultural-capital, notably Antique sculpture and Old Master paintings. This investment, however, had been comparatively recently made, after a period in which England was culturally backward. While in Europe the Catholic Church had been an important patron of art from the Middle Ages, and noble families from the Renaissance onwards had built up dynastic collections, in England such cultural development had been disrupted. The Protestant Reformation caused the destruction of much of England's heritage of medieval art and the virtual disappearance of ecclesiastical patronage. The British royal family, in the shape of Charles I, had a magnificent collection, but when Charles was deposed, the collection was dispersed. In the seventeenth and early eighteenth centuries English painting, sculpture, architecture and design remained lacking in

originality and heavily subject to foreign influence. Some foreigners regarded England's poor performance in the visual arts as an inevitable consequence of the climate.[15]

The English did, however, gradually become more interested in acquiring works of art from elsewhere, and by the later part of the eighteenth century assumed the role of 'Europe's most enthusiastic and extravagant collectors'.[16] England's new taste for works of art was amply gratified when the French Revolution and the Napoleonic wars led to the dispersal of many continental art collections. 'The storm of Revolution, as it passed in turn over the countries of Europe, shook this glorious fruit in deplorable plenty into our laps,' wrote Lady Eastlake.[17] Another writer viewed works of art almost as political refugees: 'we find the beautiful and valuable creations of art taking refuge from the turmoils of political anarchy and military despotism under the protection of England's free institutions, and well regulated social system'. He did, however, also acknowledge that economics influenced events: 'the English were always at hand with cash'.[18] Thus great collections were assembled in England in the early nineteenth century.

These collections were, however, in private hands. In the 1830s it was not too difficult for an informed inquirer to find out about them, since two German scholars thought it worth while to publish detailed surveys of art in England. Johann David Passavant's survey, published in German in 1833, appeared as *Tour of a German Artist in England* in 1836, while Dr Gustav Waagen, Director of the Royal Gallery in Berlin, published three volumes in German in 1837, which appeared the following year as *Works of Art and Artists in England*.[19] Furthermore, the right kind of people could sometimes even get to see the art. 'Many choice collections,' W. B. Sarsfield Taylor rejoiced to say,

have been occasionally opened under certain regulations in the summer season, and generally there exists a most liberal feeling on the part of the proprietors of valuable galleries and collections of paintings, sculpture, virtù, &c., with respect to the admission of respectable persons who are properly introduced. This is done to a great extent, although it is sometimes attended with inconvenience to the noble and wealthy owners of these valuable possessions.[20]

For many it was a matter of pride that England's artistic wealth had been assembled by private enterprise without public subsidy. 'The taste of the country,' Lady Eastlake insisted in the Tory *Quarterly Review*, 'has had its roots in private impulses.' Meeting the criticism that the Government had failed to contribute anything, she indignantly asked, 'Shall we stigmatize a Government which has made individuals freer than itself?' In her view, the Government deserved 'credit for that inestimable, if unintentional patronage of art, which consists in securing us the prosperity that has thus enriched our own mansions'.[21]

Not everyone was content for art to remain in the mansions of the rich, and attempts were hesitantly made to bring some of it into the public domain. In England, as elsewhere, the democratization of knowledge preceded the democratization of art: public museums existed before public art galleries. The Ashmolean Museum in Oxford (which could claim to be the earliest public museum of Europe)[22] opened in 1683, and the British Museum in London in 1759, but these were at first predominantly natural history collections. The British Museum's acquisitions of classical antiquities, such as the Towneley Marbles in 1804 and the Elgin Marbles in 1816, transformed it during the early nineteenth century into an important artistic repository. The purchase by the Government of the Elgin Marbles, although this was a confused and half-hearted act, did bring about some discussion of the nation's role as an artistic patron.[23]

Paintings had to wait a little. In Europe, royal collections of paintings and sculpture became publicly accessible with the opening of the Belvedere in Vienna (1781), the Louvre in France (1789) and the Prado in Madrid (1819), but in England the royal collection remained closed, and it was only in 1824 that the Government grudgingly agreed to create a National Gallery from the collection of a businessman, John Julius Angerstein. As with the Elgin Marbles, the fortunes of the gallery provided a focus for discussion of public patronage, and the purposes of galleries and museums.[24]

The National Gallery paintings at first remained in Angerstein's town-house, 100 Pall Mall. This cut a sorry figure beside the galleries abroad that occupied royal

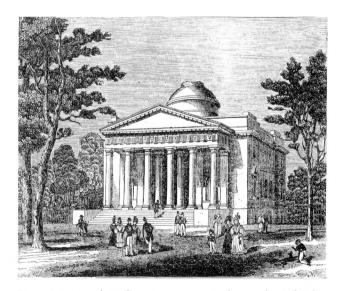

Figure 1.1 An early 19th-century museum in the neo-classical style, as illustrated in a popular paper. The Hunterian Museum, Glasgow, the building designed by William Stark, 1806, wood-engraving from the *Penny Magazine*, 1835, p. 429. Compare figure 3.4.

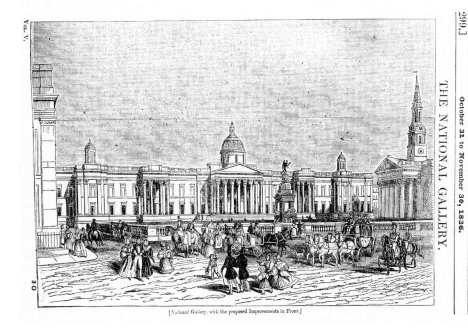

Vol. V.

[299.]

Monthly Supplement of
THE PENNY MAGAZINE
OF THE
Society for the Diffusion of Useful Knowledge.

October 31 to November 30, 1836.

THE NATIONAL GALLERY.

[National Gallery, with the proposed Improvements in Front.]

Figure 1.2
The National Gallery, London, the building designed by William Wilkins, opened in 1837, wood-engraving from the *Penny Magazine*, 1836, p. 465.

palaces. Furthermore, in Germany purpose-built museums began to appear in the 1830s. When a new sculpture gallery, the Glyptothek designed by Leo von Klenze, opened in Munich in 1830, an English writer, comparing it with the premises of the Royal Academy in England, dismissed the latter as 'the filthy and dismal little lumber-hole at Somerset House, where visitors annually grope about amid a squeeze of busts and statues'. When in the same year Berlin gained a new art gallery, the Altes Museum designed by Karl Friedrich Schinkel, an English critic praised its splendour as unparalleled in English museums.[25]

The National Gallery in London reopened in new premises in Trafalgar Square in 1838 (figure 1.2). This neo-classical building by William Wilkins provided the gallery with the kind of grandeur that was to become customary for museums. Buildings with frontages based on classical temples were already rising on the streets of British towns to accommodate town halls, theatres, banks and other institutions. The new German museums by Klenze and Schinkel adopted the neo-classical style. Wilkins used it for the National Gallery; Sir Robert Smirke's great pillared façade for the British Museum gradually emerged in the 1840s (though planned in 1823); and here and there in Britain other neo-classical museums arose: the Hunterian in Glasgow in 1806 (figure 1.1), the Fitzwilliam in Cambridge in 1837, the new Ashmolean in Oxford in 1841.[26]

These museums were, of course, primarily meant for those who could appreciate them, but the ordinary working man was entitled to venture through the portals. Inevitably he would be at a disadvantage. The architect of the

National Gallery, even while urging Government support for art, confessed in 1832 that 'there still exists amongst the lower orders a propensity to mutilate all works of Art within the reach of a walking-stick or of missiles'.[27] In 1848 the magazine *The Art Union* (p. 3), conducting one of its annual New Year surveys of art in Britain, was pleased to record that the National Gallery was 'thronged by a multitude', but described this multitude as 'struggling through imperfect powers, to the conception of the Truthful and the Beautiful in Art'. And even Dr Waagen, who prided himself on running his gallery in Berlin 'liberally', felt that some people just did not fit in:

I have at various times been in the National Gallery, when it had all the appearance of a large nursery, several wet-nurses having regularly encamped there with their babies for hours together; not to mention persons, whose filthy dress tainted the atmosphere with a most disagreeable smell ... It is highly important, for the mere preservation of the pictures, that such persons should in future be excluded ...[28]

In the early decades of the nineteenth century, then, there was no more than weak and patchy support for public art museums, and even less support for access to museums for working people. While there was a quite vigorous debate about Government patronage of the arts, this tended to be led by those who felt there was something in it for them. It may be that in older, simpler societies fine art had a public function in creating or defining the spiritual values of a nation; but in the more fragmented, competitive conditions of modern industrial society artists had less chance of speaking for society as a whole .[29] In the early nineteenth century they were often more concerned

with what advantages they might gain as a sectional group. In principle, a discussion on patronage would focus on 'the importance of Fine Arts to the Fame of a Nation' and 'the cultivation of Public Taste, and the influence of the Arts on the Morals of a People'.[30] In practice, artists concerned with their own fame would grumble that the Government had done nothing 'beyond bestowing the honour of knighthood on two or three personal favourites of the sovereign';[31] they would look to the Government to provide work; and, when considering museums and taste, would regard museums primarily as resources for artists. Many who argued in favour of greater patronage were working off resentment against the Royal Academy, which was seen as protecting the status of a small, exclusive group of top artists; John Pye's *Patronage of British Art* (1845) is the epitome of anti-Academy sentiment.

By the 1830s, however, the climate was beginning to change, and proposals could be heard that the Government should make art accessible to the whole people, rather than only to a cultivated minority. When Sir Robert Peel spoke in favour of a new building for the National Gallery during a House of Commons debate in 1832, he suggested that:

In the present times of political excitement, the exacerbation of angry and unsocial feelings might be much softened by the effects which the fine arts had ever produced on the minds of men ... The erection of the edifice would not only contribute to the cultivation of the arts, but also to the cementing of the bonds of union between the richer and poorer orders of state.[32]

Arguments were also advanced that the cultivation of the arts could be commercially useful. What such arguments show is not so much that the art Establishment was growing more generous with its treasures, but that the affairs of the art world were being caught up by developments in politics and education. It is to these developments that we must look for the impulse that led to the foundation of the V&A. The museum did not emerge from the early nineteenth-century art Establishment.

Politics and education

The origin of the V&A – which in fact began in a school – can be more convincingly located in the movements in support of the expansion of education, which gained strength in the early nineteenth century, especially after the Reform Bill of 1832. More particularly, the V&A can be seen as a pioneering attempt at vocational education.

If the patronage of art was generally left, by successive British Governments, to private enterprise, so too was the provision of education. The richest had always been accustomed to obtain individual tuition for their children. During the Middle Ages, the Church had provided education for less

rich children. After the Reformation in England had closed down the educational institutions of the Catholic Church, Protestant merchants rallied round to endow, within the supportive charity laws, grammar schools where free education was available to 'poor boys'. Although many of the grammar schools were in a state of neglect and stagnation by the end of the eighteenth century, educational provision had been much expanded by schools set up with the support of the Society for the Promotion of Christian Knowledge (a Church of England charity founded in 1699) and similar bodies. Some of the most progressive schools were created by Dissenters, adherents of religious sects outside the established Church of England, whose attitudes were sharpened by their underprivileged status. At the lowest level were 'dame schools', the sort of school that any old woman or village cobbler could open, in order to earn a pittance in return for imparting some very rudimentary instruction in reading and writing. Most of the poor remained illiterate.

Progress along the long road towards universal elementary education accelerated at the end of the eighteenth and the beginning of the nineteenth centuries, as a result of the influence of Enlightenment thinkers and the all-too-visible new presence of an urban proletariat, caused by the Industrial Revolution. It was perhaps hardly surprising that factory methods were applied to education. Whereas in the past all school teaching had been a matter of a master interacting haphazardly with a small group of children of mixed ability, the reformers Joseph Lancaster and Andrew Bell invented a way in which a single master, through the use of monitors, drills and the spirit of competition, could supervise a class of hundreds. Lancaster, a Dissenter, opened his school in 1803 and spread his methods through the British and Foreign School Society, founded in 1808. The Church of England, alarmed at the prospect of losing its control over popular education, threw its support behind Bell and the National Society for Promoting the Education of the Poor in the Principles of the Established Church, founded in 1811. The antagonism of these two agencies was to make it very difficult for the State to intervene in education without offending one or the other.

Although these new methods did increase the availability of education to poor children, the educated rich remained extremely grudging towards such provision. Most of them, remembering the French Revolution, thought that if education were given to the poor at all, its purpose should be to inculcate deferential attitudes rather than knowledge and skills: in short, to stop the poor revolting. A grim warning (which has become a classic quotation) was uttered in a Commons debate in 1807 by Mr Davies Giddy, who thought that education for the poor, 'instead of teaching them subordination ... would render them

fractious and refractory'.[33] Even the educational providers themselves talked like this. Bell himself in 1808 said that 'there is a risque of elevating, by an indiscriminate education, the minds of those doomed to the drudgery of daily labour, above their condition'.[34] The authoress Hannah More, though a zealous supporter of Sunday Schools, stressed to pupils, in 1806, that 'the learning we are able to communicate is only intended to enable you to read the scriptures, and to see, that it is the will of God, that you should be contented with your stations'.[35]

The idea that it might be useful to train workers in the skills they needed did not easily make headway. Thirty years later James Kay Shuttleworth, who, as a Government official, was at the forefront of many reforms, wrote in relation to state education for pauper children: 'In industrial training ... it is chiefly intended that the practical lesson, that they are destined to earn their livelihood by the sweat of their brow, shall be inculcated.'[36] Such a view is echoed in the words of the Catholic Archbishop Cullen, of Ireland, around 1850: 'Too high an education will make the poor oftentimes discontented, and will unsuit them for following the plough or for using the spade, or for hammering the iron, or for building walls.'[37] A comment from the twentieth century throws such attitudes into sharp relief: 'The objection to an educated working class was part of the general philosophy of the governing world,' wrote the historians J.L. and Barbara Hammond. 'The working classes were ... regarded as people to be kept out of mischief, rather than as people with faculties and characters to be encouraged and developed.'[38]

As this remark suggests, the glum view of education as a means of suppressing what was bad in human nature could be countered by a more optimistic view based on a belief in the perfectibility of man, such as Rousseau and other Enlightenment philosophers had expounded. Educational ideas of this more hopeful cast were cherished by working-class activists involved in the movements that encouraged political consciousness and solidarity in working people in the late eighteenth and early nineteenth centuries. This was the period (1780–1832) that saw The Making of the English Working Class, to use the title of E. P. Thompson's classic account.[39] Robert Owen and the Chartists took leading roles. For them, the education of adults was as important as that of children, at least in the short term, for the adults wanted to catch up with what they had missed. And the education they sought for working people inevitably had a strong political slant. They wanted institutions 'in which every branch of human knowledge may be cheaply communicated to those who have hitherto been kept in ignorance, that they may be the more easily duped'; but most of all they wanted 'that species of knowledge which, of all others, is the most closely connected with, and

essential to, their social happiness, and moral regeneration, political knowledge'. Thus wrote the Lancashire trade unionist, John Doherty.[40]

Access to works of art, the visual culture of the élite, was not high among their priorities. Nor, even, was vocational training, for, as the modern historian Brian Simon says, the Owenites did not want to create 'capable machine minders, but fully developed men and women able to take their part in building a new society'.[41] The workers' movements do not, then, provide a context in which we can place the origins of the V&A. It is true that Robert Owen proposed to include a museum in his institution 'for the Intelligent and well disposed of the Industrious Classes', in Charlotte Street in 1834,[42] and that the Chartists William Lovett and John Collins included museums among the facilities for district meeting halls, which they proposed in 1840.[43] This at least shows that museums were broadly acknowledged as a means of educational advancement by the 1830s. But the workers' movements had more urgent tasks than setting up art museums.

Between the prohibitive governing classes and the struggling workers stood a third group: progressive, democratic members of the middle classes who wanted to improve the educational lot of those below them. One of their contributions to early nineteenth-century educational provision in Britain was the Mechanics' Institutes. These spread widely, with 'extraordinary impetus',[44] in the 1820s, but eventually sacrificed the support of working people because the middle classes remained firmly in control. (We may note in passing that the Institutes sometimes proposed to include museums among their facilities, as at those in London and Manchester.)[45] Another middle-class initiative was the Society for the Diffusion of Useful Knowledge, founded by the politician Henry Brougham in 1826. This endeavoured to spread enlightenment, not by providing schools, but through cheap publications, particularly periodicals, which working people (those already literate) could afford to buy. Their publisher was Charles Knight, who issued, among much else, the Penny Magazine (1832–45) and the Penny Cyclopaedia (1833–44). Because these publications provided what the Society thought the workers ought to read, rather than what the workers might have asked for, they included a substantial amount on art, literature and history.

The middle-class progressives found themselves enjoying increased influence after the Reform Bill of 1832. This corrected glaring anomalies in Parliamentary representation, and enlarged the franchise, but retained property qualifications for voters: so there were still no working-class representatives in the House of Commons. The Whig cabinets under Lords Grey and Melbourne remained aristocratic. But the Whigs were liberal-minded (and soon to

become the 'Liberal' party),[46] committed to responding to public opinion and willing to redress grievances.[47] Moreover, individual MPs were more inclined to pursue their own causes.[48] And among the MPs was a strong group, to the left of the Government, of Radicals. Carrying the standard of 'philosophic radicalism' bequeathed by Jeremy Bentham (died 1832) and James Mill (died 1836), they believed in 'the greatest happiness of the greatest number' – which set them against the privileges of the aristocracy and in favour of social reform – and in rational efficiency in administration. They included George Grote, Joseph Hume, Francis Burdett, John Roebuck, John Bowring, Thomas Wyse and William Ewart. The Government included such progressive figures as Henry Brougham (Lord Brougham from 1830, when he became Lord Chancellor), Charles Poulett Thomson at the Board of Trade, and the Home Secretary, Lord John Russell.

It was Russell who, on 12 February 1839, announced the very first agency to be established by the British Government to administer public expenditure on elementary education (it was a Committee of the Privy Council on Education, a confusing title). The creation of this new funding body is generally regarded as an epoch-making development in the history of English education. It is not widely realized, however, that three years before the Government took responsibility for the elementary education of children, it had already set up a system for adult education in art. This came about through the activity of the Radical MP William Ewart.

The Select Committee on Arts and Manufactures

Two factors provoked Ewart's intervention. One was a concern, apparently widely shared, about the performance of British exports of manufactured goods. The other was a campaign against the Royal Academy, in which a small group of complainants made a great deal of noise. It may be better to take the latter (though less important) factor first, because, it can plausibly be argued, the involvement of the Academy gave the whole affair a prominence and impetus that it would not otherwise have attained. The Academy was (and is) a grand and dignified body: enjoying royal patronage, self-governing and very selective in its membership. In the early nineteenth century it was almost the only association of artists with any weight. Naturally, some of those outside it resented their exclusion. These included individual artists, like the sculptor George Rennie and the painters John Martin and George Foggo, and whole groups of artists such as engravers, for whom John Landseer and John Pye spoke up. Far and away the most vociferous antagonist of the Academy was the painter Benjamin Robert Haydon.

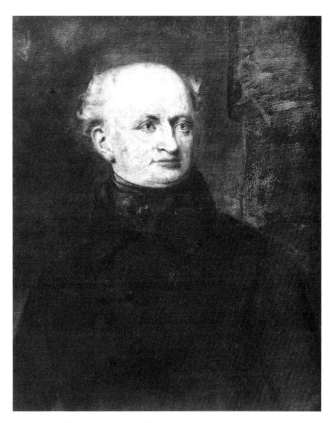

Figure 1.3 Benjamin Robert Haydon, 1786–1846, a portrait in oil by T. H. Illidge, 1838. From a negative taken when the portrait was displayed in the third National Portraits exhibition at South Kensington, 1868.

Haydon (figure 1.3) was a living demonstration of the glories and griefs that accompanied the Romantic view of the artist. He, unlike Sir Joshua Reynolds, certainly believed that artistic talent was a matter of inspiration – a divine gift. He believed that he heard the voice of God entrusting to him the reinvigoration of British painting, and urging him to 'go on' despite every reverse.[49] Yet his talent was not equal to his ambition and conviction; and he lived at a pitch of strenuous emotional intensity that overrode common sense. His paintings are huge, but with insufficient power to sustain their scale. His life, on the other hand, is forcefully depicted in his diaries as a desperate drama, alternately heroic and pathetic; the reader trembles before the spectacle of Haydon's ardent vulnerability.

Born in Plymouth in 1786, he came to London in May 1804 and set out to be a history painter – a painter of great narrative and moral subjects. He submitted his first painting, *The Death of Dentatus*, to the Academy Exhibition in 1809. It was accepted and hung, on the crowded walls where the works of even the most eminent painters had to jostle for precedence. But it seemed to Haydon that it had been relegated to a dark and inferior corner, and he never forgave the Academy. He felt that his 'prospects

were blasted for ever',[50] and for almost forty years, until his suicide in 1846, he assailed the Academy at every opportunity.

Hostility to the Academy might have been a merely negative and corrosive force, but it served to magnify Haydon's sense of mission. On his arrival in London, he recorded that 'I went into the new Church in the Strand, & on my knees prayed I might be a Reformer in the Art ... I must believe myself destined for a great purpose, a great purpose.'[51] In attacking the Academy, he felt that at the same time he was struggling to convince 'patrons, nobility and members of Parliament, that Art and Design was a great educational and economical question they should look to'. His son and biographer interpreted his whole life as devoted to this purpose: 'to remove obstructions to the extension among the people of a scientific system of Art teaching, and to obtain from the Government and the nobility the recognition of Art as a business of national concern, by the foundation of Art schools, and by the establishment of Art galleries'.[52] In his son's eyes and his own, Haydon's efforts met with success when the Government School of Design was founded. But we must remember that his remorseless persistence alienated the officials whom he addressed, and he clearly exercised less influence than he liked to think.[53] He repeatedly presented petitions to Parliament (1823, 1825, 1826, 1835, 1836)[54] and lobbied people of influence, eventually striking lucky with William Ewart, who, on 30 April 1834, acknowledged receiving a 'letter and treatises'

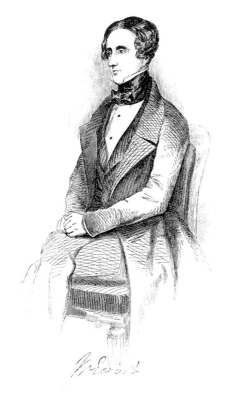

from Haydon, commenting encouragingly: 'The subject is one too *nationally* important to be lost sight of. More than one member of the House of Commons besides myself are interesting themselves in it.'[55]

William Ewart (1798–1869), the son of a Liverpool merchant, was educated at Eton and Oxford. He chose the law as his profession, but soon became a Member of Parliament, entering the House of Commons in 1829, as agitation for Catholic Emancipation and the Reform Bill was boiling up. A Radical, he was too far from the mainstream to hold Government office, but as a backbencher he promoted many progressive causes, such as free trade, better public administration and education, and he initiated legislation against capital punishment, and in favour of criminal law reform. It was he who brought in the Museums Act, 1845, which empowered borough councils to levy a rate to establish local museums, and the Public Libraries and Museums Act, 1850, which extended the earlier bill. Ewart (figure 1.4) can be honoured, therefore, as the founder of the British municipal library and museum system.[56]

Ewart and other Radical MPs were by no means averse to supporting Haydon's attack on the Royal Academy, which seemed to them 'a monopolistic body, hampering free enterprise in art and, by reason of its association with the Crown, belonging to an era of corruption, privilege and aristocratic rule'.[57] The Academy was particularly open to question in 1834 because the Government was about to offer it new quarters, at public expense, in the new building then in preparation for the National Gallery in Trafalgar Square. On 15 July 1835 Ewart successfully moved that a Select Committee be appointed to explore the issues.

To obtain a Select Committee was not a particularly momentous achievement, for at this period the Government frequently diverted private members' concerns to Select Committees in order to keep its own business moving: there were 543 Select Committees between 1801 and 1834.[58] Ewart proposed as the task of his Select Committee: 'to enquire into the best means of extending a knowledge of the Arts and of the Principles of Design among the people (especially the Manufacturing Population) of the Country; also to enquire into the Constitution of the Royal Academy, and the effects produced by it'. For the Academy, the sting was in the tail of this motion. By the time the Committee reported, the sting had been mollified, because the latter part of the motion was rephrased: 'and also to enquire into the Constitution, Management and Effects of Institutions connected with the Arts'.[59] A large Committee heard evidence during the Parliamentary session ending in autumn 1835. A smaller Committee continued in the next session, and it was in June and July 1836 that complaints about the Academy were ventilated. The appearance of Sir Martin

Archer Shee, President of the Academy, on 15 July represented the climax for Haydon. 'O God, I ask only for justice & Truth to triumph! Amen,' he wrote.[60] In his eyes, Shee was humiliated. Haydon rejoiced to see the defenders of the Academy 'examined – ransacked – questioned – racked! ... deservedly punished'.[61] Others did not see it as such a knock-out defeat for the Academy,[62] but the Report of the Committee duly criticized the 'ambiguous, half-public half-private, character of the Academy', and 'the private and irresponsible nature' of its proceedings.[63]

About half the Committee's time (141 pages of evidence) was devoted to the Academy, the rest (133 pages) to the design and sale of manufactures. It might seem odd, on the face of it, that the exalted Academy and problems of trade should be yoked together under the scrutiny of the same Committee. The ambiguity in the usage of 'Art' and 'arts', which we have already noticed, certainly helped the discussion to slide between one pole and the other. Ewart's motion spoke of *the Arts*; the Committee's Report gave as its name 'The Select Committee on *Arts* and their Connexion with Manufactures'; the Committee, in its first Report, proposed to inquire into both 'the state of *Art* in this country' and 'the state of *the higher branches of Art*'; the press spoke of the Committee on '*Fine Arts* and Manufactures'.[64] This ambiguity must have encouraged the Committee in its assumption that High Art and industry could be combined.

It was clear anyway that one of the Academy's functions was to teach artists, so it must therefore fall under judgment in any investigation of art education in England. Nikolaus Pevsner has shown in *Academies of Art*[65] that there was a strong tradition of art education in Europe from the Renaissance onwards (though England's efforts, hardly extending beyond the Academy, were weak). Pevsner demonstrates, in his fourth chapter, that in the later eighteenth century, as a result of 'mercantilism', existing academies (there were over 100 by 1790) were reshaped, and many new academies were founded, in order to support manufacturing and commerce. He gives many examples to 'prove beyond doubt the paramount importance of economic considerations', of the interests of trade, in late eighteenth-century art education (p. 158). 'As a rule academies about 1800 consisted of elementary classes for trade requirements and of advanced courses for artists' (p. 165). The exaltation of the artist as genius during the Romantic Movement reversed this practical tendency in art education, which had hardly developed in England anyway. Ewart and his Committee were confronting a problem that seemed new to England. But, as Pevsner shows, it had been tackled before, and the involvement in the Committee's inquiry of the Academy, and by implication the tradition of academies, must have added weight to the discussions.

The main problem the Committee had in view was that British products did not seem to be selling well enough abroad, because, although well made, they were not well designed. 'The commercial power of this country excelled that of all others; but one defect – the defect in the art of design – had given other countries an advantage we did not possess.' That crisp formulation was supplied by Mr Gladstone, when, later on in 1844, he was giving the prizes at the London School of Design.[66] A second problem was 'the acknowledged superiority possessed by the French in design', which 'is so generally admitted that any observation in proof thereof would be needless'.[67] This remark dates from 1845. By then, the problems were crystal clear to everyone involved, and such commentators, enjoying hindsight, seem to assume that the problems had been just as starkly evident in 1835. They express this, however, in curiously evasive language. 'Attention having been drawn to this state of things, inquiries were made as to the causes,' writes Charles Heath Wilson in 1844.[68] 'All this which was rendered suddenly visible, had been long before felt and known to those best able to judge,' claims William Bell Scott in 1870.[69] 'At length the national shortcomings in ... art-manufacture made themselves felt to such an extent that it became necessary to seek a remedy,' pronounces John Sparkes in 1884.[70] In fact, it is not easy to find expositions of the problems earlier than the Select Committee's Report. Perhaps, even if these matters were the prevailing subject of dinner-table conversations, it was necessary for the Committee to crystallize them. Certainly the Report seems to have had a powerful effect. Among one group of gentlemen in the North it aroused such a 'feeling of humiliation' that they straight away formed a 'Society for the promotion of the Fine Arts ... in their Application to Manufactures'.[71]

The witnesses before the Select Committee appearing during July and August 1835 made a strong case. Haydon was to admire the way that Ewart handled the Academicians, describing him as 'a keen little man, who perfectly understands ... their presumption, and seems determined to let them see he does', conducting himself 'with the coolest nonchalance'.[72] No doubt Ewart handled other witnesses equally competently. He saw it as his business to lead the Committee. He later wrote to Haydon that 'the Report *is as liberal a one as it was possible for me to draw under the control of the Committee*' and that 'all that is said is my own'.[73] The minutes of evidence suggest that he took the lion's share of the questioning of witnesses, that he guided them in the direction he wanted them to take, and perhaps that he had schooled them in advance.

After two opening witnesses (the very first being the great Dr Waagen from Berlin, who praised museums), the argument about the failure of British design was propounded by Ewart's colleague James Morrison, MP, who was himself a

member of the Committee but here testified as a witness. He was followed by a succession of voices from the shop floor: buyers from Harding Smith of Pall Mall, and Howell and James of Regent Street, top department stores of their day; Thomas James, a textile wholesaler; Thomas Field Gibson, a manufacturer of Spitalfields silks; Robert Harrison, a silk manufacturer; George Eld, Mayor of Coventry, speaking for ribbon manufacturers; Samuel Wiley from the papier-mâché firm Jennens and Bettridge; Claude Gillotte, a maker of Jacquard looms; and James Crabb, a room decorator. They were backed up by the painters John Martin and George Foggo, the sculptors John Henning and George Rennie, the architects J. B. Papworth and C. R. Cockerell. The latter became rhapsodical about the propitious artistic environment enjoyed by workmen on the Continent:

... the leisure of the artizans in most of the cities, of France especially, is passed in the palaces and gardens of the king, where they have beautiful works before their eyes, in architecture, sculpture and painting; a paternal and enlightened government long ago (near 300 years) provided these elegant recreations for the people, instead of passing their holidays, as our artizans do, in the pot-house. In various manufacturing cities which I have seen very lately, as Sheffield, Birmingham, Glasgow, &c., I have been struck with the degrading comparison.[74]

Witnesses representing art education followed Cockerell. A similar cast of experts appeared when in February 1836 the Committee resumed in its second session, with the leading part being taken by Dr John Bowring, MP. He too was both a member of the Committee and a witness before it. He had made studies of foreign manufactures for the Government and so spoke with special authority.

When the Committee reported, it ascribed Britain's failure to produce well-designed goods to 'the want of instruction in design among our industrious population' and 'the absence of public and freely open galleries containing approved specimens of art'.[75] So art schools must be provided. The Mechanics' Institutes were praised for what they had managed to do for art education, as were popular periodicals like the *Penny Magazine*,[76] and it might have been thought that greater support for these initiatives was the way forward.[77]

The Committee recommended that 'the principles of design should form a portion of any permanent system of national education': the enviable system in Bavaria had been described to the Committee by the eminent architect Leo von Klenze.[78] Museums were also called for. 'In nothing have foreign countries possessed a greater advantage over Great Britain than in their numerous public galleries devoted to the Arts, and open gratuitously to the people', whereas in Britain 'a fee is demanded for admission' and 'the poor are necessarily excluded'.[79]

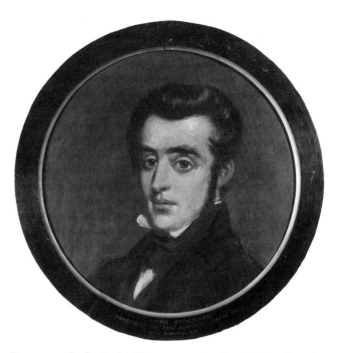

Figure 1.5 Charles Poulett Thomson, 1799–1841; MP; President of the Board of Trade, 1834, 1835–9; created Baron Sydenham, 1840. Cartoon by F. W. Barwell for a mosaic, one of a series of mosaics of the political chiefs of the museum, installed in the cloister between the North and South Courts in 1869–76.

The Report was published on 16 August 1836. But, as Quentin Bell has pointed out, 'already, before the Committee published its findings, the Government had decided that something must be done'.[80] On 11 July 1836 the Board of Trade asked the Treasury (which agreed on 15 July) to provide funds to set up a School of Design. The President of the Board of Trade was Charles Poulett Thomson (figure 1.5), a young man who had risen rapidly to ministerial rank, and earned some unpopularity thereby, but was respected for his industriousness.[81] He is not widely remembered today, because he left English politics, owing to poor health, to become Governor General of Canada in 1839 and died soon afterwards in a riding accident. He has a significant place in the history of the V&A, however, because although Haydon and Ewart created a climate favourable to the foundation of the School of Design, Thomson actually took the decisive action.

The museum in the School of Design

When Poulett Thomson took this surprisingly swift action, 'the object,' it was said, 'was to forestall Mr Ewart's report'. This manoeuvre succeeded, but only at some cost to the future fortunes of the School of Design. For, the same commentator remarked:

little was known as to the exigencies of such a school, and Mr P. Thompson [sic] did not profess to be acquainted with the Fine Arts. There was no accurate information as to what was really taught in other schools, nor was it easy to find persons acquainted with this, and there was no time for any very careful inquiry.[82]

Somewhat unprepared, then, Thomson on 19 December 1837 called to a meeting a group of interested parties who, later augmented, were to become the ruling Council of the school. The Council did not include Haydon or Ewart. It did include both artists and businessmen, but all the artists were Royal Academicians. Ewart told Haydon 'all was going wrong with the school of design', and Haydon was 'in very great irritation about this Perversion'.[83] Feeling that Thomson had been duped by the Royal Academy,[84] Haydon

and the Radicals duly created a Society for Promoting the Arts of Design, and set up a rival school in Leicester Square. This had a destabilizing effect on the Government School, but a happy result of it was that it gave Haydon the opportunity to discover his considerable talent for lecturing.[85]

The Government School of Design opened, in rooms vacated by the Royal Academy in Somerset House (figure 1.6), on 1 June 1837, with the architect J.B. Papworth as Director. Although its early days were very tentative, it did have a 'Committee on the Museum of the School of Design', chaired by Henry Bellenden Ker, a lawyer and art collector, who was a faithful and conscientious member of the Council from its first meeting until its eventual abolition. His museum committee, which also included Sir Francis Chantrey, C.R. Cockerell and C.L. Eastlake, met six times in 1837, on 27 April, 2 and 8 May, 5 June, 7 July and 4 September. Its minutes reveal little save that it 'inspected' and 'ordered' plaster casts, books and works of art.[86]

Papworth's directorship of the School was probably a kind of trial run, while the Council looked around for someone better qualified. A month after the School opened, a candidate was already in sight, recommended by Eastlake.[87] This was William Dyce, a Scottish painter (with many other talents, ranging from electro-magnetism to church music), who was at that time in charge of the School of the Honourable Board of Trustees for the Encouragement of Manufactures in Edinburgh. The Trustees, founded in 1723, set up their school in 1760. If the Council of the London School was seeking existing sources of expertise in design education in the British Isles, it could have looked only to the Royal Academy, the Society of Arts in London, the Drawing Schools of the Dublin Society or the Trustees' School in Edinburgh.[88] The Edinburgh School must have looked promising because Dyce, with his assistant Charles Heath Wilson, had just gone into print in *A Letter to Lord Meadowbank and the Committee of the Honourable Board of Trustees ... on the best means of ameliorating the arts and manufactures of Scotland* (1837). This inspired the Council of the London School to seek his advice, and to decide in summer 1837 to send him on a fact-finding tour of continental art schools. During his tour, from September 1837 to spring 1838, Dyce was empowered to purchase 'specimens of art' for the School, which were considered by a committee in April 1838.[89]

Soon afterwards, in June 1838, Papworth's post of 'Director' was abolished, and he returned to his successful architectural practice, while Dyce was appointed as 'Superintendent' of the London School. It seems that Dyce evolved big ideas about a museum in the School. This issue was not explored in the report of his continental tour, which presumably helped to get him his job (and which was published as a Parliamentary Paper by the Board of Trade

Figure 1.6
The Government School of Design shared Somerset House with several learned societies and the University of London, together with a curious selection of Government offices. From the *Post Office London Directory*, 1848.

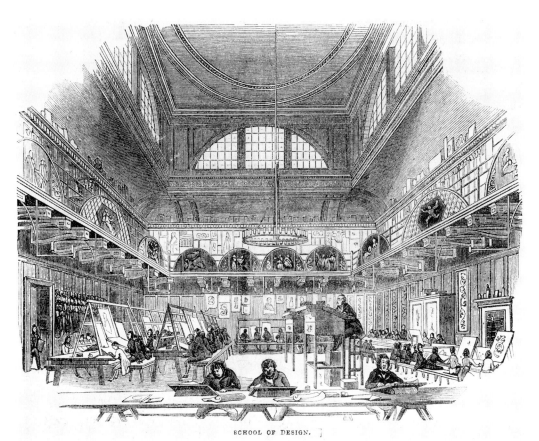

SCHOOL OF DESIGN.

Figure 1.7
The School of Design in Somerset House, in the former Exhibition Room of the Royal Academy. The copies of Raphael's panels of grotesque ornament from the Vatican Loggia can be seen along the wall on the right, while the associated lunettes are fixed to the front of the gallery. Plaster casts are propped up on top of the gallery bookcases. Wood-engraving from the *Illustrated London News*, 27 May 1843 (supplement), p. 375.

in 1840), but the Dyce Papers in Aberdeen Art Gallery include a lengthy draft letter (undated, but evidently of 1843; and unaddressed, but obviously aimed at some figure in Government) in which he advocates the foundation of 'a Museum devoted to the Archaeology of the Arts of Great Britain'. This museum, 'commencing with the earliest period of which any remains are extant', would deal with 'those arts which contribute to the adornment of life and have for their drift the development of beauty ... whether that beauty be impressed on the actual furniture of life in ... ornamental design, or expressed in the fictitious resemblances of real life proper to the higher arts', so as to provide 'a complete and progressive picture of the external aspect of society as it is related to the arts of design'. Dyce records that he had started to think about forming such a museum of industrial art soon after he was appointed to the School of Design. He then, however, discloses something of that 'tendency to frustration and defeat' that Quentin Bell detects in him,[90] for he laments that he discovered that 'much more was involved ... than I had first imagined'; and, envisaging his museum 'swelling ... to an exorbitant, not to say utterly impossible extent', he recoiled from the project.[91]

Still, Dyce did make a trip to Paris in autumn 1841 to choose plaster casts for purchase from the Ecole des Beaux

Arts, and in February 1842 *The Art-Union* magazine, describing the School of Design, called attention to the fact that it was

supplied with a variety of examples for study, consisting of prints and drawings, casts from antique sculptures of the human figure, animals, and architectural ornaments; specimens of paper and silk hangings. Of these a great variety has recently been brought from Paris by Mr Dyce ...[92]

The most significant purchase in Dyce's time was of a set of 'copies of the fresco-paintings, commonly known by the name of the *Loggie* of Raphael, in the Vatican, executed in distemper on canvas screens, by Mr Richard Evans, being of the same size as the originals'.[93] These were bought from the auctioneers, Christie's, for the large sum of £510, specially authorized by the Board of Trade. Although these were not original works of art, they loomed large in the museum for many years as a sort of talisman, demonstrating that the very greatest of artists (as Raphael was considered to be) did not scorn turning his hand to decorative design (figure 1.7).

Dyce found the School of Design hard work. Haydon, visiting him on 16 July 1842, lamented that 'a Situation like Dyce's destroys all energy ... His painting room ... announced lassitude, bad habits, & the Art given up. He acknowledged it.'[94] He had no time for his own painting,

and at the School he was caught in an administrative tangle. The Board of Trade controlled the purse-strings, but Dyce also had to try to satisfy a Council of 24 members, with whom he was often in disagreement. 'It was of course very difficult to get so large a body always to take the same views, and it was broken up into parties', was one commentator's view of the situation.[95] Another defended Dyce with indignation:

His grasp of his duties was too grand, and his idea of the artist's position too noble, to brook 'lay-element' control, and he left in disgust a position he had filled with conspicuous advantage to the industrial arts of England. He was found a wayward, sharp-edged tool in the hands of red-tapists. Despising their ignorance, he contemned their assumption ...[96]

At all events, Dyce failed to give satisfaction, and was eased aside – he thought that Henry Bellenden Ker was plotting against him – into the post of Inspector of the provincial Art Schools. The setting up of branch schools in provincial towns like Manchester and Birmingham started under Dyce and continued, despite all the tribulations at the London School, until by 1851 there were 18 of them.[97] When Dyce stepped down, his former colleague Charles Heath Wilson came from Edinburgh to succeed him in May 1843.[98]

In the letter accepting his appointment, Wilson expressed enthusiasm for the School's museum collection: 'this is a subject to which I have paid much attention'.[99] Believing that design students needed to look at real objects in museums, rather than reproductions, he argued: 'With regard to museums, our attention has been almost entirely directed to the accumulation of art and of antiquities, but no one seems to have thought of the accumulation of specimens of ancient industrial art, and also of foreign manufactures.' Just such specimens he endeavoured to gather for the benefit of students at the Trustees' School in Edinburgh, and he urged that looking at these would 'give the pupils a better idea of the various arts ... than if I were provided with all the prints that ever were published, and were to lecture from morning till night every day of the year'.[100]

Soon after Wilson's appointment in London, the Finance Committee of the Council, 'on the proposition of Mr Ker', instructed him to prepare an inventory 'of the casts, examples of ornament, specimens of manufacture, prints and drawings, in the School' and to develop the collections.[101] Ker may have had a personal interest in the collections, for he made a trip to Paris (Wilson 'could not be spared') in October 1843, buying wallpapers, lacquered ornaments, silk and glass weaving, and pottery.[102]

In the *Third Report of the Council of the School of Design*, issued in 1844, Wilson duly provided an inventory of the plaster casts, which included:

the Apollo Belvedere, Apollo of the Tribune, Venus of Melos, the Fighting Gladiator, Theseus, Ilissus, &c. with a variety of busts, masks, and portions of statues: examples of alto and basso relievo from Greek, Roman, and Middle Age Monuments, including portions of the Panthenaic Frieze of the Parthenon ... Architectural Ornament of every style and era ... specimens of Byzantine decoration, Moresque ornaments from the Alhambra, Gothic enrichments from Lincoln Cathedral, Stone Church in Kent, and other edifices in England and on the Continent ...

He went on to stress that it was not enough for the School to have such reproductions; it must also have 'real specimens of various kinds of ornamental manufactures' in order to educate the eyes of both teachers and students. He described material already acquired 'chiefly from Germany, France, and Italy', which included:

stained-paper hangings, rich embroidered silks...printed calicos, wood carving, ornaments of lacquered embossed metal,

Figure 1.8 The Musée de Cluny, Paris. Alexandre du Sommerard (1779–1842) was a pioneer collector of medieval and Renaissance applied arts. He set up his collection in the former town house of the Abbots of Cluny in 1832, and after his death it was taken over by the State as a public museum. It was a cause of envy among the English, and was often held up as an example of what was needed in London. This illustration (a wood-engraving from the popular weekly *Magasin pittoresque*, August 1850, p. 241) suggests that it attracted a family audience.

models in papier-maché [*sic*], imitations of antique stained glass from Nuremburg [*sic*], iron castings in panel work, fancy earthenware, enamelled tiles, and several examples of decorative painting, in tempera, enamel, fresco, encaustic, &c ...[103]

Ker followed up his own visit to Paris by arranging[104] for Wilson to go there in May 1844 to make purchases at the 'Triennial Exposition of Articles of Manufacture'. This was the tenth in a series of occasional (only recently triennial) exhibitions of national products, which had been held in France since 1797, and which were to furnish inspiration for the 1851 Exhibition in London. The Board of Trade supplied £1,400,[105] and Wilson duly made his acquisitions and reported back to the Council, not only about the exhibition and what it told of French taste, but also about French museums. 'However valuable museums of classic art may be,' he said, 'it ... is equally essential that museums of carefully chosen specimens of the happier periods of middle age art should be formed.'[106] And he commended the Musée de Cluny as an example (figure 1.8).

It may appear that the School of Design's museum collection was by now developing well. But it was always dogged by the problem that there was no room to display it in the School's cramped quarters in Somerset House. Some things could be hung on the walls, which had been painted red to show off the plaster casts to advantage.[107] On special occasions, such as the Annual Meeting and prize-giving, tables could be put out for the display of ceramics and small sculptures.[108] But most of the time the collection was hard for the students to get at.

Wilson was soon in trouble on other fronts.[109] He was at odds with his colleague J.R. Herbert, the Drawing Master, a survivor from the Dyce regime, who had little respect for Wilson. Attempting to assert himself, Wilson offended Herbert's students, who complained to the Board of Trade. Wilson thus had a rebellion on his hands, and Haydon now re-appeared to stoke the fires with a series of letters to *The Times* in May 1845. Throughout the summer of that year the weekly magazine the *Builder* carried regular reports and correspondence about the 'Stir in the School of Design'.

The chief issue was that 'the system pursued is not equal to the wants of the pupils; it is copy, copy, copy, and nothing more' (figure 1.9).[110] An especially controversial aspect of the system was figure drawing. Though this was a fundamental part of the training of 'real' artists, it had, at the start, been banned at the School of Design as unsuitable – even improper – for humble artisans, who, it was felt, should not be encouraged to get above themselves. Dyce introduced it nonetheless; but it remained a sensitive issue, with overtones of class conflict. More important, perhaps, was the sheer inadequacy of the curriculum. A.W.N. Pugin (although he wanted the School to promote 'Christian', that is Gothic Revival, art, which was hardly

THE SCHOOL OF BAD DESIGNS.

THE STUDY OF "HIGH ART" AT SOMERSET HOUSE.

Figure 1.9 *Punch* (1845, p. 117) pokes fun at the teaching at the School of Design. The popularity of the 'willow-pattern' decoration on ceramics was often cited as proof of British bad taste.

feasible) put it crisply. The institution 'is misnamed a *School of Design*; it is a mere *drawing school*', for the students received no training in methods of production. Furthermore, 'the school should also be a place for the formation of *operative* as well as designing artists: we want artist smiths in silver and iron, artist chasers in metals, artist glass painters, artist engravers for enriched plates, artists for the manufacture of stuffs and the production of embroidery'.[111]

Herbert having been dismissed, the troubles died down. But Wilson made the syllabus less, rather than more, practical, and a year later found three of his teachers, H.J. Townsend, C.J. Richardson and Richard Redgrave, ranged against him. The latter two had only recently been appointed, in an attempt to improve matters. Townsend and Richardson wrote letters of complaint to the Council of the School, while the bolder Redgrave wrote to the Prime Minister, Lord John Russell. Among the many complaints aired in these documents, we can, in Townsend's letter, catch a glimpse of the School's museum collection. The School, he said, now possessed 'ornamental art, books, prints, cartoons and paintings, plaster casts, and specimens

of manufacture; silks, bronzes, porcelain, inlaid and carved woods; an anatomical figure, skeleton, stuffed birds, &c. &c. &c.' But these objects

lie about the premises of the School in all directions, some locked up in presses, some ranged without labels or catalogue in a gallery where heat and bad air in the evening make all access a work of fatigue and annoyance, and where, even in the day, its situation must make it manifestly insalubrious ... and unfitted for the purposes of careful study.[112]

In response to the complaints, the Council of the School, headed now by Ker, appointed a 'Special Committee' to investigate in December 1846. It found no solution to the problems, so another Committee was set up in summer 1847. Among much else, it noticed the plight of the museum, and instructed the Director to 'prepare complete Inventories of the objects of Art in the Head School, and Branch Schools, comprising a technical description of each example'.[113] Nothing came of this, however, because Wilson was pushed aside from the directorship. He sought to become the Curator of the museum,[114] but, like Dyce, was made Inspector of the provincial schools. Although a catalogue of the library of the School of Design was published,[115] there were only 'incomplete inventories of the casts in the schools, and of the other examples of art, in manuscript',[116] and these seem to have disappeared since. Reconstructing the School's collection is now a matter of detective work.[117]

Wilson soon departed from London to be head of the Glasgow School of Design, in 1848. The Council was dissolved so that the Board of Trade could exercise tighter control. Some of the students got together in 1849 for 'mutual instruction', and again pressed the claims of the museum collection:

The school being open to the public, strangers may occasionally be seen, who, on entering, stare vacantly around, at a loss where to begin, apparently confused by the very heterogeneous arrangement of objects before them, and who, after a very short visit, depart neither improved nor gratified; whereas, with a proper arrangement and a cheap descriptive catalogue, an afternoon might be both profitably and amusingly passed by the artisan, tradesman, manufacturer, or artist.[118]

The students' plea was brought up before a House of Commons Select Committee, which investigated the School of Design in 1849, but the gloomy response from the management was that 'it is totally impossible to arrange our collection; we have no room; the specimens are piled up in a heap'.[119]

The School was not reformed, and the collection continued to be neglected. A little later, a concerned observer, George Wallis, remarked that 'as regards the arrangement of the very admirable collection of ornamental examples ...

in the possession of the School, it is certainly not too much to say that no person except the attendants, who occasionally manage to dust them at the risk of great destruction, has seen one half of them for some years'.[120]

The year 1851 was dominated by the Great Exhibition of the Works of Industry of All Nations. This fully occupied the attention of all who were concerned with arts and manufactures, so little was heard of the School of Design. The administration of the Great Exhibition was led by Prince Albert, backed by a Royal Commission of distinguished public figures. But 'the mainspring of the Exhibition from first to last' was (according to Lyon Playfair, Special Commissioner) an exceptionally dynamic civil servant, Henry Cole.[121] After the exhibition, in January 1852, Cole was put in charge of the School of Design. At long last the School had 'a man with a firm hand, a perceptive judgment, naturally a leader and organizer, at its head'. These are the words of the painter William Bell Scott, who, as a master in the Newcastle School of Design, had had an insider's view of the tribulations of the preceding years. These were now over. 'Forthwith the sky brightened and the sun began to shine.'[122]

NOTES

1 John Steegman, *Victorian Taste: A Study of the Arts and Architecture from 1830 to 1870*, London: Nelson, 1970, p. 19.

2 I have borrowed the word, though not quite legitimately, from Richard Wollheim, *Art and its Objects*, 2nd edn, Cambridge: University Press, 1992, p. 1: 'the traditional question ... a demand for a unitary answer, an answer in the form "Art is ..."; ... the best we could now hope for is a plurality of answers ...'

3 Sir Joshua Reynolds, *Discourses on Art*, ed. Robert R. Wark, San Marino, California: Huntington Library, 1959, p. 171.

4 In context it seems to mean that a well-formed work of art should have no loose ends or irregular features. Maybe it was chosen as a motto for the V&A at the end of the nineteenth century because, out of context, it seemed to foreshadow the doctrine that 'form follows function'.

5 'Polite Arts' appear in the opening sentence of the first Discourse, as the object of 'Royal Munificence'; 'the arts of elegance' in the dedication of the Discourses to the King (1778).

6 *Discourses*, ed. Wark, p. 48.

7 Ibid., p. 94.

8 Cf. Nikolaus Pevsner, *Academies of Art Past and Present*, Cambridge: University Press, 1940, p. 149.

9 '"Technology," or Science for Working Men', *Architect*, 27 July 1872, p. 43.

10 *Fifty Years*, vol. 1, pp. 103–4. Cf. the opening of his *What is Art Culture? An Address delivered to the Manchester School of Art, 21st December 1877* [privately printed, 1877], p. 1.

11 [Sir David Brewster], 'Prince Albert's Industrial College of Arts and Manufactures', *North British Review*, vol. 17, August 1852, p. 542. Oddly enough, when the Queen made a similar point in her speech to the opening of the next session of Parliament on 11 November 1852 ('The advancement of the fine arts and of practical science will be readily recognized by you as worthy of

the attention of a great and enlightened nation'), another periodical writer commented: 'The word SCIENCE appears for the first time in our history in a speech from the throne' ('The Industrial College', *British Quarterly Review*, no. 33, February 1853, p. 203).

12 *Athenaeum*, 29 September 1838, p. 707.

13 '"Technology," or Science for Working Men', p. 44. Cf. Leo Marx, 'In the driving-seat? The nagging ambiguity in historians' attitudes to the rise of "technology"', *Times Literary Supplement*, 29 August 1997, p. 3.

14 C.P. Snow, *The Two Cultures and the Scientific Revolution. The Rede Lecture*, Cambridge: University Press, 1959. F.R. Leavis, *Two cultures? The Significance of C.P. Snow ... the Richmond Lecture*, London: Chatto and Windus, 1962. C.P. Snow, *The Two Cultures: and A Second Look*, Cambridge: University Press, 1964.

15 R.W. Lightbown, 'Introduction' [n.p.] to John Pye, *Patronage of British Art*, facsimile reprint of 1845 edn, London: Cornmarket Press, 1970.

16 Iain Pears, *The Discovery of Painting: the Growth of Interest in the Arts in England, 1680–1768*, London: Yale University Press, 1988, p. 2.

17 Elizabeth Rigby, Lady Eastlake, 'Treasures of Art in Great Britain', *Quarterly Review*, vol. 94, March 1854, p. 478.

18 W.B. Sarsfield Taylor, *The Origin, Progress and Present Condition of the Fine Arts in Great Britain and Ireland*, London: Whitaker, 1841, vol. 2, pp. 372–3.

19 Johann David Passavant, *Kunstreise durch England und Belgien ...*, Frankfurt am Main, 1833. Translated [by Elizabeth Rigby] as *Tour of a German Artist in England, with Notices of Private Galleries, and Remarks on the State of Art*, London, 1836. Gustav Friedrich Waagen, *Kunstwerke und Künstler in England und Paris*, 3 vols, Berlin, 1837–9. Translated [by H.E. Lloyd] as *Works of Art and Artists in England*, London, 1838. Revised version translated [by Elizabeth Rigby, Lady Eastlake] as *Treasures of Art in Great Britain: being an Account of the Chief Collections of Painting*4 vols, London, 1854–7.

20 Sarsfield Taylor, op. cit., vol. 2., p. 253.

21 Eastlake, op. cit., p. 480.

22 Alma S. Wittlin, *The Museum, its History and its Tasks in Education*, London: Routledge, 1949, p. 112.

23 See William Saint Clair, *Lord Elgin and the Marbles*, London: Oxford University Press, 1967.

24 See the series of articles by Gregory Martin, 'The Founding of the National Gallery in London' in *The Connoisseur*, April–December 1974, especially October 1974, pp. 112–13; November 1974, pp. 202–3; and December 1974, p. 279. Also Colin Trodd, 'Culture, class, city: the National Gallery, London and the spaces of education, 1822–57' in Marcia Pointon (ed.), *Art Apart: Art Institutions and Ideology across England and North America*, Manchester: University Press, 1994, pp. 33–49.

25 *Library of the Fine Arts*, vol. 1, no. 1, February 1831, p. 30; vol. 1, no. 2, March 1831, p. 149.

26 See J. Mordaunt Crook, *The British Museum: a Case-study in Architectural Politics*, London: Allen Lane, 1972, chapters 3, 4; and *Palaces of Art: Art Galleries in Britain 1790–1990*, exhibition catalogue, London: Dulwich Picture Gallery, 1991.

27 William Wilkins, 'A Letter to Lord Viscount Goderich, on the Patronage of the Arts by the English Government', *Library of the Fine Arts*, vol. 3, no. 16, May 1832, p. 372.

28 'Thoughts on the New Building to be Erected for the National Gallery of England', *Art-Journal*, 1849, p. 123.

29 John Barrell, *The Political Theory of Painting from Reynolds to Hazlitt*, London: Yale University Press, 1986, pp. 2, 1.

30 These are chapter headings in Prince Hoare, *Inquiry into the Requisite Cultivation and Present State of the Arts in England*, London: Richard Phillips, 1806.

31 'Patronage of the Arts by the English Government', *Library of the Fine Arts*, vol. 1, no. 4, May 1831, p. 286.

32 Quoted in Martin, op. cit., *Connoisseur*, October 1974, p. 113.

33 Quoted in Harold Silver, *The Concept of Popular Education*, London: Macgibbon & Kee, 1965, p. 23.

34 Ibid., p. 45.

35 Ibid., p. 39.

36 Quoted in John Hurt, *Education in Evolution: Church, State, Society and Popular Education 1800–1870*, London: Rupert Hart-Davis, 1971, p. 24. He was writing in the *Fourth Annual Report of the Poor Law Commissioners*, 1838.

37 Quoted in Nicholas Hans, *Comparative Education: A Study of Educational Factors and Traditions*, London: Routledge, 1950, p. 120.

38 J.L. and Barbara Hammond, *The Town Labourer*, Guild Books edn, London: Longman, 1949, vol. 1, p. 68.

39 E.P. Thompson, *The Making of the English Working Class*, London: Gollancz, 1963.

40 Quoted (from *The Poor Man's Advocate*, 25 February 1832) in Brian Simon, *Studies in the History of Education, 1780–1870*, London: Lawrence & Wishart, 1960, p. 219.

41 Ibid., p. 239.

42 Silver, op. cit., p. 198.

43 Simon, op. cit., p. 266.

44 Ibid., p. 157.

45 Charles Alphaeus Bennett, *History of Manual and Industrial Education up to 1870*, Peoria, Ill.: Manual Arts Press, 1926, p. 336, quoting J.W. Hudson, *The History of Adult Education*, 1851.

46 Jonathan Parry, *The Rise and Fall of Liberal Government in Victorian Britain*, London: Yale University Press, 1993, p. 131.

47 Ibid., pp. 87–9.

48 Ibid., p. 102.

49 *The Diary of Benjamin Robert Haydon*, ed. Willard Bissell Pope, 5 vols, Cambridge, Mass.: Harvard University Press, 1960–3, vol. 4, p. 355.

50 Ibid., p. 362.

51 Ibid., p. 355.

52 Benjamin Robert Haydon, *Correspondence and Table-Talk. With a Memoir by his son, Frederick Wordsworth Haydon*, 2 vols, London: Chatto and Windus, 1876, vol. 1, pp. xii, xi.

53 Eric George, *The Life and Death of Benjamin Robert Haydon, Historical Painter, 1786–1846*, 2nd edn, Oxford: Clarendon Press, 1967, p. 151.

54 Quentin Bell, 'Haydon versus Shee', *Journal of the Warburg and Courtauld Institutes*, vol. 22, 1959, p. 347.

55 Haydon, *Correspondence and Table-Talk*, vol. 2, p. 228.

56 W.A. Munford, *William Ewart, M.P. 1798–1869. Portrait of a Radical*, London: Grafton, 1960.

57 Bell, 'Haydon versus Shee', p. 348.

58 Parry, op. cit., p. 37.

59 Bell, 'Haydon versus Shee', p. 351.

60 *Diary*, ed. Pope, vol. 4, p. 359.

61 Ibid., p. 362.

62 See Bell, 'Haydon versus Shee', passim.

63 *Report [Second Report] from the Select Committee on Arts and their Connexion with Manufactures ... Ordered, by the House of Commons, to be Printed, 16 August 1836*, pp. ix, viii.

64 *The Literary Gazette*, 1835, pp. 508, 556-7, 572.

65 See note 8.

66 *Builder*, 27 July 1844, p. 368.

67 *Builder*, 1 March 1845, p. 106 (report of Edward Bannister proposing the foundation of a school of design in Hull).

68 Charles Heath Wilson, *Address delivered ... in the Government Branch School of Design, at Spitalfields*, London: W. Clowes, 1844, p. 4.

69 William Bell Scott, 'Ornamental art in England', *Fortnightly Review*, 1 October 1870, p. 400.

70 Sparkes, op. cit., p. 28.

71 *Report read at the First General Meeting of the North of England Society for the promotion of the Fine Arts in their Higher Departments, and in their Application to Manufactures, Held 26th October 1837*, Newcastle: Mitchell (1837).

72 *Diary*, ed. Pope, vol. 4, p. 356.

73 Haydon, *Correspondence and Table-Talk*, vol. 2, pp. 233, 232 (letters of 2 October and 28 September 1836).

74 *Report [Second Report] ... 1836*, Minutes of Evidence, para. 1456.

75 Ibid., p. iii.

76 Ibid., pp. iv, vi.

77 See Quentin Bell, *The Schools of Design*, London: Routledge, 1963, pp. 65, 49.

78 *Report [Second Report] ... 1836*, p. vi; Minutes of Evidence, paras 2250-8.

79 Ibid., p. v.

80 Bell, *Schools of Design*, p. 60.

81 Charles Greville, *The Greville Memoirs*, ed. Henry Reeve, London: Longmans, 1888, vol. 2, pp. 80, 225-6; vol. 5, p. 120.

82 *The Art-Union*, 1848, p. 157.

83 *Diary*, ed. Pope, vol. 4, p. 396 (entries for 9 and 10 January 1837).

84 Letter from Haydon to Lord Melbourne, 11 January 1837, in Haydon, *Correspondence and Table-Talk*, vol. 2, p. 233.

85 Bell, *Schools of Design*, pp. 74, 157. George, op. cit., pp. 215-16.

86 *Minutes of the Council of the Government School of Design*, 3 vols, London: W. Clowes, 1847-9, vol. 1, pp. 416-23.

87 Bell, *Schools of Design*, p. 83.

88 Sparkes, op. cit., pp. 21-5.

89 *Minutes of the ... School of Design*, vol. 1, p. 31.

90 Bell, *Schools of Design*, p. 78.

91 *The Correspondence and Writings of William Dyce, R.A., 1806-1864*, typescript in the Aberdeen Art Gallery, chapter 10, pp. 331-43.

92 *The Art-Union*, 1842, p. 25.

93 *Report [Second Report] of the Council of the School of Design, 1842-3*, London: HMSO, 1843, p. 23.

94 *Diary*, ed. Pope, vol. 5, p. 184.

95 *The Art-Union*, 1848, p. 157.

96 'Hunt and Dyce', *The Art Review*, no. 2, 20 February 1864, p. 6.

97 Bell, *Schools of Design*, chapter 7, 'The Branch Schools'.

98 Ibid., pp. 142-8.

99 *Minutes of the ... School of Design*, vol. 1, p. 229.

100 C.H. Wilson, *Observations on some of the Decorative Arts in Germany and France, and on the causes of the superiority of these, as contrasted with the same arts in Great Britain ... From the Edinburgh New Philosophical Journal for October 1843*, [offprint, 1843], pp. 18-19.

101 *Minutes of the ... School of Design*, vol. 1, p. 261.

102 Ibid., pp. 290-4, letter from Ker to Wilson, 25 October 1843.

103 *Third Report of the Council of the School of Design, for the year 1843-4*, London: HMSO, 1844, pp. 17-18. For Wilson's views on casts see his 'Suggestions for Forming a Museum of Casts of the Architecture of Antiquity and of the Middle Ages', *Civil Engineer and Architect's Journal*, vol. 8, 1845, pp. 138-9.

104 *Minutes of the ... School of Design*, vol. 1, p. 320.

105 Ibid., vol. 2, p. 5.

106 Ibid., p. 23.

107 Bell, *Schools of Design*, p. 150.

108 *Builder*, 27 July 1844, p. 368, reporting on the Annual Meeting held on 24 July 1844.

109 For a detailed account see Bell, *Schools of Design*, chapters 9, 10.

110 *Builder*, 22 August 1846, p. 403. From a report on the Annual Meeting in the issue for 22 August.

111 Ibid., 2 August 1845, p. 367.

112 *Report of a Special Committee of the Council of the Government School of Design ...*, London: HMSO, 1847, p. 25. The three teachers' letters are reprinted in the Appendix of this Report.

113 *Report of the Second Special Committee of the Council of the Government School of Design*, London: HMSO, 1847, p. 4.

114 Bell, *Schools of Design*, p. 207.

115 See Eva White, *From the School of Design to the Department of Practical Art: the first years of the National Art Library 1837-1853*, exhibition catalogue, London: Victoria and Albert Museum, 1994.

116 *Report from the Select Committee on the School of Design; together with ... Minutes of Evidence ... Ordered, by the House of Commons, to be printed, 27 July 1849*, para. 3127.

117 This is being conducted by my colleague, Clive Wainwright, for publication in a book on the making of the V&A collections.

118 'Mutual Instruction at the School of Design', *Builder*, 10 March 1849, p. 113.

119 *Report from the Select Committee ... 1849*, para. 619.

120 George Wallis, 'Art, Science, and Manufacture, as an Unity', *The Art-Journal*, 1851, p. 268.

121 Thomas Wemyss Reid, *Memoirs and Correspondence of Lyon Playfair*, London: Cassell, 1899, p. 114.

122 William Bell Scott, *Autobiographical Notes*, ed. W. Minto, 2 vols, London: James R. Osgood, 1892, vol. 1, p. 181.

CHAPTER TWO
The Museum at Marlborough House

Henry Cole came from a respectable but not very prosperous family. Born in 1808, he was the son of an army officer who, after being wounded on active service, became a peripatetic recruiting officer, and then, retiring to London on half-pay, had to struggle to make ends meet. Owing to family connections, the young Henry was able to go on a scholarship to one of London's oldest and most distinguished schools, Christ's Hospital. Like the other ancient 'public schools', however, Christ's Hospital was at a low ebb educationally: Cole recalled that he 'learnt worse than nothing'.[1] He was unable to go to university, and left school at the age of 14 to earn his living. Because he had good handwriting, he was offered a place as a copy clerk by Francis Palgrave, a Sub-Commissioner working for the Record Commission on editing early Parliamentary documents. Although at first employed personally by Palgrave, Cole was, in effect, a minor civil servant, which he officially became when in 1832 he went to work directly under the Secretary of the Record Commission. He might have passed a blameless life at his Civil Service desk, but for two circumstances.

One was the fact that in 1826 his family rented lodgings in a house in Blackfriars belonging to the satiric novelist and poet, Thomas Love Peacock, who encouraged the young Cole. He gave him a start in journalism and, more important, introduced him to a circle of politically advanced young men of about his own age: among them were John Stuart Mill (born 1806), Sir William Molesworth (born 1810), Charles Buller (born 1806). Mill was the centre of this circle of 'philosophic radicals', who shared the utilitarian beliefs that had been expounded by Mill's father, James, and by Jeremy Bentham. Participation in John Stuart Mill's debating society must have been for Cole the equivalent of a university education. Its effect was manifest throughout his life: in his antipathy to old ways (especially aristocratic), his belief in universal suffrage and democratic assent (based on the principle of 'the greatest

happiness of the greatest number'), and in his enthusiasm for what would later be called 'business efficiency'. These are all utilitarian views.

The second factor that changed Cole's life was trouble at work. He was on increasingly bad terms with his boss, Charles Purton Cooper, Secretary to the Record Commission. This was largely due to Cole's stirring for reform in what certainly seems to have been an inefficient organization. Cooper sacked him in 1835, but Cole stirred all the harder, fighting his cause in public and making use of his radical contacts. He thus discovered that he had a genius for agitation and propaganda. He got his job back and was responsible for far-reaching changes in the administration of the Public Records. 'The triumphant success of Public Records Reform,' he wrote, 'brought to me inducements and offers to leave the Public Record service, and engage in other work.'[2]

Although cautiously retaining his job in the Civil Service, Cole went on to help with the introduction of Rowland Hill's Penny Postage system, and to work on the railways and docks. In the 1840s he also began to take an interest in artistic affairs, at first through publishing illustrated guide books to historic sites, such as Westminster Abbey and Hampton Court, and through producing tasteful children's books, such as he could not find elsewhere for his own young children.[3] He carried on these activities under the *nom-de-plume* 'Felix Summerly'. In 1846 he joined the rather torpid Society of Arts, gingered it up and organized a series of exhibitions of modern products, which led the way towards the Great Exhibition. Also in the late 1840s 'Felix Summerly' embarked on the production of household goods: a tea-set, a beer jug, a christening mug, a bread board, and other such things. To ensure that these 'art manufactures' (as he called them) were in the best of taste, Cole obtained the services of artists to design them, such as Richard Redgrave, William Dyce, J.R. Herbert, J.C. Horsley, H.J. Townsend, Daniel Maclise, William Mulready and the sculptor John Bell. The first five artists in this list worked at the School of Design, so it is hardly surprising that Cole and the School eventually came together.

Vignette: The version of the royal arms used on the Annual Reports of the Departments of Practical Art and of Science and Art.

In 1847 Cole met the Permanent Secretary of the Board of Trade, Sir John Shaw Lefevre, 'on board a Chelsea steamer'.[4] Exercised over the problems of the School of Design, Lefevre paid Cole to investigate and report. 'I accepted the commission, and wrote three reports, and then resigned, foreseeing the hopelessness of success, and refused to accept the fee.'[5] Cole also testified to the Select Committee on the School of Design in 1849. During 1850 and 1851, while keeping up the pressure on the School through the *Journal of Design*, a monthly periodical, which he founded and edited for this express purpose, he was engrossed in the Great Exhibition. He supplied most of the push in the early, promotional phase, and was then responsible for the prodigious task of getting all the exhibits into place in the Crystal Palace. After the exhibition he continued to play an important part in the team that Prince Albert had gathered around him, but, aged 43 and in his prime (figure 2.1), he was now looking out for a new full-time job. On 31 October 1851 he was invited to head the School of Design, and he took over there in January 1852.

When he gave his lengthy evidence to the Select Committee on the School of Design in 1849, Cole had many criticisms. A fundamental one concerned the School's mode of administration: 'till the constitution is remedied, there are no hopes of having the school working in a business and practical kind of way'.[6] Cole was a passionate opponent of administration by committee, believing that decisions were not usually reached when a crowd of people with varying opinions had to make them; that, even when a decision was made, it was impossible later on to discover who in the crowd was actually responsible for it; and that a crowd of people meeting only occasionally could not exercise adequate supervision over their staff. 'Administration by large numbers is a subject which, for the last 15 years, I have paid some attention to,' he claimed.[7] It had been one of the faults of the Record Commission, and he had put it right, so

that now 'I believe there is no department of Government in which the responsibility is more tight, and in which there is more work done, and a better account given to the public, than in the Public Record Office.' He promised that if his advice were followed, the 'heartburnings, and animosities, and constant contentions' at the School of Design would disappear.[8] As it was, there were too many cooks spoiling the broth in the governing body of the School:

Sometimes the President of the Board of Trade takes an interest in the matter, and sometimes the Vice-president; it seems at the option of the secretaries to take an interest in the matter or not; and so again, perhaps, with the legal assistant, who, being youngest and most active, takes the most interest, and in fact practically conducts the business; so with the artist members; they attend, or they do not attend, and they know something about a matter, or they know nothing about a matter, just at their option.[9]

What was needed was that direct responsibility should be taken by a firm individual, and, ideally, that individual should be someone like Henry Cole.

When he took over the Schools, Cole urged that they should become a department of the Board of Trade ('analogous to the Naval and Railway Departments') under a 'special secretary' – himself – 'through whom all the business should pass' so as to 'insure undivided responsibility and attention', which would 'work better than any special board consisting of several persons'.[10] Oddly enough, he did not gain entire control, for he had to work alongside another joint secretary, the artist Richard Redgrave (figure 2.2). But Redgrave was diplomatic, the two men got on well and they worked in harness for the rest of their professional lives, with Cole out in front, urging and pushing, and Redgrave behind, soothing, and tidying up the details. Cole did succeed in getting his own Department, which was named the Department of Practical Art.

And he was able to move the School headquarters out of Somerset House and into more spacious rooms in Marlborough House (figure 2.3). This building in Pall Mall, originally constructed for the Duke of Marlborough by Sir Christopher Wren, was now used as a minor royal residence, but had been vacant since the death in 1849 of the Queen Dowager, William IV's consort, Adelaide. Since July 1850 it had been partly used as an extension to the already crowded National Gallery, to accommodate its English paintings, notably those given to the nation by Robert Vernon.[11] Cole recorded in his diary for 19 February 1852 that Prince Albert made Marlborough House available to him on condition that he agreed to associate the Schools of Design with plans that the Prince was formulating for perpetuating the benefits of the Great Exhibition. These were to have a decisive influence on the development of the museum, as the next chapter shows. Having obtained

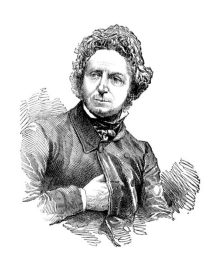

Figure 2.1
Henry Cole in 1851, wood-engraving from the *Illustrated London Almanack for 1852*. This was an 'official' portrait, made for a feature in the *Illustrated London News*, 18 October 1851, which gave portraits of all the major figures involved in the Great Exhibition.

Figure 2.2
Henry Cole and Richard Redgrave in the garden of Gore House in 1854. Redgrave was Cole's right-hand man in the Department of Practical Art and the Department of Science and Art, but during the 1850s he was busy with the restructuring and expansion of the art-education system and was not much involved in the museum.

royal permission, Cole proceeded (if we are to believe his autobiography) more or less to invade Marlborough House, disregarding bureaucratic niceties, and was officially 'upbraided' for his precipitate action.[12] His first few months were spent in asserting his authority. His appointment was controversial. 'A more unfortunate selection could not have been made,' lamented the *Art-Journal*, for Cole was 'one whose taste, knowledge, and experience are of a singularly low order'.[13] But his management style was irresistible.

What was he to do about the teaching at the Schools of Design? To the Select Committee of 1849 he had made the point, so often made by others, that 'the school was not practical', in that it did not deal with how things were made. What was needed was 'a very specific knowledge ... of proceeds and materials', but such knowledge 'the School rather evades than gives'. The London and provincial schools were 'mere drawing schools', and 'inasmuch as the masters do not understand design themselves, it seems to me impossible that they should be able to teach it'. Cole claimed to know about design because he had scrutinized 35,000 registered copyright designs when engaged in agitation for the reform of the copyright laws.[14] Furthermore, as Felix Summerly, he had had practical experience of com-

missioning and manufacturing consumer goods. And at the Society of Arts he had organized exhibitions of contemporary products.

Perhaps he let his disapproval run away with him. He was derisive about training in drawing. He approvingly quoted a manufacturer who deprecated teaching 'little girls ... to draw thigh bones, and teaching them to draw from ornamental casts and arabesques'. Even 'with regard to the arabesques of Raphael', which were so prominently honoured in the London School, Cole said, 'I do not think that there is much practical connexion between them and Sheffield ware, or Birmingham casting.' He maintained that, at the Manchester School of Design, 'the instant they introduced the system of teaching the drawing of thigh bones and *scapulae*, and insisting that every pattern drawer should go through that which could not be of much practical use to him, the school went down from being very flourishing, tumbled into debt, and declined'.[15] He was prepared to disparage in public the use of collections for students to draw from. Giving a speech at a newly established drawing school in Bradford on 2 February 1852, Cole poured scorn on their little museum.

They had figures of Venus and other castings, but he took leave to doubt whether they had any such practical bearing on

their interests in the manufacture of damasks and other fabrics as some other things had. (Hear, hear.) ... They must have something else than casts of Venus and ancient architectural models, such as they had down-stairs. (Laughter.)[16]

And yet it was hardly likely that good designs could be obtained from students who could not draw. It was one of the complaints of William Bell Scott, at the Newcastle School of Design, that the masters were expected 'to teach the working classes, who could not hold a pencil, to create new decorative designs, and even begin new trades'.[17] Cole, notwithstanding his mischievous remarks about thigh bones, was prepared in 1849 to concede that 'I do not underrate the importance of elementary instruction. On the contrary, I should wish to see it carried ten times beyond what it now is, and even to the extent of making the learning of drawing a part of the instruction in national schools.'[18] And in 1852, now in charge of the Schools, he found himself defending them against the old charge that they were 'mere drawing schools'. With characteristic cheek, he turned the imputed vice into a virtue:

It has taken a long period of 14 years to arrive at the conviction that in order to educate a competent designer, you cannot avoid the obligation of first teaching the very elements of art, a power of drawing.[19]

In thus changing his mind about drawing, Cole might have been adopting views that had already been canvassed by others. The magazine the *Builder*, for instance, had advocated back in 1846 that drawing should be taught in every elementary school. 'What we wish to do is, to make *every* school a drawing-school, and to accustom every one, gentle and simple, to the use of the black lead pencil.' In the same breath, it made a plea for free museums, on the grounds that 'by the contemplation of works of beauty, the general standard of taste would be raised, and a power of discrimination gained'.[20] This was to be exactly Cole's position.

Or perhaps he was seizing the opportunity to boost the scope of his own job. Although he was a very tough character, Cole had a rather endearing habit of noting in his diary (which is, for the most part, a very clipped record of business matters) any praise he received that endorsed his high opinion of himself. On 29 January 1852 he noted that Sir Charles Trevelyan congratulated him on his 'appointment to direct the Art of the Country'. Obviously directing art education in all the nation's schools was better than directing just a small string of Schools of Design.

Cole did, however, follow a perfectly reasonable argument to reach his new conclusion. This turned on a problem that had been puzzled over since the Arts and Manufactures Select Committee of 1835–6. If one wanted to improve the quality of British goods, where was it best to apply pressure in the cycle of production and consumption? Should one try to persuade consumers to desire better goods, and thus to demand them from the producers? Or should one persuade the producers to put better goods on the market in front of the consumers, in the hope that the newly supplied goods would win the consumers' approval? If one decided to try to influence the producers, should one target the captains of industry, the factory owners, who presumably decided what was to be made? Or the workmen who actually made the goods? It was the workmen, the artisans, who had generally been targeted. They were, after all, the weakest of the three parties concerned, and must have seemed the easiest target. By 1852, however, the attempt to re-educate the artisans did not seem to have succeeded.

Cole, in his first big policy statement, a lecture at Marlborough House on 24 November 1852, explicitly forswore the attempt to supply 'education in art to artizans only'. Enlarging on the problem to which we have just referred, about the three parties in the production/consumption cycle, he concluded:

Our first and strongest point of faith is, that in order to improve manufactures, the earliest work is, to *elevate the Art-Education of the whole people*, and not merely to teach artizans, who are the servants of manufacturers, who themselves are the servants of the public. Our first object, therefore, has been to devise means by which the department may promote all the several interests involved in the improvement of public taste. The interest of the public, as consumer and judge – the interest of the manufacturer, as the capitalist and producer – and the interests of the artizan, as the actual workman.[21]

THE VERNON GALLERY.

This collection, now placed in the rooms on the ground-floor of Marlborough House, comprising 155 pictures, 6 busts, and 1 group of figures in marble, was presented to the nation by Robert Vernon, Esq. The other English pictures, forming part of the National Gallery in Trafalgar Square, 43 in number, have also been removed hither and occupy the first two apartments on passing from the hall. The collection is open to the public gratis, on the first four days of each week throughout the year, with the exception of a month during the autumn.

MARLBOROUGH HOUSE.

Figure 2.3 Marlborough House, presented in John Weale's guide book, *London Exhibited in 1851*, as the home of the Vernon Collection. The Museum of Manufactures moved in during the following year.

In this lecture, Cole announced that his Department would not only develop the Schools of Design but would set up a system for teaching art nationwide in all schools. He did not at this stage abandon his belief that the Schools should also give tuition in materials and manufacturing processes. There were in the early days at the London School 'special classes' in architectural sculpture and construction, textile fabrics and paper-staining, metalwork and furniture, painting on porcelain, and moulding and casting.[22] But these soon faded away,[23] and Cole has been accused, in later times, of abandoning concern for design, and of setting up a vast, self-perpetuating system in which drawing masters trained students to become drawing masters.[24]

Now that Cole's Department was trying to educate not only artisans but also the general public, the museum assumed much greater importance. In 1849 Cole had dismissed the public as 'extremely ignorant and very undiscriminating', and he wanted to steer clear of them on the grounds that 'to tell upon the public taste may take many years'.[25] Now in 1852, however, it was part of his mission to educate the public: 'We cannot expect grown-up men and women to go to schools to learn the elements of form and colour,' he said, 'but the museum and lectures may become their teachers.'[26]

For Cole, the museum was not a repository for historic relics, but a way of changing people's taste. He had great confidence in matters of taste (as in most things). Before the 1849 Select Committee he insisted that 'taste has its principles as well as morals, which people understand and know'. Pressed by the Committee to accept that taste was a relative matter, he would not give ground:

I think to act upon the principle of 'every one to his taste,' would be as mischievous as 'every one to his morals'; and I think there are certain principles of taste which all eminent artists are agreed upon in all parts of the world.

As a utilitarian, he believed that good taste could be settled by common consent, by the majority vote. But he believed also that the vote would be given only to those competent to make judgments. 'Taste has certain broad rules, like all other mundane subjects. *People who attend to the matter* [my italics] can understand those rules, and arrive at conclusions which are generally the same.'[27] People who believed in good taste, however, got a nasty shock at the Great Exhibition of 1851, for there they were confronted with millions of objects in every conceivable style and taste. How to make sense of this confusion?

The history of nineteenth- and twentieth-century design used to be dominated, over many years, by a thesis, advocated pre-eminently by Nikolaus Pevsner, that the aesthetic anarchy of 1851 provoked a reaction towards a purer and more truthful taste, which found its most positive expression in the work of the architects and designers of the Modern Movement. The arrival of post-modern attitudes has weakened this thesis. But it certainly was the case that some critics in 1851 tried to cut through the muddle in the Great Exhibition, and Cole was among them. Pevsner hails as 'the earliest outspoken condemnation of the taste displayed at the Exhibition' an article in *The Times*, 'no doubt written by one of the Cole group'.[28] The article was reprinted in the *Journal of Design*, which Cole edited and in which he waged his campaign against the School of Design. The article reappeared here under the striking title 'Universal Infidelity in Principles of Design', along with another reprinted piece from the *Morning Chronicle*. This asserted that 'what we want are canons of taste – laws of beauty – principles and axioms of propriety', and contained the memorable slogan '*art has its dogmas and its orthodoxy*'. At the end of the reprinted passages, the *Journal of Design* added an editorial comment: 'Truly "art has its dogmas and its orthodoxy," which our Schools of Design have yet to learn and teach.'[29] This, presumably, was the voice of Cole, while the writers of the pieces from *The Times* and the *Morning Chronicle* seem to owe much to the hortatory fervour of Pugin.

GENERAL PRINCIPLES OF DECORATIVE ART.

The true office of Ornament is the decoration of Utility. Ornament, therefore, ought always to be secondary to Utility.

Ornament should arise out of, and be subservient to Construction.

Ornament requires a specific adaptation to the Material in which it is to be wrought, or to which it is to be applied; from this cause the ornament of one fabric or material is rarely suitable to another without proper re-adaptation.

True Ornament does not consist in the mere imitation of natural objects; but rather in the adaptation of their peculiar beauties of form or colour to decorative purposes controlled by the nature of the material to be decorated, the laws of art, and the necessities of manufacture.

PUBLISHED BY CHAPMAN AND HALL, 193, PICCADILLY, LONDON.

The dogmas of taste that are promulgated are such as these: in designed objects, ornament should be appropriate to function. (This is far from meaning that form should follow function; rather it means that grapes would be appropriate decorations on a wine glass, while fish would be inappropriate on wallpaper.) Ornament should also suit the material from which an object is made, and should be disciplined by the construction of an object. On flat surfaces ornament should be two-dimensional, not three-dimensional. Motifs from nature should be formalized. These dogmas were applied to the Great Exhibition when, in September 1851, Cole obtained a grant from the Board of Trade to purchase for the Schools of Design a selection of the best-designed objects in the Exhibition. He formed a 'Designs Purchase Committee', consisting of himself and Richard Redgrave, with the designer Owen Jones and A.W.N. Pugin.[30] At a series of meetings in autumn 1851 they combed the Exhibition for suitable purchases. If minutes of their meetings had been taken, they would have constituted a fascinating and important document of Victorian taste. No record of their discussions survives, but we do have a catalogue of the 244 objects acquired, with explanatory remarks, and an essay composed by Redgrave during this period: *Report on Design: Prepared as A Supplement to the Report of the Jury of Class XXX. Of the Exhibition of 1851.* The essay, known familiarly as 'Redgrave on Design', became the Bible of the Cole circle. Associated with it were a series of 'Principles of Decorative Art', which were printed in large format and hung up in the School of Art classrooms (figure 2.4), where they remained for many years.[31]

The museum at Marlborough House was dedicated, at the start, to putting across this programme to the world at large. Occupying a suite of rooms on the first floor, it opened to the public on 19 May 1852, remaining open for 17 days in May and June 1852, closing for the summer vacation, and reopening definitively from 5 September.[32] Giving an account of a private view on Tuesday 18 May, the *Athenaeum* recorded that the displays 'consisted of two classes of objects' and that 'the contrast between the two was somewhat startling'.[33] There were, first, designs made by students at the School of Design, but these were 'much less tempting and picturesque' than a selection of modern

No. 195.—GOTHIC BOOKCASE, OR CABINET.

Manufactured by J. G. CRACE, 14, Wigmore Street, Cavendish Square, London.

Material.—Oak, and Brass.

Price.—£154.

Peculiarities of Manufacture.—" This Cabinet is in carved oak. " The side compartments are paneled and carved in rich tracery. " The centres are filled with open brass-work, to admit a view of " the objects placed within. These compartments are divided by " carved and moulded muntins; and surmounted by a foliated " bradishing, interspersed with shields bearing monograms and " devices. In this piece of furniture the construction is made " the element of the design, and the carving of this construction " is worked from the surface."—*J. G. Crace.*

Observations.—Remarkable as a piece of furniture in which the construction has been carefully considered, and the decoration confined to the enrichment of the necessary spaces and framing in the true style of the old work, where all ornament was strictly subordinate to the construction of the article; and the locks, hinges, and other metal furniture were made ornamental portions of the whole design.

(*Above*) Figure 2.5
An entry from the first edition (17 May 1852) of the *Catalogue of the Articles of Ornamental Art, selected from the Exhibition of the Works of Industry of All Nations in 1851.*

(*Right*) Figure 2.6
An illustration of the bookcase from the *Art-Journal Illustrated Catalogue* of the Exhibition.

(*Facing page*) Figure 2.4
The first of the eight placards (11 × 15 in.) of 'Principles of Decorative Art', 'published by Authority of the Department of Science and Art' in 1853.

Figure 2.7
A plan of the main block of
Marlborough House in 1852,
showing the corridor devoted to
'Decorations on False Principles'.
From a lithographic plan printed
by Day & Son, included in the
First Report of the Department of
Practical Art, 1853. Marlborough
House also had wings in which
rooms were used by the School
of Design.

(Facing page) Figure 2.8
A page from the Catalogue of the
Museum of Ornamental Art, at
Marlborough House, 5th edition,
1853. The catalogue has very few
illustrations, and these are the
only ones in the section devoted to
'Examples of False Principles in
Decoration'.

manufactured goods – 'Art-illustrations of the highest order'. This category included the objects acquired by the School of Design before 1851, together with the specimens of good taste bought by Cole's committee from the Great Exhibition.[34]

Here were to be seen such objects as 'gorgeous scarfs and shawls from Cashmere and Lahore – glittering swords, yatagans and pistols from Tunis and Constantinople',[35] for Cole and his committee were especially impressed by Oriental products at the Exhibition. Alongside these were eye-catching western objects such as the delicately coloured 'La Gloire' vase made at Sèvres; a hunting knife representing the legend of St Hubert, made by Marrel Frères of Paris; a sword copied from that presented to General Changarnier by the City of Paris, made by Froment Meurice; and the 'Italian poets' shield, designed by Antoine Vechte and made by Lepage Moutier of Paris.[36]

The catalogue of these objects boldly explained why they were good (figures 2.5 and 2.6). An Axminster carpet (W 121) was praised because it was 'designed on the true oriental principle of a flat ground, relieved by harmoniously coloured enrichments; without any attempt at false shadows or imitations of relief'. An Indian necklace (M 15) was given credit for 'the way in which the forms are here massed, gradually diminishing in bulk from the inner ring to the extremities ... the variety of line produced by the position of the several forms; the judicious amount of

relief in each'. A sandalwood jewel box (F 17) elicited this comment:

In this example the ornaments, although rich, and covering the whole of the surface, are strictly subordinate to the constructive forms, and do not interrupt the leading lines. The adaptation of the ornament to the various mouldings and flat surfaces is admirably and fancifully felt. The box is a perfect study for the correctness of principle exhibited in all its parts.[37]

To give such analyses of the exhibits was courageous, and they still seem cogent. This didactic style was kept up in the catalogue of an exhibition of Historic Cabinet Work, which the Department staged at Gore House in 1853, but lapsed thereafter.

Even more courageous – foolhardy, perhaps – was an introductory section, in the corridor approaching the exhibition rooms (figure 2.7), in which Cole tried to demonstrate bad taste. Officially known as 'Examples of False Principles in Decoration', it came to be known as the 'Chamber of Horrors'. Cole's diary records that he was writing the catalogue of the 'False Principles' section on 12 August 1852 (figure 2.8), during the summer vacation when the museum was closed, so presumably this section was first unveiled in September. Cole observed that 'this room appears to excite far greater interest than many objects [of] high excellence', for 'every one is led at once to investigate the ornamental principle upon which his own

carpet and furniture may be decorated'.[38] Cole was trailing his coat, no doubt mischievously, and protests came – predictably – from manufacturers of products that were pilloried, with the result that the section was soon closed down. 'This I have never ceased to regret,' earnestly wrote the designer Christopher Dresser, 25 years later. He recalled some of the exhibits:

... scissors formed as birds, which separated into halves every time the scissors were opened; candle-sticks formed as human beings, with the candle fitting into the top of a chimney-pot hat or into the head; egg-cups formed as birds' nests; plaid fabrics bearing check patterns so large that it almost required two persons to wear the same pattern in order that the whole design be seen; carpets on which ponds of water were drawn with water-lilies floating upon them; and other absurdities equally offensive to good taste.[39]

Not everyone took it so seriously. In Dickens's weekly periodical, *Household Words*, on 4 December 1852, Henry Morley[40] wrote a very funny article in which a Mr Crumpet

FALSE PRINCIPLES.

No. 62.—GLASS BUTTER DISH.
No. 63.—WINE GLASS.
No. 64.—JELLY GLASS.
Observation.—In each of these articles the natural outline of the glass when blown destroyed by the surfaces being cut.

No. 65.—GLASS GOBLET, OPAL.
Observation.— Coarse form: the transparency of the material sacrificed to imitate alabaster.

No. 66.—GLASS GOBLET (FLASHED WITH OPAL AND ENGRAVED).
Observations.— Transparency, which constitutes the beauty of the material, entirely destroyed, thereby rendering it impossible to see the contents.

Examples of False Principles in Decoration.

No. 64.

No. 67.—GLASS GOBLET.
Observation.—Form unfitted for use; the vessel shrinks in the middle so that it could not be emptied without raising the foot considerably above the mouth.

No. 68.—CORNUCOPIA FOR FLOWERS.
Observations.—The constructive line very bad,—the base appearing as if stuck on, instead of forming part of the whole; transparency of the material destroyed.

No. 69.—GLASS FLOWER VASE.
Observation.— The general outline entirely destroyed by the vertical cuttings.

No. 70.—EARTHENWARE VASE.
Observation.— Ornaments copied from a funeral vase, and inappropriate (see observations, No. 81).

No. 71.—FLOWER-POT.
Observation.—Imitation in earthenware of reeds, painted blue, bound together with yellow ribbon.

No. 72.—PAIR OF SCISSORS.
Observations.—Imitation of a stork; the beak opening the reverse way; the body of the bird made to open in the direction of its length.

No. 69.

21

of Brixton testifies how the Marlborough House display has brought him to an anguished realization of how awful his own taste is. Actually, Morley had some sympathy for Cole's polemic. It is voiced through Crumpet's friend, Frippy:

My dear Crumpet, you have picked up some wholesome views, but you have swallowed them too eagerly, and choked yourself. I shall go where you have been, and take the lessons you have taken; but I shall not bolt them in a lump as you have done, and get a nightmare for my trouble; I shall discuss them in a reflective way, and leave them to be quietly digested: after which I have no doubt they will do me good. A little precise knowledge of some true principles of design is wanted just now ...

In the early days at Marlborough House there was no more than a sprinkling of older objects. Among these was some lace lent by the Queen. She and Prince Albert came to an opening ceremony on 17 May, at which she offered the loan. When, later in the day, Cole went to collect the lace, he found that the Queen had herself written out labels for it.[41] Gradually more antiquarian exhibits crept in, and, notwithstanding that Cole's first concern was to conduct a polemic about contemporary design, it was he who pursued the antiquarian material.

It is necessary to remember that Cole was well acquainted with the history of the decorative arts, even though he did not have the money to become a connoisseur or the leisure to become an art historian. At the Society of Arts, as well as organizing exhibitions of modern products, he was involved in 1850 in an exhibition of 'Ancient and Mediaeval Art'. Under Prince Albert, he sat on an organizing committee that included 'members of the several Societies promoting Antiquarian and Archaeological pursuits',[42] and of which the secretary was A.W. Franks, who was to join the British Museum in 1851. There, for 45 years, he built up the Department of British and Mediaeval Antiquities.

Cole's *Journal of Design* printed several articles about the exhibition. Unsigned (as were so many contributions to the *Journal*), these might well have been written by Cole. Even if he was not their author, he was editor of the *Journal*, and we may assume that the articles shaped his awareness of what was going on among collectors of medieval and Renaissance decorative arts. When the *Journal* considers French taste, recalling 'how sedulously the arts of the middle ages have been explored and analysed' in France, and alluding to 'the superb permanent public collections of the Louvre and the Hôtel Cluny, and the private "cabinets" of the Comte de Portalés, Sauvageot, Denon, de Bruges, &c.',[43] we may assume that Cole had some familiarity with this scene (it will be described in more detail in Chapter Four). And we can assume that he saw the sorts of things

that were displayed in the exhibition, and understood the categories with which antiquarians were concerned. The medieval and Renaissance objects that collectors acquired were, in the main, those that were precious enough to have survived, and were portable enough to move around the market and be accommodated in domestic settings. The categories were 'thus enumerated in the catalogue' of the Exhibition:

I. METAL WORK: 1. Gold and Silver; 2. Laten and other Metals; 3. Bronze; 4. Iron; 5. Damascene Work; 6. Niello. II. SCULPTURE AND CARVING 1. Wood; 2. Ivory; 3. Stone. III. ENAMEL: 1. Incrusted; 2. Translucid on relief; 3. Painted; 4. Goldsmith's Enamelled Work. IV. CLOCK AND WATCH WORK. V. FICTILE MANUFACTURES [i.e. ceramics]: 1. Greek and Etruscan; 2. Roman; 3. Della Robbia Ware; 4. Italian Majolica; 5. German and Flemish Stone Ware; 6. Henry II. (of France) Ware; 7. Palissy Ware; 8. Böttcher Ware; 9. Miscellaneous. VI. GLASS: 1. Greek and Etruscan; 2. Roman; 3. Venetian; 4. German. VII. PAINTING. VIII. TEXTILE FABRICS: 1. Tapestry; 2. Embroidery; 3. Lace. IX. LEATHER WORK. X. ARMOUR. XI. MOSAIC WORK. [44]

Cole doubtless had some such shopping list in mind as he set off to find historical material for Marlborough House. He was assisted by the retired Bond Street dealer, John Webb, who had sat with him on the 1850 exhibition committee and who served as a shadowy but influential adviser to the museum until his death in 1880. Indeed, his influence persists to the present through a purchase fund that he left to the museum.[45]

Cole's diary records expeditions during the long vacation of 1852. On Saturday 7 August, 'at Mr Webbs to select Articles for the Museum'; Webb undertook to 'lend China &c.' On Friday 13 August, 'called on Mr J. Webb and selected numerous articles ... Then to Buckingham Palace with Mr Webb. Examined old Sevres: some very fine indeed'. On Friday 20 August, 'with Mr Webb to Hampton Court to select Pictures &c.' Later, in 1853, we can follow Cole as he goes on 11 February to 'Lord Favershams to select China'; on 23 February 'to Buckingham House with Mr Webb to select china from the Stores'; on 23 April 'to Lord Spencers to see Porcelain'; and on 27 April to 'Buckingham Palace to select Tapestry'. These sorties were in pursuit of loans for the museum. They must have significantly changed the atmosphere of the displays, for already in October 1853 the Athenaeum pronounced:

A visit to Marlborough House will convince every one that the nucleus of a museum similar to, indeed even more comprehensive in its scope than, that of the Musée de Cluny in Paris, and the well-known ornamental Art-collections of Berlin and Dresden, has been firmly established, and that it has progressed with unusual rapidity and success. – The principle of borrowing for temporary exhibition the fine works of Art and virtù so profusely scattered throughout the rich mansions of

our nobility, has been eminently successful; constituting one of the most valuable features of the institution – a constant succession of novelties.[46]

Soon purchases also expanded the museum's scope. On 24 February 1853 Cole and Webb went with Richard Redgrave to look at the collection of pottery made by James Bandinel of the Foreign Office. This was bought for the museum.[47] In March 1854 a collection of models in wax and terracotta by 'various ancient Italian masters' was considered for acquisition. William Dyce and J.R. Herbert, Cole's cronies, formerly at the School of Design, brought this collection – which contained 12 wax sculptural sketches then attributed to Michelangelo – to the attention of the Government in January 1854. The collection belonged to an Italian named Gherardini, who had inherited it from a kinsman, an aged priest. It was subjected to a utilitarian acquisition test devised by Cole. The models were

publicly exhibited for the period of one month ... with the view of eliciting from the public and the artists of this country such an expression of opinion, as to their value and authenticity, as will justify the purchase or rejection of the collection by Her Majesty's Government.[48]

The Gherardini collection passed the test and was added to the museum.

In 1855 the collection of Ralph Bernal was up for sale. His was reckoned to be the only English collection which could rival the 'private "cabinets"' of France. Bernal was not only 'distinguished among English antiquaries by the perfection of his taste, as well as the extent of his knowledge', but 'his judgment was acknowledged over Europe'.[49] Cole tried hard to persuade Gladstone, the Chancellor of the Exchequer, to buy the collection outright, but Gladstone insisted that it go under the hammer at Christie's. Both Marlborough House and the British Museum (acting in concert) bid heavily, and 730 lots came to Marlborough House.[50]

In 1856 Cole made a sortie into enemy territory. Tipped off by his friend, the pottery manufacturer, Herbert Minton, he went in pursuit of the collection of a French lawyer, Jules Soulages of Toulouse, in southern France.[51] This, like Bernal's, was a wide-ranging collection embracing most of the categories of objects that had figured in the 1850 exhibition (figure 2.9). It was brought to England and exhibited at Marlborough House (figure 2.10), just as the Gherardini collection had been, so that Cole's utilitarian acquisition test could be applied. It aroused enthusiasm among some viewers. One journalist was entranced by its associations. Of a Venetian lantern he fancifully wrote: 'There it swings as it did two hundred years ago, when St Mark's bell tolled for the death of Foscari, – or on rough nights, when the

CONTENTS.

N.B.—*The arrangement of the Collection, and the numbers affixed to the objects, have been temporarily adopted from the original inventory, furnished by M. Soulages.*

spray of the Lagoon broke in over the marble steps and splashed the smiling faces of its cedar seraphs.' The exhibits evoked for him romantic places and people:

Look in one of these Soulages mirrors in a right mood, and you will see come up through the glass, like faces through the waves, a thousand dead men's countenances, still wrung with the death-pang. There Lucrezia Borgia, her white fingers stained dark with poisons, smiles again; and there the petulant Biron frowns, or Henri Quatre bows and nods.[52]

Others considered the collection in a more serious spirit. The Institute of British Architects supported the purchase of the collection as a whole by deploying the 'complete series' argument, which has been so useful to curators:

Each individual piece has its own peculiar value or merit; but when combined with others, as illustrating either the theory or history of Art, so as to complete the chain and connexion of manufactures and Art-illustration, and thus forming a series of the progressive excellence to which such productions have been carried in times past, their worth is much enhanced.[53]

Unfortunately, neither approach cut any ice with the Prime Minister, Lord Palmerston, who said to Cole, 'What is the use of such rubbish to our manufacturers?'[54] and refused to buy the collection for the nation. Unabashed, Cole contrived for the collection to be bought by the committee of the Manchester Art Treasures Exhibition, held in 1857. After being exhibited there, the collection was leased back to the museum, which gradually purchased it in instalments, as annual budgeting permitted.

Despite his capacity for financial ingenuity – or, perhaps,

Figure 2.9 The contents page of J. C. Robinson's *Catalogue of the Soulages Collection*, 1856. This gives a good idea of the sort of things collectors of medieval and Renaissance art tried to acquire in the 1830s and '40s. The elegant typography doubtless reveals the influence of Henry Cole.

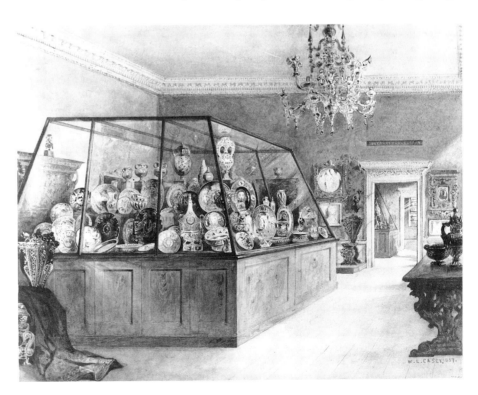

Figure 2.10 A watercolour view, by W. L. Casey, of the Second Room of the Museum at Marlborough House, in 1857, when the Soulages Collection was on display.

in order to counter any impression of sharp practice – Cole ensured that the museum was completely open about the prices it paid for objects. These were cited in most of the published catalogues, and were invariably included in the printed inventories, which were issued at intervals until, after the inventory for 1908 (published in 1912), they gave way to a discursive *Review of the Principal Acquisitions*, without prices. Labels accompanying objects on display were derived from the inventories, and also included prices. This practice was presumably instituted from the beginning. It is described as a matter of course in a memorandum on labels, which Cole was later to issue in 1864,[55] was discussed at a Select Committee that investigated the museum in 1897[56] – by which time it was regarded as a quaint practice unique to the V&A – and was finally abolished by a Committee of Re-arrangement in 1908.

It is clear from the purchases described above that the museum at Marlborough House began with a tight focus on contemporary manufactures, but soon started to favour historical decorative art. It is sometimes suggested that a clear policy change was signalled by a change in the museum's name, from 'Museum of Manufactures' to 'Museum of Ornamental Art'. But the situation was in fact less clear-cut. Cole – curiously for so decisive a man – failed to settle conclusively on a name. At the start, the Department of Practical Art's Prospectus called the museum a 'Museum of Ornamental Art', while in a handbill prepared by Cole for its opening in 1852 it was announced as 'A Museum of Ornamental Manufactures' (figure 2.11).[57] In the Department's First Report it appeared as the 'Museum of Manufactures'. This last term had been much used in Cole's campaigning magazine, the *Journal of Design*, in discussions before the museum was established,[58] but 'Ornamental Art' was the term that stuck in the end.

Some tensions can also be detected in Cole's various formulations of the purpose or mission of the museum. Fundamentally, he claimed that the exhibits were intended to exemplify the best standards. These he took to be 'a high order of excellence in Design', or 'a rare skill in Art Workmanship'. But these two qualities are not necessarily identical or even compatible, and Cole found that some exhibits, 'like most of those from the East, illustrate correct principles of ornament, but are of rude workmanship; whilst others, chiefly European specimens, show superior skill in workmanship, but are often defective in the principles of design'.[59] So it was not easy to find unalloyed examples of good design. The matter was further complicated if historical interest was permitted to enter the equation. The early published catalogues of the museum were introduced by the printed legend (in italic type for emphasis, and preceded by a pointing finger): 'The Museum is intended to contain not only works selected as fine examples of design or art workmanship, but others chosen with a view to an historical series of manufactures.'[60] If this seems to suggest that the museum was tilting towards art history, then the following, in the new catalogue of the museum published in 1855, looks like an attempt to redress the balance:

Whilst correct ideas of the history and relative importance of the various classes of objects are sought to be imparted, special development is given only to those which are calculated to exercise an influence in refining and informing the public taste.[61]

In its early years, then, the museum seems to have oscillated between manufactures and art, between influencing contemporary taste and documenting the history of taste.

This oscillation was, as we have seen, present in Cole's own views and practice. On the whole, however, Cole was on the side of manufactures and taste reform. One important consequence of this was the way in which the museum was classified. The catalogue of the collection was frequently revised and reprinted as the collection grew, and its third edition contained a 'Postscript' by Henry Cole, dated 6 September 1852, which lays down the categories into which the collection is to be divided: '1. Woven; 2. Metal; 3. Ceramic, or Pottery; 4. Glass; 5. Furniture;

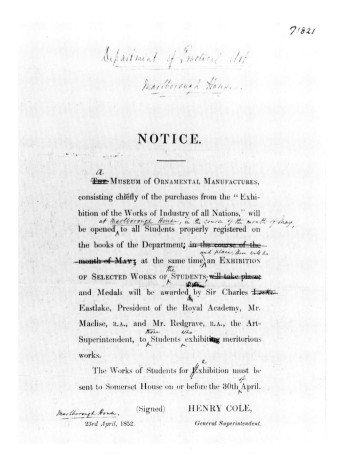

Figure 2.11 A handbill announcing the opening of the museum, with corrections by Henry Cole.

6. Various.' Cole goes on to note that 'when sufficient space is provided, a more minute subdivision will probably be desirable',[62] which implies that the classification was to apply not only in the catalogue but also to the arrangement of the exhibits in the museum. The point of arranging objects in this way, and not according to, say, date order or use, is that such arrangement is convenient for manufacturers or workmen who want to learn what is relevant to their own trade. Cole's postscript can, perhaps, be taken as marking the moment when the V&A's 'material-based' approach to its collections was established. A century later, the Director of the V&A remarked of Marlborough House that 'the basic arrangement was by material ..., a method which persists in the Museum to the present day';[63] and that method still survives, after the reforms of 1989.

The museum at Marlborough House was driven energetically towards art history by a new curator whom Cole appointed in 1853, and who took up his post during the summer vacation, while the museum was closed in August and September. He was John Charles Robinson, a young man of 28 (figure 2.12). Robinson had first trained as an architect. He then visited Paris to learn to be a painter, but emerged as a collector and connoisseur with the latest antiquarian tastes. He taught at the School of Design in Hanley, Staffordshire, where he so 'distinguished himself'[64] that he was brought to London to supervise a crash course for teachers in October 1851.[65] Moving over to the museum a few months later, he quickly showed himself to be a curator of genius. And he began to steer the museum away from Cole's polemical certainties.

His first task was to rearrange the museum, since it had been dismantled for the installation of new showcases.[66] He stuck to Cole's classification, but introduced a pragmatic note: practical difficulties made it impossible to impose the classification strictly, and he preferred 'to make the effectual display of the specimens the primary consideration'. The removal of a partition wall had caused the disappearance of the 'Chamber of Horrors' corridor, so Robinson, no doubt with relief, despatched these exhibits to the lecture room. Of the other rooms, the first was mostly devoted to metalwork, the second to textiles, the third to furniture, the fourth to pottery, the fifth to ceramics and sculpture.[67] It is to be presumed that, as more and more exhibits flowed in during the next few years, the display became more free and varied, for the fascinating series of watercolour views of the rooms, painted by W.L. Casey, J.C.L. Sparkes and C. Armytage in 1856–7 (figure 2.13), do not give an impression of a systematic arrangement,[68] but rather of the 'antiquarian interiors' favoured by private collectors in their domestic environments.[69]

There can be no doubt that Robinson deliberately set out to change the emphasis of the museum. To his first report he appended a short manifesto, 'Memoranda and Suggestions'. While Cole had wanted exhibits in the museum to demonstrate true principles, Robinson, writing about the process of acquisition, backed 'individual judgment, exercised with a due sense of responsibility' rather than 'the laying down of any binding rules', adding quickly: 'This, however, need not prevent the recognition of certain general principles ...' He went on to propose five

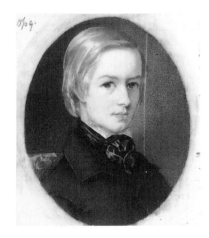

Figure 2.12 J.C. Robinson in 1852.
A miniature by W. Maw Egley.

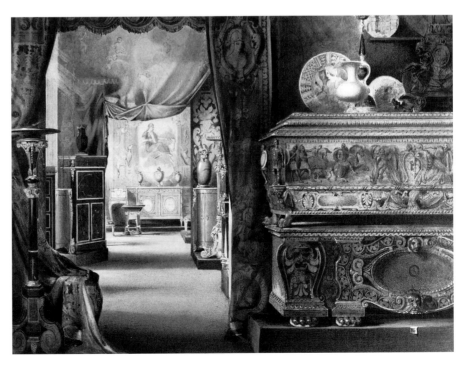

Figure 2.13 A watercolour view, by
C. Armytage, of rooms in the Museum at
Marlborough House, in 1857.

acquisition criteria (not very different from those in force today): aesthetic quality; technical interest; historical significance; 'fictitious or artificial interest to the collector' (that is, associations and provenance?); novelty.[70]

In defining the mission of the museum, he introduced the term 'decorative art': at the start of his first report; in the introduction to his new catalogue of the museum, published in May 1855 ('The object of the Museum is to illustrate the history, theory and practical application of decorative art'); and, more daringly, on the title-page of his catalogue of the museum's first circulating exhibition, published in June 1855. It is hard to be sure, even today, what might be the difference in meaning between 'decorative art', 'ornamental art' and 'applied art'. In 1843 Charles Heath Wilson accepted that the first two were synonymous,[71] and a reviewer faced with Robinson's catalogue of the circulating collection of 'Decorative Art' and the 1856 edition of the museum catalogue of 'Ornamental Art' confessed, 'We are at a loss to see where the line can be drawn between' the two terms.[72] But one cannot help feeling that in using the term 'decorative art', and not the terms that Cole used, Robinson was making some sort of point.

In the introduction to the catalogue of 'Decorative Art', Robinson defines the task of the museum to be 'the illustration, by actual monuments, of all art which finds its material expression in objects of utility, or in works avowedly decorative', and proposes a vast coverage: 'works of all periods, and all countries, from the earliest dawnings of art in classical antiquity, or the most rudimentary efforts of aboriginal nations, to the elaborate articles of contemporary art industry'. Later he had to settle for a narrower scope. It is interesting that he pleads the case of 'many things of little intrinsic value ... that have always been held to be beneath the notice of the connoisseur', but which 'in the point of view of historical sequence or merit in design' may be very important.[73] Though this seems a forward-looking, relativist view, anticipating modern ideas of 'material culture', it is probable that Robinson had in mind the decorative art objects that he himself collected: although these are priceless now, they then ranked far below painting or sculpture.

We need not assume that Cole and Robinson were seriously at odds. We have seen that Cole showed characteristic energy in pursuing antiquarian acquisitions for the museum. But it is probably true to say that for him the museum was always an instrument in a larger cause, whereas Robinson had a passion for antiquarian objects for their own sake. A comment in Robinson's catalogue of the museum's exhibition of Oriental and Old Sèvres Porcelain, loaned by the Queen in 1854, is suggestive. In Sèvres ceramics, he says, speaking no doubt with his master's voice, 'the true principles of art, as applied to pottery, are in

many ways violated'. Yet surely he is speaking with his own voice, and manifesting an instinctive feeling for works of art, when he adds: 'they are however true and genuine embodiments of the art of a particular epoch; a most florid and licentious one it is true, but still replete with a certain vitality and characteristic expression ...'[74]

Robinson, then, moved the museum in an antiquarian direction. He was prepared to argue that the art of the past helped contemporary artisans and manufacturers to improve their products,[75] but at heart he was an antiquarian connoisseur. So it is no surprise that he wanted the museum to serve, not only the art schools, and indeed the general public as consumers, but also 'the collector, whose pursuits it is, for many obvious reasons, clearly a national duty to countenance and encourage'.[76]

Furthermore, he was well versed in the workings of the art market. Cole's idea that the public should pronounce on the value and authenticity of proposed acquisitions could sometimes be useful. Even when, as with the Soulages Collection, it did not seem to work, it allowed Cole to get a head start in public relations. But Robinson recognized that dealers did not like having their goods quarantined in Marlborough House, and argued that the curator should have 'a power of immediate decision as to the purchase of objects'.[77] And he recognized that his own interventions in the market were pushing up prices: during the Marlborough House years the value of the collections 'speedily doubled or trebled'.[78]

Whatever the differences in the outlooks of Cole and Robinson, it is clear that the museum in Marlborough House was, even for those early days, a well-focused art museum. It possessed planned collections, pondered acquisition policies and had a vigorous acquisition rate (Robinson registered 1,400 objects in 1854).[79] It mounted special exhibitions, and created a travelling exhibition. Its collections were recorded in inventories and catalogues. Labelling was started, if not finished.[80] Reproductions of works of art were available, in the form of casts and electrotypes,[81] and Robinson published a lavish book of colour lithographs, *The Treasury of Ornamental Art*, in 1857.

Above all, visitors were welcomed. The museum opened at first from Monday to Friday. In 1854 Saturday was added as a free day, 'being a day of leisure with several classes of the public; the afternoon, especially, is a half-holiday in most schools, and it was thought that school teachers and children would thus be enabled to visit the collection'.[82] The attendance figures published in the annual reports show that 45,632 visitors came in the first half-year, in 1852. The figures for the following years were: 1853: 125,453; 1854: 104,823; 1855: 78,427 (the Crimean War depressed attendances); 1856: 111,768. Attendances of around 100,000 do not seem bad for a small new museum,

comprising only six rooms. The British Museum at this time was sliding down from a peak of over two million in 1851, when London was thick with visitors to the Great Exhibition, to annual attendances of something over 300,000.[83]

The museum was open free on some, but not all, days. When it reopened after the summer vacation of 1852, it was found, in the first week, that 'on Monday and Tuesday, which were free days to the public, the visitors averaged above one thousand persons each day'.[84] This would certainly have been a crowd in the small rooms of Marlborough House. One of the facilities that Cole extended to visitors was that, after paying a fee and washing their hands, they could have exhibits taken out of showcases 'for minute inspection'.[85] This could not easily be done if the rooms were crowded. So, on Wednesdays, Thursdays and Fridays, Cole introduced 'the novel experiment ... of testing, by a fee of 6d., whether the applicants really desired to *study* or not'. On paying days the attendance went down to about 80 visitors. This arrangement of free days and charging days does seem to have been adopted for pragmatic reasons. But it was welcome to Cole for ideological reasons, too. Although, throughout his life, he extracted large sums of public money from the Government to subsidize his art enterprises, he fundamentally believed that 'as a principle the Government should not attempt to do those things which the public can do for itself'.[86] In his first policy statement, the lecture at Marlborough House on 24 November 1852, he committed himself to the ambition to make his art-education system self-financing ('No one values what may be had for nothing').[87] Many would have applauded him for this, such as the journalist who praised him for not treating art as if it were 'some rickety bantling, to be ever-lastingly nursed, and nurtured, and fondled, and dandled, and cockered, and "patronized"'.[88] So Cole was quite pleased to raise some money at the door, and recorded that it paid the wages of the museum custodians.[89]

He was, nonetheless, determined that his museum should be accessible. 'The Museum is intended to be used, and to the utmost extent consistent with the preservation of the articles.'[90] A murmur of complaint arose from Robinson, who worried that 'the dust and vapour, which arise from the dense crowds of visitors on the "free" days and at holi-day times, are of positive detriment to many of the objects exhibited'.[91] But Cole thought that unvisited museums 'dwindle into very sleepy and useless institutions'.[92] Marlborough House was certainly not sleepy.

This exemplary museum had been created very quickly from almost nothing. It closed its doors, however, in the spring of 1857. This was not because it had failed, but because its success now carried it forward into a new phase of existence on a new site.

NOTES

1 Elizabeth Bonython, *King Cole: a Picture Portrait of Sir Henry Cole, KCB 1808–1882*, London: Victoria and Albert Museum [1982], p. 14. This work is the source of other biographical information in these paragraphs.

2 *Fifty Years*, vol. 1, p. 34.

3 Susanna Avery Quash, 'The Colourful Life of Sir Henry Cole', *Victorian Society Annual*, 1995, pp. 26–37.

4 *Fifty Years*, vol. 1, p. 109.

5 Ibid., p. 110.

6 *Report from the Select Committee on the School of Design ... Ordered, by the House of Commons, to be Printed, 27 July 1849*, Minutes of Evidence, para. 2015.

7 Ibid., para. 1880.

8 Ibid., para. 1878.

9 Ibid., para. 1880.

10 *Fifty Years*, vol. 1, p. 295.

11 *Athenaeum*, 23 March, 27 July 1850, pp. 318–19, 794.

12 *Fifty Years*, vol. 1, p. 284.

13 *The Art-Journal*, 1852, p. 104.

14 *Report from the Select Committee ... 1849*, paras 2013, 1954, 1962, 1927.

15 Ibid., paras 1961, 1973, 1999.

16 *Society of Arts, Manufactures, and Commerce. Art-Manufacturers' Institute, with Elementary Drawing Schools, at Bradford* [pamphlet], London: Society of Arts (1852), p. 3.

17 William Bell Scott, *Autobiographical Notes*, ed. W. Minto, 2 vols, London: Osgood, 1892, vol. 1, p. 180.

18 *Report from the Select Committee ... 1849*, para. 1976.

19 'Elementary Instruction. Addresses at the Opening of an Elementary Drawings School at Westminster ... 2d June 1852 ... Address by Henry Cole ...', reprinted in *First Report of the Department of Practical Art*, London: HMSO, 1853, p. 55.

20 *Builder*, 3 October 1846, p. 469.

21 *Addresses of the Superintendents of the Department of Practical Art, delivered in the Theatre at Marlborough House. I. On the Facilities afforded to All Classes of the Community for Obtaining Education in Art. By Henry Cole ...*, London: Chapman and Hall, 1853, pp. 12–13.

22 *First Report of the Department of Practical Art*, p. 225.

23 Cole explains why, and admits his change of view, in *Introductory Addresses on the Science and Art Department and the South Kensington Museum. No. 1. The Functions of the Science and Art Department. By Henry Cole*, London: Chapman and Hall, 1857, pp. 12–13 (para. 14).

24 See Rafael Cardoso Denis, 'Drawing or design? The Development of the National Art Training School' in Christopher Frayling and Claire Catterall (eds), *Design of the times: One hundred years of the Royal College of Art*, Shepton Beauchamp/London: Richard Dennis/Royal College of Art (1996), pp. 20–3.

25 *Report from the Select Committee ... 1849*, paras 2018, 1983.

26 *Addresses of the Superintendents*, p. 33.

27 *Report from the Select Committee ... 1849*, paras 1893, 1899, 2080.

28 Nikolaus Pevsner, *High Victorian Design: a study of the exhibits of 1851*, London: Architectural Press [1951], p. 151.

29 *Journal of Design*, vol. 5, 1851, p. 161.

30 See Anthony Burton, 'Redgrave as Art Educator, Museum Official and Design Theorist' in Susan P. Casteras and Ronald Parkinson (eds), *Richard Redgrave 1804–1888*, catalogue of an exhibition at

the Victoria and Albert Museum, London, and the Yale Center for British Art, New Haven; New Haven and London: Yale University Press, 1988, pp. 63–5.

31 See Moncure Daniel Conway, *Travels in South Kensington*, London: Trubner, 1882, p. 211.

32 *First Report of the Department of Practical Art*, p. 34.

33 *Athenaeum*, 22 May 1852, p. 585.

34 *First Report of the Department of Practical Art*, p. 378. And see Clive Wainwright, 'Principles True and False: Pugin and the Foundation of the Museum of Manufactures', *Burlington Magazine*, vol. 136, 1994, pp. 357–64.

35 *Athenaeum*, 22 May 1852, p. 585.

36 For more information on these and similar pieces, see Elizabeth Aslin, *French Exhibition Pieces 1844–78*, London: Victoria and Albert Museum, 1973; and *Art and Design in Europe and America 1800–1900* [at the Victoria and Albert Museum], intro. by Simon Jervis, London: Herbert Press, 1987.

37 Quoted from the enlarged version of the catalogue included in the *First Report of the Department of Practical Art*, pp. 246, 252, 279.

38 *First Report of the Department of Practical Art*, p. 33.

39 Christopher Dresser, 'Art Museums', *Penn Monthly*, February 1877, p. 119.

40 He is identified as author of the unsigned article in Anne Lohrli, *Household Words: A Weekly Journal 1850–1859, Conducted by Charles Dickens: Table of Contents, List of Contributors ...*,Toronto: University of Toronto Press [1973], p. 373.

41 Cole diary, 17 May 1852, NAL.

42 *Journal of Design*, vol. 2, 1849–50, p. 212.

43 Ibid., vol. 3, 1850, p. 3.

44 Ibid., vol. 3, 1850, p. 70.

45 Clive Wainwright, 'Curiosities to Fine Art: Bond Street's first dealers', *Country Life*, 29 May 1986, pp. 1528–9.

46 *Athenaeum*, 1 October 1853, p. 1162.

47 *First Report* [for 1853], pp. 267–82. And see Ann Eatwell, 'Henry Cole and Herbert Minton: Collecting for the Nation', *Journal of the Northern Ceramic Society*, vol. 12, 1995, pp. 162–3.

48 *Second Report* [for 1854], pp. 178–85.

49 *Illustrated London Almanack for 1856*, p. 14.

50 *Third Report* [for 1855], pp. 67–71.

51 Elizabeth Bonython, 'South Kensington: The French Connection', *Journal of the Royal Society of Arts*, vol. 137, 1989, p. 659.

52 *Athenaeum*, 6 December 1856, pp. 1052–3.

53 *Athenaeum*, 14 February 1857, p. 215.

54 *Fifty Years*, vol. 1, p. 292.

55 *Twelfth Report* [for 1864], p. 177.

56 *Second Report from the Select Committee on Museums of the Science and Art Department: together with the Proceedings of the Committee, Minutes of Evidence, Appendix, and Index. Ordered, by The House of Commons, to be Printed, 23 July 1897*, paras 1452–65, 7555–7.

57 NAL inventory number L.3535-1934; photograph in Picture Library, neg. 71821.

58 *Journal of Design*, vol. 5, 1851, pp. 117–18, 150–2, 181–2; vol. 6, 1851–2, pp. 122–4.

59 *First Report of the Department of Practical Art*, p. 229.

60 Ibid., p.233.

61 J.C. Robinson, *A Catalogue of the Museum of Ornamental Art ... (Part I.)*, London: Chapman and Hall, 1855, p. 5. The sentence reappears (with 'relative importance' altered to 'intrinsic importance') in *The Almanack of Science and Art. Anno Domini 1856*, London: Chapman and Hall, 1856, p. 127.

62 Department of Practical Art, *A Catalogue of the Articles of Ornamental Art, in the Museum of the Department*, 3rd edn, London: Eyre and Spottiswoode, 1852, p. 4.

63 Sir Trenchard Cox, 'History of the Victoria and Albert Museum and the Development of its Collections', *Proceedings of the Royal Institution of Great Britain*, vol. 37, 1959, p. 278.

64 *First Report of the Department of Practical Art*, pp. 5–6.

65 Ibid., pp. 82–3: 'Report of Mr J.C. Robinson, Teachers' Training Master'.

66 *First Report* [for 1853], p. 225.

67 Ibid., p. 227.

68 Fairly detailed descriptions of the ever-changing contents of the rooms are included in successive editions of the catalogue (1852 – sixth edn, 1854), but after that it is difficult to keep track.

69 Cf. Clive Wainwright, *The Romantic Interior: the British Collector at Home, 1750–1850*, London: Yale University Press, 1989.

70 *First Report* [for 1853], p. 228.

71 C.H. Wilson, *Observations on some of the Decorative Arts in Germany and France, and on the causes of the superiority of these, as contrasted with the same arts in Great Britain ... From the Edinburgh New Philosophical Journal for October 1843* [offprint, 1843], p. 2n.

72 *Civil Engineer and Architect's Journal*, vol. 19, 1856, p. 83.

73 'Memoranda and Suggestions', *First Report* [for 1853], p. 289.

74 *First Report*, [for 1853], p. 289.

75 Cf. his *Introductory Lecture on the Museum of Ornamental Art*, 1854, pp. 7–8; and 'On the Art Collections at South Kensington, Considered in reference to Architecture', a paper given at the Architectural Museum, 2 June 1863, reported in *Building News*, 5 June 1863, pp. 425–7, and 12 June, pp. 445–6, and in *Builder*, 6 June 1863, pp. 401–2, and 13 June, pp. 426–7.

76 J.C. Robinson, *Department of Science and Art. Catalogue of a Collection of Works of Decorative Art; ... Circulated for Exhibition in Provincial Schools of Art*, London: HMSO, 1855, p. 3.

77 *Fourth Report* [for 1856], p. 74.

78 *Introductory Addresses on the Science and Art Department and the South Kensington Museum. No. 5. On the Museum of Art. By J.C. Robinson*, London: Chapman and Hall, 1858, p. 23.

79 *Second Report* [for 1854], p. 167.

80 Ibid.: '... in many cases descriptive labels have ... been prepared ... and placed in the cases ...' *Fifth Report* [for 1857], p. 69: '... considerable progress has been made [at South Kensington] towards a complete system of labelling every object'.

81 *Second Report* [for 1854], p. 166.

82 Ibid.

83 *Athenaeum*, 27 June 1857, p. 828.

84 *Athenaeum*, 11 September 1852, p. 975.

85 *First Report of the Department for Practical Art*, p. 34.

86 *Report from the Select Committee ... 1849*, para. 2043.

87 *Addresses of the Superintendents ...*, pp. 8–9, 20.

88 *Athenaeum*, 27 November 1852, p. 1303.

89 *First Report of the Department of Practical Art*, p. 34.

90 *Addresses of the Superintendents ...*, p. 36.

91 *Second Report* [for 1854], p. 166.

92 *Addresses of the Superintendents ...*, p. 36.

CHAPTER THREE
The South Kensington Idea

On 24 June 1857 the Museum of Ornamental Art reopened (figure 3.1) as part of a new museum just established near Brompton on the western edge of central London. The museum adopted the name 'South Kensington Museum' because, while Brompton was a village of no importance, neighbouring Kensington had at its centre the royal residence, Kensington Palace, where Queen Victoria was born and grew up, and it was therefore a fashionable and prosperous suburb. To understand why Henry Cole's museum moved from Marlborough House to South Kensington it is necessary to look back to the Great Exhibition of 1851.[1]

The Exhibition was a very daring venture. It was not supported by Government funds, but by private loans and guarantees which, it was hoped, would be offset by the proceeds of admission charges. It had an ambitious range: envisaged at first as an exhibition of British products, it soon enlarged its scope to become 'The Great Exhibition of the Works of Industry of All Nations'. And it had a dangerously short lead-time: it could not have opened on schedule on 1 May 1851 had Joseph Paxton not ingeniously found a way of constructing an exhibition hall at lightning speed, using prefabricated parts.

Despite the risks, the Exhibition proved to be a great success. By August 1851 it was clear that it was going to make a profit, which eventually amounted to £186,000. If those who worked hardest on the project wanted somehow to perpetuate their achievement – and they did – they now had the means to do so. The use of the Great Exhibition 'surplus', as they called it, became a matter of animated discussion, and eventually resulted in the South Kensington Museum.

Even before discussion about the surplus began, Henry Cole had tried to save something of the Exhibition for posterity. In early July 1851 he persuaded the Commission in charge of the Exhibition to ask all exhibitors to contribute examples of their products (or specifications of very large exhibits, like machinery) to a 'Trade Collection', which would be preserved after the Exhibition was over. The exhibitors responded generously, and although the Commissioners had expected the collection to fit into 'a good-sized room', they found, in November 1851, that they had 12,600 square feet filled with goods ranging from British macaroni to surgical apparatus, straw hats to sheet iron, beeswax to boots.[2]

Vignette: Title panel used on the first guide books to the South Kensington Museum, 1857–60.

Figure 3.1 An invitation to the private view of the new museum at South Kensington. This duplicated letter, in Henry Cole's hand, was sent out to masters at the provincial Schools of Design. This copy went to George Wallis, then Headmaster at Birmingham, later Keeper of the Art Museum at South Kensington.

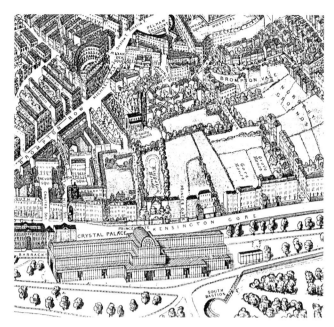

3.2 A detail from a view of London looking southwards, drawn from a balloon in 1851. Beyond the Great Exhibition building in Hyde Park can be seen the area – marked 'Gore House', 'Grove House' and 'Nursery Grounds' – which the 1851 Commissioners bought as the site for Prince Albert's proposed cultural quarter. The V&A was to fit in to the right of 'Trinity Church'.

This Trade Collection was stored in Kensington Palace,[3] and duplicates weeded from it were distributed to provincial museums.[4] The remainder came out of store in 1857 and was exhibited in the South Kensington Museum. The first *Guide* to the museum[5] suggests that it was meant to be a miniature version of the Great Exhibition, but presumably after five years it had lost much of its interest and relevance, for it was soon removed. In October 1858 Redgrave told Cole that his colleague, Richard Thompson, 'I *believe* in accordance with your wishes is about to disperse the manufacturing exhibition ... The collection is dwindling away – and it seems desirable to close it ... rather than continue in an unsatisfactory manner'.[6] So we need pay no further attention to this, Cole's first initiative.

His second initiative we have already discussed, in Chapter Two. In September 1851 Cole assembled his 'Designs Purchase Committee' to acquire from the Great Exhibition examples of good modern products for the School of Design's museum, using the £5,000 grant he had obtained from the Board of Trade. The Committee's purchases, as we have seen, formed the core collection of the museum at Marlborough House, and they came over to South Kensington with the rest of the contents of the Museum of Ornamental Art.

Cole was heavily involved in other moves to administer the Great Exhibition 'surplus', because he was one of Prince Albert's inner circle. The Great Exhibition had been officially under the control of a Royal Commission, with Prince Albert as President. The Commission consisted, as such bodies usually do, of the 'great and good' – notabilities who contributed their prestige and lent support, but did not do much actual work. Prince Albert worked tirelessly, operating through an Executive Committee, which was chaired by a capable soldier, Colonel William Reid, and included Henry Cole and Charles Wentworth Dilke. Stafford Northcote, Secretary to the Commissioners, provided liaison between them and the Executive Committee, as did the scientist Lyon Playfair, who, as 'Special Commissioner', was empowered to exercise his pronounced talent for diplomacy wherever it was needed. It was to this group, on 13 August 1851, that Prince Albert proposed a plan for using the Exhibition surplus.[7]

The plan, as summarized by the Prince's private secretary, was to create 'an establishment, in which, by the application of Science and Art to Industrial pursuits, the Industry of all nations may be raised in the scale of human employment'.[8] In other words, the aims of the Great Exhibition were now to be forwarded by some kind of permanent institution. It had quickly become clear that there was no practicable way of preserving the Exhibition itself – exhibits had to be returned to their owners, and the building could not stay, since the Government had only given it temporary leave to encroach upon Hyde Park. It was dismantled and re-erected at Sydenham in south London by a private company, which ran it as a visitor attraction, with concerts, exhibitions and pleasure-gardens, until its destruction by fire in 1936.[9]

There was considerable discussion as to what form the proposed new institution should take, but the essential first step was to secure a site. The Prince arranged for the Royal Commission for the Exhibition of 1851, which was

Figure 3.3 The South Kensington site, just as building operations were about to destroy its sylvan calm.

intended to lapse after the Exhibition, to be re-created so that it could continue to administer the profits it had earned, and invest its 'surplus' in land. A site just south of Hyde Park (figures 3.2, 3.3) was selected. Although the ownership pattern of the land was quite complicated, the Commissioners, with help from the Government, succeeded in securing most of it by 1858. This was the area on which the name 'South Kensington' was bestowed in 1856.[10]

When Prince Albert unveiled his idea to his inner circle in August 1851, it seems clear, from entries in Henry Cole's diary over the next few weeks, that they all understood that the new institution was to be in some way educational. 'A College of Arts and Manufactures', 'Industrial Schools', 'a College to teach Industry', a 'Central School for Manufactures' were among the terms bandied about.[11] Lyon Playfair was very keen on a university,[12] and it is likely that Prince Albert was, too. He had become Chancellor of the University of Cambridge in 1847, and was characteristically zealous in trying to extend its syllabus beyond classics and theology to include some modern and scientific subjects. He interested himself also in the Royal Commission on the Universities, set up in 1850. His advocacy of the importance of science and technology was ardent: 'it has altered the whole state of our existence'. His adopted nation, however, was indifferent to his mission, which proved 'the most formidable and frustrating task of his life'.[13] To put the Exhibition surplus towards a scientific university must have seemed a great opportunity.

In the early days there were those who expected to see at South Kensington a scientific university with 'laboratories and workshops', where 'an ample staff of professors, carefully selected, and uniting practical and theoretical science, will deliver regular courses of lectures'.[14] To produce this out of nothing would have been difficult, and Prince Albert's method was to adapt existing institutions to his purpose. His first ideas, recorded in a memorandum drafted in August 1851,[15] were publicly announced, at greater length and more systematically, in the *Second Report* of the 1851 Commissioners, dated 11 November 1852. 'A large portion of this report' was the Prince's 'own composition': 'it has always been looked upon as a masterly production'.[16] In his first notes the Prince proposed to gather at South Kensington 'a variety of public Societies in England', such as 'the Geological Society, Botanical Society, Linnaean Society, Zoological Society, Microscopical Society, Agricultural Society ... Polytechnic Society, Society of Civil Engineers, the Society of Arts, Manufacture, and Commerce ... the Society of Architects, of Antiquaries, Archaeological, &c.'[17] The *Report* enlarged on this with a list of almost a hundred learned societies, which might be reorganized to serve the Prince's plan. However, when Prince Albert first made this suggestion to his circle on 13 August 1851, they

'laughed at the idea of making the Antiquarian & Archaeological Societies "Commercial"' and of 'moving them' to South Kensington. Their scepticism was justified. The learned societies refused to co-operate, and as early as November 1851 Cole was noting that the Prince 'had quite given up collecting the Societies'.[18]

Although this idea failed, the Prince had another scheme for fostering scientific education. Once Cole had taken over the School of Design, Lyon Playfair (who was the Prince's closest ally in promoting scientific education) took him along to Buckingham Palace, on 29 February 1852, where the Prince disclosed that he 'wished the School to be made the first step in getting the Industrial Institute'. As we have seen, Prince Albert had already, on 19 February, offered Cole the use of Marlborough House in return for his co-operation. The new department that Cole had contrived to create, the Department of Practical Art, was concerned (as its name indicates) only with art education, and in order that it should serve the Prince's wider scheme to apply Art and Science to Industry, its title and remit would have to be changed. Prince Albert exercised his influence through the Queen upon the Government, and in March 1853 the Department of Practical Art was transformed into the Department of Science and Art. Cole, who had previously, with Redgrave supporting him, been in undisputed charge of the art-education system, now found Playfair beside him as Joint Secretary in charge of scientific education.

Cole had been able to base his national art-education system on the existing chain of Schools of Design, which had been functioning, however inadequately, since 1837. The only base that Playfair had was the Government School of Mines, with its Museum of Practical Geology. He was already a professor at this institution, and it now came within the control of the Department. Cole and Redgrave felt that 'Science was ... an incubus to Art',[19] and rather resented Playfair's arrival in the Department. It seems that – however effective he was as a negotiator and ideas-man – Playfair was lackadaisical as an administrator. 'Dr Playfair has taken himself off for his holiday of 6 weeks,' Redgrave wrote to Cole in September 1855, adding, 'there has been little else, I can't call it Holiday but absence on his part all the year'.[20]

In fairness to Playfair, it should be said that there was powerful opposition to education in science. If the Church of England and the Nonconformists were at odds with the Government and with each other over the teaching of basic literacy, they were even more resistant to the threat which they believed scientific education levelled against religious belief. Prince Albert's private secretary, Colonel Grey, warned Playfair about party disputes in education: 'Once get into that troubled sea, and you are swallowed up in the vortex of contending parties.'[21] In the event, Playfair did not

achieve much before departing in June 1858 to become Professor of Chemistry at Edinburgh University, leaving Cole in sole charge of the Department. The balance of the Department, however, was permanently changed; it continued to have a remit for science education, and in the 1870s and '80s made great strides with this under Cole's protégé, John Donnelly. When Marlborough House was vacated in 1857, the Department made its headquarters in South Kensington, and was based there until it was wound up in 1900.

Prince Albert made little further progress in establishing teaching institutions on the South Kensington site. But he had envisaged that his monument to the Great Exhibition would itself include an exhibitionary element: there would be museum collections of art and science to work their educational influence. In considering how to shape these collections so as to demonstrate 'the application of Science and Art to Industrial pursuits', he went back to the scheme that he had originally devised for the Great Exhibition. He had proposed that the Exhibition should contain four sections: Raw Materials, Machinery, Manufactures and Art. The *First Report* of the 1851 Commissioners neatly related these in a logical scheme:

The general plan for the Division of the Exhibition, originally adopted by the Society of Arts at the suggestion of His Royal Highness Prince Albert, distributed it into four great sections; the first comprising the raw materials which nature supplies to the industry of man; the second, the machinery by which man works upon those materials; the third, the manufactured articles which he produces; and the fourth representing the art which he employs to impress them with the stamp of beauty.[22]

Although, as Playfair recalled, 'the philosophical mind of the Prince Consort held tenaciously to this classification',[23] it needed, for practical reasons, to be elaborated and adapted, and Playfair produced the system of 36 classes that was actually used in the Exhibition. The Prince, still holding to his classification after the Exhibition, hoped that it could be embodied in four institutions in South Kensington. Although this did not come about, his scheme provides the key to the apparently arbitrary group of museum collections that was eventually assembled there.

Art may have seemed the easiest category to set up. The National Gallery was already pressed for space in its Trafalgar Square building, so the Prince invited it to move to South Kensington. This was an unfortunate proposal, since it was fiercely resisted. Throughout the 1850s the issue was considered and reconsidered by the Government, and Prince Albert came in for some mean-spirited criticism. The question was finally settled – the Gallery was *not* to move – by a Royal Commission that reported in 1857. But while the debates went on, this proposal cast a planning blight over South Kensington, where other developments were delayed. Because of the delay, the Prince and the Commissioners were all the more eager, in 1855, to get something going on the site. 'The Prince is urgent to do something at Kensington,' wrote Redgrave on 5 June, and he was peeved that the Commissioners did not consult him (for he was holding the fort while Cole was in Paris at the International Exhibition) about the plans they were then hatching to put up a building.[24] Into this building moved the Museum of Ornamental Art, taking the place, as it were, of the National Gallery, to form the Art section of the establishment at South Kensington.

The Machinery section was assembled without too much difficulty, largely through the efforts of Bennet Woodcroft[25] and the Commissioners of Patents. Patent law was one of the issues that had preoccupied Cole and others concerned with British manufactures. They believed that inventors were denied their just rewards because the law did not give them adequate patent rights over their inventions. A reform campaign led to the Patent Law Amendment Act of October 1852, which introduced a new system for administering patents. Woodcroft was appointed to make the system work, and took up a newly created post as Assistant to the Commissioners of Patents on 15 November 1852. In subsequent years he indexed and published virtually all existing patent specifications from 1617 to 1852, started the Patent Office Library and, at Prince Albert's behest, created a Patent Museum.

Soon after Woodcroft's appointment, the Prince summoned him to Windsor, on 29 December 1852, and asked him to build up a collection of machines for the South Kensington institution. As it happened, Woodcroft already had a collection of machines. An engineer and inventor from Manchester, he had come to London in 1847 to be Professor of Descriptive Machinery at University College, London. This post was the fruit of one of the earliest attempts to introduce technology into the English university curriculum. Woodcroft was not successful in academic life, but his position made him an eligible recipient of a collection of inventions that had mounted up at the Society of Arts since 1761, and which the Society wanted to get rid of. Woodcroft took this collection with him when he moved to the Patent Office, and it formed the basis of what he established at South Kensington. To enlarge it, Woodcroft set off, after being commissioned by the Prince, on a tour of the manufacturing districts of northern England, soliciting further exhibits, while the 1851 Commissioners struck a deal with the Commissioners of Patents that the latter would sponsor a museum of machines and the former would provide premises for it at South Kensington. Thus the Machinery section of the Prince's Kensington establishment took shape.

Raw Materials and Manufactures both presented more of

a problem. Raw materials were not, for the most part, attractive to look at; they required a lot of explanation; and they only really became interesting when they had been made into something. There was much to be said, therefore, for not exhibiting them as a separate section, but alongside (or indeed in the form of) manufactures. This case is made in the *Second Report* of the 1851 Commissioners,[26] which accepts that the 'sound philosophical principles' of the Prince Consort's scheme should be adapted towards practicality – as they had been in the Great Exhibition itself. Given that Raw Materials and Manufactures should be grouped together, on what principles should they be subdivided? The suggested answer was: according to 'the natural subdivisions of raw materials into the mineral, vegetable and animal kingdoms'. On reaching this point, the Prince and the Commissioners were gratified to discover that the Government already possessed collections of materials and manufactures in the mineral and vegetable kingdoms. The Museum of Practical Geology, part of the Government School of Mines in Jermyn Street, represented the mineral sector, while the vegetable sector was represented in the Museum of Economic Botany at Kew Gardens. If these could be brought into the South Kensington scheme, all that was needed to complete the Materials and Manufactures section was a collection of animal products.

Edward Solly was commissioned to assemble this. Solly had been a juror at the Great Exhibition, and had lobbied for the creation of a 'Trade Museum', by which he meant a reference collection of contemporary materials and products that would assist exporters and manufacturers. He advanced his ideas in a pamphlet on *Trade Museums, their nature and uses: considered in a Letter addressed by permission to H.R.H. The Prince Albert*.[27] Solly's assembly of an animal-products collection was carried out under the aegis of the Society of Arts. This Society, which had been rescued from a state of lethargy by the Prince Consort and Henry Cole (among others), was used by them as an agency for launching projects, including the Great Exhibition. Prince Albert was President of the Society from 1843 until his death, Cole was Chairman in 1852 and continued to be an energetic Council member, and Solly was Secretary in 1852–3.

On 13 April 1853 the Council of the Society agreed to sponsor Solly's animal-products collection,[28] and, following its usual method, sent out a circular to its worldwide mailing list of similar institutions. Solly requested some 250 articles, including antelope fur, bats' guano, coral, emu feathers, gelatine, honey, ivory, musk, pearls, rhinoceros horn, sharks' fins, tortoise shell, vellum and zebra skins.[29] By December 1854 the collection was 'rapidly assuming a definite form, as contributions arrive from day to day',[30] and it was put on exhibition at the Society's premises in May

1855. At a meeting on 23 May Playfair proposed a vote of thanks to Solly, reminding his audience that hitherto Britain had been 'sadly wanting in a museum which should represent the industrial applications of animal products'; that the new collection was intended to relate to the existing museums of Practical Geology and Economic Botany; and that it was now time to bring all these together in a single centre.[31] After the animal-products collection had been exhibited, the 1851 Commissioners accepted responsibility for it and quickly undertook, at a meeting on 30 June 1855, 'forthwith to erect suitable temporary buildings on the Commissioners' estate at Kensington Gore, in which this collection with other collections might be placed'.[32] So animal products duly took their place in the South Kensington Museum. The mineral and vegetable collections, however – although their relevance was stressed in the first edition of the *Guide* (p. 9) – never came to South Kensington.

It is now possible to see how the South Kensington Museum was built up along the lines of the Prince's scheme, with collections of Art, Machinery and Materials-cum-Manufactures (although only the animal part of this was settled on the site). The collecting of collections did not stop here, however. Early in 1854 the Society of Arts proposed, as a celebration of its hundredth session, to mount an Educational Exhibition.[33] The Society felt that, while professional educationists were adequately informed through 'annual reports, blue-books, and lectures', 'it requires something more tangible – more startling – to make ordinary people feel that strong interest in the question which must precede any great national pressure in favour of an improved system of popular education'.[34] So the exhibition was to consist of educational apparatus from all over the world: 'nothing that is officially authorized to be used, or is commonly used, in ... a School, would be too trifling to be of interest'.[35] The collection, rapidly assembled by trawling round the world through the Foreign and Colonial Offices, was exhibited at St Martin's Hall in July 1854. Its contents ranged from models of school buildings to india-rubbers, and included blackboards, slates, globes, microscopes, pitch pipes and tuning forks, clocks, bells and whistles, as well as all kinds of textbooks, and examples of children's work. After exhibition the collection was temporarily stored at Grove House on the 1851 Commissioners' Kensington estate[36] – Grove House stood where the Royal Albert Hall now stands – and re-emerged as part of the South Kensington Museum in 1857.

Another collection with which the Society of Arts was much concerned was Thomas Twining's Economic Museum. Twining's mission in life was the improvement of the working classes.[37] Instead of preaching morality to them, he interested himself, with admirable practicality, in

the physical conditions of their lives. He announced, with the support of the Society of Arts, that he proposed to form 'a special collection, which may be called either "The Working Man's Special Museum," or simply an "Economic Museum," the latter name affording a convenient abridgement of the phrase "Museum of Domestic and Sanitary Economy," or "Museum of Household and Health Economy"'. This would be aimed at 'facilitating the self-improvement of the condition of the Working-Classes, by collecting and exhibiting, with suitable explanations, the objects most likely to be useful to them'.[38]

There was more support abroad than at home for a project of this kind, and Twining arranged a first showing of his museum at the Paris Exposition Universelle in 1855, which had a section (Class XXXI) on 'produits de l'économie domestique'.[39] In Paris, the collection had four sections: 'I. Lodging. II. Fittings and furniture. III. Food. Stores for washing, lighting, and warming. IV. Clothing.'[40] From August to October 1856, accompanying the Philanthropic Congress in Brussels, Twining mounted a larger exhibition there, containing two further sections: 'V. Tools and instruments for handicraft occupations, both industrial and agricultural. VI. Worship, physical and moral education, instruction, recreation.'[41] Twining's collection was intended to be practically useful, commending such things as 'bricks impervious to wet', 'cheap, yet neat patterns, for iron railings', 'cheap stuffing for mattresses, &c., not liable to decomposition or vermin', 'articles of dress providing against cold, rain, snow, and rough weather', 'means for purifying water', 'improvements in cheap candles' and 'means of protection against avalanches'.[42] Had it survived, however, it would have been a quite remarkable historical record of a humble lifestyle, which it has proved beyond the reach of modern museums to reconstruct. Twining offered his collection to the Department of Science and Art, which accepted it on 23 April 1857, with the Board noting: 'Department to deal with it as may be thought most useful to the public'.[43] As this guarded comment perhaps presages, the Economic Museum was not much cherished in the long run, though it did take its place in the South Kensington Museum at its opening.

The International Exhibition at Paris in 1855 not only fostered Twining's museum, but contributed another feature to the South Kensington Museum: a 'Collection Illustrating Construction and Building Materials', which 'was obtained, partly by gift and partly by purchase' at the Paris Exhibition. It included 'building stones and marbles ... cements and asphaltes ... bricks, hollow, solid, and moulded ... lintels, jambs, exterior and interior cornices, mouldings, window dressings, &c ... fire-proof floors ... ornamental tiles ... hip and ridge tiles ... woods', along with ornamental features in terracotta, papier mâché and iron.[44]

If the South Kensington Museum was going to concern itself with both building technology, on the one hand, and art, on the other, it must have seemed fitting that it should also occupy the middle ground and concern itself with architecture. That it did so was, however, the result of chance. An Architectural Museum had been founded in 1851 by a group of architects who worked in the new Gothic Revival style; their leader, occupying the office of Treasurer for many years, was George Gilbert Scott. Although they came to promote themselves as 'the nucleus of a National Museum of Architectural Art', and professed to serve 'the public, architects, artists, and artist-workmen',[45] it is clear that their original concern was to help in the training of workmen in the Gothic style. 'The working drawings of architects are sufficient to explain to the workmen the mere mechanical parts of an architectural design,' said Scott, 'but no drawing, however exact or graphic, is sufficient to explain the carved foliage, &c., with which the architect may desire to relieve his works, unless to a workman whose mind and eye is already familiarized and trained by the study of works of the best periods.'[46] So a large collection of plaster casts of Gothic ornament was established (together with some original fragments of stonework, woodwork, textiles, stained glass, encaustic tiles and modern metalwork),[47] and accommodated in 'gaunt but picturesque premises' in Westminster.[48] When the landlord put up the rent, the Museum found itself in difficulties and approached the Department of Science and Art for support. It was sympathetically received.[49] The Department could not offer financial subsidy, but did offer space at South Kensington, with which the authorities of the Architectural Museum were, at least to begin with, pleased: 'they must all admit that they had moved from a barn into a palace'.[50]

Finally, we must notice the contribution of the Sculptors' Institute. This was a pressure group founded in 1852 to foster professional solidarity among sculptors. It tried to encourage commissions for public sculpture, and to provide an exhibition gallery in London for British sculpture.[51] It achieved the latter aim by successfully requesting space at South Kensington. Here it hoped to show not only contemporary sculpture, but also works 'of past time, as casts from the best and most characteristic works of Banks, Bacon, Nollekens, Flaxman, Chantrey, &c.'[52]

At the beginning of 1857 all these collections were waiting in the wings, ready for inclusion in a museum at South Kensington, where a building awaited them. It was not the ideal building. A few years earlier Prince Albert had commissioned drawings for a building from Gottfried Semper, the eminent German architect who had come to England in flight from Dresden in 1848, the year of revolutions, and had been given a post by Henry Cole in the Schools of

Design. As an art-historical theorist, Semper was to be influential in the development of applied-art museums in Germany, as we shall see. As an architect, he was celebrated as the foremost exponent of a revived Renaissance style, which enabled him to clothe original and innovative architectural forms in fluent classical dress. The building he proposed for South Kensington had in its façades all the variety and facility that he brought to his famous opera house in Dresden, but its most remarkable feature was a vast iron and glass roof.[53] It would have been a sort of Renaissance version of St Pancras station. Semper's proposal was costed by the builders Peto and Cubitt, and proved prohibitively expensive – 'very much I believe to the Prince's disappointment', wrote Redgrave.[54] The Commissioners consequently descended from the sublime to the commonplace, and managed to obtain from Parliament enough money for a cheap temporary building. This was well advanced by the middle of 1856, when the rooms at Marlborough House were being measured up, ready for the move to South Kensington.[55]

'Everybody predicts ill luck to the move to Kensington,' Robinson had written the previous November, 'on the score of distance'.[56] Indeed, the apparent remoteness of South Kensington became an issue of controversy. Although today it seems part of central London, in the 1850s it seemed 'out of the way, and difficult to get to ... London practically came to an end in this part, and was lost in market gardens'.[57] Not yet built over, the region seemed like the country: 'in the year 1851, partridges were shot on the ground where the Natural History Museum now stands'.[58] As the area was redeveloped, there were some (as there always are) who lamented the disappearance of the former scene. 'Green lanes! green lanes! how I regret to see you improved into fine streets,' cried a reviewer in 1859, describing how the 'sylvan beauty' of the 'umbrageous network of paths leading from Brompton to Kensington' had been destroyed to make room for the new museum.[59] 'Groves and gardens have been cleared away, perchance for the site of a new art-town,' another commentator sentimentally recorded.[60]

Many, however, reacted in a more hard-headed way. It seemed to them absurdly foolish to try to locate public institutions so far from central London. The 1851 Commissioners were criticized by business-minded people for 'sinking money in a cabbage-garden'. This taunt could be turned aside by pointing out that 'half London had ... once been a cabbage-garden or a brick-field',[61] and, of course, the investment proved a good one in the long run. But access was a problem, especially for the poor working people to whom the museum wished to appeal. The *Civil Engineer* asked, 'How are artizans ... to spare either time or money to traverse several miles into the outskirts of the

metropolis for the purposes of study?'[62] *Building News* opined that only 'once in his life' might a workman 'make a holiday trip with his wife and children to ... South Kensington, with an outlay of two or three weeks' savings, but catch him there again you never will; for experience teaches him it is a day's journey beyond his means or his might'.[63] Several years later the architect William Burges still regretted that the museum had not chosen a more central location:

Had it been placed in a more central situation, say at Charing Cross, it would have had an immense influence in educating the public generally, for people would then run in for half-an-hour when they were passing, as they do at the National Gallery: and it is precisely those half-hours that are the most precious, for people then confine their attention to one or two things and study them well, knowing that they have no time for the others; whereas when they go to see the Museum as a sight they try to see as much as possible, and nothing gets properly studied. The consequence is that the Museum at South Kensington does only one-half the good it might do, and is visited principally by students, sight-seers, and the inhabitants of the vicinity, whereas it ought to catch all and every condition of life.[64]

The assessment of visitors' behaviour that Burges makes here is a point that has been much argued over in recent times, in relation to museum admission charges.

In 1857, when it seemed that the choice of the South Kensington site might still be averted, *Building News* became quite frantic about the deficiencies of the region. Referring to the 'wilds and swamps of South Kensington'[65] and 'the swamps and "piggeries" of Kensington-gore',[66] it predicted that the museum would, in such a wet area, be perpetually 'shrouded from view in mist', and that 'the destructive effects of unwholesome damps reeking from the soil, and penetrating through every crack and crevice of the buildings, will soon be discernible upon works of art'.[67] *Building News*, indeed, believed that the whole project was a German plot, and railed against the Prince Consort:

It may be all very well for Prince Albert and the sham Princes of Germany to put a thiergarten, or any other show, where they like, and to which the serfs may resort; but working men in London, and throughout the land, who are citizens, and not German serfs, demand other treatment, and the enjoyment and control of their own property. We had quite enough of Prince Albert's interference with the public ... in the establishment of the Great Exhibition ... in the out-of-the-way site in Hyde-park ... It is time that he should be stopped, and taught that it is out of place for him to meddle with foreign policy or domestic institutions.[68]

The Prince's coadjutors, including Cole and Redgrave, were also attacked as a 'nondescript clique which ... belongs neither to the Government nor to the opposition, nor to the Court, and which is composed of parasites that cling to all

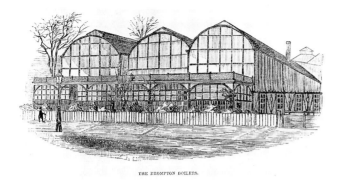

THE BROMPTON BOILERS.

Figure 3.4 A wood-engraved illustration of the 'Brompton Boilers', designed to make them look as unpleasant as possible. This appeared in an article in *The Art-World*, 15 March 1862, which denounced 'The Sky-blotches [i.e. eyesores] of London'.

with the tenacity of such foul things, and cannot be shaken off'. The 'Kensington Kit' were denounced as 'literary adventurers and artistic charlatans', who had 'failed in respectable pursuits, or in earning money and distinction in fair competition with the rest of the world'; who were 'bound together by one common tie – that of self-interest'; and who were now intent on 'exploiting the weakness of an illustrious personage, and [on] defrauding the public'. The 'Kensington Joint-Stock Art Jobbery Association'[69] was not, however, checked by this opposition, and, on the eve of the opening of the new museum, *Building News* gloomily confessed to 'the mortifying belief that sooner or later every London collection of artistic and scientific works will be

removed to the Exhibition Commissioners' property, and lost to us and to our children for ever'.[70]

The establishment of the new museum at South Kensington did, then, throw up some problems of public relations. Furthermore, its new building did not meet with universal approval. It was avowedly cheap and temporary. The Chancellor of the Exchequer had been persuaded to find money for it on the understanding that it could be reused for other purposes, or dismantled and sold.[71] It was constructed on a similar principle to that adopted in the Great Exhibition building: a skeleton of iron columns and girders, which could quickly be bolted together. It was clad in corrugated iron sheeting, with a roof chiefly of glass. A verandah-like attachment at the front slightly relieved its utilitarian appearance, and Cole tried to design a 'belfry',[72] which, however, never materialized. To liven it up, it was painted in stripes of green and white (another description says 'yellow and green').[73] Its overall form was crude: three long sheds, juxtaposed, with curving roofs (figure 3.4). The *Builder* thought that these long, curved roofs made it look like three huge steam boilers lying side by side, and applied to it the derisive nickname 'The Brompton Boilers'.[74] The *Civil Engineer* compared it to 'a huge lugubrious hospital for decayed railway carriages', and concluded that the method of construction must have been adopted in order 'to cover the largest space of ground at the cheapest possible rate'.[75]

Henry Cole was away in France when the 'Boilers' were built and refused to take responsibility for 'that unlucky iron shed'.[76] Characteristically, however, he made the best

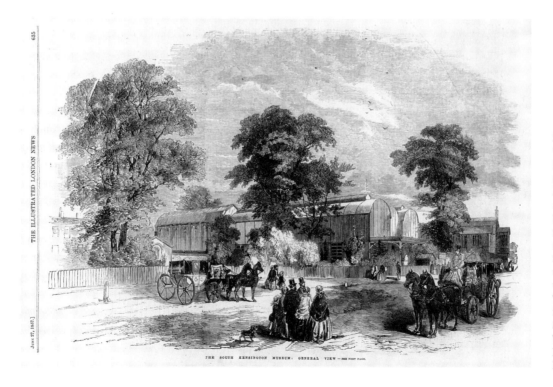

THE SOUTH KENSINGTON MUSEUM: GENERAL VIEW.—SEE NEXT PAGE.

Figure 3.5
The South Kensington Museum, wood-engraving in the *Illustrated London News*, 27 June 1857. The artist has done his best to make the museum look attractive by thrusting it into the background and filling his picture with trees and people. To the left of the Boilers is the slightly taller Sheepshanks Gallery. To the right of the Boilers, the Refreshment Rooms.

Figure 3.6 A wood-engraving
of the interior of the museum,
from the *Illustrated Times*,
27 June 1857. The caption
mentions that the museum
'opened to the public on
Wednesday last', and implies
that this is what it looked like.
In fact it was divided up into
sections by partition walls.
Such illustrations as this led
Henry-Russell Hitchcock
(*Early Victorian Architecture in
Britain*, p. 568) to argue that,
in the South Kensington
building, 'in theory, if not
necessarily in fact, there was
allowance for almost complete
rearrangement with changing
exhibition needs' so that 'the
most advanced 20th-century
museum practice could have
been used with ease'. The
building was not, however,
used as a flexible space.

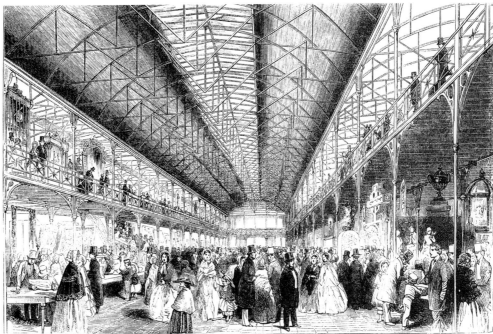

THE SOUTH KENSINGTON MUSEUM. (OPENED TO THE PUBLIC ON WEDNESDAY LAST.)

of a bad job, and tried to make improvements for the future.
Even before the Boilers came into use, he started to build out
from the back of them. A gallery for John Sheepshanks's
paintings, donated to the Department through Redgrave's
advocacy in 1856, was immediately begun (figure 3.5), and
was soon followed by galleries for the Turner and Vernon
collections, which belonged to the National Gallery but,
owing to its cramped quarters, had been exhibited at
Marlborough House and accompanied the Museum of
Ornamental Art down to South Kensington. There the
Department of Science and Art exhibited them on behalf of
the National Gallery.[77]

Because the Department had to juggle with so many
collections, the arrangement of the new museum tended
to alter from time to time, but a fairly clear picture can be
painted of its contents in the early days. The first thing that
a visitor might have noticed, on entering the apparently
capacious train-shed, was that the interior was partitioned
off into relatively small spaces. It is interesting that, in
advance of the opening, both the *Illustrated London News*[78]
and the *Illustrated Times*[79] printed wood-engraved views of
the interior that show the building as one large, unimpeded
space, in which crowds of visitors are freely promenading
(figure 3.6). The artists who drew these views for the
engravers presumably worked from architectural drawings
of the structure, adding figures and rather vaguely depicted
exhibits at whim. It is clear from early photographs and
descriptions that, right from the start, the interior was
divided up by wooden partitions, and the public could never
have seen it as a single space.

Visitors might also have been disconcerted to find that
the building was not entered from the front, through the
verandah (which in later plans was shown allocated to the
museum's photographic sales department). The part of the
building nearest to the front had been allocated to the
Patent Museum, and Bennet Woodcroft and the Patent
Commissioners fell out with Henry Cole about admission
policy. Cole continued the regime he had established at
Marlborough House: a mixed economy of paying and free
days. The Patent Museum refused to charge for admission.
So it was blocked off from the rest of the museum and
entered through its own door in a little shed attached to the
western side of the building. The main museum was entered
at first part-way along the western side, and later part-way
along the eastern side. On the west the entrance led to a
low, confined gallery containing plaster casts of classical
architecture; on the east the entrance led to a similar
gallery containing the Museum of Construction. Neither of
these galleries made a very exciting or relevant introduc-
tion to the rest.

Most visitors went straight through to the biggest space
in the museum. This was in the central aisle, which was
open to the roof. The side aisles had upper and lower
galleries. The larger part of the central space extended on
each side under the flanking galleries, so that it was rather
like a church with side chapels. This space contained the
Educational Museum (figure 3.7), which was crammed
with a wide variety of exhibits:

The main area of the Boilers presented a cheerful appearance
midway between the National Society's Repository and the

Figure 3.7
The Educational
Museum in 1859.
Through the door-
way at the back
can be seen parts of
the plaster cast of
Michelangelo's *David*
in the art section of
the museum.

Soho Bazaar, with its goodly array of models of school-build-ings, barometers and black boards, alphabets and magic lanterns, toys, pens, ink, paper and school-books, all in a row ...[80]

The exhibition seems to have been diverting even to children: one commentator spoke of 'the happy groups of children I see there, about and around me, prying with eager eye, under the direction of governesses and tutors, into the varied and instructive treasures of the glass cases'.[81] Children may not have been so enthusiastic about the weapons of punishment that were exhibited: 'the birch, the instrument of earliest application, – the fool's-cap, and long red inscribed tongue of horrible appearance, – the black-hole, the cane, and in addition to those, a heavy clog for truants, with a chain to fasten it round the leg'.[82] The Educational Museum may well have impressed visitors principally as a popular science collection, for besides articles of school equipment and a reference library, it was largely taken up with examples of teaching materials for natural history, mineralogy, geology, geography, astronomy, physics, chemistry, hydraulics, pneumatics, hydrostatics, and so on.

Visible, but not directly accessible from this section, was the Patent Museum (figure 3.8). There are rather diverse accounts of this. One commentator says that the exhibits 'are all carefully numbered and distinctly described',[83] while another, observing that 'the pleasure and advantage to be derived from the treasures here stored away, will vary according to the capacity of the observer for grouping and deduction', implies that they were in a muddle.[84] The first commentator remarks that the exhibits are 'in such bright and clean condition ... that many will be surprised that a number of them are of considerable antiquity', while another remarks on 'crumbling fragments' of 'worm-eaten wooden ... machinery', which turn out to be Arkwright's spinning jenny.[85] The principal exhibits were 'illustrations of the progress of the steam-engine', notably Symington's atmospheric engine of 1788.[86] Some visitors felt

as if we were in a charnel-house of a generation of steam-engines, whose ghastly skeletons are here exposed to view to remind us of the vanity of mechanical life. Where is now the clattering, the hissing, the pounding, the whistling, the elbowing, and spasmodic plunging in which these lifeless monsters once exulted?[87]

Also prominent were screw-propellers for steamships, including several designed by Woodcroft himself, for this was his speciality. 'Every degree of pitch that can be got out of a spiral' was to be seen in these propellers, 'and the favourite design of screw now appears to be modelled in the shape of a blade bone,' observed one visitor, imaginatively adding: 'the screw of the Rattler, for instance, ten feet in diameter, looks like the remains of the scapulae of some gigantic Ichthyosaurus'.[88] Perhaps most people would have relished the more domestic inventions: 'a patent for peeling potatoes and apples', 'a sweeping brush, which runs along the carpet on rollers, and collects all the dust in a covered box'.[89]

The western side galleries were mostly devoted to plaster casts: downstairs the Department's casts (surviving from the Somerset House days) of classical architecture; upstairs the Architectural Museum's Gothic casts (figure 3.9). This was not the most exciting part of the museum for the general public. Indeed, George Gilbert Scott claimed: 'our object has never been to make it an attractive collection to the public'.[90] He was gratified, however, to report that 'the number who visit our museum is increased since our removal by at least *twenty fold*; and, judging from appear-

ances, I am of opinion that a large proportion are of the classes which it is our object to benefit'.[91]

On the eastern side of the museum, in the upper gallery above the Museum of Construction, were the food and animal-products collections (figure 3.10). The latter did have popular appeal. Partly this was because it explained how things were made – 'many visitors stop to examine the case which contains the twenty different processes required to complete the manufacture of a beaver hat' – and even showed them in the making: 'a case of silkworms is placed here with the caterpillars actually at work'.[92] But the main appeal, surely, was the sheer incongruity of the products that derived from the same material. In the feather section, for instance, the exhibits 'carry ... one up from the child's shuttlecock to the elegant muff of turkey feathers, the stately ostrich plume, and the set of funeral plumes which decorate the carriage for the dead'. The leather section was similarly entertaining, demonstrating 'the variety of skins that can be tanned – from the goat or sheep, which can be prepared in a few hours, to the walrus and hippopotamus, which will take four or five years to tan'; it also showed some curious uses: 'the hog's skin for saddle-seats and skirts; the horse-hide for Cordovan leather; the lamb, kid,

Figure 3.8
Looking down into the Educational Museum. To the right, through the doorway, can be glimpsed the Patent Museum behind the screen that cut it off from the rest of the museum. In the upper gallery (left) can be seen part of the animal products collection.

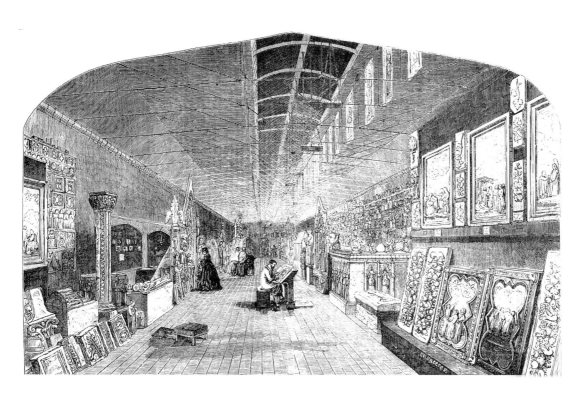

Figure 3.9
The Architectural
Museum, wood-
engraving in the
Builder, 11 July
1857.

&c., for soft coverings for the hands; the skin of the whale and seal for shoes and boots; the tough, strong hide of the rhinoceros for bullet-proof shields', ending with book bindings, 'from the simple collected and sewed leaves up to the vellum, roan, morocco, or other elegant binding'.[93]

The food collection was all that was left of Twining's Economic Museum. At first, all of this was on show,[94] and *Building News* hailed economic museums as the coming thing. 'There is little doubt economic museums will meet with equal favor in Great Britain, as they have done in Paris, Brussels, and elsewhere on the Continent.'[95] But this was a mistaken view. Most of Twining's collection went off first to the Polytechnic Institution in Regent Street and then to Twining's back garden in Twickenham,[96] and Playfair rearranged the food section, so as to explain the chemistry of food and the principles of a good diet. He had some fun in devising object lessons:

It would have been useless to display the analyses of various foods in statistical tables which no one would read, so I tried the experiment of showing the actual ingredients in a pound of food. Thus 1 lb. of maize was divided into so much flesh-forming materials, so much woody fibre, water, fat, sugar, gum, starch, etc., so that the eye could at once observe the quantities ... When a working man was told that 100 lb. of potatoes contained only 2 lb. of flesh-formers, while the same quantity of beans contained upwards of twenty pounds, he scarcely grasped the difference. But when in the same show-case he saw the small amount of flesh-formers in a pound of potatoes sprinkled over the bottom of a box, and the large amount heaped up in a corresponding box for beans, peas, or lentils, he learned a practical lesson through the eye and never forgot it.[97]

Apart from such improving displays there was much that might bring a smile to the lips of an English person: edible snails from Paris, birds' nests, sharks' fins and 'gelatinous ... lollypops' from China and Japan. 'The extent to which seaweeds are made an article of food by different nations would scarcely be believed, were they not ranged here before our eyes.' If a late twentieth-century visitor had been miraculously transported into the Food Museum, he might have been diverted by what seems to be a prototype 'breathalyser' – 'a goblet filled with a verd-green fluid, and one beside it with a dull olive-black mixture ... intended as tests of the presence of alcohol in a person's breath':

Thus, the dull dark green is a solution of bichromate of potash in sulphuric acid. This specimen, after having been breathed through for half an hour [!] by a teetotaller, retains its original colour: whilst that subjected to the breath of an individual who had taken a glass of brandy and water half an hour before, is grass-green in appearance. What is intended to be proved by thus ostentatiously holding up the hues of a glass of liquid we cannot conceive. Who wants to hunt up even the very ghost of alcohol in this absurd manner?[98]

At the northern end of the museum's upper floor was a space devoted to the Sculptors' Institute collection, which contained hardly any historical material, but had a wide range of works by some 25 contemporary sculptors, including John Bell, W. Calder Marshall, W. Behnes, E.H. Baily, and J.H. Foley.[99] From here, visitors gained entrance to the

new gallery for the Sheepshanks paintings. Predictably, perhaps, this was the part of the museum that most visitors headed for. On the opening day, the *Literary Gazette* noticed that:

fashionable ladies and gentlemen seemed somewhat at a loss what to think of the machinery, school desks, and telescopes among which they found themselves wandering helplessly on their entrance [into the museum]. They soon found their way into the gallery of pictures, which was crowded through the day.[100]

Another observer, having sampled the museum over several months, commented that 'it is a very easy matter for a visitor to distinguish, by the numbers in the different rooms, which are the most attractive parts of the Museum, and I think it must be admitted that the Sheepshanks' Gallery is by far the most crowded'.[101] Fine Art, in the shape of easel pictures, thus effortlessly achieved ascendancy in South Kensington from the very first. Redgrave, in whose special care the Sheepshanks gift lay, must have been pleased, but this cannot have been quite what Cole and Robinson intended.

A visitor to the museum searching for the decorative art collections would, when in the Educational Museum, have been ably to espy through a doorway the magnificent thighs of Michelangelo's *David*. A plaster cast of this celebrated sculpture, presented to the Queen by the Grand Duke of Tuscany, presided over the section of the Boilers devoted to the art collection. This was a part of the central hall to the north of the Educational Museum, and in this lofty space were grouped the larger objects from Marlborough House, while in the four small rooms under the Sheepshanks Gallery the smaller decorative art items were displayed. In the first of these rooms were cases of enamels, majolica, Flemish stoneware, porcelain and glass. Venetian mirrors, an Antwerp chimneypiece, a marble Italian fountain and a Della Robbia altarpiece were fixed on the walls, while stained glass was hung in the windows. The effect must have been not unlike that of Marlborough House (and not unlike the present appearance of the rooms, which contain works of the European Renaissance).

Most critics gave a fairly rambling account of individual works in this section, rather than an assessment of the whole collection. Those who did try to pass judgment tended to be advocates of good taste who found things to recoil from. *Building News*, in an irritable review, was free with its disparagement, criticizing exhibits as 'base and vulgar in conception', 'a production of the most hideous ugliness', 'of bad proportion and rude workmanship', and deploring that 'public money is so remorselessly wasted over the purchase of things little better than dire rubbish'.[102] Another critic claimed that 'it is manifest, that the majority of the examples contained in this division of the museum

outrage all the rules of decorative art'. Obviously a true believer in the principles that Cole had promulgated at Marlborough House, he demanded:

Is there here anything answering to the principles of decorative art, as published by authority of the Department of Science and Art? Where do we find in these examples ... the echo of that indisputable statement, that 'the true office of ornament is the decoration of utility'.

He considered that many of the exhibits, acquired as a result of 'that fashionable rage for articles of *vertu*', would 'debase rather than ... advance our art manufactures', unless they were accompanied by explanatory labels 'pointing out the manipulative merits, as distinct from the questions of grace or propriety of design' that could be discerned in them.[103] Prosper Mérimée, contributing a view from across the Channel, said that in the new galleries at South Kensington one could 'believe oneself in an immense bazaar', and he could not work out 'why this or that object should find itself in a school of design'. Looking at the art objects, he thought that many of them would be more appropriately placed in 'the collection of an antiquary, or even in the shop of a *brocanteur*'.[104]

The South Kensington Museum had such an extraordinary range of contents that it was difficult to assess it as a whole, and easy to dismiss it as incoherent. Even Cole spoke slightingly of it in 1857 as a 'refuge for destitute collections',[105] a phrase he ventured to repeat before the Select Committee of 1860.[106] Critics seeking to praise the museum could at least offer congratulations that it had been created

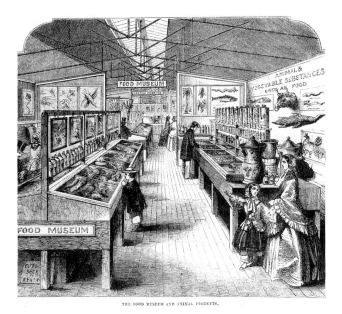

THE FOOD MUSEUM AND ANIMAL PRODUCTS.

Figure 3.10 The food and animal products collections in the upper east gallery of the museum. Wood-engraving from *The Leisure Hour*, 14 April 1859.

at all. The *Builder* urged its readers to acknowledge 'with admiration how the projectors' of the museum had 'borne up against the coldness and doubts of the great majority'.[107] Critics who looked for a unifying theme in the museum were apt to settle on education:

Education being the predominating idea in collecting the subjects here brought together, their arrangement has been made subservient to this object. Thus, we have a series of museums, which, without this key, would appear to consist of very heterogeneous materials.

It was important to stress too that the museum, like the Great Exhibition, was 'designed to afford instruction ... to the masses, as well as to the *élite* of society'.[108] As another commentator put it, 'it is not intended that this Museum should be merely an agreeable lounge or promenade to indulge or gratify curiosity alone'; rather, as a 'National Institution', it was to be 'a great instructional museum for the advancement of science and art'.[109] The *Literary Gazette* excused the confusion of the collections on the grounds that these were 'to be the text, as it were, for lectures to be delivered to classes of students'.[110] On an optimistic view, the museum could be regarded as an encapsulation of all knowledge. Alfred Darcel, the French decorative arts expert, in a book on Britain, toyed with this idea and imagined the museum rearranged, not in parallel galleries, but in a *'forme rayonnante'*, with the physical elements of the earth at the centre and their derivatives.[111]

What is perhaps rather odd is that no one alluded to the plan that had in the first place provided a coherent rationale for the museum collections: Prince Albert's fourfold scheme of Materials, Machinery, Manufactures and Art. Even when Cole was summoned before a Select Committee in 1860 to defend his fledgling museum, he did not invoke

Prince Albert in support of his vigorous assertion of the usefulness of all his diverse collections. The Prince's interest in South Kensington remained strong, although it proved difficult to get other features, besides the museum, to develop on the site. The year 1861 saw the opening of a public garden on the central part of the site, organized by the Royal Horticultural Society, which Prince Albert, as its President, had been able to connect to his cause. At the opening, he gave a speech in which he expressed the hope that the garden would 'at no distant day, form the inner court of a vast quadrangle of public buildings ... where science and art may find space for development'.[112] This was, alas, more or less his final word on the subject, for in December he died. The motto 'Science and Art' was to be, as much as anything was, the rationale behind the development of the South Kensington Museum. In the 1860 edition of its *Guide* it regrouped its various collections into an 'Art Division' and a 'Science Division', and this bifurcation remained a ruling principle of its administration until, in 1909, it split into two museums, the Victoria and Albert and the Science Museum. By that point the V&A was already world famous as an art museum, while the main development of the Science Museum was still to come.[113]

In 1857 it must have seemed, by contrast, as if the art collections, after their happy growth at Marlborough House, had been almost overwhelmed at South Kensington by all the other strange and miscellaneous collections (figure 3.11). However, J.C. Robinson, the curator of the art collections, remained to be reckoned with. 'Soon,' he wrote, looking back from the end of the century, 'the legitimate art gatherings of the museum, directly under the writer's care and purveyance, took the lead, and visibly emerged from the motley, medley chaos.'[114]

Figure 3.11
An advertisement for the museum. 'Ornamental Art' has been entirely omitted from the description of the museum given here.

NOTES

1 For a fuller treatment of what follows, see my article 'Art and Science Applied to Industry: Prince Albert's Plans for South Kensington', in Franz Bosbach and Frank Büttner (eds), *Künstlerische Beziehungen zwischen England und Deutschland in der viktorianischen Epoche. Art in Britain and Germany in the Age of Queen Victoria and Prince Albert*, Munich: Saur, 1998, pp. 169–86 (*Prinz-Albert-Studien. Prince Albert Studies*, vol. 15).

2 For the official record of this collection, see Appendix XXXVII in *Second Report of the Commissioners for the Exhibition of 1851*, London: HMSO, 1852.

3 Cole diary, 1 March 1852. See also Edgar Bowring, 'South Kensington', *Nineteenth Century*, June 1877, p. 573.

4 Letter from Edgar Bowring in *Journal of the Society of Arts*, 8 December 1854, p. 62.

5 The first *Guide* was a folio pamphlet. The 1st, 7th, 8th and 9th editions are preserved, bound together in the NAL (press mark: VS Guide).

6 MS letter, Redgrave to Cole, 15 October 1858, Cole Correspondence (NAL).

7 Cole diary, 13 August 1851. Theodore Martin, *The Life of His Royal Highness The Prince Consort*, 3 vols, London: Smith, Elder, 1876, vol. 2, p. 390.

8 *Survey of London ... The Museums Area*, p. 51.

9 See Patrick Beaver, *The Crystal Palace 1851–1936. A Portrait of Victorian Enterprise*, London: Hugh Evelyn, 1970.

10 *Survey of London ... The Museums Area*, chapter 4.

11 Cole diary, 14, 26, 28 August, 2 September 1851.

12 Ibid., 19 August, 23 September 1851.

13 Stanley Weintraub, *Albert, Uncrowned King*, London: John Murray, 1997, pp. 182–8, 207–9, 221–2.

14 [Sir David Brewster], 'Prince Albert's Industrial College of Arts and Manufactures', *North British Review*, vol. 17, 1852, p. 547.

15 Reprinted in Martin, op. cit., vol. 2, pp. 569–73.

16 Bowring, op. cit., p. 565.

17 Martin, op. cit., vol. 2, p. 571.

18 Cole diary, 13 August, 2 November 1851.

19 MS letter, Redgrave to Cole, 3 May 1855, Cole Correspondence (NAL).

20 MS letter, Redgrave to Cole, 10 September 1855, Cole Correspondence (NAL).

21 Thomas Wemyss Reid, *Memoirs and Correspondence of Lyon Playfair*, London: Cassell, 1899, p. 136.

22 *First Report of the Commissioners for the Exhibition of 1851*, London: HMSO, 1852, p. xxxii.

23 Reid, op. cit., p. 115.

24 MS letters, Redgrave to Cole, 5, 30 June 1855, Cole Correspondence (NAL).

25 See John Hewish, *The indefatigable Mr Woodcroft. The legacy of invention. A preliminary study, in commemoration of the first centenary of the death of Bennet Woodcroft*, London: The British Library, Reference Division, Science Reference Library [1979]; and James Harrison, 'Studies in the Society's History and Archives CLI: Bennet Woodcroft at the Society of Arts, 1845–57', *Journal of the Royal Society of Arts*, vol. 128, 1979–80, pp. 231–4, 295–8, 375–9.

26 *Second Report of the Commissioners for the Exhibition of 1851*, pp. 25–8, 30–1.

27 Published by Longman, Brown, Green, and Longmans, London, 1853.

28 *Journal of the Society of Arts*, 20 May 1853, p. 306.

29 Ibid., 14 April 1854, pp. 363–4.

30 Ibid., 8 December 1854, p. 62.

31 Ibid., 25 May 1855, pp. 493–4.

32 Ibid., 25 April 1856, p. 390.

33 David Layton, 'Studies in the Society's History and Archives XCII: The Educational Exhibition of 1854', *Journal of the Royal Society of Arts*, vol. 120, 1971–2, pp. 183–7, 253–6.

34 'The Educational Exhibition at St. Martin's Hall', *Illustrated London News*, 15 July 1854, p. 11.

35 *Journal of the Society of Arts*, 27 January 1854, p. 178.

36 Bowring, op. cit., p. 565.

37 See Brian Louis Pearce, 'Studies in the Society's History and Archives: Thomas Twining (1806–1895): The Determined Improver', *Journal of the Royal Society of Arts*, vol. 135, 1987, pp. 845–7, 942–4; vol. 136, 1988, pp. 62–4.

38 T. Twining, *Special Museums for the Working Classes. Memorandum ... addressed to the Chairman of the Council of the Society ... of Arts ...* [London]: Society of Arts, (1855), p. 1.

39 *Exposition universelle de 1855. Rapports du Jury Mixte International*, Paris: Imprimerie Impériale, 1856, pp. 1383ff.

40 *Journal of the Society of Arts*, 31 August 1855, p. 676.

41 Ibid., 31 October 1856, p. 780.

42 Twining, op. cit., pp. 2–7.

43 *Précis*, 1852–63, p. 159.

44 Henry Sandham (ed.), *Catalogue of the Collection Illustrating Construction and Building Materials in the South Kensington Museum*, London: HMSO, 1862, pp. 5, 9.

45 *The Architectural Museum. Report, 1860* [n.p., n.d.], p. 5.

46 Sir George Gilbert Scott, *A Guide to the Royal Architectural Museum, 18, Tufton Street, Dean's Yard, Westminster* [1876], p. 2.

47 *Architectural Museum, Canon Row, Parliament Street, Westminster. Catalogue*, London: Joseph Masters, 1855, pp. 5 (no. 115), 44–7, 53.

48 Scott, op. cit., p. 2.

49 See MS letter, Redgrave to Cole, 18 October 1854, Cole Correspondence (NAL).

50 *Builder*, 25 July 1857, p. 413.

51 Joseph Durham, 'The Sculptors' Institute', *Art-Journal*, 1854, pp. 309–11.

52 *Art-Journal*, 1857, p. 161.

53 John Physick, 'Early Albertopolis: The Contribution of Gottfried Semper', *Victorian Society Annual*, 1994, pp. 28–36.

54 MS letter, Redgrave to Cole, 30 June 1855, Cole Correspondence (NAL).

55 Cole diary, 5, 27 June 1856.

56 MS letter, Robinson to Cole, 7 November 1855, Cole Correspondence (NAL).

57 Walter Crane, *An Artist's Reminiscences*, London: Methuen, 1907, p. 44.

58 Reid, op. cit., p. 141.

59 'The South Kensington Museum', *Leisure Hour*, 7 April 1859, p. 215.

60 'The South Kensington Museum', *Illustrated London News*, 27 June 1857, p. 636.

61 John Hollingshead, *A Concise History of the International Exhibition of 1862*, London: for Her Majesty's Commissioners, (1862), pp. 33–4.

62 *Civil Engineer and Architect's Journal*, vol. 19, 1856, p. 187.

63 *Building News*, 27 February 1857, p. 203.

64 William Burges, *Art Applied to Industry. A Series of Lectures*, Oxford: Parker, 1865, pp. 5–6.

65 *Building News*, 6 March 1857, p. 225.

66 Ibid., 20 March 1857, p. 277.

67 Ibid., 6 March 1857, p. 225.

68 Ibid., 27 February 1857, p. 203.

69 Ibid., 6 March 1857, p. 225.

70 Ibid., 5 June 1857, p. 572.

71 Physick, p. 24.

72 Cole diary, 14 November 1856.

73 *Building News*, 20 March 1857, p. 277.

74 Physick, p. 25.

75 *Civil Engineer*, op. cit., p. 187.

76 *Fifty Years*, vol. 1, p. 323.

77 Physick, pp. 33–7, 39–45.

78 *Illustrated London News*, 12 April 1856, p. 380.

79 *Illustrated Times*, 27 June 1857, p. 412.

80 'Art' ['South Kensington Museum and Loan Exhibition'], *Quarterly Review*, January 1863, p. 177.

81 'The South Kensington Museum. Second Article', *Leisure Hour*, 14 April 1859, p. 234.

82 *Builder*, 15 August 1857, p. 459.

83 *Builder*, 1 August 1857, p. 428.

84 'The South Kensington Museum. Fourth Article', *Leisure Hour*, 28 April 1859, p. 264.

85 A.W. [article signed with initials only], 'Half Hours at the Kensington Museum', *Once a Week*, 31 August 1861, p. 57.

86 *Guide*, no. 1, 20 June 1857, p. 4.

87 'The South Kensington Museum', *Literary Gazette*, 27 June 1857, p. 616.

88 A.W., op. cit., p. 258.

89 Ibid., p. 259.

90 *Report from the Select Committee on the South Kensington Museum ... Ordered, by the House of Commons, to be printed, 1 August 1860*, Minutes of Evidence, para 1087.

91 *Builder*, 25 July 1857, p. 413.

92 'Visits to the Brompton Museum. Collection of Animal Products and their Application to Industrial Purposes', *Builder*, 12 September 1857, p. 523.

93 'The South Kensington Museum', *Building News*, 14 August 1857, p. 849.

94 *Guide*, no. 1, p. 9.

95 'South Kensington Museum', *Building News*, 7 August 1857, p. 818.

96 'The Food Collection in the Brompton Museum', *Builder*, 5 June 1858, p. 388; 'The Daily-Life Museum, Twickenham', ibid., 9 September 1865, pp. 638–9.

97 Reid, op. cit., pp. 150–1.

98 'Half Hours at the South Kensington Museum. No. II. – The Food Department', *Once A Week*, 16 November 1861, p. 580.

99 'The South Kensington Museum', *Building News*, 17 July 1857, p. 740.

100 *Literary Gazette*, 27 June 1857, p. 616.

101 Letter from George Lufkin, *Building News*, 27 November 1857, p. 1252. Walter Crane confirms this: op. cit., p. 44.

102 'The South Kensington Museum', *Building News*, 3 July 1857, p. 677.

103 'The South Kensington Museum', *Newton's London Journal of Arts and Sciences*, vol. 10, 1859, pp. 326, 325.

104 Prosper Mérimée, 'Les beaux-arts en Angleterre', *Revue des deux mondes*, 15 October 1857, p. 877.

105 *Introductory Addresses on the Science and Art Department and the South Kensington Museum. No. 1. The Functions of the Science and Art Department*, London: Chapman and Hall, 1857, p. 20.

106 *Report of the Select Committee ... 1860*, para 247.

107 'The Brompton Museum. The West Corridor on Ground-Floor', *Builder*, 29 August 1857, p. 496.

108 *Newton's London Journal*, p. 321.

109 'Museum of Science and Art. Kensington Gore Estate', *Illustrated London News*, 12 April 1856, p. 379.

110 *Literary Gazette*, p. 616.

111 Alfred Darcel, *Excursion artistique en Angleterre*, Rouen: D. Brière, 1858, p. 57.

112 'The Horticultural Gardens, South Kensington', *Builder*, 8 June 1861, p. 390.

113 A note on the subsequent histories of the 'destitute collections'. The Architectural Museum was jealous of its independence and felt hard done by at South Kensington. In 1869 it moved to purpose-built premises in Tufton Street, Westminster. Premises and collection were taken over by the Architectural Association in 1903. The Association moved again to Great Smith Street in 1916. By this time it no longer wanted a museum, so, by a curious reversal, the plaster casts were donated to the Victoria and Albert Museum, where they remain in store. (John Summerson, *The Architectural Association 1847–1947*, London: For the Association (1947), pp. 35ff. Peter Wylde, 'The First Exhibition: The Architectural Association and the Royal Architectural Museum', *Architectural Association Annual Review*, 1981, pp. 8–14.) The Sculptors' Institute Collection seems to have faded away by 1865 (mentioned in the 1860 guide book but not in that of 1865). By 1867, most of the Boilers had been dismantled, to be re-erected as the Bethnal Green Museum, the South Kensington Museum's East London branch (Physick, pp. 143–6). The food and animal products collections, after lingering in temporary premises at South Kensington until the Bethnal Green building was finished, were transferred there. They were refreshed and new catalogues were published. They were destroyed or dispersed in the 1920s; descriptive registers of the collections remain at Bethnal Green. After the disappearance of the Boilers, the Museum of Construction went across Exhibition Road to the central range of the 'Exhibition [i.e. of 1862] Galleries' around the Horticultural Society's garden. It was to be dispersed in 1888, but some of it was apparently preserved. The Educational Library went into a temporary reading room, while the collections went into temporary premises south-west of the growing quadrangle of the South Kensington museum. The collections were dispersed in 1888, and the library, having been merged for a time with the Science Library, was sent to the Education Department in Whitehall in 1896. The Patent Museum stayed in a remaining fragment of the Boilers, until in 1883 it was handed over to the Department of Science and Art, which rehoused it in 1886 in the 'Exhibition Galleries'. The Patent Museum and Museum of Construction were subsumed in the Science Museum: see David Follett, *The Rise of the Science Museum under Henry Lyons*, London: Science Museum, 1978, chapter 1.

114 J.C. Robinson, 'Our Public Art Museums: A Retrospect', *Nineteenth Century*, December 1897, p. 955.

CHAPTER FOUR

The Heroic Age at South Kensington

John Charles Robinson was born on 16 December 1824 at Nottingham. When his children asked him about his early life, he would not talk about it, as if some dark secret lurked there.[1] Perhaps he was disavowing humble origins, because he came to adopt the pose of 'a country gentleman to the manner born'.[2] He began his working life in an architect's office, where he became a romantic Gothic Revivalist.[3] Driven by 'a natural and irresistible vocation for art',[4] he was encouraged to go to Paris by 'friends ... who had noted and encouraged his early effort'[5] – his daughter mentions 'a benevolent old gentleman named Mr Hart'.[6] In Paris Robinson trained with the painter Michel-Martin Drölling,[7] but 'his sympathies and artistic pursuits were so mixed and various, that it was hard to choose betwixt many entrancing paths'.[8]

What happened to him in Paris is told in a profile that appeared in the French magazine L'Art in 1883. The young architect-painter was so excited by his visits to the Louvre and other French collections that 'without any premeditation, just by force of circumstances' he joined 'la confrérie des Curieux' – he became a collector and connoisseur.[9] We know little of Robinson's period in Paris, but from contemporary accounts of life there we can reconstruct something of what he experienced. He must certainly have savoured, among the passions that flourished in the city, 'the modern one, which has seized the French, for old furniture, old remnants, and old relics of past ages'. These are the words of the whimsical journalist, Jules Janin, from a foreigner's guide to Paris that he wrote in 1843.[10] He was recognizing a pursuit that had taken hold especially strongly in France because of the effects of the Revolution. The romance of

the Middle Ages had been discovered by a few cultural explorers elsewhere in Europe in the eighteenth century, and in Germany there survived undisturbed many collections of wonders, curiosities and masterpieces from the Middle Ages and Renaissance in the treasure chambers of noble and royal houses. In France, however, the Middle Ages emerged from obscurity in a startling way. The Revolution, in demolishing tyranny and superstition, cast out upon the scrap-heap the property and possessions of the monarchy, the aristocracy and the Church. 'The French revolution,' wrote Janin, 'began to break everything, to destroy books, to cut paintings in pieces with its pitiless hands, to melt gold and silver, and the most costly jewels, to tear laces, to sell – at auction even – the marbles of the tombs.' But what was cast out was immediately rescued, by 'a whole army of antiquarians, honest men, whose life and fortune are spent in collecting these scarce remains, in saving from oblivion these precious remembrances, in gathering up this noble dust'.[11]

Janin vividly evokes for his readers the mild but resolute Alexandre Lenoir, interposing himself between ravaging soldiers and threatened relics.[12] Lenoir (1761–1839) contrived, with the permission of the Government, to gather together an extraordinary collection of historical artefacts that had been displaced from their original sites by the Revolution. He used the suppressed convent of the Petits-Augustins (on the Left Bank, where the Ecole des Beaux-Arts now stands) to accommodate his Dépôt des oeuvres déplacées, and by 1795 it was laid out as the Musée des Monuments Français, with himself as curator. The exhibits were grouped in chronological order, in a series of rooms devoted to each century from the thirteenth to the seventeenth, with architectural background appropriate to the various periods. The displays were intensely evocative – the equivalent in their time of today's historical theme-parks –

Vignette: Illustration from J.C. Robinson's *Italian Sculpture* (1862), showing a terracotta relief bought from the Gigli-Campana collection, ascribed by Robinson to Antonio Pollaiuolo (though since demoted).

and the museum was thoroughly described, and recorded in illustrations.[13] It remains a pivotal incident in intellectual history and the history of museums.[14] One reason for its continuing repute is that it perished in its prime, before its glory had been dimmed by later developments. It was dismantled in 1815, after the restoration of the monarchy, and many exhibits were returned to the sites from which they had been torn. The memory of Lenoir's museum lingered, however, as an inspiration to antiquaries.

The exhibits in Lenoir's museum were mostly large in scale: funerary monuments, fragments of architectural sculpture, stained glass. Lenoir did collect smaller artefacts ('objets mobiliers') dating from the Middle Ages and the Renaissance, but did not display them. His collection was sold in 1837.[15] Another pioneer collector in this field was Pierre Révoil (1776–1842). He was a painter, who preferred medieval and Renaissance subjects ('Joan of Arc imprisoned in Rouen', 'Mary Stuart separated from her faithful servants', 'The infancy of Giotto') to the scenes of classical history that covered most canvases of the time, and he collected medieval artefacts primarily as background material for his paintings. A native of Lyons, he passed most of his life as head of the art school there. His collection was housed in the next room to his studio, and

had become a famous attraction by 1811. With a fifteenth-century tapestry, carved choir-stalls, old cabinets with iron locks and hinges, and trophies of arms upon the walls, it seemed like a chamber from the Middle Ages. All around stood church plate; small sculptures in ivory, wood and alabaster; Limoges enamels; pottery by Bernard Palissy; seals, cameos and medals; 'ustensiles de la vie privée', such as salt-cellars, knives, scissors, plates, basins, cups and lamps; items for the 'toilette des dames', such as mirrors, combs, purses, shoes; and fragments of ancient textiles.[16] Révoil's collection was considered to rank equally, where 'objets mobiliers' were concerned, with Lenoir's collection of monumental sculpture.[17] It was so celebrated that in 1830 it was purchased for the nation and added to the Louvre, where, regrettably, it was distributed among the rest of the exhibits so that it could no longer be seen as an entity.[18]

In Paris in the 1840s the young Robinson could not easily have appreciated the dispersed collections of Lenoir and Révoil, but he would almost certainly have known the collection of Alexandre du Sommerard (1779–1842). Having assembled a collection, du Sommerard was seized by the apt, yet ambitious notion that his relics should be installed in a ruin. So he rented rooms in the medieval Hôtel de Cluny, the former town-house of the Abbots of the

Figure 4.1
A Romantic view of collecting in France. This chromolithograph was included as Plate XXXIX in the first volume of plates (1838) of Alexandre du Sommerard's Les Arts au Moyen Age. It reproduces a painting, L'Antiquaire, by C. C. Renoux, which was based on du Sommerard's collection in 1828.

Figure 4.2
Charles Sauvageot in his
bedroom. This wood-engraving,
reproducing a watercolour by
James Roberts, appeared in the
weekly paper *L'Illustration*
(1858, p. 141). Sauvageot
arranged his art objects to form
a balanced *ensemble*. 'Everything
in his apartment was calculated
to achieve harmony; he followed
a law of gradation which, by
imperceptible nuances of colour
and inconspicuous variations
of form, led the viewer's attention
from quite simple objects to
the most delicate or brilliant
marvels.'

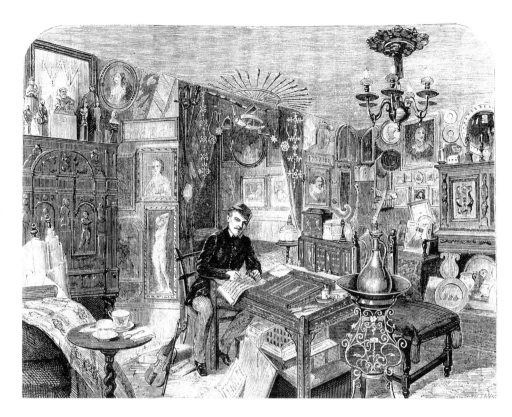

Cluniac Order, which adjoined the remains of the Roman baths in Paris. He arranged these rooms in evocative style in 1832, and opened them to the public on Sundays. He was said to draw crowds as big as those at the Louvre,[19] and he himself presided 'with exquisite politeness, explaining everything after the fashion of a very learned man, who has not lost his right of imagination and of invention' (figure 4.1).[20] The State took over both the collection and its premises in 1843, and the Musée de Cluny, rearranged more systematically in a more extensive suite of rooms, opened as a public museum in 1844.[21]

It is worth noting, perhaps, that although English commentators sang the praises (as we have already seen in the case of Charles Heath Wilson) of the Musée de Cluny as a resource for educating the taste of artisans and manufacturers, the French valued it as a means of instruction in national history. A visit to the museum would provide 'a complete course in archaeology', for one would learn 'the customs and usages of former times; ... how our ancestors understood both the spiritual and material life, how they clothed and equipped themselves, prayed and fought'.[22] Jules Janin elaborated eloquently – du Sommerard

had realized the whole history of France, but of France studied in detail, in the chapels, the manors, the palaces of her kings, in the cemeteries of her churches, in the houses of her citizens ... He reduced the whole history to a thousand little details of the greatest amusement; carpets, ribands, garments, windows, halberds, laces, dresses for the ladies, armour for the heroes,

books for the learned; he knew the condition of the people under Charlemagne by their cabinets; he knew the position of the court at the time of Francis I by their dishes and plates. It was a strange and rare history, of which he had suppressed all the noise, all the movements, all the facts, all the clamour, and left nothing but the external appearance.[23]

This feeling for objects as historical evidence (rather than as evidence of design standards) might well have communicated itself to Robinson if he visited the Musée de Cluny. Du Sommerard's collection was also a scholarly reference point for him, and for all other students of medieval and Renaissance decorative arts, on account of the magnificent catalogue – five volumes of text, with six folio volumes of luscious plates – that du Sommerard published between 1838 and 1846.[24]

Another collection that Robinson must have known was that of Charles Sauvageot (1781–1860), who began collecting in 1797, in the immediate aftermath of the Revolution, just as Lenoir and du Sommerard had done. A private man, he became known as the most indefatigable and patient of Parisian artistic scavengers, and was the model for the protagonist, Sylvain Pons, of Balzac's novel *Cousin Pons*, which was first published in spring 1847. Sauvageot's collection (as extensive as du Sommerard's) was crammed into a tiny apartment in the Rue du Faubourg-Poissonnière (figure 4.2). With 'exemplary complaisance' he admitted visitors,[25] until they became so numerous that he had to impose restrictions. Perhaps

LES COLLECTIONNEURS.

Figure 4.3 A satirical view of collectors in France. Wood-engraving by Lavieille after Gavarni, illustrating the section 'Les Collectionneurs' by Count Horace de Viel-Castel in *Les Français peints par eux-mêmes*, volume 1 (1841).

Figure 4.4 Title-page of the sale catalogue of the collection of Baron Brunet-Denon. This was mentioned by Jules Labarte (in his catalogue of Debruge-Dumenil's collection, p. 9) as one of the important collections of the first generation. It is conceivable that Robinson was in Paris when this sale took place.

Robinson, like many others, climbed three flights of stairs in the old apartment house until he found himself before a doorway surrounded by fragments of medieval stonework. After ringing the bell, he would have knocked loudly twice to show that he was a friend,[26] and would then have presented a recommendation from another connoisseur.[27]

Richard Redgrave visited Sauvageot's apartment in 1855, when he was in Paris with Cole, and recalled:

Here, in three little rooms, two of them hardly more than six feet square, is contained a collection that might be national; much of it is so good. Here, too, in these rooms, he lives. He received us on a Sunday, after church, in a dress much like that in some of Ostade's pictures – a tight velvet *surtout*, with white turned-down collar, and a white-lined velvet cap. The place was very picturesque, the light coming in dimly through stained-glass windows, and the objects were so crowded that I tucked in my sleeves from fear. He has five choice pieces of *Henri Deux* ware, and some remarkable pieces of Palissy. It is evident that he buys articles from real love of the beautiful, rather than as curiosities ... His bed was in the largest of the three rooms, with his few books; his instruments for examining and cleaning the delicate art works wanting these cares, were close at hand.[28]

Sauvageot's collection was one of the artistic sights of Paris for over 30 years, and indeed became a national collection after his death in 1860, when it went to the Louvre, to which he had donated it four years before.[29]

The early collectors of medieval and Renaissance decorative arts tended to be of modest dispositions and means. Du Sommerard had a humdrum job in the Audit Office (*Cours des comptes*), while his heart was in his collecting. Sauvageot was a violinist at the Opera, with a day-time job in the Customs; his lodgings were in an outer part of northern Paris. The Hôtel de Cluny was on the Left Bank, not yet lying expansively along the flank of the Boulevard Saint-Germain, which was still unbuilt, but accessible only

through 'dark, narrow, winding streets, where two barrows would cause a blockage, and where the wretched pedestrians are crushed between damp walls and menacing wheels'. This region, the Latin quarter, was the haunt of merry students, quick-witted *grisettes*, greedy lodging-keepers and toiling proletarians.[30] So the 'modern passion' of Paris would not have been beyond the reach of a young man in the 1840s.

The first generation of collectors, indeed, were often caricatured as scruffy eccentrics. In the 1830s and '40s there was a popular literary and artistic genre in France known as the *physiognomie* – illustrated essays on the types of people to be met in the street, and their characteristic foibles.[31] A large collection of such caricatures, *Les Français peints par eux-mêmes*, published in parts in 1839–42 and subsequently gathered in book form, introduces us to 'Les Collectionneurs' (figure 4.3), in particular an imaginary collector called M. de Menussard:

A little old man, dry, wrinkled, worn down, patched up, wrapped in a sort of brown overcoat, his head covered in a black silk bonnet, with an enormous hat mounted over it, a hat of indeterminate colour, greasy on the brim, greasy on the crown, greasy on the ribbon, greasy on the lining, greasy everywhere, a hat which for thirty years has regularly accompanied its master to all the sales, and has walked with him, whatever the weather, along the *quais* and to all the *bric-à-brac* shops ...

Although rich and well educated, M. de Menussard lives alone: 'he has no carriages, no servants; an old charwoman does his housework. His toilet, food and lodging cost little. He has never been to a play, has no friends, has never been known to have a mistress, has never travelled ...'

M. de Menussard, with his black cap, his greasy hat, his spiky and lustreless hair, his carelessly cut beard, his hands ingrained with dirt, his unpolished shoes, is, of all the lovers of this century, the most fervent, sincere, true and enthusiastic, and the most forgivable in his egoism and ferocity.[32]

For the first generation of collectors, there was not yet an organized market. Collectors had to seek for their treasures on

ignoble stalls made of four planks and two trestles and lumbered with gaping pots and jagged shards; or else they had had to set out across the most noxious gutters into the dens of tinkers, and clamber over scrap-heaps of iron, lead, copper and tin. These hovels were places of ill-fame ... The bold spirits who ventured into these limbos were considered to be a little mad, or to have fallen to the lowest depths of destitution.[33]

Medieval and Renaissance works of art could be found, going for a song, in junk shops in back alleys. The photographer Nadar, looking back to the 1830s, recalled 'an inextricable labyrinth of perilous little streets, constricted, dark and wet' near the Carrousel du Louvre. These included the Impasse du Doyenné, den of a group of Romantic writers and artists. These streets were demolished in the 1850s to make way for the new north-west wing of the Louvre. Here:

between the stagnant puddles and the heaps of trampled filth, sometimes three feet high, [were] boarded stalls where one could find, for nothing, cabinets and credence tables of the sixteenth century, marriage caskets, first impressions of Dürers and Rembrandts, armour inlaid with gold decoration, and, once in a blue moon, one of the four little ceramic candlesticks from the service of Henry II, bought for a few centimes, and for which Strauss would later pay at auction 14,000 francs ...

Although the trade in medieval and Renaissance art still operated in the flea-markets, it also had a more fashionable side. As the above quotation implies, the auction sale rooms, run by the *commissaires-priseurs*, who were licensed and regulated by the Government, provided a constantly changing spectacle of artworks. Alongside the sales of paintings and antiquities, there were regular sales of *'objets d'art et haute curiosité'*, which would have especially attracted Robinson (figure 4.4). At this period there were so few temporary exhibitions in galleries that the sale rooms played an important part in enabling art enthusiasts to extend their knowledge and expand their visual memories.

There were also collections belonging to wealthier connoisseurs who, while acquiring the more prestigious categories of collectable art, also ventured into the new field of medieval and Renaissance decorative arts. Robinson could have visited that of the Comte de Pourtalès, in a custom-built house in Italian Renaissance style, where a sculpture-lined vestibule and a grand staircase led up to a top-lit picture gallery, from which one gained access to three smaller *cabinets*, one devoted to Greek vases, another to Egyptian antiquities and the third to the count's collection of medieval and Renaissance objects.[34]

Two other important collections of medieval and Renaissance works were those of Debruge-Dumenil and Prince Soltykoff. The latter (which will figure later in this story) was only in its infancy in the mid-1840s, and was to leap forward through the acquisition of many items from the former. Debruge-Dumenil began collecting in the 1830s, concentrating at first on Oriental art, but turning to medieval and Renaissance art under the influence of du Sommerard. He collected furiously, with the intention of weeding and purifying his collection later, but died in 1838. His son and daughter then set up the collection in a gallery, 'where, since 1840, many scholars, artists and collectors were received'.[35] His son-in-law, Jules Labarte, prepared a catalogue (published in 1847), with a long historical introduction, which became a standard text. The collection was sold in 1850.

This is the scene that we may be sure Robinson got to know in Paris. There is hardly any documentation of the time that he spent as a student painter in France, but he suddenly comes into focus in a letter, written in September 1846 to his friend and fellow-artist William Maw Egley, in which he describes a trip he has taken to the towns and *châteaux* of the Loire valley. 'I am here completely moyen age,' he says. So evocative are the quietly crumbling old buildings that, forgetting his studies in modern painting, he finds he has 'become over head and ears "gothic" again'. He still looks around with a painter's eye, and he works hard at his sketching, but he reveals that he has

made some capital bargains here, have bought for a trifle a quantity of old figured silks of the 16th & 17th centuries, some fine old pieces of carpet of the time of the renaissance, a magnificent altar cover in guipure [gold or silver lace] infinitely finer & more perfect than those in the Hotel de Cluny at Paris, and amongst other things a coat in crimson satin richly embroidered with coloured silks, of the time of Louis 14th, this will be capital for your Moliere pictures, if I were richer I could collect at a trifling expense a multitude of capital artistic properties, as this country is a perfect mine of antiquities, all the booth stalls in the market places are covered with curious old tapestry, and almost every cottage [has] some relics from the numerous chateaux despoiled at the revolution.[36]

Here is Robinson the connoisseur taking his first tentative steps and, we may note, using his knowledge of what is in the Musée de Cluny to guide his purchasing.

Shortly after this he returned to Nottingham. In another letter to Egley, postmarked 31 December 1846, he describes himself working at his painting in his atelier on cold winter nights. On 1 June 1847 he was appointed Assistant Master at the Nottingham School of Art. He seems to have been something of a protégé of Charles Heath Wilson, Headmaster of the London School, who particularly commended him to the Council at its meeting on 1 June: 'the kind of person to encourage ... I believe that his services might be highly useful'. Only two months later Robinson moved to become Assistant Master at the School in Hanley in the Staffordshire potteries, doubling his salary from £50 to £100.[37] He remained friendly with Wilson, who commissioned him to make a report on design education in France,[38] thus providing him with a further opportunity to consolidate his knowledge of the Parisian antiquarian scene.

Robinson's enthusiasm for France was, however, quite eclipsed by the ecstasy that he felt on his first visit to Italy (via Cologne and Switzerland) in 1851, an ecstasy that leaps off the many scribbled pages of another letter to Egley. 'O for an electrotelegraphic writing apparatus!' he cries, 'O for a gutta percha tube fifteen hundred miles long! anything, anyhow, so I could but tell all my friends, everywhere, everything I have seen ...' He jokes thus in the accents of his age, and writes some exuberant passages of purple tourist prose, especially about Venice. But it is clear that his encounter with the historical and artistic monuments so richly abundant in Italy stirred him to the depths of his being. 'It is curious enough but I seem to have seen all this before; and I can scarcely divest myself of the notion that I once lived here centuries ago. I feel as if I had got *home* at last ...'[39] Indeed, he had found the field in art history that was to be his spiritual home for the rest of his life.

After a year at Hanley, he was ready to seek further scope for his talents. Having met his supreme chief, Henry Cole, Robinson wrote to him, with characteristic eagerness, on 24 September 1852, to 'volunteer ... *suggestions*' and attract Cole's notice (figure 4.5). Cole responded, and on 13 October 1852 Robinson was brought to London 'to instruct teachers how to teach elementary drawing',[40] that is, to head a crash course that would produce the teachers whom Cole needed for his expanding art-education system. Cole, who kept a close eye on his staff, went to Robinson's first lecture, and recorded that it was 'much too advanced' and 'went off flat'.[41] Less than a year later, however, on 12 September 1853, Robinson was transferred on a temporary basis to be Curator of the museum in Marlborough House.[42] He was confirmed in his post on 8 July 1854.[43]

At once he was thrown into rearranging the museum:

On commencing my duties as Curator of the Museum in August last [1853], I found that the suite of apartments previously occupied by the Museum was entirely dismantled, the contents having been ... removed to facilitate the extension of the collection by occupying further available space, and likewise to allow of the unimpeded fixing of many new fittings, principally glazed cases ...[44]

There was to be plenty more work of this kind, as the collection expanded, and Robinson obviously enjoyed it. 'The more we do,' he wrote to Cole, who was away on summer vacation in 1854, 'the more I see may and ought to be done in arranging, illustrating – in short in making every single object we possess tell its own tale and the whole collection a vital, teaching practical utility, brought home to everybody.'[45] Notwithstanding his enthusiasm, he was probably still a beginner at the craft of museum display, as we may judge from what Redgrave wrote to Cole at the same time: 'We shall be glad to have you back. Robinson is arranging the end room – there are many little corners want rounding off everywhere.'[46]

As well as practical display work, Robinson lost no time in embarking on scholarly work, producing in 1853 a brief exhibition catalogue of the Oriental and Sèvres porcelain lent by the Queen; in 1855 his *Catalogue of the Museum of Ornamental Art* (Part I), with 'critical or theoretic illustrations for the information of the student', and his *Catalogue of a collection of works of Decorative Art*, the travelling

Figure 4.5
The letter that Robinson
wrote to Henry Cole on
24 September 1852, to
further his career in the
Department of Practical
Art.

collection; and in 1856 a *Catalogue of the Soulages Collection*, then under consideration for acquisition. It looks as if Cole would have preferred Robinson to keep his official documentation up to date, while Robinson preferred scholarly work, for Cole noted in his diary for 2 April 1856: 'Strongly urged upon Robinson to have a printed Inventory first: but he wished to proceed with Inventory & Catalogue simultaneously & the period for completing was indefinite.'

Robinson must have learned a lot at Cole's side during the acquisition of the Bandinel, Gherardini, Bernal and Soulages Collections.[47] By spring 1857 he was ready to take an initiative on his own account. Cole records in his diary for 1 February that 'Mr Robinson called & proposed Collectors Conversazioni'. This seems to have been the beginning of the Collector's Club, later the Fine Arts Club, which has been described as 'a vehicle for Robinson's ambition both for his own gain (financially and socially) and to further the interest of his area of study'.[48] Cole loyally turned up at the early meetings at Robinson's side,[49] and their relationship warmed as their families became acquainted socially. Cole met Mrs Robinson for the first time on 22 February; the Robinsons took tea with the Coles on 1 March; Cole escorted his daughter 'Tishy' and Mrs Robinson to the Fine Arts Club on 24 March; Cole visited Robinson at home on 21 May; and Robinson 'came home to dinner with me' on 22 July.

This, of course, was the time when the museum moved to South Kensington (figure 4.6). Robinson was undoubtedly put out that the art collections were now mingled with 'outlying and more or less incongruous collections ... assimilated in an illogical and bewildering manner',[50] but it may well be that he now had more freedom of action, since Cole and Redgrave were busy with so many other things. He certainly had the opportunity to do what he most enjoyed: hunting for acquisitions. Although the market in medieval and Renaissance decorative arts was constantly rising, he knew that in Italy 'cartloads of majolica ware, innumerable cassoni, terra-cottas, and bronzes' could still be found 'wholesale at nominal prices',[51] and set out to track them down. He embarked, he recalled in 1897, on:

successive yearly expeditions, of several months' duration, in which innumerable art auctions, dealers' gatherings, old family collections, convent and church treasuries, yielded up an infinity of treasures, usually, as the label prices attached to the specimens at South Kensington attest, at fractional prices as compared with their present values.[52]

Among other expeditions, he went to Lyons in summer 1854, Paris in summer 1856, Dresden and Vienna in summer 1857, Rome and Florence in summer 1859, southern Italy in winter 1860 and Aix-la-Chapelle in 1862. Often he was in pursuit of a particular collection, but in

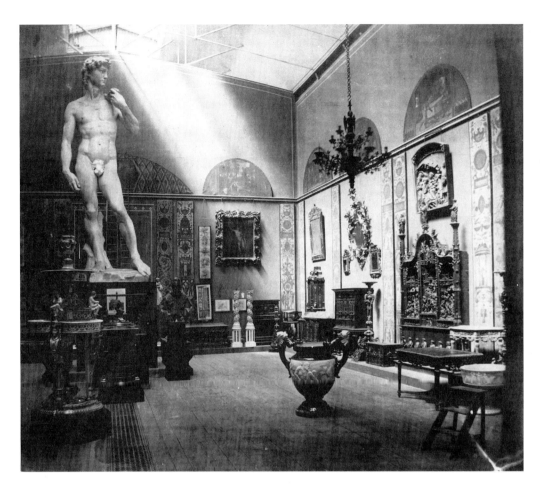

Figure 4.6
The area in the Brompton
Boilers in which the large
objects from the art
collection were arranged
in 1857. On the walls are
the copies of Raphael's
panels of grotesque
ornament and lunettes
in the Vatican Loggia.
These, acquired by the
School of Design when it
occupied Somerset House,
and displayed there, had to
be placed in the stairwell
at Marlborough House
because they were too
large to go anywhere else.
They were restored to a
place of honour at South
Kensington.

whatever town he found himself, he would set out to give it 'a thorough ransacking'.[53]

The hunt for art had both its pleasures and its adversities. In 1860 Robinson and Redgrave were travelling together. As they ransacked the many curiosity shops of Florence, Redgrave found that 'the looking over heaps of dust-covered articles, in the hope of discovery, is unendurably tedious, and wearying, but it is business and must be done.'[54] Robinson, on the other hand, doubtless relished this. But, for his impatient temperament, Italian bargaining was a sore trial. From Naples he wrote:

The loss of time here is something fearful, delays and impediments meet one at every turn, in fact to deal with Neapolitans and Neapolitan institutions one ought to have the temper of an angel and days eight and forty hours long at least.[55]

Museum curators were not immune to the normal hazards of nineteenth-century travel. In Naples, Redgrave complained of a 'continual sirocco', which had caused many to suffer from 'bilious attacks'. 'Robinson has been laid up 3 days here. He is now a little better but is easily knocked up.' Redgrave himself had a severe fall that made him 'very stiff and sore'.[56] The previous year in Rome,

Robinson had been caught in a crowd, and thereafter was 'worried with a legion of fleas ... caught of the frowsy friars and contadini I got jammed up with'.[57] In Naples in 1860 things took a nastier turn:

On Sunday night a French traveller was murdered close to this hotel by two assassins who decoyed him into a carriage & stabbed him with stilettos – the body was exposed in the morning in the public street to be identified.[58]

As Robinson returned from Naples to Rome in 1860, at a time when Italy was in the throes of revolution, he dashed off an especially scribbly letter to Cole. Was he writing in a carriage, even though he headed the letter 'Mr MacBeans' (MacBean being the British consul in Rome)? Or was he writing in the present tense to tease his wife? 'Please tell Mrs Robinson,' he wrote,

that I am all right. We came across the marches last night with an escort of Papal dragoons and with our revolvers ready in our hands, in expectation of an attack from brigands who have just re-appeared now that the road has become so lonely. The carriere, a regular poltroon, kept pulling out his two big horse pistols about a good yard long, at every stoppage or rather jolt of the carriage – luckily however nothing happened.[59]

The pursuit of art, then, could be invigorating or boring, sometimes even frightening. It could also be rather predatory. From Spain in 1866 Robinson wrote home:

I am very anxious to get authority to buy ... now is the time – this country is in semi-revolution, money has disappeared, distress prevails and whatever there is to be sold is in the market [selling for] a fraction of what would have been formerly asked. This morning I bought a *superb* cinquecento chalice for little more than the value of the silver.[60]

Robinson, like Cole, was a mighty hunter,[61] and nothing stood between him and his quarry. But he did not only have a lust to buy: more important, he had developed a discriminating eye for artistic quality.

His finest hours in the service of the museum came in the early 1860s. In 1861 the South Kensington Museum cut a dashing figure in the Paris sale rooms, at the auction of the Soltykoff collection. In the years since Prince Soltykoff had bought heavily from the Debruge-Dumenil collection, his own collection had become celebrated. 'It has,' said Clément de Ris, 'since the successive dispersals of the collections belonging to Monville, Préaux, Dusommerard, Debruge-Dumenil, Sauvageot, Rattier and Fould, become unique in importance and richness.'[62] It had been housed at first in the Hôtel Bretonvilliers on the Ile St Louis (then 'an unknown neighbourhood, a city forgotten within the city'),[63] open only on Thursdays. Then the Prince had a new mansion built, 'disliked it and sold it', built another and installed the collection. 'Then, when all was in place, he sold the mansion and the collection, ready, perhaps, to build a third mansion, and to restart a second collection.'[64] Clément de Ris recalled that 'every true Parisian, I mean anyone who really savoured the *vie parisienne*, every man of taste who did not merely vegetate in his town like a snail in his shell, had visited' Soltykoff's collection 'at least once'.

It was a favour to gain access, it was a pleasure to return, it was almost an accolade to be able to obtain access for others. The benevolence of the owner was inexhaustible, and his collection belonged more to other art-lovers than to himself. They were at home there, so much at home that they were near to denying Prince Soltykoff the right to sell his property without their agreement.[65]

Some hoped that the French Government would buy the collection *en bloc*,[66] but they were disappointed, and almost all of it went on sale in April 1861.

In South Kensington, the Board of the Department of Science and Art met on 7 March, and after approving a new official form and accepting some tenders for asphalting and bricklaying, gave permission to Robinson to go to Paris to report on the Soltykoff collection.[67] On Sunday evening, 24 March, he was back and called round to report straight to Cole.[68] Easter intervened, and on 5 April Cole went 'to see Mr Gladstone about Soltykoff. He regretted such things

must be starved, whilst the nation was "mad" with its expenditure. He directed that a letter be written asking for a special Grant'.[69] The Government made money available, and both South Kensington and the British Museum attended the sale.

The huge auction took a month, with viewing on Saturdays and Sundays, and three selling days each week.[70] It was a 'source of excitement and great competition among all the collectors and dealers of Europe'.[71] Prices were said to be 'unprecedented',[72] even 'preposterous'.[73] The French hoped that the Musée de Cluny would be able to rescue some of the collection for France. Alfred Darcel lamented:

M. Edmond du Sommerard, its curator, has been present at all the sessions of the sale, with a courage that I admire, ready to profit from any slack moment; but the struggle is fierce, and the bids fly over his head without his being able to match them. The authorities of the English museums (the South Kensington and the British Museum), armed with funds worthy of a great nation, carry off the prime pickings, while the curator of our museum of industrial arts stands disarmed beside a battle in which he cannot fight.[74]

From this sale the South Kensington Museum acquired some minor objects, but of these, said the *Art-Journal*, 'the museum has enough, and now wants but a few of the larger and more elaborate works'. So the museum was to be congratulated on getting some of the 'finest things' from the Soltykoff collection.[75] Pre-eminent among these were the Gloucester Candlestick, a column of gilt metal worked into a tangle of writhing energy, and the Eltenberg Reliquary, a toy church enamelled with vivid, jagged patterns and sheltering a congregation of pearly ivory figurines. The dealer John Webb bought a number of ivories at the sale, which he then offered to the museum, and by this route it acquired the Adoration of the Magi in whalebone, a carved tablet that compressed an earnest poignancy into its skewed, stilted forms. With exhibits like these, the South Kensington Museum, said Darcel, would soon, 'in its speciality, be the foremost museum in Europe'.[76]

If Robinson's role, in the Soltykoff sale, was to be a member of a British cultural raiding-party, he was eligible for this role because of his personal achievements at South Kensington. These were brilliantly displayed in the catalogue of *Italian Sculpture of the Middle Ages and the Period of the Revival of Art*, which he published in 1862. The Italian sculpture collection at South Kensington was founded on the Gherardini collection, enlarged by occasional acquisitions made by Robinson, and raised to unrivalled heights by the purchase of the collections of the Marchese Campana and his agent Octavio Gigli. Robinson had pursued these in Italy in 1859 and secured them in 1860. His catalogue now proclaimed, in the words of one review, 'a collection that has sprung into existence as if by enchantment under our

very eyes'.[77] The reviewer, Baron de Triqueti, acknowledged that:

the wonderful instinct which has led Mr Robinson on the track of every work of interest accessible to purchase, has accumulated at South Kensington the materials of a complete history of modern sculpture, from its revival under the original and powerful influence of Nicolo Pisano in the 13th century, until its decline in the hands of the feeble imitators of Michael Angelo, the immortal genius of the 16th century.

This collection was hailed in 1862 as 'unequalled in the world ... none of the great Continental museums have any systematic collections of Renaissance sculpture'.[78]

Not only was the collection prodigious, but the catalogue too was 'a remarkable achievement'. This was the opinion not only of contemporaries, but also of Robinson's twentieth-century successor as cataloguer of the South Kensington collection, John Pope-Hennessy. In his own catalogue, Pope-Hennessy pointed out that Robinson had hardly any earlier scholarly literature to work from, so he depended essentially on his 'powers of observation and his innate sense of quality'. Pope-Hennessy praised Robinson's catalogue as 'detached, admirably formulated, and filled with qualitative judgments which are no less valid now than at the time when they were made'.[79]

Baron de Triqueti's review, quoted above, was printed in the foremost (and, indeed, the first) academic art-history journal in Britain. Triqueti also reviewed Robinson's catalogue in the *Gazette des Beaux-Arts*, in 1863, where he delivered a still more elevated eulogy of Robinson's work at the South Kensington Museum:

It is to him, to his incessant activity, that is due the greatest part in the formation of these collections of art. It is he who has assembled this museum of Italian sculpture, it is to him that we owe the excellent catalogue published last year, which has not prevented him from giving us in the same year the catalogue of the *Loan Exhibition*, nor from publishing, at the beginning of this year, a new, revised edition of it, a work of the highest importance, containing in seven hundred and sixty pages descriptions of more than eight thousand objects. *Et nunc intelligite, gentes!* [And now recognize this, o ye nations!][80]

Triqueti alludes here to what was known in short as the 'Loan Exhibition' or 'Loan Collection', and more properly as the 'Special Exhibition of Works of Art of the Medieval, Renaissance, and More Recent Periods, on loan at the South Kensington Museum'. A set of 50 photographs of exhibits in the exhibition was published by Colnaghi, and this had the more reverberant title, *The Art Wealth of England*.

This project was first broached by Robinson in a letter to Cole in December 1858.[81] At that time, Prince Albert and his allies from the Great Exhibition of 1851 were contemplating another International Exhibition, ten years on.

Robinson suggested that it should include a display of historical art. The 1851 Exhibition had been devoted entirely to contemporary products, but since then the public's interest in historical art had been evidenced in the success of the Manchester Art Treasures Exhibition in 1857 (where the Soulages collection was displayed). Robinson proposed that, if the Exhibition Commissioners would grant them the space, his Fine Arts Club could organize a small and select exhibition for 1861.

In the event, the International Exhibition was postponed until 1862, partly on account of Prince Albert's death and Robinson's exhibition assumed immense proportions. It took place in the new South Court of the museum, rather than in the premises of the Exhibition, which was housed in a colossal temporary palace (more brick than crystal this time), further down Cromwell Road, on the site of the present Natural History Museum. Some expected that Robinson's exhibition would be at a disadvantage: 'Its unobtrusive worth is ... likely to be overshadowed by its imposing and all-absorbing neighbour, and to be recognized only by the connoisseur.'[82] But this was far from the case. 'It was said that the merits of this Loan Collection were so great as to cause it to run the International Exhibition hard in attracting visitors.'[83] The French critic, Clément de Ris, thought that Robinson's exhibition gave 'a higher idea of the wealth of the English people than the Universal Exhibition', and noticed that many visitors 'come to take a rest in the Kensington museum from what they have seen in the palace on Cromwell Road'.[84] Cole, seconded from duty at the museum, was in charge of the International Exhibition, while Robinson was in charge of what many might have regarded as a rival attraction (figure 4.7).

Planning a major exhibition for a gallery not yet completely constructed was bound to be risky; it was a race against time to finish the South Court. By 1861 the buildings that Cole had put up behind the 'Brompton Boilers' extended in the shape of an open rectangle. The galleries for the Sheepshanks, Turner and Vernon pictures formed the west side; new galleries for pictures from the National Gallery were erected in 1859 along the north side; and an eastern range came in 1860. Cole's designer, Captain Fowke, then suggested that the museum could gain much extra space by putting a glass roof over the open rectangle. The northern part, the North Court, was completed by April 1862. (Its decoration was variously described: walls of 'deep blood red' with 'cold purple grey' above,[85] or 'coloured sage green, with a frieze of lilac under the roof'.)[86] The southern part, the South Court, was intended to be much more elaborate, with ornamental wrought- and cast-iron work, arcades all round and a central balcony over an open arcade.[87] For conservation reasons, both courts needed blinds below their glass roofs. Robinson was very anxious

Figure 4.7
A view of the Loan
Collection in the
South Court,
wood-engraving
from the *Illustrated
London News*,
6 December 1862.
This shows one half
of the South Court;
on the left is the
balcony supported
on arcades, dividing
it from the other part
of the South Court,
which can be
glimpsed beyond.

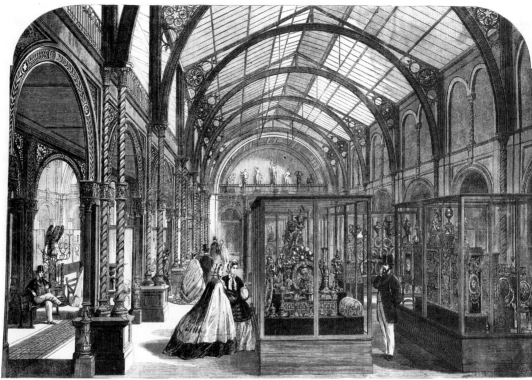

THE LOAN COLLECTION OF WORKS OF ART AT SOUTH KENSINGTON MUSEUM.

about these in May 1862: they were being fitted in the North Court, but 'the slightest inadvertence or carelessness in the workmen employed on the hanging scaffold in the centre, might not only cause the destruction of irreplaceable objects beneath but endanger the lives of the public'.[88] There had been trouble over the glass cases for the North Court in February 1862, and it looks as if those for the South Court were faulty too, for in July the Board of the Department of Science and Art minuted: 'Office of Works to be informed that glass cases not made to drawings, nor so good as ordered'.[89] The Loan Exhibition opened in early June, but a month later workmen were still painting details in the decoration of the South Court arcades.[90]

If the setting of the exhibition presented problems, there was no difficulty in assembling its contents. The policy in those days was not to pursue carefully selected individual objects for exhibition, but to write round to potential lenders inviting them to submit whatever they liked. The Crown, the colleges of Oxford and Cambridge universities, the Livery Companies of the City of London, municipal corporations throughout the country and hundreds of private collections (many of them aristocratic) were so generous with their possessions that 'from the very first, the difficulty with which the managers [of the exhibition] had to contend was how to refuse'.[91] Indeed, they could hardly keep up with the tide of exhibits that flowed in. A month after the opening, packing cases were still being unloaded

and showcases contained labels announcing '*Arrangement in progress*'.[92]

The full range of medieval, Renaissance and later decorative art was shown. Sculpture was represented in the Exhibition principally by ivory carvings, notably the collection of John Webb, comprising 132 pieces from the fourth century to the close of the Middle Ages. 'The most extraordinary feature of the exhibition,' it was said, was 'the splendid collection of ceramic art',[93] and the part of this that everybody especially noticed (it was 'at the centre of the exhibition, as if in the place of honour')[94] was the display of Henri Deux ware. These French pieces were exceedingly rare. 'Out of a total of fifty-four specimens known to exist, the Loan Collection contained no less than five-and-twenty, – that is to say, every specimen believed to be preserved in this country.'[95] In metalwork, the exhibition was 'rich beyond all compute or precedent'.[96] The eye-catcher in this category was a steel chair made in Augsburg for Rudolph II, lent by Lord Folkestone. There was much French eighteenth-century furniture, although 'medieval wood-work, with a few choice exceptions, is a complete blank in the Loan Exhibition'.[97] 'Two of the most generally popular sights were the jewels and the miniatures.'[98] Jewels, cameos and medals were displayed in profusion: one of the large showcases was estimated to contain as many as 600 items from these categories.[99] The inclusion of portrait miniatures was an unusual feature of the exhibition, and

there were many: 'The great floodgate was opened when the word had been passed to the million possessors of family miniatures to throw open their cases and unhook their lockets.'[100] There was a rich assemblage of illuminated manuscripts too. Foreigners were particularly intrigued by a display of Anglo-Saxon and Irish artefacts, a category of art little known outside Britain.

This spectacle inspired most critics (as Robinson doubtless wished) to try to come to grips with the new taste for collecting medieval and Renaissance objects, on which little had been written in Britain. Matthew Digby Wyatt's potted history of this collecting movement in the *Fine Arts Quarterly Review* was the most thorough of several similar essays. Various critical angles were explored. As we have already seen, for artistic people the Loan Collection came as a relief after the International Exhibition:

How striking is the contrast, when we pass from the whirl of revolving wheels, the ponderous masses of metal set in motion by steam, and all the marvellous automata of engineering skill that are displayed in the machinery pandemonium of the adjacent exhibition, to see in this more tranquil atmosphere how the artist's mind and the labour of a life can spiritualize material, can transform iron into delicate filigree more precious than gold, give priceless value to fragile pottery, and make a little slab of carved ivory more valuable than many tons of metal.[101]

Representing a scholarly, antiquarian viewpoint, Thomas Wright, Fellow of the Society of Antiquaries, explained that exhibitions were now recognized to be valuable because they allowed works of art to be brought together for comparison:

It was only slowly that people began to understand that one object is of small value unless you have others to compare it with, and even now the notion is not quite obsolete that every man who becomes possessed of an object of antiquity is thereby qualified to write a dissertation upon it. But, the necessity of extensive comparison once understood, it became every day better and more largely appreciated, and, of course, knowledge increased in proportion.[102]

Wright's desire to be able carefully to study the exhibits was, however, frustrated by the haphazard arrangement of the exhibition:

Every one must have felt that its utility would have been greatly increased by a little more historical arrangement, and if the visitor, in passing from one table or case to another, had been allowed to take the different classes of objects in something like their historical order, instead of jumping from new to old, and from old to new, until he lost all perception of the relations of the different classes to each other, he would, no doubt, have been benefited by it.[103]

Another critic, deploring the 'utter absence of anything like chronological order in the arrangement', lamented that the exhibition 'merely impresses the general visitor as a collection of pretty things, which leaves behind no distinct idea, or series of ideas, from which any kind of art-instruction of a useful kind can be derived'.[104]

Several critics were concerned not with antiquarian scholarship, but with how the exhibits might relate to contemporary taste. The *Quarterly Review* urged that 'the spirit which they reveal of patient conscientious work, coupled with a noble contempt for that artificial polish which is too often the modern artificer's highest aim, affords a wholesome corrective to the evils of this age of wholesale reproduction of second-rate art'.[105] Matthew Digby Wyatt grappled with the problem of whether the exhibits were to be valued for their beauty or for their rarity. 'It may seem paradoxical to say that beauty is rarer than rarity,' he remarked, indicating that he found more in the exhibition that was of antiquarian than of aesthetic interest. Of the 'rarities' he said:

We cannot but recognize how large a share personal gratification, or call it, if you will, personal vanity, has had in occasioning their existence and preservation. With few exceptions these leading rarities have been the productions of states of social existence in which capital has accumulated through the ministrations of labour to an extent far beyond the supply of material or even fantastic wants; and at such a stage the cream of labour has been, as it were, skimmed to feed the fancies, not the necessities, of the rich and noble.[106]

The title *The Art Wealth of England* encapsulates some of the ambiguities involved in the exhibition. Although the museum had been founded to raise contemporary taste and serve artisans and manufacturers, this exhibition could be taken as homage to rich collectors, as the affirmation of a change in the museum's stance.[107]

The exhibition was acknowledged by the Department's Board to be a success, and Robinson and his colleagues were awarded gratuities.[108] It should have been his finest hour. But it led to a bitter dispute with Henry Cole. There is no doubt that Robinson did tend to attract trouble, and to understand the reverse that his career now suffered, it is necessary to look back. Hardly had he taken up his post as Curator, in autumn 1853, when he was complaining to Cole about a 'rebellion' on the part of his assistant, C.B. Worsnop, who had been appointed a few months before him.[109] Cole backed Robinson, and Worsnop apologized.[110] Robinson had earned £300 per annum as Teachers' Training Master, and transferred to the museum at the same salary.[111] On 3 March 1855 he wrote to Cole asking for a rise and, having got it, asked for another one.[112]

In December 1855 Cole thought of combining the Curator's post with the Librarian's post and giving both to Robinson. Robinson disclosed this proposal to his colleagues, allegedly with 'such an offensive tone' and 'such

overbearing pretensions' that they refused to work with him, and Cole had to withdraw the plan. Robinson wrote ('with the feeling still fresh it might seem more prudent to wait [but] I think it is better I should write to you at once') to Cole in fury and mortification, insisting that, since he had been loyal to Cole and had worked hard, 'I have a right to expect a similar loyalty from those above me, and equal zeal from those beneath'.[113] This was rather an exigent tone for an employee to take with his employer. Redgrave tried to smooth matters over, telling Cole that Robinson 'is hurt beyond measure – I think his sayings & doings have been so far exaggerated that they are much explained away when matters come to be looked into'.[114] Robinson was paid a gratuity for library work that he had done, and he took up the joint post of Curator/Librarian in May 1857 at an improved salary of £450, and shortly afterwards got an assistant, Robert Soden Smith, with whom he could work amicably.[115] But he had shown himself to be a prickly colleague.

Robinson was undoubtedly highly strung. As we have seen, he and Cole grew closer around the time the museum moved to South Kensington. Cole himself had to take extended leave to recover from exhaustion in autumn 1858, and perhaps this is why Robinson felt able to confide to him his own depression:

Weak digestion & nervousness, now become habitual, are telling on my constitution – with an undiminished desire to work I find myself often physically unable, my head pains me and gets confused, and there is a constant sense of care, and as it were impending calamity hanging over me, which I cannot shake off.[116]

His intensity was, of course, a strength as well as a weakness, and his wife wrote charmingly to Cole, 'I wish he would learn to take things a little more quietly, though I suppose if one could knock his extreme enthusiasm out of him, it would be a case of Samson with shorn locks.'[117]

Ambition chafed Robinson. In May 1859 he wrote, 'I am particularly desirous to get my title changed from *Curator* to *Director*', and although he assured Cole that '*I do not wish our relative positions to be changed in the slightest degree*', the request must have irked Cole, since Robinson had already put the idea to him on 18 March 1859. And Robinson brought it up again the following year.[118] Cole was, in fact, happy to sing his colleague's praises. Before a Select Committee that investigated the South Kensington Museum in 1860, he pointed out that Robinson, 'who is now called the Superintendent of Art Collections at the South Kensington Museum, performs ... duties equivalent to those of three officers at the British Museum' for only £450 a year, 'and he has no residence, whilst two of the corresponding officers at the British Museum have 600*l.* a year and a residence each'. The Keeper of the National

Gallery got £750 a year, together with a residence. Cole was rather gratified to be able to show that he was running a highly economical operation; we cannot imagine, however, that Robinson was happy to hear that he was giving his services cheap. But Cole praised his abilities, and told the Committee that 'I think he is most unjustly treated'. He commended Robinson's devotion to South Kensington:

He has grown up from a student in the atmosphere of the South Kensington Museum; it gives him a certain social status ... and ... one can understand how a man does not like to break up his connexion; but if he took a mercenary view of the subject, he would better himself by leaving the Museum.[119]

Difficult moments continued. Robinson refused to fill in a diary form that officers of the Department were required to complete, and continued to nag for an official residence.[120] Things started to go seriously wrong in the fraught atmosphere of 1862. Cole was now 54, burly, bustling, dishevelled, overbearing, with the light of command in his eye (figure 4.8). Robinson was 38, slender, well-groomed, sardonic; and, in his eye, the light of defiance (figure 4.9). Both were hectically busy with their grand projects, the International Exhibition and the Loan Collection. Cole's father was dying, and his patron, Prince Albert, had died

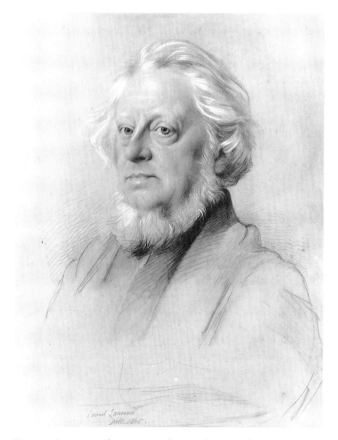

Figure 4.8 Henry Cole in 1865, a drawing by Samuel Laurence. In the National Portrait Gallery.

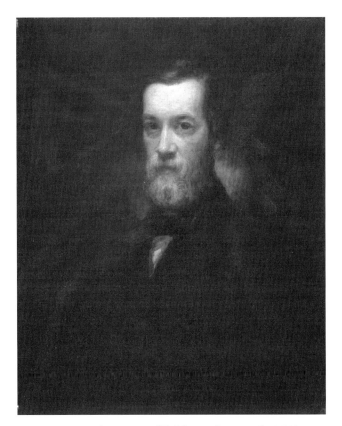

Figure 4.9 J. C. Robinson in middle life, an oil painting by J. J. Napier. In the National Portrait Gallery.

the previous year. It was not a good moment for a younger colleague to challenge him.

A danger signal comes in Cole's diary entry for 17 January 1862: 'Robinson actually renewed discussion about the Glass Cases in Cloisters' (in the North Court). As we have seen, the glass cases were a problem that did not go away, and in June 1862 Robinson and Cole were again at odds over them, causing Robinson to send a carefully phrased note of apology for sticking to his guns.[121] It was after the opening of the Loan Exhibition that the chickens came home to roost. The assembling of the exhibits had been a muddle, and many arrived late. By August, two months after the opening, only seven out of 31 sections of the catalogue had been published. This was brought to the attention of the Board, which 'urged on' the cataloguing, and insisted that the departmental rules for listing objects entering the museum should be correctly observed: evidently Robinson had been slack with his paper-work.[122] This may have been the matter at issue on 6 January 1863, when Cole's diary records a 'controversy with Robinson about titles and inventories'. Later in the day they met in Onslow Square and the persistent Robinson 'renewed his controversy'. Robinson and his staff were awarded their gratuities on 29 January, but the very next day Cole

recorded a 'scene with Robinson ... Very insolent, and I told him to leave the room'. At the next Board meeting on 4 February, it turned out that Robinson's statement of cash received from the Loan Exhibition was 'loose and unsatisfactory, and likely to mislead Board'. Furthermore, two colleagues who had witnessed the scene with Cole described it to the Board. Robinson's gratuity was withheld.[123]

The row worsened, as Robinson started writing letters of complaint to the Board and Cole had to prepare rebuttals. Robinson's temper was not improved when he was not allotted one of the four new official residences at the museum, three of which were allotted to Cole, the Deputy Superintendent Owen and the resident engineer, while the fourth was 'fitted up' for various minor functionaries, with only 'four rooms ... for art keeper ... if required'.[124] On 5 March Robinson brought up his old quarrel with Cole over exhibition arrangements in the North Court, and insisted on writing about it directly to Lord Granville, the Minister who chaired the Board.[125] By now, Cole, brooding over the management of his staff, had confided to his diary (3 February): 'Never keep a man who is dissatisfied, he is mischievous ... this would apply perhaps to J.C.R.'

The following week was completely taken up with the row. Cole spent all Tuesday in his office preparing a reply to Robinson's criticisms. Lord Granville 'thought it would be a great pity if Robinson resigned now',[126] and when the Board met on Wednesday hoped that a severe reply would be sufficient to subdue him. Robert Lowe, the junior Minister on the Board, wanted Robinson sacked. The following day the deputy head of the Department (the Assistant Secretary, Norman MacLeod of MacLeod) reported to Cole that Robinson had said the quarrel could end only with 'his or my retirement'. One cannot imagine that Cole felt any tremors at this. The Friday Board dismissed Robinson's complaints, and directed upon him a severe reproof: 'not insensible of his services, but these cannot interfere with official subordination'.[127] This should have confounded Robinson, but it did not. He was in Cole's office on Saturday morning, asking for copies of the replies to his letters so that he could continue the controversy. The following Friday he wrote direct to Lord Granville to complain about Cole's purchasing policy, and to request a seat on the Board for himself.[128] This was a truly reckless assault.

Cole now had counter-measures under way. At the Board meeting on 17 March he unveiled wide-ranging proposals for the reorganization of his staff. The time had come when 'each collection should have its Referee (one or more) ... to be distinguished for scientific or artistic knowledge'. Referees should not 'give routine attendance', but should come to the museum only when required, and it would be 'economical to combine other offices with that of Referee'. The collections would be in the day-to-day charge of

'Keepers, selected for administrative ability'. This would be applied to all the collections – Food, Animal Products, Education, and so on. As to its effect on the Art collection: '*Mr Robinson* to cease to be keeper, and be the second artistic referee'[129] (the first already existing, in the shape of Richard Redgrave). By this arrangement Robinson was deprived of all control over the collections, but he was paid a retainer to put his scholarly expertise at the service of the museum.

Robinson, still tireless in controversy ('His letters must be stopped,' Robert Lowe told Cole on Monday 23 March) was called before Granville and Lowe on 24 March, informed of the new deal and told that 'he must submit or go'. Robinson tried to fight on, resolving – Cole discovered from MacLeod – 'that he would convert Lord G. And Mr L.: or turn me out: that as for gratitude whatever I had done for him was done for my own purpose'.[130] But the crisis was past, and after a couple of weeks Robinson had to accept that he had been, to all intents and purposes, sacked. He continued to advise the museum on purchases, but was no longer Curator of the museum.

Relations between Robinson and the museum henceforth were strained. The Précis of Board Minutes tells the tale: '14 Nov. 1863 ... To be informed that it is not his duty to submit works a second time'; '12 Jan. 1864 ... No intention of varying appellation of an Art Referee'; '21 April 1864 ... To confine his purchases at Mr Piot's sale within scope of minute of 13 June 1863'; '18 June 1864 ... To be informed that it is considered inexpedient to continue discussion on subject of purchase of Playing cards'; '23 Mar. 1865 ... My Lords suggest to Mr Robinson that insinuations of unfair dealing with his correspondence should be avoided, as tending to disturb harmonious working of Department'; '20 May 1865 ... Undesirable to accept his proposal to "weed Art collections"'; '1 June 1865 ... To be desired to withdraw his comment on Turner drawings'; '22 June 1865 ... Relations of, with general Superintendent of Museum, considered ... Mr Robinson is to submit his reports to Board through the General Superintendent ... Questions put to Mr Robinson, to which he objects, are very proper ones'; '20 Sept. 1865 ... Reminded that he is not allowed to purchase objects for the South Kensington Museum on his own responsibility'; '5 June 1867 ... Generally, he need only report on character, authenticity, and value of objects. Board decides terms and conditions of purchase'; '5 Dec. 1867 ... Not invariable practice to consult Art Referee before making purchases ... It is discretionary with their Lordships to consult whom they please.'[131]

By mid-1867 the skids were under Robinson. A committee was reconsidering the office of Art Referee. Even the ever-diplomatic Redgrave was tired of Robinson: 'his quips and cranks – his one sided view of ... what a museum should be – his antiquarianism and want of catholicity as to modern as well as ancient manufactures – and his determination *not* to think any thing good which comes under the view of the Board in the first instance – not through him ... Matters cannot long go on thus ...'[132] On 23 December 1867 the office of permanent Art Referee was abolished (thus disadvantaging Redgrave, who was also an Art Referee and whose job had to be restructured). 'Competent persons (including Mr Robinson) will be asked to act as Science and Art referees, as occasion may require. They will be paid consulting fees ... Send copy of minute to Treasury, and request that Mr Robinson's superannuation may date from 1 April 1868. He is to have notice from 1 January.'

Robinson obviously protested, so on 10 January the Board wrote to him again. They carefully stated that 'no personal imputation was intended in Department's letter of 30 December, beyond statement that whilst travelling at the public expense he had sometimes purchased works of art for himself and for friends'. The denial makes clear that they did in fact think that he had been dealing on the side for his own benefit whilst working for the museum. On 18 January, in the face of further representations from him, they backed down: 'Repeat there is no intention to cast any imputation upon his honour and fidelity as a public servant ... He is considered to have acted with uniform honour.'[133]

This was a sad end to Robinson's work for the museum. His contribution to building up the collections had been inimitable. He had been the right man in the right place at the right time. When he began working for the museum, there was no public collection of medieval and Renaissance decorative art in Britain. Later, he could look back and say, 'The vacant ground has been occupied, and a National Museum of Mediaeval and Modern Art has been created at South Kensington, which has now no rival in Europe.'[134]

NOTES

1 Typescript copy of a letter to 'My dear nephews & nieces' from Robinson's daughter, Marian (Hockliffe), 1 November 1942. In a collection of copies of Robinson family memoranda in the NAL.

2 'Celebrities at home. No. DCCCX. Sir John Charles Robinson', *The World*, 20 December 1893, typescript transcription in the collection mentioned in note 1.

3 J.C. Robinson, 'Our Public Art Museums', *Nineteenth Century*, December 1897, p. 949.

4 Ibid.

5 Ibid., p. 950.

6 See note 1.

7 Ibid.

8 See note 3.

9 'L'Ecole Anglaise en 1882', *L'Art*, vol. 32, 1883, pp. 71–5.

10 Jules Janin, 'A Summer and Winter in Paris', in George Newenham Wright, *France Illustrated*, 4 vols, London: Peter Jackson [1845–7], vol. 4, p. 71. Janin's work appeared first as

L'Eté à Paris and *Un Hiver à Paris*, both published in Paris in 1843. These were reprinted in English translation as 'The American in Paris' and 'The American in Paris during the Summer' in *Heath's Picturesque Annual*, London: Longman, 1843 and 1844.

11 Ibid., p. 112.

12 Ibid., p. 167.

13 See Alexandre Lenoir, *Musée des Monumens Français*, 8 vols, Paris: Guilleminet [and other publishers for later vols], 1800–21; J.B.B. De Roquefort, *Vues Pittoresques et Perspectives des Salles du Musée des Monuments François … gravées au burin … par [J.B.] Réville et [J.] Lavallée, d'après les dessins de [J.L.] Vauzelle*, Paris, 1816; J.-P. Bres, *Souvenirs du Musée des Monumens Français … dessinés par J.-E. Biot et gravés par MM. Normand père et fils*, Paris: Didot, 1821.

14 See Francis Haskell, *History and its Images. Art and the Interpretation of the Past*, New Haven and London: Yale University Press, 1993, chapter 9; Stephen Bann, *The Clothing of Clio. A study of the representation of history in nineteenth-century Britain and France*, Cambridge: University Press, 1984, chapter 4.

15 Jules Labarte, *Description des Objets d'Art qui composent la Collection Debruge-Dumenil précédée d'une Introduction Historique*, Paris: Didron, 1847, p. 5.

16 Louis Courajod, 'La collection Révoil du Musée du Louvre', *Bulletin Monumental*, vol. 52, 1886, pp. 143–74.

17 Ibid., p. 152.

18 Labarte, op. cit., p. 10.

19 Ibid., p. 7.

20 Janin, op. cit., p. 171.

21 'Le Palais des Thermes, l'Hôtel de Cluny, la Collection Dusommerard', *L'Illustration*, vol. 1, 1843, pp. 215–17; 'Ouverture du Musée de l'Hôtel de Cluny et du Palais des Thermes', ibid., vol. 3, 1844, pp. 56–8.

22 Ibid., p. 216.

23 Janin, op. cit., pp. 169–70.

24 Alexandre du Sommerard, *Les Arts au Moyen-Age et du Renaissance*, Paris: Hôtel de Cluny, 11 vols, 1838–46. A reference to 'Dusommerard's great work' is made in MS letter, Robinson to Henry Cole, 23 October 1855, in the Cole Correspondence (NAL).

25 'Mouvement des arts et de la curiosité: Vente de la bibliothèque Sauvageot', *Gazette des Beaux-Arts*, vol. 8, 1860, p. 363.

26 Alfred Darcel, 'La collection de M. Charles Sauvageot', *L'Illustration*, vol. 31, 1858, p. 142.

27 L. Clément de Ris, *La Curiosité: Collections Françaises et Étrangères, Cabinets d'Amateurs, Biographies*, Paris: Jules Renouard, 1864, p. 283.

28 F.M. Redgrave, *Richard Redgrave, C.B., R.A.: A Memoir compiled from his Diary*, London: Cassell, 1891, pp. 147–8.

29 See Albert Jacquemart, 'Les Cabinets d'Amateurs à Paris: Collection Sauvageot', *Gazette des Beaux-Arts*, vol. 13, 1862, pp. 43–54, 228–40.

30 'Le Palais des Thermes, l'Hôtel de Cluny, la Collection Dusommerard', *L'Illustration*, vol. 1, 1843, p. 215.

31 See Judith Wechsler, *A Human Comedy: Physiognomy and Caricature in 19th century Paris*, London: Thames and Hudson, 1982.

32 *Les Français Peints par Eux-mêmes, Encyclopédie Morale du Dix-neuvième Siècle*, 5 vols, Paris: Curmer, 1841–2, vol. 1, pp. 122, 123, 125.

33 Clément de Ris, op. cit., pp. 277–8.

34 'Hôtels et Musées particuliers. Collections de M. Le Comte de Pourtalès-Gorgier', *L'Illustration*, vol. 8, 1847, pp. 376–9. Albert Jacquemart, 'Les Cabinets d'Amateurs. La Galerie Pourtalès', *Gazette des Beaux-Arts*, vol. 17, 1864, pp. 377–97.

35 Labarte, op. cit., p. 12.

36 MS letter, Robinson to W. Maw Egley, 10 September 1846, in Egley correspondence, NAL press mark 86. FF. 14.

37 *Minutes of the Council of the Government School of Design*, vol. 3, London: W. Clowes, 1849, pp. 206, 211, 250.

38 Drafts are in File 1 (items 1–14) of the Robinson Papers, Ashmolean Museum, Oxford. See also Helen E. Davies, *Sir John Charles Robinson (1824–1913): His work as a connoisseur and creator of public and private collections*, unpublished Oxford D.Phil. thesis, 1992, pp. 43–55.

39 MS letter, from Robinson to Egley, dated 'Rome 6th Aug', post-marked 1851, in the collection cited in note 36.

40 *Précis*, 1852–63, p. 10.

41 Cole diary, 2 November 1852.

42 *Précis*, 1852–63, p. 27.

43 Ibid., p. 54.

44 *First Report* [for 1853], p. 225.

45 MS letter, Robinson to Cole, 18 September 1854, Cole Correspondence (NAL).

46 MS letter, Redgrave to Cole, 17 October 1854, Cole Correspondence (NAL).

47 He may have learned from Gottfried Semper also. Semper compiled a treatise on 'Practical Art in Metal and hard materials, its Technology, History and Styles. On Collections, their History and Estates. 1854', which remains in MS in the NAL. This was apparently intended as a textbook for Semper's students (he was Professor of Metalwork at the School of Design), but it includes his theories about the classification and display of decorative arts, and, as the title implies, much erudite material about collections, both historical and contemporary. Robinson read the treatise, noting (p. 58v) that it was 'far too diffuse' for its original purpose, but it would have been useful to him as a summary of the literature on collecting. Semper's son was employed for a time in 'clerically assisting' Robinson with the catalogues of the museum and the travelling collection (*Précis*, 1852–63, p. 113).

48 Ann Eatwell, 'The Collector's or Fine Arts Club 1857–1874. The First Society for Collectors of the Decorative Arts', *Decorative Arts Society Journal*, no. 18, 1994, pp. 25–30.

49 Cole diary, 24 February, 2 and 24 March, 22 May, 3 July 1857.

50 J.C. Robinson, 'Our Public Art Museums: A Retrospect', *Nineteenth Century*, December 1897, p. 955.

51 J.C. Robinson, 'On our National Art Museums and Galleries', *Nineteenth Century*, December 1892, p. 1022.

52 J.C. Robinson, 'Our Public Art Museums', *Nineteenth Century*, December 1897, pp. 962–3.

53 MS letter, Robinson to Cole, 27 May 1858, Cole Correspondence (NAL).

54 Redgrave, *Memoir*, p. 239.

55 MS letter, Robinson to Cole, 2 December 1860, Cole Correspondence (NAL).

56 MS letter, Redgrave to Cole, 29 November [1860], Cole Correspondence (NAL).

57 MS letter, Robinson to Cole, 25 April 1859, Cole Correspondence (NAL).

58 MS letter, Robinson to Cole, 2 December 1860, Cole Correspondence (NAL).

59 MS letter, Robinson to Cole, 8 December [1860], Cole Correspondence (NAL).

60 MS letter, Robinson to Cole, 6 September 1866, Cole Correspondence (NAL).

61 He was sensitive to the fact that British museums could be accused of appropriating other nations' cultural property: see the Preface to his *Notice of Works of Medieval and Renaissance Sculpture, Decorative Furniture, &c.: acquired in Italy, in the Early Part of the Year 1859*, London: HMSO, 1860.

62 Clément de Ris, op. cit., p. 239.

63 Janin, op. cit., p. 166.

64 Alfred Darcel, 'La Collection Soltykoff', *Gazette des Beaux-Arts*, vol. 9, 1861, p. 172.

65 Clément de Ris, op. cit., pp. 39–40.

66 Alfred Darcel, 'Courrier de la Curiosité', *L'Illustration*, vol. 37, 1861, p. 254.

67 *Précis*, 1852–63, p. 330.

68 Cole diary, 24 March 1861.

69 Ibid., 5 April 1861.

70 *The Times*, 12 April 1861.

71 *Literary Gazette*, 1861, p. 423.

72 Ibid.

73 *Globe*, 15 April 1861.

74 Alfred Darcel, 'La Collection Soltykoff', p. 170.

75 *Art-Journal*, 1861, p. 239.

76 Darcel, op. cit., p. 170.

77 Baron H. de Triqueti, 'The Italian Sculpture at the South Kensington Museum', *Fine Arts Quarterly Review*, vol. 1, 1863, p. 100.

78 'The New Court, South Kensington Museum', *Builder*, 3 May 1862, p. 305.

79 John Pope-Hennessy with Ronald Lightbown, *Catalogue of Italian Sculpture in the Victoria and Albert Museum*, 3 vols, London: HMSO, 1964, vol. 1, p. x.

80 Baron H. de Triqueti, 'Les Sculptures du Musée de South Kensington', *Gazette des Beaux-Arts*, vol. 14, 1863, p. 458.

81 MS letter, Robinson to Cole, 4 December 1858, Cole Correspondence (NAL).

82 W.S.G. [article signed with initials only], 'Art Treasures at South Kensington', *Bentley's Miscellany*, October 1862, p. 349.

83 'The Loan-Collection, South Kensington Museum', *Illustrated London News*, 6 December 1862, p. 614.

84 Clément de Ris, op. cit., pp. 145–6.

85 Physick, p. 58.

86 'The New Court, South Kensington Museum', p. 305.

87 Physick, chapter 4.

88 MS letter, Robinson to Cole, 19 May 1862, Cole Correspondence (NAL).

89 *Précis*, 1852–63, pp. 375, 390.

90 Clément de Ris, op. cit., p. 150.

91 'Art' ['South Kensington Museum and Loan Exhibition'], *Quarterly Review*, January 1863, p. 185.

92 Clément de Ris, op. cit., pp. 149–50.

93 *Bentley's Miscellany*, p. 353.

94 Clément de Ris, op. cit., p. 160.

95 M. Digby Wyatt, 'The "Loan Collection" at South Kensington', *Fine Arts Quarterly Review*, vol. 2, 1864, p. 20.

96 Ibid., p. 36.

97 *Quarterly Review*, p. 191.

98 Ibid., p. 186.

99 Clément de Ris, op. cit., p. 168.

100 *Quarterly Review*, p. 185.

101 *Bentley's Miscellany*, pp. 350–1.

102 Thomas Wright, 'The Loan Museum of Art of 1862, at South Kensington', *The Intellectual Observer*, vol. 3, 1863, p. 69.

103 Ibid., pp. 76–7.

104 'Exhibition of Works of Mediaeval Art at the South Kensington Museum. Notice II. – Specimens of Metal Work', *Building News*, 11 July 1862, p. 29.

105 *Quarterly Review*, p. 197.

106 M. Digby Wyatt, op. cit., pp. 14, 25.

107 William Burges tried to reconcile the interests of the rich collector and the poor artisan in 'A Few Facts for the Workman who visits the Loan Museum at South Kensington', *Builder*, 12 July 1862, pp. 491–2.

108 *Précis*, 1852–63, pp. 403, 413.

109 Ibid., pp. 24, 27.

110 Cole diary, 15, 16 December 1853.

111 *Précis*, 1852–63, pp. 10, 54.

112 MS letters, Robinson to Cole, 3 March, 25 October 1855, Cole Correspondence (NAL).

113 MS letter, Robinson to Cole, 19 December 1855, Cole Correspondence (NAL).

114 MS letter, Redgrave to Cole, 20 December 1855, Cole Correspondence (NAL).

115 *Précis*, 1852–63, pp. 152, 164, 173.

116 MS letter, Robinson to Cole, 4 December 1858, Cole Correspondence (NAL).

117 MS letter, Marianne Robinson to Cole, n.d. (from Dairy Farm, Eton Wick, Windsor), Cole Correspondence (NAL).

118 Cole diary, 18 March 1859, 23 February 1860.

119 *Report from the Select Committee on the South Kensington Museum ... Ordered, by the House of Commons, to be Printed, 1 August 1860*, Minutes of Evidence, paras 624–30.

120 MS letters, Robinson to Cole, 2 May 1860, Cole Correspondence (NAL).

121 MS letter, Robinson to Cole, 19 June 1862, Cole Correspondence (NAL).

122 *Précis*, 1852–63, p. 397.

123 Ibid., pp. 414–15.

124 Ibid., p. 416.

125 Cole diary, 6 March 1863.

126 Ibid., 9 March 1863.

127 *Précis*, 1852–63, p. 425.

128 Ibid., p. 428.

129 Ibid., p. 426.

130 Cole diary, 26 March 1863.

131 *Précis*, 1863–9, pp. 242–5.

132 MS letter, Redgrave to Cole, 29 June 1867, Cole Correspondence (NAL).

133 Ibid., p. 245.

134 J.C. Robinson, 'Our National Art Collections and Provincial Art Museums', *Nineteenth Century*, June 1880, p. 988. See Helen Davies, 'John Charles Robinson's work at the South Kensington Museum, Part I... Part II...', *Journal of the History of Collections*, vol. 10, 1998, pp. 169–88, vol. 11, 1999, pp. 95–115.

The Supremacy of Henry Cole

If the creation of the V&A's collections was due largely to the fierce appetite and penetrating taste of J.C. Robinson (backed, though, by energetic interventions from Henry Cole), the development of every other aspect of the museum's practices was due to Cole alone. He showed a remarkable grasp, far ahead of his time, of what a successful museum needs to do; and, if he were to return to run the V&A today, he would assuredly have no difficulty in comprehending and controlling the circumstances of late twentieth-century museum life as capably as he shaped his course in the mid-Victorian cultural scene.

Oddly enough, however, he had to make a short retreat before resuming his forceful advance. Apparently indefatigable, he found in summer 1858 that he had worked himself to a standstill. On 22 July he recorded in his diary that his doctor ordered 'complete rest for 12 months or so, & advised Italy'. To Italy he went, on 28 August, but was back before the 12 months were up. He returned on 5 March 1959 to find the museum 'in very excellent order indeed'. To some extent, the museum had to continue to look after itself, for Cole was at once involved in preparations for another International Exhibition, scheduled for 1861 but held in 1862, and it was not until 1863 that he gave the museum a thorough overhaul. But its development in the early years was along lines that he determined.

To his relief, the museum turned out to be successful by the most basic criterion: visitor numbers. In a lecture given in November 1857, after the museum's first four months in South Kensington, Cole alluded to the gloomy prophecies that had predicted fewer visitors there than at Marlborough House. 'The facts have disproved the prophecy,' he pronounced. 'Now it appears that, notwithstanding the supposed disadvantage of site, the attraction having been increased, has more than overcome the diminished facility

of access.'[1] During the half-year that the museum was open in 1857, 268,291 visitors came, an attendance rate four times larger than that at Marlborough House. This was not a mere flash in the pan, for the rate hardly decreased in the following two years (1858: 456,288; 1859: 475,365), and rose thereafter (1860: 610,696; 1861: 604,550). A huge rise in 1862, to 1,241,369, was clearly due to the International Exhibition in that year.[2] But in the mid-1860s attendances held up, ranging between 646,516 (in 1867) and 881,076 (in 1868), then climbed again above the million mark in 1869 and 1870, reaching a climax in 1872, Cole's last full year, at 1,156,068.[3]

Of course, some people said that the figures were artificially inflated, because children 'amuse themselves out of school hours by running in and out of the Museum, and putting the turnstile through more revolutions than are absolutely necessary to mark their visits'.[4] But some people always say this. Since the figures were analysed and published in the annual reports of the Science and Art Department, along with copious other statistics, in characteristic Victorian manner, there is no reason to regard them as frivolous. Their importance is indicated, perhaps, by the fact that Cole posted them up on a board at the door, according to French observer, Alfred Darcel, who added that the figures were correlated, day by day, with the state of the climate, 'so that one can study the influence of rainy or fine weather on the enthusiasm of the public. It seems to me that fine weather is more favourable than bad.'[5]

One might wish that the statistics were detailed enough to permit the kind of analysis of the classes and origins of visitors that is customary today. Cole did do at least one visitor survey, however, over 'a few weeks' in September 1859. As a result he was able to say that:

of 1,530 visitors who gave their names and addresses, 71 were foreigners, 402 came from the provinces, 201 came beyond six miles, 87 came from a distance within six miles, 91 within five miles, 205 within four miles, 203 within three miles, 156 within two miles, and 114 within one mile, showing that it is not people from the immediate neighbourhood who visit the Museum.[6]

Vignette: One of the mosaic panels on the northern façade of the quadrangle. Behind the allegorical female figure, Henry Cole is pointing towards the future. On his right is Richard Redgrave. Behind Cole is Captain Fowke, with scroll, and to his right Godfrey Sykes. The other figures are members of Cole's design department.

This seems a creditable record in view of the fact that access to the museum by public transport was not easy. Walter Crane recalled that 'the Brompton 'buses were the only ones which came at all near its gates'.[7] The museum made the best of a bad job by providing 'a waiting-room adjoining the entrance hall, where visitors have the privilege of waiting until omnibuses "to all parts of London" pass by'. A contemporary magazine tartly commented: 'We cannot too highly applaud the care with which this room has been fitted up, when we reflect how long some of those visitors will have to stay.'[8] To assist wealthier visitors, the museum (adopting a device from the 1851 Exhibition) printed at the end of its guide pamphlet a list of cab fares to some 250 destinations elsewhere in London: 6d. to Belgrave Square, for instance, 1s. 0d. to Piccadilly, 1s. 6d. to Westminster, 2s. 0d. to St John's Wood or Bloomsbury, 3s. 0d. to Dulwich or Hampstead, 3s. 6d. to Hackney.

AN EASTER MONDAY AT KENSINGTON MUSEUM.

Figure 5.1 'Jack Robinson and his household are well off at Easter in the South Kensington Museum, and we heartily wish they may enjoy themselves... Too many of the fraternity of our friend Jack are in the habit of visiting those other institutions, which the vested interests that fatten on the downfall of the workman have set up at the corners of the streets, like so many mantraps to snare the simple.' Words and picture from *Leisure Hour*, 1 April 1870.

Travel to the museum quite soon became much easier, when the underground Metropolitan Railway opened its station at South Kensington in 1868.[9] Cole had boasted in advance that 'you will have a railway coming literally under cover into the South Kensington Museum'.[10] It did not get quite as close as that, but near enough to compel from one commentator the admission that:

no one is thinking of carrying a railway into Great Russell-street, or to any other museum; so there can be no doubt, as the authorities at South Kensington assure the inhabitants of this metropolis, that theirs is ... the single establishment most readily accessible from east, west, north and south.[11]

It is impossible to satisfy everyone, however, and even in 1874, after Cole had retired, Professor Leone Levi, discoursing on the economic value of museums, criticized the South Kensington Museum as 'too far west'.[12]

A crucial question with which the Department of Science and Art was challenged before its move (see above, p. 47) was: could working people (figure 5.1) afford to come to South Kensington? This must have depended to some extent on the available transport, which, as we have just seen, gradually improved; and on the conditions of admission to the museum. At Marlborough House, Cole had maintained a mixed regime: some free days, and some on which visitors had to pay. He kept this system going at South Kensington on the grounds that it 'was tried for four years at Marlborough House and proved to be very acceptable to the public'. The purpose of the system at Marlborough House was to keep down the crowds on 'student days' by imposing a fee of 6d. for entry. Since the museum at South Kensington was considerably larger than the six rooms of Marlborough House, it might be thought that this justification would not hold good. But, as we have seen, many more people came to South Kensington, so it became crowded too, especially since the interior was divided into comparatively small spaces. On 17 December 1858 J.C. Robinson wrote:

There is a ceaseless tramp from the thousands of visitors that are pouring into the Museum, it is the first day of the public Christmas week, and the crush in some parts of the museum is equal to the worst days of Marlboro' House, already (4 p.m.) nearly seven thousand have passed through, and I should think the evening will bring us up to around *ten thousand*.[13]

By the end of Cole's time, attendances on Bank Holidays (Boxing Day, Easter Monday and Whit Monday) were topping 20,000.[14] A case could be made therefore, at South Kensington as at Marlborough House, for ensuring some quieter days by means of entrance charges (figure 5.2).

The charges did elicit protests, however. 'This contemptible taxation,' it was asserted

will result in excluding working men and others of limited means, and making a select lounge for the neighbouring

EXHIBITION OF THE ROYAL WEDDING PRESENTS AT THE SOUTH KENSINGTON MUSEUM.

Figure 5.2
Crowds in the North Court, visiting the exhibition of the wedding presents of the Prince and Princess of Wales in 1863. This was the most successful of the museum's exhibitions under Cole's regime. On one of the free days, 'the number of persons admitted from ten a.m. till ten p.m. was 20,467, besides 372 babies in arms'. From the *Illustrated London News*, 25 April 1863.

aristocracy, who will take season tickets at ten shillings a year. Either it is necessary for the convenience of students that the public should be excluded, or it is not necessary, and the working classes should have free access as well as the oligarchical classes.'[15]

This criticism, for all its fine indignation, fails to understand Cole's system, and is again mistaken when it continues: 'The Brompton Museum is the first public gallery of art in this metropolis, in which an attempt has been made to tax a class of students proverbially poor.' For students did get in free on the students' days; it was the public who had to pay.

Cole's position was that at the museum 'everything was as free as it could possibly be'.[16] And he argued that, if his arrangements were considered as a whole, South Kensington was much more accessible than its competitors. The British Museum, for instance, opened to the public only on Mondays, Wednesdays and Fridays from 10.00 until 5.00 (or 4.00 in the winter months). The National Gallery opened four days a week from 10.00 until 5.00, but had a six-week annual vacation. Students were admitted to these museums on some of the closed days, but 'the public are excluded on students' or private days. At the South Kensington Museum it cannot be said that there are any private days.'[17] Those who were privileged to use the British

Museum or National Gallery on private days may not have been many: one commentator, speaking 'as an old student', opined that the British Museum on Thursdays was 'exclusively given up ... to about a dozen youths'.[18] Another sympathizer believed that 'all that is done, or said to be done' in the British Museum and the National Gallery 'during close-time is carried on at South Kensington without excluding the public', and suggested that 'the arrangement of free and sixpenny days appears to answer the purpose far better and far less vexatiously, than closing'.[19]

South Kensington opened six days a week throughout the year, and on three nights a week stayed open until 10 p.m., two of these being free. It was on these evenings that access was really convenient for working people, and they took advantage of the opportunity provided. In the early 1860s an average weekly total attendance (in round figures) might be 12,000. Of this, only 2,000 would have visited on Tuesday, Wednesday and Thursday, the three paying days: say, 600 per day plus 200 on Wednesday evening; 10,000 would have attended on Monday, Tuesday and Saturday, with almost half of these coming on Monday and Tuesday evenings.[20]

Cole's system of sticks and carrots was somewhat complicated, but in answer to criticism he was able to claim that South Kensington was getting more visitors than the

British Museum and the National Gallery anyway.[21] This rankled with his critics, one of whom claimed (absurdly) that 'when it is remembered that *no other free public exhibition is open in the evening*, any comparison between the numbers visiting South Kensington and those who go to the National Gallery and British Museum is ridiculously unfair'.[22] Cole would have riposted that his museum's willingness to open in the evenings was a virtue, not a fraud. The museum gloried in its accessibility: when, in 1868, its guide book was produced in a new crimson-covered version (which continued in print, with occasional revision, into the 1890s), the cover gave details not only of South Kensington's opening times, but also of 'Public Galleries – Free Days'. It is to be presumed that it did not do this simply in order to be helpful, but mainly to gain credit from the comparison.

Free entry to museums is often supposed, in present-day discussions, to have been a sacred principle in Victorian England. Enough has been said already to show that this question was as complicated then as it is now. It is worth going into it a little further, as it throws light on Cole's attitude to his audience. The report of the Select Committee on Arts and Manufactures, in 1836, had made a strong plea for free museums. 'Wherever it be possible, they should be accessible after working hours' – South Kensington alone took this recommendation seriously – 'and admission should be gratuitous and general'.[23] Cole on the whole stuck by the Radical agenda, and reaffirmed it at the end of his career (see below, p. 89). He insisted on the necessity for state subvention of museums, but was not averse to extracting a 'contribution' from the public where this seemed pragmatically feasible. He saw the question of accessibility in wide terms, and so did the Select Committee, whose report cannily commented that, where admission to public monuments and museums was concerned, 'a small obstruction is frequently a virtual prohibition'. As an example of this, it pointed to the entrance fees to Westminster Abbey and St Paul's Cathedral, which were also denounced by others as a 'most unjust and odious impost', a tax on 'exhibiting to the people what is in reality their own property', and an impediment to the 'moral greatness and intellectual advancement of the nation generally'.[24]

In 1841, a Select Committee on National Monuments and Works of Art, chaired by the Radical MP Joseph Hume, put pressure on the national collections to become more accessible,[25] but progress was slow, and small obstructions remained: the British Museum had no lavatories and (as a result) excluded children under eight, lest they 'commit little indiscretions'.[26] Some galleries, though not charging an admission fee, required visitors to obtain tickets in advance. In 1856 the Soane Museum insisted on advance

application by post, while for Windsor Castle tickets were to be obtained from the print dealers, Messrs Ackermann, 96 Strand, and for Dulwich Picture Gallery tickets were available from 'most of the respectable printsellers in London'.[27] No doubt these measures kept working people at a safe distance. Although, as we have seen (p. 12), nursemaids flocked to the National Gallery, their presence was deplored by influential people like Dr Waagen. The British Museum always had a reputation for wanting to keep people out. Its Director, Sir Henry Ellis, had made plain to a Select Committee on the British Museum in 1835 his disinclination to admit 'the most mischievous portion of the population ... the more vulgar class', people 'of a very low description',[28] and still in 1873 it was claimed that 'at the British Museum, the inquiry apparently always uppermost in the minds of its managers is, how seldom can we let the public in, how can we keep them away?'[29]

Cole, by contrast, made it very clear that the South Kensington Museum welcomed working people. In his introductory lecture, given on 16 November 1857, he included a rhapsodic passage that obviously so pleased him that he repeated it in his Annual Report for 1857. He was arguing (with copious statistics) that the working classes made little use of other galleries, and held up in contrast the situation at South Kensington:

In the evening, the working man comes to this Museum from his one or two dimly lighted, cheerless dwelling-rooms, in his fustian jacket, with his shirt collars a little trimmed up, accompanied by his threes, and fours, and fives of little fustian jackets, a wife, in her best bonnet, and a baby, of course, under her shawl. The looks of surprise and pleasure of the whole party when they first observe the brilliant lighting inside the Museum show what a new, acceptable, and wholesome excitement this evening entertainment affords to all of them. Perhaps the evening opening of Public Museums may furnish a powerful antidote to the gin palace.[30]

This is a very Cole-ian statement. It has a slight burlesque sting (Cole always phrased for striking effect), a hearty pride in technical wizardry and, especially at the end, explicit Victorian do-goodery. But there is also real empathy with the visitor, and an unembarrassed use of the word 'entertainment'. If there is a somewhat bossy hint that the workers should smarten themselves up before crossing the museum's threshold, it is perhaps worth noting that in the Architectural Museum at South Kensington it was observed that workmen were admitted 'in their working clothes without difficulty and without obstruction'.[31]

Experience of working-class visitors over 15 years did not bring disappointment to Cole. In a speech in 1873 he reminisced: at the South Kensington Museum

the working man could go and study any subject he wished. He could have a cup of tea for 2d. (Oh! And a laugh), or, if it were

preferred, a glass of beer; and it was a fact that thirteen millions of people had been admitted to the institution, and that only two had been turned out for drinking too much.[32]

And in another speech, earlier that year, he reflected on the new branch museum that had just opened at Bethnal Green:

When the idea of establishing it was made known, it was stated that the valuables would be greatly damaged by the rough people who inhabit that part of the metropolis. I was cautioned not to put up a majolica fountain out of doors. The greatest local authority cautioned me, but I trusted the poor people, and I am glad to say that there has not been any damage done; on the contrary, that the people have shown great appreciation of the institution, and respect for it.[33]

If it is claimed that Cole's attitude to working-class visitors, however enthusiastic, was nonetheless paternalistic, this must be conceded. His pronouncements seem to show that, in his view, working-class visitors to South Kensington were entering a privileged space, rather than their own domain. Could he, in the circumstances in which he was placed, have taken a more radical view? Others did: Victorian design reformers often pondered whether the workers might own and profit by design reform, or whether they should embrace reform and education for the sake of wealthier consumers. The dilemma emerges most clearly, perhaps, in Ruskin's convictions – both held with equal passion – that workers should find fulfilment in their work but should not get above their station. There are many other expressions of the dilemma. For instance, Cole's predecessor as head of the Schools of Design, Charles Heath Wilson, made it clear where he stood, when he wrote:

Our travelled and highly educated upper classes have acquired refined taste, which in many instances, cannot be satisfied by the present knowledge, taste, and skill of our own manufacturers and artisans.[34]

The workers, then, were to improve themselves for the sake of the 'upper classes'. Not surprisingly, there were those among the workers who felt that the exercise of their talents and the expression of their artistic ability were worth while in themselves, and not merely as means to the increased comfort of the upper classes. A writer in the *Polytechnic Journal* in 1839 protested

that design for industry is not an inferior or degrading occupation, but that, if its scope be more limited, it requires the exercise of a taste as refined, of principles as elevated, and a skill of execution even greater than is necessary in works of fine art.[35]

And the *Home Companion* (which, in its own words, spoke for 'the *élite* of the working-men') urged that the view that art was 'a luxury or an amusement ... confined to the lofty regions of taste and elegance' was now giving way in the face of 'the application of the arts to the common

purposes and conveniences of life'. The design reform movement had brought together 'the philosopher and the artizan', so that 'intellectual riches are spread over a wider surface', extending into 'the humbler sphere of toil and industry'.[36]

Furthermore, it seemed only fair that ordinary people, no less than wealthy consumers, should have an opportunity to acquire well-designed objects, if these could be produced cheaply. 'Art that the poor man's pence may reach' is what the *Athenaeum* called such things, in a review of the Department of Science and Art's first report, though lamenting that 'we are still far removed' from such art 'that inculcates the beautiful of daily life, the simple poetry of articles of domestic use'.[37] As this shows, it was not only the workers who wanted good design in everyday objects. The Egyptologist Sir John Gardner Wilkinson, making a foray into the debates on contemporary taste just after the opening of the South Kensington Museum, insisted that 'there is no reason why the humblest household object should not be beautiful in proportion, form, and colour', and argued that:

Many a simple and cheap object may be made in good taste without any additional cost; and the humblest individuals may display an innate perception of the beautiful in the ordinary ornaments of a cottage, or in the coarsest materials ... The commonest pottery, worth a few pence, may have far more to recommend it than a splendid Sèvres vase which costs some hundreds of pounds.[38]

Another example of such a view can be taken from a source closer to South Kensington, a lecture by Alexander Beresford Hope given in the museum lecture theatre under the auspices of the Architectural Museum. This wealthy connoisseur had undertaken to speak on 'The People's Share in Art' and, honestly but not without a struggle, argued himself to the conclusion, first that 'a general appreciation of art' should be 'the general property of the people; not merely of the highly educated classes', and consequently that this must lead to a demand from ordinary people for well-designed goods. These could be produced by the newly educated art-workers. They 'could be artists as truly as those who wrote "RA" after their names' and 'might produce art-objects for the million' as the RAs 'did for the higher classes'. This, said Beresford Hope, 'was the people's share in art'.[39]

A further endorsement of such views can be found in Charles Lock Eastlake's *Hints on Household Taste* (1867), an influential book that helped to move taste in a direction congruous with South Kensington's views. Although this book is renowned for its impact on middle-class domestic interiors, a repeated theme is 'that the principles of good design are not confined to mere objects of luxury, but are applicable to every sort and condition of manufacture'.[40]

Such views were propounded from within the South Kensington establishment by George Wallis, who was headmaster at the Design Schools in Manchester and Birmingham, and joined the museum in 1858 (figure 5.3). In the *People's Journal* in 1847, he argued for the value of good design in 'articles of everyday use'. Having such things around them was the best way for working people to learn taste. 'Our Art-Education,' said Wallis, 'has hitherto been *downward* instead of *upward*':

We have called upon our countrymen to appreciate the great works of great masters, without giving them the intermediate lessons in Taste which convey to their minds a sense of the beautiful through those works on which they are themselves engaged ... We have sought to educate *down* from pictures and statues, to silks, calicoes, and porcelain, instead of to educate *up* to pictures and statues, by and through those utilities of life, in the manufacture of which so large a proportion of our population is engaged for the attainment of daily bread.

Wallis's defence of 'those everyday beauties which stand at our elbows, and surround our firesides'[41] led him to a rather fierce antipathy towards the art that found favour with connoisseurs. He vented such views in a speech (chaired by Cole) to the Royal Society of Arts in 1856, in which he championed good design through mechanical production, and dismissed the disapproving attitudes of connoisseurs:

The secret of all this horror of stamping, electro-depositing, printing, power-loom weaving, and so forth, lies, it is to be feared, in the fact that the almost exclusive possession of a work becomes impossible. Duplication spoils that flattering unction which your pure and legitimate connoisseur lays to his soul as to the uniqueness of his treasure.

Ruskin, sitting in the audience, was stung to reply that 'good art should not be cheap; ... in one sense, could not be cheap; and ... that if in any sense it could be cheap, that is accessible, they were not going the right way to make it so'.[42] Wallis stuck to his views, and in 1888 was arguing in favour of exhibiting reproductions of works of art rather than originals in museums, because the former were not tainted by cash or rarity value. He was proud to embrace what would seem like 'heresy' to 'the conventional dilettanti [*sic*] collector, whose worship of the unique is so profound as to partake of the character of a *fetish*'. In a collection of reproductions, he claimed:

the vulgar, degrading, and factitious admiration of an object because it has cost a large sum of money, and is said to be valued at even a higher price, would be got rid of ... and the aesthetic qualities of art as representative of nature and the genius of bygone ages would have a chance of being recognized and appreciated.[43]

The point of gathering this sheaf of quotations is to show that radical opinions on the right of working people to enjoy the ownership of art in everyday life were current around South Kensington throughout Cole's time in office. It might be expected that he would have shared this outlook; no doubt he had some sympathy for it. But the course he steered at the museum veered away from the everyday towards the rare, expensive and luxurious. Design reformers might rage at this:

The interests of the genuine workmen have been neglected in the formation of the Museum, that a gorgeous display might be made of expensive and showy china, enamels, bronzes, &c., that attract other classes, and secure the votes of *dillettante* [*sic*] members of the House of Commons ... The managers here seem to revel in 'venerable' relics of an utterly useless order ... What use to the practical workmen of the present day is the reliquary purchased recently at the sale of Prince Soltykoff's collection in Paris for the enormous sum of £2,142?

Others, however, seemed to have had no regrets at the museum's inclination towards High Art. Although the museum had been set up to improve 'the decorative and the ornamental', by 1869 it had 'rare qualifications as a school of high art', said one commentator, acknowledging

Figure 5.3 George Wallis, Keeper of the Art Collections, 1863–91.

that 'there exist within the bounds of that magic spot the materials for a polite education in the Fine Arts'.[44]

Somewhat earlier, in 1862, a journalist had imagined visitors observing the museum's transformation into an art museum, as they participated in 'a conversation that lately was held before one of the glass-cases in which various precious works are placed, when they are lent for exhibition, at the South Kensington Museum':

'What! A thousand guineas for a single plate made of any possible earthenware! Why, I could get a glorious Titian for a thousand guineas. And fifty guineas for this very coffee cup! – fifty shillings you must mean ...'

'You do not regard these fine works in their true capacity [was the reply] ... Consider them as works of Art; or, if you prefer the phrase, as productions of Art-Manufacture. It is the Art, which suffuses itself with so rich a glow over these cups, that stamps them with their value. It is precisely the same with the Majolica dish from the Royal Collection.'[45]

Most telling, perhaps, are casual remarks from people with no doctrinaire interest in design reform, which attest to the museum's attractions as a treasure-house. 'New objects of wonder, of beauty, of luxury, are ever and anon making their appearance in the courts,'[46] wrote one visitor, while another confessed: 'whenever I am tired with every-day life, I find nothing brightens me up like a little dose of art: so to-day, being in the frame of mind referred to, I spent a couple of hours in the South Kensington Museum, my constant refuge in such cases'.[47]

Cole's intention can perhaps be summed up in a phrase he used: in the museum 'we place objects of the highest art within the reach of the poorest person'.[48] He is here steering a course between the Scylla of élitism and the Charybdis of populism, and it was no doubt necessary for him to do so. If we are inclined to regard this as official cynicism, we can balance it against the many glimpses we get of Cole's eager open-mindedness. Take, for example, the speech that he gave in Manchester, at a Missionary Exhibition, on 'the Art of Savage Nations and People considered Uncivilized'. He praised the design of African objects, announcing that 'it would be his duty to represent to the Lord President of the Council that there ought to be at the South Kensington Museum a section for showing this humbler kind of art'.[49] This idea did not come to fruition, however.

One reason for Cole's constant manoeuvring was that South Kensington was often under attack. Only three years after its opening, for instance, he had to defend it before a Select Committee. 'All that could be brought against the Museum and its management was now said,' recalled William Bell Scott, 'but the committee came to the conclusion that it was exercising a beneficial influence on the whole country.'[50] Much of the testimony to the Committee was descriptive. Cole's evidence about virtually everything

that went on in the museum occupied almost three days, and Redgrave and Robinson described their contributions more briefly. There were two potential scandals that had to be defused. It was said that the museum's photography department, which provided cheap prints of exhibits, was trying to destroy the photographic profession, to 'drive us out of the market', as one photographer said.[51] And it was feared that the gas-lighting in the picture galleries was damaging the paintings. There was also some haggling over whether the museum was infringing on the territories of the National Gallery and the British Museum; and the Committee's question, 'whether ... it is right to have one great central collection in London, or whether or not various centres of attraction should be created in different parts', still flares up in various forms.[52]

The Select Committee made only rather perfunctory investigations as to whether the museum was succeeding in its declared aim of improving British manufactures. Favourable testimony was received from the Mayor of Sheffield and two Sheffield manufacturers, from a Birmingham worthy, and from Colin Minton Campbell, a partner in Minton's, the china firm at Stoke-on-Trent, with which Cole had very warm connections through his friendship with Herbert Minton, Campbell's uncle (who died in 1858). Cole was asked how he thought the objects exhibited in the museum affected the manufacture of china, and his answer (crisp to the point of being simplistic, but no doubt designed to impress his point as forcibly as possible) is a key statement of the museum's original philosophy:

I think the first result of this kind of exhibition is to make the public hunger after the objects; I think then they go to the china shops and say, 'We do not like this or that; we have seen something prettier at the South Kensington Museum;' and the shop-keeper, who knows his own interest, repeats that to the manufacturer, and the manufacturer, instigated by that demand, produces the article.[53]

Alongside this declaration on the external effect of the museum, the Committee's evidence contains several glimpses of the museum's internal workings under Cole, who ran a tight ship, and was a 'hands-on' Director:

For the purpose of performing my duties as well as I could, I took an additional house close to the Museum, the rent of which I have paid, so as to enable me to go into the Museum early and late on Sundays and working days, and give that general superintendence which I believe has led to successful results.[54]

Because he so hated large committees, Cole made sure that he worked directly to his Minister at a very small Board, consisting of the Lord President of the Committee of the Privy Council on Education (i.e. the Cabinet Minister), the Vice-President (the junior Minister), Cole himself, the Inspector General for Art (who was Redgrave) and the

Assistant Secretary of the Department of Science and Art (Norman MacLeod). The Board usually met every Thursday, and Cole emphasized that every decision 'which is not merely a carrying out of a general principle already laid down by minute' was approved by a Minister. (The minutes of the Board Meetings show that matters on the agenda ranged from important purchases, such as those from the Soltykoff Collection, and the approval of tenders for new buildings to the appointment of an 'umbrella taker at 1l. a week' and the requisitioning of filing cabinets.)[55] Cole put it to the Select Committee that, if they 'attach any importance to individual responsibility, you have here the most perfect system you can have'.[56]

Cole's description of office accommodation (sixteen rooms where 'we are packed as close as pigs') is interesting for revealing what a very small staff he had in 1860, to run both the museum and the Department:

In the registry, I think that there are four clerks; the next room is for the assistant secretary, Mr Macleod [sic]; the next to that is devoted to the general superintendent of the museum who sits there with a clerk. Then in a little room opposite sit two clerks who conduct the correspondence with the art schools; then the next room is my own; in the next room sit two other clerks, the head clerk and another. Then ... there is a room where the three inspectors frequently sit who inspect the Art schools. The Inspector General for Art occupies the next room; the other room is used for occasional purposes from time to time; the room opposite the inspectors' room ... is occupied as a drawing office for clerks employed in making drawings about the buildings; the next room is occupied by four messengers; the next room is the engineer's office, Captain Fowke. Then the room opposite is occupied by the inspector for science and his clerk; the other is used as an examination room ... On the other side is the storekeeper's office...; then there are two rooms which contain the various examples sent from the country, prize drawings, prizes sent out and so on.[57]

Finally, the Select Committee evidence gives us a further clue about Cole's attitude to admission charges. He acknowledged that he aimed to make his Department's art-education system 'as self-supporting as possible', but, taking a rather more cautious line than when he first opened the museum at Marlborough House (see p. 39), he claimed, 'I have never held the opinion that the South Kensington Museum could be made self-supporting.' He was pressed to agree that raising the admission fees would increase the museum's income, which he conceded; but he delivered the following oblique reproach to his questioner: 'whether it would be considered shabby, or mean, or bad public policy I do not express an opinion.'[58]

Once the 1860 Select Committee had given the museum a clean bill of health, Cole was free to turn to the 1862 Exhibition. After that was over, the breach with Robinson required that he give some attention to tidying up the administration of the museum. Cole, Redgrave and Robinson had run the museum at Marlborough House with a small group of clerks (about four of them, but clerks tended to shuttle between the work of the museum and that of the Department). One of these, who joined on 31 December 1854,[59] was Philip Cunliffe Owen, younger brother of Colonel Henry Owen of the Royal Engineers, with whom Cole became friendly while they were both working on the Great Exhibition. Philip Owen soon made himself indispensable, and on 14 May 1857 was appointed Deputy Superintendent of the South Kensington Museum – Cole's administrative right-hand man.[60] Another administrator was Richard Anthony Thompson. He was the son of Cole's friend and neighbour in Kensington, John Thompson, the wood-engraver. Richard Thompson had worked as an organizer in the Great Exhibition and in the British Section of the Paris International Exhibition of 1855. He joined the South Kensington staff on 12 January 1857 to arrange the Education Museum, and in 1859 became Keeper of the Educational, Food and Animal Products collections.[61] His brother, Charles Thurston Thompson – who, after training with his father as a wood-engraver, became a pioneer photographer – was appointed on 29 July 1856 to head a photographic department at the museum.[62] And on 29 November 1856 Captain Francis Fowke of the Royal Engineers was appointed 'Architect and Engineer' to the museum. Cole got to know him through Henry Owen, and worked with him at the Paris Exhibition. These men – Cole, Redgrave, Robinson, Owen, Richard and Thurston Thompson, and Fowke – were the key players at South Kensington in the early days; and rather on the fringe at this stage was George Wallis, who had been taken on to organize an exhibition in March 1858, and in June 1859 became part-time 'Agent for the sale of reproductions'.[63]

It is obvious that Robinson was the only staff member to be a specialist art historian (though Redgrave and Cole lent a hand with artistic matters) and his involuntary departure from the permanent staff in 1863 left a big gap. His responsibilities in respect of the Art Library eventually (in 1866, after some transitional arrangements) fell to Robert Soden Smith, who had joined the museum on 19 March 1857 to help with the Sheepshanks collection and had subsequently worked in both the library and the museum, notably on Robinson's Loan Exhibition in 1862.[64] Replacing Robinson as Curator of the museum collections obviously presented Cole with a problem, and the way he solved it suggests that he was anxious above all to avoid saddling himself again with a temperamental man of learning, who would not take orders. His policy was enshrined in a Treasury report of 1865 on staffing in the Department of Science and Art,[65] which stated that:

the fixed establishment ought ... to be confined to the smallest possible number of officers who should be paid entirely by salary, should give up their whole time to the public service, and should be appointed and promoted solely with reference to their aptitude for the administrative duties of the Department; and services of a professional and technical character should be entrusted to persons selected and paid for the occasion ...

This was not aimed just at Robinson – the question of advice on scientific matters was also involved – but was certainly used against him later in 1867 when he was finally eased out.[66] The effect of this policy was that the day-to-day care of the art collections was put in the hands of an administrator – George Wallis, plucked from obscurity as agent for the sale of photographs. Was Wallis up to the scholarly requirements of the job? 'He has ..., we believe,' said the *Art-Journal*, 'no pretensions to familiarity with antique works.'[67] It did not matter, for Cole's intention was that scholarly expertise ('services of a professional and technical character') should be bought in when necessary, and in fact several experts were promptly hired to scrutinize the collection documentation that Robinson had left behind.[68] Cole's preference for administrators over scholars, and his reliance on expert advice from outside the museum, no

doubt worked out conveniently in the short term, but was to have adverse effects in the long term and must be regarded as his worst error of judgment.

Cole did in fact appoint another scholar to the museum. On 28 November 1863 John Hungerford Pollen was 'employed in arranging some of the classes of the Art collections and revising the inventory of them, at an expense not exceeding 100*l*.'[69] Pollen (figure 5.4), who was a practising artist (on the fringe of the Pre-Raphaelite group), was educated at Eton and Oxford, ordained as a clergyman in the Church of England and became a Fellow of Merton College, Oxford. His High Church leanings eventually took him over to Rome in 1852, after which he had to resign his Fellowship, and earned his living through art. W.M. Thackeray, a friend of both his and Cole's, introduced them in 1859 with a view to Pollen getting a job in the Department of Science and Art.[70] Robinson's withdrawal seemed to provide an opening. Cole was wary: 'My only fear is that Mr Pollen, accustomed as he is to go about in society, knowing every sort of person, and welcome everywhere, may feel *above his work*.'[71] But Pollen evidently gave satisfaction and in 1864 was made a Museum Keeper.[72] His function was, however, to act as editor of catalogues rather than as curator of collections. Nonetheless, it is clear that he did to some extent take Robinson's place. His daughter recalls that he bought for the museum: he 'possessed the very eye required for treasures then to be rescued from heterogeneous piles in dark and dusty corners of the shops in Wardour Street – or like places in every great and little town on the Continent'. And she remembers him 'writing at a bureau in his little square room, surrounded by plans, official papers, sketches, diagrams; or walking about amid treasures recently unpacked, pencil and paper in hand, examining and labelling objects'. One of his strong points, no doubt, was the 'sweet and lovable disposition' that enabled him to get on well with colleagues such as Thomas Armstrong and John Donnelly (who are to play contentious parts later in this story).[73]

Pollen's chief task was to ensure that Robinson's catalogue of Italian sculpture should not stand as the sole representative of South Kensington scholarship. He edited a series of similar catalogues. Two were written by himself: *Ancient and Modern Furniture and Woodwork* (1874) and *Ancient and Modern Gold and Silver Smiths' Work* (1878). Others he commissioned from established scholars: *Textile Fabrics* (1870) from Daniel Rock, Canon of St George's Cathedral, Southwark, a Roman Catholic ecclesiologist; *Ivories Ancient and Modern* (1872) from William Maskell, an Anglican ecclesiologist who converted to Rome, and helped the museum with acquisitions; *Lace* (1873) from Fanny Bury Palliser, who had translated from French the standard works by Jules Labarte on medieval art and by Albert

Figure 5.4 John Hungerford Pollen, who worked at the museum from 1863 until 1876, as Editor of Catalogues and Referee for Libraries. A pen-and-ink sketch by himself, reproduced in his daughter's biography of him.

Jacquemart on ceramics; and *Maiolica* (1873) and *Bronzes of European Origin* (1876) from the wealthy collector and connoisseur Charles Drury Fortnum, who was a friend of Cole's but had not found Robinson responsive to his suggestions for acquisitions.[74] These catalogues, and five more, make a good showing on the shelf, being thick, royal-octavo volumes bound in half-leather; and they are conspicuously elegantly printed, no doubt at the behest of Cole, who was always interested in book design.

Although Cole wanted to keep scholars at bay, the museum's staff lists, printed in the periodically issued *Art Directory* of the Science and Art Department, begin in the mid-1860s to reflect some academic lustre. Pollen appears as 'MA, late Fellow of Merton College, Oxford' and Soden Smith emerges in new plumage as 'MA, Trinity College, Dublin, FSA'. Among the junior Assistant Keepers we find C.C. Black, MA, Trinity College, Cambridge; R.F. Sketchley, BA, Exeter College, Oxford; and J.W. Appell, Ph.D. The latter is an example of a characteristic of the staffing of the Department of Science and Art that is not wholly to Cole's credit, namely, the presence on the payroll of a number of his relations. Appell, a German who had been a journalist in Vienna, joined the Department shortly after he married Cole's wife's sister, Fanny.[75] Another of Mrs Cole's sisters, Charlotte, married Charles Thurston Thompson on 13 January 1857,[76] shortly after he joined the Department. The appointment of J.F. Iselin as an Inspector for Science in the Department, on 21 December 1861,[77] was criticized in the press on the grounds that 'he is about to become one of the family of the presiding genius at South Kensington';[78] however, the understanding between him and Cole's daughter Henrietta was not allowed to develop, as Cole thought his temperament unsuitable,[79] and 'Hetty' remained unmarried. Another of Cole's daughters, Mary, married, on 5 January 1864,[80] George Bartley, a clerk in the Department, but he had been appointed in 1860,[81] and went on to have a distinguished career as an MP, so presumably did not greatly need Cole's helping hand. Of Cole's three sons, one, Alan, joined the Department on 6 May 1863, and spent his whole career there.[82] Also in the Department were Captain Fowke's son Frank, who joined in 1866,[83] a year after his father's sudden death (and who in 1870 married Cole's daughter Isabella), and Redgrave's son Gilbert, who was employed in the works division of the museum from 1863.[84] It is clear that, notwithstanding the increasing professionalization of the Civil Service after the Northcote-Trevelyan report in 1853, there was still an element of the 'family business' about South Kensington. But Cole did not give his friends and relations an easy ride: in his diary, most of them come in for sharp criticism from time to time.

Another curious feature of Cole's staff was the presence among them of soldiers. Cole had been impressed by the contribution that the Royal Engineers, or 'sappers', made as general handymen at the Great Exhibition, and he had a small corps of them on the South Kensington site throughout his incumbency. Officers of the Engineers were the type of men he liked to have about him. Captain Fowke was the first, and after his death in 1865 his post was taken by Major Henry Scott. Captain John Donnelly arrived on 8 April 1858[85] (and was still there at the end of the century, as head of the Department). Captain E.R. Festing joined Owen and Thompson to form a triumvirate of Assistant Directors (in charge, respectively, of Works, General Administration, and Arrangement) on 18 June 1864.[86] In December 1864 both Redgrave and MacLeod complained at Cole's 'partiality & promotion of the Engineers', reporting, as Cole noted in his diary, 'dissatisfaction in ye office'.[87] The dominance of old soldiers in the Department's senior echelons was to cause trouble later on.

The picket of rank-and-file sappers had been obtained from the War Office at first 'to assist in [the] arrangement of [the] Museum', with the promise that 'the men will in the evening be put through a course of architectural and freehand drawing to qualify them to become Teachers of drawing to the corps of Engineers, when they return to it, and a small number will be taught photography'.[88] When the museum opened, they acted for a time as security attendants: Walter Crane remembered that 'the place was guarded by sappers and miners in shell jackets'.[89] On 8 November 1858 the custody of the museum was 'transferred from the 40 Sappers hitherto employed to the police',[90] who could be hired for such purposes (see figure 5.1) and who continued to work at the museum into the next century. We may be gratified to learn – but not, perhaps, astonished, for such comments are *de rigueur* – that 'it is impossible to find a more civil, well-behaved, intelligent and obliging set of men anywhere in the public service than are the policemen on duty in the Museum'.[91] The sappers now specialized in fire-fighting. By 1870, they were only a small part (comprising one Sergeant and 13 rank and file) of a practical maintenance force of 60, which Cole described with great pride in an official memorandum.[92] He claimed that 'unlike other places the Museum is never closed to visitors for alterations, repairs, cleaning or re-arrangement of its objects':

The daily works of cleaning, heating, ventilation, lighting, removal and arrangement of objects ... are carried out with promptitude and without inflicting inconvenience on the visitors. The works, when necessary, are performed in the very early morning, or are carried on through the night, so as not to interfere with the use of the Museum.

In this memorandum, Cole was in fact making a last-ditch attempt to keep the flexible local workforce he had built up; but he failed, and the Government Office of Works

asserted its considerably less flexible control over building maintenance.

It will have become clear that, whatever shortcuts Cole might, in his impatience, take in running his Department, his priority for the museum was that it should serve its public. One of his priorities was intelligibility. It has to be admitted that the museum's layout – for the most part rapidly improvised in constantly changing premises – was none too clear, but Cole did his best. The early guides help-fully told the visitor that:

the walls of each department of the Museum are painted a different colour, which alone will serve as a guide to the visitor. A Plan, suspended opposite the entrance, and coloured in accordance with these divisions, may be consulted with advantage before the inspection of the Building is proceeded with.[93]

In order to ensure the 'public utility' of the displays, Cole pledged that:

it will here be a canon for future management that everything shall be seen and be made as intelligible as possible by descriptive labels. Other collections may attract the learned to explore them, but these will be arranged so clearly that they may woo the ignorant to examine them. This Museum will be like a book with its pages always open, and not shut.[94]

Later he was to issue to his staff some characteristically downright instructions on composing labels that would tell the public what they needed to know, rather than what the curator wished to say. 'In a label which is *supplementary* to the object, and does not represent the object, many ... particulars become superfluous ...; for instance, it is unnecessary that a label should state that a marble statue is a "statue in marble," which is obvious.'[95]

Whether the labelling was altogether successful may be doubted. Ruskin thought that the working man who visited South Kensington was 'not led by a large printed explanation beneath the very thing to take a happy and unpainful interest in it'; rather, 'he tires of it, and he goes back to his home, or to his ale-house, unless he is a very intelligent man'.[96] But others praised the system of 'group-labels and special labels', 'tablets, which give general particulars, and labels on each object, describing it specially'.[97] Particularly interesting is a comment from a French writer, who, observing that 'the clear and detailed inscriptions, attached to each exhibited object, communicate its interest, value and origin', concedes: 'Nous n'avons pas toute cette solicitude en France'.[98]

Museum display at this period was a wholly pragmatic business, exhibition designers having not yet been invented. Cole had a keen interest in the decoration (often very elaborate) of his galleries, and liked to conduct experiments with colours, but there is no evidence that he gave thought to the aesthetic disposition of exhibits. However, the

museum published in 1876 a book of *Drawings of glass cases in the South Kensington Museum, with suggestions for the arrangement of specimens,* with lithographic illustrations printed by Vincent Brooks and Son. This contained working drawings showing the construction of the various types of showcase used in the museum, so that other museums could commission them from cabinet-makers. But its half-title, 'Arrangement of Art Objects', suggests that its main interest was felt to lie in the plates (printed with pink and yellow tints as well as black outlines), which showed case layouts for different types of objects (divided by material: enamels, glass, metalwork, etc.). These show that somebody in the museum was interested in display techniques. The book includes one display device that was certainly due to Cole. When in 1866 he found that he was running out of wall space for framed flat material, he 'invented a stand', which enabled many frames to be hooked on to a central column in a way 'analogous to the leaves of a book'.[99] He proudly published drawings of his invention (figure 5.5) in the Department's *Sixteenth Report.*

The effect of the museum's displays must have depended to a large extent on the galleries in which they were accommodated. As we have seen, the Boilers offered a rather uncouth background, and the exhibits were very crowded.

THE STAND AS USED FOR DRAWINGS, PRINTS, WOVEN FABRICS, &c.

Cole was anxious to do better in the more permanent buildings. In the first of these, the Sheepshanks Gallery, Captain Fowke and Richard Redgrave lavished great concern on lighting, both on the gas-lighting, which was a daring innovation, and on the top-lighting by natural light, which was diffused through a laylight to avoid glare and reflection.[100] The other galleries that gradually extended round the north-east corner of the site were not particularly enterprising in form or lighting, but the museum began to take on a coherent shape when Fowke glassed in the empty rectangle formed by these galleries, so as to produce the North and South Courts. The museum was now entered by the low office building (the 'Junction'), which Sir James Pennethorne had rapidly run up in 1856 (figure 5.6).[101] Visitors, proceeding down a corridor to their right, would have had no difficulty in ignoring the Boilers, which, further off to their right, contained the non-art collections in increasing neglect and disarray, and making straight for the art collections. They would have apprehended the museum as two great, top-lit courts, surrounded by lower galleries on two storeys. The North Court, where the really large exhibits, like the Tribune from the Church of Santa Chiara in Florence, were to be found, was fairly plain (figure 5.7), but no pains were spared on the decoration of the South Court. Its serried ranks of showcases must have been rather intimidating (figure 5.8). It had been hard to make sense of these during Robinson's Loan Exhibition. After his displacement, Cole announced in his *Eleventh Report* for 1863 (p.xi) that:

The Art Collections have been entirely rearranged during the last year with the view of rendering them useful and instructive to the Art student, manufacturer, and the public, and affording every facility of reference. They have been arranged in classes as far as possible, either chronologically, or according to country, material, or trades. When desirable, reproductions of important objects in the class are added to render each as complete and perfect a representation of the branch of Art as practicable.

This looks very like a reassertion of Cole's pedagogic and systematic methods, reversing Robinson's more antiquarian and aesthetic approach. The plan in the 1865 guide book (figure 5.9) shows a fairly orderly parade of exhibits by material. However indigestible, the display in the South Court must have impressed visitors as a replete visual encyclopaedia of the decorative arts.

It could not last, however. George Wallis apologized ever more desperately in his annual reports for his failure to impose classification, until in 1870 he admitted:

I regret to have to repeat the statement of last year, that the want of space for the proper arrangement and display of objects ... very seriously hinders the final classification of several important sections of the Museum. In fact, the systematic arrangement of some portions of the courts, which prevailed to a considerable extent a year ago, has had to be broken up in order to find space for objects offered on loan ...[102]

The museum was always on the move. 'Constant novelty – ever recurring change – is the law of the place,' said one observer,[103] while another wrote:

Figure 5.6
The museum entrance (Pennethorne's 'Junction' building) in 1872, from a watercolour sketch by C. E. Emery.

(*Facing page*)
Figure 5.5
Henry Cole's pillar stand. Wood-engraving in the Department of Science and Art's *Sixteenth Report*.

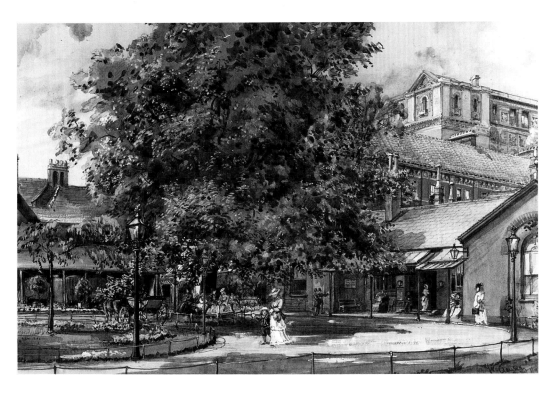

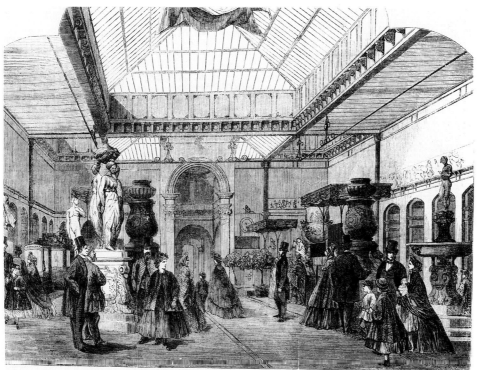

THE NORTH COURT AT THE SOUTH KENSINGTON MUSEUM.

Figure 5.7
The North Court, with the Chapel of Santa Chiara, Florence, at the rear. Wood-engraving from the *Illustrated London News*, 25 June 1864.

(*Below left*)
Figure 5.8
A view of the South Court in the 1860s.

(*Below*)
Figure 5.9
Plan of the North and South Courts, from the 1865 guide book.

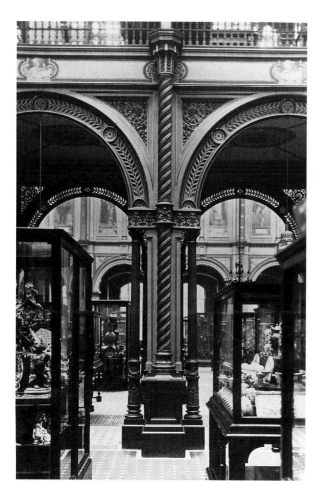

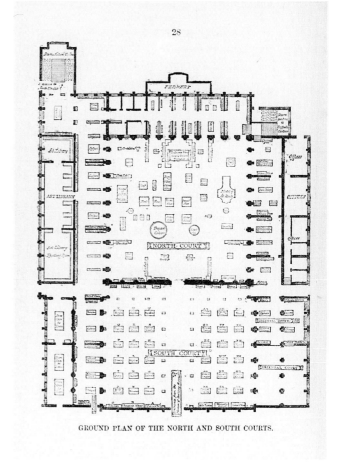

GROUND PLAN OF THE NORTH AND SOUTH COURTS.

There is always something new in the Museum, and if this lead[s] to such constant change in the arrangements that it is sometimes difficult to find what is wanted, it has the advantage of assuring visitors that they can scarcely go too often.[104]

Change occurred not only to the displays, but also to the building. An American visitor asked at the catalogue stall for a photograph of the building and, on finding none available, reproached the sales assistant. '"Why, Sir," replied the man, mildly, "you see, the museum doesn't stand still long enough to be photographed."'[105]

The museum did, in the 1860s, at last acquire a public façade. Having consolidated the north-east corner of the site with the great courts and their surrounding galleries, Captain Fowke started on another quadrangle further west.[106] This included a central block, housing three new restaurant rooms on the ground floor with a lecture theatre above, which Fowke intended as the principal entrance to the museum. It was in this quadrangle that the 'South Kensington style' of architecture made its first appearance in the museum.

Cole had researched this style, which used revived motifs of the Italian Renaissance, while convalescing in Italy in 1858–9. Its attraction for the South Kensington authorities was that it could be carried out cheaply and quickly, but

nonetheless elegantly, in brick and terracotta. It was first used in the Royal Horticultural Society's Gardens, opened in South Kensington in 1861. These solved the embarrassing problem of what to do with the main part of the Commissioners' site, the rectangle lying between the present-day Cromwell Road, Exhibition Road, Kensington Gore and Queen's Gate. At first it had been intended that the National Gallery should occupy part of this area, and the South Kensington Museum had been kept out of its way in the outlying part of the site to the east of Exhibition Road. When the National Gallery failed to move, the main rectangle remained empty until 1859, when the Horticultural Society, of which Prince Albert was President, agreed to open a formal garden there (leaving space at the southern end for the building that housed the International Exhibition of 1862). The garden was in the Italian style, with beds of flowers and coloured gravel, walks, statuary, a maze, waterworks – including ponds, canals, fountains and a cascade – and a grand conservatory. It was surrounded by arcades, behind which ran galleries, for the most part one room deep. It was on the arcades, some designed by Sydney Smirke and some by Fowke, that the South Kensington style initially appeared. Its success owed much to the sculptor who modelled the terracotta decorations, Godfrey

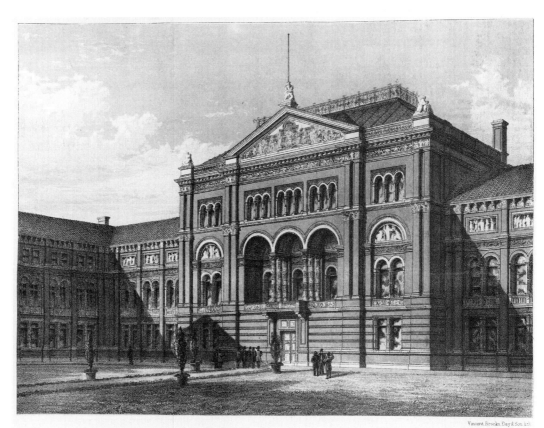

SOUTH KENSINGTON MUSEUM
DESIGNED BY CAPTAIN FOWKE R.E. THE ORNAMENTATION BY GODFREY SYKES

Figure 5.10
The lithograph, by Vincent Brooks, Day and Son, of the South Kensington Museum entrance façade (now the north side of the quadrangle) used as frontispiece in the guide books.

87

Sykes, and his associates James Gamble and Reuben Townroe; all three came from Sheffield to join Cole's in-house design team.[107]

After their work on the Horticultural Gardens arcades, they worked on the façades of Fowke's quadrangle. The central feature had, within a terracotta doorcase containing reliefs of Science and Art, bronze doors with reliefs of scientists and artists. Above were three recessed arches, supported on terracotta columns with decorative bands representing Childhood, Manhood and Old Age. In the pediment was a mosaic commemorating the 1851 exhibition. This intended entrance façade was illustrated, in a chromolithograph, as the frontispiece to the red guide books from about 1870 (figure 5.10), and it became a sort of trade mark for the museum, frequently being reproduced as a wood-engraving in foreign periodicals.[108] Fowke's new buildings offered the museum more gallery space for expansion, and so did the arcades in the Horticultural Gardens, which provided a circuit of rooms almost three-quarters of a mile in length. Into this museological race-track, across Exhibition Road, the scientific collections gradually moved. Thus the museum as a whole began to sprawl erratically, while the art collections became concentrated in the prime spaces.

Activity and change are by no means a fault in a museum. Cole intended his museum to be a lively place. It was owing to his 'energy and indefatigable perseverance', said a contemporary critic, that loan exhibitions 'became a distinctive feature' of the museum.[109] Cole's exhibition programme included *Portrait Miniatures* (1865), *National Portraits* over the following three years (these were the germ of the National Portrait Gallery), the Meyrick collection of armour (1868), *Fans* (1870), *Ancient Musical Instruments* (1872), *Ancient and Modern Jewellery* (1872) and *Decorative Art Needlework before 1800* (1873).[110] Arrangements were made with extraordinary promptitude: for the jewellery exhibition, the committee met for the first time in March 1872 and the exhibition, containing 1,485 items, opened in early June.[111]

The museum encouraged special events. From the beginning, outside bodies were urged to hire (for a fee to cover gas lighting and attendants) the lecture theatre or museum galleries for their soirées. The Fine Arts Club and the Chemical Society were among the first takers in July 1857.[112] The museum arranged lecture programmes. As any curator knows, capturing an audience for lectures is a chancy business, so it is perhaps not surprising that we find comments lamenting that the lectures were 'very little known' and 'very badly attended, owing to the inconvenient hour at which they were delivered, [and] the distance of the lecture-room from the city'.[113] Gallery lectures were tried at the start, and were successful in so far as they

attracted crowds, but had to be abandoned because the crowds became unmanageable.[114]

The comfort of visitors was regarded as important. In museological circles, Cole is still esteemed as the first museum director to open a restaurant.[115] This was originally housed in a building at the very eastern edge of the site. It was the first thing the visitor saw, and with its half-timbering and awnings was surely intended to evoke an atmosphere of pleasure-gardens. Later, in 1868, a more dignified suite of three rooms opened in Fowke's entrance block.[116]

Museum souvenir shops were almost a century away (and postcards were still in the future, too), but it is clear that Cole was sensitive to the desire of museum visitors to have visual records of what they had seen. The museum's photographic studio[117] provided prints for sale (thus causing professional photographers to complain to the 1860 Select Committee, as we have noticed). Three-dimensional reproductions of many exhibits were also available. Today museums might feel reluctant to subject historical objects to the processes necessary for producing plaster casts or electrotypes, but there seem to have been no such scruples in the nineteenth century, just as there was no inhibition about exhibiting reproductions alongside originals. After the Soltykoff sale, when Britain had seized many 'precious relics of Christian art', which had hitherto been in France, a French writer in the scholarly journal *Annales Archéologiques* sought comfort in the expectation that, in England, these objects

will be photographed, moulded in plaster, reproduced by electrotyping, copied by pencil and burin, and in various ways will be liberated to archaeologists, art historians, manufacturers and artisans, to be studied, described, imitated, copied and sold. That is a consolation in our disappointment.[118]

In 1869, the Department of Science and Art published a series of impressive catalogues of reproductions made from its own objects and those of 'continental museums and other public and private collections'. As well as photographs,[119] these included electrotypes (made by the commercial firms Elkington and Franchi), plaster casts (made in London by Brucciani, Franchi, Jackson and the British Museum, and also obtained from suppliers in Paris, Rome, Florence, Milan, Munich and Brussels), and fictile ivories (made by the Arundel Society in Britain). There were also four volumes of etchings of South Kensington exhibits by students in the Art Schools,[120] and several portfolios of chromolithographs. All these reproductions were intended, according to a legend on the catalogue title-pages, 'for the use of schools of art, for prizes, and for general purposes of public instruction'. But it was not impossible to regard such reproductions as souvenirs. In 1867, when some electrotypes of Russian silverwork were exhibited in the

museum, the makers of the electrotypes, Messrs Franchi, offered them also to the public in various finishes to suit different pockets and tastes. One bowl was offered thus:

A copper-bronzed copy ... can be purchased by collectors or others ... for 3*l.*, or a silver and oxydized copy for 4*l.*, or a gilt copy for 6*l.*, or, still more highly prized, a parcel-gilt copy, such as an abbot of any of our richest monasteries would have been proud to place upon his hospitable board, for 7*l.*[121]

Information about the subjects that the museum covered was available from the various libraries, the principal one being the Art Library. Despite being crowded into small rooms next to the North Court, and thus 'imperfectly supplied with borrowed light', the library was accessible to all and provided quick and helpful service:

The officers of the library ... seem to have not only a personal acquaintance, but an intimate friendship, with the authors whose works are on the shelves, and to take positive pleasure in affording such an introduction as the student may be blindly attempting to obtain ... More information can be garnered at South Kensington in a day than at Bloomsbury [i.e. the British Museum Library] in a week or more.[122]

Cole devised one of his most expansive schemes for the benefit of the library. Deciding that it ought to have not just a catalogue of the books it possessed, but a list of all the books ever published that it ought to possess, he set J.H. Pollen to work compiling the *Universal Catalogue of Books on Art.* This remarkable and unprecedented, comprehensive art bibliography was compiled with the help of 'upwards of 400 correspondents in different parts of the world',[123] and was eventually published as a volume in 1870. A pasted-up version (to include material published after 1870) served for many years as the library's catalogue, with press marks written against those items that the library possessed, and tantalizing blanks against those it had not yet secured.

To annex the whole world to his purposes was typical of Cole. His enthusiasm for reproductions led him, in 1864, to obtain the help of the Foreign Office in setting up an International Exchange of Copies of Works of Art.[124] Even more ambitiously, he projected 'an universal inventory of objects dispersed in churches, public buildings and such like' and, with the help of foreign correspondents, published several substantial lists towards this survey of the European artistic patrimony.[125]

On the smaller stage of Britain, he felt that he had tried to create a nationwide museum service. South Kensington, which had planted art schools all over the country, had also proffered its support in founding museums, but with less success. 'We cried and howled, as it were, in the wilderness, but no one would listen to us.'[126] Towards the end of his career, Cole returned to the Radical battlefield where it had begun, and headed a Society of Arts Committee that promoted the more energetic implementation of William Ewart's Libraries and Museums Acts of 1845 and 1850. By 1869 only 31 free libraries and museums had been established – through 'spasmodic efforts and extraordinary inducements, and by accidents of various kinds' – and Cole thought this was 'not satisfactory progress'. He led his committee to lobby the Government in favour of the proposition 'that free libraries and museums should be regarded as parts of a system of national education, and assisted by funds voted by Parliament, in addition to local rates'.[127]

All this amounts to a truly awe-inspiring record of professional activity[128] at a time when the museum profession hardly yet existed. And it must be remembered that running the museum was not Cole's full-time job. He was intermittently engaged with International Exhibitions, but his full-time job was to run the entire Department of Science and Art. In 1869, in an internal memorandum, he described his Department as:

1. A UNIVERSITY [because it granted qualifications] ...
2. A SCHOOLMASTER actually affording instruction ...
3. A MUSEUM ... open every week day ... throughout the year ...
4. A CIRCULATING EXHIBITION ...
5. A STOREKEEPER of valuable public property ...
6. A PRODUCER of special objects for its own use ...
7. AN ARCHITECT, Builder and Decorator, directing the construction and ornamentation of its own buildings ...
8. A REFEREE for other public departments ...
9. A REVENUE DEPARTMENT collecting public funds.
10. An ordinary PUBLIC OFFICE conducting correspondence.
11. A DEPARTMENT of Control charged with inspection and superintendence of various institutions receiving aid from the state ...[129]

Thus Cole (figure 5.11) exulted in his protean capabilities. Of course, such swagger invited mockery. In *St Paul's Magazine,* March 1872 (pp. 242–7), there is a thinly disguised burlesque on Cole and his department, 'the Department of Aesthetics and Commonplace', which had 'developed an incessant activity and an insatiable capacity for the absorption and dispersal of national funds'. Its 'Plenipotentiary'

had harnessed Majesty, princes, administrators, ministers of state, permanent secretaries, to aid him in spite of themselves, in forming a labyrinthine accretion of offices, departments, sub-departments, sections and sub-sections, embracing all things known and many unknown. Of these ramified bureaus probably none but he could trace the windings or define the relations.

The Plenipotentiary 'braved the impertinent criticism of the public press', for he was 'armed in triple brass, [and] he knew that metal invulnerable to the quill or to the acids of satire. He watched political movements with the keenness of a cat' and with 'the potent spell of a stage magician'

Figure 5.11 Henry Cole in about 1870, photographed by Melluish.

extracted quantities of public money for his 'mysterious and inviolable' Department: 'Its brilliancy, its audacity, its effrontery of disdain for criticism, its steady and unflinching faith in the stupidity of a British public, were splendid evidences of the genius with which it was managed.' The Department built itself a lavish abode:

The ground on which [it] was localized exhibited a perpetual transformation scene. Iron gave way to stone: wood to brick; brick to stucco; stucco to terra-cotta, or majolica, or mosaic. Aladdin's palace was scarcely so wonderful or so fickle as were the palaces of this department.

Within the palaces were to be found:

music and patents; paintings and teapots; miniatures and pulpits; old vestments and crockery; pottery and armour; chemicals, stuffed animals, and gems; chariots, models, drawings, plants, iron-mongery, furniture, food, frescoes; mechanics, hydraulics, hydrostatics, dynamics, engineering, naval architecture and the fine arts, here met in whimsical and irregular confusion.

Furthermore, the Department was always in search of more:

There was nothing so gigantic as to exceed its desires, nothing too infinitesimal to be beneath its notice. Now it purchased a rare collection of stuffed fleas for Her Majesty's Government: then, it imported a pagoda a hundred feet in diameter and

twenty stories high ...: now it expended a hundred guineas on an Icelandic costume one would have expected any ordinary showman to pick up for ten: then it purchased antique fiddles for as many pounds as they had numbered years of existence: now it invested in children's toys, then in old clothes ... It ransacked palaces and private houses, and the shops of pawnbrokers. The department was an official ostrich, with an official catalogue of the heterogeneous and indigestible contents of its stomach.

Keeping his most pointed barb until last, the writer denounced the Department for its intermixture of 'public duties and private enterprise'. Cole would probably have taken this as a compliment.

Cole lived at a fortunate moment. His attitudes were formed in the Radical Thirties and the Hungry Forties of the nineteenth century. His energy and drive equipped him to seize his chance to shine under Prince Albert's patronage. His resounding achievement at South Kensington exactly coincided with the great period of Victorian social stability and economic prosperity, which ended with the Great Depression in 1873 – that period which Geoffrey Best described in terms of qualities that can be seen as essentially those of Henry Cole: 'buoyant optimism and bold confident enterprise'.[130]

NOTES

1 *Introductory Addresses on the Science and Art Department and the South Kensington Museum. No. 1. The Functions of the Science and Art Department. By Henry Cole ... 16th Nov. 1857*, London: Chapman and Hall, 1857, p. 23.

2 *Tenth Report* [for 1862], p. 184.

3 See the comparative table in *Twentieth Report* [for 1872], p. 496.

4 *Building News*, 27 November 1857, p. 1252.

5 Alfred Darcel, *Excursion Artistique en Angleterre*, Rouen: D. Brière, 1858, p. 58.

6 *Report from the Select Committee on the South Kensington Museum; together with the Proceedings of the Committee, Minutes of Evidence, and Appendix. Ordered, by the House of Commons, to be Printed, 1 August 1860*, paras 126–30. Cole's formidable rival at the British Museum, Antonio Panizzi, also surveyed his visitors: ibid., para. 1699.

7 Walter Crane, *An Artist's Reminiscences*, London: Methuen, 1907, p. 44.

8 *Illustrated Times*, 27 June 1857, p. 411.

9 *Survey of London ... The Museums Area*, p. 194.

10 *Report from the Select Committee ... 1860*, para. 724.

11 'The Removal of the Museum Collections to South Kensington', *Building News*, 14 February 1862, p. 101. It was not until the underground Central Line opened in 1900 that a station was created for the British Museum. This disappeared in 1933 when the nearby Holborn station was remodelled. (David Leboff, *London Underground Stations*, Shepperton: Ian Allan, 1994, p. 159.)

12 Leone Levi, 'The Economic Value of Museums and Exhibitions', *Architect*, vol. 20, 1874, p. 200.

13 MS letter to Cole, 17 December 1858, Cole Correspondence (NAL).

14 'Out for a Holiday', *Leisure Hour*, 1 April 1870, p. 248.

15 'Brompton Museum', *Building News*, 10 July 1857, p. 708.

16 Words from his speech at the opening of the City and Spitalfields School of Art, reported in *The Times*, 21 November 1873.

17 *Fifth Report* [for 1857], p. 80.

18 'The Brompton *v.* British Museum', *Builder*, 8 December 1860, p. 790.

19 'A Peep at South Kensington', *Builder*, 21 November 1874, pp. 961–2.

20 This estimate is based on weekly attendance figures quoted in *Building News*, fitfully in 1859 and 1861, and fairly regularly throughout 1860.

21 *Introductory Addresses ...*, pp. 22–3.

22 'The Removal of the Museum Collections to South Kensington', p. 101.

23 *Report from the Select Committee on Arts and their Connexion with Manufactures ... Ordered, by the House of Commons to be Printed, 16 August 1836*, p. v.

24 'Admission to Cathedral and Public Buildings', *The Probe*, no. 10, 1 August 1839, p. 157.

25 Janet Minihan, *The Nationalization of Culture*, London: Hamish Hamilton, 1977, pp. 87ff.

26 *Report from Select Committee on National Monuments and Works of Art; with the Minutes of Evidence ... Ordered, by the House of Commons, to be Printed, 16 June 1841*, paras 2878–80, 2914–33, evidence of Sir Henry Ellis.

27 *The Almanack of Science and Art. Anno Domini 1856*, London: Chapman and Hall [for the] Department of Science and Art [1856], p.[42].

28 Edward Miller, *That Noble Cabinet: A History of the British Museum*, London: André Deutsch, 1973, p. 139.

29 'The Future of South Kensington Museum', *Builder*, 26 July 1873, p. 579.

30 *Introductory Addresses ...*, p. 26.

31 'Conversazione at the Architectural Museum', *Builder*, 24 July 1858, p. 497. Geoffrey Best notes that even in the streets 'workmen in their working-clothes were liable to be "moved on" by the police (*Mid-Victorian Britain 1851–75*, London: Fontana paperback, 1979, p. 297).

32 Speech at the opening of the City and Spitalfields School of Art, 20 November 1873, reported in the *Standard*, 21 November 1873, cutting in George Wallis, *Records of Art, Industry, etc., 1873–1892* [one of a series of scrapbooks in the NAL, press mark PP.34.G].

33 *Fifty Years*, vol. 2, p. 343.

34 Charles Heath Wilson, 'Memorandum relative to the Question of Collecting Examples for the School from Foreign Countries, pursuant to the Proposition of Mr Ker', *Minutes of the Council of the Government School of Design, From December 1836 to April 1844*, London: W. Clowes, 1849, p. 342. Parts of this memorandum were reprinted in the *Third Report of the Council of the School of Design, for the year 1843–4*, London: W. Clowes, 1844, where the quoted sentence was significantly toned down to 'In England the more highly educated classes have acquired a refined taste ...' (p. 20). In this form, it was quoted by Henry Cole to the Select Committee of 1860 (para. 60).

35 'Schools of Design', *Polytechnic Journal*, vol. 1, 1839, p. 61.

36 'Art-education. – A Knowledge of Practical Art', *Home Companion*, 12 March 1853 (cutting in the NAL, press mark 145.F.30).

37 *Athenaeum*, 17 June 1854, p. 754.

38 J. Gardner Wilkinson, *On Colour and on the Necessity for a General Diffusion of Taste among all Classes*, London: John Murray, 1858, pp. 171, 170.

39 'The People's Share in Art', *Builder*, 25 March 1865, pp. 202–3.

40 Charles Lock Eastlake, *Household Taste in Furniture, Upholstery and other details*, 3rd edn, London: Longmans, 1872, pp. 220–1.

41 George Wallis, 'Art-Education for the People', *People's Journal*, 1847, cuttings in George Wallis, *Records of Art, Industry, etc., 1846–1850* [one of a series of scrapbooks in the NAL, press mark PP.34.G], pp. 47ff.

42 *Journal of the Society of Arts*, 14 March 1856, pp. 292, 299.

43 George Wallis, 'The Economical Formation of Art Museums for the People', in *Transactions of the National Association for the Advancement of Art and its Application to Industry, Liverpool Meeting, 1888*, London: 22 Albemarle Street, 1888, pp. 288, 289–90.

44 *Architect*, 21 August 1869, p. 86.

45 'Art-Manufactures', *The Art-World*, 1 March 1862, p. 5.

46 'Striking Novelties at South Kensington', *Builder*, 28 August 1869, p. 678.

47 'South Kensington Museum', *Builder*, 19 December 1868, p. 932.

48 I have not yet traced the source of these words, which are quoted as 'his own words' in 'South Kensington Museum', *Building News*, 21 September 1860, p. 739.

49 *Journal of the Society of Arts*, 21 January 1870, p. 183.

50 William Bell Scott, 'Ornamental Art in England', *Fortnightly Magazine*, 1870, p. 405.

51 *Report from the Select Committee ... 1860*, para. 883.

52 Ibid., para. 731.

53 Ibid., para. 147.

54 Ibid., para. 672.

55 *Précis, 1852–63*, pp. 335 (20 April 1861); 344 (30 May 1861); 316 (13 December 1860); 178 (16 July 1857); 332 (19 March 1861).

56 *Report from the Select Committee ... 1860*, paras 161–3.

57 Ibid., para. 466.

58 Ibid., paras 166, 174, 182.

59 *Précis, 1852–63*, p. 76.

60 Ibid., p. 162.

61 Ibid., pp. 139, 240.

62 Ibid., p. 127.

63 Ibid., pp. 208, 250.

64 *Précis, 1852–63*, pp. 152, 173. *Précis, 1863–9*, s.v. Smith.

65 *Report of the Treasury Commission of Inquiry into the Establishment of the Science and Art Department* [1865], in *Cole Miscellanies*, vol. 14, f. 57.

66 See Appendix 15 in *Second Report from the Select Committee on Museums of the Science and Art Department; together with the Proceedings of the Committee, Minutes of Evidence ... Ordered, by the House of Commons, to be Printed, 23 July 1897*, which quotes a document of 23 December 1867 that includes the passage reproduced in the text.

67 *Art-Journal*, 1863, p. 230.

68 *Précis, 1863–9*, s.v. Art Inventory, 22 December 1863.

69 *Précis, 1863–9*, s.v. Pollen.

70 Cole diary, 31 July 1859.

71 Anne Pollen, *John Hungerford Pollen 1820–1902*, London: John Murray, 1912, pp. 296–7.

72 *Précis, 1863–9*, s.v. Pollen.

73 Pollen, op. cit., pp. 296, 297, 299.

74 For Fortnum, see Ben Thomas and Timothy Wilson (eds), *C.D.E. Fortnum: The collecting and study of applied arts and sculpture in Victorian England*, published as *Journal of the History of Collections*, vol. 11, no. 2, 1999. For Rock, Maskell and Palliser, see *DNB*.

75 Cole diary, 30 August, 3 September 1862, 29 September 1863, 29 November 1864. *Précis*, 1863–9, s.v. Appell.

76 Cole diary, 4, 12, 13 January 1857.

77 *Précis*, 1852–63, p. 363.

78 *Art-Journal*, 1862, p. 109.

79 Cole diary, 28 April 1862.

80 Cole diary, 5 January 1864.

81 *Précis*, 1852–63, p. 265.

82 Ibid., p. 440.

83 *Précis*, 1863–9, s.v. Fowke.

84 Ibid., s.v. Redgrave.

85 *Précis*, 1852–63, p. 211.

86 *Précis*, 1863–9, s.v. Festing.

87 Cole diary, 27, 30 December 1864.

88 *Précis*, 1852–63, p. 144.

89 Crane, op. cit., p. 43.

90 Ibid., p. 229.

91 *Builder*, 13 March 1869, p. 211.

92 See Physick, pp. 165–6 for extended quotations.

93 *Guide to the South Kensington Museum*, No. 1, 20 June 1857, p. 2.

94 *Introductory Addresses ...*, p. 21.

95 *Twelfth Report* [for 1864], p. 177.

96 Ruskin's evidence to the Public Institutions Committee, 20 March 1860. *Works*, ed. E.T. Cook and Alexander Wedderburn, London: George Allen, vol. 16, 1905, p. 475.

97 *Builder*, 17 September 1859, p. 614; 11 December 1858, p. 829.

98 'Le Musée de Kensington', *Magasin Pittoresque*, vol. 37, 1869, p. 218

99 *Fourteenth Report* [for 1866], p. 185; *Sixteenth Report* [for 1868], p. 283. John Physick recalls that, according to Elizabeth Aslin, the only surviving Cole pillar stand was destroyed in the 1970s.

100 See Michael Compton, 'The Architecture of Daylight', in *Palaces of Art: Art Galleries in Britain 1790–1990*, exhibition catalogue, London: Dulwich Picture Gallery, 1991, pp.37–47.

101 Physick, pp. 28–9.

102 *Eighteenth Report* [for 1870], p. 401.

103 'Striking Novelties at South Kensington', *Builder*, 28 August 1869, p. 678.

104 'Gossip in the South Kensington Museum', *Builder*, 19 September 1868, p. 685.

105 M.D. Conway, 'The South Kensington Museum', *Harper's New Monthly Magazine*, no. 304, September 1875, p. 488.

106 See Physick, chapters vii, viii.

107 *Survey of London ... The Museums Area*, chapter 7 and pp. 87–96. John Physick, 'The South Kensington Museum' in Sarah Macready and F.H. Thompson (eds), *Influences in Victorian Art and Architecture*, London: Society of Antiquaries, 1985, pp. 73–80. Martin Barnes and Christopher Whitehead, 'The "Suggestiveness" of Roman Architecture: Henry Cole and Pietro Dovizelli's photographic survey of 1859', *Architectural History*, vol. 41, 1998, pp. 192–207.

108 For example, in 'Le Musée de Kensington', *Magasin Pittoresque*, vol. 37, 1869, p. 217; M.D. Conway, 'The South Kensington Museum', *Harper's New Monthly Magazine*, no. 304, September 1875, p. 486.

109 'The South Kensington Museum', *Chambers's Journal*, 31 October 1873, p. 629.

110 For a full list, see Elizabeth James, *The Victoria and Albert Museum. A Bibliography and Exhibition Chronology, 1852–1996*, London: Fitzroy Dearborn, 1998.

111 *Catalogue of the Loan Exhibition of Ancient and Modern Jewellery and Personal Ornaments*, London: Science and Art Department, South Kensington Museum, 1872, pp. 2, 3.

112 *Précis*, 1852–63, p. 172. *Athenaeum*, 4 July 1857, p. 854.

113 'Lectures at the South Kensington Museum', *Builder*, 19 January 1861, p. 39. 'The South Kensington Museum', *Building News*, 25 August 1865, p. 590.

114 'Our Public Museums and Galleries', *Building News*, 10 July 1868, p. 467. *Journal of the Society of Arts*, 3 July 1868, p. 598.

115 See Kenneth Pearson, *Museums of Influence*, Cambridge: University Press, 1987, p. 49.

116 See Physick, pp. 109–10.

117 See John Physick, *Photography and the South Kensington Museum*, V&A Brochure No. 5, 1975.

118 *Annales Archéologiques*, 1861, p. 106.

119 See 'Photography; The Collection at the Brompton Museum', *Builder*, 8 October 1859, p. 659.

120 *Fifty etchings of objects of art in the South Kensington Museum*, 4 series, London: The Arundel Society, 1867–70. See Trevor Fawcett, 'Plane surfaces and solid bodies: Reproducing three-dimensional art in the nineteenth century', *Visual Resources*, vol. 4, 1987, pp. 1–23.

121 'New Art-Treasures and Reproductions at South Kensington Museum', *Builder*, 23 February 1867, p. 124.

122 'The Art Library at South Kensington', *Builder*, 9 October 1869, pp. 799–800.

123 *Fifty Years*, vol. 1, pp. 341–5.

124 *Fifty Years*, vol. 1, pp. 346–7. *Twelfth Report* [for 1864], pp. 23–31.

125 *Fifty Years*, vol. 1, p. 347.

126 'Provincial Museums of Science and Art', *Builder*, 22 June 1872, p. 485.

127 *Journal of the Society of Arts*, 11 June 1869, pp. 573–4. For Cole's views in retirement, see 'On the National Importance of Local Museums of Science and Art ... An Address ... in Birmingham', *Journal of the Society of Arts*, 23 January 1874, pp. 167–71 (a robust plea for state action, but: 'The Museums Act enforces free admission; I think it ought to allow municipalities to make a charge'). *The Duty of Governments towards Education, Science and Art* ('Observations ... to the Lancashire & Cheshire Union of Institutes at Manchester'), London: privately printed, 1875.

128 For a museologist's assessment of Cole, see Edward Alexander, *Museum Masters: Their Museums and Their Influence*, Nashville, Tennessee: American Association for State and Local History [1983], chapter 6.

129 Printed memorandum, 'July 1869. System of Administration in Practice at the Science and Art Department and South Kensington Museum and the Affiliated Institutions', in Archive: Ed 84/8.

130 Best, op. cit., p. 22.

CHAPTER SIX
South Kensington Under Threat

Henry Cole's daily workload – apart from his periodic involvement in International Exhibitions – was formidable, and the Treasury staff inspection of 1865 recommended that the functions that he combined, as Secretary of the Department of Science and Art and Director of the museum, should be separated into two posts.[1] Cole, riposting in his usual mettlesome spirit, suggested to the Treasury that his salary should be raised in recognition of his unusual exertions.[2] This brought no response, and he decided that if he had to choose between the Department and the museum, he would choose the latter.[3] In the event, he was allowed to continue to exercise both functions until his retirement.

Retirement crossed his mind as he approached his sixtieth birthday, due on 15 July 1868. He mentioned to his Minister that 'I was entitled to ask for Superannuation in July' and proposed to the Department that, rather than paying both his pension and the salary of a successor, they would find it cheaper to keep him on and pay him more.[4] By October 1870, still in the post, he was urging his superiors that he would be 'glad to give up the Secretaryship',[5] but the prospect of a smooth withdrawal was becoming increasingly prejudiced by the Department's bad relations with the Treasury. A significant cause of irritation was a letter from the Treasury to the Department, on 6 February 1867, during Lord Derby's Conservative Administration (1866–8), announcing that Cole himself, as Secretary of his Department, was to be regarded as Accounting Officer, a role previously taken by the Department's professional accountant, Mr Simkins. This led to trouble during Gladstone's Liberal Administration (which took power in December 1868), when, on 8 January 1869, a pernickety Treasury letter demanded that Cole personally sign his accounts.

Cole was riled by this, and may have been emboldened on hearing from his Ministers – Lord de Grey, soon to become Lord Ripon, President of the Council, and W.E. Forster, Vice-President – that they were 'quite disposed to protect Dept against Treasury & Audit office'.[6] Unwisely, on 5 May 1869, Cole despatched a snorter of a memorandum to the Treasury, asking that, since he was compelled to act as Accountant, he might be allowed to change the financial system: '... much reform is needed. If a private merchant's accounts were conducted as the public accounts are, he would be ruined by the cost.'[7] Not surprisingly, the Treasury rebuffed the proposal.

Such inter-departmental wrangling was not, perhaps, very much out of the ordinary, but the discord was soon exacerbated by strife between Cole and the Chancellor of the Exchequer, Robert Lowe. Cole had worked for Lowe before, when he was Cole's junior Minister (Vice-President of the Committee of Council on Education) from 1859 to 1864, during Palmerston's Liberal Administration of 1859–65. Cole's senior Minister, Lord Granville, often left Lowe alone to deal with the weekly Boards at South Kensington, so Cole got to know him well. After their first meeting Cole recorded that Lowe was 'very intelligent indeed',[8] and Lowe later returned the compliment by avowing that he 'thought there was no office so cheaply & well managed as ours'.[9] Remorseless in denouncing and destroying what they saw as the cant of others, they were ferocious in pushing through their own schemes. So long as they were on the same side, they relished each other's abrasive style. Lowe positively encouraged Cole to milk the Treasury: in 1863 he said 'he regretted he had not asked for £10,000 more in the Estimates as they passed so easily'.[10]

In 1869, however, Lowe was in charge of the Treasury and intent on controlling public expenditure. South Kensington now received no favours from him (figures 6.1

Vignette: Wood-engraved illustration from the handbook *The Industrial Arts*, published by the museum in 1876.

and 6.2). On the contrary, he tried to stop Cole's building plans, which at this juncture were focused on the implementation of a proposal by Fowke for the completion of the South Kensington buildings, and the opening of a branch museum at Bethnal Green. Throughout 1869 and 1870 there was 'much friction with Treasury'.[11] Cole's Ministers, who felt 'bullied' by Lowe and were 'both stiff about the Treasury, & its authority',[12] struggled to defend their position – and did achieve some success, for the museum at Bethnal Green went ahead.[13] The Treasury and the Audit Office harried the Accountant, Mr Simkins, who kept too much ready cash in the Department's current balance, and Cole tried to replace him[14] because he 'gave ... much reason for dissatisfaction on account of his procrastinating habits, and for promising and not performing'.[15]

Simkins, who had been with the Department since its early days under the Board of Trade, turned out to be worse than inefficient. In early June 1871 Mr Vine of the Audit Office, by whom Simkins's accounts were regularly scrutinized, spotted what he thought was a mistake, and announced that he would call at South Kensington in three days' time to investigate it. But Simkins had been embezzling from the funds at his disposal for paying wages and other current expenses, and now, fearing that the game was up, absconded. After much puzzling through the accounts, it was established that he had milked the Department of £7,703 15s. 7d.[16]

The Treasury saw its chance to crush Cole. He was officially Accountant for his Department, and R.W. Lingen, Permanent Secretary of the Treasury, argued that he ought

Antagonists.
Figure 6.1 Henry Cole, a lithographic caricature by James Tissot in *Vanity Fair*, 19 August 1871.

Figure 6.2 Robert Lowe, a lithographic caricature by 'Ape' (Carlo Pellegrini) in *Vanity Fair*, 27 February 1869. Lowe was an albino, and had very poor sight.

to have detected Simkins's fraud. Cole argued that this was the job of the Audit Office, which saw the accounts regularly and had in the end uncovered the fraud, though almost by accident. Forster, his Minister, told Cole that 'the audit office was able to check right expenditure but unable to check wrong expenditure',[17] which must have been scant consolation. The Treasury's arraignment of Cole (written by Lingen, who had long been a henchman of Lowe) was strikingly aggressive, demanding 'that Mr Cole must be removed from the position of accountant'. Cole's reply was reasoned and dignified – but perhaps only because Lord Ripon required him to soften and alter his first draft.[18] Something of his usual bluster comes through only in this rolling paragraph:

Can it seriously be maintained that when the Treasury assigned to me the duty of rendering the Appropriation Account, an appointment which they did not even communicate to me, but allowed the first intimation of it to percolate through the Audit Office months afterwards, it suddenly became my duty to undertake these technical investigations in addition to my other duties; that I became personally liable and responsible in detail for the acts of the Accountant, an agent whom I did not appoint, and could not remove, working under a system which I did not frame, which renders checking practically impossible, and which I took the first opportunity of denouncing for its inherent faultiness – can this, I say, be seriously maintained?

Cole claimed that he was being made a scapegoat for the Treasury's inefficiency, and demanded to testify before the Commons Public Accounts Committee, which he did on 23 January, 24 April and 8, 15 and 16 May 1872. He survived, and his Ministers refused to sack him at the Treasury's behest. The imbroglio delayed his retirement, however. Returning from his summer vacation in 1871, he had submitted his resignation on 26 October, but agreed that he had to stay to face the music.[19] He eventually went at the end of July 1873.

Cole's quarrel with Lowe ('internecine war' in Lowe's words)[20] left the Department battered and apprehensive. On 27 April 1872 Cole recorded that Redgrave pleaded with him 'to avoid vanquishing Lowe any more as he was so spiteful and powerful'.[21] Once the battle was over, speculation turned to who would succeed Cole in the Directorship. Cole had sounded out Henry Scott (who succeeded Fowke as head of the South Kensington Works Office, and was Secretary to the 1851 Commissioners) as a possible candidate as early as 1867,[22] and was still encouraging him in 1872.[23] By 28 April 1873 Scott had heard that Philip Cunliffe Owen was a likely contender.[24] Although Cole proffered advice to Lord Ripon on his successor,[25] Ripon kept his cards close to his chest. Cole even offered that, if John Donnelly were to be made Secretary of the Department, he would be prepared to stay on as Honorary Director. Ripon

cannily replied, 'You still want to have a hold over us.'[26] It was only on 7 July that Ripon 'told me what Cabinet contemplated ab[ou]t the Museum & asked for my objections'. Now came a bolt from the blue.

'A rumour reaches us,' wrote the *Builder* on 26 July 1873 (p. 579), 'that Mr Lowe intends to place South Kensington in the hands of the governing body of the British Museum.' With Cole out of the way, the museum was finally to be brought to heel, as it seemed to many observers. Cole's admirers praised the way in which his resolution and energy had brought the South Kensington Museum 'to its present magnificent proportions in the teeth of such virulent opposition and persistent ridicule as would have discouraged and disgusted most men, and against which no ordinary man could have successfully worked'.[27] His enemies, however, regarded Cole as an unscrupulous go-getter. They thought his Department had gained too much money and that he had enjoyed too easy access to Cabinet Ministers.[28] He had been a 'dictator', an 'autocrat'.[29] Now the officials whom he had so often outraged were trying to bring his 'kingdom under the *régime* of constitutional red tape', 'to reduce to proper subjection and discipline the province of this insolent pro-consul'.[30]

Gladstone was asked in the House of Commons whether the rumour was true, and carefully replied that the Government was indeed considering future arrangements for the South Kensington Museum, and that these 'connected themselves to a certain extent to the British Museum', because the latter's natural history collections were about to be rehoused on the 1851 Commissioners' South Kensington site.[31] Actually, the provision of the new building for the natural history collections had been under consideration since 1860, and, although the first bricks were laid in 1873, the building did not open until 1881. So there was surely no pressing reason why this project (even though Gladstone was an enthusiastic supporter of it) should suddenly become a decisive influence on the fate of the South Kensington Museum. Presumably Gladstone was stone-walling.

The controversy went quiet during Parliament's summer recess, and Cole travelled abroad on holiday. When he returned, however, he told MacLeod that he would fight to the death for South Kensington,[32] and he at once set about it by well-tried methods. Aiming to outflank his opponents, he got the Society of Arts to set up what he provisionally called a 'Museums Reform Committee',[33] in which Lyon Playfair was to be chief spokesman – until Playfair's appointment as Postmaster General compelled him to withdraw. This was an attempt to sweep up the South Kensington problem into a wider movement in support of 'National Museums' generally.[34] The campaign was to bring forth Cole's significant speech 'On the National

Importance of Local Museums of Science and Art' at Birmingham in January 1874.[35]

Cole also took advantage of his platform engagements to campaign personally. On 20 October 1873 he was due to present the prizes at the Hanley School of Art, and he delivered a fighting speech 'on the origin and work of the Department of Science and Art, and on the future prospects of the South Kensington Museum'.[36] At the very beginning he deployed a favourite and trusted weapon, as he congratulated the Hanley students on taking part in an educational system 'which the nation owed to the wise foresight of the late Prince Consort. (Cheers.)' Repeatedly invoking Prince Albert, he recapitulated the history of the Hanley School and of the entire network of Science and Art education, punching home his points with statistics. 'In 1852 ... there was ... no teaching in schools for the poor; now 194,500 children were taught drawing. There were then no night classes for artisans; now there were 538 classes, with 17,200 students ...' He went on to describe the growth of the South Kensington Museum, and to praise the value of art museums to productive industry, invoking, with many a rhetorical question, the examples of designers who had been inspired by art of the past: Flaxman, Pugin, Minton, 'the Craces, and Jackson, and Graham, and Gillows and Hollands'. Warming to his theme, he roared that:

It was simple, savage ignorance and priggish pedantry not to recognize the absolute necessity for examples of art easily consultable by the public who were consumers, by the manufacturers who were producers, and by artists and artisans who were students. (Hear, hear.)

Then, in an abrupt change of tone, he warned that:

this organization, so wisely instituted and so bravely fought for by the Prince Consort, which had already borne fruits greatly prized by the nation and imitated by foreign Governments – this organization, so indispensable for the progress of this country, commercially, socially, and morally, was now in great jeopardy.

He recalled the statesmen of both parties who had supported the Department of Science and Art, and emphasized the importance 'of a management which insured individual Parliamentary responsibility' under these Ministers. Then, mounting his hobby-horse (the futility of Boards of Trustees), he soared aloft. Would his audience not be surprised, he demanded, to learn that the museum was to be

dissevered from the system and placed in the hands of – could they guess whom? – the Archbishop of Canterbury (laughter), the Lord Chancellor, the Speaker of the House of Commons, the Bishop of London ... and some 30 other persons ... well worked with other business. (Hear, hear.) It would be asked why that excellent, over-worked Prelate, the Archbishop of Canterbury, was to be burdened with the additional work of settling whether the Hanley School of Art should or should

not borrow a cup or a dish as a pattern from the Kensington Museum ...

And from ridiculing the Trustees of the British Museum, Cole turned to condemning the state of that museum itself, and to contrasting it with the paradisal state of South Kensington. 'Were they,' he challenged his audience in his peroration, 'going to permit this work of the Prince Consort, matured and organized with great care and the labour of years, to be destroyed ...?' Finally, he gave his audience the pledge that he himself would 'preserve from the hands of the ignorant spoiler their privileges and the institution which the Prince Consort founded. (Loud cheers.)'

To hear this oration, which was described as 'a powerful political speech',[37] and which was widely reported, must have been an electrifying experience. More was to come, when Cole spoke at the opening of the reconstituted City and Spitalfields School of Art in Bishopsgate on 20 November 1873. In one of those strange reverses so typical of political life, Robert Lowe, the devil in this story, had fallen from grace during the summer of 1873. He had offended so many interests as Chancellor of the Exchequer that the Prime Minister, Gladstone, himself took over the Chancellorship in August and moved Lowe to the Home Office. Cole could not resist putting the boot in. 'Providence,' he crowed to his Bishopsgate audience, had removed Lowe 'from his sphere of mischief.'[38] He went on to denounce 'the flinty bosom of the late Chancellor of the Exchequer, who was a wilful man, a man of very bad judgment, no statesman whatever – in fact, a milk and water Rabelais'. Although no one knew what this last epithet meant, it was generally felt that Cole had gone too far with 'these wild forms of objurgation'.[39] 'We cannot but regret that Mr Cole should ... have lost his temper or his head,' said the Standard.[40] 'The public,' opined The Times, 'will not view ... leniently such a violation of the rules of good behaviour.'[41]

Cole's friends Lord Granville and Sir Joseph Whitworth urged him to make an apology,[42] which he did in a speech at Kidderminster School of Art on 23 January 1874. But he contrived so to phrase the apology as to retain the moral high ground:

The South Kensington Museum has been as my child, to which I have devoted days and nights of more than twenty years ... It has set an example which has been copied by thirty-five new museums in Europe. Some weeks ago I had to defend its present constitution, on which the life of the museum depends, and I was provoked to make some observations on a late political chief. I omitted to say that during his connection with the museum as vice-president he had shown me uniform kindness, had taken a cordial interest in the working of the institution, and had on all occasions been its champion, but had lately become its opponent, and seriously endangered the independent existence and usefulness of that museum for which I

would lay down my life. These observations have caused regret to some of my best friends; and I must have been wrong in making them, and regret having done so.[43]

Cole's campaign was probably something of an embarrassment to the colleagues he left behind. It was reported that at South Kensington 'the great C.B.'s retirement is not regarded as an unmitigated affliction', for 'the 'shoe' has 'pinched' in a good many corridors and galleries ..., and it has not always been the ex-Chancellor of the Exchequer who has ... turned on the "screw"'.[44] At any rate, while Cole campaigned, the officials were closeted in committee. MacLeod, Donnelly and Sir Francis Sandford (Cole's opposite number as Secretary of the Education Department, which was also supervised by the Committee of the Privy Council on Education) were brought together with three members of the staff of the British Museum (John Winter Jones, the Director; Charles Newton, Keeper of Greek and Roman Antiquities; and A.W. Franks, Keeper of British and Mediaeval Antiquities) to try to work out a means of implementing Lowe's plan. They conscientiously did as they were ordered, but their deliberations only served to expose the difficulties inherent in the plan. The idea had been that the British Museum should take over only the museum at South Kensington (not the Department of Science and Art with its nationwide school system), and it turned out that it did not want the whole of the museum. Lowe himself, it seems, had intended that 'such of the South Kensington Collections as were for *self-instruction* were to be taken by the [British Museum] Trustees, while what was a matter of State aid for *education* was to remain under the Science and Art Department'.[45] What this means is far from clear, but Donnelly paraphrased it for Cole: 'Brit Mus: Trio wd not take *all* of SKM, but only what Fine Art they could.'[46] It proved impossible to find a way of dividing up the South Kensington buildings so that the highly selective British Museum could control its small chosen part of the museum; and, as John Physick has described, it was left to the civil servant who acted as Secretary to the Committee, C.W. Merrifield, to find a solution.[47]

The British Museum was quietly left out of the equation. The Department of Science and Art was to survive, but it was to be brought under the control of the Secretary of the Education Department, Sir Francis Sandford, with MacLeod continuing as Assistant Secretary, in charge at South Kensington. The directorship of the museum was to be a separate post, and in February 1874 Philip Cunliffe Owen was appointed to it. South Kensington could breathe a sigh of relief and try to get back to normal.

These turbulent events, which threatened the very existence of the South Kensington Museum, may well prompt us to assess the strength of its position, at the moment when its irresistible founding Director stepped down. As we have seen, when the Museum of Ornamental Art was first set up, its only serious rivals in Britain were the British Museum and the National Gallery. Had it established a *modus vivendi* with them? And what of relations between these museums in the future?

These questions are more easily answered in respect of the National Gallery. The two institutions had close, if uncomfortable ties, in the early days. The museum at first shared Marlborough House with the English paintings from the National Gallery, and these accompanied it to South Kensington. As we have seen, the presence of paintings at South Kensington undoubtedly helped to attract visitors, but the museum and the National Gallery were drawn into tetchy territorial disputes.[48] South Kensington proceeded to acquire its own collection of paintings, in the form of the Sheepshanks Gift, and, in due course, further gifts and bequests. Consequently, when in due course the National Gallery removed its pictures from South Kensington, in May 1876,[49] there remained in the museum a substantial collection, which was described on the title-page of its catalogue (1874) as ... *the National Gallery of British Art at South Kensington: with ... works by modern foreign artists and old masters.* Editions of this catalogue appeared as late as 1907 and 1908 with the title *National Gallery of British Art, Victoria and Albert Museum,* even though Sir Henry Tate's new gallery had opened on Millbank in 1896 and also used the title 'National Gallery of British Art'. Since then, the collection has continued to reside in the V&A with no particular title. From time to time proposals are still made for shuffling the V&A's pictures around to other museums,[50] on the grounds that they are anomalous in a decorative arts museum, but discussions (like the negotiations with the British Museum in 1873) seem to centre on haggling over the star items, without progressing to the disposal of the rest. All in all, South Kensington does not seriously overlap or compete with the National Gallery, and therefore has always got along well enough with it.

There has been a keener sense of competition with the British Museum. As we have seen, Henry Cole, in the early days, set up the British Museum as an example of what the South Kensington Museum would not be: stuffy, standoffish, negligent, boring. With his Benthamite views, it suited him to believe that the British Museum was in a bad way because of its inefficient manner of administration – by a large Board of irresponsible Trustees. He pressed this argument in an article on 'Public Galleries and Irresponsible Boards' in the *Edinburgh Review* in January 1866. Interpreting the appearance of the British Museum as an index of its managerial condition, he described 'a national disgrace. An over-crowded building ... ill cared-for and ill-lighted ... specimens ... crowded in cases which are not dust-tight and sluttishly neglected; labels wanting ...

an air of sleepy, slatternly shabbiness'.[51] When he popped into the British Museum, he liked to note in his diary the continuing evidence of its inadequacy: 'Dirty & neglected' (23 November 1863); 'Bad lighting ... Dirt destroying Egyptian Mummies: Imperfect labelling ...' (31 January 1870). His ideological antipathy to the museum fuelled his anger when the proposal came in 1873 to hand over his own museum into its charge. The *Builder* might have been speaking for him when it then said: 'The British Museum is a grand institution, with noblemen, gentlemen, and scholars connected with it, but the principle which has ruled, and does rule, there, is entirely opposite to that which has made South Kensington the most useful, delightful and popular institution in the kingdom.'[52]

Aside from the issue of management, however, there were serious questions to be faced as to whether the British Museum and South Kensington were competing and over-lapping in their collecting activity. J.C. Robinson rather airily took the line that there was no conflict of interest. When he had started in the 1850s to build up collections of post-classical decorative arts, the British Museum 'had shown no sign of sympathy' with South Kensington's efforts, and had 'remained wrapped up in its accustomed exclusiveness'. Consequently Robinson pressed onwards, and in 1880 he was able to rejoice that 'the vacant ground has been occupied, and a National Museum of Mediaeval and Modern Art has been created at South Kensington, which has now no rival in Europe'.[53] It was true that the British Museum had later gone on to acquire medieval material, but, since South Kensington was in the lead, Robinson contended that the British Museum should with-draw from this field. 'No harm has yet been done by this concurrent action – if there has been rivalry, there has been no antagonism, and the nation is all the richer in art treasures; but it is perhaps time that this state of things should cease.'[54]

It has to be admitted, however, that Robinson was play-ing down the achievements of the British Museum. For his every move in acquiring medieval and Renaissance treasures for South Kensington had been matched by the feats of a curator in Bloomsbury. This was Augustus Wollaston Franks (figure 6.3). Born in 1826, he was just 15 months younger than Robinson and of rather better social origins. He graduated from Cambridge in 1849, but took only an ordinary degree, as he preferred to devote him-self to 'Church Architecture and Archaeology'.[55] His first professional foray into his chosen field was as Secretary ('a tough piece of work from which I learned much')[56] to the exhibition of Ancient and Mediaeval Art mounted by the Society of Arts in 1850. Here he would have met Henry Cole, who served on the exhibition Committee. The follow-ing year Franks joined the staff of the British Museum,

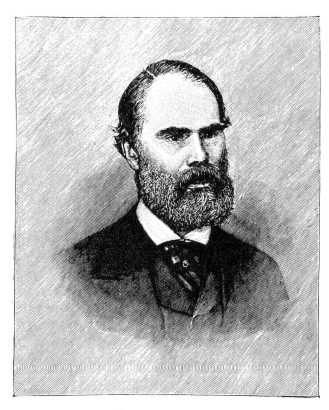

Figure 6.3 Augustus Wollaston Franks, the curator who devoted his lifetime to building up the British Museum's collection of decorative art, and establishing it as an independent department. From the *Art Journal*, 1891.

where he stayed for 45 years. His brief was to look after 'the British and Mediaeval collections', and at the start he was a member of the Department of Antiquities, which was chiefly concerned with Greek, Roman and Egyptian antiquities. When it was subdivided in 1860, Franks found himself for a time, incongruously, in the Department of Oriental Antiquities, but in 1866 he got his own Depart-ment of British and Medieval Antiquities and Ethnography. As his progress may suggest, Franks had the diplomatic skills (so obviously lacking in Robinson) to build up his posi-tion gradually within his institution. He had the advantage, too, that he was rich and a bachelor, and so was able to regard institutional pressures more lightly than Robinson could. He had a wider range than Robinson and, equal to him as a connoisseur of medieval and Renaissance decorative arts, also had the expertise to create the British Museum's collections of ethnography and of British archaeology.

Franks's relationship with South Kensington might well have been much closer than it actually turned out to be. 'With regard to the South Kensington Museum', he wrote:

I may mention that soon after it was established at Marlborough House Sir Henry (then Mr) Cole tried to persuade

me to take charge of the collections. This was early in my career, the pay was to be better, and the situation of the collections so near my Club was tempting. I had however thrown in my lot with the British Museum and stuck to it. The same proposal was again made to me when Mr J.C. Robinson resigned, with the same effect.

Yet another offer came when he took part in the discussions of 1873 on Robert Lowe's proposal to hand over the South Kensington Museum to the British Museum:

Mr Winter Jones then principal Librarian told me that I should be expected to become Director of the South Kensington Museum, that office being then vacant, if the collections were transferred to the administration of the Trustees. To this I strongly objected. I was not therefore greatly grieved that after our report the offer was withdrawn ...[57]

Robinson's achievement in building the collections at South Kensington is impressive enough; if Franks's efforts had been added to his, the results would no doubt have been prodigious.

As we have seen, Henry Cole's attitude to the British Museum was often hostile. It was often predatory, too: whatever the British Museum's faults, he wanted to gobble it up. In early discussions with Prince Albert about the development of the South Kensington site in 1852, he proposed 'to bring there the overflowings of the Brit Mus'.[58] And when, in 1854, Cole was toying with the 'idea of asking to be commissioned to report on Consolidation of Museums',[59] no doubt he had in mind that the collections of the British Museum and others might be consolidated in his own hands. He found support, unexpectedly perhaps, for his covetous desires from Antonio Panizzi, the Keeper of Printed Books (from 1837) and later (1856–66) Principal Librarian (i.e. Director) of the British Museum (figure 6.4). 'Panizzi's dream' for the British Museum 'was of a great library and galleries of Classical antiquities with the appendages of Print Room and Coin Cabinet',[60] and he had little sympathy for the other collections of the British Museum, notably natural history and the holdings that were being built up by Franks. As an administrative bruiser, he doubtless felt that Cole was a man he could do business with. (When the time approached for his retirement, he said it was a pity that Cole could not direct both museums.)[61] When Cole visited him at the British Museum on 31 March 1856, Panizzi 'was decidedly favourable to uniting their Mediaeval works' with the collections at Marlborough House; and on 18 July, when they were discussing a share-out of the objects purchased from the Bernal Collection, he said that 'indeed the whole shd be handed over [to South Kensington] & even Franks with them'. In 1858 Cole 'saw Panizzi, talked abt Commons Committee to divide the Nat: Collections. [The British] Museum shd be only for Books &

Antiquities ...'; and consequently Robinson prepared a 'Scheme of division of Museums'.[62] In 1859 Cole and Panizzi were talking about loans from the British Museum to South Kensington.[63]

These ideas for shuffling some of the British Museum's collections to South Kensington were not kept secret. Panizzi aired them publicly before the Select Committee on the South Kensington Museum, of 1860. In testifying on the relationship of the two museums, he professed himself eager to surrender medieval art to South Kensington:

I think that the Kensington Museum ought to have the comparatively few objects which we have in mediaeval art, which we have begun lately to collect ... Our mediaeval collection, though good, is not very large, and one of my objections to its continuing at the [British] Museum is, that on account of the expense and the space which would be required, we cannot make that collection what it ought to be; whereas, at the South Kensington Museum they can.[64]

But in the end nothing came of Panizzi's very accommodating offers of redistribution.

The Select Committee perhaps pursued a more realistic line when it sought to clarify the difference, rather than the overlap, between the two museums. Panizzi expressed it thus:

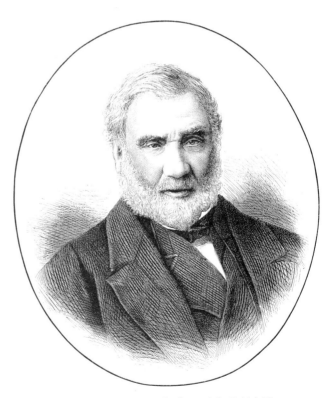

Figure 6.4 Sir Antonio Panizzi, who directed the British Museum from 1856 to 1866, and was willing to hand over its medieval and Renaissance decorative art to Henry Cole. From the *Illustrated London News*, 19 April 1879.

The British Museum, in former times, was a collection only of classical antiquities; its object was the spreading of good taste and assisting scholars in respect of classical art and learning. The South Kensington Museum seems to me to be more for manufactures and practical art, not for learning, but for improving the taste of those who purchase objects of art manufacture, and of those who manufacture such articles.[65]

A straightforward endorsement of Cole's view of the museum. Cole himself, when asked by the Select Committee on what grounds South Kensington acquired objects, replied:

Strictly with a view to aiding the manufactures of this country. We do not buy archaeological subjects, as the British Museum does sometimes, because they are curious, but we buy objects which we think will give suggestions to manufacturers, or which are objects of beauty.[66]

Beautiful, exemplary art objects at South Kensington; rare, curious, historically significant antiquities at Bloomsbury. This was the line still taken by Cole's protégé and successor as head of the Department of Science and Art, Sir John Donnelly, when facing another Select Committee 40 years later. He acknowledged that South Kensington had acquired medieval objects, but as

examples of decorative art; that is the ground upon which the experts recommended them; they recommended them as objects of decorative art, which were examples to furnish suggestions and give ... a standard of taste, but not to give the history of art; not to give the archaeology ...[67]

And his colleague, the Director for Art, concurred: 'For our Museum, I have always held that artistic quality was of the first consideration, and that the archaeological value came in afterwards, and not in a very important manner.'[68]

But we have already seen that, as time went on, Kensington acquired more and more material which some thought should be at Bloomsbury. In 1865 the *Art-Journal* published an article entitled 'Rival Museums: The British Museum and the Museum at South Kensington', which claimed that the latter 'is rapidly forgetting its origin and use, and is becoming a serious tax upon the country for the purchase of very expensive curiosities which have no right to a resting place under its roof'.[69] The design reformer, Christopher Dresser, evidently agreed. He was clear that 'the South Kensington Museum was instituted to meet a want which the British Museum never supplied. The latter concerns itself only with the world's history, the former considers the history of art.' But he admitted that the distinction was difficult to draw in practice:

I know that many objects which are found in the British Museum collections are of the highest art value, and I am also aware that many objects which have found their way into the Kensington Museum are of more interest as antiquarian specimens than as art objects.[70]

The distinction between 'art' (for the education of artists and craftsmen) and 'archaeology' or 'history' (for the satisfaction of collectors and antiquaries) was still being invoked in 1927 (by which time the South Kensington Museum had become the V&A), when the Director of the British Museum appeared before the Royal Commission on Museums and Galleries. He conceded that there was some overlap between the two museums and agreed with his questioner that 'the defence is that, though in many cases both Museums purchase and collect the same objects, they do so with a different purpose, [the British Museum] with a view to history and the Victoria and Albert with an eye to art'.[71]

A more homely formulation, focusing on those whom the museum was intended to serve ('art students'? or 'collectors'?), emerged in 1926, in a dispute about whether the V&A was justified in buying two expensive Byzantine carvings, in ivory and porphyry. The architect Reginald Blomfield, explaining his disapproval of these, wrote:

The primary purpose of the Victoria and Albert Museum is, I understand, to provide materials for the education of art students, and on the whole it has carried out this purpose in an admirable manner; but there is always a tendency to slip over to the Collector's point of view, and it was to this that our criticism was directed ...[72]

The pithy principle, 'Art at South Kensington, history at the British Museum', was underpinned by a Minute on 'Art Collections of the South Kensington Museum', authorized by 'the Right Honourable the Lords of the Committee of Her Majesty's most Honourable Privy Council on Education', issued at South Kensington on 13 June 1863, and signed by Henry Cole.[73] Since this constitutes the most officially weighty statement, from the museum's early days, of its acquisition policy, it is worth quoting at length. Believing that 'the time has come when it is necessary that, as far as possible, definite instructions should be given to regulate the increase and completion of the Collection':

... Their Lordships accordingly direct that future purchases be confined to objects wherein fine art is applied to some purposes of utility, and that works of fine art not so applied should only be admitted as exceptions, and so far as they may tend directly to improve art applied to objects of utility.

This seems to set up a fairly secure frontier between South Kensington and the National Gallery. The statement then turns to the frontier with the British Museum:

... The decorative art of all periods and all countries should be completely represented.

Classic art ought not to be omitted, but, inasmuch as the British Museum is particularly devoted to the illustration of classic art, it should be represented only to a limited extent and for the purpose of showing the impression made by it upon subsequent periods.

Cole was sent away to meet Panizzi and draw up some regulations on the acquisition of classical art,[74] which were later enshrined in another minute in which South Kensington effectively renounced any interest in classical antiquities.[75] The 1863 minute continued:

... The best works of all periods and countries should be obtained as far as practicable. Second rate works should only be acquired as substitutes until better works can be obtained.

... Where the taste of the age or country has been low, few specimens only will be necessary. On the other hand, where the art is excellent and tends especially to the improvement of modern manufactures, the specimens may be more varied and numerous.

These clauses reflected Cole's belief that absolute standards of taste existed (see above, p. 30). Today they read like a licence to the museum to pontificate about standards in a field where absolutes are no longer recognized, and they exercise a certain nostalgic fascination upon traditionally minded curators. The minute concludes in a more liberal way:

... Original works are to be obtained as far as possible, but where this would seem to be impracticable, the system hitherto pursued of representing the finest known examples by electrotypes, casts, and drawings, will be followed, it being always kept in mind that the aim of the Museum is to make the historical and geographical series of all decorative art complete, and fully to illustrate human taste and ingenuity.

The final clause ('fully to illustrate human taste and ingenuity') seems invitingly capacious, but on the whole this acquisition policy illustrates well how the museum in the nineteenth century had a somewhat limited notion of 'art', and why it attached little importance to the historical context, the 'archaeology', of the objects it acquired.

The 'art'/'archaeology' dichotomy remained useful to the V&A even when ideas of what art might mean changed in the twentieth century. The V&A staff became less interested in the education of art students, and now came to see themselves as especially expert and sensitive in the appreciation of works of art, in aesthetic discrimination, in contrast to the plodding pedants concerned with 'archaeology'. W.B. Honey (figure 6.5), Keeper of Ceramics at the V&A in the 1940s, believed that the true value of a work of art lay in its formal qualities ('composition, pattern, texture ...; linear and other rhythm; ... creative harmony or contrast of colour', etc.),[76] and, on entering the museum profession, found himself 'out of sympathy with the archaeologists ... a close corporation admitting only those with a mastery of one of their offensive jargons ... which are set up as a barrier to keep out the profane herd'.[77] And in 1991, when John Pope-Hennessy characterized the V&A 'as an institution that ... ignored archaeology, and concentrated upon works of art', it was in the context of praise for J.C. Robinson's insistence on 'intrinsic quality' in the works of art that he purchased.[78]

Figure 6.5
W. B. Honey, Keeper of Ceramics 1938–59, cultivating an aesthetic rather than 'archaeological' approach to a work of art.

Whether cleaving to art rather than archaeology or history would ever have securely differentiated the V&A from the British Museum is perhaps open to doubt. Anyway, the British Museum did not cleave to history. The Department of British and Medieval Antiquities, which lost its ethnographic holdings to another Department in 1921, was divided in 1969 into two Departments: Prehistoric and Romano-British Antiquities, and Medieval and Later Antiquities. The latter, whose coverage was now acknowledged to come further forward in time than the Middle Ages, was still in 1971 presented as a historical collection. In a survey of the museum, the writer Antonia Fraser described it as 'a rare treasure-house for those who feel that the haze of history shimmering round a priceless hoard is an additional halo enhancing it'.[79] But gradually the Department came to think of itself as a decorative arts department,[80] and it brought its coverage forward into the twentieth century. In 1979 it inaugurated a Modern Collection, which was eventually presented in a lavish catalogue as *Decorative Arts 1850–1950: A Catalogue of the British Museum Collection* (1991). Although the British Museum's collecting of decorative art objects is confined to ceramics, glass and metalwork (excluding sculpture, textiles and furniture), and although the catalogue reaffirms 'the British Museum's character as a historical collection',[81] there is an obvious overlap here with the V&A's coverage.

To those who seek the elusive ideal of an unambiguously logical arrangement of the nation's museum collections, this situation may seem to call for amendment. But the notion that objects have strictly limited meanings, which allow them to be neatly pigeon-holed in museums with neatly defined specialisms – art at South Kensington, say, or archaeology at Bloomsbury – is surely no longer tenable. In the post-modern intellectual climate, the field of 'material culture studies' has been animated by the conviction that objects have many meanings, which are imputed to them by the many different people who interrelate with them. The role of museums is now seen to be to liberate the full range of meanings in whatever ways seem feasible, rather than to police the making of meanings. No doubt there is room for the British Museum and the V&A to interpret and present their decorative arts collections in different and complementary ways. And by now it is inconceivable that one museum could smack its lips at the thought of consuming the other.

In 1876, when the take-over threat of 1873 was still a recent memory, a commentator wrote that 'South Kensington seems not to have passed beyond the stage of battling for existence, and is yet far from having attained the demure and undisturbed repose of its elder sister in Bloomsbury'.[82] Over a century later both museums enjoy a certain dowager maturity, and need to accommodate themselves to the many newer museums, which have come into existence partly owing to the success of the senior museums. In encouraging the growth of museums not only in Britain but worldwide, South Kensington has a particularly interesting record, which is considered in the next chapter.

NOTES

1 *Report of the Treasury Commission of Inquiry into the Establishment of the Science and Art Department* [1865], in *Cole Miscellanies*, vol. 24, f. 57.

2 Cole diary, 14 November 1866.

3 Ibid., 21 September 1865.

4 Ibid., 5 December 1867.

5 Ibid., 4 October 1870.

6 Ibid., 18 February 1869.

7 The source for this quotation and for the quotations below (not otherwise attributed) referring to the Simkins controversy is a series of three printed documents found in the offical file in the V&A Archives: Ed. 84/8. The first is a (draft?) minute of a meeting, entitled 'Confidential. Science and Art Department. Minute. At South Kensington, [blank] day of [blank] 1871'. This consists mostly of observations by Cole and MacLeod on the Simkins affair, with relevant correspondence between the Department and the Treasury. The second document is entitled 'Confidential. Copy of Correspondence between the Treasury and the Science and Art Department relative to the Accounts of the Department and the Defalcation of the Accountant', and consists chiefly of R.W Lingen's arraignment (30 November 1871) of Cole, and W.E. Forster's official reply. The third document is Cole's reply to the charges levelled by Lingen (30 December 1871).

8 Cole diary, 23 June 1859.

9 Ibid., 30 January 1862.

10 Ibid., 13 June 1863.

11 Ibid., 10 March 1870.

12 Ibid., 1 June 1869, 17 March 1870.

13 Ibid., 31 Jan 1871.

14 Ibid., 17 June 1870.

15 See note 7.

16 *The Times*, 10 May 1872: V&A Cuttings Book, June 1870–December 1874, p. 88.

17 Cole diary, 23 June 1871.

18 Ibid., 5 August 1871.

19 Ibid., 16, 20 January 1872.

20 Ibid., 20 April 1871.

21 Ibid., 27 April 1872.

22 Ibid., 15 October 1867.

23 Ibid., 11 October 1872.

24 Ibid., 28 April 1872.

25 Ibid., 1 December 1872.

26 Ibid., 3 May 1873.

27 C. Henry Whitaker writing to commend 'The Proposed Testimonial to Mr Henry Cole, C.B.', *Builder*, 5 July 1873, p. 532.

28 As C.W. Merrifield noted in a letter of November 1873 in Archives: Ed. 84/233.

29 'Mr Cole's Appeal to the Country', *Architect*, 1 November 1873, p. 224.

30 'The Abdication of Mr Cole', *Architect*, 12 July 1873, p. 13.

31 'Parliamentary Notes: British Museum and South Kensington', *Building News*, 1 August 1873, p. 126.

32 Cole diary, 5 September 1873.

33 Ibid., 30 September 1873; see also 13, 23 September, 16 October.

34 'National Museums', *Journal of the Society of Arts*, 21 November 1873, p. 1.

35 Printed in *Journal of the Society of Arts*, 23 January 1874, pp. 167–71.

36 Quotations from the speech as printed in *The Times*, 22 October 1873 (cutting in George Wallis, *Records of Art, Industry, etc., 1873–1892* [one of a series of scrapbooks in the NAL, press mark PP.34.G]).

37 'Mr Cole's Appeal to the Country', *Architect*, 1 November 1873, p. 223.

38 Quotations from the speech as printed in *The Times*, 21 November 1873 (cutting in George Wallis, op. cit.).

39 *Standard*, 21 November 1873, cutting in Wallis, op. cit.

40 Ibid.

41 *The Times*, 21 November 1873, cutting in Wallis, op. cit.

42 Cole diary, 8, 23 January 1874.

43 'Items of News ... Mr Cole and South Kensington', *Architect*, 31 January 1874, p. 68.

44 'Private Correspondence', *Birmingham Daily Post*, Monday 8 December 1873 (cutting in Wallis, op. cit.).

45 J.D. Donnelly's comment (p. 10) in *Report of the Committee appointed by the Lords of the Committee of Council and the Trustees of the British Museum, to ascertain and report what arrangements would have to be made to give effect to the proposal to transfer the South Kensington Museum and the Bethnal Green Museum to the Trustees of the British Museum.* Archives: Ed. 84/30.

46 Cole diary, 14 November 1873.

47 Physick, pp. 166–7. And see Archives: Ed. 84/233.

48 See Physick, pp. 39–44.

49 *Annual Report of the Director of the National Gallery to the Treasury, for the Year 1876* [dated] 22 January 1877, p. 3.

50 See *The Report of the Committee on the Functions of National Gallery and Tate Gallery and, in respect of Paintings, of the Victoria and Albert Museum*, London: HMSO, 1946 [the 'Massey Report']; Martin Bailey, 'Now if I gave you my Turners and he gave them his Germans ...', *Art Newspaper*, no. 79, March 1998, p. 22; Brian Sewell, 'The juggling act that could make London culture capital of the world', *Evening Standard*, 26 March 1998, pp. 28–9.

51 Henry Cole, 'Public Galleries and Irresponsible Boards', *Edinburgh Review*, no. 251, January 1866, p. 69.

52 'The Future of South Kensington Museum', *Builder*, 26 July 1873, p. 579.

53 J.C. Robinson, 'Our National Art Collections and Provincial Art Museums', *Nineteenth Century*, June 1880, p. 988.

54 Ibid., p. 989.

55 A.W. Franks, 'The Apology of my Life' in Marjorie Caygill and John Cherry (eds), *A.W. Franks: Nineteenth-century Collecting and the British Museum*, London: British Museum, 1997, p. 318.

56 Ibid., p. 319.

57 Ibid., p. 321.

58 Cole diary, 5 January 1852.

59 Ibid., 21 November 1854.

60 Marjorie Caygill, 'Franks and the British Museum – the Cuckoo in the Nest', in Caygill and Cherry (eds), op. cit., p. 63.

61 Cole diary, 3 August 1863.

62 Ibid., 29 January, 7 March 1858.

63 Ibid., 6 December 1859.

64 *Report from the Select Committee on the South Kensington Museum ... Ordered, by the House of Commons, to be Printed, 1 August 1860*, paras 1651, 1648.

65 Ibid., para. 1640.

66 Ibid., para. 90.

67 *Second Report from the Select Committee on Museums of the Science and Art Department, Ordered, by the House of Commons, to be Printed, 21 May 1897*, para. 1205.

68 Ibid., para. 5709.

69 'Rival Museums. The British Museum and the Museum of South Kensington', *Art-Journal*, 1865, p. 282.

70 Christopher Dresser, 'Proposed Transfer of South Kensington Museum', *Furniture Gazette*, 10 January 1874, p. 42.

71 *Royal Commission on National Museums and Galleries, Oral Evidence, Memoranda and Appendices to the Interim Report*, London: HMSO, 1928, para. 715.

72 One of a series of memoranda in Archives: Ed. 84/116.

73 Printed in *Eleventh Report* [for 1863], pp. 6–8.

74 *Précis*, 1852–63, p. 449 (1 July 1863).

75 Minute of 10 May 1864, in *Twelfth Report* [for 1864], p. 8.

76 W.B. Honey, *Many Occasions*, London: Faber, 1949, p. 16.

77 William Bowyer [W.B. Honey], *Brought out in evidence: an autobiographical summing up*, London: Faber, 1941, p. 278.

78 John Pope-Hennessy, *Learning to Look*, London: Heinemann, 1991, p. 165.

79 Antonia Fraser, 'Medieval and Later Antiquities', in Sir John Wolfenden (intro.), *Treasures of the British Museum*, London: Collins, 1971, p. 110.

80 Cf. John Cherry, *Medieval decorative art*, London: British Museum Press, 1981.

81 Judy Rudoe, *Decorative Arts 1850–1950: A Catalogue of the British Museum Collection*, London: British Museum Press, 1991, p. 7.

82 'Strong and weak points of the exhibition of scientific apparatus at South Kensington', *Builder*, 3 June 1876, p. 529.

South Kensington Conquers the World

When in 1873 the committee of staff from South Kensington and the British Museum were exploring the differences between the two museums, one theme touched upon was the notion that the former was expansive while the latter was restrictive. Norman MacLeod, Assistant Secretary of the Department of Science and Art, put the point:

The Trustees of the British Museum consider it their first duty to guard with jealous care every object which has ever come into their possession. The safety of the National Property is their first and ruling consideration and guides all their actions. The Museum is only open 3 days a week and some of the more important Collections are not shown to the General Public, but only those who can obtain special orders. [In contrast] the main feature in the management of the South Kensington Museum has been to exhibit to the greatest possible number of people the Art Treasures they have succeeded in acquiring ... While the pictures and other works of Art have been guarded as far as possible from harm, the main purpose has been to use them, even at some little risk, for the Instruction of the Community.[1]

This chapter looks at South Kensington's expansionary work: its exhibition of objects from its collections in other museums and art schools in Britain, and the satellite museums that the Department of Science and Art controlled in Britain; and the influence of South Kensington on the foundation of decorative arts museums in Europe and even further afield in the later nineteenth century.

South Kensington did not exhibit its collections only in its own building. It aimed to extend its missionary work throughout the country by circulating exhibitions to art schools and existing museums, and by assisting in creating new museums. So far as the latter aim was concerned, we have already heard (see above, p. 89) Cole lamenting that the provinces of Britain failed to exploit the help that his Department offered. There was an opposing view: that Cole was less helpful in deed than in word.

Mr Cole ... could of course afford to be very liberal in his advice ... as the head of the South Kensington Museum, which he was wont to declare was 'the storehouse of the nation,' from which the provinces had only to ask and have. Unhappily the promises were one thing and the performance another, so that this 'storehouse' phrase got to be regarded as a form of official cant.[2]

However this may be, the South Kensington Museum undoubtedly made persistent and repeatedly extended efforts to circulate exhibitions around the country. The first circulating exhibition was created in the Marlborough House days, and between 1855 and 1859 was shown in 26 towns:

It was contained in five glazed cases, so constructed as to fit together and form a stand, occupying a ground space of 12 feet by 6 feet; the base being formed of square boxes, in which the objects were packed when in transit. In addition to these cases, were seventy glazed frames, for the display of textile fabrics, lace, photographs, etc., which were furnished with stands, the whole being so contrived as to admit of ready packing. A carriage or truck constructed especially for the purpose, and adapted to travel on all railways, contained the collection and all appliances.

A second, larger travelling show visited 15 towns between June 1860 and June 1863. From 1864, the system was changed. Instead of circulating a single exhibition, the museum sent out selections of loans customized for individual locations. By the time a report was issued in 1880,[3] 258 such collections had been sent out to places ranging from Aberdeen to Penzance, Aberystwyth to Great Yarmouth. The most assiduous customers were Nottingham (to which 11,184 objects were lent) and Sheffield (9,662 objects). From 1880 onwards, local (or 'corporation') museums were eligible to receive loans; before that the loans were restricted to the Department's Art Schools and to museums associated with them.

Cole's Department directly controlled not only the South Kensington Museum, but four others. One was the Museum of Practical Geology in Jermyn Street (figure 7.1). This had been founded in 1835 by Sir Henry de la Beche, as an accompaniment to his work on the Geological Survey of Great Britain, under the Board of Ordnance, to which he

Vignette: Wood-engraved head-piece, with a portrait of Gottfried Semper, from *Kunst und Gewerbe* (1881), a magazine published by the Bavarian Industrial Museum, Nuremberg.

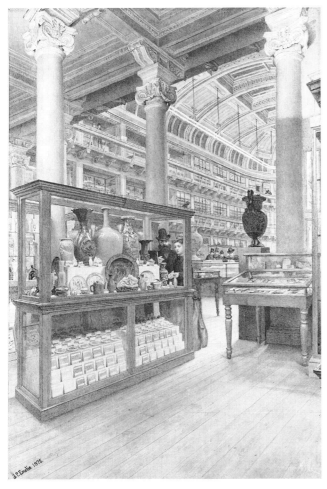

Figure 7.1
An interior view of the Museum of Practical Geology, 1875.
A watercolour by J. P. Emslie.

had been appointed in 1832. The Survey and the Museum, which were taken over by the Office of Works in 1845, were augmented in 1851 by the Government School of Mines, and this bunch of institutions was transferred in 1853 to the newly created Department of Science and Art. The Museum principally collected geological specimens, 'illustrative of the mineral wealth of the country', but also objects that showed 'the application of its various mineral substances to the useful purposes of life', notably pottery. 'In forming and developing the collection,' wrote a later Director of the Museum, 'the technological rather than the artistic side of the subject has been steadily kept in view; and it is consequently believed that though many of the specimens may be less elegant and intrinsically valuable than those in other collections, yet the Ceramic Department, as a whole, is probably unrivalled, so far, at least, as British products are concerned, in educational and scientific value.'[4] When the Department of Science and Art was subsumed in the Board of Education in 1901, this ceramic collection was passed over to the Victoria and Albert Museum. The Museum of Practical Geology was probably not at the forefront of Henry Cole's concerns as he ran his Department in the 1860s and '70s, but it is interesting to learn, as a further proof of his pervasive influence, that he had a hand in the early formation of the ceramic collection in the 1840s.[5]

Another institution taken under the wing of the new Department of Science and Art in 1853 was the Museum of Irish Industry, with its School of Mines, in Dublin. This had been founded in 1845, and worked rather uncomfortably in tandem with the Royal Dublin Society in fostering science and art education. Complicated negotiations with the Royal Dublin Society, following reports from a Treasury

Figure 7.2
T. N. Deane & Son's design for the Museum of Science and Art in Dublin. Lithograph published in the *Building News*, 14 November 1884.

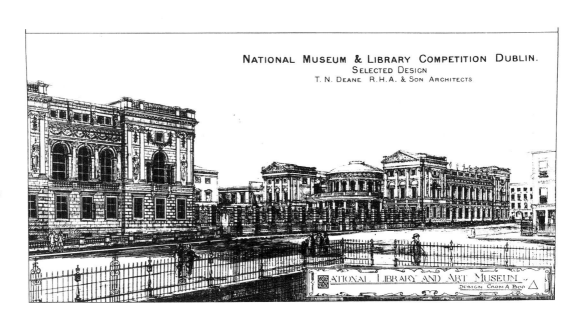

NATIONAL MUSEUM & LIBRARY COMPETITION DUBLIN.
SELECTED DESIGN
T. N. DEANE R.H.A. & SON ARCHITECTS

NATIONAL LIBRARY AND ART MUSEUM.
DESIGN FROM A BOX

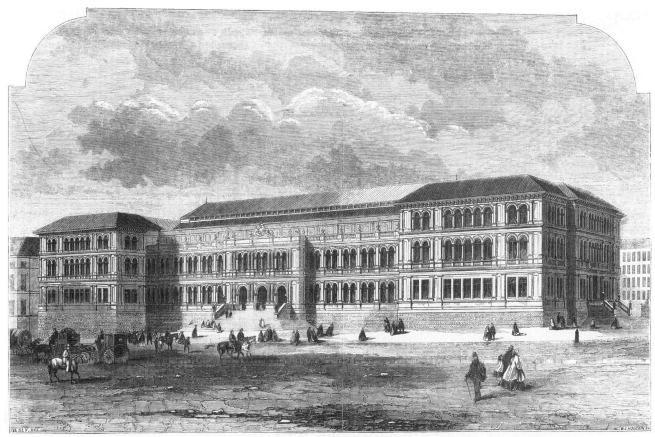

THE INDUSTRIAL MUSEUM, EDINBURGH.——Captain Fowke, R.E., Architect.

Figure 7.3 Captain Francis Fowke's design for the Edinburgh Museum of Science and Art, wood-engraving published in the *Builder*, 22 November 1862.

Commission in 1862 and a Select Committee of the House of Commons in 1864, led to the eventual foundation in 1877, under the Department of Science and Art, of a Dublin Science and Art Museum, incorporating some of the collections of the Museum of Irish Industry, which had been closed down some years before.[6] These proceedings were inextricably entangled in the political controversies of Irish Home Rule. Some saw the museum as a device to strengthen the hold of the 'Imperial system' over Ireland, and lamented: 'The Museum began as a splendid patriotic vision; we fear it will end as an unsightly South Kensington job.'[7] In due course, the museum received a fine new building (figure 7.2) designed by Sir Thomas Deane and Son, flanking and taking its classical style from Leinster House, an eighteenth-century building that formed the headquarters of the Royal Dublin Society. When, in 1921, Ireland became the Irish Free State, independent of the United Kingdom, Leinster House became its Houses of Parliament and the Museum became the National Museum of Ireland.

In 1854 Cole's Department added to its empire a museum in Edinburgh. In response to representations from Scottish notabilities, the Government agreed that Scotland should have an Industrial Museum to match those in London and Dublin. This museum incorporated the Natural History Museum of Edinburgh University. After the museum had operated for some years in temporary premises, the foundation stone of a new building was laid on 23 October 1861 by the Prince Consort, in one of his last public appearances. Captain Fowke, the Department of Science and Art's own construction expert, designed the new building (figure 7.3). Inside, it had a glass-roofed Main Hall constructed of iron, Fowke's speciality, and its exterior elevation was his first extended essay in what was to become recognizable as the 'South Kensington Lombardic Renaissance' style – here carried out in grey and red sandstone with carved decoration, for the cheaper brick and terracotta technique was not yet developed. It was built in two parts, completed in 1865 and 1888. The museum was renamed the Edinburgh Museum of Science and Art in 1864, and the Royal Scottish Museum in 1904.[8]

The fourth museum administered by the Department of Science and Art was the Bethnal Green Museum. Like the Edinburgh Museum, this arose from the Department's

positive desire to proselytize. In 1864, the Department had enough new buildings on the South Kensington site to feel that it could dispense with the 'Brompton Boilers', the first iron building, which had only been intended as temporary accommodation. Consequently, the Department proposed to the Treasury 'that this iron building might usefully be divided into three portions, and that one of these portions might be offered to the proper authorities in the north, east, and south of London, respectively, at a nominal sum, in order to assist in the formation of district museums'.[9] Henry Cole recorded in 1866, however, that although 'numerous representatives' of the 'suburban districts of the metropolis' attended a meeting to discuss the subject in May 1865, 'it is only from the neighbourhood of Bethnal Green that a definite proposition has been made'.[10] Bethnal Green therefore received two-thirds of the iron building, reconstructed inside a new brick shell and with a decent slate roof.[11] The designs for the museum, published in the *Builder* on 21 January 1871, show auxiliary buildings at the front (figure 7.4). A garden is enclosed by a cloister and flanked by Italianate pavilions housing a library, a refreshment room, and a curator's residence. A clock tower and statuary on the skyline add further dignity to the recycled building. All these features, however, were never built because the Treasury stopped the money. The Bethnal Green Museum unfortunately became a pawn in Cole's contest with Lowe, who kept trying to give it away to the local people.[12] The Department managed, however, to retain control of it.

When the Treasury refused to provide the money for an official opening, Lord Ripon and Forster decided that the Department would stump up, and the Prince of Wales performed an opening ceremony on 24 June 1872.

The museum took over two of the original collections from South Kensington, the Food Collection and the Animal Products Collection. In its first days, its upper floors accommodated Sir Richard Wallace's art collection (eventually to become a national museum in its own right, in Manchester Square), and other art collections were exhibited there for limited periods. The museum did therefore combine art and science, conforming to Prince Albert's vision. The locals hoped that it would also have an active educational role, offering technical classes to East End working people, and were disappointed that this never developed. The museum altered its displays and its policy to match the changes in South Kensington. When the Science Museum split from the Victoria and Albert Museum in 1909, Bethnal Green remained a dependency of the latter and its science collections were dispersed in the 1920s. Successive V&A Directors had various policies for it, until its role was settled in 1974 as a Museum of Childhood.

These four museums were to some extent shaped, as museums always are, by local circumstances, and by the way in which collections grow and coalesce apparently with a will of their own. But they had a shared mission, so long as they were part of Cole's empire: to embody Prince Albert's vision of art and science combined in the service of

Figure 7.4
The Bethnal Green Museum as it was meant to be. This wood-engraved perspective was published, along with a plan, in the *Builder*, 21 January 1871.

THE EAST LONDON MUSEUM OF SCIENCE AND ART.

industry. Today they have developed other missions. The Edinburgh Museum, which 'houses international collections covering the decorative arts, science, technology and working life, geology and natural history' (*Museums Yearbook*) goes furthest in achieving the Albertian ideal. But, from 1998, its variegated collections have been further diversified to include a Museum of Scotland, intended to convey Scotland's national history; and so the Albertian ideal is no longer so prominent.

South Kensington's mission was, as it turned out, emulated more successfully abroad than at home, for a chain of decorative arts museums, on the South Kensington model, spread across Europe and America in the later nineteenth century. These museums copied South Kensington because they believed that it had succeeded in what it had set out to do: to reform English taste and design by art education conveyed through schools and museums. Whether, in fact, South Kensington had succeeded in its aims is difficult to establish. Conflicting testimonies are not difficult to find. For instance, after Henry Cole's death in 1882, *The Times*, regarding him as synonymous with the achievements of South Kensington, wrote:

We need only to reflect on the contrast between the present condition of national taste and that which prevailed not merely in the region of art itself, but in all the departments of technical industry in 1851, in order to form an estimate of the vast influence exercised by Sir Henry Cole ... The reproach that England was far behind other nations in the attention it bestowed on art and design has long been wiped out, now that the Museum of Science and Art ... is regarded, more or less, as a model by all ...[13]

And yet, only a few years later in 1887, the writer of a heavy article in the *Westminster Review* on 'Technical Education and Foreign Competition' concluded that, even 'after thirty-five years of State encouragement and inspection' of design education through the South Kensington system, 'our enterprising continental rivals beat us in their own countries in common goods by their tariffs ... and then beat us abroad in some classes of superior goods by their skill, taste, and commercial aptitude – the qualities which they have so assiduously taught in their schools, and which have been so grossly neglected in ours'.[14]

A view that sought a third way between these positive and negative alternatives was that of Dr John Forbes Watson, who is quoted in 1877 as thinking that 'the existence of the South Kensington Museum has in no way originated the movement of artistic reform now pervading all England, although it has accelerated its pace'. He ascribes inspirational originality to Pugin, Ruskin and Owen Jones, and writes that:

South Kensington has not developed a single man with artistic initiative who can be compared to those just named, nor has it

added a single new idea to those which men propounded before it was ever thought of; but there are many ideas which, but for it, would have continued to this day as mere suggestions, instead of being already widely introduced into the practical arts of this country.[15]

In the face of such differing views, how might one seek a more reliable measure of what happened in Victorian taste and design? The answer that the Victorians themselves provided to this question was: look at the goods on display in the International Exhibitions. Of course, the Exhibitions themselves were regarded, not just as monitors of taste but also as educational influences, as 'great schools in which object-lessons on the grandest scale have been taught to millions of people'.[16] As *Punch* commented in 1851:

Time, the great Showman, soon will let us know
The grand results of this gigantic Show.
A finer taste – there's reason to suppose –
Will carve our furniture, and cut our clothes;
Will o'er our glass, our plate, and crockery reign,
And dye our fabrics with a nicer stain ...[17]

What *Punch* expected was duly observed to have come to pass in the next British International Exhibition in 1862. Taste had certainly changed. Roughly speaking, Rococo revival was on the wane while Gothic Revival was waxing. Was this the result of design education? A cool observer like Beresford Hope was prepared, in carefully nuanced phrases, to make a connection:

The artist has clearly had to do with the producer during the last eleven years ... He has been employed as he never used to be ... For this development much credit is due to the schools of design ... but much also to the impulse given by persons who have taught without a pencil in their hands, and whose lessons may be summed up in the one axiom to seek utility of form and reality of material first, and then to ornament in accordance with that form and that material.[18]

For an ideological warrior like Christopher Dresser, it was much simpler. In his *Development of Ornamental Art in the International Exhibition: being a Concise Statement of the Laws which govern the Production and Application of Ornament*, he cheerfully gives an end-of-term report. In surface decoration, 'we now show wall enrichments of a high order ... Progress ... is ... highly encouraging'. In furniture, 'our progress during the last ten years has been marked and satisfactory', and work is 'highly to be commended'. In glass, 'rapid progress has been made, and the art has become exalted'. In metalwork, 'we have to congratulate ourselves upon marked and encouraging progress ... works of great excellence'.[19]

Interestingly, the Department of Science and Art made an attempt to get beyond such expressions of opinion to something more quantitatively reliable. It sent the ever-ready George Wallis off to get some statistics on 'how far

designs of decorative manufactures in [the] Exhibition [of] 1862 have been executed by art students',[20] that is, by people who had been trained through the South Kensington system and were now employed by firms in the real world. Wallis sought information from 383 firms, of which 222 replied. From these replies he discovered that '344 students, in the employ of 104 manufacturers, had been engaged on the works exhibited, in the following industries:– porcelain, 72; glass, 30; precious metals and jewellery, 24; iron and brass work, 62; furniture and decorations, 47; carpets and floorcloths, 21; silk fabrics, 20; lace, 18; woollen and mixed fabrics, 21; printed and dyed fabrics, 10; other industries, 19'.[21] These numbers do not, of course, show whether the designers trained by South Kensington achieved anything worth while, but Wallis's report was better than nothing.

What really mattered was not so much the facts as the 'spin', the general impression created by the 1862 Exhibition. The received wisdom was this:

When the Exhibition of 1862 placed England at the head in the manufacture of majolica, furniture, and metals, the surprise of the Englishman was coupled with pride and delight, while the rest of Europe was seeking with astonishment for the cause of this rapid progress ... Commissioners were at once dispatched to England by all the continental powers, to examine into the workings of the South Kensington Museum, and the school system attached to it. The result was, that new systems of instruction in industrial art were instituted, by the other European governments, after the model established at South Kensington ...[22]

That was written by an American, who was not, it must be acknowledged, taking a dispassionate view, but was contributing to a vigorous campaign to establish a museum on South Kensington lines in Cincinnati.

European enthusiasts for design education and reform similarly cried up the achievements of South Kensington. The Austrian art historian, Jacob von Falke, concluding his history of taste (published in 1866) with a survey of the recent past, alluded to the collapse of taste that had been evident in the 1851 Exhibition. 'There were many, perhaps, who perceived this, but only *one* nation was intelligent enough to deduce what necessary measures must be taken. That was the English.' They recognized that the French were ahead of everyone, even though the French shared some of the common design failings. 'They saw, however, that these failings could be amended, that what was lacking could be *learned*, and they told themselves that *if* they learned the lessons and adapted their skills, they could outstrip the French and consequently all other nations.' Falke goes on to formulate the English plans for design reform – perhaps rather more crisply than they were formulated in England at the time – and explains that their result was the

South Kensington industrial art museum (which was for the benefit of the public, as well as of designers and makers) and its associated schools. In 1862, England, 'which people were used to regarding as on the lowest rank in matters of taste, had completely recovered from its debasement and stood on a level with France'.[23]

The French themselves joined their voices to what begins to sound like a chorus of tributes to English grit and pluck. M. Chevallier, one of the French jurors at the 1862 Exhibition, reported that:

rivals are springing up, and the pre-eminence of France may receive a shock if we do not take care. The upward movement is visible, above all, among the English. The whole world has been struck with the progress they have made since the last Exhibition ... Previous to that day they were renowned for their bad taste, but they have felt the question to be one of education. They have organized with great intelligence and perseverance instruction in the Fine Arts.[24]

This was echoed in 1881 in an article by Paul Villars. Reacting to the aesthetic collapse of 1851, 'the English, with that resolute and practical spirit which distinguishes them, founded a museum of decorative art in 1852, that is to say, less than a year after the first exhibition'. Villars stresses that Government money was devoted to the museum, 'an admirable sign which reveals the deplorable state to which the industrial arts had fallen at this time in England, and the importance which the government attached to elevating them by every possible means'.[25]

A similar tribute came from the Swiss architect Georg Lasius, in a brief survey of the history of applied art museums and schools. In 1851, 'the sharp understanding of the English very quickly appreciated their situation ... Intelligent men in England tried to restore the damage done to their industry, through fundamental study and good instruction in the various skills'. When they decided to set up a museum and schools, 'the task was robustly undertaken with true English energy, and when after 16 years England and France again confronted each other at the Paris Exhibition [of 1867], one could not be sure whose accomplishments were the more significant.' Other countries copied the measures taken in England – including, by the time Lasius wrote in 1878, Switzerland – but no other country 'showed such vigour and zeal in accomplishing its plans'.[26]

The English themselves readily believed this story of 'old British pluck and public spirit of our manufacturers'. In 1887 Sir George Birdwood said of the 1851 exhibition that:

it was indeed a terrible parade of our shortcomings ... but its salutary lesson was at once grasped by us, and in the aggressive spirit imbued in our blood and bone, we began that strenuous competition with the Continental manufacturers which has at last placed us, in the mechanical production of

works of applied art, at the head of all the countries of the West.[27]

We have already heard an American voice singing this song in the 1870s to the citizens of Cincinnati. Here is another, reporting to his compatriots in Philadelphia on the Vienna Exhibition of 1873:

It was there generally conceded that the most brilliant success won was in the department of the ceramic arts, and in this the palm was generally conceded to the English exhibitors. The progress made by them, and the absolute excellence they had attained, were most noteworthy. This was attributed to ... the influence of the South Kensington Museum and the system of art schools of which that museum is the great centre.[28]

All these foreign writers (and doubtless many more) were boosting South Kensington's achievements, with the purpose of persuading their own countrymen and Governments to take similar measures in design education. They were strikingly successful.

The first of South Kensington's children was the museum of applied arts in Vienna. This was the brainchild of Rudolf von Eitelberger, professor of art history at the University of Vienna. Having visited the International Exhibitions of the 1850s, he was dismayed at Austria's lack of success at the 1862 Exhibition, and on 22 July 1862 addressed a memorandum to the Archduke Rainer, recommending that Austria should have an institution to match South Kensington. Von Eitelberger was thus described, rapturously, by one of his successors:

An academic and scholar, into whose tireless intellectual activity new knowledge of the history and culture of past times was constantly channelled, a man educated in political and economic affairs to an extraordinarily high degree for his time, equipped with a fine sense of the necessary and the possible, full of lively sympathy for the moral power and technical grounding of all forms of artistic creativity, equipped with a captivating personality, a propagandist and agitator, bold, reckless when necessary, in touch with all the leading figures in society as well as with the man in the street, optimist and patriot, an Old Austrian of the best type, he united in himself all the disparate abilities needed to cultivate a new field of work with absolutely new and fruitful ideas, and to present to his astonished contemporaries in an extraordinarily short time the rich harvest of his tireless and self-sacrificing labours.[29]

Under the Archduke's patronage, an Austrian Museum of Art and Industry was founded on 31 March 1864, with von Eitelberger as Director and Jacob von Falke as Chief Curator. The museum was joined by an art school in 1868. After being accommodated temporarily in the royal tennis court, the museum moved in 1871 into a new building designed by Heinrich von Ferstel (one of the group of architects who built the Vienna Ringstrasse, a grand boulevard along the lines of the old fortifications), in an idiom which, whether by chance or intention, strongly recalled South Kensington. It was in the Renaissance revival style, built of red brick (save for the sandstone used on the basement and the door and window frames), with economical decorative medallions and panels executed by the sgraffito technique in glazed terracotta. These depicted 56 decorative artists from Jost Amman to Josiah Wedgwood, including – besides obvious candidates such as Raphael, Michelangelo and Donatello – many Germanic heroes, such as Albrecht Dürer, Johannes Gutenberg, Martin Schongauer, Wenzel Jamnitzer, Fischer von Erlach and Karl Schinkel. Inside there was a high, top-lit, colonnaded central hall, flanked by eight richly decorated galleries, one on each side with top lighting, surrounded by lower side-lit rooms, an arrangement not unlike the courts and galleries at South Kensington.

At its opening, the museum had to borrow its exhibits, notably from the Emperor, who set an example by placing all the imperial decorative art collections at its disposal.[30] Gradually the permanent collections were built up, with the distinguished help of Viennese art-history professors such as Alois Riegl and Franz Wickhoff.[31] The collections were arranged 'following the technological principles of the Kensington Museum'.[32] A special Festschrift, which the museum published to accompany the 1873 Vienna International Exhibition, shows that it energetically embraced almost all the activities that South Kensington had pioneered. It had a library and print room, arranged lectures and exhibitions, supplied publications and reproductions. Von Falke remarked that South Kensington pursued popularity to the extent that 'they did not shy away from giving concerts and arranging magnificent routs for the aristocratic public. What would people have said if we had done the same?'[33] If hesitant about these proceedings, the Vienna museum nonetheless outstripped the London museum in some respects, notably in networking. From the start it published a monthly magazine; it had a panel of 86 'Correspondents' from all over the world (including Philip Cunliffe Owen in London);[34] and it sought to plant similar museums in other towns in the Austro-Hungarian Empire: hence decorative arts museums appeared in Brünn (Brno) in 1873, Reichenberg (Liberec) in 1873, and Prague in 1885.[35] Aside from Vienna's direct influence, the surging decorative arts movement led to the foundation of specialist museums in Cracow in 1868, Budapest in 1872 and Zagreb in 1880.

In Germany, the pioneer decorative arts museum was that at Berlin. 'The first initiative towards this came from a quarter which was linked by the closest ties to the spiritual author of the first International Exhibition.'[36] Prince Albert's eldest child, Victoria, became Crown Princess of Prussia when she married Prince Friedrich Wilhelm in 1858. 'Attentively following the exertions and advances of

Figure 7.5 The Industrial Art Museum, Berlin: the interior of
the central hall. Etching included in the *Festschrift* published by the
museum to mark the opening of the building, 1881.

her homeland in the improvement of industrial art,' she
brought these to the notice of Prussia by commissioning
from Dr Herman Schwabe in 1865 a report on 'the
promotion of industrial art in England and the state of
this question in Germany'.[37] As with most of the German
decorative arts museums, additional impetus was supplied
by a local trade association, in this case the Berliner
Handwerker-Verein. Plans, suspended during the Austro-
Prussian war in 1866, came to fruition in 1867 with the
foundation of the Deutsches Gewerbe-Museum zu Berlin.
As its name implies, this was to be a museum of industry
rather than industrial art. Its collecting plan shows that its
founders intended to cover the usual fields of decorative art
(interior decoration, furniture, jewellery, weaponry and
armour, vessels, textiles, dress, and objects made of leather,
card and paper), but also wished to include building con-
struction, educational equipment, food and drink, cleaning
and lighting, and machinery.[38] This coverage closely con-
forms to the collections assembled at South Kensington in

the earliest years, when Prince Albert's ideal of 'art and
science combined in the service of industry' was fresh.

 The museum inclined, however, increasingly towards art
under its first Director, Julius Lessing. Trained as a classicist
and art historian, employed initially in journalism, and
converted to an enthusiasm for the decorative arts by
visiting the 1862 Exhibition in London, Lessing assisted at
the museum in its earliest years and was made Director in
1872.[39] In 1879 he got the name of the museum changed to
Kunstgewerbemuseum, museum of industrial *art*.[40] The
museum eventually occupied a fine building, opened in
1881 (figure 7.5). It was a *palazzo* in Renaissance style,
though this was described as 'Hellenic Renaissance',
designed by Martin Gropius. The exterior was 'adorned
with mosaics ... representing the principal epochs in the
history of civilization' and 'terracotta bands of relief con-
tain[ing] the names of great artists and scenes emblematic
of their work'. Inside there was central hall surrounded by
arcades 'borne by slender syenite pillars' and supporting 'a
frieze in low relief', coloured in imitation of maiolica, 'rep-
resenting a procession of the nations most distinguished in
art, saluting Borussia' (i.e. Prussia).[41] Two storeys of side-lit
galleries enclosed the top-lit central hall, recalling the

arrangement at South Kensington. Berlin, which was only just beginning its rise from obscure provincial town to capital city, did not have an art-loving aristocracy such as existed in Vienna, from which loans could be sought. But the Kunstkammer of the ruling Brandenburg family was transferred to the museum in 1875, and in 1869 it bought the important Minutoli collection.[42]

Mention of this collection raises the question of whether Germany, rather than South Kensington, deserves credit for inventing the decorative arts museum. For Alexander von Minutoli set up a small private museum in 1845, which prefigured in almost every aspect the decorative arts museums that arose throughout Europe in the last quarter of the nineteenth century. Minutoli was a civil servant by profession, charged with encouraging the economic regeneration of Silesia in north Germany, and an avid collector by inclination. He set up, in Liegnitz in Silesia, an institute for industrial art, which gave drawing classes, had a library, print room and workshops, and contained museum collections arranged to form both a series of chronological displays by period and a series of displays by material. Because Minutoli's museum was a private enterprise, occupying rented rooms in the castle at Liegnitz, it did not have the secure basis necessary for long-term survival, but its holdings did become a fundamental part of the Berlin museum. The question of whether it had any influence on South Kensington has been investigated, but without a positive conclusion, by Winslow Ames.[43]

There is another contender for priority among decorative arts museums, that at Stuttgart. The Society for Promoting Industry in Württemberg (Gesellschaft zur Beförderung der Gewerbe in Württemberg) set up in 1848 a Central Institute for Trade and Industry (Centralstelle für Gewerbe und Handel), which two years later began to assemble museum collections. It became the Royal Württemberg Provincial Museum of Industrial Art in 1886, and in 1896 was rehoused in a lavish new building. A *Festschrift* published to mark this event quotes from a letter of 12 October 1873 from Philip Cunliffe Owen, in which he hails this museum as 'the acknowledged Father and Patriarch of all these [decorative arts] Museums'.[44]

Whichever German museum can claim to be first in time, the Berlin museum was first in prestige, closely followed by that at Hamburg, which was founded in 1869.[45] The impetus here came from a local association, the Hamburgische Gesellschaft zur Beförderung der Künste und nützliche Gewerbe (Hamburg Society for the Encouragement of Arts and Useful Trades), founded as early as 1765. Caught up in the rising enthusiasm for industrial art museums, it set up a commission that opened its first displays in 1874, and appointed the secretary of the commission, a young lawyer named Justus Brinckmann, as Director. There were no princely collections to draw on at Hamburg, so the building up of the collections was the personal achievement of Brinckmann, who died in office in 1915. He and Lessing, who retired just before his death in 1908, were the grand old men of the decorative arts museum movement. The Hamburg museum received permanent premises (at first shared with the art school) in a building designed by K.J.C. Zimmermann and opened in 1876. Predictably, it was in a Renaissance style and, although not very elaborately decorated, did have a series of portrait medallions of German worthies. On one side, rubbing shoulders with the architect Karl Schinkel, the astronomer Carl Friedrich Gauss, the chemist Justus von Liebig, and the engineer Ferdinand Redtenbacher (all comparatively recently dead), was a portrait of Gottfried Semper, who 'although he still walks among the living, vigorous and creative, is here ranged beside the mighty dead, because his name, more significantly than that of any of his fellow-workers, stands for the mission of an industrial art museum'.[46]

As we have seen, Semper worked for South Kensington for several years, while his career in Europe was interrupted by revolutionary upheavals. It was the 1851 Exhibition that prompted him to reflect on the origins and principles of development of decorative art in his essay *Wissenschaft, Industrie und Kunst* (1852). The ideas here shadowed forth were explored at length in *Der Stil in den technischen und tektonischen Künste oder praktische Aesthetik* (Style in the Industrial and Structural Arts, or Practical Aesthetics), an unfinished treatise of which two volumes were published in 1860 and 1863. Somewhat inaccessible as a writer – he was at once emphatic and rambling, flashingly speculative and laboriously detailed – Semper was even more inaccessible to the English, because *Der Stil* was never translated from the German (the National Art Library's copy remains suspiciously unthumbed to this day). 'Perhaps many of my British colleagues,' said one of his English admirers in 1884, 'have never heard of Semper.' His countrymen, however, 'reckon him as by far the greatest architect they ever had, and, taken all round, one of Germany's brightest geniuses'.[47]

For the decorative arts museums, Semper provided a body of theory, with which pragmatic South Kensington had never bothered. And his theories were regarded (not without a degree of misinterpretation and over-simplification, it seems) as intellectual underpinning for the system of displaying exhibits according to their material, which South Kensington had adopted fitfully and for reasons of expediency. Julius Lessing judged Semper to be 'a fundamental lawyer, and creator of our industrial art museums'.[48] So powerful was the influence of Semper abroad that some foreign writers have assumed that he had more to do with the founding of South Kensington than was

actually the case. Bo Lagercrantz says that it was Semper who 'largely planned' South Kensington, while T. Frank asserts that 'much of the credit for setting up and stocking the [South Kensington] collection must go to the most prominent German architect of the day, Gottfried Semper'.[49] While these statements are not correct, a Semperian orthodoxy did prevail in continental decorative arts museums. It was to cast into greater relief a counter-movement of differing views, which began to be current at the turn of the century, and which South Kensington failed fully to understand.

After Berlin and Hamburg, many other German towns invested in an industrial art museum: Kassel (1869), Nuremberg (1869), Bremen (1873), Lübeck (1873), Leipzig (1874), Kaiserslautern (1875), Königsberg (1875), Dresden (1876), Flensburg (1876), Schwäbisch Gmünd (1876), Frankfurt (1877), Kiel (1878), Ulm (1881), Magdeburg (1882), Dortmund (1883), Düsseldorf (1883), Krefeld (1884), Halle (1885), Hanover (1886), Oldenburg (1887), Strasburg (1887), Cologne (1888) and Karlsruhe (1890).[50] Many of these, after a period of initial growth, got fine new accommodation in a burst of museum building around the turn of the century. By that time there was a free-for-all in architectural styles, but it may be worth noticing in passing a small museum which, founded in 1875, embarked on building at an early stage – perhaps because its Director, Carl Spatz, was an architect and designed his own habitation. This was Kaiserslautern,[51] in the Rhineland Palatinate, and its building, opened in 1880, was another essay in what we might venture to recognize as the South Kensington neo-Renaissance style (figure 7.6).

Outside Germany, the decorative arts museum movement bore fruit in Switzerland, where museums were founded in Lausanne (1862), Bern (1869), Winterthur (1874), Zurich (1875), Basle (1878) and St Gallen (1878).[52] Also in Holland, where the Society for the Furtherance of Industry (Maatschappij ter Bevordering van Nijverheid) opened an Applied Arts Museum (Museum voor Kunstnijverheid) in Haarlem in 1877, and the Society for the General Good (Maatschappij tot Nun van 't Algemeen) opened the Utrecht Applied Art Museum in 1884, both of these museums having associated art schools.[53] In Scandinavia, the Kunstindustrimuseet in Oslo dates from 1876. We learn that its first head, Hendrik August Grosch, 'crossed the North Sea to study museum technique at the newly founded Victoria and Albert Museum and to gather ideas for his own new venture', as a result of which the Kunstindustrimuseet 'was originally planned on the so-called "technical" principle'.[54] In Copenhagen, a Kunst-industrimuseet was founded in 1890 by the Copenhagen Industrial Society.[55] In Russia, at St Petersburg, Baron Alexander Lugdovich Stieglitz founded a school of industrial art in 1876, with a museum eventually housed in a building begun in 1885 and finished only in 1896, so elaborately grand were the designs by M.E. Mesmacher.[56] Only France seemed to hang back – strangely, since France had been in many ways the inspiration for South Kensington. Edmond Bonnaffé commented ruefully in 1877 that where 'France invents, England perfects. Dusommerard invents the museum of decorative arts and England founds Kensington'.[57] Bonnaffé was writing to support contemporary attempts to set up a French decorative arts museum. The activities of the Union Centrale des Beaux-Arts Appliqués à l'Industrie since 1864 had not brought forth a permanent museum, and in 1877 a rival Société du Musée des Arts Décoratifs was created to hurry on the task, but it was not until 1905 that the Musée des Arts Décoratifs eventually opened in a wing of the Louvre.[58]

The example of South Kensington was influential in North America, too. Across the Atlantic, in contrast with Europe, a culture of museums had hardly developed. The Americans, therefore, regarded South Kensington not so much as a paradigm of a specialist sort of museum, concentrating on the decorative arts, but more as a general

Pfälzisches Gewerbe-Museum in Kaiserslautern.

Figure 7.6
The Industrial Museum of the Palatinate at Kaiserslautern. Wood-engraving from the museum's *Report for 1891–3* (1894).

museum with a wide educational mission. The American journalist Moncure D. Conway recorded in 1875 that an eminent American artist, with whom he had walked through the South Kensington Museum, exclaimed, 'What a revolution it would cause in American art to have some such museum as this in each large city! It would in each case draw around it an art community, and send out widening waves of taste and love of beauty through the country.'[59] It was in this spirit that museums were founded in Cincinnati, Chicago, Philadelphia, Boston and other cities, as Michael Conforti has shown.[60] Even America's premier museum, the Metropolitan in New York, emulated South Kensington. At its foundation, the *New York Herald* announced:

The model of the Metropolitan Museum of Art will, as we understand, be that of the splendid museum in South Kensington Gardens [*sic*], London, which is probably the most perfect thing of the kind in the world. If we can succeed in establishing anything like the Kensington Museum in this city we shall be doing great work in [*sic*] behalf of civilization and education.[61]

It was not until a generation later that America saw the foundation of a museum that closely imitated South Kensington's specialist concern with the decorative arts. This was the Cooper Union museum, opened in 1897 by the Misses Sarah and Eleanor Hewitt in the Cooper Union, a sort of mechanics' institute, which had been set up in 1859 by their grandfather Peter Cooper. Now known as the Cooper-Hewitt Museum of Design, it has been part of the Smithsonian Institution since 1967.[62]

'Art and industrial museums, humble copies of our parent establishment at South Kensington, continue to spring up all over Germany,' commented the *Athenaeum* in 1878.[63] But the reason why all these museums came into being was not, of course, solely because of the influence of the South Kensington Museum. We must acknowledge that the industrialization of Germany and, to a lesser extent, central Europe in the last quarter of the nineteenth century was a major factor. Just as industrialization in Britain provided a propitious climate for the growth of design education in Britain in the earlier nineteenth century, so Germany and other countries felt the need for design education as industrialization rolled over them. But it remains true that South Kensington created waves that surged through Britain, and then rippled over Europe in the 1870s, '80s and '90s. Back in London, however, at this time, the museum and its parent Department of Science and Art, now deprived of their original driving force, Henry Cole, were losing some of their vigour.

NOTES

1 Memorandum in Archives: Ed. 84/233.

2 'The South Kensington Museum: Its Functions as a National Institution', *Art Journal*, 1875, p. 153.

3 *Science and Art Department ... Report on the System of Circulation of Art Objects on Loan for Exhibition as carried on by the Department from its first establishment to the present time*, London: HMSO, 1881. This is the source for all the information in this paragraph.

4 *Handbook to the Collection of British Pottery and Porcelain, in the Museum of Practical Geology*, London: HMSO, 1893, pp. v, vi.

5 Ann Eatwell, 'Henry Cole and Herbert Minton: Collecting for the nation', *Journal of the Northern Ceramic Society*, vol. 12, 1995, pp. 158–9.

6 For a full account see *Thirtieth Report* [for 1882], pp. lxxxv–cvi.

7 'The New Museum in Dublin', *Industrial Art*, vol. 1, 1877, pp. 35, 37.

8 See the centenary history by D.A. Allan and others, *The Royal Scottish Museum: Art & Ethnology, Natural History, Technology, Geology*, Edinburgh: Oliver & Boyd [1954].

9 *Twelfth Report* [for 1864], p. 20.

10 *Thirteenth Report* [for 1865], p. 162.

11 Physick, pp. 143–6.

12 Cole diary, 11 October 1871, 31 January 1872.

13 Obituary of Henry Cole, *The Times*, 20 April 1882: V&A Cuttings Book, April 1882–June 1883, p. 4.

14 Quoted in Isaac Edwards Clarke, *Art and Industry. Education in the Industrial and Fine Arts in the United States*, Washington: Government Printing Office [for the US Department of the Interior, Bureau of Education], vol. 4, 1898, pp. 925–6.

15 Quoted, without source, in 'The Imperial Museum in London', *American Architect*, 3 March 1877, p. 69.

16 T.C. Archer, 'On the Influence of International Exhibitions as Records of Art Industry', in *Reports on the Vienna Universal Exhibition of 1873. Part III. Presented to both Houses of Parliament by Command of Her Majesty*, London: HMSO, 1874, p. 5.

17 'Lines to be Recited on the Closing of the Exhibition', *Punch*, vol. 21, 1851, p. 163.

18 [A.J. Beresford-Hope], 'The International Exhibition', *Quarterly Review*, July 1862, p. 210.

19 Christopher Dresser, *Development of Ornamental Art in the International Exhibition*, London: Day and Son, 1862, pp. 34, 81, 117, 167.

20 *Précis*, 1852–63, p. 378 (8 March 1862).

21 John C.L. Sparkes, *Schools of Art: Their Origin, History, Work, and Influence*, London: Clowes, 1884, p. 74. Wallis's Report was printed in *Tenth Report* [for 1862], pp. 146–76.

22 Charles P. Taft, *The South Kensington Museum. What it is; How it originated; What it has done and is now doing for England and the World ... A Lecture, Delivered at Pike's Opera House in Cincinnati, Friday Evening, April 5, 1878*, Cincinnati: Robert Clarke, 1878, pp. 36–7.

23 Jacob von Falke, *Geschichte des modernen Geschmacks*, Leipzig: Weigel, 1866, pp. 381, 385.

24 Quoted in William Bell Scott, 'Ornamental Art in England', *Fortnightly Review*, 1 October 1870, p. 407. Compare Clément de Ris's tribute to 'that admirable practical sense which is at the bottom of everything the English do' in his comment on the Kensington system, quoted in William Burges, *Art Applied to Industry. A Series of Lectures*, Oxford: Parker, 1865, p. 3.

25 Paul Villars, 'Le Musée de South Kensington', *Revue des Arts Décoratifs*, vol. 1, 1880–1, p. 424.

26 Georg Lasius, 'Gewerbemuseum und Gewerbeschulen', *Schweizerisches Gewerbe-Blatt*, 27 July 1878, p. 208; 3 August 1878, p. 216.

27 'Proceedings of the Society. Section of Applied Art', *Journal of the Society of Arts*, 4 February 1887, p. 204.

28 Quoted, from the 'Reports of the Massachusetts Commissioners to the Exposition at Vienna, 1873', in Isaac Edwards Clarke, op. cit., vol. 3, 1897, p. 835.

29 Eduard Leisching, 'Geschichtlicher Überblick' in *Das k .k. Österreichische Museum für Kunst und Industrie 1864–1914*, Vienna: The Museum, 1914, p. 9.

30 Jacob von Falke, 'Rudolf v. Eitelberger und das Oesterreichische Museum für Kunst und Industrie', *Mittheilungen des k. k. Oesterreichisches Museums für Kunst und Industrie*, new series, vol. 1, 1886, p. 32.

31 *Österreichisches Museum für angewandte Kunst. 85 Jahre Kunstgewerbemuseum. Bericht bei der Wiedereröffnung ... 1949*, Vienna: The Museum [1950], p. 2.

32 *Das k. k. Österreichische Museum für Kunst und Industrie 1864–1914*, p. 26.

33 Von Falke, op. cit, p. 29.

34 *Das kaiserlich königliche Österreichische Museum und die Kunstgewerbeschule. Festschrift bei der Gelegenheit der Weltausstellung in Wien Mai 1873*, Vienna: The Museum, 1873, pp. 8–12.

35 Rudolf von Eitelberger, *Die Kunstbewegung in Oesterreich seit der Pariser Weltausstellung im Jahre 1867*, Vienna: K. K. Schulbücher Verlag, 1878, pp. 112ff.

36 *Das Kunstgewerbe-Museum zu Berlin. Festschrift zur Eröffnung des Museumsgebäudes* [Berlin: The Museum], 1881, p. 2.

37 Ibid., p. 3.

38 'Plan der Sammlung' in *Deutsches Gewerbe-Museum zu Berlin 1867* [pamphlet published by the museum in 1867], pp. 16–22.

39 Peter Jessen, 'Julius Lessing', *Jahrbuch der königlich Preuszischen Kunstsammlungen*, vol. 29, 1908, pp. i–vi.

40 Barbara Mundt, '125 Jahre Kunstgewerbemuseum. Konzepte, Bauten und Menschen für eine Sammlung (1867–1939)', *Jahrbuch der Berliner Museen*, new series, vol. 34, 1992, p. 175.

41 K. Baedeker, *Northern Germany ... Handbook for Travellers*, Leipzig: Baedeker, 1893, p. 61.

42 Julius Lessing, 'Das Kunstgewerbe-Museum zu Berlin', *Westermanns Illustrierte Deutsche Monatsheft*, fifth series, vol. 2, April 1882, pp. 65–82.

43 Winslow Ames, *Prince Albert and Victorian Taste*, London: Chapman & Hall, 1967, pp. 191–8.

44 *Das k. Württembergische Landes-Gewerbemuseum in Stuttgart. Festschrift zur Einweihung des neuen Museumsgebäudes*, Stuttgart: [The Museum], 1896, p. 10n.

45 Franz Adrian Dreier, 'Das Hamburger Museum für Kunst und Gewerbe feierte seinen 100sten Geburtstag', *Museumskunde*, vol. 43, 1978, pp. 90–4.

46 *Das Hamburgische Museum für Kunst und Gewerbe. Festschrift zur Eröffnung des neuen Museums-Gebäudes*, Hamburg: The Museum, 1877, p. 30.

47 Lawrence Harvey, 'Semper's theory of evolution in architectural ornament', *Royal Institute of British Architects Transactions*, new series, vol. 1, 1885, p. 29.

48 Julius Lessing, 'Gottfried Semper und die Museen', *Mitteilungen des Maehrischen Gewerbe-Museums*, vol. 21, 1903, p. 185.

49 Bo Lagercrantz, 'A Great Museum Pioneer of the Nineteenth Century', *Curator*, vol. 7, 1964, p. 180; T. Frank, 'Hungarian Art-Historian in Victorian Britain: George Gustavus Zerffi', *Acta Historiae Artium*, vol. 23, 1977, p. 123.

50 The German decorative arts museums have been thoroughly surveyed in Barbara Mundt, *Die deutschen Kunstgewerbemuseen im 19. Jahrhundert*, Munich: Prestel-Verlag, 1974.

51 On its 50th anniversary this museum had a sort of relaunch, and the book published to announce this included a potted history of the decorative arts museum movement. Here, in 1925, we find the South Kensington 'myth' still powerful, and can read once again how the English 'with great intelligence and their characteristic thoroughness introduced instruction in the fine arts for the purposes of encouraging their industry'. *Jubiläums Jahrbuch des Pfälzischen Gewerbemuseums 1875–1925*, 1925, p. 9.

52 Claude Lapaire, *Museen und Sammlungen der Schweiz*, Bern: Haupt, 1965, pp. 118, 60, 190, 203, 40–1, 156.

53 Adi Martis, 'Some organizations and their activities', *Industry & Design in The Netherlands 1850/1950*, exhibition catalogue, Amsterdam: Stedelijk Museum, 1985, pp. 22–3.

54 Thor B. Kielland (ed.), *Kunstindustrimuseet i Oslo 75 År. Om Museumsbygg, Innredning, Montering*, Oslo: The Museum, 1953, p. 165.

55 Erik Lassen, '75 years ago', *Det danske Kunstindustrimuseum Virksomhed*, vol. 4, 1964–9, p. 251.

56 *Baron Stieglitz Museum. The Past and the Present*, St Petersburg: Sezar, 1994.

57 Edmond Bonnaffé, 'Un Musée à Créer', *Gazette des Beaux-Arts*, 2 series, vol. 15, 1877, p. 329.

58 Yvonne Brunhammer, *Le Beau dans l'Utile: Un Musée pour les Arts Décoratifs*, Paris: Gallimard, 1992. Rossella Froissart, 'Les Collections du Musée des Arts Décoratifs de Paris: Modèles de Savoir Technique ou Objets d'Art' in Chantal Georgel (ed.), *La Jeunesse des Musées: Les Musées de France au XIXe Siècle*, catalogue of an exhibition at the Musée d'Orsay, Paris; Paris: Réunion des Musées Nationaux, 1994, pp. 83–90.

59 Moncure D. Conway, 'The South Kensington Museum', *Harper's New Monthly Magazine*, no. 305, October 1875, p. 665.

60 Michael Conforti, 'The Idealist Enterprise and the Applied Arts' in Malcolm Baker and Brenda Richardson (eds), *A Grand Design: The Art of the Victoria and Albert Museum* exhibition catalogue, New York: Abrams, and the Baltimore Museum of Art, 1998, pp. 37–44.

61 'The Metropolitan Museum of Art', *New York Herald*, 11 February 1871: V&A Cuttings Book, June 1870–December 1874, p. 36.

62 Russell Lynes, *More Than Meets the Eye: The History and Collections of Cooper-Hewitt Museum* [Washington]: Smithsonian Institution, 1981.

63 *Athenaeum*, 7 September 1878, p. 254.

CHAPTER EIGHT
Declining Skills and Diverging Purposes

Philip Cunliffe Owen, who had been Cole's Assistant Director for Administration, took over as Director of the South Kensington Museum in February 1874. As anticipated, he ran only the museum, not the entire Department of Science and Art. The position of Secretary of the Department was assumed by Sir Francis Sandford, who combined it with his existing post as Secretary of the Education Department, while Norman MacLeod remained in charge of the bureaucracy at South Kensington. In a weaker position than Cole had been, Owen nonetheless assured Cole that 'he intended to be captain of his ship'.[1]

Owen looked like a sea-captain, for he had a burly head, with a spade beard, a promontory nose, twinkling eyes and a gleaming pate. His father really had been a sea-captain, in the Royal Navy, and at the age of 12 Philip himself joined the Navy as a midshipman. His health, however, threatened to break down, and after five years he came out of the Navy: 'he little thought, probably, that his retirement, owing to ill-health, was really paving the way to another career in which success was comparatively brilliant'.[2] In 1854, at the age of 26, he joined the Department of Science and Art as a clerk and never looked back. By 1857 he was Deputy Superintendent to Cole. He was 46 when he became Director of the museum. A caricature in *Vanity Fair* in 1878 shows a broad-shouldered, sturdy figure. Described as 'frank and hearty', he is said to be 'known for the most genial manners, the greatest good nature, much fertility of resource, and a never-failing helpfulness'.[3]

He had a sort of double career, for 'his life would appear to have been passed in alternations between his duties at the Museum and a series of commissionerships to the various exhibitions at home and abroad, that have ... characterized the past half century'.[4] He worked on the International Exhibitions at Paris in 1855, London 1862,

Paris 1867, Vienna 1873, Philadelphia 1876 and Paris 1878; his services at the last exhibition brought him his knighthood (KCMG), which was followed by the KCB for his efforts at the Colonial and Indian Exhibition in London in 1886. He also accumulated no fewer than 13 foreign decorations, such as the French Legion of Honour, Commander of the Iron Crown of Austria, Commander of the Order of St Maurice and St Lazare, Italy, and Knight of the Order of St Olaf, Norway. By virtue of his exhibition work, he was known as 'an international man'.[5] His family circumstances also took him on an international circuit. His father lived in Avignon, and his wife was German, the daughter of Baron Fritz von Reitzenstein, a Prussian cavalry officer. Not surprisingly, Owen was 'a master of many languages',[6] which enabled him to be an effective ambassador for the museum. In 1871 he wrote to Cole, who was on holiday, to report that 'the Museum has been flooded with Foreigners. I have done my best to do the honours in your name. I have secured a friend for the Museum in each – never knowing, that they might not be angels (Foreign) in disguise'.[7]

Shortly after Owen became Director, Cole noted that 'he said he always told people that his work was to carry out what I had originated, & he was only an administrator'.[8] It may have become less necessary for Owen to avow his debt to Cole as he settled in; only three years later, he noted that while 'I can never forget my old & respected Chief', it now seemed 'that Sir Henry has no time to remember any of his old friends'.[9] But Owen continued to take the line that he was 'only an administrator', and everyone accepted him at his own estimation. J.C. Robinson said of him, 'Sir Philip Owen had no acquaintance whatever with art matters, and he made it expressly known that he had not; but he was on the other hand an excellent and most energetic administrator.'[10] Almost identical comments were made in obituaries in *The Times* and the *Illustrated London News*, which both used the term 'man of business' to describe him.[11]

His second career as exhibition organizer (figure 8.1) took him away from the museum for long periods. He spent several months at Philadelphia in 1875;[12] and was officially seconded to work on the Paris Exhibition in the calendar years 1876 and 1877, and the Colonial and Indian

Vignette: *The Dragon of Ignorance*, painted by W.E.F. Britten in 1886. This is part of a scheme of ceiling decoration in the southern galleries of the South Court. Britten depicted various mythological figures which were favourable to Art alongside two dragons – of Ignorance and Blind Fury – which were antagonistic to art, 'mailed and spiked monsters to retard, to dispute progress'.

Exhibition in 1886, with Richard Thompson running the museum in his place as Acting Director. In 1877 the *Art Journal* tartly commented: 'We hope it will not be found from experience that the Institution, to which he has but recently been promoted, can do without him altogether; inexperienced persons may reason that if he is not needed there for two years he is not necessary at all'.[13] But the journal made amends later, asserting:

Wherever his various commissionerships and secretaryships have borne him, the interests of the Museum have never been absent from his mind. Scarcely a journey has been undertaken that has not borne fruit in the enrichment of its collections ... Nobody has ever accused Sir Philip Cunliffe Owen of neglecting the interests and prospects of the band of workers with which he is surrounded at South Kensington, and it is impossible for a visitor to make, in his company, even a partial tour of the buildings under his charge, without observing the confidence and affection with which he is everywhere regarded.[14]

Owen, then, was obviously an effective man. He was not such a good Director as Cole, partly, perhaps, because 'he always seemed restless when, in the intervals between one exhibition and another, his energies were confined to the routine work of the museum'.[15] But it is necessary also to allow for the fact that circumstances were less propitious for him than they had been for Cole.

While Cole's directorship had coincided almost exactly with the great mid-Victorian economic boom, Owen's tenure coincided equally exactly (which is rather uncanny, perhaps) with 'what a contemporary observer called "a most curious and in many respects unprecedented distur-

INTERIORS AND EXTERIORS. NO. 18.

INTERNATIONAL INVENTIONS EXHIBITION.
EVERYONE OUT OF TOWN. IT IS LEFT TO THE EXECUTIVE COUNCIL AND THEIR COUNTRY COUSINS.

Figure 8.1 Cunliffe Owen as exhibition organizer. A cartoon by Harry Furniss in *Punch*, 12 September 1885, concerning the International Inventions Exhibition. Owen (centre) was on its Executive Council.

bance and depression of trade, commerce and industry", which contemporaries called the "Great Depression", and which is usually dated 1873–96'.[16] While this period of economic decline did not cast a particularly dark cloud over South Kensington or, indeed, most other aspects of life at the time, it is worth remembering that the prevailing economic climate was on the whole discouraging.

This was most obviously seen in the fact that during Owen's tenure, South Kensington's ambitious building programme was brought to a halt.[17] The Boilers had been mostly demolished and rebuilt at Bethnal Green. The heart of the museum now comprised the North and South Courts and the galleries around them. To the west, three sides of a quadrangle had been formed by building out the Lecture Theatre range in 1865–9 to meet the 'Residencies' range (1862–3). To the south, the two immense Cast Courts had been added in the early 1870s, displacing all but the rump of the Brompton Boilers. These Courts, it was said, 'display, at present, only vast blank red gables to the passengers on the Brompton Road, and are gradually edging Mr Woodcroft's Patent Museum into the gutter'.[18] On the north-west corner of the site towered the School of Naval Architecture (later the Science Schools), the most prominent monument of the 'South Kensington Renaissance' style, completed in 1874. Already in 1870, however, during Cole's directorship, the Department of Science and Art had lost control of its building and design unit to the Office of Works, whose Minister was the unsympathetic Acton Smee Ayrton, who abolished the growing of flowers in the Royal Parks in order to save money.[19] Year after year, the Treasury and the Office of Works disregarded the Department's pleas for new buildings. The existing premises consequently looked rather disorderly, as a French journalist recorded in 1873:

The buildings ..., although they are still unfinished, are vast and convenient rather than elegant or in good taste. They rise up amidst green, fresh gardens which give repose to the eye tired by all the raw red brick walls, and they can, indeed they must, augment themselves and extend their wings in response to the demands of the collections, which are more and more varied and numerous.[20]

Henry Scott (now General Scott) kept producing revised versions of his plan to complete the buildings with a seemly façade, but to no avail, and he died, exhausted, in 1883.

His final work for the museum was the Art Library range, closing the quadrangle to the south, which was built in 1877–82. The Art Library's plight in its previous premises had become a byword. It suffered from very bad light, and a 'crying want of room, which nothing but the unusual urbanity of the Librarian and his assistants can render tolerable'.[21] Robert Soden Smith (figure 8.2) now moved (from 'downstairs to upstairs')[22] into a capacious suite of

three tall rooms on the upper storey of the new range. On the ground floor were galleries, and at each end, projecting southwards, two top-lit courts. The south-facing sides of these new buildings were left as blank brick walls, because it was assumed that further building would conceal them. They made the museum look even less prepossessing than before. 'The Museum buildings have now become the most hideous, unsightly agglomeration to be seen in any city in Europe; a mass of huge, shapeless sheds turn their bare backs on the public, and irreparably disfigure the whole neighbourhood.'[23] The Brompton Road frontage was compared to 'a cross between a factory after a fire and a disused racquet-court'.[24]

Governments of both political parties remained unsympathetic to South Kensington's appeals for further funds for new buildings throughout the 1880s. Plans emanating from South Kensington were evidently dismissed because neither Fowke nor Scott had been a 'real' architect. It was only in 1890, towards the end of Owen's tenure, that at last the Government decided to complete the buildings, and they then organized a limited competition between eight architects with established reputations for public buildings. The winner was Aston Webb, then a comparatively young, up-and-coming architect; by the time construction began, in 1899, after almost ten years' further delay, he was considerably more eminent.

If Owen needed room to expand, therefore, he had to look to the rest of the 1851 Commissioners' site, west of Exhibition Road. The central part of this was occupied by the garden of the Royal Horticultural Society, enclosed by its arcades. The southern side of the garden was overlooked by the only part of Captain Fowke's building for the 1862 Exhibition that survived when the rest was demolished. Formerly the Exhibition Refreshment Rooms, these 'Southern Galleries' were soon filled up with the collection of pictures that had constituted the National Portrait exhibitions, and which remained as the embryo National Portrait Gallery, and, for a time, by the Animal Products Collection, displaced when the Brompton Boilers were partly demolished to be re-erected at Bethnal Green. The Museum of Construction was also displaced from the Boilers and moved over into the Western Arcades flanking the Horticultural Society's garden. When a new series of International Exhibitions was projected in South Kensington, to begin in 1871, new ranges of two-storey buildings were erected behind (and attached to) the Eastern and Western Arcades. The series of exhibitions was intended to continue indefinitely, but ran into financial difficulties, and the exhibition of 1874 was the last for the time being. The newly built Eastern and Western Galleries thus became available as further space that the museum gradually colonized.[25] They belonged to the 1851 Commissioners and were rented to the museum.

The first new occupant of the Eastern Galleries was the museum of the East India Company, which arrived in 1874. At this point it still belonged to the India Office, which had been trying to rehouse it ever since acquiring it from the Company in 1861.[26] Cole had often been urged to accept it at South Kensington, and eventually acquiesced. On 19 December 1867 he recorded in his diary: 'Sir Bartle

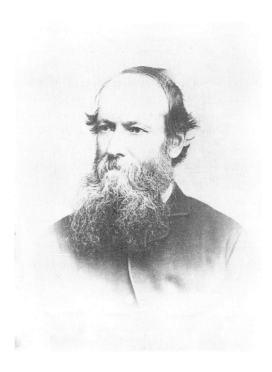

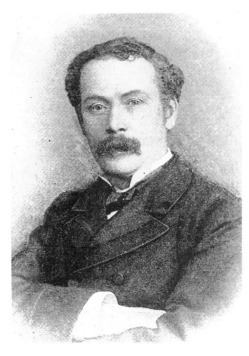

(*Far left*)
Figure 8.2
Robert Soden Smith,
Keeper of the National Art
Library from 1868 until his
death in June 1890, from a
contemporary photograph.

(*Left*)
Figure 8.3
Caspar Purdon Clarke,
an engraving after a photo-
graph by A. J. Melhuish,
published in the *Magazine of
Art* in 1891, shortly after
Clarke had been appointed,
on 15 October, Keeper of
the Art Collections in
succession to George
Wallis. On 18 December
1891 he was appointed
Assistant Director on the
retirement of Richard
Thompson.

Frere called to ask if I agreed with him that the Art of the Indian Museum shd come to Kensington. I say yes & recounted that I was converted, having opposed the idea in 1856 or so. He said he wanted the vigour of the SKM Museum to work it.'

On 11 November 1879 the India Office handed over the museum (with the exception of some natural history material that went to Kew, and antiquities that went to the British Museum) to the South Kensington Museum. The arrival of this immense new collection opened a great opportunity for a bright young man, Caspar Purdon Clarke.

Clarke (figure 8.3) was a South Kensington man through and through. Not only did he spend almost his entire career serving the Department of Science and Art, but he had been trained by the Department too. Born in Ireland (albeit of English descent) in 1846, he studied at the National Art Training School at South Kensington from 1862 to 1865, gaining the National Medallion for Architectural Design. At first pursuing an architectural career, he was a draughtsman for a couple of years at the Office of Works, and in 1867 joined the South Kensington Museum's works office, where he was involved in the Cast Courts and the Bethnal Green Museum. 'He had the great good fortune to act as immediate assistant to Mr James Wild, an eminent Oriental archaeologist and architect.'[27] Wild must have been a formative influence, since Clarke's career in many ways echoed his.

Wild started out as a Gothic Revivalist, but, always insisting on taking his own path, worked out a neo-Byzantine style for himself. However, he soon turned away from architectural practice and in the mid-1840s roamed through Egypt, Syria, Turkey, Greece, Italy and Spain, studying art and architecture, and 'collecting in his note-books a mass of delicately drawn details'.[28] Returning to England and to architectural practice, he designed a few buildings and began to work on the Great Exhibition building, when his health failed. Presumably the South Kensington works department provided a quiet haven for convalescence, but Wild did not remain tied to his drawing board. We read that while at the museum he was 'engaged on oriental catalogues, in reporting on the demolition of old houses in London in order to rescue examples of wood and stone carving worth preservation, and reporting on the buildings of Cairo'.[29] He ended up as curator of the Soane Museum.

Clarke's life path was not dissimilar. While working for South Kensington ('though not permanently employed there'),[30] he too did not remain tied to his drawing board. In 1870 he was sent by the museum to Italy to superintend the making of reproductions of ancient mosaics. In 1873 he was sent to Persia to work on various English consular buildings, and in 1876 went on a buying trip for the museum to Greece, Turkey and Syria. At the Paris

Exhibition of 1878, he was put in charge of the Indian part of the British Section, designing the Indian Pavilion, and laying out within it 'the most splendid display ever made by India in an International Exhibition, which had its immediate effect in creating that great demand for Indian art objects in this country, and on the Continent and in America, which has been growing year by year ever since'.[31] When South Kensington needed someone to put in order their new Indian Museum, Clarke was the obvious person to turn to, and in December 1879 he was appointed (initially for four months at £1 a day) 'to superintend arrangement of Indian Collection'.[32]

Clarke's efforts at display were successful:

Well arranged and well lighted, what is now the Indian section of the South Kensington Museum might serve as a model even to the Museum itself ... The arms are hung very artistically, and, with some ivory palanquins and other valuable articles lent by the Queen, occupy the principal room ... In the next room is arranged the very beautiful and valuable collection of jewellery, ranging from rude archaic goldwork to the exquisite specimens of jade inlaid with gold and precious stones in which the Great Mogul delighted. Farther on are the pottery, metalwork, textiles, &c., &c. In the rooms below is a miscellaneous collection ... including a very beautiful assemblage of carpets, ancient and modern ... There is little fault to be found with these beautifully stored rooms. Everything is not only clean, but in good order; even the famous group of the English officer and tiger which Tippoo Sahib made for his own savage diversion, and which, mute and dusty, many will remember in the gloomy hall of the United Service Museum, is cleansed, varnished, and repaired. By turning a handle you can hear our unfortunate countryman shriek and the bloodthirsty beast growl, and, if you can get someone to turn the handle for you, you can play 'God Save the Queen' at the same time on a set of ivory keys seated in the monster's interior.[33]

Clarke was kept on to expand and improve the collection by making a buying trip to India, with £5,000 to spend; 250 copies of the South Kensington handbook on *Indian Art* by George Birdwood were sent ahead 'to excite interest',[34] and Clarke was authorized by the Lord Chamberlain 'to wear the official uniform of the 5th class' when visiting 'Native Princes' as the museum's envoy.[35] On this journey, as on his other travels, Clarke distinguished himself by his empathy with indigenous peoples:

He has the rare gift of instilling into the minds of Eastern men a feeling of trust and good-fellowship, that has unlocked to him the portal of many a guarded secret in art work. This was his protection in India and Persia when searching for treasures of art in the bazars [*sic*] of almost unknown towns. To the ordinary agent such an undertaking has a strong element of danger in it, especially when the objects have a place in the religion of either Hindoos or Mohammedans.[36]

Clarke's agreeable character stood him in good stead elsewhere, too. Lady Dorothy Nevill praised his 'great

personal charm'.[37] He was described as 'accessible to all men, with the same cheerful word for king or laborer'.[38] An obituarist said that he would 'leave a golden record for geniality and good fellowship'.[39] And when his career took him to America, he was found to be 'in appearance and manner ... more American than English. He is essentially a man of the people ... and he is thoroughly democratic and approachable'.[40] In July 1883 he was appointed to the permanent staff of the museum, in a newly created Keepership, to be in charge of the 'India Museum and the Oriental Section generally'.[41]

The museum had collected some Oriental art from the beginning. In 1879 Robinson alluded to 'important collections of works of Chinese and Japanese art which have been in progress of formation at South Kensington for upward of 20 years', and which had been 'commenced by myself in the early years of my superintendence of the museum'. Inspired by the new Indian Section, he urged that these should be exhibited alongside it.[42] At this time Oriental art was still exhibited in the main buildings. 'The persistently steady influx of Eastern art renders itself daily more visible in the South Kensington Museum,' reported a journal in 1876, 'one half of the South Court being full, even to overflowing, with Asiatic products, some of which are loans, but the greater portion seem to be the actual property of the institution.'[43] Particularly prominent was Persian art, acquired by the museum through Major Robert Murdoch Smith, an enterprising officer of the Royal Engineers who combined soldiering in foreign parts with archaeology. He excavated the Mausoleum at Halicarnassus with Charles Newton of the British Museum. Later, he spent many years in Persia establishing telegraph lines, and from 1873 had a roving commission to buy there for the museum, his largest purchase being the collection of M. Richard, an expatriate Frenchman long resident in Turkey. Murdoch Smith's haul from Persia made a fine show when put on exhibition in spring 1876, even though quite a lot of the pottery had been damaged in transit, enough 'to keep a man in employment riveting for two months'.[44] In 1885 Murdoch Smith (now a Colonel) became Director of the Edinburgh Museum of Science and Art, remaining in the post until his death (as a Major-General) in 1900.

Robinson's call for the aggregation of the Oriental collections was repeated by Sir Rutherford Alcock (recently retired from a lifetime's diplomatic service in China and Japan) in 1883 in a letter to The Times,[45] and Clarke did gradually reassemble them in the Eastern Galleries, so that in 1895 he was able to claim that 'the Saracenic, Persian, Chinese and Japanese collections now being arranged in continuation of the Indian Section ... form an Oriental Museum, which for richness and extent is unequalled in any country'.[46] The only snag was that the Eastern Galleries were so far off the beaten track: 'the mass of visitors who come to the Museum have no idea that ... the Indian collection ... is exhibited across in another road', admitted the head of the Department of Science and Art.[47]

Even further away were the Western Galleries, which became the seed-bed of the Science Museum. Already, as we have seen, some of South Kensington's science collections had crossed the road and come to rest in the Southern Galleries and the Western Arcades. In 1876 the Western Galleries were occupied by a huge loan exhibition of scientific apparatus. This was instigated by a Royal Commission on Scientific Instruction, which the Government set up in 1870 under the Duke of Devonshire. In its five-year life, the Commission investigated all aspects of scientific education in England and produced a series of eight reports, in the fourth of which it recommended the assembly of a collection of scientific instruments and the combination of this with the other scientific collections at South Kensington. The scientific instruments were gathered for temporary exhibition in 1876, and much of the exhibition remained as a fixture at South Kensington. In 1883 the Patent Museum (still lingering in the remnants of the Brompton Boilers) was handed over by the Commissioners of Patents to the South Kensington Museum, and by 1886 all the science collections had been amalgamated, weeded and overhauled. In the Department of Science and Art's Thirty-fifth Report, for 1887, the term 'Science Museum' was used as a heading for the first time. More than 20 years were to pass before the Science Museum became an independent museum, but it was now a coherent entity.[48] Although this achievement took place during the directorship of Philip Cunliffe Owen, the driving force was the Royal Engineers officer John Donnelly, who, as an inspector for science in the Department of Science and Art, had powerfully promoted its activities in scientific education. In 1874 he became Director of Science, and he was subsequently to rise to the top of the Department.

The only other space for expansion in Owen's empire was the Bethnal Green Museum. This opened in 1872 despite the Treasury's attempts to squash it, and Owen was instrumental in obtaining Sir Richard Wallace's art collection on temporary loan,[49] to stand beside the Food and Animal Products collections that were transferred from South Kensington. Owen was well-disposed to the museum since he was 'known as a practical philanthropist, and has taken part in many well-considered schemes for the benefit of the working classes, especially in the promotion of temperance and thrift', rendering him as popular in the East End as in the West.[50] As the museum's guide books reveal, many other temporary loan collections were brought there – 40 of them had been in and out by 1900 – but the museum did

not flourish. Robert Lowe had been the bad fairy at its birth, and it never altogether escaped his curse.

'A glance at the Museum,' said the *Daily News* in 1879, 'will convey the impression that the main thing provided is space ... sparsely scattered with objects which serve to make its emptiness more apparent, as a few torches intensify the darkness of a cavern.' After an eloquent description of the gloomy museum and its weird exhibits, the newspaper concluded:

It has become a habit to consider the Museum at Bethnal-green too much as a place to which anything may be sent which is

not wanted elsewhere. Being only a branch of the parent-institution at South Kensington, it has no permanent director – in short, nobody to fight for its interests as an individual concern ... It is grievous that an institution established with the best of intentions and successfully launched should be allowed to dwindle into a mere refuge for specimens and spectators who have no other place in which to find rest and shelter.[51]

In 1880 a significant batch of material was sent down to Bethnal Green from South Kensington: 'all modern examples of Art manufacture acquired since 1851'. As we shall see, it is quite possible that this modern material was

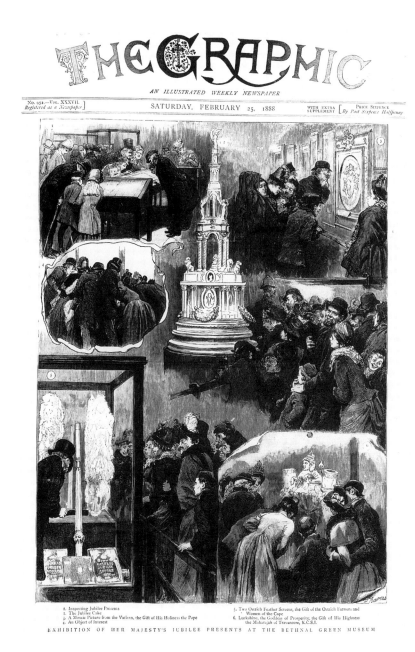

Figure 8.4 The Queen's Jubilee presents on display at the Bethnal Green Museum: the front page of *The Graphic*, 25 February 1888.

3. *Visitors to various Museums under the Science and Art Department.*

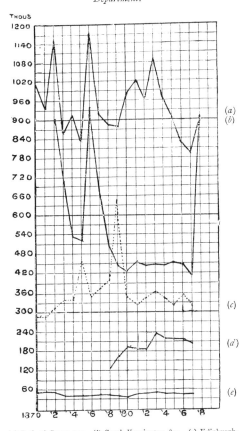

(a) Bethnal Green, 910. (b) South Kensington, 897. (c) Edinburgh.
(d) Dublin. (e) Museum of Practical Geology.

Figure 8.5 A graph showing attendances at the Department of Science and Art's museums between 1870 and 1888, culminating in the triumph of the Bethnal Green Museum. This, published in the Department of Science and Art's magazine *Science and Art* in April 1889, in an article on 'Statistics of Some Museums' by A. B. MacDowall, must be one of the earliest uses of a graph to convey museum attendance figures. MacDowall comments that 'the numbers of visitors to our Museums are generally recorded with more or less accuracy', but 'by means of the graphic method, the teaching of these figures may be made more apparent'.

'not wanted' in the main museum. However, its transfer was claimed as a benefit for Bethnal Green. 'The immediate result has been a considerable increase in visitors, and it is evident that working men greatly appreciate this opportunity of studying examples of ornamental Art bearing on their daily work.'[52]

This does not seem to have stopped the rot. A particular grievance in the East End was that the Government had failed to honour what had been taken by the local inhabitants as a promise to run a technical school in connection with the museum. This was raised in Parliament in 1882. The Minister, A.J. Mundella, admitted that 'there was an understanding 12 years ago that part of the buildings of the Bethnal-green Museum should be devoted to a science and art school. But since then the whole of the premises have been required for the purpose of the museum ...' He said that the Department of Science and Art would not give Bethnal Green special treatment. It would only follow its usual practice of giving grants to assist schools founded and partly funded by local people.[53] 'Unfairness' was how the local newspaper viewed this: 'we shall never rest until this lop sided way of distributing the public money is abandoned'.[54] But to no avail: there never was a school at the museum.[55]

The museum had just one exultant moment of glory. In 1888 the presents given to the Queen in celebration of her Jubilee, after being exhibited in St James's Palace to the rich people of the West End, were taken to the Bethnal Green Museum so that the poor in the East could see them (figure 8.4). This year, consequently, was the only time ever that Bethnal Green's attendance total (910,511) surpassed (figure 8.5) that of its parent at South Kensington (897,225). However, such exciting moments were not frequent enough. It was said that 'a sort of popular complaint' about the museum was that 'the interest in it is not kept continuously alive'.[56]

In our survey of Owen's directorship, buildings have come first. This echoes the South Kensington Museum's reports at this time, which usually started off by reviewing new buildings – or the lack of them, for the museum was constantly in quest of further space for expanding collections. New collections sometimes came (as we have seen) as a result of cultural politics: the huge addition of the whole India Museum is the prime example. Another example is a collection of plaster casts of classical statuary (figure 8.6). Such a collection would seem less than entirely relevant to a museum of post-classical decorative art, but high-level support secured its entrance to the museum. The idea of the collection originated with Walter Copland Perry, a classicist trained at Göttingen, who found himself a career in Europe tutoring the sons of distinguished English families. Returning to live in England in 1875, he threw himself

into organizing a systematically arranged museum of casts, which could convey the history of Greek and Roman sculpture much more clearly than could any of the widely dispersed museum collections of original antique sculpture. Forming a committee of peers and scholars, he lobbied the Prime Minister.[57] South Kensington tried to say that there was no available space there, but Perry was able to bring pressure to bear through Edward Poynter, who had succeeded Richard Redgrave as Director for Art in the Department of Science and Art in 1875, and the Department managed to find some money to enable Perry to make purchasing tours in Europe.[58] The resulting collection was accommodated in 1884 in one of the new courts in the Art Library range; appropriately, in the eastern court (eventually Room 45), which adjoined the huge courts containing the museum's existing collection of casts of medieval and later sculpture and architecture. Perry wrote an explanatory catalogue of his collection.

Aside from initiatives like Perry's, which were thrust upon it, the museum maintained quite a strong drive to acquire more material in the 1870s and '80s. The campaign to purchase Persian art, through Murdoch Smith, is one instance. Another is provided by a collection of Japanese art that came to the museum after it had been shown at the Philadelphia Centennial Exposition in 1876. Philip Cunliffe Owen, who was English commissioner at the Exposition, arranged for the Japanese commissioners to form this collection on behalf of the museum.[59] In China, Stephen Wooton Bushell acted as a purchasing agent for the museum.[60] In Owen's time, however, the museum's purchasing vote suffered from 'continued reduction',[61] and so the museum became more dependent on gifts and bequests. These always formed the lion's share of the museum's acquisitions. It was estimated in 1887 that the gifts and bequests up to that time had a total value (based on their value at the time of acquisition) of 'upwards of a million sterling', and that 'the amount they would realize if sold at the present day would vastly exceed this sum; while the entire expenditure of public money on objects of Art has been about £410,000, including £61,000 for the National Art Library'[62] – that is, the museum had spent £349,000 on purchasing art objects, while the gifts and bequests that had come to it were worth at least three times as much.

The bequests included, in 1876, the literary library of the historian and critic, John Forster. Once again it may seem that such an addition to a museum of decorative art was anomalous, but there had been a precedent. In Cole's time (1869), the museum had accepted the library of Forster's friend, Alexander Dyce, editor of Shakespeare and his contemporaries; his library, however, included a fine collection of Old Master drawings and prints. More obviously relevant was the collection of ceramics (notably English porcelain)

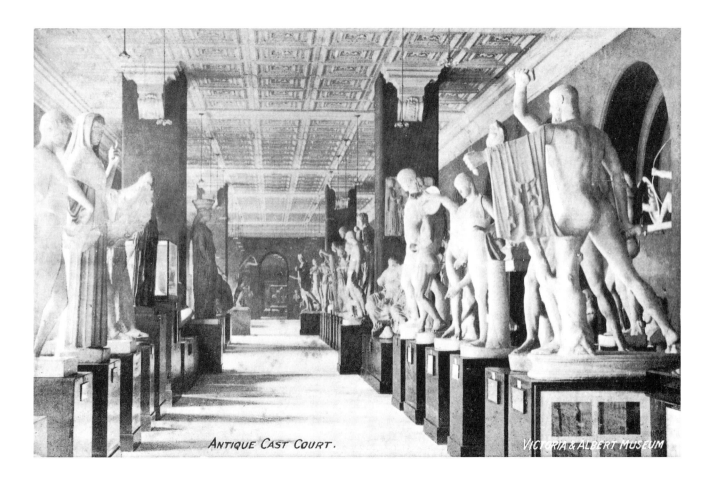

ANTIQUE CAST COURT. VICTORIA & ALBERT MUSEUM

Figure 8.6 The collection of casts of antique sculpture obtained for the museum by Walter Copland Perry, here seen, not in its first display in a top-lit court (now Room 45), but as rearranged by Dr Middleton in the adjoining gallery (Rooms 22–4). From a series of postcards published by J. J. Keliher & Co. about 1900.

donated by Lady Charlotte Schreiber in 1885. Though she and her husband formed the collection together, she was probably the driving force.[63] She can thus take first place among the very few women who can be associated with the scholarly pursuits of the South Kensington Museum in the nineteenth century. Cole moved in the orbit of the aristocratic collectors Lady Dorothy Nevill and Lady Featherstonehaugh. Mrs Bury Palliser wrote one of the catalogues – that on lace (1873) – in the series edited by Pollen. And Emilia, Lady Dilke formed an art-historical library with a view to its going to the museum library, as it did after her death in 1904.[64] Alas for the V&A's reputation among feminists, the only significant woman who actually worked on the site seems to have been Mrs Cottam, who ran the restaurant for 20 years.[65] A significant female benefactor of the 1880s, though not a scholar or collector, was Miss Isabel Constable, last surviving daughter of the great landscape painter John Constable, who donated to the museum in 1888 some hundreds of landscape sketches remaining in her father's studio, and thus gave the museum a 'commanding position' as a place to study Constable's work.[66]

The most important bequest during Owen's time came in 1882 in the shape of the collection, formed by John Jones (who had made a fortune through military tailoring), of French eighteenth-century furniture and decorative art. Writing up the collection in a series of articles for the *Art Journal*, Gilbert Redgrave (son of Richard) ventured to describe this as 'perhaps the noblest donation ever made by a private individual to any country in the world's history'.[67] The material in the collection was, as Philip Cunliffe Owen acknowledged, 'a class more keenly sought after by wealthy collectors than any other'.[68] The collection has nonetheless brought problems, one of them being that the terms of Jones's bequest require that it must always be exhibited as an entity in itself, separate from other material of similar type and period. A problem experienced at the time it came to the museum arose because, in the view of design reformers brought up in the tradition of Henry Cole, the eighteenth century in France was 'a period of very corrupt taste'.[69] Cole himself had faced this problem when, in 1869, the museum acquired a small late eighteenth-century French panelled room, the 'boudoir' of Madame de Sérilly.

He noted in his diary, doubtless with some relief, that when the connoisseur Sir Coutts Lindsay saw it, he agreed that it was 'quite right to buy good examples of bad styles'.[70] Where the Jones collection was concerned, the museum had to take account of comments like this from the *Builder*:

The work of the Louis Quinze and Louis Seize ... periods represents some of the richest, most gorgeous, and most painstaking, as well as successful work which the world has ever seen. But it also represents in many instances a most frivolous and false taste, the true indication of the likings of a society in which all was show and glitter, luxury and selfishness, and which prized richness and ostentation above the pure taste in art of which it, in fact, knew little or nothing.[71]

The Times, too, doubted the 'aesthetic purity' of the collection and asked, 'May not a feeling almost of nausea ensue from an over-seasoned richness of the artistic repast set before us?'[72]

These views are not quoted to disparage the Jones collection (which remains one of the glories of the V&A), but to highlight the difficulty the museum continued to have in keeping its mission and its audience in focus. Its tendency to incoherence seems to be betrayed in the exhibitions that were mounted in Owen's time. In this field, as in collecting, the museum was to some extent at the mercy of others. When the Queen loaned 'gold and other objects from Ashanti, including the state umbrella of King Koffee Kalkalli',[73] the museum presumably knew better than to object that these fell outside its remit. Deference to the Queen was hardly separable from deference to the nobility. 'The Museum is always ready,' taunted an ephemeral magazine, 'to open its arms to the collections of aristocratic owners who may be in search for a safe and inexpensive resting-place for their treasures, whatever may be the quality of such collections'.[74] The magazine had in its sights Lord Strafford's pictures, but might also have instanced Lord Spencer's pictures, which were imported to fill up the space left empty when the National Gallery withdrew its paintings in 1876, and which were rather dismissively described as a 'heterogeneous assemblage of family portraits, Dutch masters, and copies of well-known Italian masterpieces'.[75]

The first big temporary exhibition in Owen's time (in June–September 1874) maintained previous policy. It was devoted to enamels, 'in continuation of the series of such special exhibitions begun in 1862',[76] which had dealt with individual crafts such as armour, jewellery and needlework. As with all these exhibitions, an exhaustive range of material was assembled, to the admiration of reviewers, but the public failed to respond. 'Strange to say, the exhibition has received much less interest than it deserves,' commented the *Pall Mall Gazette*. 'Now about to close, and having been open for several months, very little interest has been taken in it.'[77] No further exhibitions along these lines were attempted.

For a few years there seems to have been a policy gap, during which the museum hosted whatever exhibitions turned up. It must be remembered that exhibitions on the 1851 Commissioners' South Kensington site could be mounted independently of the museum. For instance, the Commissioners granted space in 1877 for an exhibition, of 'Antiquities, Curiosities and Appliances connected with the Art of Printing', to commemorate the 400th anniversary of the publication of the first book printed by William Caxton in England. In the light of the V&A's policy today, which regards printing and graphic design as integral to the decorative arts, this would have been an entirely appropriate project for the museum, but in fact it was organized by an independent Caxton Celebration committee and the museum was not involved.[78] In the same year, however, the museum granted space within its own galleries for an exhibition of the finds made by Heinrich Schliemann in his excavations at Hisarlik in Turkey, which he took to be the site of ancient Troy. Such material was undoubtedly the concern of the British Museum, and Schliemann had been in touch with them. But the British Museum did not then mount exhibitions, and kept its distance from Schliemann, whose finds were controversial then and have remained so. The Trojan antiquities, which arrived while Owen was on secondment in Paris in 1876–7, occupied the museum's exhibition space for three years, from December 1877 to December 1880, and in the end the Department of Science and Art had to write to Schliemann to say that 'it has ... now become necessary to ask you to remove the collection at your early convenience'. Schliemann then presented it to the Berlin Museums.[79]

Another slightly inapposite exhibition, in 1879, was of the collection formed by Frederick Crace of maps and prints of Old London.[80] It was not unprecedented for the museum to take an interest in national history, for in 1871 it exhibited William Gibbs's bequest of Roman and Anglo-Saxon material discovered during railway excavations in Kent.[81] After exhibition at South Kensington, Crace's collection was promptly acquired by the British Museum, and the space it had occupied in the Western Galleries in the Horticultural Society Gardens was turned over to an even more inapposite exhibition, the anthropological collection of Colonel A.H. Lane Fox.[82] This had been exhibited at the Bethnal Green Museum from 1873, and was then transferred to South Kensington, where Lane Fox (who at this point became Pitt Rivers, in consequence of inheriting a fortune) expanded it and eventually arranged for it to be set up as a separate Pitt Rivers Museum at Oxford in 1885.[83] While contemplating these sallies on the part of the museum into archaeology and anthropology, it is perhaps

worth noting that in 1885 it acquired, for the permanent collections, some Tanagra terracotta figurines and gold ornaments from the Oxus.[84]

A more pertinent exhibition policy seemed to emerge in 1881 with a Loan Exhibition of Spanish and Portuguese Ornamental Art, followed in 1882 by an exhibition of Scandinavian decorative art from Norway, Sweden and Denmark. These exhibitions were, it was noted, intended to accompany a change of approach in the permanent collections, too. For 'the old classification by materials and processes is being undone, and heterogeneous gatherings of works assumed to have been produced in various countries are taking its place'.[85] In May 1882 *The Times* reported that the new attempt to 'display national styles of artistic design' had borne fruit in the creation of 'Italian, French, German, Persian, and Indian collections'.[86]

Greeting the first of the exhibitions of national art, one commentator detected a significant change of course at South Kensington:

Up to about 1876 the administration of the Kensington Museum had endeavoured to classify sections of objects in accordance with the principles enunciated in 1852. An unexampled collection of works of the potter's art was arranged: goldsmiths' and jewellers' work were placed together, carvings in wood and cabinetmakers' work formed another section, metal works another, textile fabrics another, and so on. The handicraftsman pursuing his industry in one or another of such divisions, could come to South Kensington and consult the works which belonged to his craft. From time to time there had been special exhibitions of works of various crafts. There had been one for cabinetmakers, a later one for embroiderers, another for jewellers, another for enamellers. During this year, a different series of exhibitions has been commenced. Spanish and Portuguese works were collected; and probably Scandinavian, Italian, French, German, Russian, Chinese, and American collections may follow. The aim of these national exhibitions is apart from that of the preceding 'craft' exhibitions. Their importance lies, in enabling connoisseurs and collectors, as distinct from artisans and manufacturers, to discuss the nationality of art works ... The theory that art is to be nationalized is gaining ground, and the arrangement of objects at South Kensington is being attempted in this direction.[87]

There were various views on this change. 'In making this new departure the South Kensington Museum emphasizes a study of the ethnographical as distinct from the technical and purely artistic aspects of human productions' was the downright comment of *The Times*.[88] More cautiously, the critic Cosmo Monkhouse, warning that 'the wisest manner of arranging such a heterogeneous collection of treasures as those at a museum like South Kensington may be open to discussion', accepted the new system as 'that which will contribute most to general culture'.[89] The museum's longest-standing customers, however, were disgruntled.

'While this alteration will be satisfactory to the student of ethnography ... it will be less agreeable to the manufacturer, designer, and producer, for the education of whose tastes the museum was supposed to have been organized.'[90] What is most odd about this development is that, after arousing discussion, it went no further after the Scandinavian exhibition. There were no Italian, French, German, Russian, Chinese and American exhibitions, as predicted.

It may be that what we see here is not so much South Kensington embarking on a reappraisal of cultural history, as Philip Cunliffe Owen exploiting his international contacts. Already in 1880 he had spent a month in Russia arranging for electrotypes to be made from over 200 pieces of silver in Russian collections.[91] The loan exhibition of Spanish and Portuguese Art, in summer 1881, was very much a political exercise, supported by a committee drawn from a high diplomatic level. In response to loans to the exhibition, South Kensington in return lent some of its own collections for exhibition in Lisbon. In the same year the museum sent a loan exhibition of Indian art to the Kunstgewerbemuseum, Berlin. This travelled on to Copenhagen and Stockholm, and in reciprocation came the loan exhibition of Scandinavian art in 1882.[92] Owen, it will be remembered, was deeply involved in the Colonial and Indian Exhibition of 1886, and may have been diverted by this from pursuing further international initiatives.

Within Britain, as we noticed in the previous chapter, the museum's work in circulating objects increased, for the demand for travelling exhibitions went up 'with a bound' in 1881.[93] This can, perhaps, hardly be regarded as an initiative by the museum, but rather as a not altogether enthusiastic yielding to pressure from the public and Parliament to lend exhibitions not only to the existing circuit of Art Schools, but also to the growing number of local (or 'Corporation') museums.[94]

On taking over the direction of the museum, Owen quickly made one attempt at greater accessibility. Henry Cole had projected the series of collection catalogues, under J.H. Pollen's editorship, and these appeared at a stately pace through the 1870s and '80s. They were generally well reviewed, but they were expensive and did not sell well: 'it being evident that a great deal of money must be getting spent over them, we are certainly rather moved to consider what practical purpose they are to serve,' commented one critic.[95] Owen tried to revitalize the museum's publishing programme with a series of pocket-sized handbooks ('the outcome of his personal suggestion'),[96] bound in green cloth or blue-grey paper. Some of these repackaged the prefaces to the more expensive catalogues edited by Pollen, while others explored new territory, such as Stanley Lane Poole's *The Art of the Saracens in Egypt* (1886) and Margaret

Stokes's *Early Christian Art in Ireland* (1887). Some readers greeted these as guide books to the galleries, which 'will be useful companions during a holiday visit to the Museum',[97] but in truth they were not well adapted for that purpose (*The Times* dismissed them as 'inadequate guides to the South Kensington treasures').[98] It was perhaps better to regard them as 'so well adapted for those who can only read while they run, that a man might do well to buy one on a railway bookstall and skim its contents in an express train'.[99] A flattering view from abroad was that they were 'a veritable artistic encyclopaedia, upon whose importance one could not too much insist'.[100]

The museum continued to communicate with its audience through lectures – especially, in the 1870s and '80s, through an annual series of 40 lectures, intended primarily for the students of the National Art Training School, but also open to the public, by Professor George Zerffi. Zerffi was a Hungarian nationalist refugee, operating for part of his time as a spy for the Hungarian revolutionaries, but otherwise working as an art historian. His lectures, published in 1876 as *A Manual of the Historical Development of Art*, are an attempt at a systematic history of decorative art from its origins to the present. It is as if the mantle of Semper had fallen upon him; but he was described not as a scholar, 'but rather ... a journalist gifted with the ability to teach and to synthesize the findings of ... branches of scholarship' such as 'general history, cultural history, archaeology, mythology, psychology, and aesthetics'.[101] Zerffi might be adduced as the visible evidence of the museum's intellectual life in the 1870s and '80s, but his heavily Darwinistic and racist view of art history would gain little credit today.

Despite the achievements here noticed, it is hard to resist the conclusion that towards the end of Owen's 20-year directorship the museum was running down. Would the elderly George Wallis have been allowed in Cole's time to report, as he did in 1883, that 'very little change has taken place in the Museum during the year, requiring special notice'?[102] Wallis retired as Keeper of the Art Collections in October 1891, and died soon afterwards.[103] Richard Thompson, who was 'not desirous of quitting',[104] had to go in the same year when he reached pensionable age;[105] he died in 1908. Robert Soden Smith had died in office in June the previous year.[106] The year 1892 saw the retirements of Henry Sandham, who had joined in 1859 and had been a Curator on the science side, and of Robert Laskey, the senior Assistant Keeper on the art side, who had joined in 1852. Cole's men were on the way out.

With such a lot of elderly men at the top, it would hardly be surprising if the museum slowed up. But it seemed to have a more profound debility. It had lost touch with its old audience and not yet found a new one. During the last

quarter of the nineteenth century, indeed, it seemed to have few friends in any quarter.

The whole Department of Science and Art was in bad odour with the public. Signs of this had been in evidence even in Cole's time. In 1872 it was said that 'there exists at this moment in London, and more or less throughout England, a feeling with regard to the Department of Science and Art in which the favourable recognition of its success is ominously mingled with an entire distrust of its policy'.[107] Before long, commentators found much to criticize not only in its policies but also in its methods. They found it slothful, a year in arrears in its work: 'Such a style of doing business would not be tolerated for a day in any merchant's office. Since the retirement of Sir Henry Cole ... the supervision of business details has been very lax.'[108] They found it secretive: 'The impenetrable secrecy of the operations of the present Department of Science and Art [in 1876] is in striking contrast to its open dealing twenty years ago.'[109] As time wore on, it became, like many Government departments, increasingly hidebound, showing 'an indifference to progress of all kinds. The officers have no need to care whether the world moves, for their rules and regulations alone are binding on them, though antiquated and often absurd.'[110] By 1884 distrust had deepened to the extent that a journalist could sensationally denounce the Department as 'a mere hotbed of jobbery and corruption'.[111]

As a public institution the Department had to answer at the bar of public opinion. It was observed that the 'South Kensington Museum is notoriously unpopular in the House of Commons',[112] so when the departmental estimates came up for Parliamentary approval there were usually some tetchy remarks. 'Sir W. Barttelot believed that nearly every item in connection with this museum was over-estimated ... money voted for one object was expended on another ... the accounts were not so accurately kept as in other departments.'[113] 'Mr Dillwyn expressed a hope that the Government would put its foot down and stop the ever-increasing expenditure on that overgrown and to a large extent useless establishment.'[114]

The Department's art-teaching system was often criticized. Many thought that its ladder of instruction through progressive exercises was rigid. Robert Lowe's introduction of payment by results throughout the English education system in 1861 had (whatever its positive virtues) the effect of inducing the Department's art teachers to restrict their pupils to the easier stages of the ladder, where they could be sure of good results, rather than encouraging them to risk the higher rungs. 'It is necessary for the survival of South Kensington that an immense number of students should be returned as "passing" the examinations,' commented a critic in 1894; it seemed to him that the Department's

practice of publishing specimen exam questions and answers was tantamount to rigging the results.[115] The system was over-centralized. 'South Kensington is the centre of the spider's web, and everything done there trembles down the lines, bringing joy or grief to far-off places, to little towns and obscure communities on the confines of the British Isles.'[116] Most damaging of all was the criticism that the South Kensington method of teaching drawing was crushingly boring, focusing on laborious detail while losing sight of the bigger picture. The system, said W.J. Stillman, 'seems to be analogous to what geography might be as studied by pismires – the attempt to crawl over and investigate at near sight every point and detail of the subject, without in the least comprehending the larger relations of it, much less the rhythmical tendencies'.[117] Ruskin was generally felt to support this line of criticism, though his implacable opposition to South Kensington was apt to break out in wild denunciation ('The Professorship of Sir Henry Cole at Kensington has corrupted the system of art-teaching all over England into a state of abortion and falsehood from which it will take twenty years to recover'),[118] rather than practical analysis. Edward Poynter, who moved from the Slade School to be Director for Art at South Kensington in 1875, agreed that it was 'time ... wasted' for students to spend weeks on 'painful stippling',[119] and tried to encourage them to draw with greater freedom.

But attempts to make South Kensington's art-education system more unconstrained and expressive only served to throw into stronger relief the long-standing contrary view that South Kensington ought not to be producing artists, but 'ornamentists'. When Richard Burchett retired as headmaster of the London School in 1875, the *Architect* advanced this view.[120] And when Richard Redgrave retired as Director for Art in the same year, the *Daily Telegraph* dismissed his regime as a failure:

We may consider it, in truth, the gravest accusation which, in no carping or invidious spirit, but in strict justice, must be brought against South Kensington, that it has failed, as a rule, to rear accomplished practitioners of the crafts which it was avowedly founded to teach. It has turned out a number of tolerable draughtsmen of the human figure, a few, a very few, good modellers, and a distressingly large quantity of more or less mediocre picture painters, male and female. The schools were not established to teach the painting of pictures. South Kensington was never intended to be a pleasant suburban succursal to Burlington House. It was meant to be a simple, stern, essentially technical school for the training of clever and industrious young men or women as designers of patterns for carpets, for dress fabrics, for wall papers and floorcloths; as modellers for goldsmiths, for iron and brass workers, and fancy article makers; as designers of furniture and lace curtains; as painters of pottery and *papier-mâché*.[121]

So South Kensington stood condemned for producing neither fine artists nor applied artists. And yet, in the 1880s and '90s, there was a revival of the decorative arts in Britain, the Arts and Crafts Movement. Contemporary observers allowed the Department of Science and Art no credit for this development:

The decorative artists whose labours have wrought so much change in such matters as tapestries, wall-papers, carpets, pottery, etc., have almost without exception been entirely independent of South Kensington influence, and have based their work upon principles which were in the main opposed to the formal ones inculcated in Government schools of design.[122]

Whence, then, came the inspiration for the revival? The answer of Hubert von Herkomer, once a South Kensington student, was clear: 'William Morris had done more in a few years to promote true decorative art than had been done by South Kensington during the whole course of its existence'.[123] Indeed, the Department admitted as much. Thomas Armstrong, who succeeded Poynter as Director for Art in 1881, declared at a lecture to the Society of Arts:

No impetus has been given to decorative art in our time, to compare with that which had its origin some thirty years ago, in dingy Red Lion-square, where a few young men, unknown to the public, but warmed by real enthusiasm, and as the result has shown, led by the light of genius, set to work quietly, and without advertisement, to apply art to industry, with results known to you all, which are associated with the name of, and are in the main due to, William Morris.[124]

Cole's approach had always been administrative rather than inspirational. He tried to reform taste by rules and systems. Pugin was to some extent his preceptor, but Cole did not share the romantic Catholicism that gave passion and authority to Pugin. His doctrines were rather bloodless, and so (notwithstanding his own larger-than-life personality) they lacked allure when in competition with the volcanic rapture of Ruskin, or the noble warmth of Morris. Ruskin preached that decorative art would only be reformed and revived when craftsmen were happy in their work. Although he resisted the political implications of this view, he offered, as a means of enhancing the craftsman's enjoyment, the idea of the guild, founding his own Guild of St George. Morris did see that happiness in work would involve a shift in power relations between capitalists and workers, and was led to revolutionary socialism. Important in his capacity to inspire others was also the fact that, unlike Ruskin, he was himself a vivid embodiment of his own ideal of the active, practical hand-worker. The disciples of Morris and Ruskin shared in the emotions that these prophets were able to arouse; operating mostly in guilds and groups, they generated their own emotion in a free fellowship that was quite unlike the formal drill in the classes of South Kensington, where 'suddenly, and as if

moved by some spontaneous and irresistible impulse, thirty or forty right arms, with pencils in hand' could be seen 'rigidly extended towards the model ...'[125]

If the Department of Science and Art's schools were failing to produce craftsmen, was the museum doing any better in its professed mission to provide material to inspire craftsmen? Walter Crane, surveying 'The English Revival of Decorative Art' in 1892, was cautiously polite:

The quiet influence of the superb collections at the South Kensington Museum, and the opportunities of study, open to all, of the most beautiful specimens of Mediaeval, Renaissance, and Oriental design and craftsmanship of all kinds must not be forgotten – an influence which cannot be rated as of too much importance and value, and which has been probably of more far-reaching influence in its effect on designers and craftsmen than the more direct efforts of the Department to reach them through its school system.[126]

Crane supported South Kensington as best he could, and became head of the London School (by then the Royal College of Art) in 1898–9, when he introduced important reforms. Morris too was faithful to the South Kensington schools, for which he acted as an examiner from 1876 until the end of his life, although 'the work was not interesting to him ... a severe trial to his patience',[127] and he supported the museum too by advising on purchases. On a typical occasion, Thomas Armstrong recorded the Department's indebtedness in an official minute:

He is at all times a very busy man and especially so just now but he cheerfully undertook to cross the channel twice at no little discomfort in the bad weather of the last few days in order to procure for the Dept. these patterns of old prints which, he thought, should belong to the public.[128]

Morris, of course, had reason to be well disposed to the museum, not only because he was interested in its contents, but because Henry Cole had commissioned his firm (Morris, Marshall and Faulkner, as it then was) to decorate the Green Dining Room in 1865, at a time when the firm was still in its early days.

Other leading lights of the Arts and Crafts Movement had less time for South Kensington. The excitable John Sedding disparaged the 'gentlemen-draughtsmen turned out of the Kensington Schools', since for him it was not 'the half-fledged draughtsman' but 'the full-fledged craftsman that is required'. Indeed, he was so committed to the virtues of hand-work that he thought that 'first-rate draughts-manship will not compare with third-rate craftsmanship'.[129] If craftsmen were to seek models, Sedding was not convinced that the art of the past was where they should look. 'Let us by all means study the relics of old handi-work – let us learn the secret of their charm, imitate their excellences, but put aside the thought that all good work must necessarily go along the same grooves, and conform to the same conditions.'[130] Museums, as collections of 'old handiwork', tended to devalue invention and promote stylistic imitation:

If the modern designer must ever have a pale society of ghosts at his elbow to suggest the lines of his device – if design is never to be anything more than a trick of styles – then we can't have too many museums. But to such of us who dream of new traditions for new art, museum-study is far from an unmixed good. The museum incites to copyism; it leads to style-mongering ...[131]

No wonder that in *Arts and Crafts Essays by Members of the Arts and Crafts Exhibition Society* he cried: 'No more museum-inspired work! ... But instead, we shall have design *by* living men *for* living men.'[132]

One of the motors of the Arts and Crafts Movement was that newly awakened sense of national identity that was widely felt at the end of the nineteenth century. So for Sedding, the Englishness of English art was of supreme importance. The South Kensington Museum, however, was not well equipped to exemplify this. Its initial commitment had been to universal standards of good design, and it had tended to acquire foreign work in preference to English. Furthermore, Sedding believed that English art should be studied in its natural context, the English countryside. 'Study the art *where* it grew,' he urged. 'So much of its historic interest depends on ... the localism of art.'[133] Consequently, 'we will not rely upon the museum for our illustrations, but go ... straight to the old house and old church. Clearly it is here that we shall find the old handi-crafts at their fullest and their best'. For Sedding, 'a museum' (and here he has South Kensington specifically in mind)

is a place for odds and ends; for things that have drifted; for the flotsam and jetsam of the wrecked homes of old humanity ... The old home-chattel becomes 'disharmonized' in a museum; dislocation from its old scenery is loss of romance; you cannot regard it with the same poetic interest when it is represented as a number in a catalogue, when it carries a label to inform the curious the probable date of the piece, where it was bought, what it cost![134]

The Arts and Crafts Movement was hardly the voice of the nation; it was a minority movement of recoil and retreat. But its adherents were exactly those who ought to have formed the core of the South Kensington Museum's support. If Sedding's views can be accepted as representative, then it is clear that, in the last quarter of the nineteenth century, the South Kensington Museum, like the Department of Science and Art's schools, was losing touch with its original constituency.

There was at least one attempt to retrieve the support of artisans and manufacturers. In 1886 it was announced that:

with a view of rendering the South Kensington Museum and school as directly useful as possible to manufacturers and others engaged in industries in which Art is more or less concerned, we decided to make arrangements for the admission of a limited number of persons employed in those industries to study in the South Kensington Museum with its libraries and schools without the payment of fees, for periods of from two to nine months, according to circumstances.

The idea was that if manufacturers would continue to pay the wages of their seconded employees, the museum's curators and the teachers in the school would give tuition free. This worthy effort was not successful. 'Though a notice of these industrial studentships was widely given by means of the Press in February last,' recorded the Annual Report for 1886, 'we regret to say but few manufacturers have yet availed themselves of the opportunities offered.'[135]

Already, there had been signs that the museum was moving in a different direction, when in 1880 the 'modern examples of Art manufacture' were sent to the Bethnal Green Museum on a 'temporary transfer',[136] which, for most of the material, was to last a hundred years. If the transfer of such material benefited the working men of Bethnal Green, it must by the same token have disadvantaged any working men who wanted to make use of South Kensington. The museum authorities did not enlarge on their motives for making this change, but an article in *The Times* gave the game away. 'It had long been felt,' said the writer, 'that a certain incongruity attended the mixing up of some categories of the South Kensington collections with others of totally different origin and epochs.' As the writer developed his theme, it became clear that what was at issue was a new estimation of old art (which was admirable and precious) as against modern art (which was disagreeable). 'Barbedienne's bronzes and Minton's china were in no way enhanced or illustrated by juxtaposition with the venerable works of Donatello, Orazio Fontana, or Bernard Palissy; whilst to the connoisseur and student of ancient art the association was even painfully repugnant.' It was to assuage the pain of connoisseurs and scholars that the modern art was cleared out of South Kensington; the Director 'and his energetic colleagues' were to be congratulated on 'a sagacious and timely apprehension of the progress of public opinion, not always shown by managers of our public collections'.[137] It is interesting to speculate on who, exactly, so keenly apprehended public opinion, and there is a clue in Henry Cole's diary entry for 4 February 1881: 'Met R. Thompson in Museum. He said he suggested the removal of Modern objects to Bethnal Green, not Robinson.' Whether Richard Thompson, the Assistant Director, was responsible or not, it is surely significant that the name of J.C. Robinson, champion of connoisseurs and

scholars, should have been linked with this change, even if mistakenly.

The museum seems to have been vacillating, in the 1880s and '90s, between several possible audiences. It may be asked why it could not have made a wide appeal to the 'general public', for Cole had taken the entire nation as the museum's audience, and that posture might conceivably be adopted again today. But the end of the nineteenth century, it has been argued, was a period of cultural segmentation in which more and more small groups 'mustered the confidence to deviate from the dominant values'.[138] In these circumstances, it was likely that the museum would begin to think of itself as addressing, not the general public, but a very particular public of votaries, fit though few. This gradually came to pass, and eventually the museum moved away from artisans and manufacturers towards collectors and connoisseurs.

It took some time, however, for the path to become clear. This was partly a matter of shifting tastes, which can be followed in the changing value ascribed to words like 'bric-à-brac' and 'curio'. In the museum's earliest days, contemporary art manufactures were all-important, and historical decorative art objects could be dismissed by design reformers as bric-à-brac. When the museum moved to South Kensington, huge quantities of other material arrived to obscure the view of the art objects and give a new meaning to 'bric-à-brac'. Cole's 'peculiar views', it was said in 1875, 'have made of South Kensington a huge curiosity shop', though it was possible to sort out the good art if you tried.[139] Similarly, in 1883 a critic described the museum as 'a wilderness of second-rate objects of all kinds. The whole thing thus becomes a sort of superior bric-à-brac bazaar, where only the practised eye can detect the good from the indifferent and the absolutely bad'.[140]

Some sort of refinement of the collections began to seem necessary, but there were differing approaches to this. Design reformers continued to think that the museum should get back systematically to its original mission. Frank Granger, the architect, lecturing on 'German Technical Museums' in 1890, compared South Kensington disparagingly with its foreign imitators (which are discussed further in the next chapter). Whereas they were 'well arranged from the student's point of view', South Kensington exemplified the view of 'the collector of curios'.[141] In the same year Lady Dilke compared South Kensington with the applied art museum in Vienna: 'the Austrian Museum shows, in every department, the influence of definite educational purpose', whereas 'South Kensington is disfigured by the "collecting" mania, and makes one feel as if one were visiting a gigantic bric-à-brac shop'.[142] Such views, however, in which historical art was disparaged as bric-à-brac

Figure 8.7
Evidence of the usefulness of the South Kensington Museum to scholarly enquirers. These are pages from a notebook, one of two, unfortunately by an unknown writer, which are a careful classified record of ceramics and glass in the collections of the South Kensington and British Museums. They were obviously compiled, around 1880, by someone teaching him- or herself the history of the decorative arts through the study of examples in museums.

were becoming out of date, for bric-à-brac was becoming respectable in the same measure as it was becoming expensive. The first Hamilton Palace sale came in 1883, and *The Times* commented that it 'made us all look on this fine French *bric-à-brac* with new eyes'.[143] The Fountaine collection went on sale at Christie's the following year, and the *Architect* commented on 'the large sums of good money which people of the highest character for culture can be persuaded to pay ... for articles which in the vernacular will be only called by some such name as toys'.[144] Ultimately, the museum was to come down on the side of bric-à-brac (figure 8.7).

In the 1880s, however, the museum, while losing the artisans and manufacturers, was in a poor position to cultivate the collectors and connoisseurs. For Henry Cole's chickens were coming home to roost. After the distancing of Robinson in 1863, Cole decided, as we have seen, to hire scholars only when he needed them, and to have only administrators on the permanent payroll. The unfortunate consequence of this was a widespread belief that the museum staff lacked scholarly expertise. This was not without foundation. Robinson was finally ejected in 1867. Richard Redgrave retired in 1875. John Hungerford Pollen left in 1876. The art collections were in the hands of George Wallis, who was no art historian. No doubt, the parameters of the collections having been established, he was able to proceed for a time on the basis of precedent, supplying what

appeared to be lacking. This is how the *Art Journal* described the museum's acquisition policy in 1875:

... not at all a sensational one ... but the advantage lies in the fact that the growth of the collection is sure, if apparently imperceptible; and that the various divisions are cared for according to their wants and the opportunities which present themselves for supplying these wants; thus filling up and completing the chain of Industrial Art, link by link, in a continuous and systematic manner. In recent purchases there has been a very marked filling-up of gaps in sections of the Museum which were, and in some respects still are, weak.[145]

This is not, however, a method that can be successfully pursued indefinitely. In 1879 Wallis was joined by a new Junior Assistant, Arthur Skinner (educated at Dulwich College and London University), who worked hard to advance himself, and no doubt helped to strengthen the expertise of the museum staff.

Redgrave, as the Department of Science and Art's Inspector for Art, had always concerned himself with acquisitions. His successor, Edward Poynter, who was in office from July 1875 to August 1881, went on to become a successful Director of the National Gallery, but he does not seem to have exercised his museum skills (as distinct from his educational skills) very noticeably at South Kensington. It was a different matter with his successor, Thomas Armstrong (figure 8.8). Although 'his duties at the Museum ... are nominally only consultative' – for he was

really in charge of the Art Schools network – it was well known 'that he devotes more of his time to the affairs of the great Art Museum than did his predecessors'.[146] In 1898 it was officially noted that 'under somewhat exceptional circumstances, which obtained while Sir P.C. Owen was Director, the present Director for Art was ... often employed in taking the initiative in purchasing for the Museums, not only in this Country but abroad where he was sent on several occasions'.[147] Indeed, it was said that under Armstrong, the curators were:

a mere troupe of marionettes ... The few men who do know anything about the works of art, not only have no voice in the selection and purchase of them, but they are not even consulted by the Art Director who pulls the strings. It is notorious, in fact, that the Superintendents of Sections in the Museum have, over and over again condemned, *sub silentio*, examples of art-work purchased as genuine things of the past, as gross and palpable shams.[148]

If, then, the curators, on the one hand, and the Director for Art, on the other, were judged inadequate to their task, who was left? The answer might be: the Art Referees.

When Robinson departed from the museum in 1867, the two posts of salaried, full-time Art Referee that had been

occupied by him and Redgrave were abolished. 'In future,' decreed 'My Lords', 'a staff of Art Referees of the most competent persons will be appointed, to be employed as occasion arises, the Department paying them a consulting fee when they are asked to advise.'[149] This group of 16 included Samuel Birch, Edward Bond, A.W. Franks, C.T. Newton and Reginald Stuart Poole, all of the British Museum; the Royal Academicians Sir Francis Grant, Solomon Hart, J.C. Horsley, Frederic Leighton and Daniel Maclise, who, along with the painter Eyre Crowe, acted as occasional examiners for the Department of Science and Art; Owen Jones and Matthew Digby Wyatt, from the old 1851 Exhibition group; the architectural historian James Fergusson; and Robinson himself. The Referees do not seem to have been very diligently consulted, and in 1884 the Lord President of the Council, at that time Lord Spencer, appointed a new set of committees to cover the various interests of the museum. Spencer later recalled that:

at that time, I do not know whether it is worn out now, I am afraid not wholly, there was some prejudice against the South Kensington [*sic*] in the way it was managed, and I attached considerable importance to the appointment of these committees, as I thought it would show that the officers of the department had no fear whatever of submitting what they had done, either their purchases or their arrangements, or their work, to outside men of reputation ...[150]

The new team of 13 Art Referees, under the chairmanship of Frederic Leighton, included the architect G.F. Bodley; the sculptor Edgar Boehm; the painters Edward Poynter and Lawrence Alma-Tadema; the scholars J.H. Pollen and William Maskell; and William Morris.[151] These Referees, like their predecessors, were infrequently consulted,[152] so Lord Spencer's good intentions came to little.

Allegations that the museum was in decline began to be made. In 1883 a correspondent to the *Morning Post*, writing under the pseudonym 'Art Collector' (surely a significant epithet), lamented: 'Unfortunately since the days of Mr J.C. Robinson things have totally and terribly changed, and there does not now appear to be anyone connected with this museum with any knowledge or even taste.'[153] There is an ironical dimension to this remark, since the writer was presumably unaware that Robinson had only recently been working for the museum again. Despite the breach between Cole and Robinson, Owen – who had worked briefly for Robinson in their earliest days – remained on good terms with him. 'Upon my taking up the duties of Director in 1874,' he later wrote to Robinson, 'I did not consider it proper to carry on the personal animosity which had robbed the museum for seven years of the invaluable services you were able to render to the state.'[154] So Robinson's advice on purchases was once again

Figure 8.8 Thomas Armstrong, Director for Art 1881–98, from a photograph reproduced in the *Art Journal*, 1891.

sought, and in 1879 he wrote with satisfaction to Owen that 'almost without intending it, I have found myself doing just the same kind of work as before'.[155] But this time Robinson insisted on being unpaid (so as to be 'independent and unfettered'),[156] and stood apart from the group of Art Referees of which he disapproved.

Among other tasks for the museum, Robinson wrote the catalogue of the exhibition of Spanish and Portuguese Art in 1881, and in the same year made a purchasing trip to Italy.[157] (His offer to loan 'a collection of instruments of torture, formerly used by the Inquisition, which he acquired in Spain for Mr Henry Willett, of Brighton' was not, however, accepted.)[158] But his rehabilitation with the museum was not to last long. On 23 December 1881, with the retirement of Norman MacLeod, John Donnelly took charge of the Department at South Kensington. He was not well disposed to Robinson, and a breach soon occurred over the 'Hillingford armour affair'. Robinson, exercising his new role as a sort of broker between dealers and the Department, recommended that the Department's museum in Edinburgh should buy a collection of armour formed by an artist, Mr Hillingford, and at that time offered for sale by Mr Wilson, a dealer in the Strand. Robinson wrote: 'I consider it a most interesting and valuable collection, and a great bargain. I am, in fact, strongly tempted to buy the collection myself.'[159] Donnelly and the Board interpreted the transactions between Robinson and Wilson as indicating that Robinson already owned the armour when he offered it to the Department, and that he was thus trying to make a dishonourable profit. It is not clear that this interpretation stands up, but for the Department the matter 'to say the least of it, had an ugly look',[160] and relations were severed once again.

The Department probably did Robinson an injustice. But he was a slippery character, with a penchant for remodelling history to enhance his own part in it. When he regained favour with Owen, he painted the situation thus:

No one ... is better aware than yourself that the resignation of my appointment at South Kensington, now twelve years ago, a step inexpressibly painful to me at the time, was brought about substantially from my disapproval of, and consequent inability to co-operate in much of the work then in progress in the Museum. Happily the cause[s] of disagreement no longer exist.[161]

This from a man who was sacked not once, but twice. In a later controversy between Robinson and the Museum (about fading watercolours), on the letter pages of *The Times* in 1887, Donnelly tried to smash him with the brutal truth:

Those who know the circumstances under which it was necessary for the South Kensington Museum to dispense with the services of Sir J.C. Robinson will appreciate, though probably

they may be surprised at, the tone which he adopts when writing of that institution ...

But Robinson swatted this aside:

Colonel Donnelly seems to have lost his temper, which doubtless accounts for the fact that the South Kensington administration, as represented by himself at least, does not know how to appreciate really qualified and gratuitously rendered advice in matters of art, of which nevertheless, it stands notoriously in need ...[162]

Such was the rancour that entered debates on the museum at this period.

Complaints continued. One slant that the newspapers found attractive was the assertion that, because the museum was staffed by incompetents, it was full of fakes. 'An attempt is being made,' the *Daily Telegraph* of 2 January 1885 plummily pronounced, 'to throw discredit on the genuineness of some of the purchased exhibits ... It is inferred that the authorities have been in the habit of buying spurious or counterfeit articles as originals, and that they have, from time to time, given a price considerably above what might be deemed the market value of curios.'[163] In a more vicious idiom, the gutter-press alleged: 'Works of art have been purchased by the museum which had been unsaleable drugs in the hands of all the Jew dealers in London for years, and at last have been cleverly landed upon South Kensington Museum after having been "discovered" at Florence.'[164] Despite all the museum's efforts, this impression was evidently very difficult to dislodge, for, 15 years later, a Cambridge Slade Professor could still comment: 'It has been made matter of blame to the Museum authorities that they have been misled into the purchase of many forgeries, and that many of the objects exhibited are wrongly labelled, false attributions being or having been by no means uncommon.'[165]

As is often the case in such controversies, hard evidence was sparse. A few examples of bad purchases were repeatedly quoted. There was the 'large silver and parcel gilt clock, labelled as costing the museum £1,200', which 'might have been purchased by auction at Christie's a short time before for ... about £400'[166] (it had been 'bought in' when it failed to reach the reserve price of £300).[167] Fortunately, this purchase dated back to 1870, and could be laid at the door of the Art Referee Sir Matthew Digby Wyatt, who died in 1877. From the Hamilton Palace sale in 1883:

there was a cabinet which so delighted the eyes of the Art Director with its brilliant gilding and painted panels, that it must be had if it cost a thousand guineas. This was bought for £900, which, with the dealer's commission, made its price about 1,000 guineas. Now, this precious piece of old French furniture, as our Artist Directors thought it to be, had once been a sedan chair, the gaudy panels of which had been

transmogrified into a cabinet. At the most, such a sham is worth about £50.[168]

There was also a fake piece of Palissy ware:

a platter which looked like a Palissy platter that had been broken and grimed, and then artistically mended with two strips of canvas cemented on, the two strips crossing one another in the middle of the back of the platter. After several months of exhibition at South Kensington, damp caused the strips of canvas to relax. They were taken off, to be put on again more firmly, and there on the back of the platter, just where the strips of canvas had crossed, was the imprint of a modern French maker of facsimiles, whose price for such a platter, new, hot from the kiln, and unbroken, is £10![169]

If real errors in purchasing were not numerous enough, then near-misses could be quoted. It was fortunate that the Board 'refused to sanction the purchase by the Art Director of a lot of gilt and stamped leather chair-seats which he pronounced to be fine examples of old Italian work, but which somebody recognized as modern French imitations, worth about £5, whereas the sum proposed was £250'.[170]

Inaccurate labelling was frequently adduced. Some examples were grotesque blunders. A Mr Bitmead wrote to tell the *Furniture Gazette* that he had found exhibited at South Kensington some imitation Chippendale furniture, which he himself had made, but which was labelled as genuine Chippendale. The museum ruefully admitted that the label was 'erroneous' and lost rather than gained credit by absurdly insisting that it was 'temporary'.[171] More difficult to deal with was criticism from a heavyweight art critic like Claude Phillips, soon to become Director of the Wallace Collection. He wrote three articles in the *Academy* in 1888 and 1892 attacking the attributions of some of the museum's Italian Renaissance sculpture, and casts of sculpture:

It must be evident to all who are acquainted with the technical characteristics of the Florentine and North Italian schools of sculpture of the Quattrocento, that these panels are not only not by Mino, but that they are not Florentine at all, but clearly of North Italian origin. They stand midway between the jagged and energetic manner of the Mantegazzas and Amedeo and the somewhat softer Venetian style of Pietro Lombardo, and might possibly be ascribed to the early time of the latter ...[172]

When addressed in the peremptory accents of connoisseurship, the officials of South Kensington no doubt felt lost for the appropriate words of rejoinder.

Upon these flames of criticism, oil was assiduously poured by Robinson. His most strenuous expression of the case against South Kensington came in 'an address prepared for delivery at the annual distribution of prizes at the Birmingham School of Art in 1888',[173] which deserves to be quoted at length, for its very repetitiousness emphasizes Robinson's almost obsessive chagrin:

The energy, variety of application and individual devotion to the work in hand, which characterized the earlier days of the South Kensington establishment have ... of late years been followed by a dull and comparatively stagnant regime. In this regime mere lay administrators and inexperienced, irresponsible amateurs have, in the art division of the establishment at all events, replaced and kept at a distance men of eminence of special knowledge and understanding of the work to be done ...

... At a certain period of the development of the Museum, it was decided, I shall not stay to explain upon what grounds or at whose instigation, that it was inexpedient any longer to continue the system by which the collection had, until then, been guided, and, in fact, created, that of the individual direction of a single qualified and responsible person, and to substitute, in its stead, an ill defined system of management, by lay administrators, knowing little or nothing of the business in hand, but who were to avail themselves, on their own judgement and at their own uncontrolled pleasure, of the paid services and advice of irresponsible outsiders, supposed to possess special knowledge in the several departments. At this point, I fear, I must express myself in very outspoken terms. Alike in its inception and in its results, the system has been simply preposterous.

By its means a number of entirely unqualified persons have been enabled to take upon themselves functions and powers involving the outlay of great sums of public money and at the same time, to entirely evade the onus and responsibility of so doing. The infinitely difficult, delicate and responsible work of discovery, selection and acquisition of works of art, to be added to the National Collection, has literally, in ever varying measure, been usurped by Secretaries, Clerks, Vice-Presidents, Military Officers, Academicians and outside amateurs, all alike without adequate training and experience. This difficult and onerous work, has, in short, been everybody's business and nobody's in particular ... It would be impossible, on this occasion, to give any adequate account of the astonishing blunders, which have been perpetrated under this system. They are, unfortunately, notorious throughout Europe.

Philip Cunliffe Owen retired in 1893, dying the following year. His job, which had been only half of Cole's, was again split. Now that a 'Science Museum' had achieved official existence, it seemed appropriate for it to have its own Director, and General Festing was promoted from Assistant Director to this new post. Alongside this Museum Director for Science there was to be a Museum Director for Art. Inevitably the twinned posts would have less clout than Owen had enjoyed; but at any rate it was now appropriate to seek a competent art historian, who could restore the Art Museum's shattered reputation. The art historian selected was Dr John Henry Middleton, Director of the Fitzwilliam Museum, Cambridge (figure 8.9). The 'Art News and Gossip' column in the *Westminster Gazette* of 5 June 1893, alluding to the 'strange rumours afloat about recent blunders' at the museum, hoped that 'perhaps the appointment of Professor Middleton will put an effectual stop to such alleged scandals'.[174]

Figure 8.9 Professor John Henry Middleton, Director of the Museum 1893–6, from a photograph by R. N. H. Stiles.

Middleton was born in 1846 in Darlington, the son of an architect. While he was a boy his parents moved to Italy and he was educated at a Benedictine school near Naples, acquiring a facility for languages and an experience of European travel that gave him a head-start as an art historian. When his family returned to England he went to Cheltenham, followed by Exeter College, Oxford. There, however, he had a breakdown and left without taking a degree. After being confined to his home for some years by his illness, he then spent several years in adventurous solitary travel, visiting the 'great Mahommedan university at Fez', where he studied 'the philosophy of Plato as taught there' and 'in the disguise of a pilgrim effected admission into the Great Mosque, which no unbeliever had previously succeeded in doing'. 'These Wanderjahre were the formative influence on his subsequent life. He came back to England with an unrivalled knowledge of the history of medieval art, gained from living among its masterpieces.'

Back in England, he tried architecture as a profession, training in his father's practice and under Sir Gilbert Scott.

But he was recruited to write art historical articles for the ninth edition of the *Encyclopaedia Britannica*, and this gave him the opportunity to establish himself as an art historian, then a virtually non-existent calling. From this position he attained the Slade Professorship at Cambridge in 1886. His testimonials stressed his wide range based on extensive travel, his practical grounding in technique and the minuteness of his research. His predecessor, Sidney Colvin, praised his 'great retentiveness both of eye and mind'. In Cambridge he blossomed. He became a Fellow of King's College in 1888, and Director of the Fitzwilliam Museum the following year. He was awarded a Cambridge D.Litt. in 1892 and an Oxford DCL in 1894. He must have seemed the ideal candidate as Director of South Kensington.

But the post was to prove too much for him and he would collapse in it, perhaps (as an obituary notice stated) because it 'demanded heavy administrative duties, to which his temperament and his health were alike unequal',[175] but perhaps also because of the poisonous atmosphere in the Department of Science and Art.

Middleton was allowed to get on with purchasing without interference: 'while Dr Middleton was director many things were bought on his recommendation without anybody else being referred to'.[176] And he was encouraged to busy himself in weeding out fakes from the collections and in redrafting labels. His list of 'withdrawn objects' was to be argued over at a later inquiry.[177] So far as labels were concerned, his were certainly more detailed than those they replaced (he transcribed Latin accurately and identified obscure saints previously described by *formulae* like 'figure of an ecclesiastic'), but were perhaps even less comprehensible to the ordinary visitor.[178] He moved the classical plaster casts (which offended Walter Copland Perry)[179] from their top-lit court into the adjacent gallery under the library (figure 8.6), and put in their place the tapestries that had previously been shown in the gallery. Exposing the tapestries to a 'brilliant top light' would not be regarded as good practice nowadays (even though it was claimed that the light 'falling as it does very obliquely, will produce a minimum of fading'),[180] but William Morris for one was delighted to see them given prominence and defended Middleton (who was a friend of his), thanking him for 'removing the disgrace which even the temporary neglect of the tapestries cast on the South Kensington Museum'.[181] When Middleton put up a more ambitious plan of rearrangement, involving the carting off of quantities of inferior objects to Bethnal Green, this was squashed by his superiors.

One of the superiors he had to answer to was the Director for Art, Thomas Armstrong. It was a piquant chance that just at this time, in the early months of 1894, a rather engaging portrait of the young Armstrong, as an art

student in Paris in the 1850s, was set before the world. He appeared in George du Maurier's *Trilby*, thinly disguised as 'Taffy Lynn', a huge Yorkshireman (a 'bullock', a 'bear') with Dundreary whiskers, in an 'out-at-elbow shooting-jacket' and 'his old Harrow cricket cap', enjoying 'happy times of careless impecuniosity, and youth and hope and health and strength and freedom – with all Paris for a play-ground, and its dear old unregenerate Latin Quarter for a workshop, and a home'.[182] Forty years on, Armstrong (who was actually from Manchester) looked balder and glummer, but was said to have 'a nature which preserved the zest of youth united to the wisdom of experience'.[183] As a painter he had abandoned his early exercises in realism (pictures of paupers and beggars) and had achieved success as a Victorian Olympian, with subjects such as 'Three Figures' – they are classical maidens in filmy drapes – 'on a Marble Seat, with Orange Blossoms and Marigolds'. On becoming an art bureaucrat, he almost completely gave up painting. His students praised his generous care for them, and 'his genial personality was a passport to friendship' with his colleagues.[184] A slightly tougher personality is hinted at in the speech that his chief, Donnelly, made on his retirement:

Figure 8.11 W. H. James Weale, Keeper of the National Art Library 1890–7, from a contemporary photograph.

'Mr Armstrong has always been known to go straight, and his genial, and perhaps at some times pungent humour has often made the dry bones of officialdom live, but has, I think, never hurt any of us'.[185]

Armstrong was presumably an agreeable, if occasionally abrasive, colleague for Middleton. But there was no doubt-ing the abrasiveness of his, and Armstrong's chief, John Donnelly (figure 8.10). The Department of Science and Art had, for a time after Cole's retirement, been yoked with the Education Department under Sir Francis Sandford. In 1884, when Sandford retired, it retrieved its independence, with Donnelly as Secretary and permanent head. Donnelly, it will be remembered, came to South Kensington with the sappers in 1859, having previously been a real soldier with creditable service in the Crimea. Although he intended to go back to active service, Cole persuaded him to stay with the Department. Cole had a high opinion of him, praising him publicly in 1873 as 'the youngest man I know with the oldest head',[186] and, as we have seen, even then urging Donnelly's claims to become Secretary of the Department.

Figure 8.10 Major-General Sir John Donnelly, KCB, Secretary of the Science and Art Department, photograph reproduced in the Department's magazine *Science and Art*, 1894.

Just at that juncture, Donnelly's first wife died in childbirth, so he was knocked back for a time. But he continued in his work of advancing the scientific side of the Department's work and, as Professor W.H.G. Armytage affirms, 'made a Major-General in 1887, knighted in 1893, he was in a very real sense the force behind the great expansion of technical education in the last two decades of the century'.[187] A profile of Donnelly in the Department of Science and Art's house magazine described him as 'a man of uncircumscribed *bonhomie*',[188] but there is reason to doubt this. He was not insensitive (his hobby was water-colour painting), but he could not wear his heart on his sleeve. There is a rather poignant letter from him to Henry Cole, in which he thanks Cole for his support and encouragement and laments the 'stupid shyness – or whatever the feeling for not being able to say the right thing at the right time may be called' – which had made him quite unable to speak his thanks face to face.[189] Whether or not he intended it, he evidently had a harsh manner. Sir Edward Poynter thought him a man of integrity, but 'unfortunately ... very uncompromising in what he says ... very combative ... not conciliatory ... very sarcastic ... so that he does not make matters easier for himself'.[190]

Middleton might have devised a way of submitting gracefully to tough chiefs, but he found himself under pressure from below as well as from above – caught between a hammer and an anvil. The anvil was Donnelly, who was unyielding if challenged. The hammer was the museum librarian, W.H.J. Weale (figure 8.11). The life of James Weale[191] was a passionate romance of religion and art. Born in 1832, he was educated at King's College School and destined for Oxford University. But in 1849, influenced by the writings of Pugin and Newman, he was converted to the Catholic Church, which prevented him from going to Oxford. He spent some time in a community led by Father Oakeley in Islington (where he wore a habit and was known as 'Brother Francis Mary of the Angels') and helped with teaching in the local poor school, until he was forced to beat a hasty retreat after administering excessive corporal punishment to one of his pupils. A few years later, in 1854, he married a 16-year-old Irish girl, with whom he had eleven children. A legacy from his mother enabled him to lead an independent life, and in 1855 he settled in Bruges.

Belgium provided the field for his life's work. Exploring his new territory with characteristic thoroughness, he compiled a guide book to *Belgium, Aix-la-Chapelle and Cologne* (1859), inspired by a zeal to correct the errors of all other guide books, which he exposed in a pamphlet *Some Observations on Guide-Books* (1859). He lost money heavily on this project. Fortified with his encyclopaedic knowledge of Belgium, he took up the cause of preserving ancient monuments. Always he was spoiling for a fight with those

who wanted to demolish or deface the historical buildings that he loved. Often, unfortunately, he was at odds with his own supporters (whom he organized into guilds and rallied through periodicals), leaving projects entangled in recrimination and moving on to start new ones. In the 1860s Weale turned to the study of the Flemish 'primitive' painters, drawn to their work for its religious rather than aesthetic significance. 'In Flemish art he found a spirit of seriousness answering his own, a spirit Italian paganism could never satisfy, and to it he remained true to the end of his life.' His special contribution was to burrow through the archives of Belgium, gathering a body of hitherto unknown documentary evidence, which supplied a firm basis for the history of Flemish art.

Weale returned to England, relieved by another inheritance, in 1878 and lived in Clapham. He knew Cole (to whom he had acted as a guide in Belgium)[192] and Robinson ('to whose intelligence and zeal,' he said, 'we are indebted for almost all that is good in the way of mediaeval art in the South Kensington Museum').[193] At various times from 1872 onwards he worked for short spells in the museum, cataloguing material on which he was expert.[194] In 1890, with the death of Robert Soden Smith, the post of Keeper of the Art Library became vacant. Weale sought the post 'with extraordinary credentials and with great avidity',[195] and got it, although, as the *Magazine of Art* observed, 'his appointment has caused no little irritation in the institution itself among those who naturally look to promotion as the reward of years of loyal service'.[196] 'It is possible,' wrote one of his colleagues:

that those who recommended him for the position thought they were rewarding a lifetime of strenuous work with a well-earned opportunity for the quiet pursuit of his studies in conditions favourable to his advancing years. If so they did not know their man. No sooner was he appointed than he set himself with fiery energy to reform the institution committed to his charge.[197]

Quite rightly, he found the old catalogue, which consisted of pasted-up entries from Cole's *Universal Catalogue*, 'a curiosity'. 'As the system of leaving each individual member of the staff to catalogue accessions according to his own ideas could not be allowed to continue,' he said, 'I set to work at once to draw up a set of rules',[198] which governed a new catalogue on index cards. After this, however, Weale's attempts at reform ran up against the problem of his staff. He thought most of them incompetent, but found no support from Donnelly for recruiting better-qualified men. Weale had always had a 'naturally irritable temper', which could still 'blaze into a furnace of just anger, as when an unwary vendor of obscene prints who had penetrated to his room was pursued by him, shouting with fury, through the reading-rooms'. Temper unfortunately intruded into

his official dealings. 'He was skilled neither in the art of concealing his opinions nor in paying deference to official superiors with whom he disagreed.'[199] He was soon at loggerheads with Donnelly.

Donnelly might be forgiven, perhaps, if he thought his colleagues a little odd, even comic. Middleton, 'though far from being an eccentric recluse, or of as weakly a constitution as his appearance seemed to denote',[200] was very emaciated and had, as William Morris described it, 'a thin woeful-looking beard'.[201] Weale was 'a lean, tall figure with wide yet stooping shoulders, clad in a grey coat of unfashionable cut, moving with shambling gait on out-turned feet; a full grey beard; and short-sighted eyes peering through spectacles from beneath the widest brim imaginable of a black felt hat ... the very type of the antiquary'.[202]

For Middleton, though, there was nothing comic in his situation, caught between the irascible Weale and the obdurate Donnelly. Middleton was evidently unsuited to institutional politics. 'It is very unlucky that Middleton, whose appointment I had a hand in bringing about,' wrote J.C. Robinson, 'has apparently broken down in health. I am extremely sorry for it. For I had hopes that the strength of his position through his unquestioned knowledge would have been supplemented by a strong will and a capacity for fighting. I am afraid now from all I can learn that this will not be so.'[203] Middleton took sick leave, but when 'after a year's rest he was able to return to his post, he was evidently failing, and ... the end came suddenly'.[204] He suffered from tension headaches, depression, insomnia and hypochondria. On 10 June 1896 he was found unconscious, with a bottle of laudanum and a glass beside him. He died only hours afterwards. It turned out that he had been a morphine addict since the drug had been prescribed for him as an undergraduate, for 'brain fever'. An inquest concluded that he had accidentally taken an overdose, and a verdict of death by misadventure was returned, but suicide was suspected.[205]

It seems that after this disaster there was an attempt to 'pitchfork' into the vacant directorship Henry Cole's son Alan, who by now had risen to be 'Official Examiner for Art', third from the top on the art-education side of the Department of Science and Art.[206] But Assistant Director Caspar Purdon Clarke stepped forward, 'applied to Sir John [Donnelly] for the vacancy in order to stop any movement in favour of Cole', and was successful. 'It has been a close fight,' he wrote afterwards, acknowledging, however, that 'Sir J. Donnelly has come well out of it'.[207]

Clarke was a safe pair of hands, with wide experience and a lifetime's knowledge of the peculiarities of South Kensington. He took over at a bad moment, with (as we shall see) more tribulations ahead. But, at the lower levels

of the museum's staff, renewal had begun. We have already noticed the arrival of Arthur Skinner, who stepped up to be Assistant Director under Clarke. Other bright young men had begun to come in, as the Cole generation retired. G.H. Palmer (later to become Keeper of the Library) and A.F. Kendrick (later Keeper of Textiles) started as Junior Assistants in 1889 and advanced to Assistant Keeper in 1892 and 1893 respectively. E.F. Strange (later to be Keeper of Woodwork) moved into the Art Museum from elsewhere in the Department in 1889. W.W. Watts (later Keeper of Metalwork) joined as Assistant Keeper in 1890. H.P. Mitchell (also to be Keeper of Metalwork) came as Junior Assistant in 1895.[208] New blood was beginning to refresh the museum.

This was noticeable in the museum's relations with its public. The *Art Journal*, commenting that 'the appointment of Mr Purdon Clarke as Director seems to indicate a change of policy for the better', and regretting that 'the régime of Professor Middleton unfortunately meant very little to the outside public', called attention to the fact that:

very few know ... that the gentlemen in charge of the various departments in the Museum are at all times ready to assist the earnest student, or even the ordinary amateur, in obtaining information on any point connected with the history or development of Art coming under their view. Publishers of illustrated books, Art Editors of magazines and newspapers, besides writers on the Arts and Crafts of home and foreign countries, artists wishing to secure accuracy in pictorial details, together with the teacher and the learner, all are welcomed and helped in an unostentatious but gratifying way.[209]

III.—SOUTH KENSINGTON MUSEUM AND BETHNAL GREEN BRANCH MUSEUM.

48. The Directors report that the number of visitors during 1896 was 1,135,797 at South Kensington and 383,709 at Bethnal Green, making a total of 1,519,506. This shows an increase of 123,630 as compared with the year 1895. Returns of the numbers since 1857 are given on pages 312–314.

49. In the month of June last year the Art Museum sustained a great loss by the death of the Director, Dr. Middleton, who had a European reputation in various branches of Art.

The vacant Directorship was filled by the promotion of Mr. C. Purdon Clarke, C.I.E., F.S.A.; and Mr. A. B. Skinner, B.A., F.S.A., was promoted to the Assistant Directorship.

In submitting the usual annual statement of the various Officers in the Art Museum, Mr. C. Purdon Clarke, the Director, reports as follows :—

Owing to a re-arrangement of the work and duties of the officers of the staff, several important changes have been made. The preliminary work of dealing with various classes of objects on entering the Museum, formerly performed by the Keeper of the Art Museum, is now distributed amongst the Assistant Keepers, who have been detailed to the following sections :—
 1.—Sculpture, Ivories.
 2.—Woodwork, Musical Instruments, Leatherwork.
 3.—Metalwork, Jewellery, Medals.
 4.—Pottery, Glass, Enamels.
 5.—Textiles, Lace, &c.
This arrangement affords considerable relief to the Assistant Director, who still remains Keeper of the Art Museum.

Figure 8.12 The announcement of the creation of specialist staff, the embryo of the curatorial departments, from the Department of Science and Art's *Forty-fourth Report*, for 1896.

Clarke saw the need to encourage his junior staff and to foster the expertise that had been so sadly lacking since Cole's exclusion of scholars. He lost no time. On 20 July 1896, only a month after his appointment, Clarke obtained Donnelly's approval to a proposal that five men should become subject specialists.[210] It seems extraordinary that Donnelly should have agreed to this, since he believed that the museum staff was too small to sustain experts and that what was needed was 'all-round men'.[211] But he did agree, perhaps encouraged by the fact that Clarke's rearrangement brought preferment to C.H. Wylde and T. Lehfeldt, who were well regarded by him but *bêtes noires* of Weale. Wylde took charge of ceramics and Lehfeldt of woodwork, with H.P. Mitchell looking after metalwork, A.F. Kendrick textiles and Arthur Skinner (the Assistant Director) sculpture. This is the moment (figure 8.12) when the museum once again decided to invest in object-based scholarship, the moment from which its curatorial departments,[212] which survive into the present, can be said to take their origin.

NOTES

1 Cole diary, 10 October 1874.
2 'Personal' section, *Illustrated London News*, 27 May 1893, p. 626.
3 *Vanity Fair*, 23 November 1878, p. 283.
4 J.F. Boyes, 'The Chiefs of our National Museums: No. IV ... Sir Philip Cunliffe Owen', *Art Journal*, 1891, p. 214.
5 Ibid., p. 213.
6 *Vanity Fair*, 23 November 1878, p. 283.
7 MS letter, Owen to Cole, 31 August 1871, Cole Correspondence (NAL), Box 15.
8 Cole diary, 10 October 1874.
9 MS, pencil copy or draft of a letter, Owen to the Duke of Sutherland, 29 December 1977, Cole Correspondence (NAL), Box 15.
10 *Second Report from the Select Committee on Museums of the Science and Art Department; together with the Proceedings of the Committee, Minutes of Evidence, Appendix, and Index. Ordered, by The House of Commons, to be Printed*, 23 July 1897, para. 7536.
11 *Illustrated London News*, 31 March 1894, p. 383. Elizabeth Bonython, *King Cole: a Picture Portrait of Sir Henry Cole, KCB 1808–1882*, London: Victoria and Albert Museum [1982], p. 45.
12 Boyes, op. cit., p. 214.
13 *Art Journal*, 1877, p. 61.
14 Boyes, op. cit., p. 215.
15 *DNB*.
16 Eric Hobsbawm, *The Age of Capital 1848–1875*, London: Abacus, 1997, p. 17.
17 Physick, chapter 10.
18 *Art Journal*, 1871, p. 231.
19 See cuttings from various papers in January and February 1870 in V&A Cuttings Book, January–May 1870.
20 'Le musée de South Kensington', *Journal Officiel de la République Française*, 31 January 1873: V&A Cuttings Book, June 1870–December 1874, p. 120.

21 *Art Pictorial & Industrial*, vol. 1, 1870–1, p. 198.
22 *Second Report from the Select Committee ... 1897*, para. 7033.
23 *Truth*, 20 September 1883: V&A Cuttings Book, July 1883–August 1884, p. 1.
24 John Burns, MP, in Parliament, reported in *Building News*, 26 May 1893, p. 726.
25 See *Survey of London ... The Museums Area*, chapters 7, 12.
26 See Robert Skelton, 'The Indian Collections: 1798 to 1978', *Burlington Magazine*, vol. 120, 1978, pp. 297–304.
27 'Our Illustrated Note-Book', *Magazine of Art*, vol. 15, 1891–2, p. 105.
28 C. Purdon Clarke, 'James W. Wild', *RIBA Journal*, 30 March 1893, p. 275.
29 Reginald Stuart Poole, 'Obituary. James William Wild', *Academy*, 26 November 1892, p. 489.
30 W.G. Paulson Townsend, 'Sir Caspar Purdon Clarke, C.I.E., F.S.A.: A Personal Note', *The Critic*, September 1905, p. 213.
31 *The Times*, 4 January 1883: V&A Cuttings Book, April 1882–June 1883, p. 7.
32 *Précis*, 1878–80, s.v. Clarke, p. 93.
33 *Academy*, 22 May 1880, p. 393.
34 *Précis*, 1878–80, s.v. Indian Section, p. 237 (8 July 1880).
35 Ibid., s.v. Clarke, p. 93 (8 July 1880).
36 Townsend, op. cit., p. 213.
37 Ralph Nevill (ed.), *The Reminiscences of Lady Dorothy Nevill*, London: Nelson, n.d., p. 253.
38 Townsend, op. cit., p. 214.
39 *Museums Journal*, vol. 10, 1910–11, p. 274.
40 'Our New Director', *Bulletin of the Metropolitan Museum of Art*, vol. 1, 1905–6, p. 5.
41 *Précis*, 1881–3, s.v. Clarke, p. 98 (19 July 1883).
42 Letter to *The Times*, 21 April 1879: V&A Cuttings Book, July 1879–July 1880, p. 199.
43 *The Academy*, 8 January 1876, p. 42.
44 'The Persian Collection at South Kensington', *Builder*, 8 April 1876, p. 327.
45 *The Times*, 15 December 1883: V&A Cuttings Book, July 1883–August 1884, p. 5. Cf. *Architect*, 22 December 1883, p. 393.
46 *Forty-second Report* [for 1894], p. xlv.
47 *Second Report from the Select Committee ... 1897*, para. 236.
48 *Survey of London ... The Museums Area*, chapter 19. David Follett, *The Rise of the Science Museum under Henry Lyons*, London: Science Museum, 1978, pp. 3–4.
49 Donald Mallett, *The Greatest Collector: Lord Hertford and the Founding of the Wallace Collection*, London: Macmillan, 1979, pp. 140–9.
50 Boyes, op. cit., p. 215.
51 *Daily News*, 22 September 1879: V&A Cuttings Book July 1879–July 1880, p. 22.
52 *Thirty-eighth Report* [for 1880], p. xxi.
53 *The Times*, 7 March 1882: V&A Cuttings Book, April 1882–June 1883, p. 68.
54 *Eastern Argus*, 11 March 1882: Bethnal Green Museum Cuttings Book.
55 For an analysis of how the West End establishment constructed an image of the poor people of Bethnal Green, see Cathy Ross, 'The Opening of the East London Museum of Science and Art', *Rising East*, vol. 1, no. 3, January 1998, pp. 155–67.

56 *Second Report of the Select Committee ... 1897*, para. 2023.

57 See Perry's pamphlet *On the Formation of a Gallery of Casts from the Antique in London*, London: Macmillan, 1878.

58 See the offical file in Archive: Ed. 84/168.

59 Malcolm Baker and Brenda Richardson (eds), *A Grand Design: The Art of the Victoria and Albert Museum*, exhibition catalogue, New York: Abrams and Baltimore Museum of Art, 1997, item 114.

60 Ibid., p. 233.

61 *Twenty-sixth Report* [for 1878], p. xiv.

62 Gilbert Redgrave, 'Art Education during the past Fifty Years', *Art Journal*, 1887, p. 223. Note that the purchase of prints and drawings was at that time the responsibility of the National Art Library.

63 See Ann Eatwell, 'Private Pleasure, Public Beneficence: Lady Charlotte Schreiber and Ceramic Collecting', in Clarissa Campbell Orr (ed.), *Women in the Victorian Art World*, Manchester: University Press, 1995, pp. 125–45.

64 Gilbert R. Redgrave, 'The Lady Dilke Gift to the National Art Library', *The Library*, 2 series, vol. 7, 1906, pp. 263–74.

65 See Archive: Ed. 84/222.

66 Graham Reynolds, *Catalogue of the Constable Collection*, London: HMSO, 1973, p. 3.

67 *Art Journal*, 1883, p. 124.

68 *Thirtieth Report* [for 1882], p. 504.

69 'The Jones Collection at the South Kensington Museum', *Builder*, 23 December 1882, p. 799.

70 Cole diary, 2 January 1870.

71 'The Jones Collection', op. cit., p. 799.

72 *The Times*, 12 December 1882: V&A Cuttings Book, April 1882–June 1883, p. 47.

73 *Twenty-second Report* [for 1874], p. xiv.

74 *Truth*, 20 September 1883: V&A Cuttings Book, July 1883–August 1884, p. 1ff.

75 'Earl Spencer's Pictures at South Kensington', *Architect*, 30 September 1876, p. 194.

76 *Twenty-second Report* [for 1874], p. xiv.

77 Quoted in *Building News*, 9 October 1874, p. 427.

78 See George Bullen (ed.), *Caxton Celebration 1877. Catalogue of the Loan Collection of Antiquities, Curiosities and Appliances connected with the Art of Printing*, London: Elzevir Press (1877).

79 David Traill, *Schliemann of Troy: Treasure and Deceit*, London: Penguin, 1996, pp. 123–4, 175, 185, 205–7.

80 'Old London at South Kensington', *Builder*, 12 April 1879, pp. 390–1.

81 C. Roach Smith, *A Catalogue of Anglo-Saxon and other Antiquities discovered in Faversham*, London: Chapman and Hall, 1871.

82 *Twenty-eighth Report* [for 1880], p. 493.

83 See William Ryan Chapman, 'Arranging Ethnology: A.H.L.F. Pitt Rivers and the Typological Tradition', in George W. Stocking, Jr (ed.), *Objects and Others: essays on Museums and Material Culture*, Madison, Wis.: University of Wisconsin Press, 1985, pp. 15–48; Alison Petch, '"Man as he was and Man as he is": General Pitt Rivers's Collections', *Journal of the History of Collections*, vol. 10, 1998, pp. 75–85.

84 *Building News*, 9 January 1885, p. 72, under 'Our Office Table'.

85 'The Educational and Technical Value of Public Collections', *Builder*, 5 November 1881, p. 564.

86 *The Times*, 29 May 1882: V&A Cuttings Book, April 1882–June 1883, p. 6.

87 *Builder*, op. cit., pp. 564–5.

88 *The Times*, 18 May 1852: V&A Cuttings Book, April 1882–June 1883, p. 6.

89 Cosmo Monkhouse, 'The Spanish and Portuguese Exhibition', *The Academy*, 18 June 1881, p. 460.

90 *Building News*, 5 June 1885, p. 914, under 'Our Office Table'.

91 *Twenty-eighth Report* [for 1880], p. 486.

92 *Twenty-ninth Report* [for 1881], pp. 484–5.

93 *Twenty-ninth Report* [for 1881], p. 489.

94 *Twenty-eighth Report* [for 1880], Appendix A. 'National art museums for the provinces', *Builder*, 4 December 1880, pp. 669–70.

95 'Bronzes at South Kensington', *Builder*, 24 March 1877, p. 279. And see *Second Report of the Select Committee ... 1897*, paras 1252–60.

96 Boyes, op. cit., p. 215.

97 *Guardian*, 26 November 1884: V&A Cuttings Book, October 1884–February 1885, p. 2.

98 *The Times*, 14 June 1876: V&A Cuttings Book, January–August 1875, p. 206.

99 *Athenaeum*, 13 November 1875, p. 647, under 'Fine-Art Gossip'.

100 Paul Villars, 'Le Musée de South Kensington', *Revue des Arts Décoratifs*, vol. 1, 1880–1, p. 427.

101 T. Frank, 'Hungarian Art-historian in Victorian Britain: George Gustavus Zerffi', *Acta Historiae Artium*, vol. 23, 1977, p. 129.

102 *Thirty-first Report* [for 1883], p. 241.

103 [Obituary], *Magazine of Art*, vol. 15, 1891–2, p. 69, under 'Our Illustrated Note-Book'.

104 *Athenaeum*, 26 December 1891, p. 874, under 'Fine-Art Gossip'.

105 *Thirty-ninth Report* [for 1891], p. xxxvi.

106 *Thirty-eighth Report* [for 1890], p. xxxviii. 'Obituary. Robert Henry Soden Smith', *The Academy*, 5 July 1890, p. 16.

107 'Public Distrust of South Kensington', *Architect*, 27 July 1872, p. 44.

108 'The Department of Science and Art. II. Its Administration', *Building News*, 14 January 1876, p. 29.

109 'The Department of Science and Art. III. Its Mystery', *Building News*, 28 January 1876, p. 85.

110 'The Science and Art Department's Report', *Architect*, 18 August 1893, p. 98. The *Architect*, throughout the 1880s and '90s, greeted the Department's Annual Reports with disparaging reviews.

111 *Whitehall*, 23 October 1884: V&A Cuttings Book, October 1884–February 1886, p. 3.

112 *Academy*, 18 March 1876, p. 270, under 'Notes and News'.

113 'Parliamentary Notes', *Building News*, 14 June 1878, p. 595.

114 'Parliamentary Notes', *Building News*, 17 June 1881, p. 724.

115 *Architect*, 30 March 1894, p. 201.

116 J.E. Hodgson, 'On the Failure in Results of the Government Art Schools, and a Possible Remedy Therefor', *Transactions of the National Association for the Advancement of Art and its Application to Industry, Edinburgh Meeting MDCCCLXXXIX*, London, 1890, p. 56.

117 In the *Atlantic Monthly*, quoted in 'Two European Schools of Design', *Building News*, 31 July 1874, p. 133.

118 *Fors Clavigera*, Letter 79 (July 1877), in *Works*, ed. E.T. Cook and Alexander Wedderburn, London: George Allen, vol. 29, 1907, p. 154.

119 Edward J. Poynter, *Ten Lectures on Art*, London: Chapman and Hall, 1880, pp. 140, 106.

120 'South Kensington Art School', *Architect*, 17 July 1875, p. 34.

121 *Daily Telegraph*, 20 August 1875: V&A Cuttings Book, January–August 1875, p. 39.

122 Harry Quilter, 'Criticism and Congress', *Universal Review*, 15 November 1889, p. 367.

123 Address to Storey Institute Lecture Soc., in *Journal of Education*, London, 1894, quoted in Gordon Sutton, *Artisan or Artist? A History of the Teaching of Art and Crafts in English Schools*, Oxford: Pergamon, 1967, p. 166.

124 Thomas Armstrong, 'The Condition of Applied Art in England, and the Education of the Art Workman', *Journal of the Society of Arts*, 4 February 1887, p. 217. For a later expression of the same view, see G. Baldwin Brown, 'Industrial Museums in their Relation to Art', *Museums Journal*, vol. 1, 1901–2, pp. 93–4.

125 Isabella Kentish, 'Our Schools of Design', *Once A Week*, 13 July 1861, p. 78.

126 Walter Crane, 'The English Revival of Decorative Art', *Fortnightly Review*, vol. 52, no. 312, December 1892, pp. 813–14. Cf. his remark on the effects of South Kensington ('can hardly be properly or fully estimated, though they are none the less real') in 'The Arts and Crafts', *Murray's Magazine*, November 1889, p. 650.

127 J.W. Mackail, *The Life of William Morris*, London: Longmans, Green & Co., 1899, vol. 2, p. 49.

128 Archive: Ed. 84/205: DSA Minute 697, 30 January 1883.

129 John D. Sedding, *Art and Handicraft*, London: Kegan Paul, 1893, pp. 79, 134, 80.

130 Ibid., p. 55.

131 Ibid., p. 131.

132 J.D. Sedding, 'Design', in William Morris (ed.), *Arts and Crafts Essays*, London: Rivington, Percival, 1893, p. 410.

133 Sedding, *Art and Handicraft*, p. 16.

134 Ibid., pp. 57–8.

135 *Thirty-fourth Report* [for 1886], pp. xxxiv–xxxv.

136 *Twenty-eighth Report* [for 1880], p. xxi.

137 'The Modern Art Collections at Bethnal Green Museum', *The Times*, 20 December 1880: V&A Cuttings Book, September 1880–January 1882, p. 75.

138 Peter Mandler, *The Fall and Rise of the Stately Home*, New Haven and London: Yale University Press, 1997, pp. 111–13, 133.

139 *Daily Telegraph*, 20 August 1875: V&A Cuttings Book, January–August 1875, p. 39.

140 *Truth*, 20 September 1883: V&A Cuttings Book, July 1883–August 1884, facing p. 1.

141 *RIBA Journal*, new series, vol. 6, 1889–90, p. 339.

142 Emilia F.S. Dilke, 'Art-Teaching and Technical Schools', *Fortnightly Review*, February 1890, p. 234.

143 *The Times*, 13 January 1883: V&A Cuttings Book, April 1882–June 1883, p. 48.

144 *Architect*, 28 June 1884, p. 411.

145 'Recent Acquisitions in the South Kensington Museum', *Art Journal*, 1875, p. 295. Cf. 'South Kensington Museum: Its Recent Acquisitions', ibid., 1877, p. 357.

146 J.F. Boyes, 'The Chiefs of Our National Museums. No. V ... Mr Thomas Armstrong', *Art Journal*, 1891, pp. 273, 271.

147 Department of Science and Art Minute 30187, 14 July 1898, in V&A Archive: Ed. 84/102.

148 *Truth*, 23 August 1883: V&A Cuttings Book, July 1883–August 1884, facing p. 1.

149 *Second Report from the Select Committee ... 1897*, Appendix 15.

150 Ibid., para. 5018.

151 'Science and Art Form, No.1240 ... Art Referees' in Archive: Ed. 84/8.

152 See the records of payment in *Second Report from the Select Committee ... 1897*, Appendix 9.

153 *Morning Post*, 1 February 1883: V&A Cuttings Book, April 1882–June 1883, p. 48.

154 *Second Report from the Select Committee ... 1897*, para. 7516, quoting letter from Owen to Robinson, 3 January 1883.

155 Ann Sumner, 'Sir John Charles Robinson. Victorian Collector and Connoisseur', *Apollo*, vol. 130, 1989, p. 229.

156 *Second Report from the Select Committee ... 1897*, para. 7536.

157 South Kensington Museum Minute 4199, 5 August 1881, in Archive: Ed. 84/205.

158 *Précis*, 1878–80, s.v. Willett (24 October 1879).

159 *Second Report from the Select Committee ... 1897*, para. 358. The matter was exhaustively investigated at the Select Committee: see Appendix 32 for correspondence, and the index to the *Report* for exchanges during the proceedings.

160 *Second Report from the Select Committee ... 1897*, para. 8061.

161 South Kensington Museum Minute 2455, 7 May 1881, in Archive: Ed. 84/166.

162 *The Times*, 21 September and 1 October 1887: V&A Cuttings Book, June 1887–June 1888, p. 174.

163 Cutting in official file, V&A Archives, Ed. 84/184.

164 *Truth*, 26 July 1883, p. 119, in V&A Cuttings Book, April 1882–June 1883, facing p. 1.

165 Sir W. Martin Conway, *The Domain of Art*, London: John Murray, 1901, p. 116.

166 *The Times*, 27 December 1884: V&A Cuttings Book, October 1884–February 1886, p. 2.

167 *Second Report from the Select Committee ... 1897*, para. 3679.

168 *Truth*, 26 July 1883: V&A Cuttings Book, July 1883–August 1884, facing p. 1. Cf. *Athenaeum*, 4 August 1883, p. 154.

169 James Yoxall, *The ABC About Collecting*, London: Stanley Paul, n.d., p. 48.

170 *Truth*, 26 July 1883.

171 *Building News*, 30 January 1880, p. 151; 13 February 1880, p. 210.

172 Claude Phillips, 'The South Kensington Museum', *Academy*, 24 November 1888, pp. 342–3. See also his articles, 'The South Kensington Museum. II' and 'The South Kensington Museum' in *Academy*, 8 December 1888, pp. 376–7, and 14 October 1893, pp. 324–5.

173 These words are written in Robinson's hand as the title of what seems to be a privately printed pamphlet, in the Spielmann papers, NAL, press mark Box II 86 DD.

174 Cutting in Archive: Ed. 84/184.

175 The above account of Middleton is derived from his entries in *DNB*, and in Frederic Boase, *Modern English Biography* (Supplement), London: Frank Cass, 1965; and from obituaries in *Academy*, 20 June 1896, p. 514; *Architect*, 19 June 1896, p. 394; *Athenaeum*, 20 June 1896, pp. 816–17. His Slade Professorship testimonials are printed in a pamphlet, *Testimonials in favour of J.H. Middleton* [1886]; copy in the British Library, press mark 1414.f.84.(6).

176 *Second Report from the Select Committee ... 1897*, para. 331.

177 Ibid., Appendix I. See also Department of Science and Art Minutes 30035, 13 July 1898, and 30039, 13 July 1898, in Archive: Ed. 84/102.

178 Examples are to be found in Archive: Ed 84/102.

179 The moving of the casts was raised in Parliament (*The Times*, 28 April 1894), and Copeland expressed his disapproval in *The Times*, 30 April 1894: V&A Cuttings Book, July 1891–May 1898, p. 10.

180 'Notes on Art and Archaeology', *Academy*, 6 January 1894, p. 18.

181 *Athenaeum*, 24 August 1895, p. 265. Cf. *Athenaeum*, 10 August 1895, p. 200, under 'Fine-Art Gossip', and 31 August 1895, pp. 298–9.

182 George du Maurier, *Trilby*, ed. Leonee Ormond, London: Dent, 1994, pp. 85, 109, 89, 35.

183 L.M. Lamont (ed.), *Thomas Armstrong, C.B. A Memoir 1832–1911*, London: Secker, 1912, p. 106.

184 Ibid., pp. 68–9, 54.

185 MS account headed 'Presentation of Bookcase &c. To T. Armstrong, Esqr. C.B. 24th Febry 1899': NAL.

186 In Cole's speech to the 'Art Students of Hanley', *Journal of the Society of Arts*, 31 October 1873, p. 913.

187 W.H.G. Armytage, 'J.F.D. Donnelly: pioneer in vocational education', *Vocational Aspect of Secondary and Further Education*, May 1950, vol. 2, 1950, p. 15.

188 'The Royal College of Science, South Kensington', *Science and Art*, new series, vol. 1, 1894, p. 174.

189 Donnelly to Cole, 23 June 1867, in Cole Correspondence (NAL), Box 16.

190 Letter to M.H. Spielmann quoted in Percy E. Spielmann, *Art, Books, and Friendships of Marion H. Spielmann*, typescript in NAL, press mark 86.W.72.73, pp. 161–2.

191 See, first, Lori van Biervliet, *Leven en werk van W. H. James Weale, een engels kunsthistoricus in Vlaanderen in de 19de eeuw* (Verhandelingen van de Koninklijke Academie voor Wetenschappen, Letteren en Schone Kunsten van België, Klasse der Schone Kunsten, Jaargang 53, Nr. 55), Brussels: Paleis der Academiën, 1991, which has an English summary, pp. 179–85. Also Weale's entry in *Bibliographie Nationale, publiée par l'Académie Royale des Sciences, des Lettres et des Beaux-Arts de Belgique*, vol. 30 (Supplement vol. 2), Brussels: Bruylant, 1959; Anon., 'W.H. James Weale (1832–1917)', *Ons Volk Ontwaakt*, 28 November 1926, vol. 12, no. 48, pp. 754–6; H.P. M[itchell], 'The late Mr. W.H. James Weale', *Burlington Magazine*, vol. 30, 1917, pp. 241–3; Maurice W. Brockwell, 'W.H. James Weale, The pioneer', *The Library*, 5th series, vol. 6, 1951, pp. 200–11. On his contribution to scholarship, see Francis Haskell, *History and its Images. Art and the Interpretation of the Past*, New Haven and London: Yale University Press, 1993, pp. 452–62.

192 Cole diary, 14 August 1872.

193 W.H. James Weale, *Gerard David, Painter and Illuminator* (Portfolio Monograph No. 24, December 1895), London: Seeley, 1895, p. 18.

194 *Précis*, 1863–77, s.v. Weale (1872 and 1876); *Précis*, 1884–7, p. 47 (1885), p. 129 (1887); *Précis*, 1888–92, pp. 41, 46, 58, 63, 64 (1889), 76, 84 (1890).

195 Brockwell, op. cit., p. 202.

196 *Magazine of Art*, vol. 13, 1890, p. xlvii.

197 Mitchell, op. cit., p. 242.

198 W.H. James Weale, 'The History and Cataloguing of the National Art Library', *Transactions and proceedings of the Second International Library Conference held in London, July 13–16, 1897*, London: for Members of the Conference, 1898, p. 97.

199 Mitchell, op. cit., p. 243.

200 *DNB*.

201 *The Letters of William Morris to his Family and Friends*, ed. P. Henderson, London: Longmans, 1950, p. 234.

202 Mitchell, op. cit., p. 241.

203 Letter from J.C. Robinson to M.H. Spielmann, 15 October 1894, in the Spielmann papers.

204 *Athenaeum*, 20 June 1896, p. 817.

205 *The Times*, 15 June 1896, p. 8: V&A Cuttings Book, July 1891–May 1898, p. 14. For a contemporary suggestion that he may have committed suicide, see Norman Kelvin (ed.), *The Collected Letters of William Morris*, 2 vols, Princeton: University Press, 1987, vol. 2, p. 403n.

206 *Pall Mall Gazette*, 10 July 1896, p. 4.

207 Letters to M.H. Spielmann, 14 June 1896 and 24 June 1896, in the Spielmann papers.

208 Derived from Appendix 14 ('Return showing the Age on, and Conditions of, Admission to the Situation of Junior Assistant and Assistant Keeper during the last 10 Years') of *Second Report from the Select Committee ... 1897*.

209 *Art Journal*, 1896, p. 350.

210 Clarke's minute is printed in the *Minutes of the Committee of Re-arrangement*, p. 91 (NAL, press mark VA.1908.0001).

211 *Second Report from the Select Committee ... 1897*, paras 960–1194, 1262–1331.

212 The actual staffing of the Art Museum in 1898 was given in the Select Committee's Report (*Second Report ... 1898*, p. viii) as follows:

'Director ...

Assistant Director for Sculpture, Ivories and reproductions in Plaster ...

1 Keeper and 1 Junior Assistant for Textiles.

1 Assistant Keeper and 1 Junior Assistant for the Furniture.

1 Junior Assistant for the Metal work.

1 Assistant Keeper for the Pottery ...

1 Keeper, 2 Assistant Keepers, and 2 Junior Assistants for the Art Library.

1 Keeper and 1 Assistant Keeper for the Circulation Department.

1 Keeper for editorial work ... Museum Publications, Dyce and Forster Libraries ...

1 Keeper in charge of Indian Section.'

In the five material sections, the intention was to have 'a subordinate as well as the chief man in each department' to ensure continuity of expertise. (*Second Report ... 1898*, para. 1625). A 'Proposed Staff' list submitted by Donnelly on 25 March 1898 (*Second Report ... 1898*, Appendix 9) shows each of the five departments with a Keeper, an Assistant Keeper and two Junior Assistants.

CHAPTER NINE
The Purgation of the Department of Science and Art

The swelling criticism of South Kensington eventually became a campaign. The chief sources of complaint remained the disgruntled patriarchs Robinson and Weale, but their cause was taken up by two younger men, sharper practitioners of the art of propaganda. Robinson was, of course, no mean controversialist himself. He never lost an opportunity to lament the collapse of scholarship at South Kensington, and its replacement by a 'mechanical system, carried out by mere laymen, superabundant clerks, secretaries, and storekeepers'.[1] He published a series of articles on museums in the journal *The Nineteenth Century* in the 1890s,[2] and writing letters to *The Times* was one of his favourite pastimes. (He there conducted long and acrimonious re-attributions of National Gallery paintings: he demoted a Piero della Francesca in 1874 and a Michelangelo in 1881.) He clashed in *The Times* in autumn 1891 with Alan Cole about the system of circulating exhibitions,[3] and weighed in again when this topic was brought up in a letter to the newspaper on 25 August 1894 by M.H. Spielmann, a busy and successful art journalist. 'This letter,' we are told in a biography of Spielmann, 'acted as a fuse which set off an explosion in the press,'[4] and presumably Spielmann and Robinson now made common cause in campaigning against South Kensington.

Meanwhile, Weale found a sympathetic ear for his troubles in David Lindsay, Lord Balcarres, MP for Chorley. (As the son of a peer, Balcarres, despite using his courtesy title, was allowed by the British political system to be elected as a member of the Commons until he inherited the peerage and took his seat in the Lords.) At Weale's prompting, Balcarres asked questions about South Kensington in the House of Commons. Weale's carefully shaded explanation of his highly irregular alliance with Balcarres (which he made before the Select Committee that soon afterwards investigated the museum) was this:

Well, there was a Member of the House of Commons, who is here present, who had worked in the Art Library before he was

a member of the House of Commons, and who had complained very bitterly about the deficiencies in the catalogue of photographs, and afterwards, seeing him on one occasion, I suggested to him that if he wanted a proper catalogue of photographs made it was in his power to try and get it done.[5]

Robinson and Spielmann, and Weale and Balcarres formed a cabal. Spielmann kept notebooks, correspondence and press cuttings, which eventually found their way to the National Art Library, and these give an insight into the hectic plotting that the reformers conducted behind the scenes. Spielmann and Balcarres were constantly in touch by telegram if necessary. Robinson and Weale were frequently consulted, and so was Caspar Purdon Clarke, who was the reformers' mole inside the Department of Science and Art. It was a difficult part for him to play, and they were not always sure of him. 'Clarke doesn't seem to be taking any action,' wrote Balcarres on one occasion. '*Has he begun to drift?*'[6]

Spielmann (figure 9.1) was editor of the *Magazine of Art*, contributed a regular 'Art Causerie' column to the weekly *Graphic*, and wrote for newspapers such as the *Westminster Gazette* and the *Pall Mall Gazette*. Having conducted a campaign against the Royal Academy in the 1880s, he was an experienced controversialist. In some doggerel verses that he later composed, 'The Lay of the battle of South Kensington', he described his function in the campaign:

So means were discovered to publish abroad
The evils that Kensington's vitals had gnawed.
 In spreading the facts I expended my breath –
 I shrieked them from house-tops, I told them in Gath,
 In paper, review, magazine.
 Articles, articles, showered adown –
 I used every verb, nor omitted a noun
 That would prove the Department unclean ...[7]

The issue of Circulation played well.[8] Dissatisfaction on the part of provincial museums with the service they received from South Kensington was always easily exploited. After the reforms of the early 1880s, the Circulation Department had now run down again. Anyway, the potential demand from the provinces was much greater than could be supplied from South

Vignette: The masthead device from the Department of Science and Art's house magazine, subtitled *A Journal for Teachers and Students*, first published in 1887.

Kensington's resources, which were always open to the charge of being 'ludicrously insufficient'.[9] The issue of fakes never failed, and was a peg on which to hang pleas for expert staff in the museum. It was harder, perhaps, to put across Weale's grievances. He had successfully reformed procedures in the Library, but was deeply frustrated by the staffing system. New staff for both the museum and the library were recruited, by the Civil Service Commissioners, through the same examination, which was a special exam for South Kensington in so far as it had papers in art history (figure 9.2) and a drawing test, as well as language papers. But there was no provision for getting hold of people with library qualifications or experience. So Weale found that recruits were posted to the library who could not do the work, and who in any case wanted to be attached to museum departments rather than the library.

When Weale protested to Donnelly about the inadequacy of such men, Donnelly heeded him to the extent of transferring them out of the library and into the museum. But the system seemed incapable of providing Weale with the sort

Figure 9.1 M. H. Spielmann, pen-and-ink drawing by J. H. Amschewitz, dated 1907. In the National Portrait Gallery.

KNOWLEDGE OF ART OBJECTS.

[Set only to the Art Branch Candidates.]

[Only eight questions to be attempted.]

1. Mention two remarkable painters of Rome; of Venice; of Flanders; of Holland respectively. Who were the best English painters of last century?

2. Who were Albert Dürer, Peter Vischer, Veit Stoss, and Jamnitzer? Mention some one work of each.

3. What work has been produced by Bachelier of Toulouse, Boule, Riesener, Gouthière, Grinling Gibbons, Chippendale, and during what different periods?

4. What kind of jewellery has been found in Etruscan and Greek tombs? Were the ancients acquainted with the use of enamel on metal? How far back can we trace the art of imitating precious stones?

5. What work was produced by Luca della Robbia? What is his date? Trace the origin of Majolica, and name the most famous painter of this ware, and of the lustred majolica ware. Where did each of them work?

6. Describe the character and methods of decoration of Venetian glass? What is filigree glass? How is it made into vases and dishes? What is flint glass, and what kind of decoration is applied to it?

7. Where has hard porcelain been made in Europe? Give the names of factories of soft porcelain in France and England, and of pottery in England. Mention the name of a well known English pottery maker of the last century, and of a sculptor who modelled for him. Name an English factory of decorated stoneware of earlier date.

Figure 9.2 Part of the 'Knowledge of Art Objects' examination paper set for candidates applying for the post of Junior Assistant at the South Kensington Museum in July 1895. The successful candidate in this exam was H. P. Mitchell.

of men he needed. Between his appointment in 1890 and the Select Committee in 1897 he got through six incapable subordinates, with only one, G.H. Palmer, who responded successfully to his training. Weale was particularly irritated that his staff were tested for their drawing ability. Drawing, he said 'is a very desirable acquirement, but of no practical value in an art library'.[10] It was also galling to see men come and go while Donnelly's nephew, Julian Marshall (said to be an expert on prints), was comfortably installed in the library making a special catalogue of engraved portraits, a project that was generally regarded as useless except as a means of guaranteeing employment for Marshall. The reformers were able to make quite a lot of fuss about this catalogue.

The issue which obviously gave Spielmann most enjoyment in controversy was militarism. By now the upper echelons of the Department of Science and Art were largely staffed by officers of the Royal Engineers, who had come in

Figure 9.3 The 'warriors' of South Kensington. Senior staff of the Department of Science and Art in military uniform and court dress. Front row (l. to r.): Thomas Armstrong, General Festing, Arthur Trendell (Assistant Secretary of the Department), Sir John Donnelly, Captain Abney (Director for Science), Sir Purdon Clarke and Gilbert Redgrave. Behind Trendell is Alan Cole. Behind and between Abney and Clarke is H. M. Cundall, long-serving Keeper of Circulation.

as part of Cole's team of sappers and had steadily risen up the ladder (figure 9.3). Spielmann and the reformers thought it ridiculous that 'the art education of the country has idiotically and inexplicably become vested' in the hands of soldiers, and that the museum had been turned into 'a sort of almshouse for the army ... a sort of annexe of Chelsea Hospital'.[11] Donnelly was their principal target. A different point of view came from one newspaper, in an article entitled 'The Wail of the Artists'. Here the reformers were dismissed as 'malcontents ... hypersensitive folk, full of crotchets and fads, men who little realize the value of order and resent anything like discipline'.[12] Spielmann, however, stormed magnificently:

So long as the rapping military element is established as a sort of permanent drum-head court-martial, the apparent idea will continue to prevail that the Museum is established as an annexe to the Secretary's office; that the Director is a mere functionary at the orders of the Secretary; and that South Kensington is maintained under martial law for the benefit of ex-soldiers and 'generals' in command of a handful of gallery policemen.[13]

The campaign came to a head in a Parliamentary debate on 10 July 1896 on the Department of Science and Art's

(*Facing page*) Comrades in arms.

Figure 9.4 Lord Balcarres, a lithographic caricature by 'Spy' in *Vanity Fair Album*, 1899, where Balcarres is said to have 'a reputation for ability', to be 'quite free from side [arrogance]' and to be 'known to his friends as "Bal"'.

Figure 9.5 John Burns, a lithographic caricature by 'Spy' in *Vanity Fair Album*, 1892, which, remarking that he 'has a broad chest and a big voice', describes him as 'a stubborn, rather self-sufficient, hearty, hard-working man, who is inclined to bully where he cannot persuade'.

budget. The Government proposed to reduce this on the grounds that the South Kensington Museum had not been circulating enough of its holdings to the provinces. While this was felt to be unfair (and was defeated by a comfortable majority when the House voted), many complaints were aired against South Kensington, notably by John Burns, MP for Battersea, who, as a socialist and formerly leader of a docks strike, was keen to land blows on establishment institutions. Burns had been told by 'a gentleman who knew a great deal of South Kensington' (and evidently felt the allure of alliteration) that 'where it was not a nest of nepotism it was a jungle of jobbery'. Burns went on to claim that South Kensington 'contained 25 per cent more officials than were necessary, while the departments that really did the work were undermanned. What was wanted was the separation of the sheep from the goats, and there were probably more goats browsing on the heights of well-rewarded incompetency and inefficiency at South Kensington than in any other department.'[14] He proposed that a Select Committee should be set up to investigate the museum. A.J. Balfour, Leader of the Commons, at once agreed. The reformers had drawn blood.

The Committee met for the first time the following spring, on 21 May 1897. Its chairman, rather oddly, was the Minister in charge of the Department under scrutiny: Sir John Gorst, the Vice-President of the Committee of Council

on Education. Also on the Committee was Arthur Acland, his predecessor as Vice-President under the Liberal Government that had fallen in 1895. Another member with some inside knowledge was George Bartley, Henry Cole's son-in-law, who had worked in the Department of Science and Art until he resigned in 1880 to enter Parliament as a Conservative MP. Balcarres and John Burns were spokesmen for the reformers (figures 9.4 and 9.5). Ernest Gray and James Henry Yoxall represented the interests of education: both started out as elementary school teachers; both served as President of the National Union of Teachers, founded in 1870 (Yoxall also worked as its General Secretary); and both entered Parliament in 1895. Culture was represented by Sir Henry Howorth, President of the Archaeological Institute, and William Kenrick, Chairman of Birmingham City Council's Museum and School of Arts Committee; Kenrick was an influential art patron in the Midlands, and a complete room from his Ruskinian Gothic house, The Grove, Harborne, was eventually acquired by the V&A in 1964, when the house was demolished.[15] Sir Francis Sharp Powell and Frederick Platt-Higgins were Conservative backbenchers. As usual there were members from Scotland (Dr Robert Farquharson, Liberal MP for West Aberdeenshire), Ireland (James Daly, MP for County Monaghan South) and Wales (Arthur Charles Humphreys-Owen, Liberal MP for Montgomeryshire). Mancherjee Bhownaggree, Conservative MP for North-East Bethnal Green, was obviously on the Committee to watch the interests of the Bethnal Green Museum.

The Select Committee held 27 sessions between March and July 1897, and another 26 between March and July 1898. The printed transcript of its proceedings includes 637 folio pages of Minutes of Evidence, together with a further 181 pages of supporting documentation. In this exhaustive investigation there was very little to do with the running of the museum that was not exposed to scrutiny.

On one issue everybody was agreed: the museum was hard pressed for space, and desperately in need of the new building for which plans had already been commissioned. The Committee was able to emphasize how urgently the new building was needed by calling attention to fire hazards in the old buildings on the site. Committee members evidently pried into every hole and corner in South Kensington in search of places where cooking or smoking went on, or where piles of inflammable packing material could be found. They rushed out a brief *First Report* on 21 May 1897, devoted entirely to asserting the danger of fire.

The performance of the Circulation Department was another reiterated theme. H.M. Cundall, who had been in charge of the Department for 16 years until shuffled away in 1896, had to bear the brunt of the questioning on this issue. He put up a particularly tight-lipped performance,

only becoming animated (though still defensive) when reading out – and in many cases successfully refuting – Spielmann's attacks in the press. On the whole there was agreement between the Committee and the witnesses that something must be done about Circulation.

As is inevitable when museums are held to account, there was much excited altercation about fakes and bad purchases, and about thefts and breakages. Where purchases were concerned, the usual suspects were rounded up – the £1,200 clock, the cabinet from the Hamilton Palace sale, the Palissy platter – together with some new ones such as the Molinari gateway (a stone gateway, which proved to be much rebuilt, bought by Sir Thomas Armstrong from a dealer of Milan called Molinari in 1885) and the Savonarola bust (a terracotta bust, supposed by some to be contemporary with its subject, but actually made by the modern sculptor Giovanni Bastianini, and recommended for purchase by Armstrong, Alma-Tadema and Leighton). Lists were produced of forgeries, breakages and thefts.[16] The only conclusion to be reached from these not particularly shocking lists was that mistakes were sometimes made. Another contentious issue was alleged nepotism in the staffing of the museum and the Department. Repeated attempts were made[17] to work out which members of staff were related to each other. The vast majority of the cases of relationship were among the labouring staff, and General Festing, who was in charge of such staff, took the view that 'if you have any occasion to know that anybody who has worked in the Museum for some years has a relation, and guarantees that he is a respectable man', this would work in favour of appointing him and would contribute to 'an *esprit de corps* in the place'.[18]

The reformers pursued these issues not just for the sake of scandal, but because they led on to more fundamental concerns. The issue of buying fakes was a means of highlighting the decline of expertise in the museum. The nepotism issue was a way of calling into question the museum's appointment procedures and the values espoused by its management. These matters were well worth cool analysis, but in the event were mainly explored through fierce personality clashes and attempts to settle old scores.

Donnelly was the first to take the witness stand, and endured seven sessions there in March and April. The first was fairly peaceful. In the second, the question of bad purchases was raised. Led by Bartley, Donnelly went into the Hillingford armour affair, mounting an attack on J.C. Robinson, which became so heated that the room had to be cleared for a time. In the third session, Donnelly was compelled (which must have irked him) to read out a long letter in which Robinson exonerated himself. In the fourth session, Balcarres took up the questioning, in his smoothly persistent manner, described in Spielmann's doggerel:

... And last to come, my Lord Balcarres,
 Titan of the band;
The strokes he deals – the thrusts he parries
While the war in the enemy's camp he carries,
 With aim so true, with a smile so bland,
 Extracts
 The facts
 while the foe he harries ...[19]

On this occasion Balcarres pursued Donnelly through the winding byways of the appointment and promotion procedures. Sir Henry Howorth took up this issue, and Donnelly repeated his conviction that the museum should be staffed by 'well-educated all-round men', since 'the staff is excessively limited' and 'we have not got sufficient men to be specialists'.[20]

John Burns squared up to Donnelly in the sixth session. His style of questioning was blunt and trenchant, and soon Donnelly was snapping back: 'I do not think myself that there was any necessity ... for the appointment of this Committee.'[21] Why, challenged Burns, had South Kensington got such a bad press? A conspiracy, implied Donnelly. Could he suggest any reforms by means of which 'allegations of that kind can be prevented ... yes, or no?' 'No,' grated Donnelly. 'I hope they will be exploded by this Committee, but I cannot suggest any change in the administration which would prevent people making ... unsupported statements.'[22]

Why was South Kensington 'the Cinderella of all public institutions?' demanded Burns. Was there too much of the military element there? Were things not better at the British Museum? 'The difference seems to me to be this,' fumed Donnelly, 'that in your view what is at the British Museum is right, and what is at South Kensington is wrong.'[23] Donnelly's embattled, baffled recalcitrance was fully exposed in the next session, when Burns spoke about making Bethnal Green more popular. 'There are many things by which we could make ourselves popular and attractive,' growled Donnelly, 'but I do not think it is therefore desirable that we should do them.'[24]

After Donnelly came General Festing. He had originally been appointed to look after the lighting, heating and cleaning of the buildings, and the Committee was intrigued at how he continued to discharge these prosaic responsibilities while also being Director of the Science Museum. They teased him about militarism when he described line management in terms of a military line of command, and Yoxall exposed his thin academic record, but on the whole the General got off lightly.

He was followed by Purdon Clarke, who gave brief, discreet answers to the Committee, obviously trying to offer no hostages to fortune. He was asked about fakes, thefts, breakages, Circulation and Bethnal Green, but the Committee especially tried to draw him out on the amount of discretion given to the Director in making acquisitions, and on the appointment and training of staff. Under the existing acquisition system, the Director had no independent power of purchase. If he wanted to buy something, he would have to get the approval of the Director for Art, and then recommend the purchase to the Secretary of the Department, who would then transmit it (with his own recommendation) to the President or Vice-President of the Council for a final decision. (So all the South Kensington Museum's early purchases were made, technically, by a Government Minister.) Although this system was often short-circuited in practice, these were the rules. Clarke, led by Howorth, ventured to say that 'in my opinion it would be better if the Director of the Museum was responsible for all purchases'.[25]

In respect of staff, Clarke astonished the Committee by revealing his recent changes: the division of his staff into five curatorial departments, with a subject specialist in each. 'I expect that in two or three years each of these men will know more about his subject than anyone we can find outside; he ought to with such opportunities.' It was put to him that this was 'a tremendous internal reform', and he tactfully replied that 'it had been coming on slowly; one of our technical assistants had gradually got all the textile works into his hands and was doing the work very well, and I thought it better to extend it to other branches'.[26] Thus Clarke had already shot one of the reformers' foxes.

Thomas Armstrong came to the witness stand soon after. At first genial and much more talkative than Clarke, he ran into trouble when asked about purchases, a matter on which he had a vulnerable record. He had appeared twice before the Committee and was about to appear for a third time, when the Chairman, Sir John Gorst, stepped down from the chair and put himself on the witness stand, in order to make a long statement asserting the propriety of the purchase of a Burne-Jones watercolour, which had involved transferring money from the decorative art vote into the paintings vote. Gorst was obviously trying to forestall what he feared might be a damaging attack, but he seems to have done more harm than good, and when Armstrong returned to the stand, the Committee fell on him even more fiercely. Pressed about the Molinari gateway, he became rattled. In purchasing for the museum, he was concerned with aesthetic quality rather than with authenticity, and considered himself equipped to discern the former, if not the latter. He wanted to buy the kind of object 'which was beautiful as a work of art. It does not matter to me whether it was made last week or made in the 14th century; I would buy it for its value as a work of art, or for its educational value'. When asked if he would regard himself as an expert in the 'archaeological' side of art

history, or 'in regard to the genuineness of the object', he testily replied:

Not as to its archaeological value, certainly, and not much as to its genuineness; but I have learnt a great deal about these expert opinions, and I do not believe that these authorities who assert so very loudly that they know, do really know; I think that since the days of that bust we heard about the other day, and since other things that I could tell you about if I had time, the bottom has been completely knocked out of *expertise*; nobody knows, and no two people agree.[27]

This was mere bluster, which the reformers did not allow him to forget.

During this session with Armstrong, the Chairman of the Committee again intervened in an unconventional and apparently partisan way. Balcarres reported: 'We had a series of desperate encounters today, Gorst making a violent personal attack on me while the room was open to the Public. Burns cleared the room, upheld me gallantly & Gorst got his nose pulled by members of the Committee one by one.'[28] The next session, on 1 June, brought Weale to the stand. Along with Robinson, he was the reformers' most powerful weapon. Balcarres began by leading him gently through his grievances. Weale felt it necessary, in order to justify the cataloguing reforms he had introduced, to demonstrate faults in the previous system, especially when these had led to the purchase of more than one copy of the same book. This led to elaborate haggling over small bibliographical details. Weale returned for a second session on 29 June. The interval had given time for the Department, which regarded him as a hostile witness, to try to check up on his criticisms, and Gorst, clearly briefed by the Department, several times intervened against him. Weale, though he strongly felt his grievances, was not very good at presenting clear and cogent evidence. When he appeared for a third session, armed with details of duplicate copies of prints, Balcarres could not make head or tail of the evidence that his witness was offering and asked, doubtless with some embarrassment, that Weale should take it away and reformulate it. 'I have made a note of your wish, and it shall be attended to,' said Weale, probably rather huffily.[29]

Gorst harried Weale throughout this session, which culminated in Weale's accusation that Donnelly had deliberately obstructed his efforts to get better staff. After the session Donnelly's private secretary (professedly on his own responsibility)[30] visited the office of the shorthand writers who were recording the Committee's proceedings and borrowed a paper that Weale had lent to the shorthand reporter. This was not a paper officially handed in as evidence, only a note of some figures Weale had quoted, lent to the shorthand writer to help him make his transcription correct. Donnelly's secretary paid his visit at lunchtime, when there was only a subordinate clerk in the shorthand

writers' office, and claimed access to the document on the grounds that it contained official departmental figures.[31] Although it was not possible to prove that rules had been broken, most of the Committee felt that this was not playing fair. At the Committee's meeting on 9 July, Balcarres proposed a motion that the matter was 'irregular', to which Bhownaggree proposed an amendment, which asserted that because the paper 'was obtained on behalf of Sir John Donnelly in order to enable him to give the necessary explanation to the Committee regarding it, as he has been allowed to do throughout this inquiry, the complaint raised is one on which the Committee does not feel called upon to take any action'. A vote gave a clear victory to Balcarres. This left Gorst in an impossible position, and at the next Committee meeting, on 13 July, Balcarres proposed a motion that 'the Committee have heard with great regret the decision of Sir John Gorst not to resume the chair' since 'the position of Vice-President has ... been found to be

Figure 9.6 Sir Charles Robinson in later life, a photograph by W. Pouncy of Dorchester and Swanage.

incompatible with that of Chairman of the Committee'.[32] The reformers had drawn blood again. Sir Francis Powell took over as Chairman. In Weale's last session, on 16 July, Gorst gave him an openly hostile cross-examination, but Weale seemed to have got his second wind, and stood up to this successfully.

On 13 July Robinson appeared before the Committee. He had the satisfaction of listening while the clerk read out eight letters ('I should be glad if the clerk could be allowed to read them, as I am a bad reader and I would rather somebody else read them than myself')[33] praising his probity and learning, and vindicating him in the Hillingford armour affair. He maintained a pose of gracious dignity almost successfully, but took it too far, failing to resist the temptation to exaggerate his own position. He allowed himself to say that 'after my resignation, in 1869, Sir Henry Cole, the secretary and chief officer of the Department, became also director of the museum', but, as Donnelly sharply pointed out, 'Sir Henry Cole was quite as much director of the Museum before Mr Robinson retired as he was afterwards ... There was no change in the ... authority Sir Henry Cole exercised before or after that date; he was in exactly the same position'.[34] Despite this false note, Robinson's appearance before the Committee was triumphant (figure 9.6).

After this, the excitement was more or less over. In the final sessions of the Committee in July, Gorst – now frankly acting as counsel for the defence – brought Donnelly back and took him through his evidence again, trying to repair the damage. No conclusions were reached at this stage. The operation of Select Committees is limited to one session of Parliament, so this Committee stood down, issuing a brief *Second Report*, which stated that it had more work to do and recommended that it be reappointed in the next session. The reformers worked on during the summer vacation, and the Department was not idle. When the Committee reassembled in March 1898, another scandal had broken: the 'summary dismissal'[35] (as the reformers saw it) of Weale.

Weale had reached the pensionable age of 65 on 8 March 1897. The Department, however, obtained leave from the Treasury for him to continue in his post 'for such period, not exceeding one year from 8th March 1897, as may elapse before the Report of the Committee'. No doubt it felt that there was more chance of controlling him if he was on the payroll. In the event, Weale proved uncontrollable and said just what he liked. The Department evidently decided to cut its losses, and terminated Weale's employment on 22 October 1897. It argued that the Committee had 'reported' and finished its business. Technically, as we have seen, this was correct, although the Committee had made it clear that it intended to continue its work as a newly appointed Committee in the next session. The

reformers felt that Weale had been 'punished',[36] and they were surely right. They did their best to haul Donnelly over the coals before the Committee. But the Department, despite gaps and shifty passages in the official memoranda that were put in evidence,[37] had not acted beyond its powers, so nothing could be done.

The Select Committee of 1898 concerned itself with the Science Museum, and with the needs of Scotland, Ireland and Wales. It also heard grumbles from Bethnal Green residents about the failings of the branch museum there. A Mr Lobb described it as 'a white elephant', which he entered 'only when I wanted shelter in the event of a storm'. 'Of course,' he said, 'we are pleased to let the children go in to get them out of the way now and then.' Mr Blow thought there had been no attempt to bring the museum 'into organic connection with the other educational efforts of the neighbourhood'. Mr Nokes lamented that 'there does not seem life or energy or vitality about the thing at all'. Mr Bartlett considered that people found it boring because the exhibits were always the same; 'until they know there is some fresh exhibit, they naturally do not go a second time'. The Bishop of Stepney thought the museum 'clearly out of touch at present with the people'. Despite the Committee's attempts to encourage the idea that the Borough of Bethnal Green might make some cultural initiative funded from the rates, which the Department could then support, these witnesses agreed that the area was just too poverty-stricken to support any such action; only a Government handout would meet their needs.[38]

The Select Committees of 1897 and 1898 spent a vast amount of time raking over the debris of past misfortunes and scandals. They spent comparatively little time on how the museum might improve itself in the future. Before leaving the Committees, however, it is worth noting some of their more constructive moments. Gray and Yoxall, former teachers, repeatedly asked witnesses how the museum could make itself more accessible and useful to educational institutions. South Kensington came out of such interrogation rather badly, showing a dogged reluctance to do more to help visitors than provide a label beside each exhibit – a practice established by Henry Cole half a century earlier. Gray advocated in addition 'master labels' for each showcase and hanging labels at the entrance to each room. 'Very desirable,' agreed Skinner. 'I am afraid I cannot say why it has not been done.'[39] Formal lectures for visitors were suggested, but Donnelly countered that they had been tried, without success: 'we could not get anybody to come ... The people are sick of being lectured.'[40] Informal gallery lectures were proposed, but Donnelly dismissed these too: 'very difficult ... if you had a large number of people in, and somebody began to talk loud, describing things, everybody would rush there, and those behind would stand on the

furniture or on the cases.'[41] The desirability of catalogues was emphasized, but the public 'do not buy many', said the Director of the Dublin Museum; Purdon Clarke concurred that 'we do not find that casual visitors at Bethnal Green will buy a 1s. 6d. catalogue', while admitting that Bethnal Green had managed to publish an exhibition catalogue 'two months after the exhibition was closed'.[42] To the suggestion that copies of catalogues should be provided in the galleries for public consultation, Donnelly gloomily replied:

'I do not know that they would be of much use ... but it might be tried.'

[Gray:] 'Have you ever tried it?'

'No ... We might try having two or three of them hung up. You cannot leave them about, as they would be walked off with, but you would have to tie them up in some way.'[43]

Gray called for sets of handling objects for art schools, and Yoxall urged that such a service be extended to elementary and secondary schools. 'An enormous amount of work ... quite outside the power of our present organization,' sighed Clarke.[44] In response to a suggestion that the Department should 'extend invitations' to schools to make use of the museum, Festing expostulated that if teachers 'cannot find out for themselves that there is a South Kensington Museum and things that would be useful to them in teaching, they cannot be much of teachers'.[45]

Underlying these attitudes was a conviction that the

Figure 9.7
Sir Henry Howorth,
a caricature by
Harry Furniss in
his *My Bohemian
Days* (1919).

museum existed for the sake of education, not pleasure. Visitors were expected to work hard, and the museum need not bother with those who did not do so: 'loafers who go to look at the things in a vague way'.[46] 'Most of the people that go to museums,' thought Armstrong, 'go to get into a warm place out of the cold, and if they were allowed they would read newspapers there.'[47] Best not to encourage them. Plunkett of Dublin was rather more forgiving: 'the educational is the great element,' he agreed, 'but of course we try to get those who only come in to stare, to learn a little while they are there'.[48] When discussing the functions of the Circulation Department, the museum showed itself averse to sending to provincial museums 'merely attractive objects – things which will make a show' for the general public, preferring to send things that 'will have the highest educational value' for local manufacturers and workmen.[49] Such attitudes showed that the museum was in serious need of re-invigoration, for the services that Gray and Yoxall called for were all high on the agenda of the Museums Association (founded in 1889), and should not have come as a surprise to South Kensington.[50]

As to the way forward museologically, Sir Henry Howorth alone had this in view. A whiskery, loquacious Lancashireman (figure 9.7), he had 'an active brain which seemed to have taken all knowledge for its province'.[51] He wrote books on Genghis Khan and the Mongols, glaciation and the Flood, and the Anglo-Saxon Church; and contributed countless letters to *The Times* on political subjects. Upon his lively mind recent developments in museums abroad had obviously registered, and he gently tried to open the eyes of witnesses to this wider scene. When the museum's need for more space was raised, it was he who tried to get the witnesses to take a practical and critical view of the new buildings that had been proposed. 'There are two theories about a museum,' he remarked to Sir John Taylor, Principal Surveyor of the Office of Works. 'One is the architect's theory that the birds were meant for the cage, and the other is the Museum Director's view that the cage should be made suitable for the birds which it is to contain.'[52] If this simple truth had been more clearly apprehended, much agony would have been avoided in the future.

One of Howorth's interventions is especially worth noting. He was quizzing Clarke about the best way to arrange a museum. When he offered Clarke the choice between 'the geographical arrangement, or the technical arrangement' (both of which, as we have seen, had been tried at South Kensington), Clarke predictably plumped for the technical arrangement. So Howorth pressed him gently on the possibility of grouping English material together. Clarke began to give ground a little, so Howorth continued:

Go one step further; would it, in your opinion, be better that you should fit up rooms with all their fittings as they do in

Figure 9.8
This *Punch* cartoon
pleaded with the
Government in 1897 to
give the South Kensington
Museum its promised new
building, to replace the
'Boilers', shown in the
background. Several more
years were to pass before
action was taken.

A GREAT BIG SHAME.

Mr. Punch (to John Bull). "Surely, Mr. Bull, in this year of Diamond Jubilee you will build some better home for her than these Sheds and Cellars."

PUNCH, OR THE LONDON CHARIVARI.

[March 13, 1897.]

many modern museums abroad, rather than to keep the furniture all by itself, and the tapestries all by themselves, and the other fittings of the room all by themselves: would you fit up several rooms showing the best of the period?

And Clarke, rising to the invitation, replied: 'I think we ought to do that; it has been very successfully done on the Continent, and it is the only way of giving the relative value of the objects.' Encouragingly, Howorth continued: 'In fact, you have done it to some extent?' 'We have,' rejoined Clarke, probably feeling quite proud of himself.[53] This question of museum arrangement was to be the crucial test for the V&A at the start of the twentieth century, and it is significant that Howorth opened it up here. He later tried this idea on Donnelly and Skinner, but got little response from them.[54]

The Committee's final recommendations, in its *Second Report* of the 1898 session, amounted to a severe criticism of the Department. These, and even more the minutes of the Committee's hearings, in which every scrap of the Department's dirty linen had been laundered in public, confirmed 'everything that has in the past been said against the working of the Department'. 'It would hardly be possible,' said the *Art Journal*, 'to imagine ... a more scathing indictment of a system which we have for many years been bidden to regard as infallible.'[55] The *Globe* remarked that 'although for years past South Kensington has been a reproach and a by-word, even its bitterest

assailants can hardly have conceived that matters were as bad as they have turned out to be'.[56] The conclusion was essentially simple. As *The Times* of 8 August 1898 remarked, 'the whole Department must be reorganized, the duties of the high officials in all the museums under it must be reconsidered and carefully defined'.

This did not happen. Quite the reverse. Sir John Donnelly prepared a long document rebutting every criticism directed at him, and his political superiors backed him up by publishing it.[57] Balcarres had anticipated this: 'I can well understand the line Sir John Donnelly proposes to take. By making it a personal battle he is much more likely to be successful than by defending his own departmental action.'[58] The *Art Journal* wearily commented: 'the philosophical conclusion to be drawn is, that some good will most probably come from the fierce criticism levelled at the official system, and that the authorities will quietly alter their methods, despite their frantic efforts to prove themselves in the right.'[59]

However, the Department of Science and Art was now under a death-sentence. In the last three decades of the nineteenth century, W.H.G. Armytage remarks, 'moulders of responsible opinion were beginning to feel the imperative necessity of what became known as collectivism in education'.[60] It was time to pull the system together. Because English elementary education was almost entirely in the hands of charities representing the mutually antagonistic

Figure 9.9
The young Bernard
Rackham.

interests of the Church of England and the Nonconformists, the Government's Education Department, formed in 1839, had for decades done little more than hand out grants. W.E. Forster's Education Act in 1870 succeeded in reducing the charities' influence by introducing a third party into the bargain: Board Schools – that is, schools funded by boroughs from local rates and subject to greater control from the centre. After this, measures of centralization and collectivization gradually crept in. In 1895 Arthur Acland, Vice-President of the Council, set up a Royal Commission under James Bryce, to review the existing educational provision. The Bryce Commission recommended, among other things, that the Education Department and the Department of Science and Art should be amalgamated. A first attempt at legislation to this end broke down in 1896. Donnelly stayed at his post until he reached retiring age on 2 July 1899, having 'worked from 1859 to 1899: forty out of the forty-six years of the life of the Science and Art Department'.[61] On 1 April 1900 the Department of Science and Art was amalgamated with the Education Department, to form the new Board of Education.

At South Kensington the builders moved in. For the Government at last (figure 9.8) gave permission for a start on the new building designed by Aston Webb. On 17 May 1899 Queen Victoria laid the foundation stone, and renamed the museum the Victoria and Albert Museum. There must have been a sense of new beginning.

It came as a shock to everyone when Purdon Clarke resigned in 1905 to become Director of the Metropolitan Museum, New York. He had been poached by J. Pierpont Morgan. Morgan's collection was on loan to South Kensington, and it was hoped that he might become a major benefactor; but in 1904 he became President of the Metropolitan, and henceforth devoted his energies to transforming that museum. No doubt he gave every inducement to Clarke to take the post in America, but it was suggested in the press that Purdon Clarke's resignation could also be seen as 'a dignified protest' against his superiors for not giving him the independence he might have expected after the Select Committee.[62]

Clarke had been a dependable Director and a progressive influence. He was succeeded by Arthur Skinner. Skinner's smooth rise by 'Buggins's turn' did not endear him to all his colleagues: the Spielmann papers contain an anonymous letter-draft 'To the Editor of the Magazine of Art' attacking Skinner, clearly with inside knowledge, but in terms so malicious as to make it unpublishable. But many held him in 'esteem and affection', especially for his courtesy.[63] He seems, however, to have had some difficulty in keeping on top of his work. As Assistant Director, he had, according to an official report, 'with the best intentions, attempted far more work than any one person can deal with'.[64] And it was said of him that 'he had a highly developed sense of detail, and was ... occasionally apt to lose sight of some of the wider issues ...'[65] In his perhaps rather shaky hands, the museum waited as the new buildings rose.

Not that the staff were idle. The years around 1905 saw an efflorescence of art-historical articles in scholarly

journals by Skinner himself; by E.F. Strange and C.H. Wylde, who were about his age; and by the V&A's bright young men of about 30: A.F. Kendrick, H.P. Mitchell and G.H. Palmer – all of whom we have already met – together with Martin Hardie, future Keeper of Engraving, Illustration and Design, and Bernard Rackham (figure 9.9), future Keeper of Ceramics, who both joined in 1898. The staff, Clarke had told the Select Committee, 'are all young men now'.[66] So there was hope for the future.

NOTES

1 J.C. Robinson, 'On our National Museums and Galleries', *Nineteenth Century*, December 1892, p. 1030.

2 As well as the article cited in note 1, see 'English Art Connoisseurship and Collecting', *Nineteenth Century*, October 1894, pp. 523–37; 'Our Public Art Museums: A Retrospect', ibid., December 1897, pp. 940–64; 'The Reorganisation of our National Art Museums', ibid., December 1898, pp. 971–9.

3 Letters from Robinson on 22 September, 9 and 17 November; from Cole on 29 September, 18 and 23 November.

4 Percy E. Spielmann, *Art, Books, and Friendships of Marion H. Spielmann*, typescript in NAL, press mark 86.W.72,73, p. 157.

5 *Second Report from the Select Committee on Museums of the Science and Art Department; together with the Proceedings of the Committee, Minutes of Evidence, Appendix, and Index. Ordered, by The House of Commons, to be Printed, 23 July 1897*, para. 7824.

6 Lord Balcarres to M.H. Spielmann, 29 October 1896, in Spielmann papers.

7 Percy Spielmann, op. cit., p. 163.

8 The most complete version of the case against South Kensington is Spielmann's 'The Exposure of South Kensington Museum', *Magazine of Art*, vol. 19, 1895–6, pp. 446–8.

9 E. Howarth, 'The Circulation System at South Kensington', *Museums Association. Report of Proceedings ... at the Eighth Annual General Meeting*, London: Dulau, 1897, p. 88.

10 *Second Report ... 1897*, para. 6115.

11 'Chances for Reform', *Magazine of Art*, vol. 19, 1895–6, p. 419. 'The Exposure of South Kensington Museum', ibid., p. 446.

12 *The Morning* [?], 18 September 1894. An imperfectly recorded reference (which I have been unable to verify) for a cutting in the V&A Cuttings Book, July 1891–May 1898.

13 'Chances for Reform', p. 420.

14 'Art in Parliament' in A.C.R. Carter (ed.), *The Year's Art 1897*, London: Virtue, 1897, p. 76.

15 Barbara Morris, 'The Harborne room', *V&A Bulletin*, vol. 4, 1968, pp. 82–95.

16 *Second Report ... 1897*, Appendixes 1, 28, 30.

17 Ibid., Appendixes 16, 22, 26.

18 Ibid., paras 2698–9.

19 Percy Spielmann, op. cit., pp. 165–6.

20 *Second Report ... 1897*, paras 1311–13.

21 Ibid., para. 1755.

22 Ibid., para. 1760.

23 Ibid., paras 1781, 1783, 1813.

24 Ibid., para. 1949.

25 Ibid., para. 3894.

26 Ibid., paras 3910, 3575.

27 Ibid., paras 5722, 5697.

28 Letter from Lord Balcarres to M.H. Spielmann, 28 May 1897, in Spielmann papers.

29 *Second Report ... 1897*, para. 6778.

30 Ibid., para. 7468.

31 Ibid., paras 7477, 7489.

32 Ibid., pp. vi–vii.

33 Ibid., para. 7516.

34 Ibid., paras 7561, 8107–8.

35 'A New Scandal at the South Kensington Museum', *Magazine of Art*, vol. 21, 1897, p. 341.

36 M.H. Spielmann, 'An Artistic Causerie', *Graphic*, 11 September 1897, p. 348.

37 *Second Report from the Select Committee on Museums of the Science and Art Department; together with the Proceedings of the Committee, Minutes of Evidence, and Appendix. Ordered, by The House of Commons, to be Printed, 29 July 1898*, Appendixes 2, 12.

38 Ibid., paras 2333, 2488, 2570, 2642, 3103, 2711.

39 Ibid., paras 1747–57.

40 Ibid., para. 616.

41 Ibid., para. 521.

42 *Second Report ... 1897*, paras 4705, 4179, 4178.

43 Ibid., paras 511–12, 515.

44 Ibid., paras 3040–51, 4169–76.

45 *Second Report ... 1898*, para. 794.

46 Ibid., para. 2668.

47 *Second Report ... 1897*, para. 4912.

48 Ibid., para. 4547.

49 *Second Report ... 1898*, paras 1710–11.

50 Geoffrey Lewis, *For Instruction and Recreation. A Centenary History of the Museums Association*, London: Quiller Press, 1989, pp. 9–10.

51 A.H.T., 'Obituary. Sir Henry Hoyle Howorth', *Archaeological Journal*, vol. 80, 1923, p. 308.

52 *Second Report ... 1897*, para. 7246.

53 Ibid., paras 3931–5.

54 *Second Report ... 1898*, paras 557–63, 1580–90.

55 'The Exposure of South Kensington', *Art Journal*, 1898, p. 316.

56 *Globe*, 13 August 1898: V&A Cuttings Book, June 1898–August 1900, p. 5.

57 *Museums of the Science and Art Department. Minute by the Right Honourable the Lords of the Committee of the Privy Council on Education on the Second Report from the Select Committee (1898) on the Museums of the Science & Art Department, with Appendix. Presented to both Houses of Parliament by Command of Her Majesty.* London: HMSO, 1899.

58 Lord Balcarres to M.H. Spielmann, 29 October 1896, in Spielmann papers.

59 *Art Journal*, 1899, p. 158.

60 W.H.G. Armytage, *Four Hundred Years of English Education*, Cambridge: University Press, 1965, p. 170.

61 W.H.G. Armytage, 'J.F.D. Donnelly: pioneer in vocational education', *Vocational Aspect of Secondary and Further Education*, vol. 2, May 1950, p. 20.

62 *Morning Post*, 24 January 1905.

63 *Museums Journal*, vol. 10, 1910–11, p. 276.

64 *Report of the Committee on the Administration of the Victoria and Albert Museum ...* [printed document marked 'Confidential'], 1902, p. 1.

65 *Athenaeum*, 11 March 1911, p. 286.

66 *Second Report ... 1897*, para. 4064.

Rearrangement

'The Albert Museum' was what the Queen wanted to call the South Kensington Museum, when a change of name was proposed. This suggestion came as preparations were being made in 1898 for the Queen to lay the foundation stone of the new building.[1] It was not the first time that the Prince Consort's name had been linked with the museum. In 1869 a writer in the *Builder*, contributing a series of articles on loans to the museum, tried hard, but unsuccessfully, to get the title 'Albert Museum' to stick. Another correspondent proposed 'National Museum'.[2] In 1898, as news of the proposed name-change spread, M.H. Spielmann contended that 'a clear definition of the character of the institution should be included' in the new name, and proposed 'The Victorian Industrial Art Museum'.[3] However apt that name may have seemed in 1898, it would not have been a name to conjure with in the twentieth century. The Queen was persuaded that 'Victoria and Albert Museum' would be best. But name-changes tend to be difficult to establish (figure 10.1), and as late as 1958 the museum was said to be 'still often referred to, to the authorities' despair, as the "South Kensington Museum"'.[4]

Not only did the museum change its name at the turn of the century, but it changed its nature. After blowing hot and cold over the best way to rearrange the various parts of the museum on the South Kensington site (figure 10.2), the Government finally decided that the art museum should be completely split off from the science museum, and that the latter, as the Select Committee had proposed, should be housed to the west of Exhibition Road, while the former should (with the art school) occupy all of the site to the east. This meant that the whole of Aston Webb's new building would go to the art museum. Furthermore, after a decade between 1899 and 1909 when there existed a Victoria and Albert Museum (Art) beside a Victoria and Albert Museum (Science), it was decided that the art museum alone should bear the new name. The Science Museum, now officially so

called, had to muddle along in the old buildings west of Exhibition Road, until in 1928 the first part of its new building was ceremonially opened.

Webb's new building to the east of Exhibition Road, providing at least twice as much space as the art museum had had before, offered an opportunity for the museum to redefine itself through the redisplay of the collections. A new display was almost universally felt to be necessary, as many disparaging comments reveal. Of course, some people were happy with the museum as it was. The French writer Marius Vachon, who surveyed applied art museums and schools throughout Europe, warmly praised the museum as a place of public resort:

At South Kensington, you can go in at eight o'clock in the morning, and not come out until ten o'clock at night. A restaurant makes provision for you to take breakfast, lunch and dinner; a bar provides refreshment. Are you tired of walking in the galleries? In winter, a library, admirably heated, ventilated, and lighted, offers you rest in its soft armchairs, and a variety of reading-matter; in summer, a garden offers its rocking chairs and its benches, in the shade, amid verdure and flowers.[5]

Another comment from France was transmitted by F.W. Moody of the Art School: 'M. Galland, a decorative artist of great eminence, assures me that for convenience of arrangement, for perfection of lighting and exhibition, for facility of study and reference, the Kensington Museum is superior to anything in his own country.'[6]

But many more comments can be found that deplore the museum's crowded and muddled state. Muddle had been an issue ever since, in 1857, the oddly miscellaneous collections that constituted the museum had first come to rest at South Kensington. It was a favourite taunt with Ruskin:

At Kensington ... fragments of really true and precious art are buried and polluted amidst a mass of loathsome modern mechanisms, fineries, and fatuity, and have the souls trodden out of them, and the lustre polluted on them, till they are but as a few sullied pearls in a troughful of rotten pease, at which the foul English public snout grunts in an amazed manner, finding them wholly flavourless.

Vignette: The leather casket, designed by the bookbinder Douglas Cockerell, which contained the golden key used by King Edward VII at the opening of the new Victoria and Albert Museum building on Saturday 26 June 1909.

Figure 10.1 An early 20th-century postcard, which exemplifies public confusion over the V&A's new name.

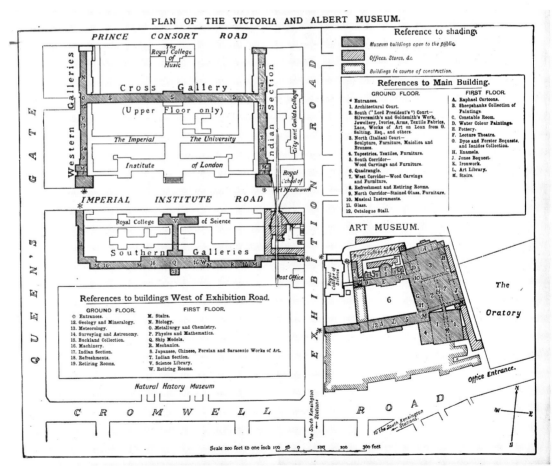

Figure 10.2 The disposition of the V&A's collections (both art and science) on the South Kensington site in 1908, just before Aston Webb's new building came into use. From a guide pamphlet published by the Board of Education (NAL, press mark VA.1908. Box 0004).

This comes from a passage that Ruskin drafted, but did not print, for one of his series of polemical newsletters *Fors Clavigera* (no. 57 for September 1875).[7] A similar comment, which he did publish, appears in a series of letters on museums and galleries in the *Art Journal* in 1880. Of South Kensington he says:

I lost myself in a Cretan labyrinth of military ironmongery, advertisements of spring blinds, model fish-farming, and plaster bathing nymphs with a year's smut on all the noses of them; and had to put myself in charge of a policeman to get out again.[8]

And in 1883 he wrote of 'the miscellaneous collection at Kensington, where Gothic saints and sinners are confounded alike among steam thrashing-machines and dynamite-proof ships of war'.[9]

While Ruskin chose to mock because he could not find the art amidst everything else, others, who were prepared to narrow their gaze to the art collections, found these in confusion. 'A whole generation,' claimed the *Journal of the Royal Society of Arts*, 'has grown up grumbling at the arrangement or want of arrangement at South Kensington Museum', where 'the objects on view were so tightly packed together that it was almost impossible to see them'.[10] A.B. Meyer, in a report on European museums, said of South Kensington that 'its excessive abundance of objects quite oppresses the receptive faculty of the most alert sightseer', and quoted the view of another critic: 'The worst possible conception of the mode of arranging museums is exemplified at South Kensington'.[11] No less an authority than Charles Yriarte, Inspector-General of Fine Arts in France, wrote in 1897 of South Kensington that 'England there possesses the entire art of Europe and the East', but 'the inconceivable treasures are becoming so much heaped up as to be a veritable obstacle to study'.[12]

It was not just that there was too much for the average visitor to absorb; many also complained that this museum, and others, were not systematically arranged for students. The British Museum was censured, back in 1859, because it suffered from 'plethora and oppletion', and the diagnostician who recognized this sinister-sounding disease went on to criticize museums as 'almost invariably too cramfull', because their managers could not resist an 'ostentatious display of accumulated treasures', 'mere curiosities, intended to be only stared at instead of being studied'.[13] For this and many other critics, a good museum was an educational museum, rather than a spectacular or enjoyable museum. Ruskin said a number of wise things about museums, but when he set up his own museum, at Walkley near Sheffield, he delivered one of those prohibitive pronouncements that his admirers accepted as having the force of law. Hung up at the door of his museum, this statement first appeared in *Fors Clavigera* no. 59, countering the proposition that 'museums are to be opened as lively places of entertainment':

A museum is, be it first observed, primarily, not at all a place of entertainment, but a place of Education. And a museum is, be it secondly observed, not a place for elementary education, but for that of already far-advanced scholars. And it is by no means the same thing as a parish school, or a Sunday school, or a day school, or even – the Brighton Aquarium.

Be it observed, in the third place, that the word 'School' means 'Leisure,' and that the word 'Museum' means 'Belonging to the Muses'; and that all schools and museums whatsoever, can only be, what they claim to be, and ought to be, places of noble instruction, when the persons who have a mind to use them can obtain so much relief from the work, or exert so much abstinence from the dissipation, of the outside world, as may enable them to devote a certain portion of secluded laborious and reverent life to the attainment of the Divine Wisdom ...[14]

This passage must have been quoted countless times by late Victorian worthies as an authoritative definition of a museum,[15] and it must have contributed not a little to making museums hard work for visitors.

For those, then, who believed that museums must be regarded primarily as educational instruments:

the usefulness of a museum in this respect does not depend entirely so much on the number or intrinsic value of its treasures as upon the proper arrangement, classification, and naming of the various specimens in so clear a way that the uninitiated may grasp quickly the purpose and meaning of each particular specimen.[16]

South Kensington consequently came in for criticism because it did not have a clear classification scheme. 'In the arrangement everything is sacrificed to the making of an artistic show; to elevate the public, as it is pretended; to please and amuse in fact.' This was the view of an American teacher who wished to study architectural ornament in the museum. Related works, he said, 'are scattered here and there over the whole of the rambling ground floor of the building', and 'where there are many examples they are utterly overcrowded'.[17] A similar grouse was raised at the Museums Association:

... There is nothing more provoking than to find specimens of the same kind scattered all over a large building. South Kensington is a striking example of the confusion that results when once strict classification is abandoned ... Bad light, crowding, and awkward positions often baffle the student. One is sometimes forced to lie on the floor, or climb a ladder, or sprawl over a case in order to examine the finer ornamentation on an object.[18]

When the South Kensington Museum incurred such severe criticism for poor arrangement, it was inevitable that great expectations would be aroused by the prospect of new arrangements in a new building. The popular writer E.V. Lucas, in his *A Wanderer in London* (1906), described

the museum as 'most shamefully huddled, but the new building will be ready soon and then one will be able to see as a whole many things that now one can examine only part by part'.[19]

For ten years the rising building loomed over South Kensington, presenting a 'splendid picture' on dark evenings, 'draped in its network of scaffolding – a great and mysterious mass of soaring lines silhouetted against the infinite delicacy of a winter sunset'.[20] Then the scaffolding was removed to reveal the long, sweeping façade, with its domes, pinnacles and central crowned tower. Its style, comments the architectural historian, J. Mordaunt Crook, 'was identified at the time as Burgundian Renaissance with Hispanic touches. Later commentators have also spotted the Certosa at Pavia peeping out from between clumps of François Premier.'[21] Crook quotes Sir John Summerson, who himself alludes to the Victorian parlour ballad 'The Lost Chord', in which an improvising organist happens upon a resonant chord which 'flooded the crimson twilight ... like the sound of a great Amen'. In his new V&A building, says Summerson, 'Aston Webb ... is like some talented organist moving from theme to theme and occasionally exploding into what, at least for the moment, seems to be the lost chord'.[22] The outside of the building was undoubtedly a grand achievement; there remained, however, the difficult question of what to do inside.

The man who took the decision – in the end, probably a wrong decision – on how the contents of the new building were to be arranged was a civil servant hardly less forceful than Henry Cole himself. As we have seen, a new Board of

Figure 10.3
Robert Morant,
reproduced from
Bernard Allen's
biography
(1934).

Education was set up in 1900, uniting the Education Department and the Department of Science and Art, and in October 1908 bringing them together physically in a new building at Whitehall – at which point the civil servants departed from the South Kensington site, leaving it to the museum men.[23] The chief civil servant of the Board of Education was Robert Morant (figure 10.3).[24] Educated at Winchester and New College, Oxford, he read theology with a view to taking Holy Orders, but this vocation was denied to him by intellectual doubts – though he was never to be short of faith in his own opinions. Seeking salvation in the wider world, he obtained a post as tutor to the royal family of Siam, where his high-minded determination raised him to a position of great influence. When, however, the French annexed parts of Siam in 1893, and Britain failed to deliver adequate assistance to Siam, Morant's position collapsed, and he returned to England with the feeling that his life was in ruins. Still in his early thirties, and in severe depression, he took up good works at Toynbee Hall, the new University Settlement founded to serve the poor of the East End of London. But soon, in 1895, he found a post in the Board of Education as what would nowadays be called a 'researcher', in the Office of Special Inquiries, set up as a 'think-tank' under Michael Sadler. From this inconspicuous position Morant had an almost unbelievably rapid rise, as he assisted the progress of Balfour's Education Act of 1902. 'His achievement, as a relatively junior officer, in mobilizing and marshalling the political, municipal, and educational forces of the country for the not unhazardous enterprise of constructing an orderly and comprehensive system of public education out of incoherent and antagonistic elements, is one of the romances of the civil service,' says his eulogistic entry in the *Dictionary of National Biography*. By April 1903 he was Permanent Secretary of his Department.

In January 1908, as the new building of the Victoria and Albert Museum approached completion, Morant turned his mind to the question of the new layout of the exhibits, and peremptorily requested from the Director, Arthur Skinner, his plans for the new displays. Skinner's reply did not satisfy him, and time was running out, so he simply thrust Skinner aside.[25] In February 1908 he appointed a 'Committee of Re-arrangement' to do Skinner's job for him. He delegated the organization of this to his personal private secretary, Arthur Richmond, who later recalled that 'Morant knew nothing about the purpose the Museum had been created to serve, what principles should govern the arrangement of its collections or whether staff changes would be necessary'. Richmond was deputed 'to study the position and report direct to Morant'. His investigations revealed that the museum

had been founded as a source of study for the improvement of design in industrial products. So far as I could ascertain the

original purpose had been forgotten or deliberately ignored, and re-arrangement was to be made largely on the principle of 'what looked well where'. This judgement may have been over-hasty, but time was short ...[26]

Morant, having accepted this briefing, left Richmond, as secretary to the Committee, to appoint its members.[27] First on board was W.A.S. Benson, who, educated at Winchester and New College, was inspired by William Morris and the Arts and Crafts Movement to adopt an artistic career; he started up his own firm producing wood and metal furniture, and took over the management of Morris & Co. after William Morris's death. He advised Richmond as they considered other possible members, to be drawn perhaps from among Arts and Crafts Movement men, architects or 'Manchester men' (i.e. industrialists). Two other men concerned with artistic production were recruited: Harry Powell from the well-known glass makers, Powell's of Whitefriars, and Lewis Day, a designer of flat pattern and a venerable figure (at 63) in Arts and Crafts circles, who had taught at the South Kensington schools and written many books on design.[28] Another member of the Committee, J.C. Wedgwood, MP, came from the pottery family (and wrote books on the family and their trade) but was not involved in the firm; he had trained as a naval architect and had become good friends with Richmond when they were both working in the Transvaal. The Chairman of the Committee was at first Sir Charles Dilke, the veteran Liberal MP and former Minister, but when, after 14 meetings, the Committee reached the stage when it had to draft its report, he stepped down, owing to 'pressure of other duties',[29] and the fifth member of the Committee was elected Chairman in his place.[30] This was Cecil Harcourt Smith,[31] Keeper of Greek and Roman Antiquities at the British Museum. He had been chosen as being 'specially identified with museum work, and of skilled experience in this particular direction of museum management',[32] and 'with a view to co-ordination of the Museums'.[33] In the light of what happened later, it seems likely that Morant had marked him out. The Committee met for the first time on 20 February 1908 to consider the brief that Morant gave them.

At this point, it is necessary to take stock of the way that museum people, especially those in decorative arts museums, thought about gallery display in the early twentieth century. We have already seen, in Chapter Seven, that the South Kensington Museum – as the pioneering museum of decorative arts – set an example that was quickly followed elsewhere, in Germany and the Austro-Hungarian empire, in Scandinavia, Russia and Eastern Europe, in Italy and the Netherlands, in France and America. Almost without exception, the new decorative arts museums, when setting up their displays, adopted what they regarded as the South Kensington system: the arrangement of exhibits according to material and technique. In the German-speaking world, this system was felt to be intellectually underpinned by Gottfried Semper's account of the history and theory of decorative art. In his massive but unfinished work, *Der Stil* (Frankfurt, two volumes, 1860–3), Semper proposed that the development of artistic form in crafted objects was essentially determined by the properties of the materials from which the objects were made. Thus, to understand the creative process, it was necessary to study, say, textile objects together, separated from objects made of clay, or wood, or stone, for different forms would be seen to emerge through the different materials. Consequently every decorative arts museum had its separate galleries of ceramics, metalwork, textiles, woodwork, and so forth.

Towards the end of the century, new ideas about the arrangement of exhibits in decorative arts museums became current. At the highest intellectual level, the changes originated from, or were registered in, the work of Alois Riegl, in his book *Stilfragen* (Questions of Style), published in 1893. Here, in explicit opposition to Semper (or at any rate to the way in which Semper's views had often been simplistically promulgated), Riegl argued that artistic forms and styles were determined by 'something in man which makes him feel pleasure in the beauty of form, something which neither we nor the followers of the theory of the technical-material origin of art are able to define'; but which he did nonetheless define as 'a determined and conscious artistic will'.[34] The products of the artistic will, of the 'will to form', would, at any one moment, probably share certain features. It made sense, therefore, to study the decorative arts of each period together, in order to see how they exemplified the 'spirit of the age', rather than to study artistic development through materials. If this approach were to be carried over into museum display, it might mean that decorative arts museums should arrange their galleries by period and by style, historically or aesthetically.

Whatever the influence of Riegl may have been, there seems little doubt that the real motor behind the change that came over the galleries of decorative arts museums was a desire to communicate with a wider public than design students alone. This comes across clearly in what is often taken as the classic statement of the new position, the comparatively short (though high-flown) introduction that Justus Brinckmann prefixed to the massive catalogue he wrote of the contents of the Hamburg Museum, which was published in 1894. Brinckmann came to the regretful conclusion that 'the successes, which were expected to result from the example set by the historic works put on show' in the museums of decorative arts 'have turned out to be less striking and less widespread than anticipated',

because these displays led students only to 'the imitation of historical forms, which gradually kills all fresh invention'. Students must look more deeply to understand the creative process. Furthermore:

if the importance of the industrial art museums is to be raised beyond the limits of a technological and aesthetic teaching resource, these institutions will no longer be able to avoid taking culture history as their basis. On this basis alone will they be sure of satisfying in the long run the healthy urge for instruction from the non-professional classes of the people, and of fulfilling their highest purpose, the education of the general taste of the nation.

Technical display must now yield to a manner of display that would enable visitors to 'see how the driving and creative forces in a people at a certain stage of its culture have found varied yet unified expression in visible or intellectually accessible monuments'. For instance, majolica will not simply be regarded as a type of ceramic, but as 'only one beam from the sun which burned through the entire life of the Italian High Renaissance, and shone no less brilliantly in bronzes, woodcarvings and textiles'.[35]

Technical arrangement had seemed apt in decorative arts museums so long as they felt that they existed primarily to teach craftsmen. But a more evocative type of display based on culture history had already been tried, as we have seen: by Alexandre Lenoir in his Musée des Monuments Français, and by Alexander von Minutoli at Liegnitz. The essential feature of such museum displays was the historical interior – usually a domestic interior, but sometimes (especially for the medieval period) a church interior. Such interiors could be pastiche reproductions, but they might also be genuine surviving monuments. Museums might establish themselves (and often did) in historical buildings. The Musée de Cluny will come to mind, and another important example was the German National Museum at Nuremberg, which in 1857 occupied a set of former monastic buildings of the fourteenth century, and thus was able to display its Gothic artefacts in a medieval church. Alternatively, museums might rescue historic interiors from destruction – especially interiors made of wooden panelling, which could relatively easily be dismantled and reconstructed – and reinstall them within museum buildings. This became common practice in the closing years of the nineteenth century.

The South Kensington Museum acquired the little 'boudoir' of Madame de Sérilly in 1869; a panelled room from Sizergh Castle, Westmorland, in 1891; a room from the Old Palace at Bromley-by-Bow in 1894; and a panelled room from Clifford's Inn in London in 1903 (with more to follow). The Berlin Museum acquired two Renaissance panelled rooms in 1884, from the castles of Haldenstein (near Chur) and Höllrich (near Würzburg), and thus, as its

historian points out, embarked on heritage preservation, 'a new dimension in its collecting practice, for which one seeks in vain in the statutes and programmes of industrial art museums'.[36] By 1910, according to the guide book published then, there were several more historical rooms in the museum. The Hamburg museum acquired a room-setting in the Art Nouveau style from the Paris Exhibition of 1900, but it also had two nineteenth-century period rooms, from the Abendroth'sches Haus in Hamburg and from a house in the Johannisstrasse in Lübeck, which were accommodated in a little extension built out in 1908 into the museum garden.[37] These three major industrial art museums were, however, somewhat hesitant about period rooms, compared with museums that acquired decorative art as documentation of the cultural history of their region or nation.

The Museum Joanneum in Graz, Austria, which was devoted to the history of Styria, rehoused its department of Kulturgeschichte und Kunstgewerbe in a neo-baroque building in 1895, where a fine series of period rooms was accommodated. A lavish portfolio of photographic views of them was published in 1906.[38] The Swiss National Museum in Zurich acquired a series of historical interiors in the 1880s, and its new building of 1898 was built in a deliberately picturesque manner around them. Some of the smaller and more remote industrial art museums, which were especially interested in the art of their regions, gathered period interiors. That at Flensburg in Schleswig-Holstein opened, in 1903, a new building constructed around its collection of rooms.[39] Nearby Kiel also possessed period rooms, which were built into its new building of 1911.[40] The Flensburg museum also included a reproduction room, a German Renaissance state-room, which had been made by the Flensburg wood-carving school for the Paris Exhibition of 1900, and had been presented thereafter to the museum by the local citizenry. The Vienna museum did even better, for it accommodated on its top floor copies of four historic Austrian interiors made by various Austrian art schools for the Paris Exhibition of 1900.[41]

A pioneer in the construction of reproduction interiors was the Museum Carolino-Augusteum in Salzburg. When its third director, the landscape painter Jost Schiffmann, took over in 1870, he set about transforming its rooms into appropriate period backgrounds for its collections of decorative art – not an easy task, since all the rooms in the old building that it occupied had vaulted ceilings. Nonetheless, he established a series of settings from Gothic to Rococo, photographs of which were published by Charles Normand in 1893,[42] and which survived until they were destroyed in the Second World War. The industrial art museum at Düsseldorf did something similar. In its new building of 1896, behind a neo-Renaissance façade, almost

all the exhibition rooms on the second floor, around an eclectically classical central hall, were confected in period styles. The museum made no bones about acknowledging that they were reproductions; the guide book proudly named the architects, designers and craftsmen who had been involved in making them (figure 10.4).

By far the best-known example of pastiche period settings was the Bavarian National Museum at Munich. This was designed by the architect Gabriel Seidl, and built between 1894 and 1900. Not only did Seidl provide interiors in the principal architectural styles from Romanesque to the present, but he expressed his interiors on the exterior of his long building, which consequently embodied a brief history of architecture, chronologically from left to right, with a monumental German Renaissance tower in the middle. The new museum was celebrated in a majestic book of photographic reproductions, published in 1902.[43] The many

views of the galleries show that not only were their walls, ceilings and floors styled to suit the period exhibited, but so were the showcases, which, though of standardized design, were clad with panels of period ornament (figure 10.5). Despite the provision of these ingenious receptacles, many exhibits were placed on open display, in order to increase the sense of a real-life environment. This tended to put exhibits at risk, both of damage from visitors and of deterioration from dirt and light. From a professional, curatorial point of view, many objections to this mode of display could be raised, and Justus Brinckmann was among those who raised them.[44] But such displays did, after all, present a visual spectacle that was more interesting and evocative for ordinary visitors than the serried ranks of pots or pans that were set out for specialists. And in the closing years of the nineteenth century there was quite a fashion among museum architects for creating picturesque buildings in pastiche styles.[45]

Curators of applied art who were tempted to create picturesque, evocative, contextual displays might, perhaps, have felt that they were straying too far towards the practices of ethnographic museums. Brinckmann was not afraid of this: historical, contextual displays, he affirmed, offered to industrial art museums a method 'which – let us say it straight out – has long been recognized as the only correct way in ethnographic museums'.[46] If other art curators did recoil from ethnography, they might nonetheless have found support for the new mode of display from no less distinguished a fine-art curator than Wilhelm Bode, Director of the Berlin Gemäldegalerie from 1890, and Director General of all the Berlin Museums from 1905, who hung his Old Master painting galleries in the new Kaiser-Friedrich-Museum with an intermixture of appropriate decorative art, so as to evoke the surroundings in which the original owners of the pictures might have placed them. 'Pictures and sculptures require a few good pieces of furniture, and occasionally some tapestries and decorative products of the applied arts in the character of that particular time. Thus every museum room, as a whole, will make an advantageous and distinguished impression and the effect of the pictures and statues will be heightened.'[47]

Enough examples have been mentioned (and many more could be cited) to show that at the turn of the century there were powerful influences encouraging industrial art museums to turn away from the technical/material mode of display towards historical/aesthetic, mixed-media arrangements. The motivation for such changes lay largely in the desire to communicate more directly with the public at large. In this connection, one further museological development needs to be noted. The problem of 'plethora and oppletion' was felt most acutely in scientific museums, where long, exhaustive series of biological or geological

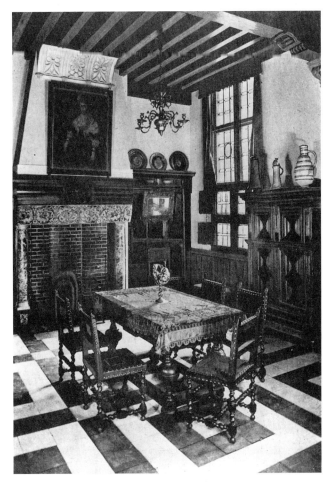

Figure 10.4 A Flemish Room in the Kunstgewerbemuseum, Düsseldorf. Genuine fragments were used in this reproduction, which was designed by Professor Claus Meyer. Firms involved in the reconstruction were Opderbecke & Neese (marble floor), Gebrüder Lanio (plasterwork), Gassen & Blaschke (glazing) and B. Ch. Koch (carpentry). From the museum *Guide* (1906).

specimens were apt to have a dispiriting effect on the non-specialist visitor. An answer to this difficulty was devised in the 1860s by Professor Louis Agassiz in the Museum of Comparative Zoology at Harvard University. This was the principle of 'dual arrangement', whereby the best and most important objects of any type were separated out to make a clear, simplified exposition of a subject, easily understood by the average visitor, while the rest of the relevant material was installed nearby for consultation by specialists.[48]

This idea had quickly been taken up in Britain by J. Edward Gray of the British Museum, who expounded

it to the British Association for the Advancement of Science in 1864.[49] Again, at a meeting of the Association in 1889, its President, Professor W.H. Flower, restated the principle (of 'the two distinct objects for which museums should be arranged: that of general instruction and interest to the public, and that of study by those who have a more serious and more intellectual interest in the objects displayed'), disclosing that it would have been adopted, but for lack of funds, in Alfred Waterhouse's new building for the Natural History Museum in London.[50] This principle could well be applied to art museums, too, but it did not come to the fore in artistic circles until the early

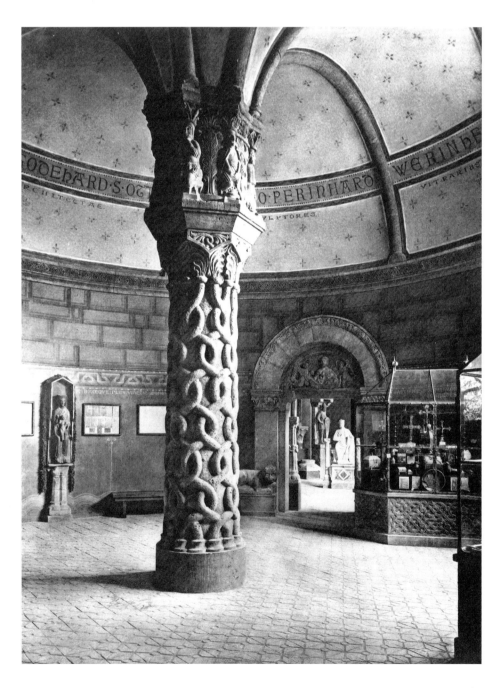

Figure 10.5
The Romanesque room in the Bavarian National Museum, Munich. Note the showcase: the same type of case was used elsewhere with different period ornament on the lower panels. From *Der Neubau des Bayerischen Nationalmuseums in München* (1902).

twentieth century when the Museum of Fine Arts in Boston, in the US, started to plan new premises to replace its old (South Kensington-inspired) building in Copley Square. The Boston Museum made exceptionally conscientious efforts to acquaint itself with up-to-date museum theory, and these were summarized by its Secretary, Benjamin Ives Gilman, in an article of 1909, which shows the interplay between the American 'dual-arrangement' theory and the European developments already mentioned above.[51]

We need to know to what extent those involved in re-arranging the Victoria and Albert Museum were aware of all these new ideas: there is evidence to suggest that they knew what was going on. We have already noticed how, at the Select Committee of 1897, Sir Henry Howorth commended mixed-media period rooms to the staff of the museum, and received a ready response from Purdon Clarke, at least (though not from Donnelly and Skinner). We know that Skinner made trips to German museums.[52] Clarke visited Berlin for the opening of the Kaiser-Friedrich-Museum in 1904, calling also at the Kunstgewerbe-museum.[53] Both Skinner and Clarke went to the opening of the Musée des Arts Décoratifs when it finally attained a permanent home in the Louvre buildings in Paris in 1905.[54] There they would have observed that:

instead of classifying everything according to periods, families, or materials employed, in such a way as to bore the visitor and give art the aspect of science, the organizers of the museum have so distributed the examples as to show enough order and connection to facilitate study, but with sufficient variety to give them the feeling of life; thus a piece of tapestry is seen, as it should be, over a bed, a chest, or a seat, not placed in a line between an earlier and a later specimen.[55]

In 1898 Clarke had been brought up to date on how the new buildings at the Bayerisches Nationalmuseum in Munich were arranged, by no less authoritative a source than the Empress of Prussia.[56]

We do not know whether the South Kensington authorities kept an eye on the current literature entering the National Art Library, but the various guide books and photographic publications about new museum displays, mentioned as sources in the descriptions just given, were there for them to consult. Nor do we know which periodicals they read, but it is difficult to believe they were unaware of an article on 'How an Art Museum should be Organized' in the mainstream Magazine of Art, July 1903, by their departmental colleague, the Director of the Dublin Museum of Science and Art, Lt-Col G.T. Plunkett. Here Plunkett alludes to the 'two main lines upon which [museum] classification may be based, the one according to the material employed, and the other by the countries or periods to which the works belong', concluding that 'it may

be at once and unhesitatingly stated that the latter is the better and more correct system ...'[57]

Since many of the South Kensington staff published in the Burlington Magazine, we may assume that they noticed its editorials in 1905–8, which ranged widely over museum policy. The 'Boston system' of dual arrangement was especially noticed in April 1906,[58] and expressly commended to South Kensington in September 1908: 'In almost any vitrine at the South Kensington Museum ... one might select one or two objects which would gain immensely by isolation, and which at present suffer from the direct competition of inferior objects of a like kind.'[59] The South Kensington Museum was not particularly ardent in its support of the newly founded Museums Association in Britain, but it would have been hard for it to miss the significance of the 1903 Annual Conference at Aberdeen, which focused particularly on European developments. The President, F.A. Bather, of the Natural History Museum, gave an impressive tour d'horizon of the new display fashion for period rooms, and the Museums Journal, in reporting his address, included 36 illustrations of museum interiors ranging from Munich to Oslo.[60] The Museums Journal also noticed the Boston system. We have already cited (four paragraphs previously) Benjamin Ives Gilman's article; further reports on progress at Boston followed.[61]

If it seems reasonable to conclude that the curators of the V&A must have had some inkling of these developments in the museum world, we must still ask whether the members of the Committee of Re-arrangement would have been equally informed. A sign that they were is to be found in a letter of 1 February 1908, from Cecil Smith to Arthur Richmond: 'I send you herewith the Boston Report and the paper by Lewis Day.'[62] This last allusion proves to be the best possible guarantee that they knew all about the subject. For Lewis Day (a member of the Committee) delivered a lecture to the Society of Arts on 10 January 1908, in which he faced the new fashions in museum display in Germany head-on, and rejected them. His Chairman at that lecture, Aston Webb as it happened, said that 'he had seldom heard so delightful a lecture delivered in so interesting a manner'. So Day must have been a master of oratorical charm (figure 10.6).

Day's opinions, however, were bleak. Museums, he granted, were often bewildering, 'but that is not the fault of the museum ... but of those who come all unprepared'. Historical arrangement (which he called 'object-lessons') was no good: 'it is sheer misuse of art to reduce it to the service of history'. 'Education by way of object-lesson is a form of teaching so elementary as to be out of place in a great museum; it belongs by rights to the Kindergarten.' 'A museum is, after all, only a sort of enquiry office. It is not the place to inspire the sentiment we feel in a room that

people live in, in a church where they worship.' 'A museum is not a story book, but a work of reference.' 'The rational idea of a museum building is not so much that of a palace of art ... as of a glorified warehouse. That is what a museum actually is – a storehouse.' 'The arresting of attention and the arousing of interest are the business, not of the museums ... but of the schools.' 'I grant you a technical museum is a deadly place until you come to it with a purpose; but it's no use trying to make it lively.'[63] Clearly, Lewis Day had no time for the new display methods, and his implacable conviction doubtless influenced the Committee of Re-arrangement. The Committee did try to check the matter out. Richmond and Wedgwood were sent on fact-finding visits to European museums, and their reports in the Committee's Minutes[64] show that they assessed both 'material' and 'historical' layouts, finding a fairly equal balance of each in the museums they surveyed.

While the Committee was aware, then, of new methods, its brief left it little choice but to stick by the old. For Morant stated:

The Museum was originally founded as an instrument for stimulating the improvement in this country of such manufactures

Figure 10.6 Lewis F. Day, from *The Year's Art 1900*.

and crafts as require and admit of decorative design ... The precise nature of its original purpose has not been throughout rigidly observed ... The Museum lacks a clear definition of function ... The board are now anxious to secure that the precise purposes intended to be fulfilled by the Museum shall be clearly realized and co-ordinated.[65]

Morant's brief gave the Committee the choice between two factors that should determine the arrangement:

the one, the direct practical purpose of stimulating the craftsman and manufacturer and inspiring the designer and student who is engaged in the production of objects of modern manufacture, and the other, the spread of a knowledge and appreciation of Art in its widest and deepest sense.[66]

It is pretty obvious that a Committee of hand-picked manufacturers and designers, faced with Morant's appeal to precedent, would incline to the former. They did, and consequently recommended a scheme of material-based arrangement.

When their Report (adopted on 29 July 1908) was published on 21 November, there were signs of public dismay. The *Burlington Magazine* backed the aesthetic/historical method: 'This system, in that it presents the arts in their true character, in relation to the life of the age which produced them has, from the point of view of the general public, a very definite educational advantage over any such scheme as classification by materials.' But it accepted that the Committee 'had no option in the circumstances but to reject this excellent principle. The Terms of Reference left them but little choice.' It conceded that the matter was 'settled inexorably' in favour of arrangement by materials.[67]

In the *Daily Telegraph* Claude Phillips, Director of the Wallace Collection, protested vehemently against the Committee's line, pleading for 'some breathing time ... some opportunity for a general expression of opinion ... The whole question is too momentous, too much the concern of every Englishman, to be decided in this summary fashion.' For him, museums

exist in the first place for the aesthetic delight and the instruction of the citizen: for his instruction, not in the technical processes and technical developments of art alone, but in its far-reaching influence on the history and the social life of the nation, in its expression of the culture of the world at its greatest and representative moments.[68]

Phillips alluded to new displays at the Louvre, the Musée des Arts Décoratifs, the Bavarian National Museum and the Kaiser-Friedrich-Museum, and warned that, if the V&A disregarded these examples, 'a great wrong will be done'. The *Morning Post* cautioned that 'the superb arrangements at Berlin have led travellers and students to make odious comparisons' with South Kensington, and urged the Committee to 'clean the Augean stables'.[69] Advocates of the aesthetic/historical method wrote to Clarke, now at the

Metropolitan Museum, New York, urging him to condemn the Committee's Report, but he staunchly wrote to *The Times* to support it: 'I have been called upon to curse ... and I am forced to do my duty and to bless the Board of Education ... The Government has fortunately found a strong man in Sir Robert Morant.'[70]

Someone who came to know the truth of that remark was Arthur Skinner (figure 10.7). For when the Committee's Report was published, there also came the announcement that its Chairman, Cecil Harcourt Smith, was to be appointed to a new, 'extremely onerous and responsible post' of 'Director and Secretary of the Art Museum'.[71] One dreadful day in December, the senior staff of the museum were called to the Board Room, where they were seated in order of seniority. Before them was Sir Robert Morant (recently knighted, in 1907), flanked on his right by Cecil Smith and on his left by Arthur Skinner. Morant announced to his shocked audience that Skinner's post had been abolished. He was to become Keeper of the Department of Architecture and Sculpture. Smith would be their new Director.[72] Skinner, 'relegated' – as it seemed to his friends – to a 'comparatively sinecure office',[73] felt his humiliation deeply, and died 15 months later at the age of 50, 'of a broken heart – "an official murder" as someone remarked at his funeral'.[74]

There was a further melancholy irony in the timing of Skinner's death, on 7 March 1911. Only a fortnight later, on 23 March, the V&A opened a display, in the new building, of the bequest of George Salting, one of the most munificent and splendid benefactions ever bestowed on the museum; it was largely due to Skinner that this collection came to rest in South Kensington. Salting, the heir to immense wealth based on sheep-farming in Australia, found himself 'in early middle life ... in London, with a fortune of £30,000 a year, no desire to marry, no philanthropic instincts, and a vague interest in art and curiosity ... He gave up his life to collecting'[75]. He concentrated at first on Oriental art, and his collection was on loan to the V&A for many years after his interest shifted to European medieval and Renaissance art. He bought much at the sale in 1893 of the collection of Frederick Spitzer, which had been formed in the palmy days of collecting in this field in Paris. Salting used to visit the V&A 'regularly one or two afternoons a week',[76] and Skinner became 'one of his principal advisers'.[77] 'With tact and sympathy, with unvarying patience,' wrote the *Evening News*, Skinner 'kept his old friend faithful to the idea that the nation should be his heir and South Kensington the last home of his treasures.' Skinner 'should have died their guardian'.[78]

As it turned out, the Salting Bequest had to be displayed all together. But the Committee of Re-arrangement's proposal for the display of the rest of the V&A's collections in material divisions was carried through remorselessly,

Figure 10.7 Arthur Banks Skinner, Director of the Victoria and Albert Museum, 1905–8.

with only one modification. The Committee had decreed that the Indian Collections, which formed a separate, cultural grouping in their outlying galleries, should be split up and integrated into the material divisions that were to prevail in the new building. A very vigorous press campaign, and a deputation to the Board of Education led by Lord Curzon, averted this threat and the Indian Museum retained its identity.[79] The other Oriental material was, however, integrated with the Western art. The Committee's plans went ahead, and enough of the exhibits were in place to justify an official opening by the King, Edward VII, on 26 June 1909. Harcourt Smith was knighted during the ceremony.

Criticism was not silenced by the first evidence of the new gallery displays. The *Daily Telegraph* returned to the attack:

At a time when the chief museums of Europe have been striving to show above all things the essential meaning ... of beautiful things, and to illustrate, by means of judicious grouping and ordering, successive periods of art in all their various phases, with that inter-connection of the different categories which alone can enable the student to appreciate at

their true value the artistic products of a given period – at such a time the authorities have deliberately chosen to take what we cannot but hold to be a retrograde step ... For one technical student or artificer who will derive instruction ... from the forced and unnatural ... schemes of arrangement adopted ... a thousand visitors bent on deriving the higher aesthetic pleasure ... from the magnificent collections ... will be repelled and disconcerted.[80]

'Retrograde step' was a phrase used also by *The Times*.[81]

Richard Graul, Director of the industrial art museum at Leipzig, surveyed the recent developments in museum display in Europe, and emphasized how the community of decorative art museums had expected that a great contribution to the new thinking would be made through the V&A's rearrangement:

How much there would be to learn and admire! We know what excellent men there are in the service of the English national collections, and we acknowledge their authority. We are convinced that they were thoroughly capable of solving, in an exemplary way and in the light of modern ideas, the exacting problems involved in the appropriate presentation of the collections of the Victoria and Albert Museum. It is, then, all the more remarkable that the insight of such generally recognized professionals has had no chance, or not a sufficient chance, to influence the preparation of the 'Rearrangement'. This extremely important matter has been settled with astonishing speed by bureaucrats, and the result is a bitter disappointment, the more bitter because there should have been no reason to expect such a disaster in this case.[82]

English critics could not be quite so outspoken. The *Burlington Magazine* bit its lip, suggested that really successful display would only be achieved 'by paraphrasing the report of the Committee of Rearrangement far more freely than is possible at the moment', and hoped that Cecil Smith would yet be able to manage some sort of 'compromise'.[83]

What distressed most people, of course, was the imposition of a rigid system of arrangement by materials, a 'scientific or pseudo-scientific mode of classification and arrangement', which made the museum seem like 'some immense, finely-appointed modern hospital for the analysis and dissection of applied art rather than that of a temple of the higher delight ...'[84]

But if the classification system (figure 10.8) came in for criticism, so too did the clinical architectural setting. In Cole's time, the museum tried to create elaborately decorative settings for the exhibits, with strong colours and much use of painting, sculpture, mosaic and other art forms as background. By the twentieth century, fashion had changed. Pastel colours or, even better, plain white were now thought appropriate,[85] and wall surfaces should be kept plain so as not to clash with exhibits.[86] These principles were adopted in the new V&A, but left something to be desired. 'There is a terrible flatness and newness in the appearance of the buff-painted walls,' commented one critic,[87] while a French observer described the wall paint as whitewash (*'lait de chaux'*) and deprecated *'ce blanc*

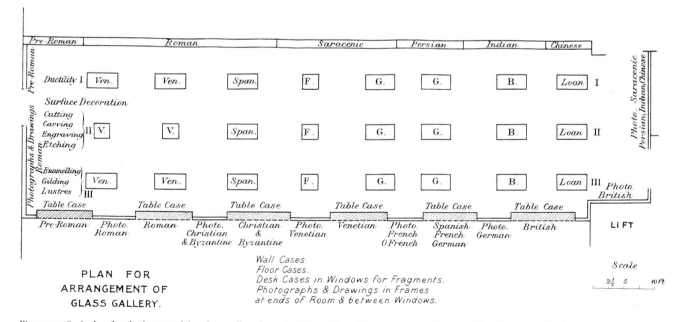

Figure 10.8 A plan for the layout of the glass gallery from the Committee of Re-arrangement's report. The Committee 'wish it to be understood that, although in every case they have laid down the main lines upon which they consider the collections should be arranged, they cannot at this stage indicate the precise position of every object, nor indeed of all groups of objects' (p. 25). They did, however, offer this specimen plan, prepared, as their Minutes reveal (p. 106), by Harry Powell. Note that the main divisions are between 'ductility', surface decoration by various forms of incision, and surface decoration by applied coatings.

éclatant.[88] Sir Claude Phillips went on grumbling about 'the nakedness of the gaunt South Kensington galleries, [which] too much resemble Metropolitan railway stations'.[89]

The shapes of the rooms were not sympathetic. There were immensely long galleries and corridors, where one might find 250-yard stretches of uninterrupted textiles or ceramics (figure 10.9), interspersed with enormously lofty courts, which dwarfed such few large pieces of furniture or sculpture as could be found to put in them (figure 10.10). And the remorselessly extending rows of showcases in the smaller galleries immediately induced museum fatigue.

Raymond Koechlin, writing in France, avowed that the 'pitiless logic' of the displays had given to the museum 'a singular coldness',[90] and Claude Phillips thought that in the new setting many objects lost their souls: 'the soul, the mysterious flower of spiritual beauty that is in them retires within itself, folds itself up, shrinks from contact with cold, unsympathetic surroundings'.[91]

A realization must have come to South Kensington, and perhaps even to Whitehall, that the new arrangement was not an unalloyed success. When Smith wrote a preface to the new guide book in May 1913, he noted rather apologetically that 'the question of classification ... has always been a difficult one; but the balance of expert opinion has generally been in favour of grouping by industries'. And a memorandum on 'The Purposes and Functions of the

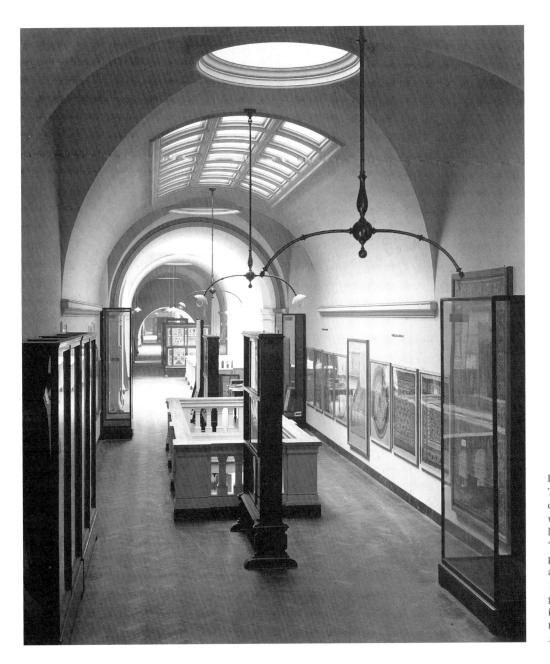

Figure 10.9
The new V&A. Textiles on display in Room 114, which stretched the entire length of the building. 'The whole of the "long passage," extending altogether to about 1,000 ft. in length, will be given up to the Museum's immense collection of textiles.' (*The Times*, 21 November 1908)

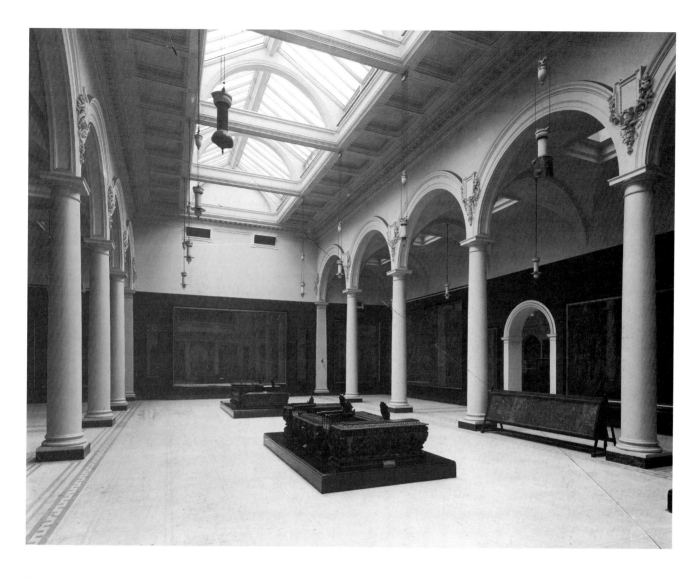

Figure 10.10 The new V&A. One of Aston Webb's top-lit courts, with a sparse selection of exhibits. 'A little mean and commonplace appear ... the groups (or little islands) of European Renaissance furniture which occupy the floor of this court.' (*Daily Telegraph*, 26 June 1909)

Museum', prepared in 1912 for the new Advisory Council, and written by or for Morant's successor, Lewis Amherst Selby-Bigge, was much less dogmatic than the brief for the Committee of Re-arrangement, acknowledging that the museum must be 'hospitable' to a variety of audiences.[92] A minor reform initiated by the Committee, which is worth noting in passing, is that henceforth the museum did not include acquisition prices on object labels – a practice, it will be recalled, that Henry Cole had instituted and that had been observed ever since his time.[93]

The new arrangement was, anyway, an organizational triumph, for which Smith (assisted by Clarke's son, Stanley, as co-ordinator)[94] can receive credit. Under the iron hand of Morant, no other course could have been followed. At first

it seemed as if the iron hand would never relax its grip. Arthur Richmond was installed as Assistant Director, presumably to keep an eye on Smith on Morant's behalf. Richmond, who had already discovered that 'it is not easy to be private secretary to a human dynamo',[95] was feeling the strain of working for Morant. He was soon to have a protracted nervous breakdown, from which he eventually emerged into other areas of public life, where he achieved some success and earned a knighthood. Fortunately for the museum, Morant's reign came to an abrupt end. His fearsome determination had offended many in the educational world, and when in 1911 he was caught up in endorsing some rude words by one of his officials against the local-authority school inspectorate, 'all the pent-up indignation against the Education Act of 1902 was let loose',[96] and focused on him. However, Lloyd George, the Chancellor of the Exchequer, was in need of a human dynamo to set up his new National Insurance system, and Morant was moved to become Chairman of the National Insurance

Commission. At the Education Department he was replaced by Selby-Bigge, a man committed to consultation and consensus.[97] Things calmed down at the museum. Arthur Richmond left. The administrative staff of the museum continued, however, to be seconded from the Board of Education, to which they looked for promotion, so their loyalty to the V&A usually came second to their loyalty to their ministry. This system lasted until the V&A was placed under a Board of Trustees in 1983.

Smith remained faithful to the mission entrusted to him by Morant. He was himself trained as a classical archaeologist, and his chief interest in the V&A was in the watercolour collection,[98] but he fully accepted his new role as spokesman for industrial art.[99] In speeches throughout his career he reiterated his position: against antiquarian museums, in favour of the V&A as a means of industrial education (figure 10.11), concerned about the V&A's coverage of contemporary art. At a conference on 'The Future of Craft Museums' in 1916 he declared:

We have, I am glad to say, left long behind us the stupid popular fallacy that a museum is a stagnant collection of curiosities, and have come to recognize more than ever recently that such an institution is, or should be, a living and a powerful educational force ... It cannot be too often realized that the Victoria and Albert Museum was at the outset intended to serve as a museum of manufactures, to illustrate the application of art to some purpose of utility, and to afford instruction and assistance to manufacturers, designers, students, and the public.[100]

He made the point even more forcibly in a newspaper interview in 1919, when he said that 'a good museum should be one of the most potent influences that can be exerted in the development of trade', going on to deplore the stultifying effects of antiquarianism:

A museum is not a sort of antique repository merely providing cheap models for copying, and by its vicious insistence on the past tending to destroy all imagination in the artist of the present, who falls victim to its soporific lure.[101]

Smith had his own original slant on how the museum was to go about its business of reforming taste:

If we are ever to cut the vicious circle which is composed of manufacturers who will not make because the public will not buy, and the public who will not buy because manufacturers will not make, the solution is, I am convinced, in the proper education of the salesman.

He was glad to say that on Saturday afternoons the museum attracted a large lecture audience 'composed almost entirely of buyers and salesmen from the shops in London'.[102]

Smith's conviction that the museum should involve itself with contemporary industrial art met with a difficulty. When he first went to the Victoria and Albert Museum, he later recalled, 'it was a general rule to acquire nothing that was less than fifty years old',[103] with the result that 'it might almost be supposed, by anyone who knew only the contents of the museum, that art had stopped short somewhere about 1860'.[104]

This break of continuity in a Museum which has for its principal object to illustrate and stimulate the craft of design and workmanship by means of the finest examples obtainable

BALUSTERS of VARIOUS DESIGNS. ENGLISH. LATE 17TH OR EARLY 18TH CENTURY. AT STH: KENS: MUSEUM.

Figure 10.11
Proof that the V&A was still used for its original purpose. This drawing, made in about 1910, is one of many in a sketchbook belonging to George Hutchings, who was training with a furniture-making firm and often visited the V&A to study and draw.

is, to say the least, unfortunate. Instead of supplying a stimulus and standard, its tendency is too often to encourage a slavish copy of the antique ...

Smith could perhaps have tried to redirect the interests of his staff towards the acquisition of contemporary objects, but he chose rather to set up a special unit to do this task. He was worried that museums might place themselves in an invidious position if they went shopping for contemporary material, and highlighted two problems: 'firstly (though this is less crucial), they lay themselves open to the charge of using public funds to encourage selected tradesmen...; and secondly, experience shows how difficult it is, as a question of taste, to set the things of one's immediate environment in their true perspective'.[105]

He may have had in mind the controversy aroused a few years earlier, when George Donaldson, one of the jurors at the Paris Exhibition of 1900, was so impressed by the furniture there displayed in the 'Art Nouveau' style that he purchased a whole collection of examples, and donated them to the museum – a most valuable and far-sighted gesture. When, however, the collection was put on display in the summer of 1901, a furore broke out. Lewis Day was in the forefront, denouncing these 'ill-mannered specimens of upstart art ... the delirious art of men raging to do something new', and other members of the artistic establishment supported his protest that such work should not be 'endorsed by the educational authorities'.[106] The Architectural Review, incredulous that the authorities could 'admit pretentious trash like this to the hospitality of a national museum', wrote about Art Nouveau as if it were the plague. 'Even were South Kensington a pathological museum for design-disease', this gift would not be acceptable.[107] Donaldson's collection was hastily banished to Bethnal Green, where it was exhibited with a notice warning British art students not to copy it. A few years later E.F. Strange, Keeper of Woodwork at the V&A, felt able to dismiss Art Nouveau as a European aberration, and to pronounce with relief that 'in this country, happily, although there was a moment of danger, its baneful influences have not availed against the national conservatism'. (He was constrained to admit also that 'in the case of furniture, our artists, in spite of well-nigh heroic attempts, have failed to create a new style', while refraining 'to their credit' from adopting the Art Nouveau style.)[108] During this brouhaha the Architectural Review, following Lewis Day, suggested that 'it would be a wholesome rule' for the museum 'to be extremely stingy in admitting anything contemporary. Works of art ought to be filtered through the appreciation of a generation at least before they are taken into our museums'.[109]

Cecil Smith agreed with this, but felt that the museum must do its duty by contemporary art. His way of getting

round the difficulty was to recommend an independent mediator, in the form of a specialist body, a 'central Museum and Institute of modern industrial art'. He proposed this in a confidential pamphlet in 1914,[110] but the war delayed further action until 1920, when the British Institute for Industrial Art, under the joint auspices of the Board of Trade and the Board of Education, came into being.[111] Smith saw the BIIA as:

a Purgatory, as it were, for the crystallizing of taste. The Institute acquires selections of the output of each year, which stay in its permanent collection for a period, at the end of which time it is intended that they shall again pass under review, and the cream will then pass into the National Collections. By this means it is hoped that the museum will maintain a real touch with the craftsmen and manufacturers of the day ...[112]

In its heyday the Institute organized exhibitions, both at the V&A (1923, 1929) and elsewhere.[113] Within two years of its foundation, however, its funds were cut,[114] and in the end it was reduced to one lady, Miss A.P. Carter, in an office near the North Court. Dissolved in 1934, it passed its remaining collections to the V&A.[115] Although it had the grave limitation that it dealt only with British modern art, and the lesser disadvantage that it was to some extent duplicating the activity of the Design and Industries Association, it was a praiseworthy attempt to keep the V&A up to date. In the long run, though, its effect on the museum was probably detrimental, for while it existed it absolved the V&A curators from concerning themselves with contemporary art, and when it ceased to exist, the V&A staff continued to enjoy the licensed abstention from the twentieth century that they had grown used to.

Even those who believed in encouraging good modern design must sometimes have sensed that there was a gap between their faith and their works. Smith, opening a BIIA exhibition in Cambridge in 1921, forthrightly asserted that he

wanted people to realize that the industrial art of England was not necessarily a luxury for the few, or for the upper classes, something which was necessarily expensive, but merely that it meant industrial quality, and quality could come with cheapness, just as much as it could come with expensiveness.[116]

Martin Hardie of the Department of Engraving, Illustration and Design, at a prize-giving at Wolverhampton School of Art in 1922, declared that 'there may be far more art in a well-designed chair, or some simple object of pottery or metal, than in the painting that hangs on the line in the Royal Academy', and commended to his hearers the artistic worth of a toothbrush: '... that tooth-brush ... – think of its finely-shaped, thought-out, well-adapted handle – is another illustration of how nothing is too humble or ordinary to be without the saving grace of artistic

treatment'.[117] The V&A actually owns two toothbrushes, acquired in 1939 and 1962; it has many thousands of objects that can be described as 'luxuries for the few'.

If the staff were not active in acquiring toothbrushes, it must be conceded that there was much else to keep them busy in the revitalized museum. Purdon Clarke's division of his curators into material-based departments was confirmed by the Committee of Re-arrangement, which added to the departments one of Engraving, Illustration and Design ('EID' for short) to curate graphic art, which until then had been one of the Library's responsibilities. Smith nurtured his departmental scholars, obtaining for them the same pay and conditions as were enjoyed by their colleagues at the British Museum.[118] He insisted to the Board of Education ('I feel very strongly on this point') that:

the Officers of the Museum should be, and in most cases already are, the best experts on their own subjects: where they are not so, that is a defect of staff, which it lies with the Board to remedy: but it is in my view essential that the Board should take this view, and uphold it against all criticism; otherwise there will certainly be a tendency to slide back into the old vicious state of things ...[119]

In other words, Cole's system of working with administrators, who called in outside experts only when they were needed, was now scrapped. Smith's view of his staff was that 'the function of curators is primarily that of research, and then, beside the collecting, the digestion of the material and its preparation, so to speak, for public consumption and for teaching'.[120]

In order to foster expertise, the Committee of Re-arrangement insisted on locating curators' offices near to their galleries. This was not easy to achieve in Aston Webb's building, which had instantly become 'notorious' among museum people for having been 'designed without storerooms, work-shops, or offices'.[121] (To be fair to Webb, his brief was virtually silent about these facilities.) The departmental offices were squashed into light-wells and other crannies, late in the day, and their separation, in little clusters all over the building, may have done something to foster the independent, even uncooperative spirit that grew up in the Departments. It is interesting to speculate whether this might have been allayed if a suggestion made in 1937 by an Office of Works architect, to centralize the curators' offices in the attics round the quadrangle, had been carried out.[122] Since 1997 curators' offices have been grouped together in a new Centre for Research and Conservation in the north-west corner of the museum, but it is too soon to say whether this new environment has altered behaviour. Incidentally, in the early years of the twentieth century curators who ventured out of their offices into the galleries were expected to wear hats. This was apparently because other visitors in the galleries would be wearing hats, and

if curators were bareheaded they would be easily recognisable and possibly open to attack.[123]

Smith encouraged his curators to make study tours,[124] and set them to work on a series of catalogues of the entire museum collections, which was intended to develop over many years as appropriate expertise became available.[125] Many volumes did appear, in quarto format with blue paper covers or blue cloth bindings, during Smith's directorship and that of his successor. They included tapestries (1914), Coptic textiles (1920–2) and medieval woven fabrics (1925) by A.F. Kendrick; English silversmiths' work (1920) by H.P. Mitchell and W.W. Watts, chalices (1922) and pastoral staves (1924) by Watts, and rings (1930) by Charles Oman; Korean pottery (1918) and maiolica (1933) by Bernard Rackham; Japanese lacquer (1924) and Chinese lacquer (1925) by E.F. Strange; English furniture, chronologically in four volumes (1927–31) by Oliver Brackett, H. Clifford Smith and Ralph Edwards; ivory carvings (1927–9) by Margaret Longhurst; and Italian sculpture (1932) by Longhurst and Eric Maclagan. The same format was adopted for an annual *Review of the Principal Acquisitions*, which ran from 1911 to 1938. It replaced the previously printed annual inventory lists by expository essays accompanied by illustrations.

In 1913 an Advisory Council was set up, to advise the Board of Education 'on questions of principle and policy, and on the conditions and needs of the museum'.[126] Smith brought sub-committees of the Council face-to-face with curators in his office for a long series of meetings in which the entire collections of the museum were assessed, and reports prepared on 'deficiencies'. These were eventually collated as a *Report on the Principal Deficiencies in the collections of the Victoria and Albert Museum ... adopted by the Advisory Council ... on 13th February 1914.* The use of the word 'deficiencies' seems to put an unduly deprecatory gloss on what we now recognize as a formal acquisitions policy, the first since Henry Cole's statement of 1863 (see page 101). This report also argued the case for increasing the purchase grant.[127] The inadequacy of the documentation systems for the collections had been pounced upon by Morant. When he 'discovered that there [were] no finding lists nor card indices', he 'issued an ultimatum that these should be provided at once and all the departments worked seven days a week until they were completed'. These were to form the basis of a quinquennial stocktaking of the museum's holdings, which was long kept up in spirit, though in practice a 'dipping inventory' usually had to suffice.[128]

The curators appointed in Smith's time had much more impressive educational qualifications than those of most of the nineteenth-century appointments. Of course, academic qualifications are not everything. It was impossible then

(and is almost impossible now) to take degrees in the subjects with which the V&A is concerned; much has to be learned on the job. Smith himself attended no university, and learned on the job at the British Museum. Curators such as A.F. Kendrick, G.H. Palmer, W.W. Watts and H.P. Mitchell left school for the world of work, and came into the museum after some years in more mundane pursuits. But a new policy of graduate entry was adopted around 1898. One of the first to take advantage of it was Rackham, who came with a First in Classics from Pembroke College, Cambridge.[129] In the same year came Martin Hardie, from Trinity College, Cambridge; in 1900 A.J. Koop (later Keeper of Metalwork) from Pembroke, Cambridge, and H. Clifford Smith (later Keeper of Woodwork) from University College, Oxford; in 1905 Eric Maclagan from Christ Church, Oxford. Near the end of Smith's directorship came another shoal of bright young men, to be mentioned again later: in 1922 James Laver from New College, Oxford, Kenneth Codrington from Corpus Christi, Cambridge, and Leigh Ashton from Balliol, Oxford; in 1924 Charles Oman from New College, Oxford. Not that an Oxbridge education was *de rigueur*: Oliver Brackett (1897) came from Birmingham School of Art, Basil Long (1906) from Aberystwyth and Heidelberg universities, and Herbert Read (1922) from Leeds. Nonetheless, the predominance of Oxbridge men must have changed the atmosphere of the museum considerably.

Smith had to concern himself with much else besides the intellectual life of the museum. Owing to both the new building and the new bureaucracy of the Board of Education, almost everything in the museum's administration had to be reformed. There is no doubt that Smith was an excellent administrator, combining 'fine scholarship with business ability'.[130] The files are full of his patient, courteous but forceful minutes, often written in his own hand, which was strong and clear, with an easy, graceful swing.

Among the issues that had to be faced was the museum's security system. This had been in the hands of the police (with some help from the sappers in the early days), but the Treasury found them expensive, and in 1911 a small cadre of warders was brought in to share the work with them. In wartime, savings were even more necessary, so Smith, who preferred police to warders, conceded that 'it is open to question whether the superior advantages offered by the constable are such as to warrant the enormously enhanced cost', and from 1916 the present warding system operated.[131] This involved having a senior administrative officer resident in the museum (a provision maintained until the 1970s), and Smith had terrible trouble with the Office of Works in getting appropriate accommodation. For months the unfortunate Museum Superintendent, Hart,

had to sleep on a camp-bed in his office.[132] Smith gave to such matters as much scrupulous care as he devoted to academic questions.

There is reason to think (from the tone of occasional minutes)[133] that the enjoyment of the visitor was not Smith's highest priority, but he conscientiously put in place several public service facilities. Lord Sudeley ran a vigorous campaign to institute guide lecturers in museums, under the slogan 'The Public Utility of Museums',[134] and on 1 October 1913 the V&A, in response, took on Mr Leslie Faraker as Official Guide. 'Mr Faraker has a pleasing baritone voice,' the *Daily Express* recorded the following day, 'and a complimentary way of saying "As you will remember" when expounding some interesting historical fact connected with the exhibits.' When Faraker was called up in the First World War, volunteers took on his task and continued to work in the museum after the war.

The museum's visitors were said to be 'of all kinds'. Schools came in parties, and 'if the pupils are very young, they are properly guided. Soldiers in training frequently compose special parties, and, of course, students, both in London and from the provinces. In summer Americans are numerous.'[135] Individual children were encouraged through the activities begun in wartime by an especially vigorous volunteer, Miss Ethel Spiller, who developed an enterprising holiday programme, which eventually earned her the OBE.[136]

When the Christmas holidays begin there is a good deal of bustle in the Entrance Hall of the Museum some minutes before 11 o'clock in the morning. Boys and girls troop in with a business-like air; they greet one another as old friends and reminders pass round that clean hands and faces are desirable ... Whir-r-r-r, round goes the revolving door three or four times and finally a gang of a dozen grubby urchins emerges helter-skelter, dragging in a few babies and little girls with them.

A 'pinafored friend', Miss Spiller we presume, leads the older children away to draw objects in the galleries, while the babies look at picture books 'on the floor in out-of-the-way nooks with a junior helper to turn over the leaves and tell the stories'. On other days there is textile craft (decorative stitchery, carpet knotting and weaving), making linocuts and stencils,[137] and pottery.[138] Miss Spiller was widely praised for making the V&A accessible to children, to whom the museum was not naturally attractive: 'nowhere else,' said *The Times*, 'do children so soon begin to get tired at the knees and to think of meal-times'. But they responded to Miss Spiller and her assistants, because, as one of these said, 'we try and make them feel it is a holiday, and that we are not teachers, but "aunties"'.[139] The curator of the Bethnal Green Museum, A.K. Sabin, followed Miss Spiller's example and set that museum on the path towards its present function.[140]

Figure 10.12 A caricature by Max Beerbohm, 'Preparing for the International Theatre Exhibition'. The venerable stage designer Edward Gordon Craig (right) stands in contemplative posture, while his 16-year-old son, Teddy, directs Martin Hardie, who, with a hammer in his pocket, seems to be undertaking the manual labour of hanging the pictures.

Other visitor services promoted by Cecil Smith included evening lectures by curators, which received extraordinarily good press coverage.[141] He inaugurated the sale at the museum of its own postcards in 1914.[142] Special exhibitions were not a major feature of Smith's regime; it had begun, after all, with the re-installation of 145 permanent galleries, so some relief was perhaps due to the staff. Two exhibitions are worth noting, however: in 1921 the *Franco-British Exhibition of Textiles*, 'which brought the largest number of visitors ever recorded in one day' to the museum, according to Smith's successor, writing in 1944;[143] and in the following year the *International Theatre Exhibition* (figure 10.12), from which the museum bought 'a large number of designs and models', so as to form 'the nucleus of a comprehensive collection of the Art of the Theatre'.[144] Last but not least of Smith's achievements to be listed here was the abolition, from 1 July 1914 (after an unsuccessful bout with the Treasury in 1909),[115] of admission charges to the V&A.[146]

Smith undertook diplomatic responsibilities outside the museum. He rallied round the Museums Association, in order to foster 'a much closer measure of co-operation between the curators of local museums and the National Institution' that he led: the V&A.[147] The officer in charge of the Circulation Department, J. Bailey, regularly attended the Association's meetings, and was President of the Association in 1925–6. The Circulation Department was reorganized as part of the Re-arrangement proceedings. In the past, borrowers from provincial museums had been allowed to select loans from among the objects exhibited in the museum's permanent galleries, but this was now thought too disruptive, 'with the result that the Circulation Department may now be considered as equipped with what is at least a working collection, although it may be necessary for some years to come to make further additions in order to meet the growing needs of this department'.[148] It seems that the Circulation collection was not equal to the demands made upon it, and an *ad hoc* committee (which included Bailey) made an unsuccessful plea to the Board of Education for more in 1922.[149] Nonetheless, the Museums Association recognized that Smith had done his best: 'he was unable to realize his ideals in this connection' for 'the special annual vote which his committee advocated ... never materialized.'[150] When the Association was pondering the desirability of a diploma for museum curators in 1920, Smith outlined a scheme by which candidates could be trained at the V&A, 'beginning with a few months in the administrative office and proceeding to various departments for expert and specialized training'.[151]

In the wider world, he was active in the work of the International Museums Office, predecessor of ICOM, often chairing meetings in Paris, 'where his linguistic gifts and personal charm were of great advantage'.[152] He lectured for it on labelling in 1929, and attended its conferences as the delegate of the Museums Association: an International Conference for the Study of Scientific Methods for the Examination and Preservation of Works of Art in Rome in 1930, and an International Conference on the Protection and Preservation of Monuments of Art and History in Athens in 1931.[153]

Smith's directorship was disrupted by the First World War. Many staff departed into the armed services, but the museum carried on as best it could, making its own contributions to the war effort. In summer 1915 it hosted an exhibition of the work of the Serbian sculptor, Ivan Meštrović, which was presented as an expression of 'the unconquerable spirit which inspires our Serbian allies'. Opening the exhibition, the Under-Secretary for Foreign Affairs, Lord Robert Cecil, expressed the hope that German aggression could be countered by 'British liberty and French enlightenment, but perhaps the final answer is destined to be given by the idealism of South-Eastern Europe'. Predictably there were some in the artistic establishment who criticized Meštrović's work as 'unwhole-

some', 'barbarous and repugnant', but most people found it 'colossal', 'titanic', 'irresistible', 'overwhelming', and the *Manchester Guardian* commented that 'it has been brought home to many people here for the first time that art can be an expression of real national emotion and aspiration, and not only an expensive bric-à-brac for rich people's houses'.[154] When the Government closed down most of the museums as an economy measure early in 1916, the V&A (along with the National Gallery) was allowed to stay open, and hosted British Industries Fairs in the spring of 1916 and 1917, and an exhibition of *Allied War Photographs* in summer 1917. Even when half of the museum was requisitioned in June 1917 as offices for the Board of Education (driven out of Whitehall to make room for an expanded Admiralty), the rest remained open. The museum produced a *Guide Sommaire* in French for Belgian refugees.[155] But when hostilities ceased it took some time to get back to normal: the V&A 'was one of the last [museums] to be set free after the war'[156] – free from the Government departments that had been billeted on it. So Smith, having introduced the greatest shake-up in the museum's history, had to do much of his work again in the 1920s.

After the war, in the mid-'20s, the museum had very high attendance figures, usually over one million per calendar year. When the Treasury published comparative figures for all the public museums and visitor attractions for the year ending 31 March 1922, the V&A came top, with 1,108,204, Kew Gardens being the runner-up.[157] Whether the museum really wanted to be popular is perhaps open to doubt. The exhibition of *Franco-British Textiles* in 1921 was exceptionally popular, attracting a total of 340,691 visitors. 'This is a most gratifying record, but far more important is the fact that 450 students and designers took the fullest advantage' of the exhibition. These were the words of the *Morning Post*.[158] They probably represented the opinion of the museum. At any rate, they were an inescapable conclusion for anyone who thought that the V&A existed primarily to serve designers and manufacturers, rather than the general public. But if the V&A was concerned to serve only 450 people out of 340,691, this meant that it was cold-shouldering almost 99.9 per cent of its visitors. Such an attitude would be absurd. The more the general public came, the less credible was the view that the V&A should be a technical museum serving industry. And the less desirable its layout seemed. Cecil Smith did not waver in his support for what Morant and the Committee of Re-arrangement had imposed. But some voices continued to express doubts. In 1920 the museum arranged a small exhibition of Spanish decorative arts, with objects of different materials mingled together. This inspired the influential artist and critic Roger Fry to comment:

As is well known, the Victoria and Albert Museum was founded with a view to encouraging technical study, and therefore the administration and arrangement follow the technical divisions as opposed to the historical grouping of most museums. No doubt this method has advantages for the student of a particular craft who wishes to see a great many examples of technique from different periods and countries. But for the student of art in general it is somewhat disconcerting not to be able to follow a particular style of design through its embodiments in different materials.

Of the Spanish exhibition, he said: 'it is, therefore, a very desirable innovation that has just been made'.[159] But one swallow did not make a summer.

Cecil Smith retired in October 1924 (figure 10.13). He seems to have been an unusually effective Director. When he was appointed, in rather troubled times, the *Illustrated London News* commented that the V&A staff hailed his arrival 'with enthusiasm ... Tired of confusion, the various departments have that feeling of relief which schoolboys know when, their class having been left for a period to go its own ways, a master of determination takes them in hand.'[160] The determined master proceeded to pull the museum together. Looking back, as he retired, he recalled

SIR CECIL HARCOURT – SMITH · C·V·O· LL·D·
DIRECTOR & SECRETARY · VICTORIA & ALBERT MUSEUM · 1909–1924.

Figure 10.13 Cecil Smith, the curator: an etched portrait by Malcolm Osborne, whose original drawing was presented by the V&A staff to Smith on his retirement.

Figure 10.14 Cecil Smith, the courtier (extreme right), with King George VI, Queen Mary and others at the opening of the Franco-British Exhibition of Textiles at the V&A in 1921.

that when his work at South Kensington began, 'the Museum was out of touch with modern industrial art', and congratulated himself that 'steps were taken to bring the Museum up to date. Modern work has been introduced and now annual exhibitions of industrial art are held'.[161] He therefore stuck to Morant's line to the end. But a few months after his retirement, at a dinner in his honour, he disclosed that he had not been entirely contented with his lot. 'I regret chiefly,' he said, 'that I have failed in spite of repeated attempts to secure the detachment of the Victoria and Albert Museum from the Board of Education and the

establishing of it, like the British Museum, under its own body of Trustees. I am convinced that, sooner or later, this must be effected.'[162]

Smith had a fine record as Director of the V&A, which has been allowed to speak for itself here. He also had the great advantage that he looked the part (figure 10.14): commanding and sprucely handsome. 'He had a noble appearance; he was tall and straight-backed and elegant: in his youth he had been known as "The Light Dragoon",' recalled James Laver,[163] and 'in his age, with his white hair and moustache, his immaculate clothes and his ambassadorial manners, he was an impressive figure on all occasions'.[164]

NOTES

1 Physick, p. 214.

2 *Builder*, 6 February 1869, p. 109; 10 April 1869, p. 289.

3 *Graphic*, 3 April 1897, p. 410.

4 William Gaunt, *Kensington*, London: Batsford, 1958, p. 101.

5 Marius Vachon, *Pour la Défense de nos Industries d'Art*, Paris: Lahure, 1899, pp. 277–8.

6 F.W. Moody, *Lectures on Decorative Art*, London: Bell, 1908, p. 57.

7 Ruskin, *Works*, ed. E.T. Cook and Alexander Wedderburn, London: George Allen, vol. 29, 1907, p. 560.

8 Ibid., vol. 34, 1908, p. 249. Reprinted in *On the Old Road*, Orpington: George Allen, 1885.

9 Ibid., vol. 33, 1908, p. 307. In *The Art of England*, 1884.

10 *Journal of the Royal Society of Arts*, 30 July 1909, p. 754.

11 A.B. Meyer, *Studies of the Museums and Kindred Institutions of New York City, Albany, Buffalo, and Chicago, with Notes on some European Institutions*, for the Smithsonian Institution, Washington: Government Printing Office, 1905, pp. 529–30.

12 Quoted in *Second Report from the Select Committee on Museums of the Science and Art Department, Ordered, by the House of Commons, to be Printed, 21 May 1897*, Appendix 8.

13 'Our Overgrown National Collection', *Building News*, 1 April 1859, p. 306.

14 Ruskin, *Works*, vol. 28, 1907, p. 450. See Edward Bradbury, 'A Visit to Ruskin's Museum', *Magazine of Art*, vol. 3, 1879–80, pp. 57–60.

15 Two examples of its use: by Lionel Cust in *Transactions of the National Association for the Advancement of Art and its Application to Industry, Liverpool Meeting, 1888*, London: for the Association, 1888, p. 286; in Thomas Greenwood, *Museums and Art Galleries*, London: Simpkin, Marshall, 1888, pp. 5–6.

16 Greenwood, op. cit., pp. 7–8.

17 G.A.T. Middleton, 'Architecture at South Kensington Museum', *Architectural Record*, vol. 7, 1898–9, p. 389.

18 W.C.F. Anderson, 'An Art Student on Museums', *Museums Association. Report of Proceedings ... at the Tenth Annual General Meeting*, London: Dulau, 1900, p. 109.

19 E.V. Lucas, *A Wanderer in London*, London: Methuen, 1906, p. 255.

20 *The Tribune*, 12 September 1906.

21 J. Mordaunt Crook, *The Dilemma of Style*, Chicago: University Press, 1987, pp. 214–15.

22 John Summerson, *The Turn of the Century: Architecture in Britain around 1900*, Glasgow: University Press, 1976, p. 17.

23 *Board of Education Report for the Year 1907–1908*, London: HMSO, 1909, p. 8.

24 Bernard M. Allen, *Sir Robert Morant: A Great Public Servant*, London: Macmillan, 1934.

25 Physick, pp. 234–5.

26 Arthur Richmond, *Another Sixty Years*, London: Geoffrey Bles, 1965, p. 56.

27 Correspondence in Archive: Ed. 84/33.

28 D.M. Ross, 'Lewis Foreman Day, Designer and Writer on Stained Glass', *Journal of the British Society of Master Glass-Painters*, vol. 3, 1929–30, pp. 5–8.

29 *Report of the Committee of Re-arrangement*, 1908, p. 36.

30 *Minutes of the Committee of Re-arrangement* (typescript), pp. 68–9. NAL, press mark VA.1908.0001.

31 He was known in his early life as Cecil Smith. 'Harcourt' gradually crept in, and it seems that when, after retiring from the V&A, he became Surveyor of the Royal Works of Art in 1928, he took a hyphen and became 'Harcourt-Smith'.

32 R. Morant to Sir Edward Maunde Thompson, 4 February 1908, in Archive: Ed. 84/33.

33 W.A.S. Benson to A. Richmond, 3 February 1908, in Archive: Ed. 84/33.

34 Arturo Carlo Quintavalle, 'The Philosophical Context of *Stilfragen*' in Demetri Porphyrios (ed.), *On the Methodology of Architectural History*, London: Architectural Design, 1981, p. 19.

35 Justus Brinckmann, *Das Hamburgische Museum für Kunst und Gewerbe. Ein Führer durch die Sammlungen zugleich ein Handbuch der Geschichte des Kunstgewerbes*, Hamburg: The Museum, 1894, pp. v, vi, vii.

36 Barbara Mundt, '125 Jahre Kunstgewerbemuseum. Konzepte, Bauten und Menschen für eine Sammlung (1867–1939)', *Jahrbuch der Berliner Museen*, new series, vol. 34, 1992, p. 177.

37 *Hamburgisches Museum für Kunst und Gewerbe. Rundgang ...* (Flugblatt 17), 1916, p. 3. Max Sauerlandt, *Das Museum für Kunst und Gewerbe in Hamburg 1877–1927*, Hamburg: Martin Riegel [1927], p. 8.

38 Karl Lacher, *Altsteirische Wohnräume im Landesmuseum zu Gratz*, Leipzig: Hiersemann, 1906.

39 *Festschrift aus Anlass des 25jährigen Eröffnungstages des Museumsgebäudes am 19. August 1928*, Flensburg: Kunstgewerbemuseum, 1928, pp. vi, vii. For views of them, see *Bilder aus dem Flensburger Kunstgewerbe-Museum*, Flensburg: The Museum, 1907.

40 Gustav Brandt, *Führer durch die Sammlungen des Thaulow-Museums in Kiel, des Kunstgewerbe-Museums der Provinz Schlesw.-Holstein*, Kiel: The Museum, 1911, p. ii.

41 *Führer durch das K.K. Österr. Museum für Kunst und Industrie*, Vienna: The Museum, 1901, pp. 205–8.

42 Charles Normand, *Musées Européens, Les Arts Décoratifs ... Chambres et Décorations intérieures en Styles Anciens (au Musée de Salzbourg)*, Troisième Album de l'*Ami des Monuments et des Arts*, Paris (1893).

43 *Der Neubau des Bayerischen Nationalmuseums in München*, Munich: Bruckmann, 1902.

44 Justus Brinckmann, 'Das Bayerische National-Museum und die Museumstechnik', *Museumskunde*, vol. 2, 1906, pp. 121–8.

45 Jörn Bahns, 'Kunst- und kulturgeschichtliche Museen als Bauaufgabe des späten 19. Jahrhunderts' in Bernward Deneke and Rainer Kahsnitz (eds), *Das kunst- und kulturgeschichtliche Museum im 19. Jahrhundert. Vorträge des Symposions im Germanischen Nationalmuseum, Nürnberg* (Fritz Thyssen Stiftung: Studien zur Kunst des neunzehnten Jahrhunderts, Band 39), Munich: Prestel, 1977, pp. 176–92.

46 Brinckmann, *Das Hamburgische Museum ...*, p. vii.

47 Niels von Holst, *Creators, Collectors and Connoisseurs*, London: Thames and Hudson, 1967, p. 260, quoting from Bode's *Mein Leben*, 1930; cf. Wilhelm Bode, 'Das Kaiser Friedrich-Museum in Berlin zur Eröffnung am 18. Oktober 1904', *Museumskunde*, vol. 1, 1905, pp. 12–13. And see Malcolm Baker, 'Bode and Museum Display: The Arrangement of the Kaiser-Friedrich-Museum and the South Kensington Response', *Jahrbuch der Berliner Museen*, new series, vol. 38, 1996, pp. 143–53.

48 See Gilman, 'Aims and Principles', cited below, pp. 33–4.

49 David K. Van Keuren, 'Museums and Ideology: Augustus Pitt-Rivers, Anthropological Museums, and Social Change in Later Victorian Britain', *Victorian Studies*, vol. 28, 1984–5, p. 173.

50 *Builder*, 21 September 1889, p. 204. And see Mark Girouard, *Alfred Waterhouse and the Natural History Museum*, London: The Museum, 1981, pp. 49–50.

51 Benjamin Ives Gilman, 'Aims and Principles of the Construction and Management of Museums of Fine Art', *Museums Journal*, vol. 9, 1909–10, pp. 28–44.

52 See reports in V&A Archive: Ed. 84/205.

53 See V&A Archive: Ed. 84/206.

54 Ibid.

55 *Museums Journal*, vol. 5, 1905–6, p. 245.

56 Physick, pp. 208–9.

57 *Magazine of Art*, new series, vol. 1, 1902–3, p. 448. Plunkett also wrote to *The Times* to promote his ideas on 13 August 1908: V&A Cuttings Book, November 1906–October 1908, p. 2.

58 Frank J. Mather, 'Art in America', *Burlington Magazine*, vol. 9, 1906, pp. 62–3.

59 'Museums', ibid., vol. 13, 1908, p. 322.

60 Francis Arthur Bather, 'Museums Association. The Aberdeen Conference, 1903. Address by the President', *Museums Journal*, vol. 3, 1903–4, pp. 71–94, 110–32 and plates.

61 'The New Building for the Museum of Fine Arts in Boston', *Museums Journal*, vol. 7, 1908–9, pp. 163–70; Arthur Fairbanks, 'The Museum of Fine Arts in Boston in its New Quarters', ibid, vol. 9, 1909–10, pp. 365–70.

62 Archive: Ed. 84/33.

63 Lewis Foreman Day, 'How to Make the Most of a Museum', *Journal of the Society of Arts*, vol. 56, 1908, pp. 146–60.

64 'Foreign Museums' in *Minutes ...*, pp. 313ff.

65 *Report of the Committee of Re-arrangement*, 1908, p. 4.

66 Ibid., pp. 4–5.

67 'Reorganisation at South Kensington – I, II', *Burlington Magazine*, vol. 14, 1908–9, pp. 129–33, 198–200.

68 'Art Notes. Victoria and Albert Museum', *Daily Telegraph*, 7 November 1908: V&A Cuttings Book, November 1908–March 1910, p. 1.

69 *Morning Post*, 14 November 1908: V&A Cuttings Book, November 1908–March 1910, p. 1.

70 *The Times*, 11 February 1909: V&A Cuttings Book, November 1908–March 1910, p. 7.

71 Physick, p. 244.

72 This account is derived from a typescript, 'Some notes on a career in the South Kensington (Victoria and Albert) Museum, 1898–1938' by Bernard Rackham (p. 7). Rackham presented this document to the Ceramics Department, with the requirement: 'I particularly wish that what I have written should not be published in whole or part in the Press and that it should not be allowed to go outside Ceramics'. Although technically (by avoiding direct quotation) I have not breached this request, I suppose I have breached it in spirit and I must hope that Rackham will grant me his posthumous indulgence.

73 *Museums Journal*, vol. 10, 1910–11, p. 275.

74 Physick, p. 244.

75 Obituary in *The Times*, 14 December 1909: V&A Cuttings Book, November 1908–March 1910, p. 114.

76 Obituary of Skinner, *Athenaeum*, 11 March 1911, p. 286.

77 'The Salting Bequest. The Display at South Kensington', *The Times*, 23 March 1911: V&A Cuttings Book, April 1910–March 1911, p. 16.

78 *Evening News*, 9 March 1911: V&A Cuttings Book: April 1910–March 1911, p. 120.

79 *Museums Journal*, vol. 8, 1908–9, p. 435.

80 *Daily Telegraph*, 26 June 1909: V&A Cuttings Book, November 1908–March 1910, pp. 11–12.

81 Obituary of Purdon Clarke, *The Times*, 30 March 1911: V&A Cuttings Book, April 1910–March 1911, pp. 121–2; reprinted in *Museums Journal*, vol. 10, 1910–11, p. 274.

82 Richard Graul, 'Zur Neuaufstellung des Victoria und Albert-Museums in London', *Kunstchronik*, new series, vol. 21, 1909–10, p. 84.

83 *Burlington Magazine*, vol. 15, 1909, p. 268.

84 Claude Phillips, 'Art Notes. More About South Kensington', *Daily Telegraph*, 31 July 1909: V&A Cuttings book, November 1908–March 1910, pp. 13–14.

85 Cf. Lewis Foreman Day, op. cit., p. 153.

86 Cf. Aston Webb as quoted in Physick, p. 224.

87 *Museums Journal*, vol. 11, 1911–12, p. 265.

88 Raymond Koechlin, 'Le nouveau Musée de South Kensington', *La Chronique des Arts*, 6 November 1909, p. 273.

89 *Museums Journal*, vol. 20, 1920–1, p. 168.

90 Koechlin, op. cit., p. 273.

91 *Daily Telegraph*, 31 July 1909.

92 Archive: Ed. 84/107.

93 *Report of the Committee of Re-arrangement*, p. 23, section 12.

94 See Stanley Clarke's progress reports in Archive: Ed. 84/155.

95 Richmond, op. cit., p. 24.

96 Allen, op. cit., p. 259.

97 W.H.G. Armytage, *Four Hundred Years of English Education*, Cambridge: University Press, 1965, p. 204.

98 E.R.D. Maclagan in *Royal Commission on National Museums and Galleries. Oral Evidence, Memoranda and Appendices to the Interim Report*, London: HMSO, 1928, para. 2786.

99 Perhaps the best example of Smith's carefully moderate approach is his Truman Wood Lecture on the Paris International Exhibition of 1924: 'The Modern Note in Industrial Art', *Journal of the Royal Society of Arts*, vol. 74, 1925–6, pp. 32–42.

100 'The Future of Craft Museums', *Museums Journal*, vol. 16, 1916–17, p. 152.

101 'Sir Cecil Smith on Art Museums and Industry', *Museums Journal*, vol. 19, 1919–20, p. 55. And compare 'True Use of Museums', ibid., vol. 21, 1921–2, p. 241; C.H. Smith, 'Industrial Art', ibid., vol. 24, 1924–5, pp. 156–60; 'Art and Commerce. Sir C.H. Smith on Co-operation', ibid., p. 272. As well as other speeches referred to in this section, see 'True Use of Museums. Sir Cecil H. Smith on their Part in Education', *Observer*, 26 March 1922: V&A Cuttings Book, February–July 1922, p. 76.

102 'The Future of Craft Museums', p. 153. Cf. his references to 'demonstrations given in his own museum to the buyers for various large business houses' in 'Art and Industry in Sweden', *Museums Journal*, vol. 20, 1920–1, p. 199; and to 'classes for distributors' in 'Industrial Art', p. 160.

103 'The Wembley Conference, 1924', *Museums Journal*, vol. 24, 1924–5, p. 59.

104 'The Future of Craft Museums', p. 152.

105 The last two quotations are from Smith's pamphlet (pp. 4, 3) mentioned below.

106 Lewis F. Day, 'The "New Art" at South Kensington', *Manchester Guardian*, [no day cited] June 1901: V&A Cuttings Book, June 1901–June 1903, p. 1.

107 'Pillory. L'Art Nouveau at South Kensington', *Architectural Review*, vol. 10, 1901, pp. 104–5.

108 E.F. Strange, 'Applied Art in 1906', in A.C.R. Carter (ed.), *The Year's Art 1907*, London: Hutchinson, 1907, pp. 10, 11.

109 'Pillory. L'Art Nouveau…', p. 105.

110 Sir Cecil H. Smith, *Confidential. Proposals for a Museum and Institute of Modern Industrial Art*, privately printed pamphlet dated 30 April 1914. NAL, press mark VA.1914, Box 0012. The source of the last three quotations, pp. 4, 3, 5.

111 Nikolaus Pevsner, *An Enquiry into Industrial Art in England*, Cambridge: University Press, 1937, pp. 154–5.

112 C.H. Smith, 'Industrial Art', p. 159.

113 'The British Institute of Industrial Art', *Studio*, vol. 83, 1922, pp. 210–15.

114 *The Arts Enquiry. The Visual Arts. A Report sponsored by the Dartington Hall Trustees*, London: Oxford University Press, 1946, p. 79.

115 *Museums Journal*, vol. 33, 1933–4, pp. 369–70.

116 'Art and Industry', *Cambridge Independent Press*, 14 October 1921: V&A Cuttings Book, March 1921–March 1922, p. 104.

117 Martin Hardie, *Our Duty to Art. An Address given on Nov. 2, 1922, at the Annual Prize-Giving of the Wolverhampton School of Art*, [Wolverhampton School of Art?], pp. 5, 8.

118 *DNB*.

119 Archive: Ed. 84/107, an annotation by Smith appended to a draft memorandum on 'The Purposes and Functions of the Museum' compiled on the setting up of the Advisory Council.

120 From a speech reprinted in *The Teachers' World*, 15 August 1923: V&A Cuttings Books, Times 4, August–October 1923, p. 107.

121 *Museumskunde*, vol. 1, 1905, p. 170 (in a review by F.A. Bather of David Murray, *Museums: Their History and Their Use*, 1904).

122 Cited in Eric Maclagan's 'Some Notes on the Future Development of the Victoria and Albert Museum Site', May 1937, p. 17, in Archive: Ed. 84/292.

123 Rackham, 'Some notes', p. 13.

124 Archive: Ed. 84/207.

125 Minute from Smith to 'Secretary', 4 February 1913, in Archive: Ed. 84/213.

126 *Museums Journal*, vol. 12, 1912–13, pp. 252–3.

127 All the reports are in Archive: Ed. 84/106.

128 C.C. Oman, 'The Department of Metalwork, 1925–1939', p. 8. This is a typescript kept in the Department of Metalwork.

129 See his obituary in *Burlington Magazine*, vol. 106, 1946, p. 424.

130 *Athenaeum*, 14 November 1908, p. 618.

131 RP 16/3789 in Archive: Ed. 84/203. Also Ed. 84/196,199.

132 RP 17/507 and 17/1992 in Archive: Ed. 84/203.

133 See Smith's notes on a report of a lecture by C. Hallett in Archive: Ed. 84/213.

134 Lord Sudeley, 'The public utility of museums', *Nineteenth Century*, December 1913, pp. 1211–19. *The Public Utility of Museums. Copy of Letters and Leading Articles in the 'Times' and other papers*, pamphlet printed by T.J.S. Guilford, Kingston-on-Thames [1912], NAL, press mark Box I. 21.D.

135 'A Popular Museum. Holidays at South Kensington', *Morning Post*, 18 May 1921: V&A Cuttings Book, January–August 1921, p. 202.

136 *Museums Journal*, vol. 15, 1915–16, pp. 147–8, 345; vol. 16, 1916–17, pp. 186–7; Ethel M. Spiller, 'The Children's Christmas Holidays at the Victoria and Albert Museum, 1917–19', ibid., vol. 17, 1917–18, pp. 177–80; ibid., vol. 26, 1926–7, p. 45.

137 Ethel M. Spiller, 'The Children's Christmas Holidays at the Victoria and Albert Museum', *Bulletin of the Metropolitan Museum of Art*, vol. 17, 1922, pp. 177–9.

138 Unidentified cutting in V&A Cuttings Book, April 1920–January 1921, p. 295.

139 'Dolls of All Nations. History in Miniature. Children's Room at South Kensington', *The Times*, 29 December 1918: V&A Cuttings Book, January 1915–April 1916, p. 185. 'The Children's Room', *The Times*, 28 December 1915, ibid., p. 184.

140 Anthony Burton and Caroline Goodfellow, 'Arthur Sabin, Mrs. Greg and the Queen', *V&A Album 4*, 1985, pp. 354–66.

141 Archive: Ed. 84/170.

142 Archive: Ed. 84/174.

143 Obituary by 'E.M.' in *Museums Journal*, vol. 44, 1944–5, p. 41.

144 James Laver, *Museum Piece, or the Education of an Iconographer*, London: André Deutsch, 1963, p.132.

145 Archive: Ed. 84/97, minute from Arthur Richmond to the Accountant General, 24 June 1909.

146 *Museums Journal*, vol. 14, 1914–15, p. 25.

147 C.H. Smith, 'Industrial Art', p. 159.

148 *Report of the Board of Education for the Year 1908–1909*, London: HMSO, 1910, pp. 98–9.

149 'Joint Committee to Enquire how far the Circulation Department of the Victoria and Albert Museum meets the Needs of the Provinces', *Museums Journal*, vol. 22, 1922–3, pp. 163–5.

150 'Sir Cecil Harcourt Smith', *Museums Journal*, vol. 24, 1924–5, pp. 89–90.

151 'The Museums Association. Winchester Conference, 1920', *Museums Journal*, vol. 20, 1920–1, pp. 55–6.

152 Obituary by E.R.D. Maclagan in *Museums Journal*, vol. 44, 1944–5, p. 40.

153 Cecil Harcourt Smith, 'Labelling', *Museums Journal*, vol. 28, 1928–9, pp. 344–6; 'International Conference on the Examination and Preservation of Works of Art', ibid., vol. 30, 1930–1, pp. 221–3; 'Conference on the Protection of Monuments', ibid., vol. 31, 1931–2, pp. 419–20.

154 *Nottingham Guardian*, 21 June 1915: V&A Cuttings Book, January 1915–April 1916, p. 2. *The Times*, 25 June: ibid. Selwyn Image in *The Times*, 30 June: ibid., p. 3. Whitworth Wallis in *The Times*, 2 July: ibid., p. 5. 'Colossal': *Glasgow Herald*, 26 June: ibid., p. 5. 'Titanic': *Public Opinion*, 9 July: ibid., p. 8. 'Irresistible': *Observer*, 27 June: ibid., p. 4. 'Overwhelming': *Daily Telegraph*, 28 June: ibid. *Manchester Guardian*, 24 August: ibid., p. 118.

155 *Museums Journal*, vol. 16, 1916–17, p. 120.

156 *Museums Journal*, vol. 20, 1920–1, p. 231.

157 'Museum Surprise', *Westminster Gazette*, 24 November 1922: V&A Cuttings Book, November 1922–February 1923, p. 33, and see p. 39 for further information.

158 'Franco-British Textiles', *Morning Post*, 21 April 1921: V&A Cuttings Book, January–August 1921, p. 165.

159 Roger Fry, 'Art. An Exhibition of Spanish Art at the Victoria and Albert Museum', *New Statesman*, 11 December 1920: V&A Cuttings Book, April 1920–January 1921, p. 274.

160 *Illustrated London News*, 21 November 1908, p. 706.

161 Interview in *Westminster Gazette*, 11 September 1924: V&A Cuttings Book, Times 9, October–December 1924, p. 57.

162 'A Great Museum Director', *The Times*, 16 January 1925: V&A Cuttings Books, Times 10, December 1924–February 1925, p. 143.

163 Laver, op. cit., p. 88.

164 James Laver in *DNB*.

CHAPTER ELEVEN
Reconsideration and Further Rearrangement

Cecil Smith was succeeded by another physically striking figure, the thin, beaky Eric Maclagan, Keeper of Architecture and Sculpture (figure 11.1). One of his peers said of him: 'He was above all a representative of civilized man. His character had acquired that peculiar polish, that perfect balance of mind, sense and memory which is the mature fruit of a long summer of civilization.'[1] Sometimes he seemed languid and aloof, with his 'limp figure' and 'polite apathy', moving 'among his colleagues like an exquisitely courteous ghost'.[2] But he was scintillating when animated. Here he is, described in 1926 in the diary of a young lady:

His conversation is like an entertaining encyclopedia; at one moment he is the fastidious gourmet, descanting on snails and cuttlefish stewed in its ink; the next he is the harassed curator battered by tasteless royalty and down at heels gentry seeking loans; soon after he is the collector penetrating the secrets of dealers' premises and opening up such vistas of romance as were never previously suspected. Wilder than any fiction are the stories of fakes and antiquities. Then there were limericks, after dinner speech stories, discussions in art, in fact every branch of brilliant conversation – delivered in his soft delicious voice, with his suave manner and quiet humour, beautiful English and stock of foreign languages; truly he is more wonderful than any book.[3]

Maclagan's father was Archbishop of Canterbury; his wife was a Lascelles, related to the Royal Family; his son became an Oxford don and Richmond Herald of Arms: Maclagan's natural habitat was the Establishment. His university degree, in *litterae humaniores* (classics and philosophy), was a fourth class, a special sort of degree at Oxford given to those who had first-class minds but had not been paying attention to their work. Perhaps Maclagan was already looking towards art history. He soon established a

high reputation in this field, serving as Charles Eliot Norton Professor at Harvard University in 1927–8 (his lectures being published as *Italian Sculpture of the Renaissance*, 1935), and lecturing also at the universities of Belfast (1932–3), Dublin (1934–5) and Hull (1925). He was President of the British Committee that organized the XVth International Congress of the History of Art in London in 1939, taking his place at the head of a group including such great founding fathers of English art history as Kenneth Clark, T.S.R. Boase, David Talbot Rice and Ellis Waterhouse. Although he did not publish a great deal, and was an assiduous committee man, it is clear that his inclinations lay towards scholarship, and it was natural that the V&A should incline that way too during his directorship.

At the start, he was obviously not averse to calling attention to his accession: almost the first thing he did was to get the main entrance floodlit. It was reported that 'with all its high windows glowing with light, and the main entrance blazing with the new illuminations, the Museum is one of the most brilliantly lighted buildings in London'.[4] But such flourishes did not continue, as the museum settled down under what was described as 'the highly fastidious direction of ... Sir Eric Maclagan'.[5]

When called upon to define the function of the V&A, Maclagan had a formula that was subtly different from that of Cecil Smith. He thought the V&A had four tasks:

... it satisfies communally a kind of collecting instinct of the nation; ... it serves as an inspiration for artists and craftsmen; ... it serves as a means of providing information for historical students; and ... – which I suppose is the highest of its functions – it possesses and displays masterpieces which can be enjoyed aesthetically by the public.[6]

The V&A's mission to reform industrial art is here played down; although still present, it is balanced by commitments to collecting, antiquarianism and aesthetic enjoyment.

Vignette: The illustrative device used on the cover of museum guides from 1935.

When asked in 1928 whether the V&A had become 'a mere museum for connoisseurs and collectors', Maclagan agreed that the description was 'fair but for the insertion of the word "mere"'.[7] It seems reasonable to conclude from these remarks that in the inter-war years what might be called Cole's vision of South Kensington was losing some of its recently refurbished shine, while Robinson's vision of a museum for collectors and connoisseurs was glowing again.

Maclagan's various official pronouncements were always marked by good sense, and his underlying attitudes have to be picked up from small signs. He was fond of a passage in H.G. Wells's *Tono-Bungay* –'one I am conscious of having quoted too often' – which attributes to museums 'a strange, independent life of their own'.[8] Maclagan used this phrase to point up the way that collections seem to grow without obvious human impulsion, but it is perhaps not straining too far to detect here also a sense that a museum like the V&A, long-established and with a fine new building, enjoyed a position of assured status and autonomy – a strange, independent life of its own. Not everyone would have had such confidence. For instance, Sir John Kenyon, Director of the British Museum, in a lecture in 1927 on

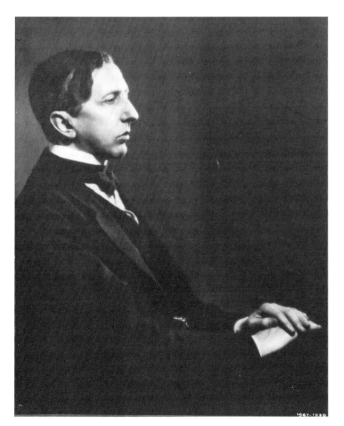

Figure 11.1 Sir Eric Maclagan, who habitually wore (as Leigh Ashton informed readers of *The Times* in an obituary note) a black tie wound twice round his stiff collar and tied in a bow.

'Museums and National Life', stressed that 'service is the note of the modern museum'; and, arguing that 'any institution which demands public support ... must show that it is rendering a corresponding service to the nation', he remarked that 'museums are continuing to grow, to demand more buildings, more staff, more expenditure of all kinds. The question may rightly be asked, are they worth it?'[9] There is no sign that Maclagan agitated himself about this question. We may assume that he believed that the V&A had a safe place in national life. And although his own testimony on the issue of public accountability is not available, we can say that his directorship gave rise to such complaints about the V&A as this, made in 1939: 'Its Art historian's preoccupation has blinded it to the fact that it exists by public support and has a public function.'[10]

Of course, Maclagan was sufficiently shrewd and well-intentioned to speak up for the museum's public function; but he did not seem to like the public very much. 'If we are to be entirely candid as to the view taken by Museum officials with regard to the public', he told an audience of curators (obviously expecting that his listeners would sympathize with his joke), we might describe the public

as a noun of three letters beginning with *A* and ending with *S*. We humour them when they suggest absurd reforms, we placate them with small material comforts, but we heave sighs of relief when they go away and leave us to our jobs.[11]

On another occasion, he said that 'the public, once they entered a public building, seemed to become incredibly stupid ... slow at times to take advantage of the opportunities which were offered to them in ... museums'. It was up to them, he thought, to seize their opportunities: 'everything had not to be done by the director of the museum'.[12]

In another speech, Maclagan reflected that the growth of a museum was like biological growth:

There is a time, to return to my biological analogy, in which growth is the primary function of the organism whether child or sapling; rapid, reckless growth calling for all the energy available. But that period comes to its natural end. The rate of growth slows down and the main business of life begins. Analogies are proverbially dangerous; and the very last future which I would anticipate with equanimity for a Museum would be one of stagnation and mere existence.[13]

Again, he is thinking primarily of collections, and goes on to suggest that acquisition rates be slowed down. But it is surely possible to detect here his sense that the V&A had reached a state of ripe maturity in which a certain deliberate recession from the hurly-burly would be appropriate.

Such attitudes can also be detected among certain members of his staff, who evidently regarded employment in the museum as an opportunity to escape from dreary jobs in the world of affairs into a calm environment where the self could be cultivated. Herbert Read, for instance, was

'profoundly unhappy' in the Civil Service, in 'a desperate state of dissatisfaction and revolt', before he joined the museum in 1922 and entered upon a life 'full of interest and enlightenment', in which 'sensibility' and 'critical activity' were the reigning virtues.[14] W.B. Honey, too, had a miserable time in the clerical grades of the Civil Service, until, 'after many years' journeying in the wilderness', he joined the museum and at last 'found myself among men such as I had for long wanted to know ... They had sensibility and informed taste which I had so long striven in loneliness to acquire.'[15] Even in the museum there was official work to be done, of course, and it sometimes grated on their tender souls. 'I should not have chosen, had I been free,' said Honey, 'to write at length on such themes as *Dresden China* and *Old English Porcelain*, books that have had the ironical effect of branding me as a lover of trivialities.'[16] Herbert Read eventually felt 'sweated' in the museum, and left to find fame and fortune elsewhere after ten years, even though Maclagan had sized him up as next Director.[17]

Another young curator who was drawn to the literary life was James Laver, who recalled that 'I intended to be a writer. But as I had no private income ... I wanted a job of some sort.' The museum provided it. But 'all the time I regarded myself as an author who happened to be in a museum, rather than as a museum official who happened to write books'.[18] Laver was not in search of an ivory tower, for he had wide interests outside the museum, especially in the world of the theatre, to which his wife, the actress Veronica Turleigh, gave him an *entrée*:

I found myself, against my will, divided into two distinct personalities, at least in the minds of other people. To my colleagues at South Kensington I had become a cigar-smoking, Savoy-supping, enviable but slightly disreputable character, hobnobbing with chorus girls and hanging around stage doors. To Gertrude Lawrence and her friends I was something 'in a Museum', engaged in mysterious and apparently useless activities quite outside their comprehension; a character out of *The Old Curiosity Shop*, hardly fit to be let out alone.[19]

The latter part of this remark suggests that the public image of museum curators at that time was not a particularly engaging one. A portrayal of curators as idle, disdainful officials is to be found in Anthony Powell's first novel *Afternoon Men* (1931). The novel aims primarily to evoke the sterile world of the 'Bright Young Things', and the V&A was not one of the important arenas for their hectic desperation. But perhaps Powell's inane curators give a hint of the museum's atmosphere in those dilatory days. Such a mood seems to be conjured up also in the following reproach, which was flung at the V&A in 1937:

Here ... are some of the loveliest things on earth, whole rooms of English furniture, and Raphael cartoons, and Pellé's bust of Charles the Second – here they are, snatched from the hands of private men, sterilized, caged together in tasteless surfeit, imprisoned without hope of release. Here, too, perhaps saddest of all, is a great staff of experts – unhappy custodians, bound by hated necessity to the prisoners of their great seraglio, yet pleased with a gloating pleasure that other men cannot get near them to enjoy them.[20]

This is obviously written with malicious intent, but it adds to our impression that the inter-war V&A was an inward-looking place. Another hint that a studied negligence was good form in those days emerges from the fact that, although Maclagan did hold staff meetings, he chose to hold them at monthly intervals on Fridays at 12 o'clock: 'I must admit the hour of 12 was rather selected in order that they should not last too long ... sometimes they really only take 10 minutes...'[21] C.C. Oman recalled that their infrequency was a disadvantage, since 'important matters for discussion do not arise once a month, and unimportant ones were discussed instead'.[22]

The older members of the V&A staff seem to have suffered from an insular mentality. Oman noticed that few of them felt any professional need or obligation to visit foreign museums.[23] The newer recruits were, however, a talented company. Just before Smith retired, as we have seen, Laver, Codrington, Ashton, Oman and Read arrived. Read was one of the most distinguished intellectuals to be nurtured by the V&A, even though he advanced to other things. Codrington, after heading the Indian Section, went on to a professorship in Indian Archaeology at London University. Laver (see figure 12.12) had one of the liveliest minds the V&A has ever supported. He is generally thought to have written too much too fast (partly to finance his colourful lifestyle outside the museum), but his range and perspicacity were immense, and his fame was considerable. He wrote innovatively on fashion, and was often thought to be in charge of the V&A's fashion collection,[24] though this belonged to the Textiles Department, and Laver spent his life in the Prints and Drawings Department (which was, of course, an excellent base for his inter-disciplinary explorations). Sometimes he was assumed to be 'Sir James Laver, Director of the V&A', although he did not attain either of these distinctions. He is immortalized in the works of Stephen Potter, who anatomized the petty stratagems of English snobbery in his ironic handbooks on *Gamesmanship*, *Lifemanship* and *One-Upmanship*. In a section on 'Exhibitionship', Potter advises museum visitors who want to appear to be in the know that:

it is a fairly good gambit ... to be friendly with the attendants ... Address them by some such name as 'Kemp', and say, 'Good morning, Kemp. Is Mr Laver in today?' 'Mr Laver' is what is called an 'OK exhibition name'.[25]

W.B. Honey joined Ceramics (later to become Keeper) in 1925, and in the same year Philip James (educated at

University College, London) joined the Library, from which (after bracing it with needed reforms) he proceeded to arts administration, becoming Director of Art at the Arts Council. In 1926 came Ralph Edwards (Hertford College, Oxford and *Country Life*) to the Woodwork Department, and – a significant moment – the V&A's first two women curators, Margaret Longhurst to the Architecture and Sculpture Department, and Muriel Clayton to Engraving, Illustration and Design. James Wardrop joined the Library in 1929: by self-education he had transported himself from industrial Paisley, in Scotland, to the Italian Renaissance, becoming an erudite expert on humanist calligraphy, and a consummately skilful practitioner of the revived italic hand.[26] In 1931 the ebullient *bon viveur* Hender Delves Molesworth (University College, Oxford) brought his 'boundless enthusiasm in four languages' to the pursuit of the newly fashionable Central European baroque.[27] The no less ebullient Charles Harvard Gibbs-Smith entered the Library in 1932, and we will meet him again later.

George Wingfield Digby (Trinity College, Cambridge; Grenoble, the Sorbonne, Vienna), whose polished aristocratic reserve was the opposite of ebullience, came to Textiles in 1934, and, taking scholarly advantage of the fact that in those days 'a young assistant keeper could get lost in the museum's library for four days before his absence was noted',[28] laid the foundations of his exhaustive knowledge of medieval and Renaissance tapestry (see figure 12.16). Peter Floud (Wadham College, Oxford), arriving in Circulation in 1935, was to be a trail-blazer in the post-war museum. Graham Reynolds (Queen's College, Cambridge) came to Engraving, Illustration and Design in 1937, where he was joined in the Paintings section in 1938 by John Pope-Hennessy (Balliol College, Oxford). The Orientalist Basil Robinson (Corpus Christi College, Oxford) arrived in 1939, just before the Second World War swept him and many others away to the army or to service in other Government departments.

The museum staff, being civil servants, were divided, as was the Civil Service at large, into two groups, which might be regarded as 'gentlemen' and 'servants', and the gap between these classes was almost unbridgeable. All the luminaries we have just surveyed belong, of course, to the 'gentleman' class. The other class tends to have faded out of history, but it seems only fair to note the arrival in 1929, as a technician in the Library, of C.G.E. Bunt, who wrote and published inextinguishably on all conceivable aspects of art – not altogether to the approval of his superiors.

To its staff, then, the museum may have seemed a comfortable haven. How did it appear to its audiences? As we have seen, its original obligation to artisans and manufacturers was still, in the twentieth century as in the nineteenth, being continually recalled to it, by Cecil Smith

among others. So art students and commercial designers remained an important audience, even if the museum directed them towards the history of art rather than to contemporary design (figure 11.2). The museum continued to be a place of resort for the tourist, though it was now so much bigger than it had been in the nineteenth century that a London guide book could say in 1913 that 'the most inveterate sightseer will probably be ... in a state of collapse' after perambulating its galleries.[29] The main change brought by the early twentieth century was that the museum consolidated its appeal to collectors and connoisseurs, as these two overlapping constituencies grew larger and stronger.

The economic background for the burgeoning pastime of collecting beautiful and interesting old things was the decline of English landed society. After the 'Great Depression' of the 1870s and '80s, agricultural estates never recovered their efficacy as a source of income, and more and more country houses and their contents were sold up. 'After 1885 ... wealth derived from land no longer played any significant part in the saleroom. In England the nobility were henceforward seldom to appear in the market as buyers, but incessantly as sellers.'[30] While the nobility's

Figure 11.2 The museum being used by a student, who is copying the St George Altarpiece in about 1934–5.

great treasures were snapped up by American millionaires, their lesser possessions floated on to a rising bourgeois collectors' market.

In recent years, collecting, which used to be an enclosed and self-sufficient world, has been penetrated by investigators of several kinds. As a deep-rooted human foible, previously celebrated in affable, roguish *causeries*,[31] it has lately been subjected to sterner analysis from the points of view of psychology, anthropology and sociology.[32] Such analysis, while exposing some of the ill-judged pretensions of collecting, has had the effect of giving it a democratic warrant as a pastime for everybody. This was dramatized in the series of 'People's Show' exhibitions in British museums in the early 1990s,[33] which celebrated collectors of bookmarks, beer mats, milk bottles, teabags, and such things. For those who value collecting in more traditional ways, a kind of connoisseurship of collecting has been fostered in the *Journal of the History of Collections* (published from 1989 onwards), where collecting is presented in full academic dress, though at a safe distance from modern critical theory. Despite all this activity, an empirical assessment of early twentieth-century collecting in England is still wanting.[34]

In the absence of quantified information, we have to rely on impressions. For our purposes, an interesting source is Lady Dorothy Nevill, born in 1826, and, as a good friend of Cole and Purdon Clarke, constantly associated with the South Kensington Museum throughout its development until her death in 1913. In 1902 she was invited to write about her collection, which prompted her to two reflections. The first was that, in her early days, collecting 'was confined to the very few, and the taste of even the most skilled of these would, I fear, compare none too favourably with that of the expert of to-day', whereas 'now, of course, almost everyone has, or pretends to have, some knowledge of or appreciation for books, pictures, engravings, china, or furniture'. The other point she stressed was the recent appearance of the 'systematic collector'; by 1902, she said, 'everything has become so specialized, with, I think, good results'.[35] Lady Dorothy acquired all sorts of things just because she liked them, but in the twentieth century aspiring collectors were always advised to choose their special line and stick to it methodically.

An indication of the rising enthusiasm for collecting is the publications produced for collectors. Not only were more books issued, but they tended to come in series. One of the earliest was the 'Collector Series' published by George Redway from 1897. It was launched with the rather tentative, even apprehensive, statement:

The instinct for collecting has been made the butt for much cheap ridicule by those who confound it with the mere aimless bringing together of objects which have no other merit than

their rarity. But it has repeatedly been proved that skill and patience are more helpful to success in collecting than length of purse, and it is especially for those who desire to purchase their amusement with intelligent economy that this series has been planned.[36]

The series seemed to do well enough, and others followed. Methuen's 'Connoisseur's Library' was the most handsome, printed with wide margins on thick, deckle-edged paper, and bound in crimson cloth with gold-blocked decoration. At least 15 volumes appeared between 1904 and 1912, two being by V&A authors: Martin Hardie on *English Coloured Books* and Clifford Smith on *Jewellery*. Another substantial series was the chunky 'Chats' books published by T. Fisher Unwin from 1905 (*Chats on Old Furniture*, ... *on Old Prints*, ... *on Pewter*, and so on): 22 volumes appeared by 1920, many written by the versatile Arthur Hayden (who conducted a 'Chats on Collecting' column in the *Lady's Pictorial*), and some survived in print, in new editions, for many years. Stanley Paul's 'ABC Series', from 1910, included many books on collecting, among a wider range of topics. Herbert Jenkins's 'Collector's Series', from 1913, discloses that a taste for collecting is extending downmarket, for these books are said to be 'intended for those who love interesting old things, and more especially for those who like to search in the byways where "picking up" may still be practised, rather than keep to the less thorny path where the only passport necessary is a well-filled purse'.[37] Heinemann's 'Collectors' Pocket Series', from 1916, also evidently catered to the cheaper end of the market. Newnes published a 'Library of the Applied Arts', which included A.F. Kendrick's *English Embroidery* (1905). This series was bought up by Batsford in 1910, and reissued as 'Batsford's Collector's Library'.[38] Batsford was one of the most active English publishers in the art and architecture field, and Harry Batsford, recalling how 'museum research became a regular part of the firm's work about 1908', praised the V&A for its helpfulness, saying that it was 'staffed entirely by angels', and that 'you never went to the Library or Print Room without some joyous discovery'.[39]

Periodicals also responded to the growing popularity of the new pastime. Collectors' columns appeared in *The Lady*, *The Ladies' Field* and *The Queen*. Articles from the latter (the 'Great Organ of the Upper Classes') were republished in book form in 1903, 1904 and 1907 and, in introducing the last volume, the 'Editress' commented that it had been 'prognosticated that it would be impossible to keep such a column going, as in time it would wear itself out for want of fresh subjects. So far from this being the case, we have never lacked for writers or subjects'.[40] This confirmed her remark in the second volume that 'the vogue for collecting ... encourages the belief that intelligent interest in this direction is on the increase'.[41] It is worth noting the

importance of women in sustaining this interest. In 1897 the author of a book entitled *The Connoisseur* could write that 'the ideal connoisseur must be a man who has practised art with success in the commencement of life, and has relinquished his profession for the study and acquisition of works of art'.[42] While this accurately describes the route that many nineteenth-century collectors followed, it clearly fails to take account of women collectors in the twentieth century.

Among other general magazines that ran collectors' columns was *Country and Town*. It called its column 'Antiques and Curios' and had an arrangement to obtain valuations, in response to readers' enquiries, from the London Curio Club Ltd, 107 Regent Street, which must have been the first antiques supermarket, with its 'unique collection of Antiques and Curios of the value of upwards of £40,000, comprising choice specimens of Antique Furniture, China, Pottery, Silver, Pictures, Engravings, Prints, Tapestries, Miniatures, Clocks, Jewellery, and an unlimited assortment of charming Bric-a-Brac and Curios, all of which are marked in plain figures'.[43] Notice that the plural noun 'antiques', a recent coinage, following on the use of the adjective as applied to furniture, pottery, and so forth, was by now fully in use.

A further stage in the consolidation of the collectors' market was the appearance of specialized periodicals. A straw in the wind was the special quarterly supplement, *The Collector*, produced, from March 1898, by the newly founded *Architectural Review*, which was rather inclined to spawn supplements, and this particular one does not seem to have lasted beyond four issues. But hard on its heels came the monthly *Connoisseur*, which, in its first issue of September 1901, evinced a buoyant mood:

The first thought of the reader of THE CONNOISSEUR will perhaps be one of surprise that the idea of a magazine for collectors has not occurred to anyone ... before this. THE CONNOISSEUR proposes to fill [an] empty place in the world of contemporary periodical publication ... There is no question of creating a demand; the demand exists, and we hope to supply it. That it exists has been proved to us by the unanimous welcome with which the idea of a magazine for collectors has been received by those for whom it is intended ... Within the last decade the number of collectors has grown by leaps and bounds ... Not in a spirit of doubt and uncertainty is THE CONNOISSEUR launched on the tide of public opinion.[44]

The expectations of the magazine were not disappointed, since it ran until 1992. Its characteristic scrolled, pictorial section-headings indicated its coverage: Old Furniture, Old China, Old Books, Old Violins and Musical Instruments, Engravings, Pictures, Silver and Plated Ware, Lace and Needlework, Pewter, Stamps and Autographs; and two central features, 'Collections Visited' and 'In the Sale Room'. It was soon followed by the *Burlington Magazine*, founded in March 1903. This journal was at pains to position itself on a higher plane than the *Connoisseur*, regarding itself primarily as serving art history (it is still Britain's premier art-historical journal). But it needed the support of collectors, so, while disparaging the person who 'collects railway tickets or – dare we add? – postage stamps', it declared that 'the collector who is also a sincere *amateur*, a true lover of the arts, has our whole-hearted sympathy'.[45] It certainly advertised in other collectors' publications, listing 'subjects dealt with' that would appeal to collectors. The list included Sculpture, Bronzes, Enamels, Goldsmith's Work, Medals, Ivories and Stained Glass, which made clear that the *Burlington Magazine* had lofty interests, in contrast, perhaps, with some of the periodicals in which it advertised, such as the unassuming *Collectors' Lists*, a transitory little magazine from Manchester. This included in its 'list of Collectible Items' such things as Baxter Prints, Buckles, Door-knockers, Keys, Masonic Emblems, Regimental Badges and Toby Jugs.[46]

If a busy community of collectors was formed in the years before the First World War, it grew even busier after the war. The foundation of the British Antique Dealers' Association on 14 August 1918 reflected the existence of a burgeoning group of suppliers; by 1927 the literary pundit J.C. Squire could remark upon 'the shops which have sprung up in multitudes since the war, having "Antiques" written in Gothic lettering across their Queen Anne fronts'.[47] Further specialist periodicals appeared. January 1922 saw the start of the still-flourishing American magazine *Antiques*, which set out to stir up *camaraderie*, offering its readers a 'common rallying ground' and encouraging them to 'jaw back' in response to its articles.[48] A similar magazine published in New York from 1923 to 1933 was *The Antiquarian* (which changed its name to *Fine Arts* in December 1931). In England, a magazine along these lines began in June 1927, with the rather misleading title *Old Furniture: A Magazine of Domestic Ornament*. It was edited by the V&A's E.F. Strange, after his retirement as Keeper of Woodwork, and a considerable part of each issue was usually written by V&A men – Kendrick on carpets and tapestries, Rackham on English Delft and Wedgwood, Oman on wallpapers, James on musical instruments, Honey on porcelain and, of course, Strange on furniture. This monthly magazine changed its name, reasonably enough, to *The Collector*, in January 1930, but closed at the end of that year, just overlapping with the still flourishing *Antique Collector*, which first appeared modestly in September 1930 and gradually established itself. Like the American *Antiques*, this promoted *camaraderie*, attributing its success to 'friendliness', and congratulating itself on attracting subscribers in Zurich and The Hague, 'from Riga to Vancouver,

BC, from Jaipur to Durban'.[49] The *Burlington Magazine* and the *Connoisseur* continued to thrive, and were joined in 1925 by England's third major art journal, *Apollo* (still in good health), which bore the subtitle 'A Journal of the Arts'. It is significant that in 1933 *Apollo* changed its subtitle to 'The Magazine of the Arts for [in bigger type] Connoisseurs and Collectors', and changed its coverage accordingly to suit this still unsated audience.[50]

In 1922 a contemporary observer saluted a flourishing scene:

Since 1881 ninety-four books about antique-collecting (excluding books about pictures) have been published in the English language alone. Of these just half have appeared within the last fourteen years. So we may conclude that the instinct of antiquarian possessiveness is growing at an extraordinary pace. Indeed what the British Museum catalogue suggests is positively proved by the Post Office Directories, which show that in 1860 there were only eighteen antique dealers as against four hundred and twenty-seven in the present year. There are now enormous numbers of people who 'collect,' who like to read about collecting, who wish to write about it ...[51]

To a collector of antiques, almost any museum would provide something of interest. The short-lived *Antique World* (1930–1), for instance, offered its readers a series of 'Museum Rambles' in the London Museum, Guildhall Museum, British Museum and the National Museums of Wales and Scotland. But of all museums, the Victoria and Albert was best equipped to satisfy antiques enthusiasts, with its wide-ranging collections of beautiful and interesting old things, first acquired as 'industrial art', but now eligible to be re-categorized as 'antiques'. The new role of the V&A is neatly suggested in the title of an article written in 1921 by Malcolm C. Salaman: 'The Modern Adventure in Print Collecting. The Victoria and Albert Museum as a Training School for Collectors'.[52] By substituting any other of the V&A's fields for 'Print', one could have used this as an all-purpose advertising slogan for the V&A in the inter-war years. In 1928 the lowish-brow paper *Bazar, Exchange and Mart* affirmed that the V&A 'has become a haunt for collectors and a training ground for connoisseurs'. It went on to say: 'No wonder then that it is said to attract more people every year than any other museum in the country.'[53] The second comment does not follow logically from the first, but it is interesting that the *Bazar* felt that the audience of collectors and connoisseurs was now powerful enough to carry the V&A to success.

The museum also attracted dealers. Already in the previous century Purdon Clarke had told the Select Committee of 1897 that 'every day when the dealers come' one would find 'in our art reception room ... often five or six people sitting waiting with bags full of objects'.[54] The dealers were,

of course, hoping to sell to the museum. But as the expertise of the museum developed, so collectors and dealers would come for the advice of the staff – in the form of 'opinions' on objects, though never of valuations, which the staff, as public servants, were forbidden to offer. To examine and pronounce upon the stream of objects that passed by was considered to be an essential part of the training of a curator. Max Friedländer recalled how his position as assistant to the great Dr Bode in Berlin gave him just this sort of training. Bode was at the centre of a 'close network of connections with collectors and dealers all over the world, with the result that in his study works of art were offered for sale, placed on show and came up for judgment each and every day'.[55] The curators of the V&A might not have had Dr Bode's global powers of attraction, but they too communicated with collectors and dealers as part of their daily work, and it must have been easy for them to come to accept these as the museum's core audience.

It may seem odd, at first glance that, once the concept of 'antiques' became accepted, the museum never promoted itself as a museum of antiques; and perhaps odder still that no museum anywhere seems to have done so. If it had, however, the V&A would have aligned itself with collectors of what might be viewed as trivial objects – Toby jugs, Apostle spoons, Coventry ribbons. The museum's instincts would have drawn it towards some higher, more exclusive ground. Always its allegiance had been, one way or another, to art. We have already argued that when the museum came on the scene, the word 'art' still retained much of its base meaning of 'skill', and was generally used in the plural (the 'polite arts', the 'mechanick arts'). In early debates about the museum and the art schools associated with it, art in the singular was often used to mean an ornamental quality that could be added on to objects of utility. It also came to evoke an uplifting quality that appealed to the moral conventions of middle-class society. However, art began to claim 'autonomy'. Philosophical discussion of abstract words like 'beauty' conduced towards an understanding of art as an abstract quality. Boosted by Romantic ideas of the individual genius of artists, 'art' began to refer not so much to things made or the skills needed to make them as to an artist's insight or personal expression. A crucial moment for England was the Ruskin vs Whistler trial of 1878, during which – without ever quite asking the question 'Is it art?' – experts haggled over who was entitled to define Whistler's paintings as art. The Aesthetic Movement proclaimed the independence of art, 'Art for Art's Sake', and claimed that a work of art offered, to those sensitive enough to receive it, an emotional or even spiritual experience of a unique kind.

Increasingly, art galleries and museums saw it as their mission to cherish, and to impart to their visitors, that

emotional or spiritual experience that art alone could give. Curators would believe something like this:

To be seen in its perfection is the whole of what a work of art as a work of art was made for ... The ultimate end of every artwork is to be beheld and felt as it was wrought, and this end it fulfils whenever anyone stands before it and perceives in it the artistic content it was meant to convey, enters into the soul of the artist through the gateway of his work.

These are words of Benjamin Ives Gilman, of the Boston Museum of Fine Arts, in an article in which he explains that some museums (art museums) are intended to convey an aesthetic experience, and are filled with works selected solely for aesthetic quality, while other museums have practical and didactic aims; and in which he goes on to assert, startlingly, that these two types of museum 'are mutually exclusive in scope, as they are distinct in value', for 'where the sphere of education begins, the sphere of art ends'.[56]

What is interesting about this view – that art has a world of its own – is that it commanded wide acceptance in the early twentieth century. A scientific curator, addressing the Museums Association in Britain in 1906, had no difficulty in getting hold of the idea, when he defined an art museum as an institution:

where the objects are regarded simply as material for aesthetic contemplation; where they are arranged so that each may be seen to the best advantage and most surely produce its full effect of ministering to the cultivated enjoyment of the onlooker, without any regard to the increase or diffusion of knowledge.[57]

In the face of this attitude, the utilitarian purposes that had lain behind the foundation of many art museums rapidly began to recede.

In America, they retreated also because the American millionaires who were calling the tune as patrons of the museums were interested only in art objects that were 'the best'. While for the millionaires the best was measured primarily in financial terms, there was a natural presumption that the most expensive artworks were also the best in aesthetic terms. Caspar Purdon Clarke found this out when he went to the Metropolitan Museum on the coat-tails of Pierpont Morgan. He wrote home: 'I shall have to struggle to make a South Kensington Museum of this one, as the dominant feeling is that it should be high and dry like the British Museum and the National Gallery. They still believe in salvation through culture ...'[58] Had he stayed in England, Clarke would have found that the South Kensington Museum was getting higher and drier all the time, as it too adopted the gospel of 'salvation through culture'. This trajectory presented a problem for old-timers at South Kensington, for, as W.W. Watts remarked, 'the aesthetic faculty does not exist in the majority of visitors ..., or, if it

exists, it is so untrained and undeveloped that you cannot appeal to it'.[59] The inevitable result was that the museum became more and more inhospitable to ordinary people, as it bestowed its favours sparingly on 'high-and-dry' initiates. And the desired ambience for a high-and-dry museum was reverential, even devotional. It was perfectly summed up by the world's most eminent and influential connoisseur, Bernard Berenson, in the commandment he delivered to the V&A on museum display in 1927: 'The masterpieces should be placed in such a way that the spectator would instinctively feel that he was in the presence of something sacred, aloof, compelling a mood more akin to worship than curiosity.'[60]

This account of the ethos of the V&A in the early decades of the twentieth century is necessarily somewhat speculative, for the ethos must have been cultivated as a kind of religious faith, and would have lost some of its power if too explicitly stated. That it prevailed, however, is surely demonstrated by the fact that it was criticized by several commentators who were in a position to know what they were talking about. A Royal Commission on National Museums and Galleries was appointed in 1927, to co-ordinate museum policy and, incidentally, to look for ways of cutting costs. Pluckily refusing to consider the latter ('economies have already been carried too far'), the Commission did make many useful recommendations. It was before this body that Maclagan affirmed that the V&A was a museum for collectors and connoisseurs, only to be told that some 'counterpoise to over-emphasis of the dealer-connoisseur side' was necessary at the V&A.[61]

The inter-war period also saw two reports on provincial museums, commissioned by the Carnegie Foundation, and undertaken by Sir Henry Miers in 1928 and S.F. Markham in 1938. While they contained little specifically on the V&A, they did make some comments on the national museums as a group. Miers commended recent attempts 'to break away from the collecting bias and to establish museums for public rather than personal purposes, and with reference to educational needs'.[62] And Markham strikingly claimed that:

at present two cultural peoples exist side by side in this country. There is the world of the scholar and the connoisseur ... [associated with] our great national institutions ...; and beneath it and all around it is a great body of Englishmen and Englishwomen who have had little opportunity of any definite education since they left school ...

For the sake of this larger public, the Report urged, 'the task of the future is to get the missionary spirit crusading further into everyone connected with museums and art galleries'.[63] Just after the Second World War, the Dartington Hall Trustees published a Report on *The Visual Arts*, summarizing inquiries that their Art Department had been

making since 1941. Surveying falling attendances at national museums in the inter-war years, this Report commented that 'the numbers might be very much greater if the directors and their staffs were as interested in attracting and educating the public at large as they are in the specialist needs of students and connoisseurs'.[64] These testimonies show that many people perceived museums like the V&A to be stand-offish, and to be addressing themselves to a limited and exclusive audience rather than the public in general.

Some signs of unease at the V&A's increasing inclination towards collectors came to the surface in the Advisory Council. After its first flurry of activity in Cecil Smith's directorship, it quietened down to the extent that, at its meeting on 7 April 1916, Lord Lytton expressed the fear that it 'would gradually subside into complete inactivity'. Enough business was found to keep it occupied, but the tension did not rise again until, during Maclagan's directorship, Reginald Blomfield took exception to the acquisition of some Byzantine carvings. As we have already seen (p. 100), he insisted that the V&A should buy things that were useful to art students and deprecated the 'tendency to slip over to the Collector's point of view'. It was part of the Advisory Council's duties to make an annual review of purchases, but this necessarily took place after they had been made. Maclagan, when testifying to the Royal Commission on National Museums and Galleries in May 1928 was emphatic that the Council 'does not advise on, or control, the purchase of individual objects', that its members 'do not intervene before the purchase is made' and that they 'are not even consulted'.[65] At this moment, however, the Council was trying to flex its muscles by setting up sub-committeees or a standing committee to vet purchases before they were made. This matter was prominent at its meetings from 1927 until 1932, when, at a meeting on 5 February, a Chairman's Report concluded that:

The scheme ... to enable the Director to obtain an expression of opinion from the Advisory Council on proposed purchases, proves to be unworkable. Although the general opinion of the Council was in favour of adopting the scheme, scarcely any invidual members were prepared to serve on the Standing Committee.[66]

The issue was still rumbling in 1934, when, at a meeting on 15 June, the Council decided that, if it could not influence purchases, it would at least make periodic inspections of the Departments to keep them up to scratch. On the whole, Maclagan seems to have successfully deflected the Council's attempts to inhibit the powers of the curators.

If this divergence between Director and Advisory Council seems to confirm a drift towards exclusivity at the V&A, it must in fairness be noted also that Maclagan followed Smith's example in supporting the Museums Association, of

which he was President in 1935 and 1936, and in offering the V&A's help in the training of provincial curators.[67] Moreover, it was normal practice, from the beginning, for the Advisory Council to include a provincial museum director. After the Second World War, Trenchard Cox occupied this role for a time, while Director at Birmingham, and before he became Director of the V&A.

In Maclagan's time, many aspects of the V&A's life continued along the lines established by Smith, as is witnessed by the museum's brief Annual Reports, published, from 1919 to 1938, as an appendix to the annual review of acquisitions. Each year the same four aspects of museum life were assessed: exhibitions; publications; lectures, and classes for children; and visitor attendance figures. In respect of the latter, Maclagan presided over a gentle but steady decline. After the end of the war attendances shot up, and in the 1920s usually topped a million (the total in 1924 was 1,318,049, which the annual report hailed as 'the largest number hitherto recorded during any year'). From 1927 they gradually dropped to a low of 736,483 in 1938. Visitor attendance figures tended to be discreetly disregarded at this period. The Markham Report (mentioned above) has nothing resembling a comparative table of attendances, and comments that 'we cannot assess the service that a museum renders to the community by counting the number of visitors – as well attempt to assess the precise skill in a football match by the gate it draws' (p. 102). The Dartington Report, however, does have a little table, which reveals that all museums saw a decline in attendances during the 1930s (p. 144). The V&A's falling figures may well, therefore, have been due to circumstances beyond Maclagan's control; the gloomy atmosphere of the Great Depression could have been a factor.

A more local factor might have been changes in the museum's opening hours, but it is difficult to come to a conclusion on this matter. Evening opening had been one of South Kensington's most progressive policies right from the beginning, but had been suspended during the war. The museum resumed the practice in 1924, remaining open until 9 p.m. on Thursdays and Saturdays. In 1927 Maclagan regretted that the pre-war closing time of 10 p.m. could not be reinstated.[68] In 1930 it was, only to be abolished on 1 October 1931, owing – as the annual report explained – 'to the necessity of effecting economies in public expenditure'. An attempt to reinstate evening opening in 1937–8 was abandoned 'as relatively few visitors seemed to wish to avail themselves of the extended hours'; ever since then, 6 p.m. has been the usual closing time.

Gallery lectures, suspended during the war, were eventually reinstated in 1925 – twice a day at 12.00 and 3.00, by a team of three lecturers that included Miss Ethel Spiller.

She continued indefatigably to welcome children: with her 'devoted band of voluntary helpers, drawn in part from the older girls at London schools', she lay in wait for children 'at the Main Entrance of the Museum in a little "tabernacle" which is temporarily erected for their use in a corner of the Central Hall'.[69] In 1927 Thursday evening lectures by members of the curatorial staff and others were introduced. While intellectual matter was thus supplied to nourish the inner man, the physical needs of visitors were still catered for in the restaurant, though standards had dropped. Maclagan fondly recalled its former excellence, which was 'owing to the real genius who used to preside at the grill and who was killed during a Zeppelin raid'.[70] And the League of Arts maintained a programme of Saturday afternoon concerts in the Lecture Theatre in autumn and winter, with poetry recitals and other entertainments during May. Concerts had first been tried in 1923, at the end of Smith's directorship (the National Gallery having pioneered them six months before),[71] and continued through Maclagan's regime until the Second World War.

Maclagan was, therefore, not remiss in cultivating the public. Museums did not at that time go in much for 'what is generally now known as publicity' (to quote Sir Robert Witt's words at the Royal Commission of 1927).[72] Indeed, the Dartington Report noticed that 'in London the national art collections have had scarcely any publicity, except what the London Passenger Transport Board has provided free of cost'.[73] As early as 1910 the V&A's new Aston Webb building had appeared in a line illustration on a poster for 'England's Treasure Houses' issued by the Underground Railway Company Ltd (predecessor of the LPTB). But it was in the 1920s that the Underground, led by the enterprising Frank Pick, and emulating the success of the overground railway companies, went in for posters in a big way on its trains and stations. By publicizing attractions that people could easily reach by Underground, the company could boost its passenger numbers, especially outside the rush hours. At first the V&A was usually featured on general posters for museums, though it got a poster of its own by Edward McKnight Kauffer in 1922, and Austin Cooper provided designs for an attractive evocation of ceramics at the V&A in a series on museums in 1932,[74] and for an exhibition, appropriately, on posters in 1931. During the '30s posters were regularly provided for special exhibitions at the V&A. These were usually no more than an illustration with typography in the Underground's house style, but were no less helpful for that.

Whether the V&A quite got the hang of the idea that publicity is meant to stimulate demand may, perhaps, be doubted. In 1936 Maclagan instituted a rather important piece of re-display (mentioned further below). He did not think to advertise it in advance; only when it seemed to be attracting approval did he write, in an almost offhand way, to Frank Pick:

The public really seem to be rather enthusiastic about the newly re-opened Octagon Court with its display of English furniture, etc. from 1750 to 1830 ... Both yesterday at the private view and to-day when it is open to the general public a number of people have hailed it as a real improvement. Do you think the London Passenger Transport Board would be inclined to make it the subject of one of their ... posters ...?[75]

They did. The image projected by the V&A through London Underground posters was to an extent determined by the Underground Company and its designers. One of the most engaging visions of the V&A came in a series of press advertisements on the theme 'Who says "London's dull on Sunday"?' in 1928. The V&A's panel in the series commended the museum enthusiastically to a family audience (figure 11.3). But the museum's connection with the Underground went further than graphic publicity. In 1938, in response to Pick's invitation, the V&A set up displays in a large circular 'shop-window' showcase that had been built in the new concourse at the Leicester Square Underground station (figure 11.4). The displays were devised by Leigh Ashton, an up-and-coming man at the V&A.[76]

In the publications programme, the pre-eminent features were the series of catalogues initiated by Smith, which continued to appear at a leisurely pace (culminating appropriately in Maclagan's catalogue of Italian sculpture in 1932), and the annual review of acquisitions, maintained until 1938. However, under Maclagan an attempt was also made to produce publications with more popular appeal. In

Figure 11.3
A press advertisement featuring the V&A, from a series, with drawings by Arthur Watts, issued by London Transport in 1928, to encourage Sunday travel.

WHO SAYS 'LONDON'S DULL ON SUNDAY'?

Dull? Take your children—or borrow some one else's—and test it at the Victoria and Albert Museum. Toys for all ages on view. Open Sundays 2.30 to 6.

Book to South Kensington Station
UNDERGROUND

Figure 11.4 One of the V&A's displays in Leicester Square
Underground Station in 1938.

1926 a series of 'Small Picture Books' was inaugurated –
slim pamphlets containing some 20 illustrations and a very
brief text; 55 of these had appeared by 1938. Their plain
coloured-paper covers, with simple typography, were dis-
creet, if not drab, and were only livened up after the Second
World War, when reprints of some of the series were issued.
Nonetheless, these little books can be still be useful for the
glimpses they offer of unexpected corners of the collection:
Roman alphabets (no. 32), peasant pottery (no. 39),
leatherwork (no. 44). Coloured postcards had been avail-
able to supplement the monochrome collotype cards since
1922, and in 1931 colour printing entered the museum's
publications, in two 'Picture Books in Colour'. These had
attractive patterned covers, similar to those on the series of
three fatter picture books, *100 Masterpieces*, which covered
'Early Christian and Medieval', 'Renaissance and Modern'
and 'Mohammedan and Oriental' art.

A fairly vigorous exhibition programme was maintained.
Some of the exhibitions were of limited local interest: year
after year the museum gave space for the exhibitions of the
Civil Service Arts Council (which presented 'pictures by
Civil Servants of every grade, from expert advisers to post-
men and girl clerks')[77] and the Royal College of Art
Sketching Club (which showed not students' course work,
but 'holiday work ... first attempts to use ... newly acquired
knowledge for free expression').[78] The Department of
Engraving, Illustration and Design regularly mounted
exhibitions of two-dimensional art, including several on
theatrical subjects (French and Russian stage designs,
1927; Sir Henry Irving, 1930; Sarah Siddons, 1931;
Covent Garden Theatre, 1932; Victorian pantomimes,
1934), for since 1925 the Department had had its own
theatre section, the Gabrielle Enthoven Collection, ruled as
her own domain by Mrs Enthoven herself, and destined to
be the nucleus of the V&A's Theatre Museum. The most
influential of EID's exhibitions was *Drawings, Etchings &
Woodcuts by Samuel Palmer and Other Disciples of William*

Blake in 1926, which was the result of an approach from Palmer's son, a very old and irascible gentleman living in Canada. He loaned much work by his father, some of which was bought by the museum.[79] This exhibition was important in rehabilitating English Romantic painting and illustration in the esteem of both critics and the general public.[80]

The British Institute of Industrial Art arranged a series of exhibitions on modern design, which were continued in 1934, '35 and '36 by its successor, the Council of Art and Industry. Major exhibitions of historic material included *Works of Art belonging to the Livery Companies of London* (1926), *British and Foreign Posters* (1931), *English Illustrated Children's Books* (1932, 'one of the most popular temporary exhibitions held in the Museum') and the ground-breaking *Exhibition of Early Photography* (1939). Undoubtedly the exhibition nearest to Maclagan's heart was *Mediaeval English Art* in 1930. 'All other events in the history of the Museum during 1930,' wrote Maclagan (in the annual review, p. iii), 'were overshadowed by the great Exhibition of English Mediaeval Art' (although this was itself somewhat overshadowed by the Royal Academy's exhibition of Italian paintings the same year). It contained 1,106 exhibits borrowed from all over the country (exploiting Maclagan's powerful connections in the Church of England) and abroad.

In his influence on the scope of the V&A, Maclagan was perhaps not a force for progress, but in his attempts to present the collections more interestingly he was perceptive and in the end effective. In respect of contemporary design, he made it clear to the Royal Commission of 1927 that he did not want the V&A to purchase examples of modern art.[81] Because of the V&A's historical concern with contemporary design, he had a seat among the Governors of the British Institute of Industrial Art and, when the Council for Art and Industry superseded the Institute in December 1933, Maclagan took his seat on the new body. But the Institute's collections, when handed over to the V&A, were quickly transferred to Bethnal Green, to join the Margaret Bulley Collection of Modern Decorative Art. This collection contained 'specimens of Continental as well as of English work'. It had been 'brought together less as a representative group than as an expression of the taste of an individual collector deeply interested in modern tendencies of design' (as the Bethnal Green Museum's annual report in the annual review cautiously phrased it). After being on loan to the museum, it had been donated, thus infiltrating some modern design into the museum, despite official indifference.

Maclagan also served as a member of the Board of Trade's Committee (the Gorell Committee) on Art and Industry in 1931. But it seems likely that he used his positions on such committees to distance the V&A (no doubt with exquisite courtesy) from the increasingly zealous design reform movement of the 1930s. His stand-off was reciprocated. The Gorell Committee, in its paragraphs on 'The Historical Setting' for design reform, alluded to the founding purposes of the South Kensington Museum, but concluded that its 'influence has not been wholly beneficial', and regretted that Sir Cecil Harcourt Smith's efforts on behalf of modern design had been hampered by lack of funds. It hoped that the V&A's Circulation Department would continue to make examples of modern art available for exhibition, but noted that it had been 'urged in evidence, that some manufacturers and distributors are strongly antipathetic to museum [sic] and museum administration in this connection'. In effect, it wrote off the V&A, and called for 'the creation ... as ideally desirable, of an Institute of Modern Industrial Art to supplement the work of the Victoria and Albert Museum'.[82]

The propagandists for design reform in the 1930s – one of them self-approvingly remarked that 'industrial design had ... been discovered and identified by a few far-sighted and exceptional people at the end of the First World War'[83] – simply left the V&A out of their view of the history of industrial design. It is true that the V&A earns one footnote in Herbert Read's classic *Art and Industry* (1934), but Read had had a personal connection with the museum through working there for a time. However, he could be seen as 'an outsider to [the] design movement, approaching it by way of museum curatorship and art criticism', while 'figures within the movement ... were typically employed in the spheres of journalism, advertising and commercial art'.[84] When writers like John Gloag, Noel Carrington, Geoffrey Holme and Anthony Bertram looked at the history of industrial art, the V&A might as well not have existed. They were, after all, arguing for a complete break with the past, so there was little point in crying over what must have seemed to them to be no more than wasted effort on the part of the museum. Gloag was the most historically minded of the group, and it is noticeable that when he sketches 'A Short History of Design in Industry' in his *Industrial Art Explained* (1934), he skips straight from the Society of Arts in the 1840s to William Morris, without mentioning the early history of the South Kensington Museum. It seems that Cole and his circle were first rehabilitated by Nicolette Gray in an article in the *Architectural Review* in 1937, but it was not until after the Second World War that they were brought in from the cold, eventually to earn an honoured place in Pevsner's *Pioneers of Modern Design*.[85] In the 1930s it is clear that the V&A had lost interest in modern design, and modern designers and design critics had lost faith in the V&A.

A critic remarked early in 1939 that 'a pair of [Victorian]

papier mâché chairs must, one thinks, be the most modern examples of furniture which the Director of the Victoria and Albert Museum tolerates at South Kensington, the few examples of chairs and tables in "Art Nouveau" style in the possession of the authorities being relegated to Bethnal Green'.[86] Note the use of the words 'tolerates' and 'authorities', which suggests that the V&A's antiquarianism was regarded by this time as strict and unbending.

Most people visiting the V&A must have been looking not for modern design but for the history of the decorative arts. But, as we have seen, the galleries that they found in the V&A's huge building were far from interesting or evocative. In 1927 appeared Charles Richards's short but authoritative book on *Industrial Art and the Museum*. The V&A got a chapter to itself, but Richards pronounced a damning verdict on the museum:

It can hardly be said, as now arranged, to be an effective instrument for the cultivation of public taste. For this latter purpose, the material as exhibited is too vast in extent, and too highly specialized as to display. The strictly departmental arrangement makes impossible any impression of the unity of past styles that might be gained through composite presentations in which varied examples of a period are shown in relation. It also renders impossible the charm to be attained through such dispositions. The succession of great numbers of similar objects in each of the departmental displays, even when arranged with the greatest care, cannot be other than monotonous and

Figure 11.5
The site of the 'Object of the Week' display near the main entrance of the museum.

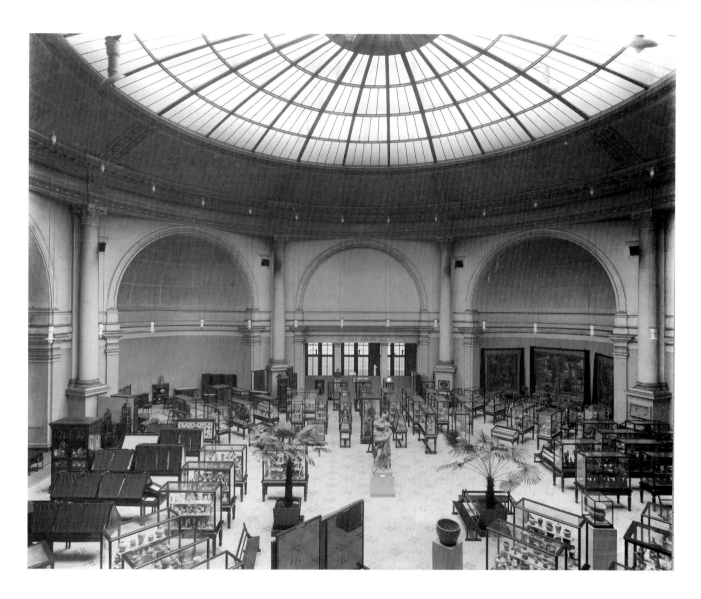

Figure 11.6 The Octagon Court, when it was used for a very diverse, almost chaotic, display of loaned objects.

fatiguing in effect. For the student, the expert, the designer, the craftsman, and the amateur, the Victoria and Albert Museum is a wonderful treasure house. For the layman, it is over-whelming in its vastness and lacks both informing quality as to the history of design and appeal in its individual displays. As it stands today the Museum represents the stage of development exemplified by the German museums of industrial art prior to the opening of the present century ...[87]

Maclagan had to face this issue when he appeared before the Royal Commission on National Museums and Galleries on 11 May 1928. Several interested bodies had sent papers to the Commission urging that the V&A's arrangement should be modified. The Federation of British Industries pointed out that 'in other countries the classification according to material has been to some extent abandoned

in favour of an arrangement which aims at illustrating the development of particular historical periods by means of combined displays of carefully selected specimens'. It conceded that the whole of the V&A's collections could not be shown in this way, but urged that some period galleries be established, while 'secondary galleries' could continue to show objects arranged by material.[88] The British Institute of Industrial Art sent a long paper suggesting a quite detailed three-tier system.[89] Maclagan was sympathetic, but thought the Institute's ideas too elaborate.[90] However, when his colleague Bernard Rackham went before the Commission on 19 October 1928 he was able to say that 'my Director is ... already preparing a memorandum to be laid before the Commission, outlining a possible scheme for reorganization of the whole Museum'.[91]

It was to take many years to reorganize the museum. Meanwhile, small gestures were made: 1931 saw an attempt to make the V&A more comprehensible to visitors,

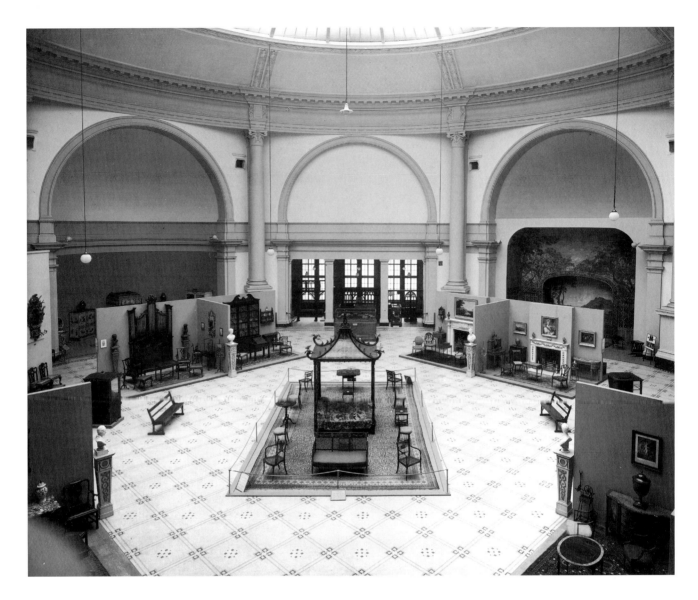

Figure 11.7 The Octagon Court, after it had been fitted up to contain a display of 18th-century furniture and decorative art in 1936.

through the 'Object of the Week' scheme. Every week an object was taken from its usual place in the galleries and shown 'in a specially selected position'. Although this sounds as if the objects were given star treatment, the reality was somewhat less prepossessing, since the special position was a recess in one of the stairwells near the main entrance, the kind of nook to which, in a domestic setting, one might consign gumboots and old umbrellas (figure 11.5). Although the scheme was proudly regarded by the museum as a contribution to accessibility, and as rescuing visitors from 'optical indigestion',[92] it struck some critics as a very lame gesture. It was said that the V&A, instead of providing in its displays an 'objective survey, carefully classified and arranged organically, so as to link together the parts of the whole', merely 'prefers to cater for the "expert" by providing him with a selected masterpiece each week, to be viewed in isolation'.[93] Nonetheless, the scheme lasted from 1931 to 1939, featuring some 400 exhibits,[94] and was imitated, in the form of 'Picture of the Month', at the National Gallery and Liverpool.[95]

Maclagan's exhibition of *Mediaeval English Art* in 1930 set a more significant precedent. It was widely noted by critics – and approved – that this exhibition was arranged chronologically, so that the

phases of art between the seventh century and the Renaissance are shown in broadly grouped periods, such as from the seventh century to 1200, the opening of the thirteenth century to the Black Death, and the final stage, reaching to the first beginnings of the Renaissance. This grouping of the rare paintings, furniture, silver, illuminated manuscripts and sculpture according to date is of considerable value both for historical perspective and for comparison.[96]

These period groupings were a departure from the V&A's norm: the display of its permanent collections by material and technique. 'It would have been easy to exhibit all the manuscripts in one corner,' said W.A. Thorpe, 'to congregate the sculpture ..., to allow a continuous peering at stitcheries'. But the period arrangement here adopted allowed 'the ideas, sentiments, beliefs of an epoch as these affect the design of a work of art or are present in its subject matter' to emerge.[97] Furthermore, as another critic observed, 'it should be remarked that a good many of the objects are actually owned by the Victoria and Albert Museum, but that owing to their being normally decentralized in its various departments, they now seem to be brought under observation for the first time'.[98]

This exhibition might also have been regarded (though this does not seem to have been said at the time) as a response to the urgent plea from the Royal Commission of 1927 that the V&A should develop a display of English decorative arts. The Commission had said:

Nowhere in London is it at present possible to see any ordered sequence or illustration of the English arts and crafts. In accordance with the 'classification by material' arrangement of the Victoria and Albert Museum, English work will be found scattered among a large number of different departments ... Carefully chosen examples of English work from the different

departments would form, we believe, a most instructive and beautiful display.[99]

Maclagan's first opportunity to satisfy such calls for rearrangement came in 1933 when the 'Moot of Senior Officers' agreed that the Octagon Court, hitherto used as a corral for loans (figure 11.6), would be turned over to the Furniture Department so that it could space out its now crowded chronological sequence of exhibits. Maclagan suggested that the four-apsed court might be devoted to four displays of English art from different periods (Elizabethan, Stuart, Georgian, etc.). The Furniture Department thought this would disrupt their galleries too much, and it was eventually decided to use the court for eighteenth-century art only, which would leave the earlier furniture galleries undisturbed. However, everyone agreed that here, for once, furniture would be intermingled with appropriate material from other departments. Screens were set up to define room-like spaces, and were painted green, while the walls and dome were painted white and grey. The Advisory Council chose the colours and took two months to do so. J.L. Nevinson from Textiles and Ralph Edwards from Furniture co-ordinated the project.[100]

The new gallery opened in February 1936 (figure 11.7), and was hailed as a 'small revolution'.[101] 'The appearance of

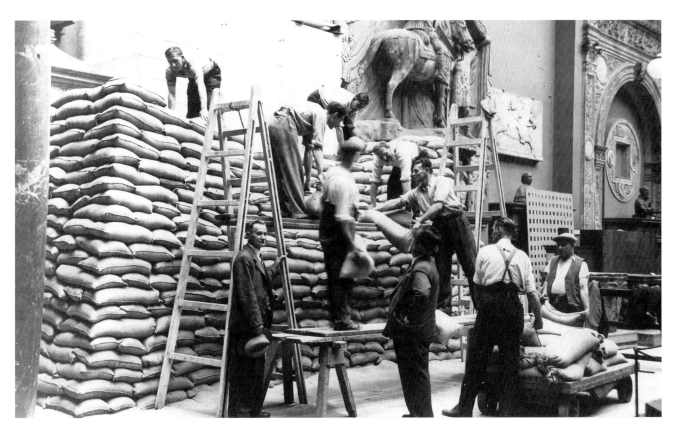

Figure 11.8 Preparing for war: immovable objects in the museum were protected by sandbags.

woods or in stone, while the eighteenth-century busts are now supported upon marble or scagliola pedestals of their own period'. But he did group the English sculptures together, and in chronological order.[104]

When war broke out in 1939, the V&A was more seriously disrupted than it had been during the previous war. This time the galleries were entirely stripped of movable objects (figures 11.8–10), which were taken away into safe keeping, for fear of bombs. Some material went to Montacute House in Somerset, some to deep storage in Westwood Quarry, Bradford-on-Avon. The Raphael Cartoons were too large for a long journey, so they were bricked up in a specially constructed bomb-proof shelter in

Figure 11.9 Preparing for war: portable objects were taken away to places of safety.

this hitherto forbidding court, until lately crowded with showcases, has been completely transformed, and there can be no doubt at all that the bringing together of objects which were never intended to be segregated in categories has resulted in an immense gain.'[102] Yet these new arrangements stood as a reproach to the old. 'They point the way to a better museum ... nearer to the heart of the public. The museum as it stands, with its multifarious departments and their wealth of objects, ranged in never-ending series, is very largely unintelligible ...'[103]

Maclagan made a personal impact on the museum's mode of presentation only in respect of his own special field, the sculpture collection, which he rearranged 'in a manner which may be accepted', according to his *Times* obituary, 'as a model of museum display'. The changes seem mostly to have been matters of taste: 'all the chocolate-coloured bases have been or will be covered with a walnut ply-wood which is extremely effective in giving tone to works in other

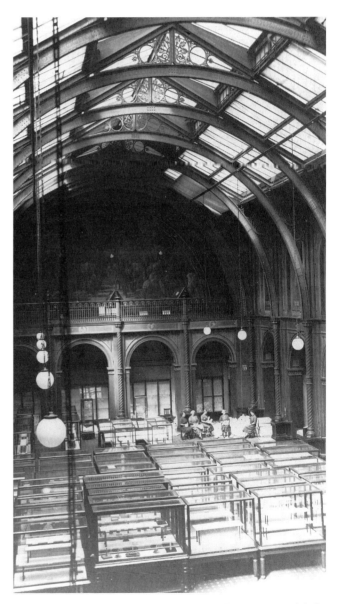

Figure 11.10 Preparing for war: a group of staff preparing 'wads' of tissue paper for packing objects, in the South Court, which has been stripped of exhibits.

His successor was already waiting in the wings. Leigh Ashton joined the museum in 1922, and moved through the Departments of Architecture and Sculpture, Textiles and Ceramics, spending periods of years in each. He was best known as an Orientalist, and in 1935–6 organized a major Royal Academy exhibition of Chinese art, which gained much praise for its exquisite presentation. In 1937 he was given the status of 'Crown Prince' in the V&A when he assumed the hitherto unknown post of Keeper of Special Collections, at the same time serving as Secretary to the Advisory Council and Assistant to the Director. He spent the war with the Ministry of Information, but was officially recognized as nominated to succeed Maclagan.

Ashton's strength was in showmanship. The *Burlington Magazine* remarked that 'the best directors need not necessarily be the best-known scholars' (a bold opinion for those times) and commended Ashton because 'he has had the good sense to realize that his finest talents did not lie in scholarship'.[108] He did not alienate his scholarly colleagues – when he was appointed, a Ministry of Information press release proclaimed him 'one of the best known connoisseurs in the country' (figure 11.13),[109] – but he wanted to move away from the ethos that had prevailed under Smith and Maclagan:

Figure 11.11 Margaret Longhurst, who became Keeper of Architecture and Sculpture in 1938.

the V&A basement. Despite this wholescale dismantling, the museum, responding to Government urging, was the first national museum to reopen (with only a very limited range of displays) in order to encourage public morale, on 11 January 1940.[105] The war brought good fortune to Margaret Longhurst (figure 11.11) and Muriel Clayton (figure 11.12). Since their male colleagues were seconded to war work elsewhere, they became the first women to hold keeperships of V&A Departments – of Sculpture and Textiles respectively.

In May 1944, as the end of the war came in sight, Maclagan's thoughts turned again to rearrangement, and he prepared a memorandum for his Advisory Council,[106] urging that arrangement by material should now give way to arrangement by culture and period, and that displays should feature fewer objects, and those the important ones, while the rest should be placed in reserve collections. He recalled that he had been thinking such ideas before the war,[107] but had had to put them aside. Now their time had come, but it was for his successor to implement them. He retired in March 1945.

Figure 11.12 Muriel Clayton, who became Acting Keeper of Textiles in 1938.

Figure 11.13 Leigh Ashton. The caption to this officially issued press photograph called attention to Ashton's renown as a connoisseur.

The emphasis lay, in my view, in those years on connoisseurship and collecting; it had shifted a considerable amount from the original conception [of the museum], in which the objects were primarily exhibited for design and taste value to objects exhibited for taste only. Not that in any way the desired result of improving the taste of the public and the design of manufactured goods had disappeared, but to use a modern expression the slant had altered. In a contented and rich world the collector was considered at perhaps too high a value.[110]

Ashton was prepared to change the slant again.

He inherited an empty museum, and had a free hand in arranging the contents as they returned from wartime evacuation. It took some time. In a crisp and well-balanced handbill on 'The Victoria and Albert Museum and its History',[111] issued in January 1947, his public relations officer rather cleverly stated:

The [museum's] presentation to the public is made either within ... material divisions, or through style and period groups taken from them; or again, by means of 'theme' arrangements according to subject matter, or type of object. Thus there is a continual and varied process of appeal to the Museum's visitors.

This was making the best of the museum's incoherent pre-war practice. When the handbill was reprinted in April 1948, however, it was possible to say:

The re-arrangement of the 'V & A' (now in progress) will present two equally important, but distinct kinds of display ... The Primary Collections will exhibit objects by style, period or nationality ... The Secondary Collections will be kept together by materials, which follow the division by departments, i.e. Sculpture, Ceramics, Engravings, Metalwork, Paintings, Textiles, Woodwork, etc.[112]

Thus the V&A, in its display methods, seemed at last to be realizing the ambitions that many had cherished for it since 1909.

The new sequence began, in the central court straight ahead of the main entrance, with European (including British) art of the late classical, early Christian and early medieval periods. Later medieval art (divided between Italian and north European Gothic) continued in the ground-floor galleries south and east of the quadrangle; and then the Italian Renaissance followed in the galleries north and west of the quadrangle. At the point where the sequence reached the Exhibition Road entrance, it divided in two. The basement perimeter galleries, along Exhibition Road and round the corner to the main entrance, contained continental art from 1525 to 1825. The upper floors of the perimeter galleries contained British art. At last the V&A provided the long-awaited conspectus of the art of its own country. Since the museum's British collections were by now larger than its European collections, the British Galleries were more extensive than the continental. Starting at 1500, with the Tudors and Stuarts, they reached 1750 at the main entrance, then doubled back overhead, continuing to 1820. Islamic art and Far Eastern art filled the large courts on each side of the Early Medieval Court. The new arrangement was in place by the end of 1951. The departmental collections, still arranged by material, were disposed on the upper floors and towards the back of the building.

While the main layout now provided, in the Primary Galleries, a historical survey such as the V&A had resolutely forsworn in 1909, Ashton did not, in justifying his rearrangement, look back to the controversies of the turn of the century. After all, the intervention of two world wars had consigned to oblivion the philosophical debates about how the decorative arts should be classified and arranged. Ashton's approach was primarily aesthetic. 'Our methods of display in the main collections aim at showing the object to its best advantage, while providing as much information as possible without interfering with the public's aesthetic approach to the object.'[113] In his new guide book of 1952 he stressed that the Primary Galleries, 'specially set out in a connected series', exemplified new design techniques: 'not just the re-arrangement of objects in cases, but the completely new design and layout of the cases, the lighting and the objects, to form a unified display' (p. 13). He had not much sympathy for Aston Webb's architecture, describing

the V&A as 'over-decorated', and 'the most intractable building I have ever known'.[114] One critic, disparaging 'the previous crowded jumble of beautiful things in a somewhat ornate architectural setting' and commending Ashton's 'new disposition of selected masterpieces sparsely displayed against restful backgrounds', explained that:

in order to achieve this, much of the Edwardian architecture, with its too numerous mouldings and fussy 'features,' has been camouflaged by blank screens distempered in carefully chosen tints, light grey or cream, or – in the case of the Islamic Room – green.[115]

Clearly, Ashton's aesthetic was veering in the direction of the currently fashionable modernist 'white cube'. But he was objective enough to emphasize that 'we have merely masked the outworn but important architectural features of the Museum and any successor of mine can uncover them if taste changes'.[116]

Few critics bothered with philosophical justifications for the new layout. The religious magazine *The Tablet* was a lone voice in remarking that:

when the arts of a period are brought together in one place and set in order as if they were characters on a stage at some great point of dramatic tension, then something happens that may well cause the student of humanities to rub his eyes in amazement. The delicate and tricksy spirit of the age is powerfully present.

'This presence in the air as of subtle music' was detected by the writer especially in the late Gothic and early Renaissance galleries. Philosophy and history apart, however, this critic praised Ashton's displays on the grounds that 'never have the devices of art-showmanship been more imaginatively employed'.[117] This was the line that most of the other critics took. One said of the new galleries that they were 'judiciously selected and admirably displayed. For the lighting, the spacing and grouping, so as to entice and hold the visitors' attention, no praise can be too high'.[118] Another commended the fact that 'aesthetic considerations have always predominated in the arrangement', even to the extent that 'chronological progression ... has frequently had to be sacrificed to considerations of effect'.[119] Ashton himself, perhaps with tongue in cheek, commended his new displays to 'the lay visitor' on the grounds that they would not cause 'gallery feet' or 'museum headache',[120] and some newspaper reports took up this theme: 'Museum reshuffle will end those lines of vases'.[121]

In laying out the V&A afresh, Ashton seems to have trusted to his own taste, without help from professional designers. This is slightly surprising, since he had just had an opportunity to see at close quarters a prodigy of modern exhibition design. The rearrangement of the V&A after the war was postponed so that a large part of the lower galleries could be used in 1946 for the Council of Industrial Design's

Figure 11.14
Ashton as museum planner. He is studying what appears to be the ground plan of the *Britain Can Make It* exhibition, perhaps considering what he can put in its place.

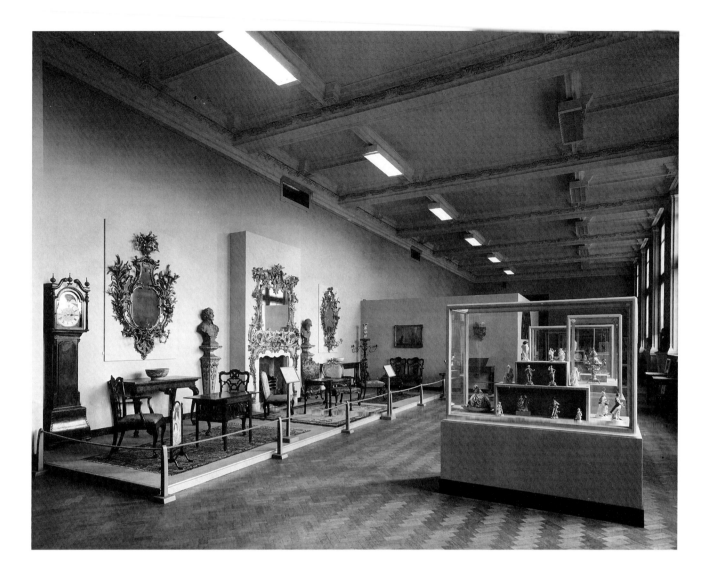

Figure 11.15 Room 125 in 1951: 18th-century English decorative art as shown in Ashton's rearrangement of the museum. The show-cases are adaptations of those supplied for the new building in 1909: their turned legs have been replaced by solid bases, and their brown varnish has been covered with light-coloured paint.

massive exhibition of British products, *Britain Can Make It* (figure 11.14). This was designed by James Gardner, and design predominated over exhibits, not least because so many exhibits were being gathered from so wide a catchment area that Gardner could never be sure what they might be.[122] His spectacular settings have probably never been equalled in the V&A since. (Nor did Gardner, doyen of English exhibition designers, work there again.)

Ashton must have decided that he did not want (or could not afford) his museum to look like this. He once remarked:

I do think far too much emphasis has been placed on the integrity and the skill of the designer. I would challenge any designer to put up as good a show as any intelligent museum man with a couple of carpenters and a good lighting man ... I think that there has been far too much emphasis on displaying the objects, rather than on the objects themselves. The whole point of a good museum is that the objects speak for themselves; and they do not, if they are intelligently shown, require a particular setting designed for them.[123]

His taste was the taste of the time: in some ways modernist, but also in tune with Berenson's requirement that museums should celebrate masterpieces in an atmosphere akin to worship. Ashton inclined towards plenty of space ('instead of having to contend with distracting neighbours, the work of art is left alone in its purity and calm')[124] and pale colours. It was reported that 'he has had wall strips painted experimentally so that various types of exhibit may be judged against various tints and shades'. Pale grey was evidently a favourite: 'the loveliest light grey, a dawn-mist tone which is not only poetically right but also enhances the tints and textures of ancient embroideries and incrustations [*sic*].'[125] The total effect was evidently felt to be aesthetically seductive (figure 11.15):

He has slowly created inside his grim barracks a series of manageable compartments where the visitor can stroll about at his ease without the least sense of oppression; where he can contemplate works of art against a background and in surroundings not so dismally dissimilar from those for which they were originally designed; where presentation, lighting, and juxtapositions tell him just as much as, if not more than, explanatory labels; where sight-seeing is transformed for him from a tedious duty into a pleasure.[126]

The new galleries, then, were acclaimed. It may be, however, that Ashton has received almost too much praise. One of his successors called his displays 'a revolutionary change' and hailed Ashton as 'among the first to envisage the rapidly increasing demands of a new public',[127] while another, in respect of these galleries, said that 'in the European museum field Leigh Ashton was a highly innovative figure'.[128] An obituary claimed that Ashton 'completely revolutionized the techniques of museum display, forever changing the public's viewing habits and their perception of a museum'.[129] But, as we have seen, his rearrangement was to a large degree what had been widely urged since the beginning of the century and was foreshadowed in the plans of his predecessor.

The new structure that Ashton introduced into the museum has remained to the present day. Many sections of his gallery arrangement scheme have been refurbished or renewed, and space has been found to extend the sequences from the 1820s, where Ashton stopped, up to the end of the twentieth century. But the shape that Ashton gave to the museum is what the visitor still experiences: a chronological narrative, supplemented by study galleries devoted to collections in various materials. Now that higher standards of conservation have made gallery installations immensely expensive, both in physical construction and in complexity of organization, it is unlikely that there will ever again be an opportunity to reconstruct the V&A in its entirety in one process. (It is much easier to re-hang a picture gallery even as large as the Tate than it is to shift around the millions of diverse objects in the V&A.) As we shall see, reconstruction has been contemplated in principle, but resources have never made it a practical proposition. Leigh Ashton's modelling of the V&A may well remain for all time.

It institutionalizes in the V&A a tension between Cole's idea of a museum – as being concerned with design and with the methods of craft and industrial production (represented in the material-based study galleries) – and something else, which is represented in the sequence of chronological galleries. This 'something else' might be history as expressed in material culture, the history of political events and social conditions as these have been registered in the paraphernalia that people use in their lives. This sort of history, however, is not to be found in the V&A. 'We are not a social history museum' is a mantra still repeated piously by many V&A staff. Ashton's taste meant that his new Primary Galleries presented their contents as Art, as masterpieces, reposing in all their purity and calm, speaking for themselves, and inducing a reverent mood of aesthetic contemplation. The collections constantly belie the view of them as artistic masterpieces, for many things in the V&A are, as its founders intended, objects of everyday use. But the sequence of Primary Galleries makes the best of the artistic masterpieces that the museum does possess, and thus enables it to rank itself (as the British Museum, for instance, cannot convincingly do) as one of the world's foremost art museums. If history is here at all, it is art history. This aspect of Leigh Ashton's legacy could, if it were so desired, be changed more easily than his gallery sequence. But, after almost half a century, his consecration of the museum to art history and aesthetic pleasure endures.

NOTES

1 Obituary by 'K.C.' in *Burlington Magazine*, vol. 93, 1951, p. 358.

2 Ibid.

3 Quoted from Diana Woolner's diary, 12 January 1926, in *Egyptian Archaeology*, no. 7, 1995, p. 35.

4 'The South Kensington Museum', Westminster Gazette, 25 March 1925: V&A Cuttings Book, Times 11, February – April 1925, p. 240.

5 'Obituary. Carl Winter', *Museums Association Monthly Bulletin*, vol. 6, no. 4, July 1966, p. 28.

6 *Royal Commission on National Museums and Galleries. Oral Evidence, Memoranda and Appendices to the Interim Report*, London: HMSO, 1928, para. 2780. Cf. *Museums Journal*, vol. 26, 1926–7, pp. 67–8.

7 *Oral Evidence ... Interim Report*, para. 2879.

8 E.R.D. Maclagan, 'The Future of Museums. Presidential address to the Museums Association', *Museums Journal*, vol. 35, 1935–6, pp. 154–5.

9 F.G. Kenyon, *Museums & National Life. The Romanes Lecture*, Oxford: Clarendon Press, 1927, pp. 6, 18.

10 'The Victoria and Albert Museum', *Architectural Review*, vol. 85, 1939, p. 274.

11 E.R.D. Maclagan, 'Museums and the Public. Presidential address to the Museums Association', *Museums Journal*, vol. 36, 1936–7, pp. 182.

12 Comments after a lecture on 'Museums and Education' by Sir Henry Miers, reported in *Journal of the Royal Society of Arts*, 22 February 1929, p. 387.

13 Maclagan, 'The Future of Museums', pp. 164–5.

14 Herbert Read, *The Contrary Experience: Autobiographies*, London: Faber, 1963, pp. 246, 259, 266, 267.

15 William Bowyer [W.B. Honey], *Brought Out in Evidence: An Autobiographical Summing-Up*, London: Faber, p. 277.

16 Ibid., pp. 277–8.

17 James King, *The Last Modern. A Life of Herbert Read*, London: Weidenfeld and Nicolson, 1990, pp. 97, 98.

18 James Laver, 'Museums and How to Break Out of Them', *Museums Journal*, vol. 64, 1964–5, pp. 144–5.

19 James Laver, *Museum Piece, or The Education of an Iconographer*, London: Deutsch, 1963, p. 153.

20 Christopher Hobhouse, *1851 and the Crystal Palace*, London: John Murray, 1937, pp. 152–7.

21 *Oral Evidence...Interim Report*, para. 2797.

22 C.C. Oman, 'The Department of Metalwork, 1925–1939', p. 8. This is a typescript kept in the Department of Metalwork.

23 Oman, op. cit., pp. 1, 5, 7, 8.

24 Doris Langley Moore in *DNB*.

25 Stephen Potter, *One-Upmanship*, Harmondsworth: Penguin, 1978, p. 163. First published 1952.

26 Reynolds Stone, 'James Wardrop', *Bodleian Library Record*, vol. 8, 1967–72, pp. 297–306.

27 Obituary by Peter Cannon-Brookes in *Apollo*, vol. 108, 1978, p. 288.

28 Obituary by Natalie Rothstein in the *Independent*, 14 January 1989.

29 *A Pictorial and Descriptive Guide to London and its Environs*, Thirty-seventh edition, revised, London: Ward, Lock, 1913, p. 172.

30 Gerald Reitlinger, *The Economics of Taste. Volume II, The Rise and Fall of Objets d'Art Prices since 1750*, London: Barrie and Rockliff, 1963, p. 226.

31 For example, Philippe Julian, *The Collectors*, London: Sidgwick & Jackson, 1967.

32 See, for example, John Elsner and Roger Cardinel (eds), *The Cultures of Collecting*, London: Reaktion, 1994; Russell W. Belk, *Collecting in a Consumer Society*, London: Routledge, 1995; Susan M. Pearce, *On Collecting: An Investigation into Collecting in the European Tradition*, London: Routledge, 1995; Susan M. Pearce, *Collecting in Contemporary Practice*, London: Sage, 1998.

33 See Janine Romina Lovatt, 'The People's Show Festival 1994: A Survey' in Susan M. Pearce (ed.), *Experiencing Material Culture in the Western World*, Leicester: Leicester University Press, 1997, pp. 196–254.

34 But see, as an indication of what might be done, Stefan Muthesius, 'Why do we buy old furniture? Aspects of the Authentic Antique in Britain 1870–1910', *Art History*, vol. 11, 1988, pp. 231–54

35 Lady Dorothy Nevill, 'My Collection', *Connoisseur*, vol. 1, 1901–2, p. 151.

36 Frederick Wedmore, *Fine Prints* (in the 'Collector Series'), London: George Redway, 1897, publisher's announcement at the end of the book (in the NAL copy).

37 H. W. Lewer and Maciver Percival, *The Bric-à-brac Collector. A Practical Guide* (in the 'Collector's Series'), London: Herbert Jenkins, 1923, p. 5.

38 Hector Bolitho, *A Batsford Century*, London: Batsford, 1943, p. 36.

39 Ibid., p. 117.

40 Ethel Deane (ed.), *The Collector...Reprinted from the Queen Newspaper*, vol. 3, London: Horace Cox, 1907, 'Preface'.

41 Op. cit., vol. 2, 1904, 'Introduction'.

42 Frederick S. Robinson, *The Connoisseur. Essays on the Romantic and Picturesque Associations of Art and Artists*, London: George Redway, 1897, p. 18.

43 *Country and Town*, 1 December 1909, p. 157.

44 *Connoisseur*, vol. 1, 1901–2, pp. 1–2.

45 *Burlington Magazine*, vol. 1, 1903, p. 5.

46 *Collectors' Lists* appeared quarterly from no. 1, August 1911, to vol. 2, no. 8, 1913.

47 J. C. Squire, 'Books of the Day' [review of Herbert Read's *Stained Glass*], *Observer*, 17 January 1927: V&A Cuttings Book, Times, March–May 1927, p. 1.

48 'Antiques speaks for itself', *Antiques*, vol. 1, 1922, p. 8.

49 'Speaking Personally...', *Antiques*, vol. 5, 1934, p. 57.

50 See Paul Goldman, 'Apollo: "A Journal of the Arts"', *Connoisseur*, vol. 191, 1976, pp. 184–8. See also, in this special issue of *Connoisseur*, articles on the *Burlington Magazine* by Benedict Nicolson and the *Connoisseur* itself by Bevis Hillier.

51 Bohun Lynch, 'Collecting and Antiques', *London Mercury*, January 1922, p. 334.

52 Malcolm C. Salaman, 'The Modern Adventure in Print Collecting. The Victoria and Albert Museum as a Training School for Collectors', *The Bookman's Journal and Print Collector*, 1 April 1921.

53 'Our National Museum of Beauty', *The Bazar, Exchange and Mart*, 5 November 1927: V&A Cuttings Book, Times, December 1927 – January 1928, p. 80.

54 *Second Report from the Select Committee...1897*, para. 4232.

55 Max J. Friedländer, *On Art and Connoisseurship*, London: Cassirer, 1942, p. 15.

56 Benjamin Ives Gilman, 'On the Distinctive Purpose of Museums of Art', *Museums Journal*, vol. 3, 1903–4, pp. 215, 216.

57 W.E. Hoyle, 'The Education of a Curator. Presidential Address', *Museums Journal*, vol. 6, 1906–7, p. 15.

58 Ralph Nevill, *The Life & Letters of Lady Dorothy Nevill*, London: Methuen, 1919, p. 279.

59 W.W. Watts, 'Some Uses of a Museum of Industrial Art', *Museums Journal*, vol. 8, 1907–8, p. 157.

60 In a letter to Lord D'Abernon, Chaiman of the 1927–8 Royal Commission, who had sought the views of Berenson and other eminent foreign authorities on the British museums. See *Oral Evidence...Interim Report*, p. 303.

61 *Royal Commission on National Museums & Galleries. Final Report, Part II*, London: HMSO, 1930, recommendation 29, pp. 81, 88.

62 Sir Henry Miers, *A Report of the Public Museums of the British Isles (Other than the National Museums)...to the Carnegie United Kingdom Trustees*, Edinburgh: Constable, 1928, p. 10.

63 S.F. Markham, *A Report of the Public Museums of the British Isles (Other than the National Museums)...to the Carnegie United Kingdom Trustees*, Edinburgh: Constable, 1938, p. 174.

64 *The Arts Enquiry. The Visual Arts. A Report sponsored by the Dartington Hall Trustees*, Oxford: Oxford University Press, 1946, p. 145.

65 *Oral Evidence...Interim Report*, paras 2773–5.

66 The Advisory Council minutes and papers are in the V&A Archive.

67 Eric Maclagan, 'Co-operation of National with Provincial Musuems', *Museums Journal*, vol. 29, 1929–30, pp. 298–301.

68 *Oral Evidence...Interim Report*, para. 2830.

69 Maclagan, 'Museums and the Public', p. 184

70 *Oral Evidence...Interim Report*, para. 2987.

71 'Museum Concerts', *The Times*, 10 January 1923: V&A Cuttings Book, November 1922 – February 1923, p. 159. 'Art and Artists. Music at the National Gallery', *Morning Post*, 18 July 1922: ibid, June – November 1922, p. 36.

72 *Oral Evidence...Interim Report*, para. 2947.

73 *The Arts Enquiry*, p. 146.

74 Reproduced in Jonathan Riddell, *Pleasure Trips by Underground*, Harrow Weald: Capital Transport Publishing, 1998, p. 58.

75 Letter of 31 January 1936, in Archive: Ed. 84/296.

76 'Underground Musuem Display. Exhibit at Leicester Square Station', *Museums Journal*, vol. 38, 1938–9, pp. 24–5. Cf. Charlotte Benton, '"An insult to everything the Museum stands for" or "Ariadne's thread" to "Knowledge" and "Inspiration"? Daniel Libeskind's Extension for the V&A and its Context. Part II', *Journal of Design History*, vol. 10, 1997, pp. 319–20.

77 Caption to a photograph reproduced in the *Star*, 19 March 1927: V&A Cuttings Book, Times, March – May 1927.

78 'Art Students Out of Bounds. Fine Holiday Work at South Kensington', *Evening News*, 5 November 1927: V&A Cuttings Book, Times, December 1927 – January 1928, p. 50.

79 Laver, op. cit., pp. 106–7.

80 Cf. Geoffrey Grigson, *Samuel Palmer, The Visionary Years*, London: Kegan Paul, 1947, pp. ix–x.

81 *Oral Evidence...Interim Report*, para. 2816.

82 *Art and Industry. Report of the Committee Appointed by the Board of Trade under the Chairmanship of Lord Gorell on the Production and Exhibition of Articles of Good Design and Every-day Use*, London: HMSO, 1932, paras. 12–14, 15, 18, 50, 60, 96.

83 John Gloag, *The English Tradition in Design*, London: King Penguin, 1947, p. 32.

84 Robin Kinross, 'Herbert Read's *Art and Industry*: a History', *Journal of Design History*, vol. 1, 1988, p. 36.

85 See Anthony Burton, 'Richard Redgrave as Art Educator, Museum Official and Design Theorist' in Susan P. Casteras and Ronald Parkinson (eds), *Richard Redgrave 1804-1888*, catalogue of an exhibition at the Victoria and Albert Museum and the Yale Center for British Art, London: Yale University Press, 1988, p. 61.

86 'Commonsense Collecting. I – The Charm of the Victorian', *The Times*, 28 February 1939: V&A Cuttings Book, Times K, May 1938 – July 1940, p. 155.

87 Charles R. Richards, *Industrial Art and the Musuem*, New York, Macmillan, 1927, pp. 47–8.

88 *Oral Evidence...Interim Report*, p. 267.

89 Ibid., pp. 257–63.

90 Ibid., pp. 222–4.

91 *Royal Commission on National Museums and Galleries. Oral Evidence, Memoranda and Appendices to the Final Report*, London: HMSO, 1929, para. 3357.

92 Charles Harvard [i.e. C.H. Gibbs-Smith], 'Our National Treasure Houses. – IV The Victoria and Albert Museum', *Apollo*, vol. 26, 1937, p. 16.

93 'The Victoria & Albert Museum', *Architectural Review*, vol. 85, 1939, p. 274.

94 A.C. Carter (ed.), *The Year's Art, 1939*, London: Hutchinson, 1939, p. 31.

95 *The Arts Enquiry*, p. 148.

96 M. Jourdain, 'Furniture at the Exhibition of Mediaeval Art', *Apollo*, vol. 11, 1930, p. 470. See also Egerton Beck, 'Medieval English Art at the Victoria and Albert Musuem', *Burlington Magazine*, vol. 56, 1930, p. 292.

97 W.A. Thorpe. 'Medieval Pottery at South Kensington', *Apollo*, vol. 12, 1930, p. 331.

98 Fred Roe, 'English Mediaeval Art at South Kensington', *Connoisseur*, vol. 86, 1930, p. 23.

99 *Royal Commission on National Museums & Galleries. Final Report, Part II.*, London: HMSO, 1930, para. 40.

100 Archive: Ed. 84/156.

101 'The Octagon Court', *The Cabinet Maker*, 8 February 1936, p. 238.

102 'Changes at the Victoria and Albert Museum', *Country Life*, vol. 79, 1936, p. 124.

103 *Architectural Review*, vol. 85, 1939, p. 274.

104 'National Sculpture Collection. Better Lighting and Mounting', *The Times*, 29 July 1933: V&A Cuttings Book, Times E, June–December 1933.

105 *Museums Journal*, vol. 39, 1939–40, pp. 454–5.

106 In V&A Archive: Ed. 84/292.

107 Cf. Eric Maclagan, 'Museum planning', *RIBA Journal*, vol. 38, 1931, pp. 527–48.

108 *Burlington Magazine*, vol. 97, 1955, p. 335.

109 Text attached to the back of an official press photograph.

110 Leigh Ashton, '100 Years of the Victoria & Albert Museum', *Museums Journal*, vol. 53, 1953–4, p. 47. Much the same lecture is printed in *Journal of the Royal Society of Arts*, 26 December 1952, pp. 79–90.

111 NAL, press mark VA.1947.Box.0006.

112 NAL, press mark VA.1948.Box.0004.

113 Ashton, op. cit., p. 47.

114 Ibid.

115 M.S. Briggs, 'New Galleries at the V. And A. Museum', *Builder*, 20 January 1950, p. 94.

116 Ashton, op. cit., p. 47.

117 'Lamp-Lighting the Past', *The Tablet*, 7 July 1951: V&A Cuttings Book, V&A and V&A Exhibitions, 1949–54, p. 86.

118 'Reopening at Kensington', *Connoisseur*, vol. 116, 1945, p. 54.

119 'Continental Art at the Victoria and Albert Museum', *Apollo*, vol. 51, 1950, p. 51.

120 *Illustrated London News*, 7 January 1950, p. 14. This feature provides illustrations of the galleries, as do further features on 6 May 1950, p. 709; 17 March 1951, p. 421; and 13 October 1951, p. 589.

121 *Evening Standard*, 24 May 1949: V&A Cuttings Book, V&A and V&A Exhibitions, 1949–54, p.6.

122 James Gardner, *The ARTful Designer. Ideas off the Drawing Board by James Gardner*, n.p.: Lavis Marketing, 1993, p. 129.

123 *Journal of the Royal Society of Arts*, vol. 97, 1948–9, p. 864.

124 'Late Gothic and Renaissance Art at the Victoria and Albert Museum', *Burlington Magazine*, vol. 93, 1951, p. 130.

125 John Davidson, 'Behind the scenes at the V&A. Our Most Fascinating Treasure House', *Leader Magazine*, 12 February 1949, p. 13.

126 'Sir Leigh Ashton', *Burlington Magazine*, vol. 97, 1955, p. 335.

127 Trenchard Cox, 'The Museum in a Changing World', *V&A Bulletin*, vol. 1, no. 1, 1965, p. i. Cf. the allusion to Ashton's 'revolution in technique of display', *Burlington Magazine*, vol. 97, 1955, p. 335.

128 John Pope-Hennessy, *Learning to Look*, London: Heinemann, 1991, p. 163.

129 Elizabeth Devine (ed.), *The Annual Obituary 1983*, Chicago and London: St James Press, 1984, p. 133.

A Prosperous Interlude

VICTORIA AND ALBERT MUSEUM

One review of Ashton's new V&A said, with a note of mischief: 'The modern museum offers us all the benefits of the modern department store, except of course for the shop assistants, with pastel shades, soft lighting, and culture without tears.'[1] This would probably not have disconcerted Ashton, still less his public relations officer, Charles Gibbs-Smith, who would have been only too keen to provide the museum equivalent of shop assistants, too.

It was curious, said Gibbs-Smith, 'to find how many museum officials either patronize, resent, despise, dislike, or even *hate* the public'. All 'status seekers, anti social scholars and stuff-pots in general' on the staff of museums should be locked away, so that they did not spoil the experience of visitors. 'Our duty as museum officers is to consider as broad a spectrum of the public as possible; ... we should cater for, and seek to attract, every conceivable kind of human being, regardless of intellect, income, colour, creed, age, or sex.' A far cry from the grudging sentiments of Lewis Day in 1909 – and perhaps a kindlier view than that of marketing people today, who are inclined to believe in targeting narrow sections of the public. Gibbs-Smith took the view, and so presumably did Ashton, 'that in art museums, the provision of enjoyment and interest for the visitor is the overriding justification for their existence'.[2]

Gibbs-Smith was one of the V&A's great eccentrics. Quintessentially English, he went to an American university, Harvard, because he was descended from its founder. Trained as an art historian, he made for himself a parallel academic career as an aeronautical historian, building on his war work in aircraft recognition. This eventually led to the distinction of his appointment in 1978 as first Lindbergh Professor of Aerospace History at the Smithsonian Institution, Washington. Yet he never travelled in an aircraft. Unskilled in domestic management, he lived in a Kensington hotel until it ceased to accept permanent residents. As he then seemed likely to be left abandoned in the streets, the V&A found him a little flat in the museum building. He moved in with ample stocks of gin and instant mashed potato (then recently invented). He made daily journeys between his flat and the museum's office entrance,

along the back lane, on a collapsible bicycle (also recently invented). Warm-hearted and approachable, he was to be found around the museum at all hours, and exercised a sort of pastoral ministry to generations of staff of all ranks.[3]

He joined the museum, in the Library, in 1932 (figure 12.1), but came into his own under Ashton, when he built up a new department, controlling publications, press and publicity, information services, educational services, copyright, photography – and plaster casts, which the museum still produced.[4] The department was at first called Museum Extension Services, and later Public Relations, when this became acceptable. In an address to the Special Committee on Public Relations of ICOM (the International Council of Museums) in 1950, Ashton claimed that Gibbs-Smith's department was the 'first of its kind in the country and, so far as I know, in Europe'.[5]

Ashton and Gibbs-Smith tried to create a museum where things happened, a common enough ambition today but still fairly unusual then – in England, at any rate. They tried to arrange recorded music concerts,[6] movies in the lecture theatre, and social functions. Live concerts of classical

Vignette: Illustration used on museum guides from 1949. The lettering is in Eric Gill's 'Perpetua' typeface, which was adopted by the museum's printing shop in 1938, on Philip James's advice, for use in printing labels and notices.

Figure 12.1
The young Charles Gibbs-Smith.

Figure 12.2
A concert in the
museum quadrangle,
1950.

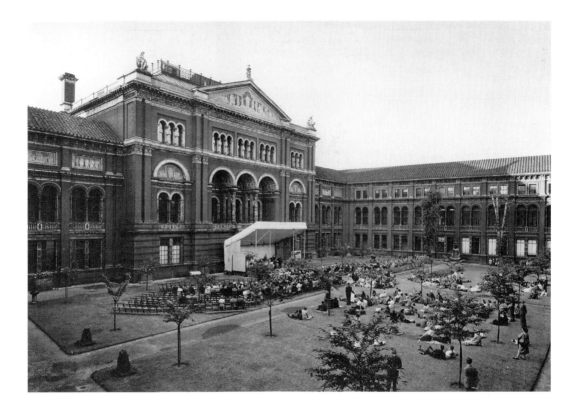

music took place out of doors in the quadrangle (figure 12.2), 'which was found to be acoustically excellent' (until aircraft noise from flights to the rapidly developing Heathrow Airport interfered with the music), and indoors in the Raphael Cartoon Court, which was rather too resonant.[7] As Ashton said, 'I think that all Museums should have a programme of the sister arts, more particularly those of music and the film.'[8] The Standing Commission on Museums and Galleries (permanent successor to the Royal Commission of 1927) bestowed its approval: 'The sum of these enlightened activities is most impressive and places the Victoria and Albert Museum without question in the forefront of Museum development in this country.'[9]

It is no surprise that even before getting his gallery reforms under way, Ashton instituted a vigorous exhibition programme. Interestingly, however, the V&A's most conspicuous exhibitions in the years just after the war were two that it housed but did not originate. The first of these (from November 1945 to January 1946) was an exhibition devoted to paintings by Picasso and Matisse – contemporary painting would not normally have fallen within the V&A's remit – which was arranged by the British Council and the Association Française d'Action Artistique. The Matisse paintings constituted a retrospective of the artist's work, and were quite acceptable to British taste: still-lifes and odalisques in vibrant colours. The Picasso paintings, however, were recent work produced during the war, disturbing images that affronted the British public. A rela-

tively objective view of what struck the eye was provided by a spectator who said that the canvases made him feel as if he were in

a dissecting room, with noses, legs, breasts, torso and feet all jumbled up, with radiators, fire-irons, window frames, armchairs and other junk, trimmed inconsequentially with ladies' hats; and through it all, at all sorts of angles and places, an alarming series of piercing eyes.[10]

The impact of the paintings on the sensibility and the moral sense of the British public provoked words like: monstrous, hoax, insult, nonsense, nausea, horrors, freaks, bilious, squalid, corrupt,[11] 'degrading, demoralizing, decadent, and degenerate'.[12] A correspondent in an American magazine recorded that:

a respectable bookshop keeper in Grosvenor Street, a policeman, and a waiter have all told me the same thing, as well as the well educated mass who were not so polite about it – that the pictures were blinking rot, the man ought to be locked up, and little Willie can do better aged five.[13]

Although professionals might regard this exhibition as 'the most important single exhibition of painting since Roger Fry introduced modern French art to this country at the Grosvenor Gallery in 1910',[14] the general public were attracted to it chiefly by the controversy, 'jamming the gallery week after week as for a football game. On the closing day the waiting line ran twice the length of the museum'.[15] The public's extreme response to the Picassos was a strange phenomenon. One critic noticed

a sort of moan under the normal humming of the crowd, produced by a hundred breaths drawn in together. One could sense the ripples of repulsion and of almost terror washing back inwards from the walls. And that is rare from a people so conservative of its emotion.[16]

The general assumption was that the paintings stirred up unresolved feelings occasioned by the war.

If this exhibition at the V&A succeeded in frightening everybody through evoking war, the other exhibition supplied from outside was intended to have quite the opposite effect of encouraging the British to profit from peace. The *Britain Can Make It* exhibition, already mentioned above, was held in autumn 1946. It was originated by the Council of Industrial Design, which the Government had set up on 12 January 1945, in the face of circumstances not unlike those that prevailed when the V&A was first conceived. A European war had interrupted trade and Britain needed to recover its overseas markets. The CoID exhibition was intended to demonstrate Britain's capacity to do this.

The V&A's relationship with the CoID was uneasy. Although Leigh Ashton was consulted at an early stage about the exhibition, the V&A did not have a seat on the new Council. Perhaps this was the result of the museum's rather unenthusiastic attitude to the British Institute of Industrial Art and the Council for Art and Industry. But the museum, however unenthusiastic, had been represented on these bodies and felt that it was entitled to be on the new Council. Institutional rivalry had a part in its pique, for Sir Kenneth Clark, Director of the National Gallery, was on the Council (albeit 'in a personal capacity'), while Ashton was not. The CoID at first intended to purchase for the nation examples of modern design, and Clark was Chairman of the Committee that was to select these. Ashton could not stomach 'the Director of the National Gallery being in a position to cut across this Museum without any reference being made to it', and railed against 'a dictatorship on modern design controlled by Sir Kenneth Clark'. His attitude seemed more than a little dog-in-the-mangerish, since he was inflexibly opposed to the V&A purchasing examples of modern design, complaining that the CAI, through its purchases, 'had landed this Museum with an enormous mass of practically useless material'. He would countenance borrowing material for exhibition, but not buying it.

The Council was not particularly keen to be at the V&A: the museum had been selected as a location for the exhibition only after various other sites had fallen through. And the V&A was not particularly keen to extend hospitality to the Council: the museum insisted that it should be made known in publicity that the exhibition was located at the V&A by order of the Government. Both sides, however, eventually came to an accommodation, with Ashton

using the exhibition as a bargaining point with the Government in his efforts to extract funds for the repair of war damage.[17] Afterwards Gordon Russell, Director of the CoID, said that 'in my more irresponsible moments I argue with [Ashton] as to whether the Victoria & Albert Museum put the Council of Industrial Design on the map, or the Council of Industrial Design showed Londoners where to find the Victoria & Albert Museum'.[18] The *Britain Can Make It* exhibition was very successful, drawing unprecedented crowds, which queued along Brompton Road up to the Oratory church.[19]

Under Ashton's regime the museum staged about four substantial exhibitions each year. *Masterpieces of English Craftsmanship* in 1945 and *Style in Sculpture* the following year were staged in a specially built setting under the dome near the museum entrance (figure 12.3). So far as possible, the installation concealed Aston Webb's classical columns behind screens with simpler, modern lines, incorporating built-in showcases. (They were Aston Webb showcases, with just a little of their varnished mouldings discernible through the apertures cut in the disguising screens.) Within the showcases, perspex stands were used to support objects, a new feature in museum display, for perspex (mouldable transparent plastic), invented in 1935, had been available only for the war effort until it came back into civilian use in 1945.[20] These exhibitions, interesting not only for their physical presentation, but because they illustrate distinct concepts, do credit to Ashton's showmanship.

The V&A continued to co-operate with outside bodies in organizing exhibitions. A new coadjutor was the Arts Council of Great Britain, founded in 1945, which did not have a gallery of its own, and therefore placed its exhibitions in appropriate museums and galleries. *Masterpieces of French Tapestry* (1949), *Pictures for Schools* (1947), *Old Master Drawings from the Albertina, Vienna* (1948), *William and Mary and their Time* (1950) and *Victorian Photography from the Gernsheim Collection* (1951) were all Arts Council exhibitions, and there were joint exhibitions with the British Council, the Society of British Film Art Directors and Designers, the English Ceramic Circle, London Transport, the Rural Industries Bureau, the Arts and Crafts Exhibition Society, the National Book League, the National Federation of Women's Institutes and other bodies.[21]

Perhaps the most influential home-grown exhibition was *Victorian and Edwardian Decorative Arts* in 1952. This was a quite daring excursion into territory from which the V&A usually recoiled. In the museum's early days it had acquired Victorian art (because it was then contemporary art), but this had been banished to Bethnal Green in 1880, where it became more and more unfashionable. Ashton's new displays at South Kensington came no further up to date than 1825. The 'Victorian Revival' began in the 1920s, when

Figure 12.3 Leigh Ashton's installation for the *Style in Sculpture* exhibition in 1946.

some young aesthetes like Harold Acton, Robert Byron and John Betjeman cut a little dash by collecting Victorian bric-à-brac.[22] But this was still rather a joke. A noteworthy development in V&A circles was the *Victorian Exhibition* staged in aid of St Bartholomew's Hospital in June 1931 at 23A Bruton Street. This was planned by a committee chaired by Cecil Harcourt Smith, and a reception on 23 June was attended not only by Smith's successor Maclagan but also by the young Trenchard Cox, under whose directorship the V&A's Victorian gallery was eventually to open in the 1960s. The 1931 exhibition featured such amusing trivia as a firescreen, a hexagonal concertina case, an ivory workbox, a shell box, a Baxter print of Windsor Castle, sand pictures, silhouettes, playbills and memorabilia from the Great Exhibition. The exhibits were displayed in room settings – drawing room, library, bedroom, nursery – and these gave rise to requests in the press for the V&A to set up a 'Victorian home' display.[23] The V&A did not respond to such frivolity. It was not until 1951 that it contributed to

the rehabilitation of the Great Exhibition, through a centenary exhibition devised by Charles Gibbs-Smith. Then, in the following year it disclosed that it had been fostering, in respect of Victorian and Edwardian artefacts, the kind of serious art-historical interest that had hitherto been reserved for earlier periods. The pioneers of the new approach were curators in the Circulation Department. Led by Peter Floud, they included Elizabeth Aslin, Shirley Bury and Barbara Morris. Their exhibition was a 'major turning point'[24] in the Victorian Revival.

The centenary of the V&A's opening at Marlborough House in 1852 provided a respectable reason for staging the *Victorian and Edwardian Decorative Arts* exhibition, which opened in October 1952. The brilliant young design critic, Reyner Banham, welcomed its 'eye-popping, hair-raising richness ... colour against colour, texture against texture, and pattern against ripe, bold, florid pattern – everywhere pattern':

Textiles and hangings twenty feet up the walls; the floor nicely cluttered with furniture, massive or flimsy, staid or eccentric. But not, *repeat* not, pretty or whimsical or amusing. This exhibition could be the death of the cult of fashionable Victoriana, for the imposing seriousness of what is to be

Figure 12.4
The lecturer,
Miss Beatrice
Goldsmid,
at work
with a group
of adults.

Figure 12.5
Mrs Renée
Marcousé talking
to a group of
children.

seen here reveals the tawdriness of the interior decorator's XIX Century fantasy.

The organizers of the exhibition had emphatically not chosen exhibits on the basis of their looks, but had admitted only what could be assigned to individual designers with secure provenance. Banham congratulated Floud on rescuing such designers 'from the oblivion of neglect and indiscriminate fancy', and was sufficiently impressed by their work to conclude that 'the whole orthodoxy of the descent of modern design appears to be in need of overhaul'.[25]

The Circulation Department received yet another of its periodic shake-ups under Ashton. It had been reshaped under Smith, when increasing demand for its services, combined with the exigencies of rearranging the collections, had made it obvious that it must have its own collections for loan, rather than operating as a sort of museum jackdaw, constantly purloining objects from the galleries. Since 1880 the Department had lent not only to art schools but also to museums and galleries; from 1919 it extended the loan service to secondary schools. After the Second World War, demand from schools looked likely to mushroom, 'for, as a consequence of the Education Act of 1944, the number of potential borrowers was suddenly increased by several thousand'. The Department aimed to set up a schools service gradually, over a period 'as long as ten years'.[26] This never came about, however. The Department did, indeed,

offer 'School Loans', but this term meant termly loans of framed material to art colleges and teacher-training colleges. Its more ambitious exhibitions went to 'public museums, art galleries and libraries'.[27] Serving secondary schools was too much to manage. The Department prided itself on the high quality of the historical material that it was able to exhibit, and also stressed its special interest in the contemporary. In 1950 it commented, proudly but perhaps a little bashfully, that 'the special requirements of Art Schools have naturally led to an emphasis on contemporary work, with the result that the Circulation Department's contemporary collections are now much more extensive than those of the main museum'.[28] In 1959, with greater determination, it pronounced:

The scope of the Department's collections is ... in many respects wider than that of the parent Museum, since it includes a high proportion of modern and recent objects ... The Circulation Department has been concerned more than the other Departments with modern work. It attempts to acquire systematically the best of contemporary work in this country and abroad. In this sense it acts as the growth-point of the Museum, and in most of the decorative arts its collections rank as the national collections of the present and of the past hundred years.[29]

But it is perhaps an index of how thoroughly antiquarian the V&A had now become that when Circulation, the 'modern' department, developed a consuming passion, it was (as we have seen) for Victorian and Edwardian art.

Figure 12.6
Television outside-broadcast vans at the museum in 1951. V&A exhibits had first appeared on television in a studio broadcast in 1939.

Certainly, this was regarded by the rest of the V&A as recent enough to be beneath notice, but it was hardly contemporary.

The museum addressed its audience, then, through events and exhibitions. Educational activity continued: lectures were now provided for adults by Miss Beatrice Goldsmid (figure 12.4) in Gibbs-Smith's department, with Miss Helen Lowenthal succeeding her in 1953,[30] while Mrs Renée Marcousé worked with schools (figure 12.5).[31] Gibbs-Smith cultivated the media with enthusiasm (figure 12.6), and was himself an experienced broadcaster. Under his control, museum publications brightened up considerably. It took some time to get major scholarly work into print. There were no more catalogues in the series that Cecil Harcourt Smith had begun; presumably the war's disruptions finally killed off this leisurely project. The Small Picture Books, however, were often reprinted, now in much more attractive dress; and they were joined by a series of Large Picture Books, which, while still aiming primarily at visual appeal, allowed staff to write at greater length. A series of more academic Museum Monographs was instituted. An observer might well have assumed that these were intended as a vehicle for the magisterial work of John Pope-Hennessy on Italian Renaissance sculpture, since four of the first six (appearing through 1949–52) were by him, but gradually other curators joined in.

In appearance, museum publications became much livelier, because from 1949 they were produced through His Majesty's Stationery Office. This Government department, originally set up to supply office equipment, also undertook official printing – from Parliamentary proceedings and Government reports down to savings certificates and radio licences. Its printing style had always been severely workaday and economical, but the post-war years saw an expansion in the 'popular "glossy" end of the Stationery Office's publishing activity'.[32] Sir Francis Meynell was appointed typographical adviser in 1945, and a 'Layout Department' was set up the following year under Harry Carter. Under the aegis of these distinguished typographers, artistic design was now applied to appropriate publications. Clearly, publications from an art museum were prime candidates for the new treatment, and one commentator, surveying HMSO's improvements, reported that 'the Victoria and Albert Museum is very exacting in matters of taste and workmanship, and publications for the Museum are carefully designed'.[33] Since the Stationery Office was a public body, it did not have to make a profit, only cover its costs. It issued such a wide range of publications that obscure, scholarly treatises from museums could be subsidized from receipts from the enormous sales of such items as the Denning Report on the Profumo Affair (the Government sex-scandal of 1963), or the report of the House of Lords debate on

D.H. Lawrence's novel *Lady Chatterley's Lover* at the time when this was on trial for obscenity in 1960.[34] From the V&A's point of view, the link with the Stationery Office was very useful, since official publications were supplied free 'for official use', and quantities of the museum's publications were sent out to other museums and libraries in order to obtain their publications in exchange.

Still feeling at ease in its spacious new building, the museum perhaps had no need to expand. It did so, nonetheless, by acquiring three 'stately homes'. In his book, *The Fall and Rise of the Stately Home*, Peter Mandler has shown how the country houses of the aristocracy were, in the mid-Victorian period, widely regarded with patriotic pride, and how they were often opened by benevolent owners as playgrounds for the poorer classes. Later in the century the aristocracy, beleaguered by agricultural decline, withdrew into their strongholds and kept the people at bay. After the First World War, as new forms of taxation bit, country houses were transformed into 'white elephants', and many were sold or destroyed. Then came a recognition of their importance as part of the country's heritage, and an increasingly active preservation movement. At the head of the preservationists was the National Trust, a private charity that had been founded in 1895. The National Trust arose out of attempts to safeguard the British countryside, as its full name, 'The National Trust for Places of Historic Interest or Natural Beauty', implies; and to begin with it bought land rather than buildings. In the 1930s the preservation of country houses became a political issue, and the Government and the Trust pulled together, in a typically English informal alliance, to tackle the problem. Taking advantage of Government tax concessions, the Trust's Country Houses Committee began a rescue campaign, which owed much to the personal intensity of the Committee's secretary, James Lees-Milne. He began work just in time, as the economic effects of the war brought one aristocratic family after another to the point where they could no longer keep up their houses. In 1945, when the Trust published a history of its first half-century, Lees-Milne felt confident enough to assert that 'for centuries now the great houses of Britain, with their infinite appeal and varied associations, have epitomized many aspects of this island's history, and they are at long last venerated as the traditional archives of our past and present'.[35]

As Lees-Milne's published diaries show, he made use in his campaigns of his contacts in the V&A, especially H. Clifford Smith and Ralph Edwards of the Woodwork Department, and Ashton himself. (Ashton is portrayed in the diaries, in Lees-Milne's characteristically uncharitable manner, as sweating a lot in hot weather: 'Leigh started to melt like a monstrous lump of butter'.[36] And Ralph Edwards does not escape. He is seen at work, 'directing an army of

Figure 12.7 Leigh Ashton arranging a showcase with curator
Michael Stewart.

slaves. With his beady eyes, raucous voice, little moustache
he looked like a seedy sergeant-major, cane in hand instead
of under the arm on the parade ground'.)[37] After the war,
the V&A, Mandler tells us, 'was now itching (under an
aggressive new director, Sir Leigh Ashton) to acquire some
complete houses with collections as satellite museums'. Its
first catch was Apsley House, at Hyde Park Corner in
London, the nineteenth-century residence of the Duke of
Wellington. The Duke gave the house and contents to the
nation in 1947, and it was placed in the care of the V&A,
which still runs it. Then came two co-operations with the
National Trust, which, when houses were offered to it, had
to find various ingenious ways of financing their upkeep. In
the case of Ham House, a seventeenth-century house on the
Thames bank near Petersham, and Osterley Park House, in
the western suburbs of London (a mansion remodelled by
Robert Adam in the late eighteenth century), the Trust
accepted ownership of the properties (in 1948 and 1949
respectively), while the V&A took responsibility for main-
taining them and opening them to the public. In adminis-
tering Apsley, Ham and Osterley, the V&A was able to study
the domestic decorative arts in context, and these houses
served in effect as research stations for the Furniture
Department's work on seventeenth-, eighteenth- and nine-
teenth-century interior decoration. For a time there seemed
to be a prospect that the V&A's involvement with country
houses would bring one of the greatest of them all,
Chatsworth in Derbyshire, into its ambit. When its owner,
the Duke of Devonshire, was faced with a huge bill for death
duties in the early 1950s, he offered Chatsworth to the
nation, and the Advisory Council's minutes for its meeting
on 9 June 1955 record that he and the V&A had reached an
agreement on how the museum would take it over and

administer it. The Inland Revenue, however, did not approve this arrangement.

Ashton's directorship, though a very busy one, was somewhat shorter than it might have been because he was overtaken by alcoholism. John Pope-Hennessy recalled the onset of Ashton's drink problem:

I first noticed what was wrong when, one day after lunch, I was arranging a wall case of medieval objects. I was dissatisfied with it, and when Ashton came through the gallery I asked him to put it right. 'My dear, take all the objects out, and I will do it,' he replied, so all the objects were removed from the case, and he slowly put them back in exactly the same positions they were in before.[38]

This is an interesting vignette of museum life for reasons other than for what it tells about Ashton's decline. First, it gives us a glimpse of the showman at work: the staff were used to him intervening to give his personal touch to gallery displays, and knew that he did display work better than they could.[39] Second, it was the job of curators – even curators of the eminence of Ashton and Pope-Hennessy –

MUSEUM SWORDS SMUGGLED OUT IN TROUSER LEG

Figure 12.8 John Nevin, 'the Magpie of Nightingale Close'.

physically to set out objects in cases (figure 12.7), a task that would now involve teams of designers, conservators and technicians.

During his frequent indispositions, Ashton was loyally protected by his secretary, Miss Gammack, and the museum was run by his assistant, Terence Hodgkinson (later to become Director of the Wallace Collection). But Ashton had to retire early in 1955, and ended his life in a nursing home.

It was during Ashton's twilight that the museum was overtaken by one of the biggest scandals in its history. Some objects proved to be missing, and suspicion fell upon a 58-year-old museum assistant, John Andrew Nevin (figure 12.8). When Detective-Sergeant Ernest Bellamy turned up on the doorstep of Nevin's little house in Nightingale Close, Chiswick, with a search warrant in pursuit of stolen goods, Mrs Nevin blurted, 'I have never taken anything in my life. I have accepted things, that's all. I told him not to bring all that stuff home.'

Enough was found to charge Nevin with theft from the museum. This was in April 1954. When the police went back to make further searches, Nevin had feebly tried to conceal his booty:

Inside the dust bag of the vacuum cleaner, and hidden in the dust, were 21 sword-guards and a jade figure. Behind the lagging of the hot-water tank were gilt figures, while a large number of very valuable and exclusive watches had been put in a bag inside the water cistern, with the result that they have been ruined ...

By the end of April the police had found 1,000 museum objects, 'ranging from a rare 17th century Russian tankard to a beautifully embroidered Persian prayer rug'. By 21 May the total was up to 1,400, including 'specimens of Spode ware, a Flemish tapestry of the "Baptism of Christ", a Swiss gold snuff-box, ... two inlaid tables, ... a bronze statuette', together with 'six Elizabethan trenchers, a Japanese tray, a cake basket ...' When Nevin went on trial in June, he pleaded guilty to 25 charges of theft and asked for 1,935 other charges to be taken into consideration.

Nevin had started work at the museum in 1930, and for the next 23 years helped himself to anything that took his fancy. His job was to move objects around, so it was not difficult for him to move things into his own possession. The convulsive shifting around of objects occasioned by the war made his depredations even easier. He did not sell or damage what he took, but kept it carefully in his little rented council house. All he would say was: 'Taking the things became an obsession as I was attracted by the beauty of them.' The popular press was intrigued by this crazy character (who must indeed have been slightly mad), and dubbed him 'The Magpie of Nightingale Close'. According to the *Daily Sketch*:

Figure 12.9 Trenchard Cox with HM Queen Elizabeth II in 1962.

Nevin … would walk proudly and stiffly down the road home. Neighbours thought he walked stiffly from Army training. The truth is that there were priceless swords, Japanese carved scabbards, and once a Spanish blunderbuss down his trouser legs.

The *Daily Express* imagined Mr and Mrs Nevin taking tea from 'fragile painted cups and saucers', after which 'homely-looking Mrs Nevin would put on her apron – a rare piece of 18th century tapestry – to wash up'. When Mrs Nevin went out shopping, her bag, according to the *Daily Mirror*, 'was a beautiful piece of seventeenth century leatherwork'.

Nevin was sentenced to three years' imprisonment, and Mrs Nevin was put on probation. The museum came in for expected criticism. 'Is there an inventory? When last was it checked? Do the officials know so little about their exhibits that nearly 2,000 of them can disappear before anybody notices that anything is missing?'[40] There were museum records, but Nevin had tampered with them to cover his tracks. It took a long time for museum staff to sort through his loot in Chelsea Police Station, identify the pieces and return them to their proper place.

Ashton's successor was Trenchard Cox (figure 12.9), the first – and so far the only – V&A Director to come to his post from a provincial museum: he had been Director of the Birmingham Museum and Art Gallery. Interchange of staff at any level between national and provincial museums in Britain remains rare. Cox was, however, by no means a homespun countryman. With an impeccable educational background (Eton and King's College, Cambridge, where he took a First in Modern Languages), he had learned the ropes in the museum profession at national museums (the

National Gallery, the British Museum and the Wallace Collection), with a period of study in Berlin. After war service, he went to the Birmingham Museum: 'it seemed to many of his friends an unpromising field for one born and bred in London with decidedly metropolitan tastes'.[41] He was very successful, and became recognized as the spokesman for British provincial museums.[42] On reaching the V&A in 1956, he was in a position to 'appraise, only too well, the finer shades of prejudice and snobbishness' that caused national museums to stand aloof from provincial museums, and he worked to overcome the differences: 'It would be my dearest wish that, before I retire from office as a museum director, this deplorable gap should be further bridged.'[43] His mild demeanour, with owlish looks and lamb-like tones, was transfigured by his eager benevolence. At the V&A, 'within weeks of his arrival he had become renowned for knowing the names of all members of staff, not to mention the husbands of the cleaning ladies'.[44] In his early days he also held a series of drinks parties at his home for museum staff, and even the most diffident were not allowed to resist his attempts to get to know them.[45] His kind and scrupulous temperament enabled him to act as a reconciler not only within the British museum profession, but within the V&A itself, where prickly departmental Keepers were charmed into co-operation. 'For an institution in which the departmental heads had not been on speaking terms and junior staff felt discouraged, the change was dramatic.'[46]

Cox confessed that, while at Birmingham, he had taken Leigh Ashton's work at the V&A as his model. So it was not likely that he would undo any of Ashton's displays for ideological reasons. In fact he committed himself to continuing his predecessor's work – notably in the revised Continental Baroque galleries, opened in May 1958.[47] He did, however, have to make some changes to the building, for the very practical reason that by now, after half a century of use, Aston Webb's palace was running out of space.[48] 'One of my first tasks as Director,' he recalled, 'was to re-establish the Indian Collections in new Primary and Study Rooms.'[49] This was because in 1955 the Indian Collections were quite abruptly expelled from the Eastern Galleries (on the western side of Exhibition Road), which, along with the neighbouring Imperial Institute building, were to be demolished to make way for extensions to Imperial College. Although much of the collections had to go into store, an Indian Primary Gallery opened in December 1956 in Room 41.[50] This was one of five lofty courts that formed an architectural core in Aston Webb's building, within the multi-storey perimeter galleries. (The two outer courts, Rooms 41 and 45, predated Webb, but were neatly absorbed in his scheme.) As we have seen, two of the five courts had been devoted by Ashton to Islamic and Far Eastern art, while the

central court contained Early Medieval Art, leading on to the rest of the Primary Gallery sequence. This latter gallery was to be the scene of another space-saving manoeuvre in 1966–7, when its upper portion was filled in to accommodate new book stacks for the adjoining Library. While this development greatly eased the Library's problems and rationalized its storage, it effaced Aston Webb's cornices and barrel vault. Such a treatment of a historic interior would not be permitted today. But, now that museums try to exclude natural light, no present-day architect would build such enormously high, top-lit halls as Webb had provided, enclosing such tantalizing quantities of wasted space.

A more sympathetic solution to the space problem was found for the nearby Octagon Court, where the great dome enclosed a vast amount of empty air. Here, a free-standing circular platform was erected in 1960–2. Underneath this a new costume display was installed,[51] and on top of it was a new gallery for the musical instrument collection, eventually opened in 1968.[52] A less successful expedient along the same lines was the insertion of a new picture gallery in the upper parts of the North Court.[53]

While four of the five central rooms just mentioned were occupied by Primary Collections, the fifth (Room 45) was used, until 1983, as the museum's principal temporary exhibition gallery. In addition to this, the Department of Engraving, Illustration and Design and the Library each had exhibition galleries (Rooms 70–3 and 74 respectively), and the Circulation Department showed many of its travelling exhibitions in a small gallery near the new restaurant (Room 38A). The more or less ceremonial spaces near the front entrance also continued to be used for temporary exhibitions from time to time. The V&A could therefore sustain a lively exhibition programme, usually encompassing about a dozen shows per year during Cox's time. Perhaps the most important, in terms of art history, was the Arts Council exhibition of *Italian Bronze Statuettes* (1961), organized by John Pope-Hennessy (figure 12.10). Important in other respects was *Finlandia* (1961–2), an exhibition of modern Finnish design. First, it was an exhibition of contemporary material. Second, it represented the sort of contemporary design with which the museum (in other words, the Circulation Department) felt comfortable – not the 'hard' modernism of Germany, but the softer

Figure 12.10
The *Italian Bronze Statuettes* exhibition in 1961. A traditional display, using stock equipment from the museum.

Figure 12.11
The *Finlandia*
exhibition, 1961.
The contribution
of the designer is
evident.

modernism of Scandinavia and northern Europe. And third, it seems to have been the first exhibition staged by the V&A (aside from *Britain Can Make It*) to have been through-designed by a professional designer, Timo Sarpaneva (figure 12.11).[54]

Large and splendid exhibitions supported by the Arts Council included *The Orange and the Rose* (1964), which explored Anglo-Dutch cultural history, and in 1963 an exhibition of the English medieval embroidery known as *Opus Anglicanum*, which was the principal achievement of the medievalist Donald King, who later became Keeper of Textiles in 1972. Two exhibitions which most adeptly caught and influenced public taste of the time were staged in the galleries of the Department of Engraving, Illustration and Design by Brian Reade, a melancholy, long-featured curator with glinting black (dyed) hair. These were devoted to the Art Nouveau posters of *Alphonse Mucha* (1963) and to the *fin de siècle* illustrations of *Aubrey Beardsley* (1966). The latter exhibition has been hailed as 'an important event', which

influenced contemporary design mightily, from the floral wrappers of *Oz* magazine, to the insistent black and white of the 1960s mini, to, alas, the cover of every single record by Yes. The rediscovery of Beardsley helped shape the look of the 1960s ... and gave succour ... as that naughty decade progressed with its ... sexual experiments.[55]

The museum's publication programme now began to bring forth weighty tomes alongside the picture books. Weightiest of all were the three red volumes of John Pope-Hennessy's *Catalogue of Italian Sculpture* (1964), with, as its nearest rival, Graham Reynolds's thick green *Catalogue of the Constable Collection* (1960). In thus producing catalogues of sculpture and of Constable, its major holdings of fine art, the V&A was positioning itself on the highest ground it could expect to occupy, in the realm of art history as it was then constituted. (Graham Reynolds became Keeper of the Department of 'Engraving, Illustration and Design' in 1959, and two years later dropped this rather workaday title in favour of 'Prints and Drawings', a more dignified locution associated with museums of fine, rather than applied, art.) Other substantial publications in Cox's time were Peter Ward-Jackson's *English Furniture Designs of the Eighteenth Century* (1958) and W.G. Archer's *Paintings of the Sikhs* (1966). A prolific writer in the 1960s and '70s was John Hayward, who eventually left the museum to work in the auction houses. It was during Cox's time that, from about 1963, the museum's publication programme began to include contributions not only from the senior staff (Keepers and Assistant Keepers) but from the grades below (Senior Research Assistants and Research Assistants), who were also permitted to give lectures in the Thursday evening lecture programme.[56]

Figure 12.12 Peter Floud (centre) and James Laver.

The most interesting corporate venture in the intellectual field continued to be the exploration of Victorian design in the Circulation Department. This was under the 'indefatigable, almost visionary leadership'[57] of Peter Floud (figure 12.12), whose sudden death in 1960 was a great loss to the museum. Although Nikolaus Pevsner lamented that Floud had been 'the only scholar who was doing consistent, thorough and imaginative research' into Victorian design,[58] this was not quite true: he left his team behind and they carried on with the work. Floud published little, but his team – including his successor as Keeper, Hugh Wakefield – produced a number of books on Victorian embroidery, pottery, glass and furniture. In 1962 they mounted a centenary exhibition recalling *The International Exhibition of 1862* ('in all its tawdry banality', said a critic not yet reconciled to Victorian design),[59] and October 1964 saw the opening of the first stage (of three) of a new Primary Gallery, in the British sequence, devoted to Victorian Decorative Art. The gallery was completed in 1966. As in the exhibition of *Victorian and Edwardian Decorative Arts*, the emphasis here was on documented star pieces, and the museum was at pains to assure the public that the new galleries were not merely a 'timely response ... to the current fashion for collecting Victoriana':

Instead of attempting – in the manner of the Victorian rooms that are now becoming a regular feature of our local museums – to evoke a 'typical' Victorian ambience, they are designed to chart a path through the conscious art movements of the period, concentrating on designers and in general eschewing the typical in favour of the original and the significant.[60]

Because there was no room at South Kensington for a Primary Gallery of European and American Decorative Art of the nineteenth century, this was later established at Bethnal Green by Elizabeth Aslin, and opened in January 1971.

The opening of the Victorian gallery showed that, with the passage of time, the V&A had become more comfortable with the art of the previous century. But there was still a communal block about recent art, epitomized in a remark by James Laver. Although he was as sympathetic as anyone to what was going on around him, he felt that the art of the past had to serve time in purgatory (to use Cecil Smith's phrase) before it became worthy of reception in the heaven of the V&A. He said:

I have spent a good part of my life in trying to plot the 'gap of appreciation' – that is the time which must elapse before a discarded style comes into favour again. It seems to be a law of our own minds that we find the art forms of our fathers hideous, the art forms of our grandfathers amusing and those of our great-grandfathers attractive and even beautiful.[61]

The idea that our tastes are ruled by such a mental law is, of course, nonsense, but V&A curators seemed to need to believe it.

Trenchard Cox's memory is still revered in the V&A because of his care for his staff. He felt that 'perhaps because of its very richness and complexity and the unplumbable resources of its treasures', the V&A 'remains a mystery to the outside world' in respect of its administration and working life.[62] But the workings of the institution were of great interest to him, and he did much to improve them. Two important functions of the museum were given recognition in the staffing structure. The V&A had for long possessed a band of craftsmen (the 'Art Work Room') who restored exhibits by the light of their inherited skills: 'our workshops,' said Cox, 'in which the most expert craftsmen of many kinds are employed (cabinet-makers, gilders, embroideresses, to name but a few), are ... among the busiest sections of the museum'.[63] In 1960 the workshops were gathered up into a new Conservation Department headed by Norman Brommelle, a scientifically qualified conservator formerly at the National Gallery. The V&A's educational work had been gradually expanding under the aegis of Gibbs-Smith's Public Relations Department. In 1956, still within that department, it was made a semi-autonomous section, in the charge of Madeleine Mainstone, a strenuous educational missionary. It was later to become an independent department. Cox's assistant, Michael Kauffmann, recalled other changes in the staffing structure, designed to make it less constricting:

Figure 12.13 From the right: Charles Gibbs-Smith, Terence Hodgkinson and Ray Smith. Smith joined the museum straight from school as a Boy Attendant, before the Second World War. He was one of a group of such staff who rose by sheer practical competence to senior administrative positions, and for whom room had to be found in the promotion system. After 40 years he retired with the paradoxical job title 'Senior Research Assistant (Administration)'.

For the first time, Research Assistants, many of them women, were able to cross the class divide to the Assistant Keeper grade, and also for the first time, a black warder was promoted to Supervising Warder. With hindsight it is clear that these changes were inevitable, not to say long overdue, but in the early 1960s they would not have occurred without the initiative and active support of the director.[64]

It was necessary to improve the prospects of promotion for the staff, since most spent their entire working life in the museum (figure 12.13). Although long service was a source of pride – when the Queen visited the museum in 1962, she was introduced to staff who had been employed for 26, 28, 32, 34 and 36 years[65] – it could also be dispirit-

ing if the structure was too rigid to provide due reward. The well-being of the staff was not the first priority of Cox's successor, so Cox's efforts to raise the museum's morale were all the more important.

When Cox retired at the end of 1966, John Pope-Hennessy was appointed to the directorship. When he joined the V&A just before the war, he worked in the Department of Engraving, Illustration and Design, but had to break off his career for war service. 'As soon as the war ended I agreed to return to the Victoria and Albert on condition that I be appointed to the Department of Sculpture.'[66] The uncompromising tone of this reminiscence indicates the ascendancy that Pope-Hennessy enjoyed within the museum; this was unchallengeable in later years, but was presumably effective even in 1945.

Pope-Hennessy (figure 12.14) is the only Director of the V&A apart from Henry Cole to have written an autobiography. (Roy Strong's diaries are full of immediacy, whereas autobiographies may be expected to provide a considered retrospect.) Cole's autobiography is a wholly official

account, and Pope-Hennessy's hardly admits the reader to intimacy. Given these limitations, a comparison of the two life stories is instructive. Cole's is about *trying*: about his almost neurotic need always to be breaking new ground, changing the world and keeping everyone else on the hop. The title-page bears Cole's motto: 'Whatsoever thy hand findeth to do, do it with thy might'. Such bustle was not for Pope-Hennessy. His autobiography presents a man who is apparently effortlessly discharging, with supreme accomplishment, a defined and esteemed task in a settled world. Pope-Hennessy's background – he was from a family of colonial administrators – no doubt helped him to play a

Figure 12.14 John Pope-Hennessy exerting charm upon Miss Jennie Lee, appointed in 1964 as the first Government Minister for the Arts in the Labour Government. James Lees-Milne thought that Pope Hennessy 'has little natural charm and when he endeavours to exhibit this exiguous quality attains it more readily than ordinary people' (*Ancient as the Hills*, 1997, p. 148). Pope-Hennessy got on well with Jennie Lee, and ensured that the V&A fell in with her plans for opening national museums on Sunday mornings. The V&A had Sunday-morning opening from 7 April 1968 until 6 April 1969, when funding difficulties curtailed the experiment.

social role securely, and added assurance to the role of cultural diplomat, which came increasingly to him as he grew more distinguished.

The role that he principally wished to play, however, was a scholarly one. After school at Downside, Pope-Hennessy went to Balliol College, Oxford, to read history, but at once set out to conquer the world of art history, getting to know the best scholars and studying the best museums on an international circuit. In 20 years in the Sculpture Department of the V&A he acquired visiting professorships and membership of learned societies on a scale that put him, in academic status, far ahead of anyone else in the museum. His distinction, combining a glittering intellect and a dominant personality, made it almost inevitable that he would become Director.

He was a forbidding man, with a basilisk stare which could freeze those he disapproved of. James Lees-Milne recorded that his circle were 'agreed that of all the high-brows we knew John Pope-Hennessy was the least tolerant of silly people'.[67] He spoke in a high, strangled drawl (a 'screech', as Roy Strong called it),[68] which seemed to compel mimicry (not to his face, of course) from anyone who ever heard it. Colleagues who were interviewed by him in his office were seated beside his desk in a low chair, which held them in a semi-recumbent posture, looking up at him as if at a dentist. The sensitivity of his art historian's eye was renowned and, as an accomplished pianist and vigorous typist, he obviously had considerable manual dexterity; it was all the more surprising, then, that his handwriting was an illegible confusion of formless scrawls.

Upon his accession, he was seen as the natural leader of his profession. 'The seat of power, from the point of view of the English museums, will now be situated at the Victoria and Albert Museum'; and it was expected that, in relations with Government, his 'influence behind the scenes will be considerable'.[69] It is probably true that the museum gained more lustre from his presence at its head than it was able to bestow on him.

Perhaps because he enjoyed such ascendancy in a settled world, he did not make many changes to the museum. But he certainly made it work harder. The Advisory Council, which rarely dealt with policy issues in Pope-Hennessy's time, was treated to exhaustive reports of the achievements that he extracted from his staff in the accepted fields of curatorial activity. Each quarterly Council meeting would listen to Pope-Hennessy's recitation of 50 or more important acquisitions, exhibitions, building works, publications or staff changes, and there were few opportunities for Council members to advance their own concerns – though the formidable architect Jane Drew embarked, at the meeting on 11 June 1970, upon a campaign to improve the restaurant. It is interesting that it was in Pope-Hennessy's incumbency

Figure 12.15 Part of the new Eighteenth-Century Continental
Primary Galleries, 1972.

that the Council, for the very first time (so far as the minutes
reveal), took note of visitor attendance figures, at their
meeting on 12 December 1968. They might perhaps
have maintained their lofty ignorance of this mundane
matter, were it not that the Conservative party in opposi-
tion was already promoting a policy of admission charges to
national museums.

To the public the most noticeable development in the
V&A was that 'under John Pope-Hennessy's directorate it
has radically stepped up its exhibition program'.[70] Whereas
there were a dozen exhibitions a year in Cox's time, in
Pope-Hennessy's there might be up to 30. The ones he
particularly recalls in his autobiography are those that
involved an element of diplomacy: the Anglo-Soviet exhibi-
tion (1967), which brought the Russian Head of State,
Alexei Kosygin, to South Kensington; *Hungarian Art
Treasures* (1967) which took Pope-Hennessy to Budapest,
and *Baroque in Bohemia* (1968), which took him to Prague;
and the Council of Europe's *Age of Neo-classicism* exhibition
in 1972. His wide cultural interests found expression in
three major biographical exhibitions devoted to creative
figures who were not visual artists: *Berlioz and the Romantic
Imagination* (1969: an Arts Council exhibition at the V&A),

Dickens (1970) and *Byron* (1974). For these he gathered
together expert planning committees, which he chaired
himself. At that period any biographical exhibition could
not help but be influenced by the memory of Richard
Buckle's celebrated Shakespeare exhibition at Stratford in
1964, and these three were distinguished by their evocative
presentation, the settings for *Berlioz* and *Byron* being
created by the stage-designer Alan Tagg. Biographical exhi-
bitions on this scale have hardly been seen since in Britain.
In the 1970s the Victorian lobby in the museum was still
flourishing, and produced two large exhibitions: *Victorian
Church Art* (1971–2) and *Marble Halls* on secular architec-
ture (1973).

Within the established gallery sequence, several galleries
were refurbished. The Eighteenth-Century Continental
Primary Galleries, laid out by the Furniture Department,
were opened in 1972. In basement galleries, not the most
spacious in Aston Webb's building, these displays were
further constricted by the introduction of air-conditioning.
The final effect, in a series of recessed spaces around a
central alley, was small-scale and 'boxed-in' (figure 12.15).
Pope-Hennessy himself revised the Gothic and Renaissance
galleries around the quadrangle, completed in summer
1970. He modelled them on his memories of Wilhelm
Bode's Kaiser Friedrich Museum in Berlin,[71] but the amount
of space available somewhat diluted the effect of the

exhibits. Pope-Hennessy did not undertake major construction works, but he left his mark on the building. Folk memory[72] assigns to him responsibility for covering up acres of the mosaic floor of the museum with black linoleum. This is regarded by preservationists as a crime, not least because, if the lino is stripped off, it brings the mosaic up with it. But the strikingly patterned floors are very difficult for designers to work with, and several have been concealed in more recent times under later installations – but carefully, so that they can be revealed again, undamaged. Though in some ways a very traditional curator, Pope-Hennessy had no difficulty in recognizing that designers should play a role in museum display,[73] and appointed the V&A's first in-house designer, Ivor Heal, in 1970.

Owing to his long experience in the museum, Pope-Hennessy had a keen sense of the strengths and weaknesses of its departments, but he chose to make only one change to the structure, a very important one. Recognizing that it was anomalous for the museum to treat its Indian holdings as a separate entity, while its Far Eastern and Near Eastern holdings were dispersed among the material-based departments, he created an Oriental Department. This consisted of the existing 'Indian Section' to which was now added a new 'Far Eastern Section'. Chinese and Japanese art was gathered together and put in the charge of the new section. This was headed by John Ayers, and specialist staff were recruited.[74] In due course, the two sections became independent departments, and their existence raises the question whether an Islamic or Near Eastern Department should be created, too.

Curatorial life in general followed accustomed tracks. Although increasingly busy with exhibitions, curators continued to engage in a daily dialogue with collectors and dealers. For the collector Stowers Johnson, who devoted several pages of a book to describing an opinion session at the V&A, the museum was still 'essentially a Teaching Gallery where exhibits are arranged for one to learn from. The things there are collectors' items, some are actual collections given by collectors such as you or me.'[75] Antiquarian interests and object-based research were the norms in the museum, and the pressure to conform was powerful. Those who did not conform stood out. One such was Hungarian-born Robert Kenedy, a fully fledged modern intellectual: poet, novelist and influential critic (mostly in the journal *Art International*) of contemporary art. He was an Assistant Keeper in the Library, and died prematurely in 1980. It says something of the museum's limitations that he was generally regarded as an amusing exotic. Tarred with the same brush was Carol Hogben (Mr) – as he was obliged to sign himself, owing to his ambiguous first name. He was the Circulation Department's specialist in contem-

Figure 12.16
George Wingfield
Digby in 1966.
Digby was Keeper
of Textiles
1947–72.

(*Left*) Figure 12.17
Claude Blair in 1968. Blair was Keeper of Metalwork 1972–82 and, after his retirement, led the 'Save the V&A' campaign in 1989–91.

(*Above*) Figure 12.18
Peter Thornton in 1970.
Thornton was Keeper of Furniture 1966–84, and subsequently Curator of Sir John Soane's Museum, 1984–95.

(*Left*) Figure 12.19
John Physick in 1970.
A historian of sculpture and architecture, Physick was Keeper of Museum Services 1975–83, and eventually Deputy Director under Roy Strong.

porary art. It is true that his character had some sharp angles, but this would hardly have been noticeable among the jagged personalities of the V&A, were it not that his interest in the contemporary marked him out as eccentric.

Pope-Hennessy tried to give a higher profile to traditional curatorial work. Just before he became Director, he was instrumental in launching the quarterly *V&A Bulletin* (1965–8), published by Her Majesty's Stationery Office. After its demise he launched the *V&A Yearbook* (4 volumes, 1969–74), published by Phaidon Press. These were outlets for the kind of article most favoured by curators: very narrowly focused essays about a single object or group of objects. There proved to be insufficient readers with a taste for such fare to support these periodicals. Even when Pope-Hennessy's successor, Roy Strong, tried a third time with the *V&A Album* (1982–9), in which curators' dry crusts were interspersed with more popular features and advertisements, economic reality again condemned the venture to failure. Among the many estimable essays in these periodicals, it is worth noticing, in the *Bulletin* in 1967, a series of three articles by Peter Ward-Jackson, of the Prints and Drawings Department, on 'Some main streams and tributaries in European ornament from 1500–1750'. While these articles may have seemed fairly arcane, they were not without significance in the history of the museum, for they disinterred a body of graphic material that had been of great importance to applied-art museums in their early days, had been discredited by the Modern Movement (in the eyes of which, famously, ornament was a crime) and now, under Ward-Jackson's scrutiny, started on the road back to rehabilitation.

During his tenure of office, Pope-Hennessy despatched administrative business quickly and preserved plenty of time for academic work, a style that he was unable to keep up at the British Museum, where he became Director in 1975. As he pointed out,[76] the British Museum, which was run 'at arm's length' from Government under a Board of Trustees, had to conduct all its own administrative business. The V&A, however, was still part of the Civil Service (as it had been since Cole's day), and its Director was relieved of much administrative business by the officials of the Department of Education and Science. Pope-Hennessy was to be the last Director to profit from this arrangement. By 1986 his successor had to acknowledge ruefully that 'we have entered the era of the curator-manager'.[77] Pope-Hennessy wrote scathingly of the decline that he perceived to have set in at the V&A under his successors: the index to his autobiography has an entry for 'Victoria and Albert Museum, collapse of'. But profound changes were about to take place in British cultural politics, and it is doubtful if even Pope-Hennessy's monumental personality could have withstood them.

NOTES

1 'Museums – Post-War Fashions', *Apollo*, vol. 51, 1950, p. 84.

2 Charles H. Gibbs-Smith, '"The Fault … is … in Ourselves"', *Museums Journal*, vol. 64, 1964–5, pp. 227, 229, 231, 232.

3 Author's personal knowledge.

4 See his job description in Archive: Ed. 84/411.

5 Also in Archive: Ed. 84/411. The address includes references to movies and social functions.

6 See Archive: Ed. 84/319.

7 'Museum Gallery Concerts. Acoustics at South Kensington', *The Times*, 31 October 1950: V&A Cuttings Book, Times N, March 1950–August 1952, p. 77. Information about aircraft noise from John Physick.

8 Letter from Ashton to Alfred Clark, 23 June 1945, in Archive: Ed. 84/319.

9 *The National Museums and Galleries: the War Years and After. Third Report of the Standing Commission …*, London: HMSO, 1948, p. 38.

10 Letter from Lord Broughshane, 'The Problem of Picasso', *Journal of the Royal Society of Arts*, 1 February 1946, p. 169.

11 Herbert Read, 'The Problem of Picasso', ibid., 18 February 1946, p. 127.

12 F.A. Mercer, 'The Writing on the Wall', *Studio*, vol. 131, 1946, p. 91.

13 'London Letter', *Art News*, March 1946, p. 59.

14 *Museums Journal*, vol. 45, 1945–6, p. 198.

15 John A. Thwaites, 'London Letter: Why do the English Hate Picasso?', *Magazine of Art*, vol. 39, May 1946, p. 176.

16 Ibid.

17 For a fuller account, see Doreen Leach, 'Further Sources for Researching the *Britain Can Make It* Exhibition 1946. A. Notes on the Material Contained in the Victoria & Albert Museum Archives' in Patrick J. Maguire and Jonathan M. Woodham (eds), *Design and Cultural Politics in Post-war Britain: the* Britain Can Make It *Exhibition of 1946*, London: Leicester University Press, 1997, pp. 224–9.

18 *Journal of the Royal Society of Arts*, 26 December 1952, p. 90.

19 James Gardner, *The ARTful Designer: Ideas off the Drawing Board by James Gardner*, n.p.: Lavis Marketing, 1993, p. 141.

20 Museum photographs (negative numbers M1951–2) show object supports made of what seems to be perspex but could be glass. Perspex was certainly in use by April 1951: 'Italian Renaissance medals … are mounted on simple transparent plastic frames' ('Late Gothic and Renaissance Art at the Victoria and Albert Museum', *Burlington Magazine*, vol. 93, 1951, p. 130; and see museum photograph J800).

21 See Elizabeth James, *The Victoria and Albert Museum. A Bibliography and Exhibition Chronology, 1852–1996*, London: Fitzroy-Dearborn, 1998.

22 Humphrey Carpenter, *The Brideshead Generation*, London: Weidenfeld and Nicolson, 1989, pp. 39–41, 104–5.

23 Reception: *The Times*, 24 June 1931. Description: 'Art Exhibitions. "Age of Artistic Curiosity"', *The Times*, 2 June. Letters: *The Times*, 10 June, 16 June. V&A Cuttings Book, Times, January–August 1931, pp. 220, 188, 201, 210.

24 See Peter York's chronology of the revival in 'Victorian Values' in his *Modern Times*, London: Futura, 1985, pp. 52–61. Also Jonathan Penny, 'Towards the Victorian Society', *Victorian Society Annual*, 1994, pp. 23–7.

25 Reyner Banham, 'Here's Richness', *Art News and Review*, vol. 4, no. 21, 15 November 1952, p. 3.

26 *V&A Museum Circulation Department. Its History and Scope*, London: Victoria and Albert Museum [1950], p. 7.

27 Hugh Wakefield and Gabriel White, *Circulating Exhibitions* (*Handbook for Museum Curators*, part F, section 1), London: The Museums Association, 1959, p. 14.

28 *V&A Museum Circulation Department ...*, p. 3.

29 Wakefield and White, op. cit., p. 8.

30 Helen Lowenthal, 'The Function of Museum Lecturers', *Museums Journal*, vol. 61, 1961–2, pp. 280–3. For programmes of the lectures by Goldsmid and Lowenthal, see V&A Archive: Ed. 84/407.

31 Renée Marcousé, *The Listening Eye: Teaching in an Art Museum*, London: HMSO, 1961.

32 Hugh Barty-King, *Her Majesty's Stationery Office. The Story of the First 200 Years, 1786–1986*, London: HMSO, 1986, p. 84.

33 Charles Batey, 'The Printing of His Majesty's Stationery Office', *Penrose Annual*, vol. 44, 1950, pp. 35–6.

34 Barty-King, op. cit., pp. 85, 88.

35 James Lees-Milne (ed.), *The National Trust: A Record of Fifty Years' Achievement*, London: Batsford, 1945, p. 61.

36 James Lees-Milne, *Midway on the Waves*, London: Faber, 1985, p. 77. Cf. James Lees-Milne, *Caves of Ice*, London: Chatto & Windus, 1983, p. 169.

37 Lees-Milne, *Midway on the Waves*, p. 84.

38 John Pope-Hennessy, *Learning to Look*, London: Heinemann, 1991, p. 163.

39 Information from G.D.A. McPherson.

40 *Recorder*, 14 June 1854: V&A Cutting Book, V&A and V&A Exhibitions, 1948–1954, p. 231. The rest of this account is put together from copious and repetitive cuttings in this volume.

41 'Profile: Sir Trenchard Cox', *Apollo*, vol. 77, 1963, p. 147.

42 Cf. Trenchard Cox, 'The Provincial Museum', *Journal of the Royal Society of Arts*, vol. 97, 1948–9, pp. 555–68.

43 Trenchard Cox, 'Presidential Address', *Museums Journal*, vol. 63, 1963–4, pp. 175, 173–4.

44 C.M. Kauffmann, 'Obituary: Sir Trenchard Cox (1905–95)', *Burlington Magazine*, vol. 138, 1996, p. 258.

45 Information from John Physick.

46 Kauffmann, op.cit., p. 258

47 Trenchard Cox, 'History of the Victoria and Albert Museum and the Development of its Collections', *Proceedings of the Royal Institution of Great Britain*, vol. 37, 1959, pp. 303, 295. Cf. 'Primary Galleries at the V. & A.', *Museums Journal*, vol. 58, 1958–9, pp. 65–7.

48 Physick, chapter 16.

49 Cox, 'History of the Victoria and Albert Museum ...', p. 295.

50 W.G. Archer, 'New Indian Galleries', *Museums Journal*, vol. 56, 1956–7, pp. 234–6.

51 Peter Thornton, 'The New Arrangement of the Costume Court in the Victoria & Albert Museum', *Museums Journal*, vol. 62, 1962–3, pp. 326–32.

52 Peter Thornton, 'The new musical instrument gallery at the Victoria and Albert Museum', *Museums Journal*, vol. 68, 1968–9, pp. 168–70.

53 'New Galleries at South Kensington', *Museums Journal*, vol. 57, 1957–8, pp. 264–6.

54 Barbara Morris, *Inspiration for Design: the Influence of the Victoria and Albert Museum*, London: Victoria and Albert Museum, 1986, pp. 198–200.

55 Waldemar Januszczak, 'A bad boy who never grew up', *Sunday Times*, 'Culture', 11 October 1998, p. 2.

56 Information from John Physick, whose *Engraved Work of Eric Gill* (1963) and *Duke of Wellington in Caricature* (1965) are cases in point.

57 Obituary of Floud, *Graphis*, March/April 1960, p. 177.

58 Obituary of Floud, *Architectural Review*, vol. 127, 1960, p. 154.

59 George Savage, 'The Victorian Wasteland', *Studio*, vol. 164, 1962, p. 206.

60 Anthony Radcliffe, 'The Victoria and Albert Museum and the Decorative Arts of the Nineteenth Century', *The Victorian Society Annual Report* [London], 1966, p. 58.

61 Robert Wraight, *The Art Game*, London: Leslie Frewin, 1965, p. 42.

62 Cox, 'History of the Victoria and Albert Museum ...', p. 299.

63 Ibid., p. 291.

64 Kauffmann, op. cit., p. 258.

65 Official file in V&A Archive: accession number A0116.

66 Pope-Hennessy, op. cit., p. 77.

67 James Lees-Milne, *Midway on the Waves*, London: Faber, 1985, p. 52.

68 Roy Strong, *The Roy Strong Diaries, 1967–1987*, London: Weidenfeld & Nicolson, 1997, p. 117.

69 'Editorial. Changes at the Top', *Apollo*, vol. 85, 1967, p. 159.

70 *Art in America*, September/October 1970, p. 99.

71 Pope-Hennessy, op. cit., p. 43.

72 No doubt there is an official file on this matter, but I have not located it.

73 John Pope-Hennessy, 'Design in Museums', *Journal of the Royal Society of Arts*, vol. 123, 1974–5, pp. 717–27.

74 John Ayers, *Oriental Art in the Victoria and Albert Museum*, London: Scala/Philip Wilson, 1983.

75 Stowers Johnson, *Collector's Luck*, London: Phoenix House, 1968, p. 92.

76 In a broadcast interview with Alan Borg, BBC Radio 3, 'Third Ear', 7.05 p.m., 31 May 1991.

77 *Victoria and Albert Museum. Report to the Board of Trustees. October 1983–March 1986*, 1986, p. 9.

CHAPTER THIRTEEN
Cultural Politics in the Late Twentieth Century

From the Second World War into the 1970s culture was valued and encouraged by the political powers in Britain. 'In a single decade,' Janet Minihan has written, 'during and after the Second World War, the British Government did more to commit itself to supporting the arts than it had in the previous century and a half.'[1] In wartime, morale had to be kept up, and promoting activity in the arts was one way of cheering people and raising their sights towards higher things while in adversity. The foundation in 1941 of CEMA, the Council for the Encouragement of Music and the Arts, put the State's authority (and the State's money, alongside private funding) behind a wide-ranging programme of support for the arts.

As the people of Britain were caught up in the war effort, a sense of common purpose developed, breaking down some of the class barriers that segmented British society. The common purpose survived after the war ended, and led to the election in 1945 of a Labour Government, determined to share out more equally the country's prosperity, and to extend to everyone the chance of a better life by means of the support which the State could give in education, health care and insurance provision. The 'Welfare State', which was thus created, promoted not only social justice but culture. CEMA was re-established in 1946 as the Arts Council of Great Britain, and disbursed Government patronage widely. When the Conservative party recovered power in 1951, it maintained its predecessor's concern for social and cultural advancement. Labour returned to government in 1964, and in 1965 issued the first White Paper on funding for culture, *A Policy for the Arts*, after which all political parties had to equip themselves with such a policy. It was in this favourable atmosphere that the

V&A developed under Ashton, Cox and Pope-Hennessy. Although money was not always easily available, because Britain did not perform economically as well as might have been expected from the winner of the war, prosperity in general increased, and museums – along with other public bodies – were able to follow a course of steady expansion.

Museums were not the most obviously innovatory parts of the cultural scene, though art galleries concerned with contemporary art provided a showcase for avant-garde activity. In the world beyond museums, historians of the period[2] are apt to highlight such artistic developments as the 'Angry Young Men' dramatists of the 1950s, the new wave of British film-makers in the '60s, the rise of British pop-music, with the Beatles emerging as counter-cultural heroes, the increasing influence of television and a new hedonism in personal habits, prompted by the availability of more consumer goods and the liberalization of the law, and evoked in the phrase 'the Swinging Sixties'. Most of this passed the V&A by, though (as we have noted) the museum did make a contribution to the 'permissiveness' of the '60s in its Aubrey Beardsley exhibition in 1966. The new buoyant cultural activity was accompanied by the construction in academic circles of new disciplines to interpret it, such as cultural studies and media studies. These too left the V&A cold.

In 1974, however, when Pope-Hennessy's successor arrived, it looked as if the museum was at last to be connected up to the Swinging Sixties, or at any rate to 'Swinging London', a phrase said to connote 'the highly publicized carryings-on of the beautiful, the wealthy, and the successful'.[3] From the beginning, V&A Directors had been, one way or another, official appointees. From Smith to Pope-Hennessy, they were chosen and appointed by the incumbent Government Minister for education. But the vacancy caused by the departure of Pope-Hennessy, and

Vignette: Cartoon from the *Independent*, 22 October 1988, suggesting the impact of commercialization of the V&A.

subsequent vacancies, have been filled by open competition. In the competition to succeed Pope-Hennessy, several senior curators of the V&A, as well as senior figures from outside, were beaten by a young and controversial figure, Roy Strong, then Director of the National Portrait Gallery.

He was 38 when he became Director of the V&A. The product of a lower middle-class home (his father was a commercial traveller), he had been educated at Edmonton County Grammar School in North London, and read history at Queen Mary College (a college of London University sited in the unfashionable East End), taking a doctorate at the Warburg Institute. In 1959 he joined the National Portrait Gallery as an Assistant Keeper. His great opportunity arose when the directorship of the Gallery became vacant in 1967. Virtually unknown to the general public, and apparently a shy, academic figure, Strong had made enough of a mark within the Gallery, at that time a backwater in the museum world, to get the directorship at the early age of 31. He then re-created himself as a picturesque celebrity. 'From that moment everything took off,' he recalled, 'and Dr Strong of the fedora hat and maxi-coat, the Regency velvet jacket and ruffled shirt, stepped into the media limelight.'[4] An American journalist described him with a degree of wonderment:

Strong may be said to have been a sort of high-class hippy – a mod, if not slightly mad, curator given to sporting shoulder-length hair, a fierce mustache, large hats and exquisitely tailored, yet slightly bizarre outfits. Trendy is what the British called Strong. Trendy and outré and ever so delightfully

shocking ... Strong lived dangerously. He went everywhere, saw everyone, appeared in the company of the young, the talented, the beautiful, spoke eloquently, elegantly and recklessly on radio and television, and made himself every inch the center of attention.[5]

Strong had a solid academic record, and his acceptability as a scholar could only have been enhanced by his marriage to the designer Julia Trevelyan Oman, a descendant of that group of Victorian families described by Noel Annan as the English 'intellectual aristocracy',[6] and daughter of Charles Oman, former Keeper of Metalwork at the V&A. This was not enough, however, to outweigh his flamboyant persona, which at first did not endear him to his new senior colleagues in the museum. These were mostly much older than he, and had developed tough carapaces under Pope-Hennessy. Near the end of his directorate, Strong looked back to the early days and recalled 'not having had an easy time at all (they couldn't have liked someone aged thirty-eight coming in over their heads)'.[7] His diaries, published ten years after he left, recorded some of the agonizing snubs he received.[8] It was not until the senior Keepers retired and gave way to a younger generation, who were on more equal terms with Strong, that he was able to establish a co-operative and democratic way of life in the museum. In 1982 he recorded that 'over nine years I have moved the V&A in a direction where at least we can reach a sensible joint decision after debate. It took a long time, but it's here'.[9]

Strong began to keep diaries in order to record his meetings with 'interesting people',[10] especially fashionable and

Figure 13.1
Roy Strong in his earlier days at the V&A, at the opening of the exhibition *American Art 1750–1800* in 1976, with HRH Princess Alexandra and Sir Angus Ogilvy.

nobly born people, for he revelled in his opportunities to move in high society. The diaries are therefore a rather patchy record of his museum work, stressing moments of high drama rather than quiet achievement, but they can be supplemented by the record of his years at the museum published in the *V&A Album* after his resignation.[11] Strong's predominant characteristics (and in this respect Henry Cole's mantle sat well upon him) were energy and restless inventiveness – sometimes so restless that he left his colleagues floundering in his wake. His 15-year directorship saw an impressive list of innovations, the more impressive because they were achieved in the face of mounting adverse pressure from the political world.

Strong may have been a creation of the Swinging Sixties, but by the time he came to the V&A this period was over, and Strong, always up to the minute, had moved on (figure 13.1). Velvet and ruffles were things of the past. He was now conservatively dressed ('the brown suit is superbly tailored and cunningly matched with a silk tie'),[12] but still in the height of fashion – some of his cast-offs were offered to and accepted for the V&A's costume collection.[13] Strong's eagerness to move in fashionable circles was undiminished, and he felt that it was important to do so for the sake of the museum. He told an interviewer:

I believe that part of the rôle of the Director of a museum is to be seen socially – not just frittering away time, but over a dinner-table in London one will learn more of use than sitting with papers in this office ... It is important to have one's antennae tuned in to the entire society around one and which the museum serves.[14]

And he hoped that fashionable social circles would respond by supporting the museum. 'What could be a greater compliment to a museum than that it is attracting the creators and trend-setters of its society?'[15] The trend-setter in charge was to keep on experimentally varying his image through the years.

Aside from fashion and fashionable people, the aspect of Strong's interests that seems most obviously to have been carried over from the 1960s was photography. To be a photographer, like David Bailey or Lord Lichfield, or to be a much-photographed model, like Jean Shrimpton or Twiggy, was a peak achievement in the '60s. The fashionable aura surrounding contemporary photography extended to the history and art of photography. At the Portrait Gallery, Strong had become friendly with Cecil Beaton, and had mounted an exhibition of his work in 1968. He boosted the Gallery's photograph collection, and led a high-profile campaign in 1972 to acquire an album of early Victorian portraits by Hill and Adamson. At the V&A he found a large photographic collection, originally assembled as an image-bank for designers and, later, art historians, languishing in the Library.[16] Because it had been built up from

the museum's earliest days, it contained much that was now of precious historical value, and many images that now commanded respect as art; such material had been quarried by Gibbs-Smith for his pioneering exhibition of early photography in 1939. 'Here was an area in which to leave a mark,' thought Strong.[17] He moved the collection to the Prints and Drawings Department, and put it in the charge of a specialist curator whose brief was to develop it as an artistic collection.[18]

Though Strong's scholarly reputation rested on work on Elizabethan painting, he was, as will have become evident, not an antiquarian by nature. His passionate involvement with the present moment naturally led him to try to bring the V&A back into touch with contemporary art and design. To some extent, this could be done by opening the museum's doors to outsiders. One of his earliest moves was to invite the Crafts Council, in 1974, to run a shop selling contemporary crafts within the V&A. This continues to flourish to the present day. With the help of his Education Department, Strong arranged two Christmas shows in which craftsmen were posted around the galleries demonstrating their skills. *The Makers* (Christmas 1975) and *Man-Made* (Christmas 1976) were among the biggest crowd-pullers during his regime, almost overwhelming the museum with visitors.

Later, in 1981, taking advantage of a cranny of unused space in a back area known as the Boilerhouse Yard, Strong extended the museum's hospitality to a gallery devoted to exhibitions on industrial design, which was funded by Sir Terence Conran, founder of the Habitat stores, and later a V&A Trustee.[19] 'Perhaps more than any other individual, Conran has made modern design widely available to and even loved by the British middle classes,' wrote a commentator, adding rather sharply: 'And those who have bought from Habitat stores will feel at home in this puritanical, white-tiled, low-ceilinged chainstore gallery.'[20]

The 'Boilerhouse Project' (as it was called) approached industrial design from various angles. Some of its exhibitions took a philosophical view, such as *Taste* (1983), *National Characteristics in Design* (1985) and perhaps the opening exhibition *Art & Industry* (1982). The latter might also be called historical, since it surveyed 'a century of design in the products we use', featuring great designers such as Peter Behrens, Norman Bel Geddes and Ettore Sottsass. *Images for sale: 21 Years ... from Design and Art Direction* (1983) and *The Good Design Guide: 100 Best Ever Products* (1985) were similar exhibitions of exemplary graphics and objects. Some exhibitions were case studies of individual firms, products or designers, such as *Sony Design* (1982), *Memphis in London* (1982), *The Car Programme ... How they designed the Ford Sierra* (1982) and *Kenneth Grange* (1983). Quirky topics surveyed included *Handtools* and

Robots in 1984, and plastic shopping bags in 1985. There was one exhibition of student design from Kingston Polytechnic (1984), and two with sociological overtones, *New Design for Old* (i.e. for older people) and *14:24 British Youth Culture*, both in 1986.

The Director of the project was Stephen Bayley, a former academic making a bid to establish himself as a design guru, and attracting some crabby attention from the established guru, Peter York. Was the Boilerhouse, asked York, 'a laboratory? a main service area? a gym? a men's room?':

Anyway, past reception, it's all white tiled, every living inch of it's white tiled, with those not-quite glossy white tiles with the special grouting you get in shops with the Italian Look ... It takes a while to suss out where the *exhibits*, so to speak, actually are in the Victoria and Albert Museum's Boilerhouse annexe ... There is, however, one irresistible tableau in the Hyper-Realist style, the best thing there. On the far right hand there *seems* to be a kind of window with venetians against it, and if you peer in there seems to be *a young man with everything* on display in an office interior in the style popularly known as Hi-Tech. And this young man *seems* to wear a bow-tie, a perky but tasteful daytime bow-tie of the kind worn on special occasions by those who have been to art school, and everything else a modern person should have. It must be something like those American sculptures of elderly tourists with every sag, every class-correct detail of polyester outwear rendered amazingly in modern materials. And it's there to make the point about Art Businesses, or something like that. When it moves, however, one realizes it's little Stephen Bayley, who runs the show here, living the design life.[21]

The Boilerhouse Project eventually grew beyond the V&A, being transformed into the Design Museum, which opened at Butler's Wharf on the south bank of the Thames in 1989. Unfortunately, the relationship between Roy Strong and Terence Conran, always tense, became acrimonious, especially after Strong gave a hostile review to Conran's 'authorized biography' in 1995.[22] The Boilerhouse's programme, nonetheless, added a new dimension to the V&A – a sense of polemical engagement with contemporary design – and conspicuously attracted a student audience.

While it was not too difficult for Strong to bring in outsiders with an interest in the contemporary, converting the insiders was a more difficult task: 65 years had passed since Cecil Smith absolved his curators from concern with the present, and the V&A's antiquarian attitudes had become deeply rooted. Strong found an ingenious way of putting the twentieth century on to his curators' agendas, through the money allocated for purchasing objects. He had undisputed control of the purchase grant, but he knew that, wherever he directed its resources, he could rely on the curators to spend it, because buying things was the heart of their job. 'Curators are like seals at the zoo,' he said; 'you

have to give them fish twice a day, give them jewellery or books or whatever. They adore purchasing.'[23] So in 1975 he decreed that a part of every department's purchase grant must be earmarked for post-1920 objects, and the departments duly turned their acquisitive urges in this direction.

As we have seen, responsibility for the contemporary had been assigned to the Circulation Department during most of the twentieth century. One of the disasters of Strong's directorship (to be described below) was the abolition of this department. The only redeeming feature of this event was that thereafter the twentieth-century holdings amassed by Circulation were redistributed to the departments, and so were several former Circulation staff who specialized in the twentieth century. This diaspora had the effect of implanting an interest in twentieth-century design throughout the museum, where it quickly took hold. A gallery of twentieth-century British Art and Design was opened in November 1983. The rehabilitation of the present in the V&A was one of Strong's most important achievements.

Strong had a keen nose for trends, and in his early days at the museum made his mark not by re-living the Swinging Sixties but by espousing a new movement with a quite different mood. This was what came to be called the 'heritage movement'. To take an interest in the past seems to be an entirely natural human instinct in times of rapid change, and the late twentieth century was undeniably such a time. The fragmentation of society that resulted from the 'permissiveness' of the 1960s and the wider range of available consumer choices, together with the dizzying enlargement of everybody's mental horizons occasioned by the new media, left many people longing for the 'good old days'. They were enabled to recapture something of the good old days in two ways: both by visiting and savouring genuine survivals from the past and by enjoying modern reconstructions of history. Preservationist campaigns consequently became ever more powerful, while the leisure industry (embracing an increasing number of museums) rushed to provide for the public simulated experiences of the past. By now, 'heritage' has been put into some sort of perspective by contemporary historians and critics. David Lowenthal's books perhaps take the widest view of why we need history.[24] Robert Hewison's *The Heritage Industry* is a more close-up account of how it has been served out to us.[25] There have been many denunciations of the false notes of 'heritage', an easy target. Patrick Wright's books tease out its ambiguities with unusual subtlety,[26] and Raphael Samuel's bring a warmer sympathy to the more demotic uses of history than most heritage buffs have countenanced.[27] The body of literature represented by these and other publications only began to take shape in the mid-1980s. But Strong was on the band-wagon in 1974 with a V&A exhibition

entitled *The Destruction of the Country House 1875–1975* (figure 13.2).

Of all the things that might have stood in need of preservation, none could be more congenial to the V&A than country houses, and efforts to rescue them had been going on for decades, as Peter Mandler has shown in *The Fall and Rise of the Stately Home*.[28] Nonetheless, it was bold of Strong to position the V&A in a campaigning stance, not least because one of the potential threats to the heritage at this juncture was the effects that the Labour Government's tax policies might have on the owners of inherited wealth and property. The exhibition was very influential. Mandler uses it as the climax point of his narrative. Two

more campaigning exhibitions followed: *Change and Decay: The Future of our Churches* in 1977 and *The Garden: A Celebration of 1,000 Years of British Gardening* in 1979. These exhibitions, all with important effects, showed that the V&A could argue a case (as distinct from presenting a pretty show), which it had not chosen to do since Cole's 'Chamber of Horrors'.

Strong brought in outsiders, such as Marcus Binney, John Harris and Peter Burman, to help with these exhibitions, but it is worth noting the participation in the first of Peter Thornton (see figure 12.18), Keeper of the Furniture Department, which had for years been assembling an archive of material on country houses. The early curators of

Figure 13.2
The 'Hall of Destruction' (where a sepulchral voice intoned the names of demolished country houses) in the exhibition *The Destruction of the Country House*, 1974, designed by Robin Wade.

the department had been concerned to establish a canon of English furniture, Ralph Edwards's work with Percy Macquoid on the *Dictionary of English Furniture* (1924–5) being especially important. Later generations turned to study the use and context of furniture, and Thornton made an important contribution here in his *Seventeenth-century Interior Decoration in England, France and Holland* and *Authentic Decor: The Domestic Interior 1620–1920* – influential books, which reproduced and interpreted contemporary representations of historical interiors[29] and inspired quite a crop of similar publications. The Furniture Department was able to test out its ideas in the V&A's three stately homes, Ham House, Osterley Park and Apsley House; and for a brief period it looked as if they might get a fourth. Mentmore Towers in Buckinghamshire came on the market in 1977, and Strong hoped to persuade the Government to rescue it and hand it over to the V&A. Nothing came of this, except that the museum was able to acquire a few pieces from the rich contents of the house, which had been a Rothschild family home. The repercussions of the Mentmore affair upon statutory provision for the rescue of the heritage are a story that has been told elsewhere.[30]

There was ample scope for the conservation of historic architecture in the V&A itself. The building presented formidable practical problems of upkeep: 'the leaking roof (figure 13.3) ... rotten and inadequate drainage, a leaking and obsolete heating system, an overloaded and dangerous electricity system besides wet and dry rot'.[31] While trying to deal with these, Strong was also able, with the advice of his

Deputy Director, John Physick (see figure 12.19), the historian of the V&A's architecture, to restore several historic interiors. For years two of the museum's suite of three original Refreshment Rooms had been closed up and used as stores. The third, the William Morris Room, better esteemed, had remained open as an exhibit. Between 1974 and 1978 the adjoining Gamble and Poynter Rooms (renamed after their designers) re-emerged in splendour. Also restored were the Lecture Theatre (1977), the Cast Courts (1978–82), the Entrance Hall (1983–6) and the National Art Library (1986). The façades around the quadrangle were cleaned in 1977, and the Pirelli garden was opened on 30 May 1987 by HM the Queen Mother. The architectural qualities of the buildings were now valued and shown off, after being shame-facedly covered up for most of the century.

Museums inexorably expand, even under inactive Directors. The hyper-active Strong gave a push to every chance of development. An important expansion on the South Kensington site came with the opening of the building that was renamed the 'Henry Cole Wing' (figure 13.4). This block had been erected in 1867–71 as the School of Naval Architecture, had become the Royal School of Science and, when this was absorbed into Imperial College, continued in the college's use as the Huxley Building. It had been promised to the museum since Cox's time, and, when it eventually fell into the museum's hands, the task of converting it to museum use presented many problems. At one stage in the planning it was allotted to the Indian collections, but eventually the decision was taken to devote

Figure 13.3
The effects of the V&A's leaking roof. Buckets catching the drips after a thunderstorm on 22 July 1981.

it to the V&A's two-dimensional holdings: Prints, Drawings, Paintings and Photographs. It functions therefore as a 'flat art' gallery within the larger museum of three-dimensional exhibits. Strong saw the project through to the opening by HM the Queen on 17 March 1983.[32] Off-site, more storage space became available to the museum in 1984 in a building shared with the Science Museum and the British Museum in Blythe Road near Olympia. This new area made possible more constructive use of space at South Kensington.

Further opportunity for adjustment at South Kensington came when the Theatre Museum moved out and achieved its own distinct identity. The Theatre Museum had its origin in the V&A's Enthoven Collection, which had been quietly growing as part of the Prints and Drawings Department since 1925. To this were added the collections of the British Theatre Museum Association (started in May 1957), and others. The knots had been tied in Pope-Hennessy's time, but Strong saw the project through, from the appointment of a new Keeper, Alexander Schouvaloff, in 1974 to the opening of the museum, by HRH Princess Margaret, in its own premises in Covent Garden on 23 April 1987.[33] Strong also relaunched the V&A's other branch museum at Bethnal Green. This had never quite seemed to work, even in its early and most hopeful days, and the twentieth century saw further attempts to redefine it. Cox thought it should be a museum of English costume; Pope-Hennessy used it as a London showplace for the exhibitions of the Circulation Department.[34] Strong concluded that its best feature was the toy collection, which had been started as a Children's Corner by Arthur Sabin, but had grown to be the liveliest part of the museum. He relaunched it accordingly in 1974 as a Museum of Childhood. An important collection of children's books, the Renier Collection, hitherto in the charge of the V&A Library, was transferred to Bethnal Green, and many other objects in the V&A that were associated with children, especially children's dress, were added, while other material at Bethnal Green unconnected with childhood was gradually returned to the V&A.[35] The museum was thus shaped into a National Museum of Childhood, a title it was empowered to use from 1997, just as the Theatre Museum used the title National Museum of Performing Arts. The 'Branch Museums' (which tried to shed the unflattering title 'out-stations' by which they had been known) became fully functioning museums, collecting, exhibiting and interpreting in their special fields. In so far as they viewed their holdings, necessarily, in a wider context than the purely aesthetic, they perhaps contributed to the development of an interest in material culture at the V&A.

At South Kensington, several galleries within the existing sequence were refitted: Continental Baroque (1978), the

Figure 13.4 The Henry Cole Wing. A hidden splendour in this strange building is the monumental staircase seen here, with Dr Michael Kauffmann, Keeper of the Department of Prints and Drawings when it was rehoused in the Henry Cole Wing in 1983.

Dress Collection (1983), the Medieval Treasury (1986). Two new galleries were introduced: British Art and Design 1900–60 (1983) and the Toshiba Gallery of Japanese Art (1985). As its name implies, the latter marked a notable shift in the museum world, as major projects began to be achievable only with the support of sponsors. The contents of the Continental Nineteenth-Century Gallery at Bethnal Green were brought back to the V&A and re-installed in 1987 as Art and Design in Europe and America 1800–1900. As these changes to the permanent collections proceeded, Strong came to feel that the time had arrived for a 'radical re-thinking of the principles of display' in the V&A,[36] and appointed a committee, which in 1985 produced a report entitled *Towards 2000*. The committee's task was to review Leigh Ashton's system of Primary and Secondary (now usually called Study) Galleries, and to see whether a better system was conceivable. After deliberating, it decided to keep the Ashton system but to reconceptualize it as 'Art and Design' and 'Material and Techniques' galleries. Though this may seem less than revolutionary, it did represent a significant change in the museum's thinking.

The museum had started out with a single preferred system of arrangement – the 'material' system – which had in due course become pitted against the 'aesthetic/historical' system. The Ashton arrangement (whether arrived at for pragmatic or ideological reasons) was a compromise between the two. But by 1985 many V&A staff realized (whether on a pragmatic level or through their apprehension of new tendencies in current intellectual life such as semiotics and structuralism) that there were not just two right ways to lay out a gallery, but many. *Towards 2000* stated that 'the way in which we present the collection to the public needs to take account of a wider range of approaches that reveal different and alternative patterns of significance' (p. 2). This relatively simple proposition is liberatingly suggestive and seems likely to animate the V&A's display policy for some time to come.[37] That the curatorial mind is now able to hold in balance alternative patterns of significance in relation to the objects it studies was demonstrated in the exhibition *A Grand Design* in 1997.

Whether modes of display technique can be devised to reveal alternative significances remains to be seen. Considering itself primarily an art museum, the V&A has continued, on the whole, to let its objects speak for themselves, rather than explicating them by means that have become customary in other types of museum. It has not, for example, bothered much with 'interactivity', a concept

Figure 13.5 The *Bodybox* exhibition, 1974–5. A scene during installation, with the Exhibitions Officer, Victor Percival (right), and the head of the technical workshops, Charlie Kennett, testing out the child-friendly exhibits.

much in vogue elsewhere, based on the idea that visitors should not be passive spectators in exhibitions, but should be physically or intellectually involved through various ingenious learning devices. All the more reason, then, to recall the V&A's interactive *Bodybox* (1974–5), an exhibition chiefly for children and designed to stimulate an empathetic response to sculpture (figure 13.5).[38] This was mounted by the V&A Education Department, which eagerly supported Strong's adventurous gambits, in the face of scepticism from curatorial departments. Strong's reciprocal support for the Education Department resulted in the appearance in April 1977 in the dignified art history journal, the *Gazette des Beaux-Arts*, of a photograph of him looking very un-chic in a short-sleeved T-shirt emblazoned with the words 'Summer Search': he was advertising the Education Department's summer programme.

There were profound changes in the museum's structure during Strong's directorship, but not all of them were wished for. The desired changes included the following. In 1975 the Circulation Department and the Education Department were united under the Keepership of Madeleine Mainstone to produce an ambitious, refreshed Department of Regional Services.[39] This was Strong's attempt to tackle the hoary problem of how the V&A was to satisfy the high expectations of help and guidance that provincial museums still had of it. It aimed to go beyond the accepted practice of just shipping groups of objects out to borrowing institutions, by pro-viding 'road-shows' of educational activity to enhance the exhibitions.

An Archive of Art and Design was set up by Strong in order to make it easier for the V&A to acquire the entire working papers of modern designers. Quite frequently the whole contents of studios were offered to the museum. It might seem reasonable that either the Library or the Prints and Drawings Department should take responsibility for these, but their cataloguing and housekeeping procedures – intended for individual books or choice individual works of art – were ill adapted to cope with such bulk acquisitions; and even if they were to take the bulk, the Prints and Drawings Department would reject documents that were intermingled with pictorial material, while the Library, welcoming the documents, would reject the pictures. The solution was to allot the task to the new unit, operating within the V&A Library. This library was itself in need of reform. Under a succession of scholarly Keepers, and protected by the cocoon of the museum from much contact with other libraries, it had become old-fashioned in its methods, and was subjected to severe criticism from its users.[40] Strong set in train a revolution in May 1985 when he appointed a university librarian, Elizabeth Esteve-Coll, to head it. She had trained as an art historian, and as a librarian had run a specialist art-college library, before

rising to become Librarian of Surrey University; so she was eminently qualified to rejuvenate the V&A Library, which she did with cheerful determination.

What has been said so far about Strong's directorship has been a record of enterprising innovation, for which he can take much personal credit. Powerfully testing political events challenged him almost from the start, however. In 1976 Harold Wilson's Labour Government ran into an economic crisis and took measures for financial retrenchment, which included an 11 per cent cut in the staff of the Civil Service. The staff of the V&A (and the Science Museum) were civil servants, so Strong had to get rid of 80 colleagues. He chose not to debilitate the entire V&A by shaving a bit off every department (as the staff associations, arguing for fair play, urged him to do), but to close one department, the recently reformed and upgraded Regional Services. It was generally thought at the time that by this proposal Strong 'hoped to reverse, or at least modify, Government thinking ... by creating as emotive a publicity campaign as he could possibly imagine'.[41] Strong later acknowledged this: 'If any threatened gesture would be likely to lead to a reprieve, this would be the one'.[42] But the 'desperate gamble'[43] failed. The Labour Education Minister, Shirley Williams, accepted the proposal, and over two years Regional Services was wound down and the required reduction in staff was achieved by redeployment and natural wastage. This was a deeply painful wound to the museum.

Although the gamble failed, Strong intrepidly played the same card in another round of staff cuts in 1981, threatening to abolish the National Art Slide Library, which the V&A ran. This had begun in a small way in 1898, for the use of lecturers in the museum itself, but was soon made available to outside borrowers as well. It grew and was several times reorganized, and by 1981 was widely used by art lecturers, who bestirred themselves to save it. This time the Minister (now the Conservative, Norman St John-Stevas) backed down.[44]

After the Regional Services débâcle, Strong had begun to campaign for the V&A to be 'devolved' and granted 'Trustee status' – that is, to be run not as part of the Civil Service, which made it vulnerable to Government cuts, but (like the British Museum and the National Gallery) by a semi-independent Board of Trustees. He set up a Keepers' Advisory Committee on Devolution in October 1976, which recommended, among other things, that a Board of Trustees should include representatives of outside interests, such as regional museum directors, financial and industrial concerns, academic art historians, designers, collectors, art colleges, the British Tourist Authority and the National Trust. In 1978 Strong entered into discussions on devolution with Shirley Williams's ministry, while lobbying vigorously in the media. 'In going out and challenging the

Government I was fully aware that I was laying my head on the block.'[45] In the event, he made little progress with the Labour Government.

In 1979, however, a Conservative Government came to power under Margaret Thatcher. As this regime dug in, it became clear that it was determined to put an end to the consensus politics that had endured since the war, and to apply the businessman's standard of profit and loss ('the bottom line') to every aspect of life, disregarding, so far as possible, such inhibiting factors as a sense of the public good or social solidarity. For the Conservatives, advocates of private enterprise, the 'public sector' was the enemy, and confrontations were sought, in the cultural domain no less than in the industrial. To some extent Strong sympathized with Mrs Thatcher's assault on the well-entrenched world of public service, because he was battling against it in the museum. 'I Thatcherized the V&A,' he was to say later.[46] From the start he had felt opposed by 'the unions'. Since the V&A staff were civil servants, the unions he had to deal with were only the Civil Service staff associations (various associations for different grades of staff), which were hardly the most rabid of workplace wreckers. But towards the end of Pope-Hennessy's time there had been an upsurge of activity in the unions (the result, perhaps, for different reasons, both of a Labour Government in power in the world at large, and of an autocrat in power in the museum), and Strong felt that 'now in the hands of certain younger members of the curatorial staff they have become absolute HELL'.[47] For someone, like Strong, in a hurry to change things, resistance from the trade unions is an obvious occupational hazard. It was frustrating, however, and when Mrs Thatcher stood up to the unions on the national stage, Strong admired her. In the end, though, he was disappointed in her, expressing his disillusionment in a newspaper article in 1990: 'what began as a welcome and healthy development has led to a loss of balance'.[48] Strong had hoped to be able to bring new blood into the V&A at senior levels (which the unions opposed), but the staff cuts of 1976–8 put paid to this.

While financial provision for the museum was no better under the Conservatives than it had been under Labour, Strong retained the hope that the V&A would attain 'its liberty' under the new Government.[49] A possible step in this direction came in 1981. Mrs Thatcher had set up a gadfly agency, the Rayner Scrutiny, to promote reform in the Civil Service by injecting the business ethos, and saving money. This was overseen by Sir Derek Rayner, head of Britain's most successful chainstore, Marks and Spencer. A Rayner Scrutiny of the V&A, led by a retired civil servant, Gordon Burrett, began investigations in 1981 and reported in May 1982. It introduced the V&A to managerialism, recommending that the museum should establish 'timed and

costed objectives', 'internal policy reviews', 'a management information system'. The museum 'should be encouraged to introduce admission charges' and 'to foster more restrictive acquisition and bolder disposal'. Its exhibitions should be 'self-financing or profit-making'. The Theatre Museum project should be abandoned, the Bethnal Green Museum of Childhood should become self-financing or close down. Among these uncomfortable exhortations to modernize was one welcome recommendation: that the V&A should become a Trustee Museum.

The museum responded in a 'Commentary by the Director and the Keepers on the Rayner Scrutiny'. The devolution proposal was welcomed, and it was suggested that a Board of Trustees should include nominees representing the Royal College of Art, the Museums Association, the National Trust, the Royal Society of Arts and the British Academy. The suggested managerial systems were accepted. But in relation to the Theatre Museum and Bethnal Green, the Commentary insisted that 'the Scrutiny is utterly unrealistic in supposing that the out-stations could ever be financially self-supporting' (no figures had been provided in the Report to back up its recommendation); and it rejected 'the notion that any worthwhile exhibitions policy ever has been or can be overall self-financing or profit-making'. The Theatre Museum and Bethnal Green both had to fight fierce campaigns in the media during summer 1982, but succeeded in inducing Paul Channon, Minister for the Arts, to announce in August that the Government would not pursue the recommendations to close them. This was another traumatic moment for the museum.

The Conservative Government was ideologically committed to reducing the size of the Civil Service, and in order to achieve at least the appearance of this, it 'hived off' various parts of it to independent control. In furtherance of this policy, the National Heritage Act of 1983 devolved the V&A to the control of a Board of Trustees, who were directly appointed by the Prime Minister and included no members serving in a representative capacity. The first Board was chaired by Lord Carrington, with Robin Holland-Martin, a long-time member of the old Advisory Council, as Deputy Chairman. It included eminences from the Establishment such as HRH Princess Michael of Kent and Lord Barnett, the former Labour Minister; people with expertise in business and finance, such as Ian Hay Davison, Andrew Knight and John Last; and academics such as Professors Sir John Hale and Christopher Frayling. Practical experience of modern design was provided by Sir Terence Conran, David Mellor and Jean Muir, while heritage was represented by the preservationist Marcus Binney. Membership of the Board has changed over the years, but the balance of talents has remained much the same.

The museum now began to put in place in its administration the mechanisms for future planning and appraisal that have dominated its institutional life ever since.[50] One of the first acts of the Trustees was to appoint in 1985 the architects Michael Hopkins and Associates to produce a Master Plan for the Building (issued in 1987). Hitherto, while the museum was run as part of the Civil Service, the care of the building had been the responsibility of the Property Services Agency of the Department of the Environment. Although there were many dedicated staff in this department, its work, inhibited by Civil Service cheese-paring, always tended to look drab, even mean. The Conservative Government 'untied' all the museums from their links with the PSA, and from now on they dealt directly with their own architects. In the V&A's case there was an immediate, and stylish, improvement in works carried out on the building.

Strong tried to energize the staff for the new world by setting up in 1985 a Future Policy Committee. The apprehensions of the staff can be sensed in the nickname given to this group, the 'Armageddon Committee', but it usefully ventilated many issues. Another challenge to the habitual assumptions of curators was a Treasury staffing report, which ascribed more importance to 'decision making' and 'integrative skills' than to 'academic excellence' in the work of a curator.[51]

At the heart of the drive towards managerialism was a financial agenda. If museums could not succeed in being self-supporting, they must at least try to 'generate income'.

Figure 13.6 Merchandise on sale in the V&A shop in 1979.

Figure 13.7
First steps towards
cherishing visitors: the
desk of the Friends of the
V&A at the museum
entrance in 1982.

The first national museum to charge for admission was the National Maritime Museum in 1984. The Trustees of the V&A decided to bite the bullet on 13 June 1985, and on 18 June Strong and the Trustees' Chairman, Lord Carrington, announced that a scheme of 'voluntary donations', modelled on that of the Metropolitan Museum, New York, would be introduced. The museum also embarked on other schemes for income generation. Strong had founded the V&A Associates in 1976 as a source of fund-raising, and now, ten years later, a body of American Friends was started. A Special Events Unit tried to raise funds by hiring the museum out as a venue for parties. The publications and products sold in the V&A shop had been livened up in recent years (figure 13.6), but entrepreneurial expansion proved difficult under Treasury accounting rules, while the museum remained part of the Civil Service. Now a commercial firm, V&A Enterprises, was started, to exploit opportunities for marketing and retailing.[52] 'The V&A could be the Laura Ashley of the 1990s,'[53] said Strong provocatively at a press conference launching the museum's Future Development Programme in autumn 1985, shortly before the voluntary admission charges came into force on 4 November.

The drive towards managerialism woke museums up to the importance of their visitors, who now came to be seen as 'customers'. No longer was it possible for museums to content themselves with serving a select group of initiates. They must now attract everybody. Many museums had already begun, from motives rather distant from managerialism, to try to attract a wider audience,[54] and although the V&A was not at the forefront of this newly inspired bountifulness, its audience had begun to change. An observer had described this in 1977:

The museum is still the haunt of the technician, the professional – the potter, textile-weaver, furniture-maker, costume designer. And there is a constant flow of antiques collectors who consult staff experts to authenticate the period or the maker of a piece of porcelain, a silver spoon, a satinwood table. But the galleries are always thronged with the general public as well. Youngsters crowd through, pointing and chattering, absorbing the human heritage as painlessly as if it were a huge iced lolly. And the rest of us, quiet and meditative, drift from case to case, sensing, however obscurely that *homo sapiens* isn't quite the twit he often seems to be.[55]

In 1985, when admission charges started at the V&A, Strong reminded his staff of their duty to their customers. If people were to pay for entry, they would expect not only a warm welcome (already provided, since 1982, by the Friends of the V&A at an Information Desk, figure 13.7), but value for money in the displays, so the museum's public face must be smartened up. 'This must take precedence,' ordered Strong, 'over virtually all other departmental

work.'[56] Lord Carrington, similarly concerned for the museum's public face, achieved two aims that he set him-self. Since the staff cuts of 1976–8 the museum had been closed to the public on Fridays: it reopened on Fridays from 6 November 1987 onwards. And the façade along Cromwell Road was cleaned, the money being found by a thoroughly entrepreneurial expedient: the hiring out of advertising space on hoardings erected beside the cleaning scaffolds.[57]

In insisting on the museum's duty to please its public, Strong remained consistent with his early persona as show-man. Then, he had seemed an *enfant terrible*. Increasingly, however, his pronouncements reveal a quite traditional curator struggling to keep ahead of a world that was chang-ing rapidly around him.[58] Many of his achievements were overshadowed by the rise of the managerial culture. Perhaps, therefore, his long-term legacy to the V&A may rest not so much on fundraising or showmanship as on two changes that he brought about in the V&A's intellectual attitudes.

One of these has already been mentioned: his re-intro-duction of a concern for modern and contemporary art and design into the consciousness and activities of the museum. His second influential change was the setting up, jointly with the Royal College of Art (where Christopher Frayling, Professor of Cultural History, was the prime mover), of a post-graduate MA course in the history of the decorative arts. At first headed in the V&A by Charles Saumarez Smith (who eventually went on to be Director of the National Portrait Gallery), this acted as a conduit for new ideas,

Figure 13.9 Elizabeth Esteve-Coll.

which were much needed in the V&A. The museum's cura-tors, as art historians, pursued a discipline based on the close study of objects. While valuable in itself, this was not how art history was studied in universities and colleges, which in any case rarely included the decorative arts in their syllabuses alongside fine art. So the V&A's object-based specialists had been able to sustain their disciplines almost in a private world. When a seminal (if rather flimsy) work entitled *The New Art History* appeared in 1986, a retired member of the V&A staff denounced it for 'dogma-tism and charlatanry' and said that its stress on feminist, Marxist, structuralist, psychoanalytic and social perspec-tives on art history 'stultifies and impoverishes'.[59] When a similar book entitled *The New Museology* appeared in 1989, attempting to apply new ideas to museums, a V&A reviewer found it 'vainglorious', its writers 'style victims, not independent thinkers ... mere epiphytes, producing theories which may be decorative, dull or irritating accord-ing to taste, but which sadly lack relevance, freshness and bottom'.[60] These books were not particularly good, and the attacks of the highly intelligent V&A reviewers undoubt-edly diminished their credibility. But the point is that the books represented the direction that art history and museology might well take (and, in the event, did take) in the future, and the V&A could not afford to turn its back on them. The V&A/RCA course helped to get new ideas such as these books proffered into the V&A's mind-set, connecting

Figure 13.8
Rueful Strong:
a cartoon by Gerald
Scarfe in the *Sunday
Times*, 30 March
1986.

the museum up to the wider intellectual world, and the effect has been tonic.

Strong decided to offer his resignation in 1987. The problems which the managerial culture had put before him, together with some misfortunes (like floods in the museum) for which he was not personally to blame, weakened his position (figure 13.8). One critic commented that his role 'has lately come to resemble that of chief coconut in the cultural fairground'.[61] Articles kept appearing in the press with titles like 'Whatever happened to the Strong touch?',[62] 'A treasure house of disasters ... the hidden problems of the V&A',[63] 'Reform or bust? ... the future of the Victoria & Albert Museum',[64] 'Wanted: a *really* strong man to save our heritage of treasures'.[65] Strong also now found himself 'at the mercy of an intractable and capricious Board of Trustees'. Although he had been glad to escape from the bureaucracy of the Civil Service, he now found that administration by Trustees could be just as difficult. Of some members of his Board Strong said: 'They want power without responsibility and have no feeling or sympathy for the terrible problems of the public sector.'[66] He was no doubt wise to step down. In his 14-year incumbency many improvements had been achieved, but circumstances were becoming increasingly difficult.

In view of the tone of the criticisms of the V&A just mentioned, there was a general feeling that the Trustees would be likely to choose a 'manager' as Strong's successor. When they appointed the V&A's Chief Librarian, Elizabeth Esteve-Coll (figure 13.9), it was assumed that her dynamic reorganization of the National Art Library had helped to earn her the post. She had also come to be a leading figure in the museum's forward planning. When the Hopkins Master Plan was in preparation under Roy Strong, curatorial input to it came (in the absence of anything better) in the form of the report *Towards 2000*, and a Curatorial Liaison Committee was set up to mediate between the architects and the interests represented in *Towards 2000*. Esteve-Coll chaired this committee, and thus became spokesperson for the future. In personal terms, she was well liked in the museum on account of her straightforward, unassuming personality and her infectious determination to make things work, and the press praised her 'humour, warmth, and responsiveness'.[67] Not much was disclosed about her background, beyond the tantalizing information that 'she travelled the world with her Catalan sailor husband before turning to librarianship in her thirties'.[68]

The staff waited to see how she would tackle the big job of reorganizing the whole V&A. For a couple of months after succeeding to the post in January 1988 she played herself in. Then in March 1988 she set up a working party under John Murdoch, Keeper of the Prints and Drawings

Department, with a confusingly wide brief, which really boiled down to finding a new organizational structure for the museum that would lop £750,000 off the staffing bill. This was necessary because staff salaries swallowed up a very high percentage of the museum's grant-in-aid, and were growing so fast that by mid-1991 they would exhaust the entire grant-in-aid. A graph was circulated to impress this point (figure 13.10). The working party, reporting in April 1988, did not succeed in recommending a single preferred organizational model, but instead furnished a selection of options advanced by various members – 'six different structures being proposed by its eight members'.[69] No action was taken for some time.

In October 1988 Esteve-Coll took a group of senior staff for a residential weekend at Dunford House, Sussex, to consider 'how the institution is best organized to achieve a fast and flexible response to Government and the public'.[70] In this meeting, the first of a continuing series of weekend think-tanks outside the museum, the work – inevitably somewhat tentative and even, for participants unused to this kind of thing, disturbing – was more concerned with defining the problems than with finding solutions.

The following January, on the 26th, Esteve-Coll obtained the Trustees' support for her own reorganization plan, and announced it to the museum on the 27th.[71] The nub of the plan was the decision 'to recast the curatorial role in order to separate housekeeping from scholarship'. Housekeeping – 'the recording, documenting, moving, storing and conserving of objects' (para. 2.4) – was to be discharged by a Registrar's Department (para. 3.2.iii), while scholarship would be concentrated in a 'research department' (para.

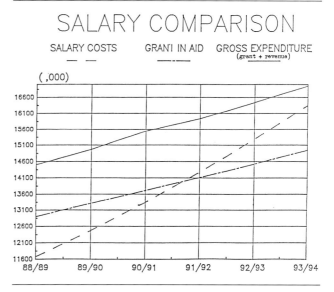

Figure 13.10 The graph circulated in 1988, to show that the V&A was on the way to bankruptcy.

OBSERVER MAGAZINE
19 FEBRUARY 1989

MINE, ALL MINE!

*The British Establishment
in Maggie's grasp*

Figure 13.11 A cartoon by Trog on the cover of the *Observer
Magazine*, 19 February 1989, showing Mrs Thatcher clutching a
group of British institutions, including the V&A.

3.2.ii). The aim was 'a clear-cut separation of scholarship
and housekeeping, i.e. one in which knowledge and expert-
ise about the collections is divided from physical responsi-
bility for managing the collections' (para. 3.1). In the short
term, the curatorial departments would be amalgamated:
Ceramics, Metalwork and Sculpture in one group, Textiles
and Furniture in another, Far Eastern and Indian in
another (para. 3.4). The Keepers expressed to the Director
cautious disagreement with her plan, pleading: 'we hope
to be able to agree with you the method by which the pro-
posals are to be fleshed out'.[72] The following week, on Friday
3 February, the Director offered voluntary redundancy to
nine members of staff: her Deputy Director, five Keepers of
Departments and three other senior staff.

Immediate alarm followed. About 70 per cent of the pro-
fessional staff, through their staff associations, passed votes
of no confidence in the Director and called for her resigna-
tion. The press picked up on the affair ('Recrimination on
Show at the V&A', 'The Massacre of the Scholars')[73] and the
correspondence columns were filled with controversy
('International outrage boils over V&A shake-up').[74] A
'Save the V&A' campaign was begun by a retired Keeper,

Claude Blair (see figure 12.17), and a London dealer,
Wolfgang Fischer.[75] It produced a 12-issue newsletter
between 13 March 1989 and March 1991. One of the
V&A's Trustees, Professor Martin Kemp, resigned. Of the
nine members of staff offered redundancy, one declined and
remained on the staff, while the others acquiesced and
departed on 23 March 1989. John Mallet, Keeper of
Ceramics, emerged as their unofficial leader. A patrician
figure, he had often seemed uncomfortable in the Strong
years. Now he showed defiance, as he wrote to Esteve-Coll
to accept redundancy and to assure her that 'those who
offer it to me enjoy my sincerest contempt'.[76] He even cut a
rather gallant figure as he addressed most of the V&A staff
at a farewell party for the eight departing curators in the
City Livery Hall of the Fishmongers' Company on 20
March. The reverberations of these events spread to the
extent that the Royal Society of Arts eventually organized
an International Conference on Scholarship in Museums on
2 October 1990.[77]

Esteve-Coll, who had been described by one of the pro-
bing news hounds as 'an immediately likeable, common-
sensical woman ... who is not easily intimidated',[78] set
about restoring the shattered morale of the staff. On
Monday 12 June she addressed them, saying, 'I am acutely
aware that the events of the last four months have left us all
feeling bruised, unhappy and bewildered ... I am highly con-
scious of how you feel.'[79] Gradually a new staff structure,
involving elements of compromise, was put in place, and
measures were taken, through training and the setting
up of new forums for communication, to raise the spirits of
the staff.

What in retrospect is to be made of this furore? Some
thought that it was Thatcherism applied to the arts. The
critic Robert Hewison, in *Culture and Consensus: England,
Art and Politics since 1940* (1995), took it as one of the 'key
cases' in his disapproving demonstration of the decline
of public subsidy for the arts. For him it exemplified the
imposition of 'the values of the enterprise culture, as
the national museums collectively experienced the now
familiar tactics of financial pressure and politically calcu-
lated appointments of trustees and senior staff'.[80] Arthur
Marwick, in *Culture in Britain since 1945* (1991), had taken
a similar view. The staff redundancies, along with other
recent developments, led him to assert that, of all the cul-
tural institutions, 'the Victoria and Albert Museum capitu-
lated most gleefully' to the value-for-money ideology.[81]

A contrasting view was that of Linda Christmas in
*Chopping Down the Cherry Trees: A Portrait of Britain in the
Eighties* (1989). More sympathetic to the Thatcher
Government than Hewison, she saw 'the battle for the soul
of the Victoria and Albert Museum ... as a perfect cameo for
the eighties'. The V&A had had a splendid past:

Now the museum's roof leaks after years of neglect and the old-era scholarly staff lack the will and the inclination to do much about the situation. The keeper barons of the various departments enjoy competing with each other but not with the outside world ... On to the scene came a new director ... She did not belong to the art establishment; she didn't go to public school, or Oxbridge and the Courtauld Institute, and she had radical plans to put an end to the debilitating drift to ensure the museum's survival. It meant getting rid of nine employees, most of whom enjoyed a high reputation, but who were considered unwilling or unable to adapt to a new way of doing things. She was attacked by the old school ...[82]

A similar version of events was given by another journalist:

The V&A's troubles stemmed from the fact that it was in the control of curators whose noses were so stuck in their research material that they had ignored the daily running of their departments. They were intellectual snobs who conceived of the museum as a sacred temple of connoisseurship, fit only for the enlightened few and where the encroachment of the general public was merely tolerated. Each obsessively guarded his area of speciality with the pettiness of little tyrants ...

This sad state of affairs required the 'necessarily brutal' reforms, which in turn led to 'a rash of cruel and personal assaults' upon Esteve-Coll.[83]

These assessments, by outside commentators, present Esteve-Coll's role in more or less villainous or heroic terms.

Figure 13.12
Jean Muir, the fashion designer, who served on the V&A Advisory Council 1979–83, and as a Trustee from 1983 until her death in 1993. She is here seen at a V&A exhibition in 1979.

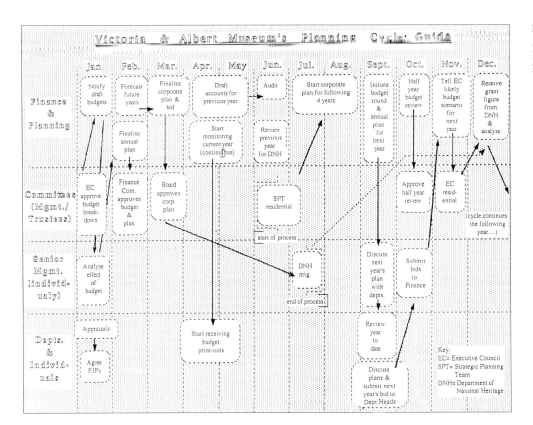

Figure 13.13
A chart showing the V&A's Planning Cycle, issued in December 1994.

A variant view proposed by those who were against Thatcherism was that Esteve-Coll was merely an unfortunate stooge, and the real villains were the Trustees. As we have seen, Strong eventually disclosed his irritation with the Trustees for whom he had worked; and during the crisis in Esteve-Coll's time, Professor Martin Kemp, the Trustee-Who-Resigned, made some criticism of his former colleagues in the *Burlington Magazine*.[84] Over the years there developed a genre of periodical article in which businessmen Trustees were denounced for their presumed ruination of cultural institutions (figure 13.11).[85] The role of the V&A Trustees in the restructuring of 1989 will only become evident when their records are studied by historians in later times. Meanwhile, it can be said that the Trustees, as viewed from the grass roots in the museum, made the kind of impression that might be expected: some seemed formidably effective and helpful, some less so, but all appeared to have the interests of the museum at heart. Some provided very useful professional skills, such as the accountant Ian Hay Davison, and Clifford Chetwood, who, as Chief Executive of Wimpey & Co., had a lifetime's experience of the construction industry to offer the museum's Buildings and Estate Department. Some had personality: everyone's favourite Trustee was the fashion designer Jean Muir (figure 13.12), and it is hard to imagine her in a plot to subject the museum to business values. One cynical observer opined that businessmen trustees would be best occupied in digging into their pockets. 'The new-type trustee is obviously no good at management, so let us instead see their money. I have never known any museum so badly managed ... as the V&A in recent years, when it began to bang its empty drum about good management.'[86]

In the face of conflicting partisan views, museum insiders might be prone to agree with the American curator, Michael Conforti, who thought that the V&A affair had been 'too often linked in the popular press to Thatcherism expressed in the cultural realm', and suggested that it was 'in reality a controversy with far more subtle and complex origins and opposing goals'.[87] One thing that can be said is that Esteve-Coll never conveyed that there was any political dimension to her plans; indeed, she never talked at all about her political views. It may well be that she should be regarded, not at all as an ideologue, but as a modernizer and pragmatist. And it is clear that any incoming Director would have had to adopt a programme of managerial reform for the V&A. Strong, who said that he found the museum 'living off its past',[88] had struggled to bring it up to date, but events in the world around outstripped him, and reform remained unavoidable. In the late 1980s all the national museums had to undertake some kind of 'restructuring', and few escaped without controversy. There were 'storms at sea' and 'mutiny' at the National Maritime Museum in 1987,[89] 'Trouble at Tate?' in 1989[90] and strikes at the Natural History Museum in 1990.[91] Nor did other cultural

V&A Corporate Plan 1995 - 1999 March 1995

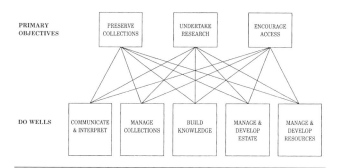

VICTORIA AND ALBERT MUSEUM

Corporate Plan 1995 - 1999

OVERVIEW

MISSION The Museum exists to increase the understanding and enjoyment of art, craft and design through its collections

Figure 13.14 The opening section of the V&A's Corporate Plan 1995–9, following the format devised by KPMG for the Department of National Heritage.

institutions avoid the chill winds. To take only three examples, the Royal College of Art, the London Zoo and the Design Council were all turned upside down.[92] The V&A's turmoil was not all that different from troubles elsewhere, though it is true that the V&A affair showed that, however effete and incompetent the curators might be thought to be, they certainly did not lack the ability to foment a hubbub, a talent that had always been cherished in the museum.

In the end Esteve-Coll achieved the biggest improvement in the general management of the museum since 1909. Under an Assistant Director (Administration), people with financial and business qualifications were recruited, and fortunately proved to have strong pragmatic instincts, which kept the show successfully on the road. Although the V&A had been devolved from the Civil Service, it was still funded by Government and, in order to earn its grant-in-aid, was obliged to provide for the Department of National Heritage detailed forward plans (figure 13.13). The Strategic Plan for 1992–7, for example, covering the activities of some 800 staff, listed 330 projects, under 69 objectives, within a framework of 12 categories of museum activity: 1. The Buildings, 2. Collection Management, 3. The Knowledge Base, 4. The Audience,

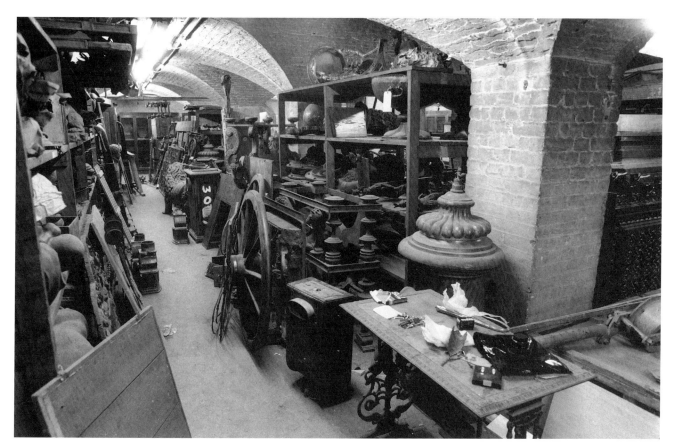

Figure 13.15 A mistake of the past: a museum store in 1986. Unfashionable and undervalued objects tended to be relegated to obscure corners during the 20th century. The last of such pockets of neglect were cleared up as part of Esteve-Coll's drive to improve collections management.

5. Display, 6. Exhibitions, 7. Research, 8. Education, 9. People, 10. Safety & Security, 11. Finance, 12. Information Technology. Subsequently, from 1994, the DNH, advised by the management consultants KPMG, required museums to follow a simpler model, involving: articulating a Mission, deriving from it Primary Objectives, defining 'Do-Wells' to realize the Primary Objectives, and linking in Major Change Objectives; while also providing Performance Measures for everything undertaken (figure 13.14).

While these planning procedures tightened up the V&A's administration, its care of its collections was also addressed. The material-based groups of curators survived (leading the 'Save the V&A' campaign to claim that 'our immediate goals have been achieved'),[93] but they were re-aligned as a single department under a 'Surveyor of Collections' who, along with the Heads of Conservation, Research and the National Art Library, reported to an Assistant Director (Collections). This made possible a comprehensive overhaul of curatorial methods. A *Collections Management Procedures Manual* (incorporating a Collections Management Policy) was inaugurated and kept updated. The museum's heavy investment in computer technology also helped to raise documentation standards to a consistently higher level. Esteve-Coll was particularly eager to improve the V&A's collection management (figure 13.15) because, early in her directorship (20 April 1988), she had been summoned, with the Director of the British Museum, before the House of Commons Public Accounts Committee to comment on a report (viewed as tendentious within the museum profession)[94] on the management of the two museums by the Comptroller and Auditor General. There she conceded that the V&A's record was 'a horrifying story'.[95] By the end of her directorship the situation had greatly improved.

The projected Research Department came into being. There was a general feeling, however, that it should not be an ivory tower for a privileged few, but should promote research as widely as possible through all areas of the museum's intellectual work, and a Research Policy, published in 1993,[96] was framed in accordance with this view. The Research Department, as it has developed, has come to have three ingredients. It comprises a small number of permanent staff, a group of Research Fellows funded from outside for periods of varied length, and museum staff on secondment from departments. For the latter, a spell in the Research Department provides a much-needed opportunity for concentration, to work on a book or catalogue, or on an exhibition. The museum's periodic *Research Report* records the impressive amount of published work that emanates both from the Research Department and the collections.

The Chairman of the V&A Trustees (from 1988), Lord Armstrong – who supported Esteve-Coll through thick and thin – claimed this for the new structure: 'Instead of being a federation of largely autonomous individual departments, the museum can be expected to become an institution with its own distinct personality and a coherent set of purposes and priorities.'[97] It might be argued, in the light of the present account of the V&A's history, that the museum has never been lacking in 'distinct personality'. It is true, however, that Esteve-Coll fostered a more open assessment of common purposes and priorities. At senior staff weekend conferences (constantly nudged to think more about the V&A's audiences by an American facilitator, Tony Merlo, working *pro bono*) consensus gradually developed, in an unthreatening and unthreatened atmosphere. The greater organizational coherence achieved through Esteve-Coll's staff restructuring seemed likely to be reinforced through plans to relocate the curatorial staff together in and around a new 'RCA' block, previously studios behind the museum used by the Royal College of Art, to be converted for use as a 'Centre for Research and Conservation in the Arts'. These new premises came into use in 1997, under Esteve-Coll's successor.

A definitive view of the V&A 'restructuring' perhaps needs more detailed analysis of the controversies than is possible here. It is worth contesting one popular error, which was much put about, namely, that under Esteve-Coll the V&A's curators were reduced in favour of administrators. In 1978 the V&A's staff divided as follows: curatorial staff, 24.8 per cent; administrative and service staff, 35.6 per cent; conservation and scientific staff, 7 per cent; security staff, 32.6 per cent. The figures for these categories in 1992 were: curatorial, 31.8 per cent; administrative, 29.4 per cent; conservation, 7 per cent; and security, 31.8 per cent.[98] While these are only rough-and-ready statistics, they do perhaps imply that things have not, from the curatorial point of view, become worse.

Alongside the troubles just described, the museum's normal work went on. New 'Art and Design' galleries were opened: the Nehru Gallery of Indian Art (1990), the Tsui Gallery of Chinese Art (1991), the Samsung Gallery of Korean Art (1992), and a Twentieth Century Gallery that incorporated the material in the existing British Gallery into a thematic international treatment (1992). The 'Materials and Techniques' galleries also began to be overhauled. The Glass gallery was completed in 1994, and work started on the Ironwork and Silverwork galleries.

The exhibition programme proceeded unabated. Among the exhibitions staged under Esteve-Coll, one or two proved contentious. *Elton John at the V&A* (1988) showed the popular singer's collection shortly before it was auctioned by Sotheby's; *Visions of Japan* (1991–2) was a high-tech extravaganza; *Sovereign* (1992), a tribute to the Queen's 40 years on the throne, was felt by some to be 'intellectually vapid';[99] *Sporting Glory* (1992–3), an exhibition of sporting

trophies, came to a sad end when its promoters went bankrupt. But there were about 175 other exhibitions during the period, which demonstrated the V&A's continuing wide interests and balanced judgment.

Esteve-Coll was also criticized for approving an advertising campaign, originated by Saatchi and Saatchi, which commended the V&A with the slogan: 'An ace caff with quite a nice museum attached'. Undoubtedly successful in catching public attention – its slogan was so memorable as to be included in the *Oxford Dictionary of 20th Century Quotations* in 1998 – this campaign can perhaps now be placed, not as an act of sacrilege, but as 'merely the most blatant example of a new spirit of breezy irreverence, mock-Philistinism and canny self-mockery which has become increasingly noticeable of late in arts marketing'.[100]

One of Esteve-Coll's highest priorities for the V&A was to improve its education service. It was in Strong's time that the V&A first used audience research. A survey made in 1984 by the Office of Population Censuses and Surveys disclosed that the V&A 'seems to appeal particularly to a highly educated audience, 51 per cent of its visitors having continued their education up to or beyond their twenty first birthday'.[101] Strong had been proud of the V&A's brainy audience, and did not think the V&A had much to offer to children: 'frankly, our collections are virtually meaningless to anyone below the age of 14 or 15'.[102] Esteve-Coll disagreed, believing that the collections could be made meaningful to everyone, and, through the turbulent years, a new, well-thought-out Education Department emerged, embracing schools, adult education and community education.

The free-booting political atmosphere of the 1980s seemed to be dissipating by the spring of 1990. A new tax, known as the 'poll tax', had earned the Conservative Government deep unpopularity. The financial disciplines that had been applied to hospitals, schools, universities and other public bodies, while initially promoting efficiency, were now seen to be threatening respected institutions with collapse. Small businesses, especially in the retail sector, were in difficulties. On 22 November 1990 Margaret Thatcher, faced with challenges within the Conservative party, resigned as Prime Minister. The managerial culture continued to dominate British life, but its brash certainties were now tempered by doubt and puzzlement.

Esteve-Coll had been appointed initially for a period of five years. By now, most directorships of national museums were period appointments. In 1991 there was speculation as to whether she would be invited to stay on when her contract ran out in 1992.[103] The Trustees expressed their confidence in her by asking her to continue for another five years. Her own confidence had no doubt been increased by surviving the troubles of 1989, and she began to reveal

more of herself in newspaper interviews. As Elizabeth Kingdon, she had been brought up, an only child, in Yorkshire, in a middle-class, Anglo-Catholic family – 'a bookish household, where weekend visits to museums and historic architecture were a matter of course',[104] and poetry was quoted at the breakfast table.[105] She starred in *Hamlet* in her all-girl school,[106] and while working as a waitress in the holidays hung around to catch sight of T.S. Eliot, who was staying in the hotel next door.[107] Her head full of Yeats and Synge, she went on to read English at Trinity College, Dublin. So far, this sounds like the making of a bluestocking, but at Dublin she ran counter to everyone's expectations:

Before she even completed her first year, she had fallen in love with a Spanish sea-captain, a man 30 years her senior, and run off to sea with him. José Esteve-Coll was a Spanish Civil War veteran, an anti-fascist who became a political refugee and never again returned to Spain. The 10 years she spent at sea with him – always the sole woman to be on board – seem to have been idyllic. She read enormous amounts of Spanish and French literature and taught herself Italian.[108]

It was not entirely a pleasure cruise. 'She can remember being petrified in a hurricane off the coast of Brazil: "Forty-foot waves crashing down on the iron windlass, twisting it beyond recognition".'[109] This can only have been good training for when, after re-entering academic life, she eventually launched herself on a sea of troubles at the V&A.

She did not complete her second term, because she was 'head-hunted' for the post of Vice-Chancellor of the University of East Anglia,[110] and left the V&A at the end of September 1995. Now honoured as Dame Elizabeth (just as her predecessors had been knighted), she signed off with some characteristically forthright remarks:

I know now that the attacks were because I was a woman and because I didn't have the conventional background. At first, the idea that I was being attacked because I was a woman seemed irrelevant in the late 20th Century. But there is a masculine Oxbridge club. No doubt the right background would have helped. I was a nobody from Yorkshire. The fact that I have a first class honours degree was ignored. And anyway, it's fun pillorying a woman. It's a soft target ... I broke the ground by being the first woman director and introduced a different way of running a museum. You speak for your time. A great national collection belongs to the people, not elitist art historians.[111]

NOTES

1 Janet Minihan, *The Nationalization of Culture: The Development of State Subsidies to the Arts in Britain*, London: Hamish Hamilton, 1977, p. 215.

2 See Bryan Appleyard, *The Pleasures of Peace: Art and Imagination in Post-War Britain*, London: Faber, 1989; Arthur Marwick, *Culture in Britain since 1945*, Oxford: Blackwell, 1991; Robert Hewison, *Culture and Consensus: England, Art and Politics since 1940*, London: Methuen, 1995.

3 Marwick, op. cit., p. 127.

4 Roy Strong, *The Roy Strong Diaries 1967–1987*, London: Weidenfeld and Nicolson, 1997, p. 7.

5 John Gruen, 'The privilege and passion of directing museums', *Art News*, January 1977, pp. 58–9.

6 Noel Annan, *Our Age: Portrait of a Generation*, London: Weidenfeld and Nicolson, 1990, p. 7.

7 Antony King Deacon, 'Strong vibrations: a conversation with Dr Roy Strong', *Woman's Journal*, November 1978, p. 164.

8 *Roy Strong Diaries*, pp. 134–6.

9 Ibid., p. 319.

10 Ibid., p. xii.

11 See Jonathan Voak, 'Directorship of Sir Roy Strong: A Chronology of Major Events, Acquisitions, Exhibitions 1974–1987', *V&A Album Golden Edition*, 1987, pp. 27–48.

12 Deacon, op. cit., p. 161.

13 John Windsor, 'A Dandy Has His Day', *Independent*, 29 March 1997, Long Weekend section, p. 21.

14 'A Marriage of Talents', unidentified article from a women's magazine, in the author's possession.

15 Roy Strong, 'Thinking and Doing in the United Kingdom: The Museum as Communicator', *Museum*, vol. 35, 1983, p. 81.

16 See C.H. Gibbs-Smith, 'The Photograph Collection of the Victoria & Albert Museum', *Museums Journal*, vol. 36, 1936–7, pp. 46–53. This description of the collection gives a good idea of one aspect of Gibbs-Smith's mind, his fascination with systems and gadgetry, which he had no difficulty in combining with an open, zestful interest in every corner of human life.

17 *Roy Strong Diaries*, p. 138.

18 Mark Haworth-Booth, *Photography, An Independent Art: Photographs from the Victoria and Albert Museum 1839–1996*, London: V&A Publications, 1997.

19 Stephen Bayley, 'The Boilerhouse Project: A New Venture for Museums and for Design', *International Journal of Museum Management and Curatorship*, vol. 2, 1983, pp. 153–8. Simon Tait, 'How the Design Museum caught the eye of the Establishment', *Financial Times*, 9 January 1999.

20 Jonathan Glancey, 'Potboiler at the V&A', *Architectural Review*, vol. 171, February 1982, p. 5.

21 Peter York, *Modern Times*, London: Futura, 1984, p. 26. See also Patrick Wright, 'Bottling It', *Guardian*, 16 May 1997, Friday Review, pp. 2–3, 5.

22 Nicholas Ind, *Terence Conran: The Authorised Biography*, London: Sidgwick & Jackson, 1995. Roy Strong, 'Shopping Conran', *Sunday Times*, 16 July 1995, Section 7, pp. 1–2. Stephen Bayley, 'So, who is the most stylish of them all?', *Evening Standard*, 25 July 1995, p. 12.

23 'Londres savoir exposer: la politique d'un musée', *Connaissance des Arts*, no. 351, May 1981, p. 65.

24 David Lowenthal, *The Past is a Foreign Country*, Cambridge: University Press, 1985; David Lowenthal, *The Heritage Crusade and the Spoils of History*, London: Viking, 1997.

25 Robert Hewison, *The Heritage Industry: Britain in a Climate of Decline*, London: Methuen, 1987.

26 Patrick Wright, *On Living in an Old Country: The National Past in Contemporary Britain*, London: Verso, 1985; Patrick Wright, *A Journey Through Ruins: The Last Days of London*, London: Radius, 1991.

27 Raphael Samuel, *Theatres of Memory: Volume 1. Past and Present in Contemporary Culture*, London: Verso, 1994; Raphael Samuel, *Island Stories: Unravelling Britain. Theatres of Memory, Volume II*, London: Verso, 1998.

28 Peter Mandler, *The Fall and Rise of the Country House*, London: Yale University Press, 1997.

29 Peter Thornton, *Seventeenth-century Interior Decoration in England, France and Holland*, London: Yale University Press, 1983; Peter Thornton, *Authentic Decor: the Domestic Interior 1620–1920*, London: Weidenfeld and Nicolson, 1984.

30 Arthur Jones, *Britain's Heritage. The Creation of the National Heritage Memorial Fund*, London: Weidenfeld and Nicolson, 1985.

31 'Director's Report' in *Victoria and Albert Museum. Report of the Board of Trustees October 1983–March 1986*, 1986, p. 8.

32 See C.M. Kauffmann, 'Huxley into Cole: A New Wing at the V&A', *Museums Journal*, vol. 82, 1982–3, pp. 209–11.

33 See Alexander Schouvaloff and Catherine Haill, *The Theatre Museum*, London: Scala, 1987; and Jean Scott Rogers, *Stage by Stage: the Making of the Theatre Museum*, London: HMSO, 1985.

34 Anthony Burton, *Bethnal Green Museum of Childhood*, London: Victoria and Albert Museum, 1986, p. 44.

35 See Anthony Burton, *Children's Pleasures: Books, Toys and Games from the Bethnal Green Museum of Childhood*, London: V&A Publications, 1996; Anthony Burton, 'Design History and the History of Toys: Defining a Discipline for the Bethnal Green Museum of Childhood', *Journal of Design History*, vol. 10, 1997, pp. 1–21.

36 'Director's Report' in *Victoria and Albert Museum. Report of the Board of Trustees October 1983–March 1986*, 1986, p. 8.

37 See Charles Saumarez-Smith, 'The Philosophy of Museum Display – The Continuing Debate', *V&A Album 5*, 1986, pp. 31–8.

38 See Peter Fuller in *Art and Artists*, February 1975, p. 36.

39 Roy Strong, 'Forty Years On: the Victoria and Albert Museum and the Regions', *Museums Journal*, vol. 75, 1975–6, pp.vi–viii (December 1975).

40 For example, letter 'The National Art Library', *Burlington Magazine*, vol. 121, 1979, p. 382.

41 *Burlington Magazine*, vol. 120, 1978, p. 271.

42 *Roy Strong Diaries*, p. 161.

43 Roy Strong, 'My biggest mistake', *Independent on Sunday*, 25 March 1990.

44 'Recent amputations at the V&A', and letter, 'The National Art Slide Library', *Burlington Magazine*, vol. 123, 1981, pp. 133, 163.

45 *Roy Strong Diaries*, p. 210.

46 Robert Hewison, 'A Strong Case for Revenge', *Sunday Times*, 4 May 1997, p. 4.

47 *Roy Strong Diaries*, p. 148.

48 Roy Strong, 'The Age of Ignorance', *Sunday Correspondent*, 11 February 1990.

49 *Roy Strong Diaries*, p. 248.

50 These have included the publication of regular reports (not undertaken since 1911). See *Review of the years 1974–1978*, ed. A.P. Burton, London: HMSO, 1981. [No report for 1978–83.] Then Board of Trustees' Triennial Reports, 1983–6 and 1986–9, ed. Jonathan Voak, and 1989–92 and 1992–5, ed. Susan Laurence.

51 See Anthony Burton, 'The Image of the Curator', *V&A Album 4*, 1985, pp. 384–5.

52 Nicky Bird, 'Christmas Shopping at the V&A', *Arts Review*, 22 November 1985, Book Supplement, pp. 9–12.

53 'Towards a More Consumer Orientated V&A', duplicated text of a statement made by Roy Strong at the press conference to launch the museum's Future Development Programme, 31 October 1985.

54 See Neil Cossons, 'The Museums Boom: When is a Museum not a Museum', *Listener*, 2 August 1984, pp. 13–17.

55 Charlotte and Denis Plimmer, *London: A Visitor's Companion*, London: Batsford, 1977, p. 194.

56 Memorandum to all Keepers, 19 June 1985.

57 David Lister, 'Adverts pay for cleaning of V&A', *Independent*, 9 May 1989.

58 Roy Strong, 'The museum as communicator', *Museum*, vol. 35, 1983, pp. 75–81; Roy Strong, 'Scholar or Salesman? The Curator of the Future', *Muse*, summer 1988, pp. 17–20 ('my final words to the museum profession').

59 A.L. Rees and F. Borzello, *The New Art History*, London: Camden Press, 1986. Review: Graham Reynolds, '"The Hungry Sheep ..."', *Apollo*, vol. 124, 1986, pp. 376–7.

60 Peter Vergo (ed.), *The New Museology*, London: Reaktion, 1989. Review: Simon Jervis, 'Objects are not Ideas', *Apollo*, vol. 131, 1990, pp. 274–5.

61 Hugo Davenport, 'Goodbye Tradition: Hello Commerce', *Daily Telegraph*, 3 July 1987.

62 By Tom Pocock, *Evening Standard*, 17 June 1985, p. 7.

63 By John Whitley, *Sunday Times*, 30 March 1986, p. 47.

64 By Gillian Darley, *Crafts*, no. 78, Jan/Feb 1986, p. 12.

65 By Robin Simon, *Daily Mail*, 19 June 1987.

66 *Roy Strong Diaries*, pp. 375, 379.

67 Rosemary Hill, 'Victoria, Albert and Elizabeth', *Sunday Telegraph*, 10 January 1988, Women section.

68 Ibid.

69 J.V.G. Mallet, 'The V&A Crisis', *Art Monthly*, May 1889, p. 2.

70 Invitation to participants, 27 September 1988.

71 The paper, a Trustees' paper entitled 'Recommendations for Restructuring the Staffing of the V&A', with the running number VABT(89)5, was circulated 'To All Staff' on 27 January 1989 with a covering note by the Director. The quotations that follow are taken from the copy preserved by the author.

72 Memo reporting a *Special Keepers' Meeting*, signed by Anthony Radcliffe and Santina Levey, 26 January 1989.

73 *The Times*, 11 February 1989; *Observer*, 12 February 1989, p. 15.

74 *Guardian*, 17 February 1989.

75 'The Apollo Portrait: Wolfgang Fischer', *Apollo*, vol. 131, 1990, pp. 182–5.

76 *Independent*, 18 February 1989.

77 Proceedings published in *Museum Management and Curatorship*, vol. 9, no. 4, December 1990.

78 Peter Watson and Laurence Marks, 'Massacre of the Scholars', *Observer*, 12 February 1989, p. 15.

79 A printed version of the speech was circulated, and the quotation is from the author's copy.

80 Hewison, *Culture and Consensus*, pp. xv, 268.

81 Marwick, op. cit., p. 145.

82 Linda Christmas, *Chopping Down the Cherry Trees: A Portrait of Britain in the Eighties*, London: Viking, 1989, p. 304.

83 Brett Gorvy, 'Portrait of a Populist', *Antique Collector*, December 1991/January 1992, p. 34.

84 Martin Kemp, 'The Crisis at the V and A', *Burlington Magazine*, vol. 131, 1989, pp. 355–7.

85 For example, Pat Gilmour, '"Irresponsible" Trustee Systems v. Advisory Councils', *Art Monthly*, June 1979, pp. 13–15; Noel Malcolm, 'Maggie's Little Helpers', *Observer Magazine*, 19 February 1989, pp. 15–21; Robin Simon, 'A Question of Trust', *Tatler*, February 1990, pp. 50–2; Rupert Christiansen, 'Jobs for the Boys, the Bullies and the Ignorant Rich ...', *New Statesman*, 18 July 1997, pp. 40–1.

86 Graham Hughes, 'Victoria and Albert Museum', *Arts Review*, 24 February 1989, p. 133.

87 Michael Conforti, 'Museums Past and Museums Present: Some Thoughts on Institutional Survival', *Museum Management and Curatorship*, vol. 14, 1995, p. 352.

88 *Roy Strong Diaries*, p. 135.

89 David Bradley, 'Storms at Sea', *FDA Newsletter* [Association of First Division Civil Servants], April 1987, p. 5; 'Mutiny at the Maritime', ibid., June 1987, p. 7.

90 Maurice Davies, 'Trouble at Tate?', *Museums Journal*, vol. 89, 1989, p. 12 (November 1989).

91 *Guardian*, 25 April 1990. See David Lister, 'Scientist hits at "Disney" museum plan', *Independent*, 5 May 1990, p. 2. *Guardian*, 11 May 1990, p. 28.

92 Laurence Marks, 'Picked Clean by the Piranha', *Observer*, 8 December 1991, p. 53. Paul Brown, 'Private Theme Park for London Zoo Rejected', *Guardian*, 7 January 1992, p. 3. Lynda Relph-Knight, 'A Future Design Council: Sorrell's Blueprint Exposed', *Design Week*, 25 March 1994, pp. 10–11.

93 *Newsletter*, no. 11, March 1990.

94 Ian G. Robertson, 'President's View: "The Guilty Men"', *Museums Bulletin*, June 1988, vol. 28, p. 46.

95 *Committee of Public Accounts. First Report. Management of the Collections of the English National Museums*, 1988, Evidence, para. 3568.

96 *The Art Newspaper*, no. 32, November 1993, pp. 17–18; and see Charles Saumarez Smith, 'The Practice of Research at the Victoria and Albert Museum', *Museum Management and Curatorship*, vol. 12, 1993, pp. 349–59.

97 Letter to the *Independent*, 9 December 1989.

98 These rough calculations are derived from the staff lists given in the V&A's *Review of the Years 1974–1978* (Staff at 31 December 1978) and *Report of the Board of Trustees April 1989–March 1992* (Staff at 31 March 1992).

99 Laurence Marks, 'Rent the V&A to Show your Holiday Snaps', *Observer*, 19 July 1992.

100 Paul Taylor, 'Ads for art's sake', *Independent*, 22 October 1988.

101 Patrick Heady, *Visiting Museums: A Report of a Survey of Visitors to the Victoria and Albert, Science and National Railway Museums for the Office of Arts and Libraries*, London: HMSO, 1984, p. 15.

102 Strong, 'Thinking and Doing ...', p. 81.

103 'Esteve-Coll's Future in the Balance', *Evening Standard*, 11 June 1991, p. 6.

104 Gorvy, op. cit., p. 34.

105 Judy Goodkin, 'A Childhood: Elizabeth Esteve-Coll. "My dog was my constant companion"', *The Times*, 2 November 1991, Saturday Review, p. 54.

106 Malcolm Brown, 'EC of the V&A', *Airport*, December 1989, p. 25.

107 Goodkin, op. cit.

108 Brown, op. cit., p. 26.

109 Suzie Mackenzie, 'The people's choice', *Guardian*, 12 June 1991, p. 37.

110 Simon Midgley, 'Deep VC Fishing', *Guardian*, 28 January 1997, Higher Education supplement, p. iii.

111 Katherine Hadley, 'The art mafia tried to break me because I am a woman – but I have triumphed over the chauvinists', *The Mail on Sunday*, 27 August 1995, p. 16.

CHAPTER FOURTEEN
And Now ...

Elizabeth Esteve-Coll was followed as Director by Dr Alan Borg. This chapter reviews the new projects that he initiated, and then considers the museum's present and future mission in the light of the vision of its founders.

Present projects

In her last Report to the Trustees, in 1995, Elizabeth Esteve-Coll reviewed the museum's financial position. 'Funding from Government has not increased in real terms in recent years ... we must increasingly seek ways to generate funding of our own.' The same old story, the reader might think. But there was one very important new factor: 'the National Lottery, a scheme of ... enormous significance for any museum, creating at a stroke the most powerful source of patronage for generations'.

The National Lottery was set up by the Conservative Government headed by John Major in November 1994. Subscribers bought tickets for a weekly draw (twice-weekly, from February 1997). Of the takings, 50 per cent was distributed in prizes to subscribers and 28 per cent to five good causes, namely the arts, charities, heritage, sport and a Millennium Fund, intended to support special projects to commemorate the year 2000. Through the arts, heritage and Millennium channels, very large sums of new money thus became available to museums, if they were able to convince the disbursing authorities of the worthwhile nature of their projects. Making applications for Lottery support was, however, something of a lottery in itself. Esteve-Coll viewed the influence of the Lottery with disquiet:

A museum of the size and complexity of the V&A must plan its progress in a structured way... Grant-in-aid and the process by which bids are submitted and evaluated, even on the current annual rather than three-year budget cycle, enables such scheduling to be done with a fair degree of confidence. By contrast the scale of individual Lottery awards, the variety and length of the bidding processes and the uncertainty that any bid will succeed seem all too likely to throw the delicate ecology of a museum's five-year development plan into complete disarray. Yet whatever the drawbacks, the potential gains from a successful Lottery bid are so enormous that they cannot be ignored.[1]

This was the principal challenge that faced the new Director, Dr Alan Borg, who took over on 1 October 1995.

Borg (figure 14.1) was an art historian, educated at Westminster School, Brasenose College, Oxford, and the Courtauld Institute, London. He spent the first few years of his career teaching art history in American universities. He might seem, therefore, to be in the traditional mould of V&A Directors. Some commentators, like the *Art Newspaper*, were relieved to hail him as a 'medievalist director'.[2] But he was praised elsewhere for his 'prowess as a fundraiser', was credited with a 'strong populist streak'[3] and was described as a 'presentation wizard', who was a 'stickler for detail' in display.[4] These capacities had no doubt been developed during his slightly unusual trajectory in the museum world, which he entered as an Assistant Keeper at the Tower Armouries in 1970. After this he moved in 1979 to be the first Director of the Sainsbury Centre for the Visual Arts at the University of East Anglia, where he installed the Sainsburys' idiosyncratic collection, which combined modern art and antiquities with African, Oceanic and indigenous American art, in a 'high-tech', high-profile modern building by Norman Foster. From here he moved in 1982 to the Imperial War Museum in London, where he

brought space and elegance to a dull, cramped building through a conversion designed by Arup Associates, and imaginatively redisplayed collections that had previously only attracted military buffs, so as to enhance their appeal to the public at large. He seemed, then, a reassuringly seasoned and well-equipped museum administrator. 'If he had "safe pair of hands" tattooed on his forehead it could not be plainer,' said one journalist.[5] More excited, another noted in Borg 'the natural leonine grace of a former sportsman (he was a fencing Blue at Oxford)'.[6]

'Some great museums,' Borg remarked, 'are like oil tankers – you can't actually stop them or turn them around too quickly. Nor should you try to.'[7] It emerged that one of his competitors for the directorship had proposed to reform the V&A by ending its coverage at 1900, and sending away all its more recent material to join the twentieth-century fine art in the Tate Gallery's new modern branch on Bankside.[8] Borg did not embark on such convulsive measures, and was later to disparage 'rationalizations'. To a suggestion that the V&A should shed its fine-art holdings

Figure 14.1 Alan Borg in 1998, with a model of Daniel Libeskind's proposed Spiral building.

he said: 'There is more than one way of looking at art. The V&A was founded with a variety of aims, one of which was to demonstrate the links between the fine and decorative arts ... Art, like life, is about diversity and is all the more enjoyable for it.'[9] Thus committing himself to diversity in the V&A, Borg refrained from restructuring it again and made comparatively few administrative changes. Esteve-Coll's 11-strong Executive Council became a Director's Council of 15, meeting monthly, while Borg worked chiefly through weekly meetings of his Central Management Team of five (rising in July 1998 to eight). A few committees were discontinued. Borg's principal structural change was the creation of a Department of Major Projects, to drive forward the large developments for which, in consequence of the Lottery, more dedicated provision now had to be made; major projects could no longer be accommodated by the normal practices and structures. In anticipation of the projects to come, he at once overhauled the V&A's fundraising department, the Development Office. The curators of the material-based departments were made to feel more comfortable by 'the restoration of the departmental names', as the *Burlington Magazine* approvingly noted (adding: 'V&A watchers will recall that in an attempt to maintain that radical restructuring plans had been adhered to, the departments had first been called "sections" and then, absurdly, "collections"').[10] The curators moved in 1997 into the new Centre for Research and Conservation in the Arts, which had been begun under Esteve-Coll.

An early test of the museum's poise under its new Director was a television programme broadcast on BBC2 on Wednesday 23 October 1996. This was an hour-long documentary on the museum, by Susanna White, in a series called 'Modern Times', which operated by letting film crews loose in arts institutions to record daily life there from the viewpoint of a 'fly on the wall'. This technique had been deployed to riveting effect in a four-part documentary on the Royal Opera House, Covent Garden: entitled 'The House', this seemed to reveal a disintegrating institution, beset by quarrels and crises. Scenes in which overwrought bosses sacked dejected minions, on camera, were disastrous for the Opera House's image, although its public relations people defiantly claimed that all publicity was good publicity. There was gleeful anticipation that the V&A was at risk of suffering similar damage from the 'docusoap' in which it had agreed to co-operate. But some kind of corporate instinct for self-preservation took over, and the programme on the V&A turned out to be a damp squib: 'cheerfully banal', 'droning on'.[11] Those participants whose histrionic abilities attracted the cameras were rather peripheral figures, while the important people in the museum contrived to deliver bland, contained performances, which gave no hostages to fortune. Perhaps the

'reserve' that journalists had observed in Borg[12] had communicated itself to the museum.

One issue that Borg was expected to confront was admission charges. He had been running a museum with a regime of compulsory admission charges, and it was made known that he 'does not like the halfway house of voluntary contributions', preferring either free admission or a fixed charge.[13] Since the V&A's voluntary system had been introduced in 1985, the Trustees had regularly reassessed this arrangement, which by 1994/5 was providing about 4.7 per cent of the museum's income. By 1996 it was clear that this percentage must be increased. Otherwise the museum would face financial difficulties, which could only be relieved by damaging cuts to the museum's activities. On 17 May 1996 the Trustees announced that compulsory charges were to be introduced. One factor in their decision was a curious quirk of the tax laws, whereby money-making institutions were allowed to claim back the Value Added Tax they paid on their expenditure. In respect of most (but not quite all) of their transactions, free museums – even museums like the V&A, which asked for a 'voluntary contribution' – did not get this tax relief. If the V&A were to charge for admission, however, it could reclaim more on VAT and thus receive a useful addition to its funds. Inevitably, the Trustees' decision to charge led to some criticism. Detecting the influence of John Major's Conservative Government, now in a state of terminal decline, the *Burlington Magazine* jeered: 'Alas, the trustees seem to have given in to the blackmail of an expiring government.'[14] But the decision was not taken on ideological grounds; it was a question of survival.

At the general election on 1 May 1997 the Labour party won by a huge majority, and their young leader, Tony Blair, formed a new Government. The new Minister for the Arts was Chris Smith, but he had not shadowed this role in opposition and had to read himself in, so it took some time for Labour's policies to become clear. By 15 October 1997 the *New York Times* felt that it had understood: 'Labor Talks Up British Art While Cutting the Budget'. In an article under this headline, it concluded that 'the first signs were encouraging', but 'the arts world is already disappointed'. In February 1998 the *Art Newspaper*, studying the latest budget figures, concluded: 'Culture no richer under Labour'. While emulating the preceding Conservative Government in keeping a firm grasp on the money, the Labour Government broke with its predecessor, however, in adopting a populist approach to the arts.

One aspect of this was the boosting of popular culture such as pop music and film, as against more élite art-forms such as opera. To some extent this was signified when the former 'Department of National Heritage' was renamed 'Department for Culture, Media and Sport'. The Prime

Minister led the way in the rebranding of British culture. Footballers and pop-singers were entertained at receptions at 10 Downing Street and 'Britpop' and 'Cool Britannia' were the slogans of the day, denoting the preference for demotic and youthful cultural forms. Popular entertainers, however, eventually rebelled against their recruitment as Government ambassadors: 'the honeymoon between pop and the Government is well and truly over,' said a newspaper article in March 1998.[15] And the custodians of more traditional culture, feeling that 'the arts are being harmed by the Prime Minister's personal antipathy', fought back.[16] The fizz of enthusiasm for low culture soon evaporated, and when Chris Smith (a cultivated man and well-liked as an individual)[17] brought out an account that puffed it, *Creative Britain*, in May 1998, the book fell flat.

Another aspect of Labour's populist approach to the arts was less ephemeral. While the Conservatives, with their free-market ideology, did nothing to discourage admission charges, Labour believed in free admission in principle. Those with long memories could recall the admission charges imposed under the Tory Prime Minister Edward Heath on 1 January 1974, and promptly abolished in March of the same year when Harold Wilson's Labour Government took over. Chris Smith made clear that Labour still had a commitment in principle to free admission, and supported the museums and galleries that still stuck to this policy. But he could not enable museums that charged to return to free admission, because he could not obtain public money to compensate them for the loss of income that would result if they did so. Eventually, his hand was forced by the financial problems of the British Museum, which had always been at the forefront of the free museums.

The British Museum had embarked upon an ambitious building programme, supported by grants from the Lottery. It could hardly have avoided adopting this programme, because the British Library, part of the museum since its inception, was due to move away from the museum site in Bloomsbury in 1998 to its new site in St Pancras, leaving the museum with a hole in the middle, which had to be redeveloped. The museum's administration, already branded as inefficient by an internal report (the 'Edwards Report'), now seemed, as it embarked on large-scale redevelopment, to have taken on more than it could chew. 'The problem is,' explained the weekly *Economist* in November 1997, 'that while £97m is pouring in from the lottery and other donors for redevelopment, lottery money cannot be used for routine costs. By next year, say the museum's bosses, cash will be so tight that it will be unable to pay staff salaries and will have no choice but to start charging visitors.'[18]

A very vigorous campaign was begun, to persuade the Government to bail the British Museum out. 'A state

of national emergency' was the title of an article in the weekly *New Statesman* (7 November 1997) by the fiercest of the lobbyists, Neil MacGregor, Director of the National Gallery, which also offered free entry to visitors.[19] Throughout November the campaign hotted up. 'Frantic bid to save Museum from meltdown' was a screaming headline in the *Evening Standard* on 3 December. By this time, the museums that did charge for admission were feeling somewhat affronted by the campaign. On 29 November 1997 *Independent* columnist David Lister reported that the

well-orchestrated campaign for free admissions by all the great and the good lost its united front yesterday. Alan Borg, director of the V&A, broke ranks, saying that he and the heads of other charging museums would not tolerate extra money being given to the free museums to keep them free and no help being given to the charging museums.[20]

And on 3 December *The Times* reported that the V&A was trying 'to block ... a proposal under consideration by the Government to give the British Museum extra cash to stave off the introduction of admission charges'.[21] Chris Smith was able, shortly afterwards, to bail out the British Museum for one year only, extracting promises of greater efficiency in future. But 'the art world expressed anger that more money for the British Museum meant less for others'.[22]

The Minister for Culture now faced the dilemma that whatever he did would displease someone; and he was increasingly forced to forsake considered policy in favour of rescue operations, as one esteemed institution after another got into difficulties. He was assailed by a swelling chorus of complaint, in which, among many angry voices, 'V&A head savages squeeze on arts cash'.[23] On 17 March 1998 it seemed as if Smith had been saved in the nick of time by the Chancellor of the Exchequer, who, in the Budget, announced an extra £89m to promote access in museums. On 24 July Smith announced the details of a plan that would use this money to ensure that all British museums and galleries would have free entry by 2001. Free admission for children would be implemented in 1999, for pensioners in 2000 and for everyone in 2001. 'This is a very good day for museums,' said a V&A spokesperson,[24] although it made no immediate difference to the V&A in the first year. For, while the V&A's admission system charged adults £5 (concessions £3), all children under 18 were admitted free anyway, as were full-time students, pre-booked educational groups, disabled people with carers and unemployed people. Smith's package was acclaimed, but seemed to begin to unravel from the start. Already, on 2 August, the Museums Association was quoted as saying, 'the amount of money is unlikely to be enough',[25] and by January 1999 the plans were reported as being in jeopardy. 'A Whitehall insider said: 'Of course Chris is very disappointed by not being able to make all museums free, but he

just was not able to persuade his Treasury colleagues that it was that big a deal.'''[26] The mixed economy in the museum world seemed set to stay, and the V&A's adoption of compulsory admission charges, which had seemed for a time to set it at odds with the Government, now began to look like a prudent and unavoidable measure, especially in light of the fact that, even if the promised new funding appeared, there was no guarantee that it would continue beyond 2001.

The V&A, like most other museums, has for some considerable time tried to augment its state subsidy by generating income, not only by admission charges, but through commercial activities. It continues to hire itself out for functions (in 1999 hire fees range from £750 for half a day in the Seminar Room to £10,000 for an evening dinner in the Raphael Gallery), and its sales of books and other merchandise contribute usefully to the museum's funds. 'V&A Enterprises', which runs the corporate entertainment, retailing, licensing and publishing activities, gradually geared up during Esteve-Coll's time and, rearrayed in a purple and gold livery, flourished under Borg. In recent years profit has come especially from licensing – that is, encouraging manufacturers to produce goods based on items in the museum, and giving them the right to use the museum's logo as endorsement on the goods.[27] Of course not everyone approves of museum trading. One journalist, condemning 'the V&A's passionate affair with Thatcherism', denounced the museum as 'tarnished by years of mercenary marketing'.[28] But the museum's other functions are bound to suffer if it does not make money.

Nothing but approval has been given to the V&A's publishing activities, which were rebuilt from scratch from 1994 onwards. Although V&A staff have a good record of producing readable introductions to their subjects, these always tended to be published by commercial publishers, while the museum itself specialized in publishing fact-hoards for the erudite initiate (in the form of catalogues) and souvenir albums for the novice (in the shape of picture-books). The museum now aims at the middle ground, at the intelligent general reader, who takes pleasure in ideas as well as objects. In recent years substantial and invitingly designed books have been published on many of the museum's main subjects of interest: European sculpture, Western furniture, silver, decorative ironwork, glass, portrait miniatures, British watercolours, photographs, and the collections at the Bethnal Green Museum of Childhood. Books on fashionable dress sell best of all, while the Oriental departments sustain a quiet flow of publications in their fields. In the last few years the V&A's publishing programme has emerged from debt, broken even and gone on to make a modest profit.

The V&A's publications indicate that its intellectual life is

healthy, and this was evidenced also in the travelling exhibition about the V&A's own history, *A Grand Design: The Art of the Victoria and Albert Museum*. The Baltimore Museum of Art in America initiated this project, in Esteve-Coll's time, collaborated in shaping the contributions from a wide range of V&A curators and launched the exhibition, after its opening at Baltimore in October 1997, on a tour to Boston, Toronto, Houston and San Francisco, with a showing in England, at the V&A, in autumn 1999. When this exhibition was first broached, in the midst of Esteve-Coll's managerial revolution, it was welcomed by the 'Young Turks' of the V&A as an opportunity to reassert and, importantly, to reassess the V&A's intellectual and curatorial values. The exhibition can be viewed as an anthology of 'treasures of the V&A', but it is more than that. Carefully structured to present six contrasting facets of the V&A's collections, it shows how the museum has constantly reconfigured them, not only physically through changing display practices, but intellectually, in terms of their meaning and value. In thus subjecting itself to self-reflexive analysis, the V&A has taken an unusual, if not unparalleled, step in the museum world. The exhibition's message, or rather its cluster of messages, seemed to be conveyed successfully in its American showings.

The V&A can claim, notwithstanding the traumas of recent years, to be in good intellectual shape – and this was one important message of *A Grand Design*. It can claim also to be managing its finances better. But, as we have seen, the economic outlook for museums is not encouraging: while there were high hopes of better times under a Labour Government, in the event the State's regular subsidy to museums – year in, year out – has declined still further in the 1990s. The depressing effects of this retrenchment are exacerbated by the uncertainties attendant on the funding of special projects through the National Lottery. When the Lottery was instituted, every arts organization in the country that was not catatonic felt that it ought to make an application. Of course, there was not enough money for everyone. Consequently many organizations put a great deal of work and money into preparing an application, to the demanding standards that the Lottery required, only to find that all this had been wasted when the application was refused. This was the first snag about the Lottery. Even if an application was successful, however, further problems could arise. One of these was financial. Lottery grants were made on condition that some matching funding was provided by the applying institution, from private sources. Even prestigious and well-organized institutions found that this side of their funding could often go wrong, leaving them with a financial shortfall. A second problem was organizational. Some institutions proved to be unequipped to take on the extra effort that was involved in pushing through major projects, and began to collapse under the strain.

A genre of newspaper story was soon established, featuring threatened Lottery projects. Sadler's Wells Theatre, the Royal Albert Hall, the Royal Court Theatre, the Ikon Gallery, Birmingham, the Cambridge Arts Theatre, the Quay Arts Centre in the Isle of Wight, the Tate Gallery and the British Museum were all mentioned as early recipients of Lottery money, where projects were being vigorously and successfully implemented, but where the accounts seemed not to add up.[29] The principal example of a major institution that collapsed was the Royal Opera House, Covent Garden. It had received one of the earliest and largest Lottery grants (£78.5m) in 1995, but by 1997 the strain of trying to keep the opera and ballet companies together and of performing at other venues, while the Covent Garden house was closed for rebuilding, was too much for its debilitated management. Repeatedly teetering on the edge of insolvency, it was discomfited by a scathing report from the Commons Select Committee on Culture and a severely critical special investigation demanded by the Minister. And it was shaken, within months in 1997–8, by the departures, in various degrees of defeat or disillusionment, of two successive Chief Executives, the Chairman and the entire Board, the Director of Opera, and the Head of Education, together with threats that the Musical Director would resign and the ballet company secede. Covent Garden recovered eventually, but stood as a dreadful warning of how the bounty of the Lottery could distort the operations of an institution, rather than assist them.

Arts institutions hoping for help from the Lottery were not pleased when in July 1998 the Government decided to divert some of the available funds away from arts projects (among other things) towards health and education.[30] They resented the growth of a bureaucracy devoted to processing applications ('Lottery pays millions to arts advisers'),[31] and were disillusioned at the amount of Government money being poured into an entirely new (and, in the opinion of some, ill-advised) project, the Millennium Dome at Greenwich, apparently at the expense of established institutions.[32] The *Independent* newspaper concluded that 'the lottery, far from being the bottomless cornucopia paying for a revival of British culture, has turned out to be one of its chief enemies',[33] and in January 1998 Lord Gowrie, then Chairman of the Arts Council, said that 'to many arts bodies the lottery has represented a curse rather than a blessing'.[34]

Conscious of the dangers, the V&A nonetheless had to advance onto the Lottery battlefield, if it was not to stagnate. Borg boldly decided to pursue not one but two projects, and prudently delegated their administration to the new Major Projects Department. The rest of the

museum's work was to some extent protected from the turmoil; on the other hand, it was to some extent subdued in favour of the major projects. The first project was the redesign of the entire sequence of Art and Design (formerly 'Primary') Galleries devoted to British art, from the Tudors to the end of the nineteenth century (Rooms 51–8, 118–26). These might well be thought of as a jewel in the V&A's crown, but, as it happens, they were among the most neglected of the main galleries. During the directorships of Strong and Esteve-Coll, the Japanese, Chinese, Korean and Indian galleries (known as the Cultural Galleries) had been refurbished, because it was possible to persuade sponsors from the countries involved to invest in the V&A. Earlier, the sequence of Continental Art and Design Galleries (Rooms 1–9) had all been refurbished (with public money) between 1974 and 1987. But the British Galleries remained almost as Leigh Ashton had left them, except that (as we have seen) they were extended in the 1960s to include the Victorian period. Small attempts had been made to smarten up the Tudors (1983) and the Stuarts (1990), but as a whole these displays were tired and dingy. Borg resolved to tackle the whole sequence of galleries. 'The initial idea was to tackle the galleries one at a time; Borg said no, do them all at once. The staff tell him it will take seven years; he insists it will only take five.'[35]

Leigh Ashton gave the impression that he rearranged the whole museum with the help of a man and a boy ('I would challenge any designer to put up as good a show as any intelligent museum man with a couple of carpenters and a good lighting man'), but things were very different in 1995, and the project had to be approached like a military campaign. Architects, designers, structural engineers, quantity surveyors, mechanical and electrical experts, and project managers from outside, had to be welded into a team with the museum's own conservators, curators and educators (figure 14.2). It was the first time that educators had been involved from the beginning in planning V&A galleries. Some creative tensions might be expected to develop. Curators, educators and conservationists always pull in different directions; and the design team (as a museum press notice pointed out) 'combines the well-known modernist Dinah Casson with David Mlinaric, celebrated for his work on historic interiors'.[36] While Mlinaric has been described as 'the prince of purists whose restorations ... have passed every scholarly test',[37] Casson is credited with the view that 'if a tapestry dating back to Charles II needs a shocking pink surround, it will get one', and she 'sees nothing wrong in placing a Queen Anne chair against a bare concrete wall'.[38]

The curatorial staff are divided into teams to deal with the three sections of the project: Tudors and Stuarts,

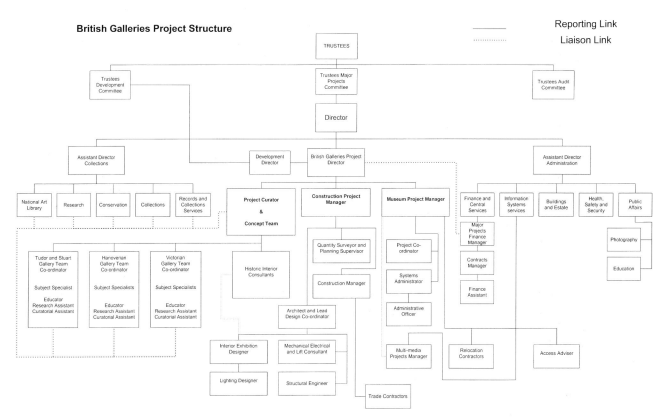

Figure 14.2 A staffing chart for the British Galleries project, showing the elaborate organization needed.

14.3 A sketch by Casson Mann for a section of the British Galleries dealing with neo-classicism in the late 18th century.

Hanoverians, Victorians. This way of conceptualizing the content of the galleries has led some nostalgic observers to conclude that a reverentially monarchical slant survives in the V&A's thinking, while others have thought that the prominence of the 'Tudors and Stuarts' and 'Victorians' in the National Curriculum history course might have had something to do with the choice of titles. Each section has a full-time co-ordinator and junior curators seconded from the museum departments, along with specially recruited researchers; and many other curators are supplying advice.

Whereas, in Ashton's galleries, chronology and style were the ruling concepts, indeed almost the only ideas underlying the displays, the new galleries will tell many more stories and treat a much wider range of themes, through significant groupings of objects (figure 14.3). At present there is only one V&A gallery, that devoted to Late Gothic and the European Renaissance, where the visitor is invited to regard objects as exemplifying themes, such as 'Industrial production in 16th century Germany' or 'Images and religion in the Netherlands and France': this approach will pervade the new arrangement of the British Galleries. The aim of the galleries is to make the collections comprehensible, using whatever means of interpretation are available, including videos and interactive devices. Predictably, perhaps, this seems to have alarmed some. One press report quoted a 'keeper, nervously anonymous' as saying, 'The point of these objects is that they are so fine that they enrich our experience and our understanding just by themselves'.[39] Another claimed that 'the museum world is deeply divided' over the V&A project: 'the worry is that the galleries will be turned into a glorified theme park.'[40] Another raised the prospect that the galleries could be accused of 'dumbing down'.[41] The gallery team passionately rejected the implication that some sort of cynical trivialization was envisaged; they were clear that their aim was to make the V&A comprehensible to a wider audience. Making sense of the V&A's collections has been one of the main themes of this book: in the light of what has been surveyed earlier, it could be argued that the V&A's record in explaining itself has not always been creditable, and that its galleries have often seemed specialized and 'aloof' (to use the term proposed as a virtue by Berenson in 1927). The museum today could do a great deal to make itself more comprehensible before approaching the point at which accusations of 'dumbing down' might be sustainable.

The second of Borg's projects was the erection of a new building in the last unoccupied space on the site, the court-

yard between the main building and the Henry Cole Wing, which had been the site of the Boilerhouse experiment. The aim, at the start, was to provide an environment in which visitors could be helped over the threshold of the V&A, which, it was thought, seemed inhospitable to many. The building was known briefly as 'the Key': 'as its name suggests, The Key aims to "open up" the collections to a wider public'.[42] It was possible to disparage such attempts to ease access to the museum. The critic James Fenton, in an important article on the V&A, remarked:

It was explained to me recently that there was a phase, throughout the museum world, in which all the old main entrances were thought to look wrong and off-putting, and so new extensions were built ('usually by I.M. Pei') to provide ... a supposedly friendlier and less awesome approach.

Fenton thought that 'the signs are that we may have weathered this trend', and implied that Borg's new building ('our old friend, the new wing with its user-friendly entrance, designed to bring in a new generation') was already *vieux jeu*.[43] But there is no good reason why the provision of more welcoming access should be regarded as outmoded, and many would argue that it was high time for the V&A to open up.

An international architectural competition attracted entries from 70 practices, of which eight were shortlisted. The winner was Daniel Libeskind, a Polish-born American architect, best known as a theorist and teacher, and something of an unknown quantity, for he had few completed buildings to his credit. His project for the V&A was immediately controversial. The site was very constricted, and overlooked on three sides by strongly articulated Victorian and Edwardian façades. It was very difficult, therefore, to insert into it a free-standing construction with size and presence. Libeskind designed an irregular building of interlocked wedges, seen by some as explosive and by others as resembling a tumbling pile of children's building blocks (figure 14.4). Whatever functions the building might or might nor perform, it was certainly noticeable. The V&A was not 'playing safe'.[44]

As Libeskind worked on the plans for the building (a load-bearing construction despite appearances to the contrary) with engineer Cecil Balmond of Arup Associates, it acquired the name 'The Spiral', a tag hinting at some of the elaborate geometry involved in the design. Having been introduced to Britain, Libeskind rapidly became well known. He was commissioned by the Imperial War Museum to design a branch museum for them in Manchester, and two Holocaust museums that he had designed, in Osnabrück[45] and Berlin,[46] opened during 1998. Libeskind and Frank Gehry were often linked as 'deconstructionist' architects, because of the fractured and unbalanced appearance of their buildings. Gehry's style, however, was applied in

various places to various purposes, whereas Libeskind's buildings were, it was claimed, 'profoundly contextual',[47] developing out of the particular needs and circumstances of each commission. He developed a specialization in museums devoted to the memory of Jewish people during the Second World War, and his buildings were vehemently symbolic, to the extent that they hardly needed exhibits. Their success contributed, it was said, to a 'general unease being felt in the global museum community about the tensions between the function of the museum as an icon within the city or indeed the country as a whole and its duty to protect and house many diverse items of perceived cultural worth'.[48]

What was Libeskind's Spiral, as an icon, meant to say about the V&A? A perhaps mischievous suggestion was that it celebrated the incoherence of the museum, its constantly changing identity:

I suspect that Daniel Libeskind has managed with symbolic brilliance to seize upon precisely this characteristic of the V&A in his proposed model for a new building in the Boilerhouse Yard. Instead of looking for intellectual lucidity and clarity of intellectual form, he has created a building which is a deliberate dissonant jumble of different boxes knocking up against one another in angry discordance, clashing against the existing architecture. It's a grand building, striving for effect, but also to the outsider oddly purposeless, as if one is not quite expected to know what exactly it is doing there.[49]

Others, especially traditionalist architectural critics, have assumed that its purpose is simply to draw attention to itself, as Frank Gehry's museum at Bilbao has so successfully done, 'to achieve global acclaim by pushing architectural invention to the very edge of the grotesque'.[50] Simon Jenkins has called the Spiral 'son of Bilbao'.[51] Gavin Stamp has deplored the 'state of affairs in which the new building – as landmark, as image, as symbol of modernity, as expression of individual genius – is much more important than the function it is meant to serve',[52] and Giles Worsley, taking a similar line, has dismissed the Spiral as 'a triumph for Gesture Architecture'.[53]

It has been repeatedly stressed by the museum that the building does fulfil the functions required of it in the brief. This being so, the question of the value of gestures should perhaps be faced head-on. Giles Worsley has claimed that those at the V&A who commissioned the Spiral wanted a 'building that will proclaim them to be modern and forward-looking'. Is this a bad thing? A principal theme in this book has been the V&A's irresolute attitude to the contemporary. In the light of what has been surveyed, would not a gesture on such a scale towards the contemporary be a significant development for the V&A? Borg has commented that in 'our huge, rambling building, you could walk around for ages and fail to realize that we are involved

with contemporary art. But the contemporary is at the centre of what we do'.[54] This will certainly strike a chord with many who want to see the museum revitalized:

Despite the (often thwarted) dynamism of some younger curators, a jobsworth civil service attitude still reigns (grades, tea breaks, cellular offices for senior staff etc.). What the place needs is a great big kick up the backside. And that's where Mr Libeskind comes in. For the V&A the Spiral building could generate a mood of progress ... it will attract a keen, fresh and international audience.[55]

One does not have to go all the way with this cry from the world of avant-garde design to feel that a decisive signal towards the contemporary would do the V&A good.

These two major projects set off enthusiastically. An application to the Heritage Lottery Fund for the British Galleries project was made in 1996. It was turned down. In July 1997, however, the HLF granted the V&A £1.083m for further work on the project. In support of the Spiral an initial application was made to the Millennium Fund. It was turned down. A subsequent application to the Arts Council Lottery Fund has remained under consideration for a long period. Aside from funding, this project had to obtain the approval of the planning authority, the London Borough of Kensington and Chelsea, where there was fierce local opposition to what was regarded as an intruder on a historic townscape. At this point the V&A might well have been dismayed. 'What is the Victoria and Albert Museum doing wrong?' asked journalist Simon Tait. 'Its two bids for Lottery cash have been turned down and its 50-year masterplan for survival is now at risk.'[56] The acerbic art critic Brian Sewell thought he knew the answer. 'The V&A's problems in attracting funds to secure its future come in the wake of decades of haphazard direction and a series of ill-focused, whimsical and tawdry exhibitions ... If not quite an Augean stable, the V&A is certainly the run-down Harrods of the museum world.'[57] This was a moment that required the 'steely nerve and the determination underneath of a hunter, tooth and claw',[58] which one journalist had detected in Borg at his appointment.

Work on both projects continued undeterred. The old British Galleries were due to close, so that the exhibits could be removed and the structure be stripped out, on 31 July 1998. The museum gritted its teeth and refused to postpone the deadline. On 22 July, just in time, came the news that the HLF had made a grant of £15m to the project. The project proceeds and, in the now closed galleries, the transformation scene is under way.

The application for planning permission for the Spiral was due to come before Kensington council's Planning Committee on 16 November 1998. It was known that the council's planning officers had recommended that it be refused. The press shook its collective head over the failure of another V&A project. 'V&A's Extension Spirals into a Nosedive,' crowed one newspaper.[59] But the cliff-hanger worked in favour of the project. As it had become better known, it had attracted warm support, especially among architectural enthusiasts, who shared Borg's view of Libeskind as 'a contemporary genius'.[60] Jonathan Glancey, hailing it as the V&A's 'Great White Hope', and chiding that 'nothing remotely like Daniel Libeskind's sophisticated and daring building has been seen in Britain before', urged the planners to support 'adventurous new architecture'.[61] The Royal Fine Art Commission and English Heritage backed the project. Some of Britain's most celebrated architects, such as Richard Rogers, Norman Foster and Denys Lasdun, spoke up for it.[62] In the event, the Planning Committee did give the go-ahead for the building. The newspaper that had predicted the nosedive was forced to eat its words and confess, 'V&A Triumphs'.[63]

This narrative comes to a close in spring 1999, as the two major projects hold out the hope that the new millennium will see the V&A renewed.

The past in the future

Looking back at the story of the V&A between 1836 and the present, we may be tempted to speculate on what it can teach us about the fundamental nature and purposes of the museum, and on how the museum's history might influence its development in the present and future. There is, of course, no necessity for what the V&A does today to copy or echo what it has done in the past. Indeed, some may think that the conditions of the present – the post-modern collapse of value – might require stern new intervention from museums in order to rescue Western culture. But taking a less apocalyptic view, and assuming that some sort of continuity is feasible, we may reasonably try to extrapolate from our past, especially since the V&A, like all museums, carries its past with it, like the shell on the back of the snail. This past is not just a legacy of policies (which can fairly easily be changed or abandoned if necessary), but a formidable accumulation of collections. These cannot easily be abandoned or even reshaped, and they inevitably constrain the present activities of the museum.

The collections are often seen nowadays primarily as national treasures, as part of the nation's heritage. That view of museum collections is, however, a relatively recent one. The idea of national heritage emerges out of the zeal for the preservation of historical monuments that gathered force in Britain in the later nineteenth century; the most significant portents were the foundation of the Society for the Protection of Ancient Buildings in 1877 and Sir John Lubbock's attempts in the 1870s to enact preservation

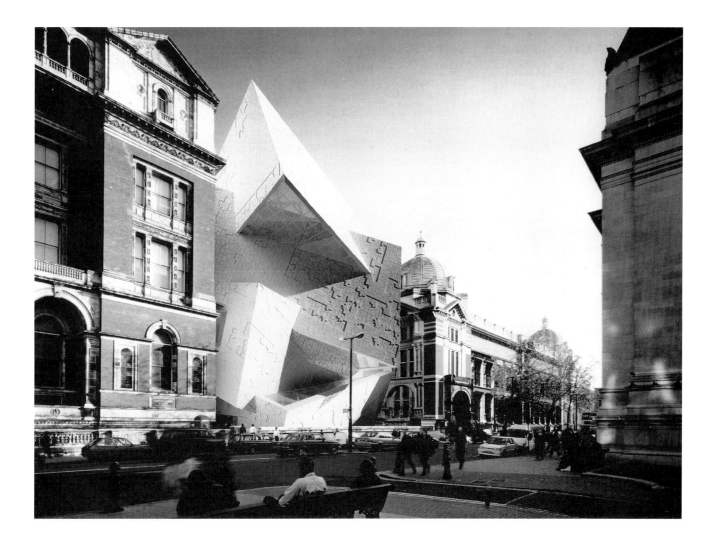

Figure 14.4 The Spiral: a photomontage showing the view south-wards down Exhibition Road with the Spiral in place. Image: Midler Hare; model: Millennium Models; photography: Peter MacKinven.

legislation, culminating in the Ancient Monuments Protection Act of 1882. Gradually, through the ensuing century, cultural property came to be regarded, along with ancient monuments, as part of the country's heritage.

Cole and Robinson, in the 1850s and '60s, did not, there-fore, have at their disposal a rhetoric of national heritage. To be sure, the idea that 'the nation' should purchase historical art was often on their lips. And they had no inhi-bition about regarding the nation's collections as financial assets. Such a view is implicit in the title given to the port-folio of photographs accompanying Robinson's great Loan Exhibition of 1862: *The Art Wealth of England* (p. 66). Henry Cole, in his downright way, made the view fully explicit. Sometimes, it was reported, 'economists would ... start up in the House of Commons and oppose the grants to art, as a waste of public money':

Mr Cole's answer to his critics was unique ... 'Gentlemen, the nation has expended a certain amount of money in buying up Majolica plates and Cellini vases, cabinets and examples of art workmanship in every material and style and period. If it repents of its bargain, I am prepared to find a responsible com-mittee to take the collection off the nation's hands at the price given for it, and pay interest, and compound interest, for the money which has been sunk.' This set the economists a-thinking and inquiring; and they found, that so well had purchases been made, and so greatly had masterpieces of industrial art increased in value, that, if the collection were brought to the hammer, the nation would be unnumbered thousands of pounds in pocket ...[64]

To say that the museum was a sort of art-investment bank was not, however, the same as claiming that it guarded the national heritage.

Historical art had to be commended in other terms. High art was accorded widespread admiration, while decorative art had to work harder to gain respect. All the same, the arguments in support of exhibiting the two types of art were much the same.

When in 1850 the Society of Arts arranged its exhibition of *Ancient and Mediaeval Art*, which was an important foreshadowing of the South Kensington art collections, it justified the exhibition by means of its usefulness to three constituencies:

To the Artist and Manufacturer, an opportunity is afforded of comparing the handiwork of ancient times with the productions of our own skill and ingenuity; to the Amateur, means are supplied of correcting the taste and refining the judgment; to the Archaeologist, materials are presented for observation and study; the very facts and *data* upon which his science is founded are spread out before him.

The Society did not argue that its exhibits were 'heritage' and, indeed, was so unsure of their historical appeal that it admitted that Renaissance objects were 'old fashioned' and medieval works 'products of an age ... considered dark and barbarous'.[65]

There were some, nonetheless, who pressed the claims of heritage. A reviewer of the exhibition regretted that it was confined to art, and omitted 'many relics of the highest historical value', going on to rehearse a case for the 'national heritage', though not using those words:

With the single exception of the British Museum, there is literally no place in this great metropolis to which the thousands of enquiring foreigners who will visit these shores [for the 1851 Exhibition] can resort for the purpose of acquiring any information relative to those treasures of antiquity which this country is well known to possess; and there can be but little question that an Exhibition of Antiquities on a large scale would form an agreeable contrast and relaxation to minds fatigued with the contemplation of improved spinning jennies, or the latest inventions of Sheffield, Paris, Calcutta, or St Petersburgh. Such a scheme, if carried into effect, would tend materially to assist the formation of a department for British antiquities in our national museum [i.e. the British Museum], which has been for some time in progress. It is becoming every day more desirable that records should be preserved of 'merrie England in the olden time.'[66]

If we try to view the early South Kensington Museum through the eyes of the writers just quoted, we may well conclude that the argument most likely to be advanced in its favour was its usefulness to artists and manufacturers, to amateurs and to archaeologists (though, as we have seen through the course of this book, there might be different opinions as to which of these parties should be most favoured). Further, if arguments about the national heritage were advanced, those advocating preservation would have looked to the British Museum to do it, rather than to South Kensington, which in its early days concerned itself less with English than with foreign material. Later, the idea of Englishness was to be important for the museum,[67] but not in the early days.

In asserting 'the public value of [the museum's] collec-tions', and endeavouring to 'confirm their public utility',[68] Cole was accustomed to take his stand on their educational function. It will have become clear from the first chapter in this book that the very first stirrings of the museum, within the School of Design, were in an educational context. Furthermore, so long as the museum used the title 'South Kensington', the collections were inextricably linked in the public mind with the art-school system, which was also referred to for short as 'South Kensington'. The museum's 'historic mission', then, has to be seen as placing education higher than preservation. Some would welcome that as a guiding precedent for the museum's contemporary mission, but others would not.

If the V&A is to be prized above all as an educational institution, many (especially its own employees) might claim for it a status as the Eton or Oxford of museums. It is worth recalling, however, the attempt made in Chapter One of this book to 'place' it in the educational economy of Britain in the 1830s: here it was concluded that the School of Design entered upon the scene at more or less the same level as the Mechanics' Institutes; 15 years later the South Kensington Museum seemed ripe for absorption into Prince Albert's 'Industrial University', an institution that would have struck out on a quite different path from England's older universities. However much status the V&A may have subsequently attained within the Establishment, it was at the start quite a radical venture aimed at the underprivileged.

Whether 'education' now provides a fitting star to which the museum's waggon may be hitched depends on how you define 'education'. In the museum's early days, the definition (though radical and innovative at the time) was a very narrow one. The museum collections were intended to provide models from which, in a deeply historicist age, craftsmen and designers could copy, so as to produce better goods. Later, when Cole took over, the museum's mission was seen as being concerned not only with producers but, even more, with consumers. In Cole's phrase in the *First Report of the Department of Practical Art* (p. 2), the museum was to be a means 'by which all classes might be induced to investigate those common principles of taste, which may be traced in the works of excellence of all ages'. This phrase may well be the nearest we can come to an original mission statement. For there was no resounding declaration of faith when the Department of Science and Art began: it was just inaugurated by a Treasury Minute. Eventually, in 1864, it obtained a royal charter of incorporation, but this merely authorized it 'to do any act or thing that may be conducive to the attainment of the objects for which the said Department has been founded or incidental thereto'.[69] In the absence of anything more distinct, Cole's phrase was often cited in later times as a rationale for the museum – as,

for instance, in Charles Gibbs-Smith's small picture book, *The History of the Victoria & Albert Museum*, first published in 1952.

The mention of 'all classes' seems to provide for the museum a wide, democratic basis, which is agreeable to our present-day outlook. There is no such expansive attitude towards taste, however. When Cole speaks of 'those common principles of taste, which may be traced in the works of excellence of all ages', we can be sure (for we have examined his beliefs about taste in Chapter Two) that he is taking a very authoritarian position. People interested in taste are very often extremely firm about it. A century after Cole, Nikolaus Pevsner could be heard asserting that good taste must be imposed 'from on high', that the visual 'language of our century' must be 'universal'. 'Don't say that it is only natural for different classes to wish to express themselves in completely different styles, one modern and one, say, Georgian.' A single style affirmed by everyone, would, in Pevsner's view, be 'a healthier state of affairs'. 'How can it be accomplished here? Don't ask me. I only know that it must ...'[70]

Although Cole and Pevsner were in the same business of laying down the law on taste, their tastes would not have been the same. And, as it happened, the modernist standard of taste that Pevsner asserted in the 1950s would probably not have been the kind of taste of which the V&A approved at that time. These differences go to show, as does all the evidence, that it is indeed natural for people (as individuals, if not as whole classes) to express themselves in different styles. The desire of design pundits to lay down the law is futile – though seemingly irresistible. There is no doubt that Cole wanted his museum to lay down the law in matters of taste. There is certainly a doubt whether Cole's museum had any real authority to do so, even if it was an educational institution supported by the State's money. Surely there is no doubt that the V&A today, in an atmosphere of post-modern pluralism, cannot set itself up as an arbiter of taste with any degree of credibility.

Even if the museum had in the past the confidence to assert laws of taste, can it be proved that they were accepted on a wide scale? If there is, from time to time, an obvious relation between a swing of taste in the museum and in the world at large, how can we prove that the museum influenced the world, rather than vice versa? The evidence is grievously flimsy. When the museum took a negative stand in matters of taste, as it did against Art Nouveau (p. 169), it had little effect. Why should it have had a positive effect on other issues of taste?

If Cole's mission to lay down the law on taste cannot be a valid one today, what about his belief that the museum would have the power to influence the design of consumer goods? Again, the crucial question here is whether this assumed power can be proved ever to have been effective. What sort of evidence can be adduced? As we have seen (pp. 108–10), the International Exhibitions of the nineteenth century did seem to provide some kind of structured, reasonably objective scale of judgment, against which the South Kensington Museum showed up well. In more recent times, when far more variables enter into calculations about the effect of the museum, the evidence is again thin. 'One of my assistants,' ventured Cecil Smith in 1924, 'believes that the reintroduction of the wide skirt was brought about by the creators coming here and studying that special phase in our costume exhibition.'[71] Barbara Morris's book, *Inspiration for Design: The Influence of the Victoria and Albert Museum* (1986), makes the best of what can only be a rather weak case.

It is worth reflecting that museums of painting do not try to demonstrate that they directly influence the work of contemporary painters; nor do science museums try to prove that they directly inspire more inventions; nor geological museums that they cause the production of more oil; nor military museums that they win battles. These museums see their educational mission in terms of encouraging appreciation and understanding in their visitors, rather than in terms of measurable results. It seems rather eccentric of the V&A still to want to prove that it is actively changing the world. Cole's sense of conviction still perhaps imbues the museum. But today we are considerably more sophisticated about 'performance indicators' than his contemporaries were, and it is all the harder therefore to prove that any particular effects have been caused by the museum.

If the museum accepts that times have changed, and that it should reckon its influence upon visitors in terms of arousing appreciation and understanding, rather than in imposing doctrinal conformity, it will have to admit that its effects upon visitors are many and varied, and largely unpredictable. If this realization of the diversity of response is reflected back on to the collections, it will illuminate the fact that these have, not simply a single significance as a monolithic standard of taste, but infinitely varied meanings that can be revealed in different ways at different times to different people. The 'polyvalency' of things is nowadays the museum world's first article of faith, professed in the terms 'material culture' and 'cultural material'. These by no means render 'art' obsolete, but do imply that art objects are only a sub-set of all objects, not a category apart.

Is this a view that can be traced back to the V&A's founders, and thus incorporated in its 'historic mission'? Only with difficulty. The phrase that concludes Henry Cole's acquisition policy of 1863 (p. 101) may seem to imply it. 'The aim of the Museum,' he says, is 'fully to illustrate human taste and ingenuity.' This may seem, when

quoted by itself, to be a charter for a museum of material culture in the widest sense, but the phrase is, in context, only a gloss on a more restrictive aim, 'to make the historical and geographical series of all decorative art complete'. Robinson may seem even more sympathetic to the wide expanses of material culture when he says:

True forethought would suggest the collection of many things of little intrinsic value, the real importance of which, in the point of view of historical sequence or merit in design, may nevertheless be very considerable. There are numerous classes of objects that have always been held to be beneath the notice of the connoisseur, and which have never yet been exalted to the level of collections – many phases of taste and characteristic expression, of which, from the trivial or valueless vehicle in which they are embodied, in a few years all trace or record is lost; such works of earlier periods, many examples of which will suggest themselves, should above all be secured. How constantly does it happen that gold is given for things whose value once was pence![72]

As we have already suggested (p. 38), Robinson probably has in mind the kind of medieval artefacts that were regarded as rubbish in his day, but are now among the V&A's most precious treasures. All the same, these remarks by Cole and Robinson indicate that their minds would have been capable of extending to embrace the modern concept of 'material culture'.

One of material culture's most prominent advocates has recently claimed for it the status of 'a relatively new and distinct discipline', which nonetheless brings together participants nurtured in other disciplines, such as 'anthropologists, archaeologists, scholars of American studies, historians of technology, art historians, folklorists, cultural geographers, and others'.[73] This inter-disciplinary fusion may remind us, perhaps, of Prince Albert's efforts to create a great inter-disciplinary federation in South Kensington. He only got as far as grappling Science and Art together administratively, and in 1909 they were disconnected. The V&A then withdrew behind the frontiers of the apparently autonomous realm of Art, but it is salutary to remember that the museum's territory was at first envisaged as being much more extensive. In recent years the quiet domain of Art, in which the V&A felt itself comfortable, has been thrown open to interlopers from social history, literary theory and ideologies such as Marxism and feminism. We have seen (p. 232) that some V&A staff were hostile to this, but others welcomed the breezes from the world outside, and the museum has become somewhat more expansive.

What is at issue at this point in our meditations is the *type* of object that the V&A collects. Limits of chronology and geography are easier to fix. It has been clear from the start that the V&A's chronological coverage runs from Late Antiquity or the Early Middle Ages (i.e. where the British

Museum left off in the 1850s) to the present. Its geographical coverage leaned in the early days towards Europe (because the museum was based on the premise that the example of Europe was necessary to redress the decline in British decorative art), but gradually rebalanced to include Britain. The example of the International Exhibitions, especially that of 1851, held up before the museum the possibility of worldwide coverage. Indian and Near Eastern objects were among the earliest purchases by the museum from the 1851 Exhibition, and Britain's colonial involvements ensured that Indian and Near Eastern art continued to be welcome in the museum. Material from Africa, however, was never acquired – even though, fleetingly, Henry Cole thought that it should be (p. 80). Far Eastern art impinged on the West in the later nineteenth century, and settled easily into the museum's holdings of decorative art in one or another material, though it was not at that stage studied as evidence of the culture of China or Japan. The chronological and geographical boundaries of the museum's field are, then, fairly easy to define. But whether the museum is to collect mousetraps, steam locomotives, flint arrowheads and nose flutes is more difficult to decide. What is it that determines that chalices are allowed in while coffins are kept out; swords in, woodworking tools out; hats in, spectacles out; teapots in, beermats out; pianos in, bells out; T-shirts in, banknotes out … ?

The museum may, in a spirit of generosity or adventure or prescience, extend its range in the future. But this inevitably requires a reconsideration of what modern management-speak calls its 'core concerns'. What, in the end, is the museum about? The V&A has the drawback that its name does not describe what it is about – a problem shared by many museums named in honour of famous people. The Tate Gallery has the same problem, and has commissioned a design consultancy, Wolff Olins, to find it a new name.[74] In the September 1998 issue of the *V&A Magazine*, Alan Borg light-heartedly challenged his readers (primarily the Friends of the V&A) to find 'a neat, snappy name that actually encapsulates all the things we do'. The idea that the V&A might change its name was taken surprisingly seriously in the media, but the general view was that the existing name was an asset. 'The V&A is a world-class brand name,' commented a museum professional in the *Museums Journal* for October 1998 (p. 13); 'most cultural institutions would give their eye teeth for something as strong'. The problem remains, though, that the name does not describe the scope and purpose of the museum. The subtitle generally used in publicity today, to explain the museum to the world at large, is 'The National Museum of Art, Craft and Design', and this serves as well as any unpretentious selection of plain terms could do.

For insiders, however, the terms 'ornamental art', 'industrial art', 'decorative art' and 'applied art' constantly jostle for consideration. We know more or less what we and others mean by them, and they have equivalents in most languages. A search for precise definitions could sustain long and complex debate. One thing stands out, however. Alongside 'art', these categories encompass 'use'. Decorative art, said J.C. Robinson, is 'art which finds its material expression in objects of utility'.[75] Not all art is useful; indeed it is often claimed as a virtue for high art that it is not useful. Not all useful things are artistic. But there is a middle ground occupied by objects that can offer satisfaction to those who contemplate their aesthetic quality, but that also have practical functions. The V&A has, throughout its existence, presented its exhibits as worthy objects of aesthetic contemplation, but has been little concerned to explain their utility. Perhaps this is a slant that deserves greater attention. The investigation of utility in objects necessarily involves some consideration of those who use them: consideration, in other words, of the social context of objects. This too has been little explored in the V&A's galleries. It can be encapsulated in some such formula as: 'The V&A is concerned with artistic objects made by humankind for use in religious, social and domestic life.' This is a generalization that fits quite closely and comfortably, though it does not make the blood run faster. Here is a more aphoristic formulation. If we take the view that the V&A's forward progress might, perhaps, be orientated by a triangulation process, taking as its points of reference art, utility and the social context of art, then the V&A might call itself 'A Museum of Art for Use in Life'.

If a single ruling concept is sought to sum up the museum's concerns, perhaps it might be 'human creativity'. The V&A's web-site does, indeed, state that the collections 'span at least 3,500 years of mankind's creativity'. (It is in the Oriental collections that the museum's chronological span extends back beyond the early Middle Ages.) An eloquent elaboration on the theme of creativity was supplied in the 1880s by the American, Moncure Conway. Not for nothing was Conway a preacher before he was a journalist. Of South Kensington he said:

It is a Museum of Civilization, where each work is a heart. There sat a man doing his very best to advance the whole world; there marched a brave invader of Chaos and Disorder; a reason worked through him like that which turns a bit of mud into a lily. It is a supreme joy to trace these foot-prints of the universal Reason. A flute-key that wins one more soft note from the air; a pot flushed with some more intimate touch of the sunlight; an ornament which detaches a pure form from its perishable body – such things as these exhibit somewhat finer than themselves, namely, man elect still to carry on the ancient art which adorned the earth with grass and violet, and

framed the star-gemmed sky and spotted snake. The student shall also learn here the solidarity of genius. In distant regions of the world these men worked at their several tasks, sundered by land and sea, but here they are seen to have been members of one sacred guild, like that described of old: 'They helped every one his neighbor; and every one said to his brother, Be of good courage. So the carpenter encourageth the goldsmith, and he that smootheth with the hammer him that smote the anvil, saying, It is ready for the soldering; and he fastened it with nails, that it should not be moved.' From manifold regions of the world, through ages linked each to each by national piety, their works have come here to unite in one mystical symphony of excellence.[76]

Not quite up to the standard of Ruskin or Pater, but there is real passion here, and it is good to see such evidence that the museum can arouse emotion.

Even to wrestle in the space of a few paragraphs with the problem of economically defining the V&A is enough to show how difficult the task is. Better, perhaps, just to stress that the museum *exists*; that, through a process of historical development, it has come into being, and no one can gainsay its presence. If a historian were to succumb to the temptation to adopt that attitude, then the resulting story of the V&A would probably be just a celebratory account. Such a history could take the line that from small acorns grow great oaks. It could exult in the emergence, from an odd little teaching collection in an ill-starred college, of one of the world's greatest museums. The present account is, however, driven by the question 'Why?' Instead of charting the irresistible rise and rise of the V&A, I have tried to show what I think is the truth of the matter – that the museum has developed, as institutions do, fitfully, sometimes by design, sometimes by accident, sometimes getting stuck in blind alleys, sometimes leaping forward; always influenced by a mixture of human motives. These final reflections on how the aims of the founders have worn through the years emphasize the frequent disjunction between intention and achievement. I hope nonetheless that this account of the V&A's history has not seemed merely to be a chapter of accidents, but can stand as a positive record of achievement, sustained by vision.

Perhaps the best way for the museum to ensure that it remains lively and purposeful is for it to carry on asking 'Why?'; to meet the challenge of constantly explaining itself to the widest possible audience. This challenge has been urgently present for all museums in recent times, but it was there for the V&A from the first. 'All classes', said Cole, were to be addressed. J.C. Robinson, often thought to be the highest and driest of curators, wrote this (which all curators should hang over their beds): 'To elucidate and explain a work of art down even to the capacity of a child is not necessarily to vulgarize it. The refined connoisseur may enjoy the choicest specimen none the less because it is made

the vehicle of instruction to the unlearned.'[77] And Cole again, in a burst of bracing eloquence:

Other collections may attract the learned to explore them, but these will be arranged so clearly that they may woo the ignorant to examine them. This Museum will be like a book with its pages always open, and not shut.[78]

NOTES

1 *Victoria and Albert Museum. Report of the Board of Trustees, 1 April 1992–31 March 1995*, London: Victoria and Albert Museum, 1995, p. 11.

2 'Alan Borg – a safe choice for the Victoria and Albert Museum', *Art Newspaper*, June 1995.

3 Antony Thorncroft, 'Jackpot for the V&A', *Financial Times*, 27 May 1995.

4 'V&A's new leader is presentation wizard', *The Times*, 20 May 1995.

5 Peter Popham, 'The Trouble with the Victoria & Albert', *Independent*, Section Two, Tuesday 19 December 1995, p. 7.

6 Joanna Pitman, 'The Man who can Play to the Galleries', *The Times*, 26 May 1995, p. 18.

7 Victoria McKee, 'Riding into the V&A', *Sunday Times*, Sunday Review,

8 William Feaver, 'Game, Set and Match to Borg', *Observer*, Review section, 21 May 1995, p. 4.

9 Letter in *Evening Standard*, 15 April 1998.

10 'Editorial. Getting and spending at the V.&A.', *Burlington Magazine*, vol. 138, 1996, p. 499.

11 Lynn Truss, 'Dusty old institutions defy being dusted off', *The Times*, Thursday 24 October 1996, p. 47; Victor Lewis-Smith, 'What a Way to Waste a Year', *Evening Standard*, Thursday 24 October 1996, p. 31.

12 'V&A's new leader ...'

13 'New V&A chief "not opposed to admission fees"', *The Times*, 20 May 1995.

14 'Editorial. Getting and Spending ...'

15 Sean O'Hagan, 'Labour's Love Lost', *Guardian*, 13 March 1998, G2, pp. 12–13.

16 John Tusa, 'Why I'm Worried about Tony', *The Times*, 11 March 1998. John Tusa, 'What Tony Said Next', *Guardian*, 4 July 1998, Saturday section, p. 5. Brian Sewell, 'Footsteps of the Three Disgraces', *Evening Standard*, 30 April 1998. Hugo Young, 'Culture? No, these people prefer to be seen with Noel Gallagher', *Guardian*, 21 May 1998, p. 20.

17 Nigel Reynolds, 'So Why do they all Hate Mr Nice Guy?', *Daily Telegraph*, 12 June 1998, p. 10.

18 'Charge of the Tight Brigade', *Economist*, 15 November 1997, p. 39.

19 Neil MacGregor, 'A state of national emergency: if Britain's museums start charging admission, the doors will close to the people', *New Statesman*, 7 November 1997, pp. 36–8. Cf. Roger Rosewall, 'We must fight this betrayal of our great museums', *Mail on Sunday*, 16 November 1997, p. 32. Andrew Marr, 'Don't end one of our few great Enlightenment legacies', *Independent*, 26 November 1997, p. 23. Robert Anderson, 'The joy of discovery must be free for all', *Daily Telegraph*, 27 November 1997, p. 27.

20 David Lister, 'The Week in the Arts', *Independent*, 29 November 1997, p. 20.

21 Dalya Alberge, 'V&A tries to block entry subsidy', *The Times*, 3 December 1997.

22 Dalya Alberge and Philip Webster, 'Smith accused over £1m museum U-turn', *The Times*, 19 December 1997.

23 Dan Glaister, 'V&A head savages squeeze on arts cash', *Guardian*, 6 February 1998, p. 2.

24 Dalya Alberge, 'Museum charges will be scrapped by 2001', *The Times*, 25 July 1998, p. 2.

25 Roger Tredre, 'Money too tight for free galleries', *Observer*, 2 August 1998, p. 16.

26 Mark Fox, 'U-turn as Labour Keeps the Museum Turnstiles', *Express on Sunday*, 17 January 1999, p. 2.

27 'Museums: Designer Profits', *Economist*, 16 August 1997; Richard Phillips, 'V&A Pioneers a Brand New Strategy', *Independent on Sunday*, 15 February 1998, Business section, p. 4.

28 Jonathan Glancey, 'My friends went to the Tate and all they got me was this lousy pair of gloves', *Guardian*, 19 July 1997, The Week, p. 6. Cf. Brian Ashbee, 'Takeaway Art', *Art Review*, May 1997, pp. 60–3.

29 Robin Stringer, 'Now is the winner of our discontent', *Evening Standard*, 27 August 1997. 'Our national talent for the art of losing money', *Observer*, 9 November 1997, pp. 16–17. Felicity Owen, 'That race against time', *Spectator*, 6 June 1998, p. 38. Antony Thorncroft, 'Funding the new temples of culture', *Financial Times*, 25 November 1998. Joanna Pitman, 'How the lottery has played to the Tate Gallery', *The Times*, 2 February 1999.

30 'Blair begins to divert Lottery money', *Art Newspaper*, November 1997, p. 6.

31 *Independent*, 27 July 1998, p. 1.

32 Brian Sewell, 'If we are spending £800m on this ... Can't we spare £10m for these?', *Evening Standard*, 25 November 1997, pp. 8–9.

33 Editorial, 'Museum charges will always be too high a price to pay', *Independent*, 1 December 1997, p. 12.

34 Dan Glaister, 'Dome rises as axe falls again on arts cash', *Guardian*, 17 January 1998, p. 3.

35 Peter Popham, op. cit.

36 V&A Press release '£15 Million Lottery Grant for V&A's Innovative British Galleries Development', 22 July 1998.

37 John Whitley, 'The V&A Team', *Daily Telegraph Magazine*, 17 May 1998, p. 53.

38 Nonie Niesewand, 'Dinah Lights the way at the V&A', *Independent*, 29 January 1998.

39 Whitley, op. cit.

40 Joanna Pitman, 'Smile! You're being done up', *The Times*, 22 July 1998.

41 Nonie Niesewand, 'The decorators are in at the V&A until 2001', *Independent*, 24 July 1998.

42 E. Jane Dickson, 'Ms Poppins' £100m dream', *Daily Telegraph*, 23 December 1995, p. A4.

43 James Fenton, 'Object Lessons', *New York Review of Books*, 15 January 1998, pp. 40, 45.

44 Robert Armstrong, 'Why the V&A didn't play it safe', *The Times*, 4 June 1996.

45 Jonathan Glancey, 'Right Side of the Wall', *Guardian*, G2, 27 July 1998, pp. 10–11; Giles Worsley, 'The Museum of No Way Out', *Daily Telegraph*, 22 July 1998, p. 20.

46 Jonathan Glancey, 'The Hole in the Heart', *Guardian*, G2, 27 January 1999, pp. 14–15; 'Memorializing the Unborn', *Art Newspaper*, July/August 1998, pp. 12–13.

47 Jeremy Melvin, quoted (p. 79) in Charlotte Benton, '"An insult to everything the Museum stands for" or "Ariadne's thread" to "Knowledge" and "Inspiration"? Daniel Libeskind's extension for the V&A and its Context. Part I', *Journal of Design History*, vol. 10, 1997, pp. 71–91.

48 Mark Irving, 'Daniel Libeskind likes his Buildings Tall and Thin ...', *Scotsman*, 31 October 1998.

49 Charles Saumarez Smith, 'Grand by whose design?', *Journal of Victorian Culture*, vol. 3, no. 2, autumn 1998, p. 352.

50 Rowan Moore, 'Just blame it all on Bilbao', *Evening Standard*, 29 December 1998.

51 Simon Jenkins, 'Pilgrimage to Bilbao', *The Times*, 18 September 1998.

52 Gavin Stamp, 'All Rise for the Superstar Architects', *Independent on Sunday*, 22 November 1998, Real Life Section, p. 2.

53 Giles Worsley, 'Gesture Buildings, Gesture Politics', *Daily Telegraph*, 18 November 1998.

54 'Edging toward the Cutting Edge – and Commerce', *Art Newspaper*, February 1999, p. 24.

55 'Editorial. Inside Story', *Blueprint*, December 1998, p. 9.

56 Simon Tait, 'Going for Broke', *Evening Standard*, 11 March 1997, p. 29.

57 Brian Sewell, 'A Farce that Must Not Run and Run', *Evening Standard*, 13 March 1997, p. 28.

58 Joanna Pitman, 'The Man who...'

59 Dan Glaister, 'V&A's extension spirals into a nosedive', *Guardian*, 13 November 1998, p. 28.

60 Alan Borg, Letter: 'Be Libeskind to spiral design', *Kensington & Chelsea News*, 12 November 1998.

61 Jonathan Glancey, 'Great white hope', *Guardian*, G2, 2 November 1998, p. 10.

62 David Taylor, 'Architecture world hails Libeskind Spiral approval', *Architects' Journal*, 19 November 1998.

63 Editorial, 'V&A triumphs', *Guardian*, 18 November 1998, p. 23.

64 Walter Smith, *Art Education, Scholastic and Industrial*, Boston: Osgood, 1872, pp. 19–20.

65 *Catalogue of Works of Antient and Mediaeval Art, Exhibited at the House of the Society of Arts, London, 1850* [cheaper version in smaller type], p. 2, 'Prefatory Remarks'.

66 'The Exhibition of Ancient and Mediaeval Art', *Illustrated London News*, 13 April 1850, p. 252.

67 Charles Saumarez Smith, 'National Consciousness, National Heritage, and the Idea of "Englishness"', in Malcolm Baker and Brenda Richardson (eds), *A Grand Design: The Art of the Victoria and Albert Museum* exhibition catalogue, New York: Abrams, and the Baltimore Museum of Art, 1998, pp. 275–83.

68 *Introductory Addresses on the Science and Art Department and the South Kensington Museum. No. 1. The Functions of the Science and Art Department. By Henry Cole ...*, London: Chapman and Hall, 1857, pp. 20, 21.

69 *Twelfth Report* [for 1864], p. 22, and see p. xix.

70 Nikolaus Pevsner, 'Arts, Manufactures and Commerce 1754–1954. The Three Bicentenary Lectures. I. The Arts', *Journal of the Royal Society of Arts*, 16 April 1954, p. 404.

71 'Dress Fashions – From the Museum!', *Evening Times*, 11 September 1924: V&A Cuttings Book, Times 9, October–December 1924, p. 82.

72 'Memoranda and Suggestions', *First Report* [for 1853], p. 229.

73 'Introduction', in W. David Kingery (ed.), *Learning from Things: Method and Theory of Material Culture Studies*, Washington: Smithsonian Institution Press, 1996, p. 1.

74 'Expanding Tate May Choose New Identity', *Evening Standard*, 14 September 1998.

75 J.C. Robinson, *Department of Science and Art. Catalogue of a Collection of Works of Decorative Art; ... Circulated for Exhibition in Provincial Schools of Art*, London: HMSO, 1855, p. 4.

76 Moncure Daniel Conway, *Travels in South Kensington, with Notes on Decorative Art and Architecture in England*, London: Trübner, 1882, pp. 111–12. The biblical quotation is from Isaiah 41.6–7.

77 *Introductory Addresses on the Science and Art Department and the South Kensington Museum. No. 5. On the Museum of Art. By J.C. Robinson*, London: Chapman and Hall, 1858, p. 8.

78 *Introductory Addresses ... No. 1 ... By Henry Cole ...*, p. 21.

Attendance Figures

From the Annual Reports of the Department of Science and Art

Museum of Ornamental Art, Marlborough House

Year	Figure
1852 (Oct–Dec)	25,397
1853	125,453
1854	104,823
1855	78,427
1856	111,768
1857 (1 Jan–7 Feb)	16,662

South Kensington Museum

Year	Figure
1857 (from 22 June)	268,291
1858	456,288
1859	475,365
1860	610,696
1861	604,550
1862	1,241,369
1863	726,915
1864	653,069
1865	692,954
1866	756,075
1867	646,516
1868	881,076
1869	1,042,654
1870	1,014,849
1871	939,329
1872	1,156,068
1873	859,037
1874	914,127
1875	830,212
1876	1,173,351
1877	913,701
1878	884,502
1879	879,395
1880	981,963
1881	1,017,024
1882	961,726
1883	1,093,810
1884	963,117
1885	899,813
1886	823,999
1887	788,412
1888	897,225
1889	874,808
1890	831,460
1891	919,573
1892	957,112
1893	1,174,211
1894	1,057,279
1895	1,040,628
1896	1,135,797
1897	1,017,314
1898	977,305

Victoria and Albert Museum (Art and Science)

Year	Figure
1899	954,445

From the V&A Annual Reports

Year	Figure
1900	846,489
1901	836,848
1902	855,931
1903	856,943
1904	848,969
1905	878,200
1906	843,746
1907	925,313

Victoria and Albert Museum (Art only)

Year	Figure
1908	397,257
1909	718,921
1910	967,592
1911	752,570

From The Year's Art

Year	Figure
1912	730,151
1913	692,426
1914	563,848
1915	574,577
1916	650,507
1917	*785,000
1918	*489,000

From the V&A Annual Reports

Year	Figure
1919	675,990
1920	941,186
1921	1,276,548
1922	913,040
1923	1,035,880
1924	1,318,049
1925	1,190,707
1926	1,103,318
1927	1,020,006
1928	937,577
1929	930,463
1930	827,681
1931	791,527
1932	806,076
1933	820,317
1934	810,361
1935	794,886
1936	859,969
1937	763,439
1938	736,483
1939	*487,000
1940	*105,000
1941	*90,000
1942	*211,000
1943	*324,000
1944	*184,000
1945	*561,000
1946	*858,000
1947	*608,000
1948	*912,000
1949	*723,000
1950	*963,000
1951	*908,000
1952	*795,000
1953	*787,000
1954	*1,035,000
1955	*739,000
1956	*775,000
1957	*790,000
1958	*873,000
1959	*853,000
1960	*964,000
1961	*886,000
1962	*1,010,000
1963	*854,000
1964	*1,010,300
1965	*976,900

From internal source

Year	Figure
1966	1,111,581
1967	1,219,253
1968	1,306,909
1969	1,262,567
1970	1,460,082
1971	1,785,814
1972	1,359,696
1973	1,303,083
1974	925,032
1975	1,064,651
1976	1,245,740
1977	1,956,142
1978	1,594,137
1979	1,644,381
1980	1,393,182
1981	1,368,460
1982	1,677,063
1983	1,817,757
1984	1,577,608
1985	1,644,952
1986	1,003,306
1987	916,476
1988	996,501
1989	952,992
1990	903,688
1991	1,068,428
1992	1,182,402
1993	1,072,092
1994	1,410,162
1995	1,224,030
1996	1,271,964
1997	1,062,296
1998	1,149,818

* rounded-out figures from internal source

Credits and Acknowledgements

We are grateful to the following individuals and institutions for permitting the use of their material in this publication.

Nicholas Bromley: 8.7

Director, British Geological Survey (NERCO copyright reserved): 7.1

Mrs Hockliffe: 2.12

the *Independent*: vignette, chapter 13

London Transport Museum: 11.3.

Hazel Nash: 10.11

Desmond O'Neill Features: 13.5.

The National Portrait Gallery, London: 4.8, 4.9; Reserved / National Portrait Gallery: 9.1.

John Physick: 8.6

Harold Rackham: 9.9

Scarfe / Times Newspapers, 1986: 13.8

Trog / the *Observer*: 13.11

Robin Wade Design Associates: 13.2

We are also grateful to Elizabeth Bonython for permission to quote unpublished copyright material by Henry Cole.

Index

Pages including illustrations are indicated in *italic*.

The precursors of the Victoria and Albert Museum have separate entries as *Museum of Ornamental Art* and *South Kensington Museum*. Buildings and institutions outside London are usually to be found under their place-name; this applies also to exhibitions outside London.